EXPLORING ART

EXPLORING ART

A Global, Thematic Approach

REVISED FIFTH EDITION

Margaret Lazzari
Gayle Garner Roski School of Fine Arts, University of Southern California

Dona Schlesier
Emerita, Divine Word College

Australia • Brazil • Mexico • Singapore • United Kingdom • United States

Exploring Art: A Global, Thematic Approach,
Revised Fifth Edition
Margaret Lazzari, Dona Schlesier

Product Director: Marta Lee-Perriard

Senior Product Manager: Vanessa Manter

Product Assistant: Teddy Coutracos

Marketing Manager: Laura Kuhlman

Senior Content Manager: Lianne Ames

IP Analyst: Ann Hoffman

Senior IP Project Manager: Betsy Hathaway

Production Service: Joan Keyes, Dovetail Publishing Services

Compositor: MPS Limited

Art Director: Sarah Cole

Text Designer: Frances Baca with Shawn Girsberger

Cover Designer: Sarah Cole

Cover Image: © 1993 Jaune Quick-to-See Smith

For product information and technology assistance, contact us at
Cengage Customer & Sales Support, 1-800-354-9706 or
support.cengage.com.

For permission to use material from this text or product,
submit all requests online at
www.cengage.com/permissions.

Library of Congress Control Number: 2019940275

Student Edition:
ISBN: 978-1-337-70991-0

Loose-leaf Edition:
ISBN: 978-1-337-90903-7

Cengage
20 Channel Center Street
Boston, MA 02210
USA

Cengage is a leading provider of customized learning solutions with employees residing in nearly 40 different countries and sales in more than 125 countries around the world. Find your local representative at **www.cengage.com**.

Cengage products are represented in Canada by Nelson Education, Ltd.

To learn more about Cengage platforms and services, register or access your online learning solution, or purchase materials for your course, visit **www.cengage.com**.

Printed in the United States of America
Print Number: 01 Print Year: 2019

BRIEF CONTENTS

CONTENTS

Part III

MAKING ART PART OF YOUR LIFE 437

PREFACE

From the very first edition of *Exploring Art*, we envisioned a revolutionary approach to teaching and learning art appreciation. All other existing art appreciation course materials were devoted almost exclusively to Western art—and covered it in chronological order. We decided instead to emphasize ideas with examples of art from around the world. We believed our approach would be more meaningful to our readers, most of whom had not studied art before taking an art appreciation course. Our overall intent has always been to have the student become more curious about the art produced by fellow human beings around the world and develop the desire to see and learn more about it. The success of *Exploring Art* proves this.

Now, here is the revised fifth edition, which continues the goals we set out for all previous editions. This revision maintains the existing narrative and weaves into it the answers to these questions: Why should anyone study art? What benefit comes from studying art?

The revised fifth edition shows you that art enriches your life. It shows art that deals with the issues that affect both the individual and the community. Studying art can make you better at any job with a visual component to the work. It helps you better understand your cultural heritage. It can make you a better visual thinker. It helps you understand the world today and helps develop a worldview along with communication, politics, economics, religion, or trade. Understanding art is essential to becoming a responsible world citizen.

ORGANIZATION OF THE TEXT

Exploring Art opens with a letter to students that outlines the many benefits of studying art. It clearly lays out the reasons to pursue art appreciation. Check it out right after this Preface.

Next come the four introductory chapters, which provide a foundation for understanding and appreciating the world art. These chapters (1) define art and discuss artists, (2) present the basic elements of art and architecture, (3) examine the full range of art materials and media, and (4) lay out the fundamental concepts in art criticism.

They are followed by ten thematic chapters, which are world tours featuring art that embodies human dreams, visions, desires, fears, and speculations. Students are enriched and challenged when studying art in the context of themes and ideas that appear in every culture, across the ages. The global approach allows you to see the similarities that connect cultures as well as their differences. The themes (*Survival and Beyond, Religion, The State,* and *Self and*

Society) show art to be a meaningful endeavor that deals with fundamental human concerns. The chapters present topics of deep interest, such as human survival, places of worship, memorial practices, politics, social protest, family structure, sexuality, self-identity, technology, nature, and entertainment.

Chapter 15 was new in the fifth edition and has been reworked for this revised edition to show connections among art, visual culture, and mass media. It starts with ways to bring art into our lives. This revision expands the discussion to show ways to use your understanding of art to critically evaluate mass media and popular culture. This product gives you tools to analyze art and assess its influence in your life. You can use those same tools to be critical about all the images you see that circulate in advertising, news, entertainment, and all forms of mass media.

SPECIAL FEATURES

In addition to solid explanations of artworks and their context, *Exploring Art* has some special features.

We are still very excited about *Art Experiences*, a feature that was new to the fifth edition. We believe that everyone can understand art on a deeper level when they make it rather than simply read about it. Each chapter has several *Art Experiences* with projects for students to make art related to the chapter theme, using accessible materials and processes such as found objects, collaged imagery, diagrams, videos, or digital photos. The projects are designed to be successful for students at all levels of art skill.

All chapters open with a brief introduction and Preview. *Chapter Opening Videos* are also available in MindTap. These features present overviews and key ideas for each chapter and, in the case of the videos, also answer this question: Why do these ideas and artworks matter in everyday life?

Each of the thematic chapters (5–14) opens with a cluster of features that improve students' historical and geographic understanding of the art. The History Focus briefly covers world history within a designated time period, and artwork from the chapter is tied to the events discussed there. Each thematic chapter has both a World Art Map, which geographically locates the works in that chapter, as well as a more specific detail map. The final component of these historical and geographic features is a Timeline, so students can chronologically place the chapter's artwork in relation to major world events and cultural achievements. These features make students aware of the larger social, political, and cultural context that serves as a background to the art they are studying.

In addition, most sections of the thematic chapters present a focus figure, which is often a Western example. This is helpful for instructors whose art history training was Western based. Focus figures encourage class discussion because they use the compare-and-contrast method in relation to the other works in that section.

NEW TO THIS EDITION

Here are the key changes to the revised fifth edition, as well as those that were new in the fifth edition of *Exploring Art*.

- The *Open Letter to Students* is new to the revised fifth edition. This feature lays out clearly all the cultural and real-world benefits of studying art.

▨ New *Chapter Opening Videos*

Each chapter has a *Chapter Opening Video* in MindTap that takes a closer look at a key idea in that chapter. It also asks questions that encourage students to connect the chapter topics to their everyday lives.

▨ New *Section Openers*, completely updated for the revised fifth edition.

Now, each section opens with new images that reflect the "art in your life" focus of the revised fifth edition. They include a popular Japanese woodblock print, a person making a ceramic vessel, and public art along transit lines in North Carolina.

▨ New *Art Experiences*

Each chapter has three boxed *Art Experiences* assignments. These give students an opportunity to make their own art and share it with their classmates, making the chapter's art relevant to students' lives.

▨ Redesigned Timelines

The layout of the Timelines at the beginning of each thematic chapter is now horizontal so that the chronology can be seen more clearly. More images have been added to help students draw chronological connections.

▨ Enhanced World Art Maps

The World Art Maps at the beginning of each thematic chapter have more geographically placed images than in previous editions.

▨ Revised Chapters 1 and 15

Chapter 1, "Art and Art Making," thoroughly explores definitions of art, how it is described and classified, and how it fits into our overall culture. It also looks at artists. Chapter 15, "Art in Your Life," is an exciting addition to the narrative. It illustrates how students can put into action all that they have learned from their art appreciation course.

▨ Analysis Guide, new in the revised fifth edition

The book now ends with an Analysis Guide that steps students through the process of researching and evaluating any work of art, whether it is familiar or totally new to them.

▨ New and updated images

We have added several exciting images from contemporary non-Western artists. We have also updated many of the existing images throughout the text.

▨ An emphasis on art outside the traditional museum

We explore different kinds of museums and how they are evolving. We look at works that are beyond the walls of an art museum. They include street art, political graffiti, public art, temporary public installations, and design.

Following is a chapter-by-chapter summary of changes in the revised fifth edition, as well as those that were new in the fifth edition:

Chapter 1: This chapter has been heavily rewritten and compressed from what was presented in both Chapter 1 and Chapter 5 in the fourth edition. The last section has been further rewritten in the revised fifth edition. Figure 1.7, a diagram with side-by-side comparisons of art styles, is updated. The evolution of art museums is tracked across several new images (Figures 1.12, 1.13, 1.15, and 1.17), and art seen outside of conventional museums is represented by Figures 1.14, 1.18, 1.19, 1.24, and 1.26. For the revised edition, a new image has been added to compare art to other creative fields, such as fashion (Figure 1.29).

Chapter 2: Five new images, including works by Paul Klee, Dan Flavin, Giorgio de Chirico, and Marcel Duchamp, update the discussion of elements and principles. Figure 2.34 has been replaced with a higher quality image in the revised fifth edition.

Chapter 3: Five new images give increased breadth to the discussion of media and materials, including a silverpoint drawing by Hans Holbein, an etching by James McNeill Whistler, an example of street art from the Arab Spring (in particular, Egypt in 2011), a new Alexander Calder mobile, and a surrealist exquisite corpse collage/drawing with Jean Arp and others. The *Art Experiences* encourage experimentation with media and grounds.

Chapter 4: This chapter gives students the basic approaches to analyzing art, and in the revised fifth edition, this is extended to analyzing mass media imagery as well, as seen with the cigarette ad in the new Figure 4.22. We build on the new direction started in the fifth edition with Figure 4.5, which looked at contemporary information design within a general discussion of symbols. Other new fifth edition images include *Black Iris* by Georgia O'Keeffe and *Tomorrow Is Never* by Kay Sage.

Chapter 5: This chapter discusses the theme of food and shelter. It includes a new and contemporary example of architecture by Zaha Hadid to further the discussion of late-twentieth-century public architecture. The new *Art Experiences* tie students' art making to their perceptions of food and shelter.

Chapter 6: This chapter has been edited for easier reading and better flow of ideas, with new *Art Experiences* features that connect student art making to chapter concepts. In the revised fifth edition, the discussion around primordial couples was rewritten to include the roles of couples within a culture.

Chapter 8: The chapter's theme is mortality and immortality. The topic of memorials has been updated with a new image of the World Trade Center. The idea of memorials and divinity becomes personal through art making in the *Art Experiences*. In the revised fifth edition, Figure 8.9 has been replaced with a higher quality image.

Chapter 10: Two new works, one by Tomatsu Shomei and the other by Doris Salcedo, lend further force to the chapter's theme of social protest and affirmation. The *Art Experiences* pick up on these hot topics, which are meaningful to students.

Chapter 13: This revised chapter contains exciting new images from both the distant past and contemporary times. New works by Julie Mehretu, Ai Weiwei, George Rickey, Claude Monet, and Qian Xuan illustrate artistic responses to the chapter's theme—nature, knowledge, and technology—and students are invited to do the same in *Art Experiences*. Figure 13.12 is now a higher quality image.

Chapter 14: Building on changes from the fifth edition, the focus of this chapter in the revised edition continues to be on historical and contemporary links among art, entertainment, and visual culture. New fifth edition figures include both an image of an Iatmul drum and images of children interacting with contemporary technology and handheld devices. Figure 14.33 is new to the revised fifth edition and shows an ancient Egyptian board game that is a work of art.

Chapter 15: In the fifth edition, this chapter had a new focus, which was getting art into students' lives, and having them engage with it. We looked at public art, street art, and temporary installations. The revised fifth edition adds a discussion of immersive experiences in art and visual culture, especially those using new technologies. In the fifth edition, more than half of this chapter was new material with thirteen new images. Contemporary artworks by Anish Kapoor, Rafael Lozano-Hemmer, Do Ho Suh, and Banksy appear for the first time in the fifth edition, while this revised version also features Nao

Bustamante, Yayoi Kusama, and Kehinde Wiley. The revised fifth edition has more coverage on craft in everyday life and its relation to art.

Chapter 15 now concludes with an Analysis Guide, which helps students to use their art appreciation skills to analyze works of art or visual culture, even those they may have never seen before. With this, students go beyond repeating what they have learned about art and, instead, use their own analytical skills to evaluate new experiences.

Chapters 7, 9, 11, and *12*: These chapters were all edited for easier reading and better flow of ideas for the fifth edition. New figures in these chapters include a photo of the Great Stupa in Sanchi, India, in Chapter 7 along with higher quality images for Figures 7.9 and 7.11 replaced in the revised fifth edition; a film still of Cindy Sherman, a work by Manual Álvarez Bravo, and a photo of a 2010 performance art piece by Marina Abramovic in Chapter 11; and a new image of Bisj poles in Chapter 12.

CONTEMPORARY FOCUS

We are proud of the large number of contemporary artworks in the revised fifth edition of *Exploring Art* as well as the balance between Western and non-Western works and in the representation of gender, as can be seen in this impressive list of contemporary artists:

Marian Abramovic	Anish Kapoor	Gerhard Richter
El Anatsui	William Kentridge	George Rickey
Judith Baca	Barbara Kruger	Faith Ringgold
Banksy	Maya Lin	Pipilotti Rist
Manuel Álvarez Bravo	Rafael Lozano-Hemmer	Kay Sage
Nao Bustamante	Roberto Matta-Echaurren	Doris Salcedo
Dale Chihuly	Lee Alexander McQueen	Richard Serra
Christo and Jeanne-Claude	Julie Mehretu	Cindy Sherman
Olafur Eliasson	Mariko Mori	Yinka Shonibare
Lucien Freud	Takashi Murakami	Jaune Quick-to-See Smith
Frank Gehry	Wangechi Mutu	Kiki Smith
Robert Gober	Yoshitomo Nara	Frank Stella
Andy Goldsworthy	Bruce Nauman	Do Ho Suh
Leon Golub	Shirin Neshat	Rirkrit Tiravanija
Zaha Hadid	Louise Nevelson	Bill Viola
Tim Hawkinson	Chris Ofili	Kara Walker
Damien Hirst	Juan O'Gorman	Andy Warhol
David Hockney	Claes Oldenburg	Ai Weiwei
Jenny Holzer	Catherine Opie	Kehinde Wiley
Arata Isozaki	Tony Oursler	Yayoi Kusama
	Nam June Paik	

TEACHING AND LEARNING RESOURCES THAT ACCOMPANY THE TEXT

MindTap for *Exploring Art: A Global, Thematic Approach*, Revised Fifth Edition

MindTap is a fully online feature that helps students engage with course content and increases their comprehension. Instructors and students can

personalize it and access it on computers or smartphones. It is a great platform for Cengage's authoritative content, assignments, and services.

Students

MindTap guides you through your course via a learning path where you can annotate readings and take quizzes. Concepts are brought to life with zoomable versions of more than 600 images, and videos expand your knowledge of particular works and art trends. Increase your knowledge of various media by watching videos of studio art demonstrations in ceramics, painting, sculpture, encaustic, and more. Examine themes chronologically through interactive timelines, and expand your understanding of the most essential visual elements, including those of principles of design, style, form, and content, through interactive foundations modules. You can find resources for research, including food-for-thought questions and links to reputable sites and journals, as well as use numerous study tools, including mobile-optimized image flashcards, a glossary, and more!

Instructors

You can easily tailor the presentation of each MindTap course and integrate activities into your learning management system. The Resources for Teaching folder in MindTap and the Instructor Companion Site hold resources including instructions on how to use the online test bank; Microsoft PowerPoint® slides with high-resolution images, which can be used as is or customized by importing personal lecture slides or other material; course learning objectives; and more.

Cengage Mobile App

Exploring Art: A Global Thematic Approach, Revised Fifth Edition, is now more accessible than ever with the Cengage Mobile App, empowering students to learn on their terms—anytime, anywhere, online or off.

- The eReader provides convenience as students can read or listen to their eBook on their smartphone, take notes, and highlight important passages.
- Flashcards and quizzing cultivate confidence. Students have instant access to readymade flashcards and quizzes to engage key concepts and confidently prepare for exams.
- Notifications keep students connected. Due dates are never forgotten with Cengage Mobile course notifications, which push assignment reminders, score updates, and instructor messages directly to students' smartphones.

Resources for Teaching Art Globally and Thematically

The Instructor Companion website houses multiple resources to help you successfully teach your course. The Transition Guide and Instructor's Manual provide suggestions for teaching each chapter's content thematically and globally, supplying sample lecture organization methods along with numerous topics for discussion, food-for-thought questions, activities, and video resources. The Lecture Notes and Study Guide for each chapter allow students to take notes alongside the images shown in class. This resource includes reproductions of the images from the reading, with full captions and space for note-taking either on a computer or on a printout. It also includes a chapter summary, key terms list, and learning objectives checklist. Also located on the

Instructor Companion website are the test bank; and a Microsoft PowerPoint® deck for each chapter that provides talking points for chapter artworks.

ACKNOWLEDGMENTS

We wish to thank once again the entire team at Cengage whose efforts and creativity help shape *Exploring Art*. Product Manager Vanessa Manter was supportive of every revision we wished to make. Learning Designer Paula Dohnal oversaw the updating and revision of the online and learning assessment components, with outstanding results. We are grateful also to Production Assistant Teddy Coutracos. We have been impressed with Marketing Manager Laura Kuhlman's strategies to help introduce our book to potential adopters.

Of course, a book is nothing without its production staff, and we have been very fortunate to work with some exceptional people. We are grateful to Lianne Ames, Senior Content Manager, who has been excellent at maintaining quality at every step; Sarah Cole, Senior Designer; Cheryl DuBois at PreMediaGlobal; and Joan Keyes of Dovetail Publishing Services for pulling all the details together. We would also like to thank Ivy Cooper, Southern Illinois University, Edwardsville, for creation of the Image Quizzes and Chapter Quizzes; Anne McClanan, Portland State University, for the creation of the Test Banks; Karen Schifman, California State University, Northridge, for her work on the Instructor's Manual (with Transition Guide) and website assets; and Cheryl Dullabaun, California State University, Northridge, for her work on the PowerPoint® slides.

Our sincere thanks to the reviewers for their input: Jawad Ali, California State University, Fullerton; Jennie Bower, Eastern New Mexico University–Roswell; Cat Crotchett, Western Michigan University; Dahn Hiuni, Shepherd University; Julie Jack, Tennessee Wesleyan College; Leslie Lambert, Santa Fe College; Caryl Linkenhoker, West Virginia State University/KVCTC; Jessica Smith, Wilbur Wright College; Cynthia Stollhans, Saint Louis University; Montana Torrey, Lane College; and Joe Zubrick, University of Maine at Fort Kent.

Both of us are indebted to the valuable experiences and the support of our respective teaching institutions, Divine Word College (Dona) and the University of Southern California Roski School of Art and Design (Margaret). Our colleagues and the students who comprise the intellectual lives of these institutions have shaped our work and made it possible. Thank you to our families and friends, who have provided interesting perspectives, good advice, and moral support throughout. They are too many to name. We mourn the passing of Dona's husband, Douglas Schlesier, who always had valuable insights for the first five editions of the book. Margaret's husband and daughter, Michael Dean and Julia Lazzari-Dean, have been great supporters throughout. Our children or grandchildren have grown up with this book, and the wonder of these new lives continues to inspire us. And we thank each other, once again, for our mutual support. This collaboration has sustained us and gotten us together where neither could have gone alone.

May there be peace and tolerance in our world.

May the appreciation of world art help to get us there.

Margaret Lazzari
Dona Schlesier

Dear Students:

Some of you may ask, Why should I study art appreciation? Here are some real benefits:

Art can enrich your life.
> *Art appreciation can put you in touch with your intuition, not just your logical side.*
>
> *Art tells great stories that make you feel life more deeply, both as an observer and an art maker yourself.*
>
> *Art helps you care about the gift of vision and the objects humans have crafted for our visual joy.*

Art is a major part of culture around us.
> *Everyone makes videos or photos, plus there is advertising, information graphics, broadcast media, film, and games. And also art. This is a visual culture, and art is the oldest part of it.*
>
> *Art is also totally relevant to our everyday lives. Historical and contemporary art speak to our joys and struggles today.*

Art appreciation gives you a vocabulary and framework for every visual thing you encounter in life.
> *Art is organized visual information (pictures and patterns) that influences its audience.*
>
> *Art is aesthetic and can make you more aware of other aesthetic things around you, like your clothes, your house or furniture, your neighborhood buildings, your favorite poster, and so on.*
>
> *Our art appreciation book, with its global approach, can connect you with your family's cultural heritage, your past, and the heritage of others.*

Art conveys information.
> *A picture is worth a thousand words.*
>
> *More than just eye candy, images can convey information clearly and make intuitive sense.*
>
> *A compelling picture can make people stop and read something rather than pass it by.*
>
> *A lot of relationships are better understood visually rather than verbally. Just one example is Leonardo da Vinci's drawing that connects divine creation, human proportions, and geometric simplicity (The Vitruvian Man, Figure 1.28).*

Art can help you in your career.
> *Art is fluid intelligence (solving new problems, identifying patterns), in contrast to crystallized intelligence (memorizing facts).*
>
> *Our Art Experience boxes encourage you to make art and begin to train your eye, useful skills in many careers. For example, dentists study color matching and carving skills to make a new tooth for you. Scientific researchers rely on the recognition of pattern in their work. Marketers depend on visual messages.*
>
> *Finally, art is a career—artists, designers, curators, architects, museum staff, art educators, graphic designers, public art administrators, art writers, and more!*

Come on a journey with us as we share with you our love of art and art appreciation.

With warm regards,
Margaret Lazzari and Dona Schlesier

I

INTRODUCTION TO ART

Art enriches our lives with vivid images, compelling stories, color, light, and space. You can find art in museums, in your home, in public places, and on your phone. The chapters in Part I lay a foundation for understanding art and visual culture.

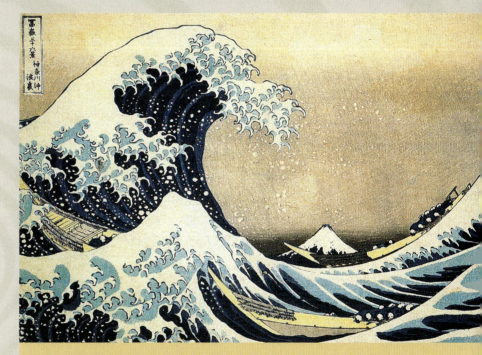

Katsushika Hokusai. *The Great Wave Off Kanagawa* from the series *Thirty-six views of Mt. Fuji*, 1831. Woodblock print, ink, and colors on paper, 9⅞″ × 1′ 2¾″.

Five thousand copies of this famous woodblock print were created because its mix of beauty and danger made it popular in the 1800s. It is still popular today and can be found in museums, on the Internet, and on hundreds of products.

CHAPTER 1 ART AND ART MAKING

The definition of art, craft, design, and visual culture, and the ways we describe and categorize them

CHAPTER 2 THE LANGUAGE OF ART AND ARCHITECTURE

Art's formal elements and the principles for organizing them

CHAPTER 3 MEDIA

A survey of art media and how they are used

CHAPTER 4 DERIVING MEANING

The ways that we come to understand meaning in art and architecture

Art is not what you see, but what you make others see.
—*Edgar Degas*

I never paint dreams or nightmares. I paint my own reality.
—*Frida Kahlo*

Art is the Queen of all sciences communicating knowledge to all
the generations of the world.
—*Leonardo da Vinci*

I found I could say things with color and shapes that I couldn't
say any other way—things I had no words for.
—*Georgia O'Keeffe*

I am for an art that is political-erotical-mystical, that does some-
thing other than sit on its ass in a museum.
—*Claes Oldenburg*

Every child is an artist. The problem is how to remain an artist
once he grows up.
—*Pablo Picasso*

From around the age of six, I had the habit of sketching from life.
I became an artist, and from fifty on began producing works that
won some reputation, but nothing I did before the age of seventy
was worthy of attention.
—*Katsushika Hokusai*

A work of art reflects its origins but at the same time it should
be able to reach out to people.
—*El Anatsui*

When the subject is strong, simplicity is the only way to treat it.
—*Jacob Lawrence*

Art should reveal the unknown, to those who lack the experience
of seeing it.
—*Jaune Quick-to-See Smith*

. . . it's easy for us to depict things of this physical world, of the
way we live now, but it's very difficult to depict things that are not
seen but have a profound effect on us.
—*Cao Guo Qiang*

Art is everywhere, except it has to pass through a creative
mind.
—*Louise Nevelson*

For me nature is not landscape, but the dynamism of visual
forces. . . . These forces can only be tackled by treating color and
form as ultimate identities, freeing them from all descriptive or
functional roles.
—*Bridget Riley*

Whether I'm painting or not, I have this overweening interest
in humanity. Even if I'm not working, I'm still analyzing people.
—*Alice Neel*

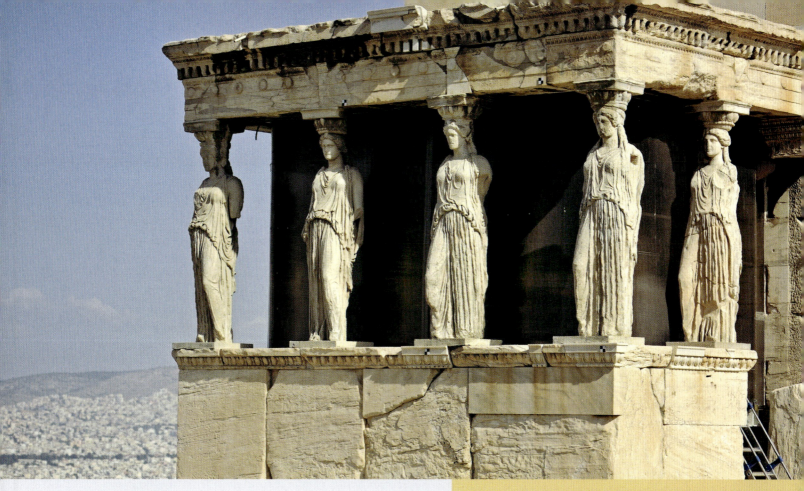

1.1 *Porch of the Caryatids*, Erechtheum, Acropolis, Athens, c. 421–405 BCE.

1

ART AND ART MAKING

Humans make art to understand life, to communicate emotions and ideas to others, or to simply create something beautiful. Here are ways to understand and appreciate art.

PREVIEW

What is art? No single definition holds for all times and places, but this chapter gives a few working definitions. It also covers the ways that we describe, classify, and study art and the way that art fits into our overall visual culture. At the end, we look at artists, creativity, and the making of art.

Look also for Art Experience boxes, which encourage you to photograph art, make art, or analyze images or objects around you.

TOWARD A DEFINITION OF ART

To answer the question "What is art?" we need to know *for whom* and *when*. For example, the ancient Greeks of the fifth and fourth centuries BCE believed that art should both glorify man and express intelligence, clearness, balance, and harmony, as exemplified by the *Porch of the Caryatids* (Fig. 1.1). If we look at ancient Chinese culture, we find sculpture and porcelain works that express the power of the emperor. For the United States at the beginning of the twenty-first century, we define art like this: *Art is a primarily visual medium that is used to express ideas about our human experience and the world around us.*

Basically, the definition of art is not universal and fixed. It fluctuates and changes because cultures are alive and changing, and we will see more examples of this in the middle of this chapter. However, for now, you can begin to analyze and understand art from any time and place by focusing on four major areas: **function, visual form, content,** and **aesthetics.** We will discuss them one by one, but in fact they are all interrelated.

Function

When you look at any work of art, one first question is "For what purpose was this originally made?" At the time it is created, a work of art is intended to do a job within a culture. Here are some of its many functions:

- Art reflects customs and concerns related to food, shelter, and human reproduction (Chapters 5 and 6).
- Art gives us pictures of deities or helps us conceive of what divinity might be. It is also used to create a place of worship (Chapter 7).
- Art serves and/or commemorates the dead (Chapter 8).
- Art glorifies the power of the state and its rulers. It celebrates war and conquest—and sometimes peace (Chapter 9).
- Art reveals political and social justice and injustices (Chapter 10).
- Art records the likenesses of individuals and aids us in understanding ourselves, our bodies, and our minds, thoughts, and emotions (Chapter 11).
- Art promotes cohesion within a social group and helps to define classes and clans (Chapter 12).
- Art educates us about who we are within the world around us (Chapter 13).
- Art entertains us (Chapter 14).

Finally, the art of the past serves to educate us about earlier cultures, while contemporary art is a mirror held up to show us our current condition.

ART EXPERIENCE Be an art photographer. Use your camera or phone to photograph five or more objects you think function as art, and explain why you chose them. Choose objects that are familiar to you in your daily routine.

Visual Form

Another primary question to ask about a work of art is "What elements compose it, and how are they arranged?" Almost all artwork has physical attributes, so it can be seen or touched and so ideas can be communicated. For any work of art, its materials have been carefully selected and organized, as have its line, shape, color, texture, volume, and so on. Chapters 2 and 3 are all about visual form, but we will compare two artworks here to introduce the basic ideas.

Figure 1.2 is the *Veranda Post: Female Caryatid and Equestrian Figure*, carved before 1938 by Olowe of Ise in Nigeria. Its function was to symbolize and strengthen the power of a Yoruban ruler. Compare it to Figure 1.3, another sculpture intended to assert the authority of a ruler, the *Equestrian Statue of Marcus Aurelius*, from the Roman Empire around 175 CE. In two very different cultures, a ruler on horseback functions as an image of power.

But the visual form of each is different—and in ways that are meaningful to each culture. In the wooden *Veranda Post*, horizontal elements are minimized, while verticality emphasizes the authority of the king on top. For the Yoruban culture, inventive forms and rich details were important, so we see a pistol, spear, dramatic headdress, textures, small female figures (caryatids), and so on. The visual form of this sculpture is suitable for a Yoruban king.

In contrast, the *Equestrian Statue of Marcus Aurelius* has a roundness and a volume that are different from the visual form of the *Veranda Post*. Extraneous items and details, including armor, are stripped away, referring to the fact that Marcus Aurelius was a philosopher as well as an emperor. Also significant is the material, hollow-cast bronze, which is durable, expensive, and difficult to work. Bronze distinguishes this piece as a costly and important royal Roman portrait.

Scholars, art historians, and museum curators study art from the past, like these two sculptures, and educate us about the ways in which visual form and function are intertwined in works of art. By studying art, they (and we) glean considerable information about the historical moments from which they come. These scholars also study content, which we will see next.

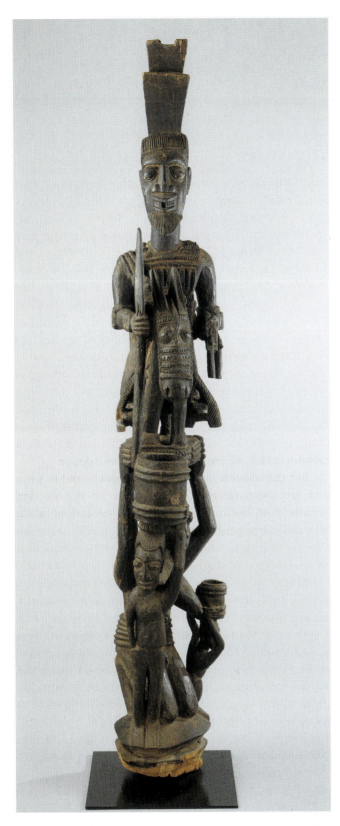

1.2 OLOWE OF ISE. *Veranda Post: Female Caryatid and Equestrian Figure*, Yoruba, before 1938. Wood, pigment, 5′ 11″ high. Metropolitan Museum of Art, New York.

In Nigeria, this sculpture was meant to reinforce the power of the local king.

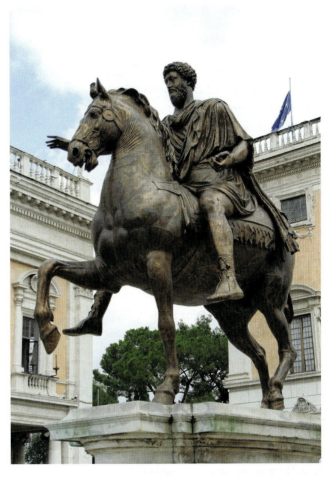

1.3 *Equestrian Statue of Marcus Aurelius*, Rome, c. 175 CE. Bronze, approx. 11′ 6″ high. Musei Capitolini, Rome.

This sculpture was also meant to reinforce the ruler's power but in this case in ancient Rome.

ART EXPERIENCE Be your own artist. Choose one of the many functions of art described in this chapter, and create an artwork that serves this purpose. What decisions did you make about visual form?

Content

Art has content, which is the mass of ideas associated with each artwork. Asking about content is critical to understanding any artwork. If you consider the entirety of art production, you will see that it reflects humans' perceptions of and responses to all aspects of spiritual life and earthly life, from birth to death and the hereafter, and of everything in between. It brings everything from the mundane to the cosmic into sharp, concentrated focus.

Content is communicated through the following:

▪ The art's imagery
▪ Its symbolic meaning

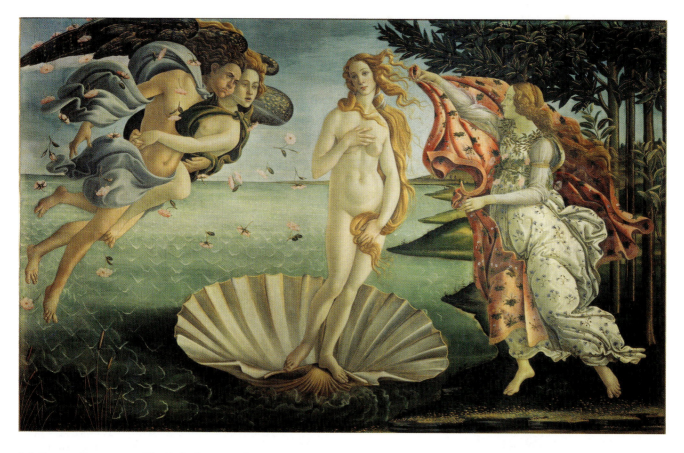

1.4 SANDRO BOTTICELLI. *The Birth of Venus*, Italy, c. 1482. Tempera on canvas, approx. 5′ 8″ × 9′ 1″. Galleria degli Uffizi, Florence.

The content of a work of art includes its imagery and its cultural references. Some content is obvious, but other content is hidden.

- Its surroundings where it is used or displayed
- The customs, beliefs, and values of the culture that uses it
- Writings that help explain the work

Content can both be immediately apparent and require considerable study. For an example, just by looking at Sandro Botticelli's *Birth of Venus* (Fig. 1.4), from 1482, and Pablo Picasso's *Les Demoiselles d'Avignon* (Fig. 1.5), from 1907, you immediately see the imagery. Both are paintings with multiple figures in the composition, and female nudity is at least part of the subject matter. *Venus* is painted in a more realistic, traditional style. The blocky, simplified *Demoiselles* appears to be more modern and less interested in popular ideas of beauty. In visual form, both paintings seem balanced side to side, with a figure in the middle.

However, much of the content is not readily apparent and requires deeper study. *The Birth of Venus* celebrates an ancient Greek myth and glorifies the beauty of the female body. When it was painted in 1482, it reflected the ideals of the early Italian **Renaissance,** which elevated the importance of man, emphasized learning, and held the ancient Greeks and Romans in high esteem. But the period was marked by conflicting currents because the Catholic Church was a major force at that time and it disapproved of the depiction of pagan deities.

Likewise, the content of *Les Demoiselles d'Avignon* is revealed only upon study. Originally, Picasso intended to paint a brothel scene of prostitutes with their male customers. But he made radical changes as the work progressed, ending with an image of intertwined figures and space that began an art movement known as **Cubism.** He was influenced by African masks, like the *Ceremonial Mask Known as a Mboom or Bwoom*, from the Kuba or Bushongo culture of Central Africa, circa nineteenth–twentieth centuries (Fig. 1.6). At that time, African artworks like the *Mask* were being brought to Europe through colonial trade, and they dramatically influenced Western art. Also, Picasso's blending of figure and space echoed the theories of scientists like Albert Einstein on the mutability of matter, energy, and space. Clearly, the content contains complex ideas related to European ideas of sexuality, to colonialism, and to modern scientific theory, all of which may require study to learn and understand.

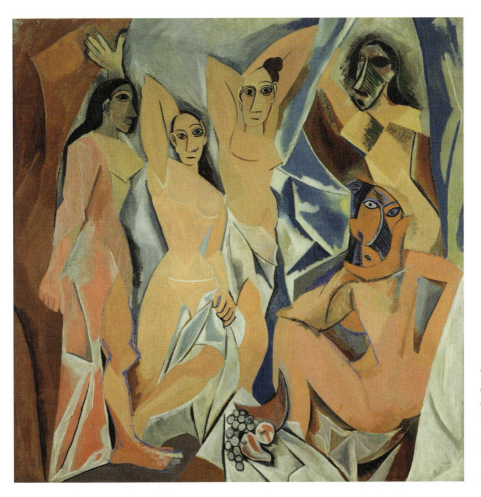

1.5 PABLO PICASSO. *Les Demoiselles d'Avignon*, Spain/France, 1907. Oil on canvas, 8′ × 7′ 8″. The Museum of Modern Art, New York.

Artwork reflects the cultural moment when it was made—in this case, the modern era at the beginning of the twentieth century.

1.6, *right* *Ceremonial Mask Known as a Mboom or Bwoom*, Kuba, Central Africa, c. nineteenth–twentieth centuries. Wood, beads, shells, and cloth, head-sized. Royal Museum for Central Africa, Tervuren, Belgium.

Influences can cross cultures. The works of modern artists such as Pablo Picasso were influenced by African masks.

In the same way, the *Ceremonial Mask Known as a Mboom or Bwoom* has its own obvious and hidden content. Visibly, it is a decorated helmet mask, made of wood, beads, shells, and pieces of cloth. Less apparent is the fact that it was originally used in African **masquerades,** which are traditional celebrations that blend dance, art, song, and ritual. Many African peoples stage masquerades to reenact important creation events, spirit works, and ancestor stories. This mask represented the people over whom a king asserted his authority.

Thus, all three works (Figs. 1.4, 1.5, and 1.6) have a mass of meaning, or content, explained by scholarly research and critical writings. We will delve more deeply into how meaning is embodied in art in Chapter 4, Deriving Meaning.

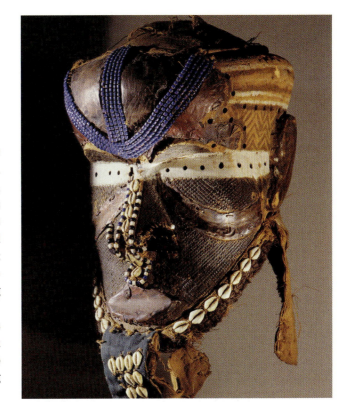

Aesthetics

The last basic question regarding any artwork is "What are its aesthetic qualities?" Aesthetics involve the look and feel of an artwork and the attributes that elevate it above other objects. These change from age to age and from place to place. While some cultures may value the look and feel of a well-executed oil painting, others may value the intricacy and pattern of finely woven natural materials.

Aesthetics is also a body of written texts that deal with art, taste, and culture or that examine the definition and appreciation of art. Ancient Greeks wrote about aesthetics as they understood it. Thinkers from India, Japan, and China wrote about their cultures' aesthetic systems. In several African, Oceanic, and Native American cultures, the practice of art demonstrated a clear aesthetic long before there was written material about it. You are thinking aesthetically when you reflect critically while reading a book like this one. Aesthetics as a body of knowledge goes beyond individual tastes, since it reflects the preferences of a large segment of the culture's population.

In the eighteenth and nineteenth centuries in the West, aesthetics focused on the idea of beauty, and the standard for beauty was ancient Greek sculpture, such as the *Porch of the Caryatids* on the Erechtheum (Fig. 1.1). This approach led to the notion that aesthetics was essentially about beauty and that beauty could be universally defined for all times and places. That universalist position is discredited now because there is no worldwide agreement about what constitutes beauty and because philosophers today consider many qualities other than beauty as significant attributes of art. What do you think is the role of beauty in relation to art today?

Art and Style Vocabulary

We pause for a moment in our discussion to learn some basic terms to describe art and art styles. These will be helpful for the rest of this chapter and throughout the book.

Art is **representational** when it contains entities from the world in recognizable form. Another related term is **naturalistic,** which is recognizable imagery that is depicted very much as seen in nature (Fig. 1.7).

In **idealized** art, natural imagery is modified in a way that strives for perfection within the bounds of the values

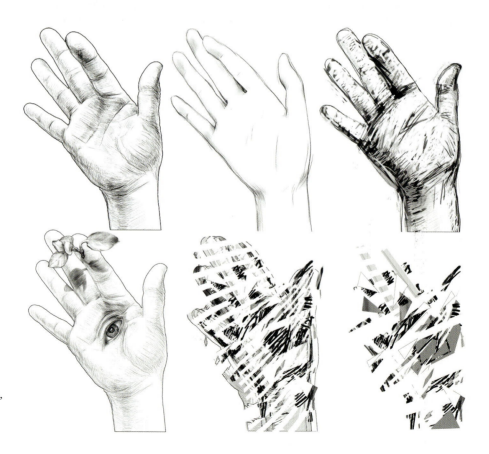

1.7 An illustration of, from left to right by row, naturalistic, idealized, expressive, surreal, abstract, and nonobjective drawings.

and aesthetics of a particular culture. The *Veranda Post* (Fig. 1.2) and the *Equestrian Statue of Marcus Aurelius* (Fig. 1.3) are both rendered in idealized styles, yet they are quite different because each culture had its own definition of what is ideal. Idealized art is often orderly and balanced vertically and horizontally.

In addition to naturalistic or idealized, representational art can be expressive or surreal. **Expressionism** or **expressionist** art communicates heightened emotions and often a sense of urgency or spontaneity. Expressive styles frequently appear bold and immediate rather than carefully considered or refined. They often feature distorted imagery and may appear asymmetrical or off balance. **Surrealism** or **surreal** refers to art with a bizarre or fantastic arrangement of images or materials, as if tapping into the workings of the unconscious mind (Fig. 1.7).

In contrast to representational art is **nonobjective** (nonrepresentational) art, which contains forms that are completely generated by the artist. Another term, *abstract art*, is often used to mean the same thing as nonobjective, but there is an important distinction. **Abstracted** imagery has been derived from reality by distorting, enlarging, and/or dissecting objects or figures from nature (Fig. 1.7). Pablo Picasso's *Les Demoiselles d'Avignon* (Fig. 1.5) is abstract, but the manipulated imagery is still recognizable. Therefore, Picasso's work cannot be called nonobjective.

All of these terms can be used to describe **style,** either of the art output of a whole culture or of that of an individual artist. A **cultural style** consists of recurring and distinctive features that we see in many works of art emanating from a particular place and era. For example, the cultural style of ancient Egyptian art (with strong outlines and flattened figures in flattened space) helps us to group its paintings across hundreds of years. Stylistic differences make the art of ancient Egypt readily distinguishable from other cultural styles. (To further define, **culture** is the totality of ideas, customs, skills, and arts that belong to a group of people. In contrast, a **civilization** is a highly structured society, with a written language or a very developed system of communication, organized government, and advances in the arts and sciences.)

Cultural styles are recognizable across a broad spectrum of art objects created by a people. For example, during the seventeenth-century reign of King Louis XIV of France, the court style, which was ornate and lavish, could be seen in everything from architecture to painting, furniture design, and clothing (see the background in Fig. 1.17). Even hairstyles were affected, with big elaborate wigs. What qualities do you see shared by contemporary art, popular music, and the latest ads for clothing?

Differences in cultural styles become apparent when studying a particular art form that appears across the globe. For example, Islamic mosques are built around the world to provide a place for Muslims to congregate and pray together. But local styles differ from each other, as we can see with the *Grand Mosque* in Djenne, Mali (Fig. 1.8),

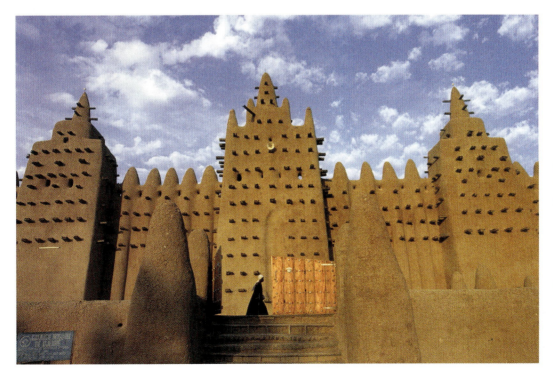

1.8 *Grand Mosque,* Djenne, Mali, 1906–1907.

All mosques have certain necessary features, but here they are translated into architectural styles that are favored by North Africans and that use readily available materials.

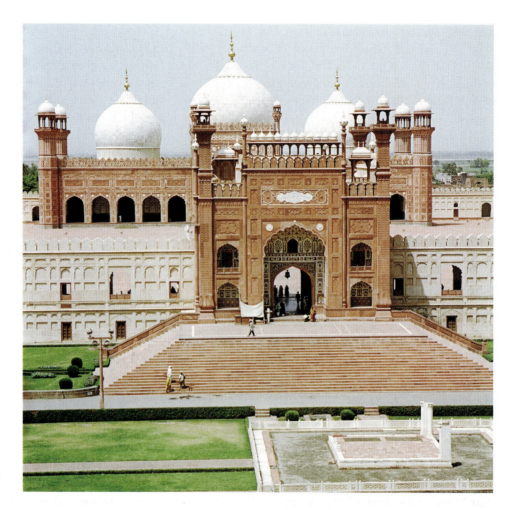

1.9 *Badshahi Mosque*, main entrance, Lahore, Pakistan, 1672–1674.

This is a mosque translated into a Pakistani architectural style.

1.10, *right* VINCENT VAN GOGH. *Portrait of Mme. Ginoux (L'Arlesienne)*, 1889. Oil on canvas, 1' 11½" × 1' 7½". Galleria Nazionale d'Arte Moderna, Rome.

Vincent van Gogh is well known for his unique painting style, yet even his work reflects cultural and artistic influences.

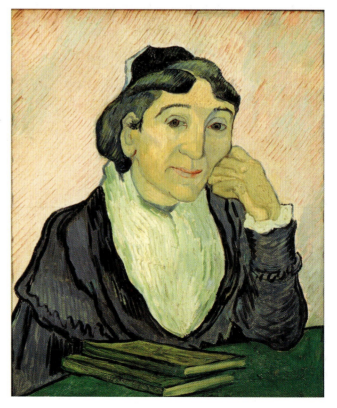

and the *Badshahi Mosque* in Lahore, Pakistan (Fig. 1.9). Both are imposing buildings with towers, yet each design is influenced by its cultural preferences and by locally available building materials. And cultural styles are not static. They evolve as a result of many circumstances, including changes in religion, historical events such as war, and contact with other cultures through trade or colonization.

Style can also refer to the work of an individual artist, who can develop a unique, personal style. The artist Vincent van Gogh is famous for his expressive paintings rendered in thick paint with broad areas of strong colors, like the *Portrait of Mme. Ginoux (L'Arlesienne)* (Fig. 1.10), from 1889. However, no artist operates in a vacuum. Van Gogh's unique style shares attributes with the styles of other artists of his time, including Impressionists such

1.11 PAUL GAUGUIN. *Woman in a Coffeehouse, Madame Ginoux in the Cafe de la Gare in Arles*, 1888. Oil on canvas, 2′ 4¾″ × 3′ ¼″. Pushkin Museum of Fine Arts, Moscow.

Note the similarities and differences between Gauguin's and van Gogh's paintings of Madame Ginoux.

as Claude Monet (see Fig. 14.14) and Postimpressionists such as Georges Seurat (see Fig. 13.29) and Paul Gauguin Fig. 1.11). All of these artists applied bright colors in a thick way and often chose subject matter from everyday life.

Paul Gauguin and Vincent van Gogh were closely associated for a while, sharing lodgings and painting together, as evident in Gauguin's *Woman in a Coffeehouse, Madame Ginoux in the Cafe de la Gare in Arles* (Fig. 1.11). Each painting has shared and unique qualities. Note the similarity in Madame Ginoux's pose but the differences in her attitude, in the overall scene, and in the color choices. Between these two artists' examples, which one appeals to you more, and why?

ART WITHIN VISUAL CULTURE

Art is part of **visual culture;** that is, it is part of the vast amount of imagery that humans create and proliferate, that comes to us through all kinds of media, and that is so important in our everyday lives.

Imagine life 200 years ago, with few books, few pictures, no phones, no television, no computers, no Internet, and so on. Compare that lack of visual culture with today, when we are inundated with images and visual objects that humans make. Consuming that imagery has become far more fascinating and absorbing to many people than the actual world in which we live. Visual culture is the result of technological innovation in the broadest sense, whether it is the development of chalk, oil paints, printing, or

personal computers. The images we make are distributed through many means, such as mass media, the Internet, galleries, museums, stores, and ads.

We will look at some of the categories within visual culture in a moment. Before we begin, however, remember that these categories are culturally determined. Some cultures, both past and present, do not even have a term that corresponds to ours for art. And other cultures have their own categories of art that differ from those in the United States. One example, which we already mentioned in relation to Figure 1.6, is the masquerade in sub-Saharan Africa, an important ritual art form that has no direct equivalent in the United States. (The only remotely related celebrations are Halloween and Mardi Gras, which are connected to the Christian traditions of All Soul's Day and Lent, respectively.) Another example of different categories for art comes from the Japanese, who value **ikebana** as an art form, unlike most Western cultures. The closest translation of ikebana is "flower arranging," but it is much more than that, as it is a disciplined art form governed by strict rules and mixed with spiritual awareness.

CONNECTION The Japanese also value traditional puppetry as an art form. For more on Japanese Bunraku puppetry, see Figure 14.20.

That said, let us turn to three categories of visual culture in the United States today: **fine art, popular culture, and craft.**

1.12 Sculpture Gallery in the Musee des Beaux-Arts, Lyon, France.

These are examples of Fine Art from the late 1800s.

Fine Art

Fine art is a category of refined objects considered to be among the highest cultural achievements of the human race. Fine art is believed to transcend average human works and is produced by artists with unique sensibilities. Museums and galleries are institutions closely associated with fine art.

As we mentioned at the very beginning of this chapter, cultures are constantly evolving in their definitions of what constitutes art. In the 1800s, fine art in Western cultures consisted of oil painting, sculpture, and architecture, usually in the idealized styles seen in Figure 1.12, and was mostly located in palaces and churches.

Since the 1800s, fine art has expanded dramatically, along with the overwhelming growth of visual culture. Now it includes all kinds of new media, such as film, photography, prints, and, most recently, installation, performance, video, and computer art (Fig. 1.13). An exhibit of fine art might include almost any kind of material or technology—or even junk. You can find art in public spaces and recreation areas (see Figs. 15.4 and 15.6), in addition to museums. Street art is also a potent force in communities, sometimes as commissioned murals and sometimes as unsanctioned graffiti and paintings. Figure 1.14 shows a beautifully drawn rooster that covers a two-story wall in a small public square in San Juan, Puerto Rico.

In addition, definitions of fine art are in flux when Western people look at art from other cultures. In 1880, works like the *Mask Known as a Mboom or Bwoom* (Fig. 1.6) would not have been displayed in art museums in the United States or Europe. But now the art from Oceania,

1.13 An exhibition at the Pinakothek Der Modern in Munich, Germany's largest museum of modern art.

There has been a major expansion in materials used in art making and in the ways art is displayed.

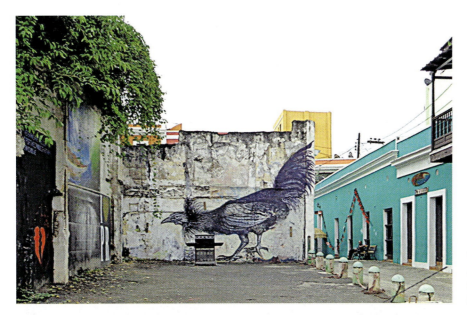

1.14 An example of street art in San Juan, Puerto Rico, 2013, which is possibly referring to the popular culture of cock fighting.

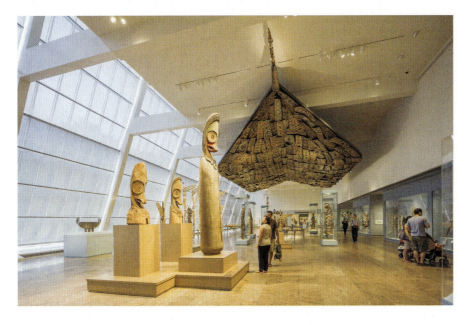

1.15 Interior of New York's Metropolitan Museum of Art, with permanent installations of the arts of Africa, Oceania, and the Americas.

the Americas, Africa, and Asia is a prominent part of major art museums in Western cultures (Fig. 1.15).

Do you think all art across world cultures is "fine art"? And two other questions to ponder: Is it necessary to have the word *art* in Western vocabulary? Would its lack make a difference in the creativity in Western culture?

Popular Culture

Popular culture in Western nations consists of magazines, comics, television shows, advertising, folk art, tattoos, customized cars, graffiti, video games, posters, websites, calendars, greeting cards, dolls, souvenirs, toys, movies (as opposed to art films), snapshots, and commercial photography (as opposed to fine photography). This category also encompasses graphic design, product design, and information design. Popular art is often perceived as being more accessible, inexpensive, entertaining, commercial, political, naive, or colorful than fine art. Among all categories of visual culture, this one is growing the fastest.

It is important to study popular culture while studying fine art because the two are interrelated and parts of a continuum that contains much of the visual imagery that Western culture produces. Popular culture and fine art often influence each other. Popular culture objects share many attributes of fine art, in that they can also be analyzed along the lines of function, visual form, and content. They reflect the values and structures of our social systems, political hierarchies, and religious beliefs.

Popular culture is studied academically in visual culture, art history, philosophy, and anthropology courses. Some objects from popular culture eventually "become" art—for example, popular prints like *Las bravisimas calaveras guatemaltecas de Mora y de Morales* by José Guadalupe Posada (Fig. 1.16). Now carefully preserved in a university library, this print was originally inexpensive and widely distributed like an editorial cartoon, with large, running skeletons (*calaveras*) that represent two assassins who brought death and chaos to Guatemala over a century ago.

Some artists want to occupy the space between fine art and popular culture. For example, *Kiki*, from 2010 (Fig. 1.17), is by the contemporary Japanese artist Takashi Murakami, who produces paintings, designer handbags, and installations of large-scale inflatable art. His work is a blend of Western and Japanese fine art, popular culture, design, and **animé** (contemporary Japanese animation) and always reflects a self-conscious consumerism. Murakami also sells multiple-edition prints of works on paper and canvas through galleries and the Internet. His 2010 exhibit in the Palace at Versailles juxtaposes the magnificent yet pompous array of the palace's marble and gold with the brash plastic brightness of his sculpture.

A subcategory of popular culture, called **kitsch,** comprises artwork that is shallow or pretentious or overly calculated to be popular. Objects or images are kitsch if they display an emotional appeal that is generalized, superficial, and sentimental. Unlike the best

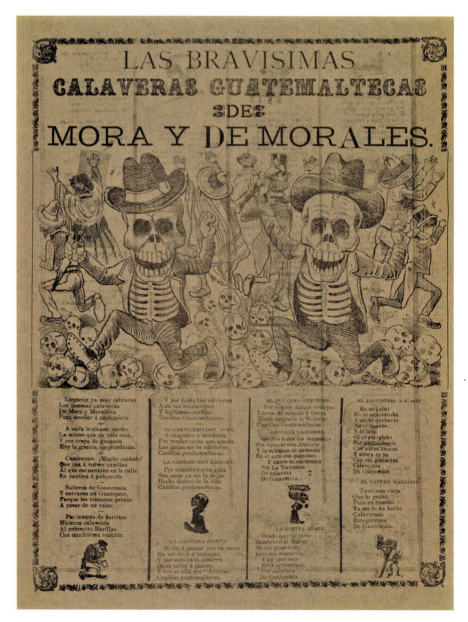

1.16 JOSÉ GUADALUPE POSADA. *Las bravisimas calaveras guatemaltecas de Mora y de Morales*, 1907. Pictorial broadside verse, full sheet, printed recto and verso, lavender paper, zinc etching. University of New Mexico Art Museum, Albuquerque.

The boundary between fine art and popular culture is often blurred. This poster, which was inexpensive and widely distributed at the time it was made, is now collected in libraries and museums.

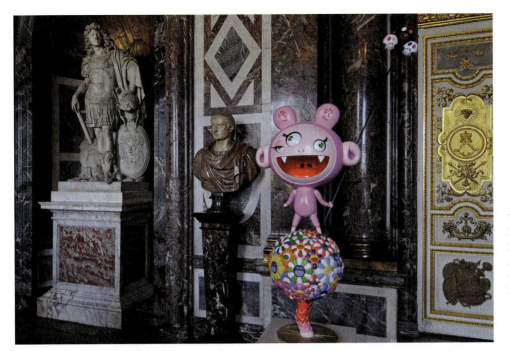

1.17 TAKASHI MURAKAMI. *Kiki.* Manga sculpture in the Venus Drawing Room. Exhibition in the state apartments and gardens of the Chateau Versailles outside of Paris in 2010.

Notice the contrast between the fine art surroundings and the popular culture qualities of *Kiki.*

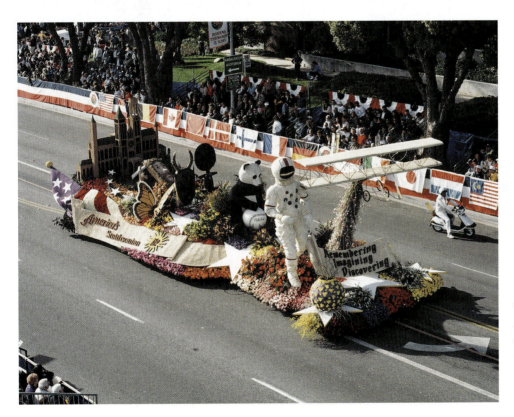

1.18 *The Smithsonian Institution's 150th Anniversary Float* in the 1996 Rose Parade in Pasadena, California.

Artwork that is sentimental or calculated to please may be considered as kitsch.

of fine art or popular culture, kitsch does not provide an original experience, a uniquely felt emotion, or a thoughtful, introspective moment. *The Smithsonian Institution's 150th Anniversary Float* in the Rose Parade (Fig. 1.18), with its collection of images from astronauts to the first airplane to pandas to butterflies to baseball, is meant to appeal to all and offend none. The museum buildings appear diminutive and cute—not like sites of serious research.

Like all other categories of visual art, the idea of kitsch is evolving and changing. Critics such as Susan Sontag have reclaimed some kitsch as **camp,** which means that objects and images of such extreme artifice (and often banality) have a perverse sophisticated and

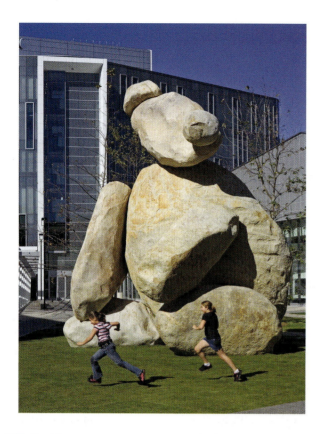

1.19 TIM HAWKINSON. *Bear*, 2005. 23′ 6″ high, 370,000 lbs. Stuart Collection, University of California, San Diego.

This work is a cross between a toy and monumental art.

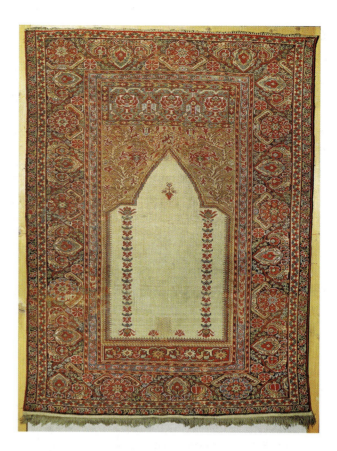

1.20 *Gheordez Prayer Rug*, Turkey, eighteenth century. White mihrab (prayer niche) with two Turkish floral columns. Wool, 5′ 5¾″ × 4′ ¾″. Museum fuer Angewandte Kunst, Vienna.

This rug is an example of an object that could be classified as fine art or as craft.

aesthetic appeal and that they reveal "another kind of truth about the human situation" (Sontag 1966:287). Other artists incorporate and transform sentimental or cute items in their work. The artist Tim Hawkinson, who is known for his inventive, humorous, or fantastic art, created the nearly 200-ton stone *Bear* (Fig. 1.19), a cross between a teddy bear and Stonehenge. There is an interesting association between the surfaces of a soft, fuzzy childhood companion and the rounded, weathered surfaces of ancient stones.

Do you think there should be a demarcation between fine art and popular culture? Why?

CONNECTION Stonehenge contains circles of ancient, enormous boulders, presumably set up for agricultural rituals, and is located in southern England. See Figure 7.26.

Craft

Craft refers to specific media, including ceramics, glass, jewelry, weaving, and woodworking. Craft usually involves making objects rather than images, although craft may involve surface decoration. Often, craft objects have a utilitarian purpose or perhaps evolved from a utilitarian origin. In addition, however, they display aesthetic and/or conceptual attributes that go beyond mundane use. Like the distinction between fine art and popular culture, the art/craft distinction is culturally specific and in flux.

We will look at one example here, but we could take up literally thousands of craft objects and analyze their relation to or distinction from fine art. The *Gheordez Prayer Rug* (Fig. 1.20), from eighteenth-century Turkey, is a good example of an object that might be categorized as craft or art. Like other woven objects, it is craft, but its aesthetic qualities and ritualistic uses carry it beyond a utilitarian function. The intricate pattern echoes tile work in mosques, and the white niche in the center is like a **mihrab,** an architectural feature in a mosque that marks the direction of Mecca.

Other Categories

There are other ways to categorize art. Disciplines such as drawing, photography, and sculpture may be grouped as separate categories. And, of course, as we have already seen, some cultures have their own distinct categories outside of these previous examples. We will see all of these forms again in later chapters in this book.

Art can be categorized chronologically according to cultural styles through the years, like "a history of Renaissance art" or "art from the Middle Ages." A geographic approach studies the art from a particular area, usually also in chronological order—for example, "the art of Africa" or "the art of the American West."

This text's approach is thematic. Fundamental concepts and themes form our basis for discussing art from many different cultures, as seen in Chapters 5 through 14. These fundamental global experiences include food, shelter, reproduction, sexuality, deities, places of worship, politics, power, social protest, social affirmation, the mind, the body, race, gender, class, clan, nature, knowledge, technology, entertainment, and visual culture.

Other divisions are possible! You as an observer of art can create your own categories for grouping artworks, and these areas can vary according to your preference. What new categories would you add?

ABOUT ARTISTS

A discussion of art would not be complete without looking at artists, their training, and the roles they play in society.

The Context for Art Making

Artists make art, but before we begin that discussion, we want to discuss the many ways that many other people contribute to the process of making art. These include patrons, technicians, skilled workers, craftspersons, laborers, members of institutions, and the regular person on the street.

When we think of big works like the Egyptian *Stepped Pyramid of Djoser and Tomb Complex* (Fig. 1.21), from 2650 BCE, we realize, of course, that many people contributed to building this project, including engineers, skilled workers, and thousands of laborers, supervised by priests and architects. But even the concept of a pyramid was a "group project." The pharaoh was the patron who provided the funding and impetus for the project. The design of the pyramid was the vision of one architect, Imhotep, and he was able to build structures in stone that were higher and larger than any seen before. Nevertheless, all earlier Egyptian tombs were prototypes that enabled him to conceive his design; Imhotep's own design was a key development for the later refinements in the pyramid style to be

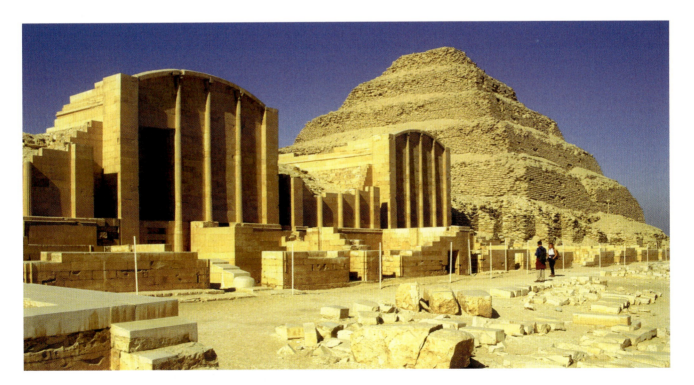

1.21 Imhotep. *Stepped Pyramid of Djoser* (right) *and Tomb Complex*, Saqqarah, Egypt, 2650–2631 BCE.

Works of art are the products of artistic vision and the cultural environment that fosters it.

made in the *Great Pyramids* of Giza (see Fig. 8.4). Plus, the members of the Egyptian priest class already had developed complex belief systems about the afterlife, and their rituals directed the design of temples and tombs.

Other art forms—film, architecture, and any work of large scale—obviously require the active participation of many people to be realized. Even small-scale work, such as a student's oil painting, requires the input of teachers, past painters, and art critics to provide the necessary background of skills and ideas. The materials are developed by artists and scientists and manufactured by art supply firms. The student probably has financial support, showing that parents, politicians, wealthy donors, or university administrators consider the study of painting to be important enough to pay for it.

Training Artists

Artists need to acquire skills. Traditionally, many started as **apprentices** in established art workshops to learn materials, manual skills, and styles from mature artists. There are examples of this system all around the world. For example, Leonardo da Vinci was trained as an apprentice in the workshop of the artist Andrea del Verrocchio, where he received an education in humanities as well as learning chemistry, metallurgy, painting, casting, and more. Throughout Africa, artists traditionally were trained in the apprentice method, learning the tools and methods as well as aesthetic standards. Most apprentices do preliminary rough work, and the master artist finishes the piece.

In addition to apprentice systems, more structured institutions have existed for training artists. In medieval Europe, specialized societies called **guilds** preserved technical information for artists and regulated art making.

Persian royalty from the thirteenth to the seventeenth centuries sponsored the **kitab khana,** libraries and workshops of highly trained artists who produced fine illuminated manuscripts. Art **academies** in Europe appeared in the fifteenth century. One of the most famous was France's powerful Académie Royale de Peinture et de Sculpture, founded in 1648 by King Louis XIV to control the decorative arts, architecture, painting, and landscape architecture for his enormous, lavish palace at Versailles and its surrounding gardens as well as for his other residences. Although art academies still exist in much-modified form, most artists in the United States today study art in a college's or university's art department.

Some artists are self-taught, receiving no formal art training. Some work in isolation. For fourteen years, James Hampton of Washington, D.C., worked on *The Throne of the Third Heaven of the Nations Millennium General Assembly* (Fig. 1.22), laboring over it daily from the time he finished his day job as a janitor until the middle of the night. He dreamed of opening a storefront ministry after retirement. By the time he died, he had produced a heavenly vision with 180 pieces, made from inexpensive or cast-off materials.

Making the Art Object

How does an artwork get made? In many cases, individual artists make their own artwork. Michelangelo Buonarroti did most of the painting on the colossal *Sistine Ceiling* because he was dissatisfied with the work that his collaborators did (see Fig. 7.21). Vincent van Gogh painted all his own paintings because, as he wrote to his brother Theo, he valued the act of creation more than life itself.

1.22 JAMES HAMPTON. *The Throne of the Third Heaven of the Nations Millennium General Assembly*, c. 1950–1964. Gold and silver aluminum foil, kraft paper, and plastic over wood furniture, paperboard, and glass, 180 pieces in all, overall configuration: $10\frac{1}{2}' \times 27' \times 14\frac{1}{2}'$. Smithsonian American Art Museum, Washington, D.C.

Some artists are untrained, as is the case with James Hampton, who produced this large sculpture in the evenings after working his day job.

1.23 ANDO OR UTAGAWA HIROSHIGE. *Basket Ferry*, Kagowatashi, Hida Province, nineteenth century. Woodblock print, 1′ 1½″ × 9″. Leeds Museums and Galleries (City Art Gallery), United Kingdom.

Prints in nineteenth-century Japan were the products of collaborations among skilled professionals, including the artist, the block carver, the papermaker, and the printer.

But sometimes art objects are made by workshops, by communities, in collaborations, and through group commissions.

CONNECTION Peter Paul Rubens maintained one of the largest and most prolific workshops in seventeenth-century Europe, producing vast numbers of artworks and employing many skilled workers. See the *Abduction of the Daughters of Leucippus* (Fig. 12.9).

We have already discussed apprentices in workshop situations in Italy (and in the rest of Europe) and in Africa as well as the kitab khana of Persia. Even today some artists hire assistants to help build, assemble, paint, or produce their works of art. Sometimes art making is a collaborative activity among professionals of equal standing. The knowledge and skill of each collaborator are essential to the final art product. An example is traditional Japanese prints, like *Basket Ferry* by Ando or Utagawa Hiroshige (Fig. 1.23), requiring the combined skills of many professionals, all commissioned by a publisher. The artist makes an original drawing, but the print itself is executed by a host of other professionals, including a papermaker, an engraver, and a printer, as illustrated in Figure 3.14.

In addition, sometimes communities come together to make a work of art. An early precedent occurred in medieval Europe, when citizens of small, growing cities built impressive cathedrals that were symbols of community pride (see Fig. 7.39). Trained craftsmen were surely needed, but the average untrained townsperson provided labor and support.

artists followed formulas or copied other works because their culture valued the re-creation of old forms more than innovation.

Some artists blend both approaches. Jaune Quick-to-See Smith's *Genesis* (Fig. 1.25) contains aspects of innovation and self-expression, but at the same time she is re-creating old forms. On the one hand, Smith has applied thick, expressive, gestural strokes of oil paint on top of a collaged layer of newspaper articles, photocopied images, and pieces of fabric. On the other hand, she is preserving old forms. Referring to Native American creation myths, she has incorporated native symbols, sculptures, and lines from stories, along with glorifying the buffalo, an animal with mythical standing. She has blended traditional native imagery and mythology into late-twentieth-century art styles. To Smith, all her works are inhabited landscapes, full of life, which is an essential Native American cultural idea.

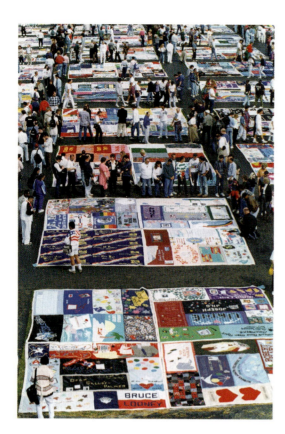

1.24 Displaying the *AIDS Memorial Quilt*, Washington, D.C., October 11, 1992.

Ordinary people contributed to the making of this work of art and also contributed to the funding for it and for AIDS research.

CONNECTION In the lower-right corner of *Genesis*, Jaune Quick-to-See Smith has drawn an image of a 700-year-old Native American ceramic vessel called *Mother and Nursing Child* (see Fig. 6.32), showing the importance of re-creating and preserving old forms.

The *AIDS Memorial Quilt*, begun in 1989 (Fig. 1.24; a different view is on page 242), provides a contemporary example of community art making. The *AIDS Memorial Quilt* is a composite of thousands of 3- by 6-foot panels, each made by ordinary people to memorialize someone they lost to AIDS. It is a collection of individual remembrances, which together create the whole fabric. Individual panels may be naive or may be sophisticated, but collectively they are very moving. The quilt is an ongoing effort of the Names Project, begun by gay activist Cleve Jones in San Francisco in the 1980s. It is also used as a fund-raising tool for AIDS research.

Innovation and Self-Expression

How important are innovation and self-expression in art making? **Innovation** is the making of something that is new. **Self-expression** refers to individual artists' own personal ideas or emotions, embedded in the works of art they make. While innovation and self-expression can be seen in much of the art made in the United States today, they are not ubiquitous. And there are some cultures in which

Creative People in Various Cultures

Artists, designers, and craftspeople are all creative, but their roles vary across cultures. For example, most people practice some kind of art form on the Pacific island of Bali, where art and religion are entwined with everyday life. Every household makes daily offerings to deities crafted with colorful food, flowers, and woven leaves, or performs rituals. For special temple festivals, large sculptures are made from fried, colored rice dough like the *Sarad offering* (Fig. 1.26). Another example comes from traditional Sepik culture in Papua New Guinea, where both men and women engage in creative work, but men make certain kinds of arts or crafts, while women make others. Likewise, among the Navajo of North America, different kinds of creative work have been tied to gender roles.

CONNECTION Read more on the Sepik rituals and artworks in Chapter 12, page 353.

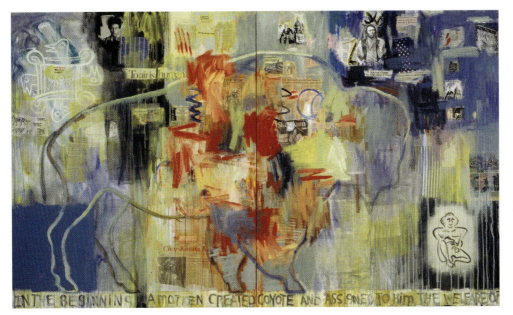

1.26 *Sarad offering* in Bali. Crafted of dyed rice dough, intricate sarad offerings are made during temple festivals by Balinese women. Bali, Indonesia, c. 1990.

In Bali, making art is tied with everyday rituals, and almost everyone participates.

1.27 *Baule Seated Female Figure*. Wood. Private collection.

Baule artists are not associated with the sculptures they produce; rather, the owners/commissioners of the artwork are associated with the artworks because they perform the rituals that give the works their meaning.

In other cultures, artists are skilled workers who received special training, but they remain anonymous. For example, medieval artists and craftsmen who built the large cathedrals were like anonymous skilled construction workers today. In Communist China from the 1950s to 1980s, artists were not allowed to seek personal glory but rather to work anonymously to make art for the common good. Among the Baule people of West Africa, artists are skilled professionals, and the best of them earn prestige and high pay but the artists' names are not associated with the sculptures they make. Rather, the owner of the piece performs rituals and develops the artwork's spiritual cult, like the *Baule Seated Female Figure*, which represents a spirit wife (Fig. 1.27). A Baule ritual sculpture could be less effective if its human maker is emphasized.

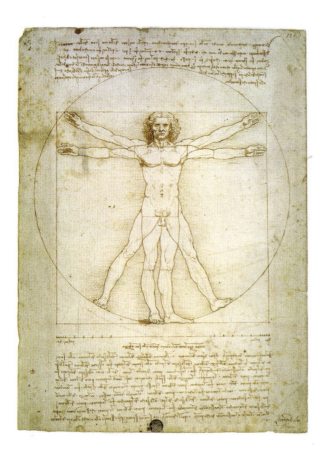

1.28 LEONARDO DA VINCI. *Proportions of the Human Figure (Vitruvian Man)*, c. 1492. Pen and ink on paper, 1′ 1½″ × 9²/₃″. Galleria dell' Accademia, Venice.

Artists can be considered geniuses in some cultures and during some time periods; for example, Leonardo da Vinci was renowned for his artistic skills and contributions to science.

Other cultures combine the role of sculptor and priest. In the Cook Islands in Polynesia, the artists-priests who carved ritual sculptures trained for a long time to acquire the art and spiritual power inherent in their tools and materials. Monks produced medieval manuscripts, illustrated prayer books, or bibles.

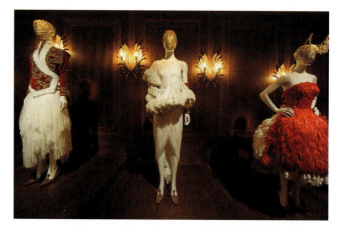

1.29 LEE ALEXANDER MCQUEEN. Display from the 2015 exhibition *Savage Beauty* at the Victoria and Albert Museum, London.

This exhibit of McQueen's fashions in a major art museum was elaborately staged like his spectacular runway shows.

And, of course, in some cultures, artists are considered people with special or prized skills. In particular, in Europe during the Renaissance, many European artists were considered to be creative geniuses. One example was Leonardo da Vinci, an artist and inventor who contributed also to hydraulics, zoology, geology, optics, physics, botany, and anatomy through drawings like the *Proportions of the Human Figure* (Fig. 1.28). To Leonardo, careful observation of the natural world was the foundation of both science and art.

Creative people abound in our culture today. They can be subdivided into artists, designers, or crafts persons, but for some, their output breaks boundaries. For example, the runway shows of fashion designer Lee Alexander McQueen were often shocking, lavish spectacles that borrowed from art, theater, architecture, and history. His designs reshaped the body, feet, and head. After his death, his distinctive fashions were featured in blockbuster exhibits such as *Savage Beauty* (Fig. 1.29) in major art museums in New York and London.

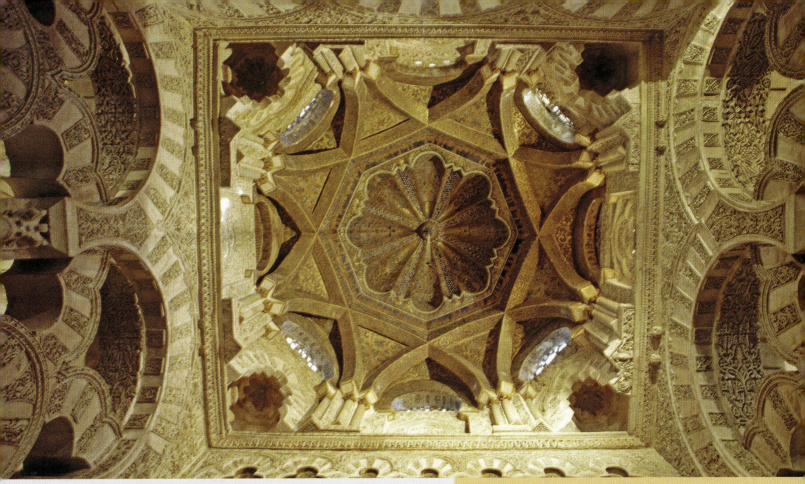

2

THE LANGUAGE OF ART AND ARCHITECTURE

We communicate ideas through languages: oral and written language, numbers, music, and, of course, art. For the language of art and architecture, the grammar consists of (1) the formal elements and (2) the principles by which those elements are composed or structured.

PREVIEW

The language of art and architecture consists of the visual elements and the principles by which they are arranged within the composition. The elements of art are line, light and value, color, texture and pattern, shape and volume, space, time and motion, and chance, improvisation, and spontaneity. The principles of composition are balance, rhythm, proportion and scale, emphasis, unity, and variety. In addition, some artworks engage other senses besides vision.

Architecture also has structural systems, which keep buildings standing. Some common structural systems in traditional buildings are load-bearing walls, post-and-lintel architecture, wood frame construction, arches, vaulting, and domes. Traditional structures can be simple or highly complex, as in the Interior of the Dome of the Great Mosque of Cordoba *(Fig. 2.1). Recent architectural innovations include steel frame buildings, reinforced concrete structures, truss and geodesic construction, and, finally, suspension and tensile construction.*

For this chapter's Art Experiences, you may choose to identify color schemes, find examples of the formal elements in the environment, or photograph structural systems in buildings.

FORMAL ELEMENTS

Words are basic to oral and written languages. Likewise, the basic units of visual language are the **formal elements,** which are line, light and value, color, texture and pattern, shape and volume, space, and time and motion. Some works also contain the elements of chance, improvisation, and spontaneity as well as engaging senses other than sight.

Line

Mathematically, a **line** is a moving point, having length and no width. In art, a line usually has both length and width, but length is the more important dimension.

Lines made with drawing or writing materials are **actual lines.** They physically exist and can be broad, thin, straight, jagged, and so on. **Implied lines** in an artwork do not physically exist, yet they seem quite real to viewers. For example, the dotted line has several individual, unconnected parts that can be grouped into a single "line." The top of Figure 2.2 shows both actual and implied lines.

Lines have **directions:** horizontal, vertical, diagonal, curved, or meandering. The direction can be meaningful. Horizontal lines may imply sleep, quiet, or inactivity. Vertical lines may imply aspiration and yearning, as if defying gravity. Diagonal lines suggest movement because they occur in the posture of running

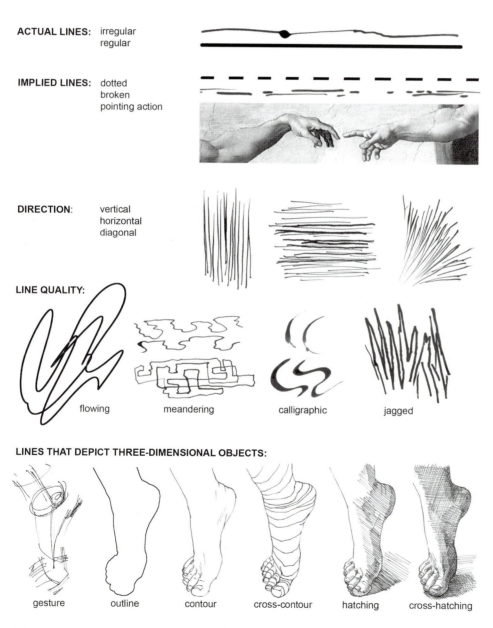

2.2 Lines.

2.3 UTAGAWA KUNISADA. *Shoki the Demon Queller*, c. 1849–1853. Woodblock print, 1′ 2″ × 9½″. Burrell Collection, Glasgow, Scotland.

Most lines in this print are bold and calligraphic, except for those in the hair and beard, where fine lines depict texture.

2.4 PAUL KLEE. *Bounds of the Intellect*, 1927. Oil on canvas, 1′ 4″ × 1′ 10″. State Gallery of Modern Art, Munich, Germany.

This contains delicate, repetitive, precariously balanced lines.

animals and blowing trees, whereas curving lines may suggest flowing movement. These are generalizations because the overall context of the artwork affects the understanding of any specific lines. In *Shoki the Demon Queller* by Utagawa Kunisada (Fig. 2.3), c. 1849–1853, the man's upper body leans to the left, implying movement, as does the diagonal line of his sword. His robe's sweeping curves and jagged diagonal lines imply a furious energy.

Line quality conveys emotional attributes. *Shoki the Demon Queller* contains lines of many different qualities, such as the thick strokes at the bottom hem of Shoki's robe, the fine wispy lines of his beard, and the crisp lines of the sword blade. Line quality can express a range of emotions and characteristics, such as crispness, fragility, roughness, anger, refinement, whimsy, and vigor. Contrast the thick, angular lines of *Shoki* with the thin, delicate, obsessively repetitive lines of Paul Klee's *Bounds of the Intellect* (Fig. 2.4), from 1927. Also, it is important to note not only the quality of lines but also

their arrangements. In *Bounds of the Intellect*, the lines are highly organized at the bottom and increasingly precarious as they go up.

Lines can indicate the volume of three-dimensional objects, as seen in the foot drawings at the bottom of Figure 2.2. **Gesture** lines are rapid, sketchy marks that mimic the movement of the human eyes when examining a subject. Gesture drawings are like maps that show the location, size, and orientation of one part in relation to other parts—but without details. The foot gesture drawing in Figure 2.2 indicates the changing directions of the lower leg, the arch of the foot, and the toes. It also shows the thickness around the ankle and the way the toes flatten against the ground. Gesture lines are often preliminary marks that are covered over as the drawing progresses. However, gesture lines have a quick, energetic quality that some artists like to maintain through to a finished artwork.

Figure 2.2 contains examples of all the following kinds of lines, which depict three-dimensional objects.

2.5 ALBRECHT DURER. *Artist Drawing a Model in Foreshortening through a Frame Using a Grid System*, from *Unterweysung der Messung* (Instructions for Measuring). Woodcut.

Many thin, parallel lines create the illusion of a gray tone. Groups of parallel lines layered on top of each other create darker gray tones.

An **outline** follows the outer edges of the silhouette of a three-dimensional form with uniform line thickness. Outlines flatten a three-dimensional form into a two-dimensional **shape,** which is discussed more on page 35. **Contour lines** mark important edges of three-dimensional objects, including outer edges and key internal details, using varying line thickness. Objects are clearly identifiable in contour line drawings. **Cross-contours** are repeated lines that go around an object and express its three-dimensionality. Cross-contour lines are usually preliminary, exploratory marks, but some appear in a final drawing, like the belt around Shoki's waist. Lines can also produce tones or values (different areas of gray), as in parallel lines of **hatching.** Parallel lines in superimposed layers are **crosshatching,** which can be seen both in the foot drawing in Figure 2.2 and in Albrecht Durer's *Artist Drawing a Model in Foreshortening through a Frame Using a Grid System* (Fig. 2.5). A few layers of crosshatching appear as light gray, while multiple layers appear as darker grays.

Linear elements can exist in space. Any thin string, rope, wire, chain, stick, or rod used in a sculpture can function like a line. The length of the *Linguist's Staff* from Ghana (Fig. 2.6), from the 1900s, gives it an obvious linear quality. Advisors/translators who attend local rulers carry these staffs as a sign of their position; the sculpture on top refers to local proverbs. In architecture, columns are linear elements. Exposed beams and thick steel cables also are linear, as seen later in this chapter in Gunter Behnisch's and Otto Frei's *Olympic Stadium, Munich* (Fig. 2.44).

Light and Value

Light is the basis for vision and thus necessary for art. **Light** is electromagnetic energy that, in certain wavelengths, stimulates the eyes and brain. The sun, moon, stars, lightning, and fire are natural light sources, whereas incandescent, fluorescent, neon, and laser lights are artificial. In art and architecture, light might be an actual element, as in Dan Flavin's, *Untitled (To Donna) 6*, 1971 (Fig. 2.7). Flavin's work is made of nothing but lights in a corner. The light fixtures form a frame, very much like the frame that sets a painting apart from its environment. His glowing work is mounted on a white wall, but the luminous, subtle color mixing creates an ethereal space. In buildings, the control of light is an essential design element, whether with skylights, windows, or artificial lights.

Most art does not emit or manipulate light itself but rather reflects **ambient light,** which is the light all around us in our world. In two-dimensional art, artists use value to represent the various levels of light that reflects off of objects. **Value** is one step on a gradation from light and dark. **Tone** is another word for value. In an **achromatic value scale** (Fig. 2.8), the value goes from white to black, with the continuum of gray tones in between. Value can also be associated with color: red can still be red, but it can be lighter or darker. Different values of color are shown in the **chromatic** value and intensity scales in Figure 2.8.

Artists can carefully manipulate gradations in values to create the appearance of natural light on objects. This is called **shading** or **modeling,** and it can be seen in the

2.6 *Linguist's staff (okyea mepoma)*. Akan artist. Nineteenth–twentieth centuries. Wood and gold leaf, 5′ 1″ × 8⁷/₁₆″ × 1⁵/₈″. Princeton University Art Museum, New Jersey.

A long, thin, three-dimensional object can act like a line in space.

2.7 DAN FLAVIN. *Untitled (To Donna) 6,* 1971. Fluorescent lights, 8′ × 8′. Albright-Knox Art Gallery.

This is an example of an artwork that is light emitting.

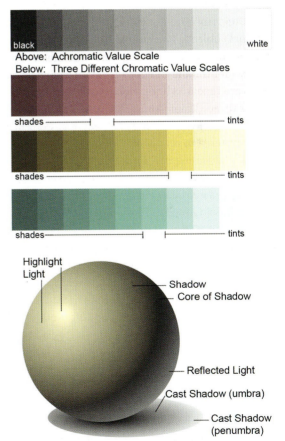

Above: Achromatic Value Scale
Below: Three Different Chromatic Value Scales

black / white
shades — tints
shades — tints
shades — tints

Highlight
Light
Shadow
Core of Shadow
Reflected Light
Cast Shadow (umbra)
Cast Shadow (penumbra)

The ball illustrates values creating the illusion of volume.

2.8 Value and intensity diagram.

2.9 ROSSO FIORENTINO. *Recumbent Female Nude Figure Asleep*, 1530–1540. 5″ × 9½″. British Museum, London.

In this drawing, shading mimics light washing across the human form.

drawing of the ball in Figure 2.8. Renaissance Italians used the term **chiaroscuro** to describe these light-dark gradations that produce the illusion of objects in space. For example, in Rosso Fiorentino's *Recumbent Female Nude Figure Asleep* (Fig. 2.9), from 1530–1540, the human body seems to emerge from the paper because of the range of values and shading in reddish-brown chalk.

A range of values can also express emotion. Stark, high-contrast drawings may carry a strong emotional charge, like *Shoki the Demon Queller* (Fig. 2.3), whereas the more subdued tones in Fiorentino's drawing may lull the viewer.

Sculpture and architecture may have value differences simply because of the many angles at which light hits and reflects off their three-dimensional surfaces, as with Louise Nevelson's *Mirror Image I* (Fig. 2.10), from 1969. All the carved wooden forms and stacked boxes are painted black, but the light bouncing off of various surfaces appears as gray or as black. Other sculptures may have tonal variation caused by their three-dimensionality and variations in their painted surface.

Color

Color is a wonderful phenomenon that people are lucky to enjoy. Color is visible in **refracted** light, when a prism

breaks a light beam into a **spectrum** of color, or in a rainbow after a storm. Color is also visible in **reflected** light, when objects around us absorb some of the spectrum and bounce back the rest. Those rays that are reflected to our eyes are the color of the object.

The properties of color are hue, value, and intensity. **Hue** is the pure state of color in the spectrum and is that color's name, such as red, blue, yellow, green, violet, or orange. **Value** in color is lightness and darkness within a hue, as we already saw in Figure 2.8. When black is added to a hue, a **shade** of that color is created, whereas the addition of white results in a **tint** of that color. **Intensity** in color is the brightness and dullness of a hue. Synonyms for intensity are **chroma** and **saturation.** A high-intensity color is brilliant and vivid, whereas a low-intensity color is faded or dull. Black and white have value but not intensity among their properties. **Neutral** colors are very low-intensity colors such as cream, tan, and beige. In Thomas Gainsborough's *Mr. and Mrs. Andrews* (Fig. 2.11), the most saturated colors are in the blue satin dress. Mr. Andrews' neutral-color jacket is a low saturated color. Foreground greens are warm and intense compared to the cool, blue-gray greens in the distance. **Local colors** are the colors we normally find in the objects around us. In this painting, the blue dress, yellow hay, and gray-and-white clouds are all in local colors.

2.10 LOUISE NEVELSON. *Mirror Image I*, 1969. Painted wood, 9′ 9¾″ × 17′ 6½″ × 1′ 9″. Collection of the Museum of Fine Arts, Houston.

This is a completely black sculpture, but we see a range of dark gray values, caused by light hitting and reflecting off the raised areas.

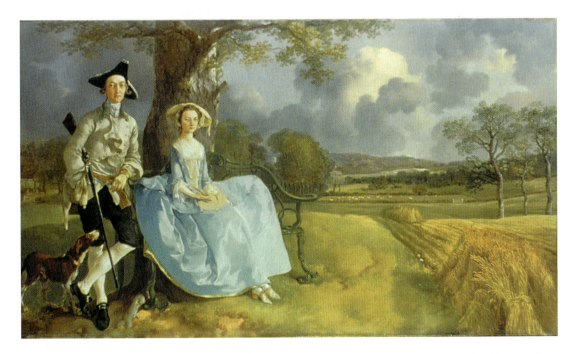

2.11 THOMAS GAINSBOROUGH. *Mr. and Mrs. Andrews*, 1750. Oil on canvas, 2′ 3½″ × 3′ 11″. National Gallery, London.

Areas of saturated color include Mrs. Andrews' dress and the foreground greens and yellows. Neutral colors were used on Mr. Andrews' attire and the tree trunk.

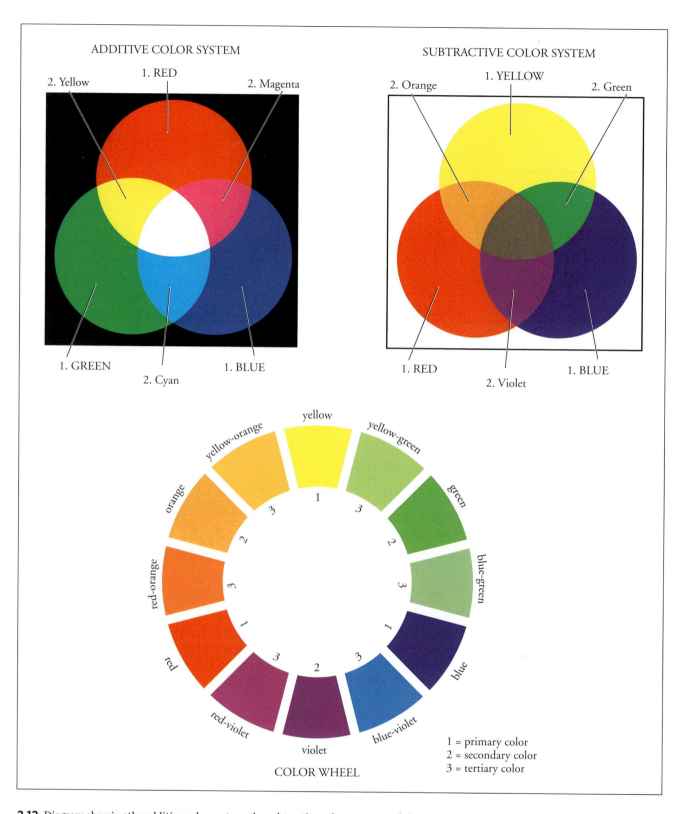

ADDITIVE COLOR SYSTEM

2. Yellow
1. RED
2. Magenta
1. GREEN
2. Cyan
1. BLUE

SUBTRACTIVE COLOR SYSTEM

2. Orange
1. YELLOW
2. Green
1. RED
2. Violet
1. BLUE

COLOR WHEEL

yellow
yellow-orange
yellow-green
orange
green
red-orange
blue-green
red
blue
red-violet
blue-violet
violet

1 = primary color
2 = secondary color
3 = tertiary color

2.12 Diagram showing the additive color system, the subtractive color system, and the color wheel for mixing pigments.

Artists mix colors through one of two systems: additive and subtractive (Fig. 2.12). The **additive color system** applies to light-emitting media. In additive color systems, absence of light produces darkness (or black), and all light added together results in the brightest, whitest light at the center of Figure 2.12A. In our diagram, we see what happens as red, green, and blue lights are mixed. Theater lighting, performance art lighting, light

displays, and computer and video monitors use the additive color system.

In the **subtractive color system,** artists mix pigments to control the light that is reflected from them. **Pigments** are powdered substances ground into oil, acrylic polymer, or other binders to create paints. In the subtractive color system, white is a pigment that reflects almost the entire spectrum of light. Black absorbs almost all light, reflecting back very little. Our diagram shows the mixing of red, yellow, and blue. Mixing more and more pigments gives darker results because the mixture increasingly absorbs the available light, as we see in the center of Figure 2.12B.

Primary colors combine to produce the largest number of new colors. Various art media have their distinct primary colors. For example, for light-emitting media, the primary colors are red, blue, and green, as we see on our additive color system diagram. **Secondary colors** result from mixing two primary colors. Again, in light-emitting media, the secondary colors are yellow, cyan, and magenta. For paints and pigments, the primary colors are red, yellow, and blue, while the secondary colors are orange, green, and violet. Mixing one primary color with one of its neighboring secondary colors produces a **tertiary color.** Blue-green is a tertiary color in paint. **Analogous colors** are those that are similar in appearance, especially those in which we can see related hues, such as yellow, yellow-orange, and orange. Analogous colors are next to each other on the color wheel. **Complementary colors** are opposites of each other and, when mixed, give a dull result.

In paint, red and green are complementary colors. The color wheel and Figure 2.13 again show us this relationship. We can see the various colors on the **color wheel** in Figure 2.12C, which applies only to color mixing with paints and pigments.

Many color images we encounter in our lives are commercially printed, including the color images in this book. Commercial printers use semitransparent inks, with these primary colors: yellow, magenta (a bright pink), and cyan (a bright blue-green), plus black added for darkness and contrast. The secondary colors are blue, red, and green. You can easily see these primaries, and their resulting mixtures, if you use a strong magnifying glass while looking at a newspaper's color photograph. You encounter these same inks and the same CMYK (cyan, magenta, yellow, black; K = black) primaries in your home computer printer. Color printouts are made basically from mixtures of these colors. (However, your home printer may feature a wider range of ink beyond the basic CYMK in order to give more saturated results.) The chart in Figure 2.13 sums up the primary and secondary colors in various media, plus other color attributes.

Color perception is **relative,** meaning that we see colors differently, depending on their surroundings. Light-emitting media stand out in dark rooms, like watching television in the dark. In a very bright room, the television image is barely visible. Conversely, reflective media need a lot of light to be seen well. A spotlight on a painting makes its colors vivid, whereas a dim room makes them difficult

COLOR PROPERTIES IN VARIOUS MEDIA

	Paint	Light-Emitting Media (e.g., Computer Monitor)	Commercial Printing or Computer Printer
Color System	subtractive	additive	subtractive
Effects of Environmental Light Levels	more room light, the brighter the colors	less room light, the brighter the colors	more room light, the brighter the colors
Primary Colors	blue, red, yellow	red, green, blue	cyan, magenta, yellow, black (CMYK)
Secondary Colors	violet (blue + red)	yellow (red + green)	red (magenta + yellow)
	green (yellow + blue)	cyan (green + blue)	blue (cyan + magenta)
	orange (red + yellow)	magenta (red + blue)	green (yellow + cyan)
Complementaries	blue – orange	red – cyan	cyan – red
	red – green	green – magenta	magenta – green
	yellow – violet	blue – yellow	yellow – blue
Mixture of All Primaries	gray or dull neutral	white	black

2.13 Chart showing color properties in various media.

The three small center squares above seem to be different shades of orange, but they are all the same.

The two small pink squares above seem to be the same but they are different.

Stare at the white dot at the center of the flag for 30 seconds and then look at a white wall. It will appear to be red, white, and blue. Color perception shifts due to eye fatigue.

2.14 Relativity of color perception.

to see. Because natural light is constantly changing, our visual perception is also, so there is no single, fixed, permanent state that the painting "looks like."

We also experience **relativity of color perception** when we look at certain combinations of colors. In Figure 2.14, the colors in the center of the top row of squares appear to be different even though they are exactly the same, while the dull pink squares in the second row appear to be the same but are different. Eye fatigue also affects our color perception. Stare at the white dot in the center of the "flag" in Figure 2.14 for one minute. You will soon notice that you have trouble seeing the colors, which at first were so clear and bright. After the minute has passed, look at a white wall

to see an afterimage of the flag, with colors shifted to red, white, and blue. Because of eye fatigue, your eyes see the complements, or opposites, of the printed colors.

Colors associated with the sun and fire, such as yellows, reds, and oranges, are considered **warm.** Colors associated with plant life, sky, and water, such as greens, blues, and violets, are **cool.** Warm and cool colors can affect an audience both physically and emotionally. Certain colors in the surroundings can actually influence your alertness, sense of well-being, and sense of inner peace.

Colors can be symbolic and, thus, associated with ideas or events. The colors of a country's flag are tied to concepts of national identity and patriotism. Certain colors might

2.15 *Lion Capital* of column erected by Ashoka at Sarnath, India, c. 250 BCE. Polished sandstone, approx. 7′ high. Archeological Museum, Sarnath, India.

The careful carving of the sandstone results in smooth surfaces and areas of distinct texture.

2.16 *Detail of Deesis Mosaic in Hagia Sophia,* believed to be 1185–1204. Mosaic tile.

Some media, like mosaic, have a texture that is inherent in the materials themselves.

mean a holiday or a celebration, such as red and green for Christmastime in Western cultures or red for a wedding in Asian cultures. One color may be associated with different, and even contradictory, ideas. For example, you might think of blue in relation to the ethereal, to purity, or to depression. Yellow might mean cowardice, or it might mean youth, spring, and rebirth. Associations change from culture to culture (so the red for weddings in Asia becomes white in Western cultures).

Texture and Pattern

Texture is a surface characteristic that is tactile or visual. **Tactile texture** consists of physical surface variations that can be perceived by the sense of touch. Sculptures often have distinctive tactile textures, as in the *Lion Capital* from Sarnath, India (Fig. 2.15), c. 250 BCE. The gleaming smooth sandstone on the lion's legs contrasts with the rough texture of the lion's mane. Sometimes a medium has an inherent texture. For example, mosaic is a method of creating a picture out of small colored glass or stone pieces, which are affixed to a surface, as seen in Figure 2.16, *Detail of Deesis Mosaic in Hagia Sophia.* Each mosaic piece reflects ambient light in a slightly different direction. **Visual texture** is illusionary. In *Mr. and Mrs. Andrews* (Fig. 2.11), Gainsborough

manipulated the paint to create the illusions of lustrous satin, bristly hay, and fluffy clouds, even though the painting surface is flat.

Texture can be simulated, abstracted, or invented. **Simulated** textures mimic reality, as in *Mr. and Mrs. Andrews*. Texture can be **abstracted** as well, meaning that it is based on some existing texture but has been simplified and regularized. The mane on the *Lion Capital* is an abstracted texture. **Invented** textures are products of human imagination.

Building materials often have unique textures. Just think of marble, stone, wood, concrete, cloth, glass, stucco, plaster, metal, brick, or glazed tile, each with a different visual appeal, and each with its own texture.

Texture and pattern are related: If a pattern is reduced drastically in size, it is often perceived as a texture, and if a texture is greatly increased in size, it is likely to be perceived as a pattern. The lion's mane on

the *Lion Capital* can be read as either texture or pattern. **Pattern** is a configuration with a repeated visual form (or forms). **Natural patterns** occur all around us, in leaves and flowers, in cloud and crystal formations, in wave patterns, and so on. In natural patterns, the repeated elements may resemble each other but not be exactly alike. The intervals between elements also may vary. The tree branches and furrows in the field in *Mr. and Mrs. Andrews* (Fig. 2.11) simulate natural patterns. **Geometric patterns** have regular elements spaced at regular intervals. They are common in math, interior design, and art. The Chilkat *Blanket* (Fig. 2.17) is covered with bold patterns abstracted from human and animal forms. The eyes overall were intended as a form of protection and power.

Pattern in art is often an organizing element, as with the *Blanket*, and the extensive use of pattern makes a striking visual impression. Some patterns are totally

2.17 *Blanket*, Tlingit people, Chilkat style. Mountain goat wool and cedar bark, 2′ 7″ × 5′ 11″, excluding fringe. The Newark Museum, Newark, New Jersey.

The black and yellow patterns are abstracted from human or animal features and have a geometric quality.

invented, some are geometric, some contain highly abstracted forms (like the *Blanket*), and some are inherent in the materials, like wood grain. Pattern also functions as **decoration** on objects such as wrapping paper, wallpaper, and fabric. Pattern's function in these instances is to give visual pleasure.

Pattern serves various functions in architecture. It creates visual interest, whether it is a repeated structural element or surface decoration. In the *Great Mosque of Cordoba* (Fig. 2.18), pattern appears both in the multiple arches and in the beige and terracotta banding, which is ornamentation that is not structurally necessary. Figure 2.1 is another view of the mosque interior, with more structural and surface pattern. These patterns may function to direct your eye to certain features of a building, like entrances or domes. Pattern can also have symbolic value. In Islamic religious architecture, the amazing, rich patterns express the idea that all the wonder of creation originates in Allah.

Pattern is also an important tool for thinking visually. Pattern helps organize ideas and concepts into visual **diagrams** that make relationships clear. Pattern is the basis of flowcharts, street maps, mechanical diagrams,

and floor plans. We see patterns in the creative work of many artists, engineers, and scientists. Pattern is inherent in almost all structural systems in architecture, which is evident in the diagrams later in this chapter (pages 46–51).

Shape and Volume

Shape is a two-dimensional visual entity. We have names for many **regular shapes,** such as *circle, square, triangle, hexagon,* and *teardrop,* and they are often **geometric. Irregular shapes** are unique and have no simple, defining names. Instead, they are the dark patches of a cat's fur, the splatter of spilled paint, or the outline of a human body. Irregular shapes are often **organic** or **biomorphic,** in that they resemble living beings. Shapes can be defined by outlines or by an area of color surrounded by a contrasting area. *Bounds of the Intellect* (Fig. 2.4) contains many geometric shapes.

Volume is three-dimensionality, in contrast to two-dimensional shape. Like shape, volume can be regular or irregular, geometric or biomorphic. Shape and volume may simulate reality, may be abstracted from reality, or may

2.18 *Great Mosque of Cordoba,* interior, Spain, 786 CE.

The arches are a vast network of pattern, and the color banding adds to the intensity of the pattern.

2.19 *Car.* Wire child's toy, Africa.

This toy's mass is very little compared to its volume.

be invented. The child's toy from Africa, *Car* (Fig. 2.19), is a wire outline of a vehicle, but it is hollow and without any of its interior substance. Volumes may have more or less physical bulk, or **mass.** An open or wire frame structure, like the *Car*, can have a large volume but little mass. The solid stone *Lion Capital* (Fig. 2.15) has both volume and mass.

Shape and volume are key elements in architecture. Look at the buildings around you. What are their predominant shapes? What volumes do they enclose? How much mass do the structures have? What spaces surround them?

Space

In this section, we look at three kinds of space in relation to art: (1) the space in two-dimensional artwork; (2) the space of sculpture and architecture, which is both its mass and the voids it contains; and (3) the space of performance art and installation.

First, we consider space in two-dimensional art. Two-dimensional art has **planar space,** the height and width of the picture surface. In *Bounds of the Intellect* (Fig. 2.4), the orb and staircase occupy space in the height and width of the picture plane. In contrast, artists can create the illusion of deep space on the flat surface of two-dimensional art. Overlapping imagery and placement on the page are two simple ways to achieve illusory space in depth in a drawing or painting. Again, in *Bounds of the Intellect*, the forms at the bottom of the picture are overlapping, creating a more complex space than what we see at the top of the same image.

More complex illusions of space are created through **perspective,** a group of methods for creating the illusion of depth on a flat picture plane. **Atmospheric perspective** (or **aerial perspective**) refers to the light, bleached-out, fuzzy handling of distant forms to make them seem far away. We have already seen two works that illustrate atmospheric perspective: (1) Durer's *Artist Drawing a Model* (Fig. 2.5), where foreground shapes are bold and heavily shaded compared to the light, linear handling of the distant landscape; and (2) *Mr. and Mrs. Andrews* (Fig. 2.11), where the distant landscape is less colorful and less detailed.

Another kind of perspective is **linear perspective,** which operates on the theory that parallel lines appear to converge as they recede. They seem to meet on an imaginary line called the **horizon line,** or at eye level. The horizon line corresponds to the viewer's eye level in a picture, determining what the viewer perceives as "above" or "below."

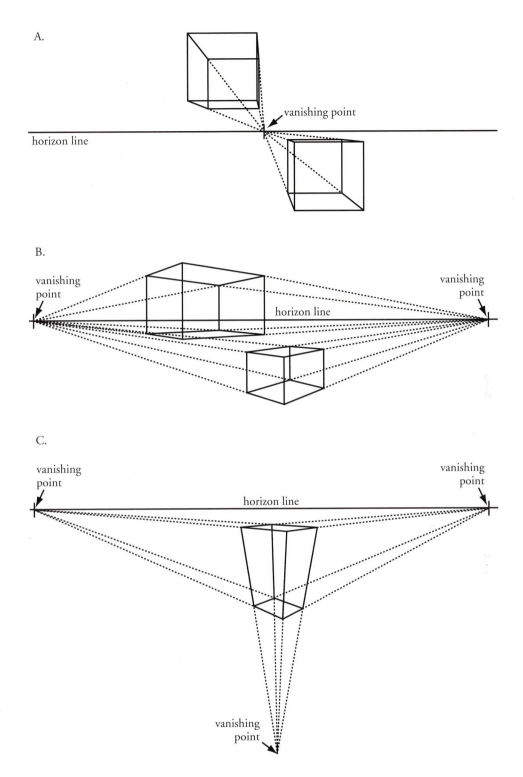

A.

vanishing point

horizon line

B.

vanishing point

horizon line

vanishing point

C.

vanishing point

horizon line

vanishing point

vanishing point

2.20 Diagram of linear perspective.

The three types of linear perspective—one-, two-, and three-point—are shown in the diagram in Figure 2.20. In **one-point perspective** (Fig. 2.20A), the frontal plane of a volume is closest to the viewer, and all other planes appear to recede to a single vanishing point. In **two-point perspective** (Fig. 2.20B), a single edge (or line) of a volume is closest to the viewer, and all planes appear to recede to one of two vanishing points. In **three-point perspective** (Fig. 2.20C), only a single point of a volume is closest to the viewer, and all planes seem to recede to one of three vanishing points. Figure 2.5, *Artist Drawing a Model*, is a precise exercise in one-point perspective. Ronald W. Davis'

2.21 RONALD W. DAVIS. *Cube and Four Panels*, 1975. Acrylic on canvas, support 9′ 2½″ × 10′ 10¾″. Albright-Knox Art Gallery, Buffalo, New York.

Three-point perspective creates the illusion of forms that receded to the left, to the right, and downward.

2.22 An example of an isometric projection (A), and an example of an oblique projection (B).

Cube and Four Panels (Fig. 2.21) is an example of three-point perspective. In this case, the eye level of the viewer is above the cube, and sides recede in three directions.

Two other systems to show space in a picture are isometric perspective and oblique perspective. **Isometric perspective,** which is especially used in architectural drafting, renders planes on a diagonal that does not recede in space (Fig. 2.22A). The side planes are drawn at a 30-degree angle to the left and right. In **oblique perspective,** a three-dimensional object is rendered with the front and back parallel (Fig. 2.22B). The side planes are drawn at a 45-degree angle from the front plane. Figure 2.23 is *Festivities*, a detail of a Japanese screen depicting popular festivities from the Muromachi period. Oblique perspective is used to depict the architecture and people behind the fence, under the cloud.

2.23 *Festivities*, detail of a screen depicting the popular festivities that took place at Shijo-gawa, Kyoto, late Muromachi period, sixteenth century. Seikado Library, Tokyo.

The artist has used oblique perspective to give a sense of space going back from the lower left to the upper right.

2.24 GIORGIO DE CHIRICO. *Gare Montparnasse (The Melancholy of Departure)*, 1914. Oil on canvas, 4′ 7″ × 6′. The Museum of Modern Art, New York.

This example of multipoint perspective shows an unreal or illogical depiction of space.

Artists may use **multipoint perspective** in an image, so that various sections conform to different perspective systems. They also may use amplified or distorted perspective to give their image dramatic emphasis. In *Gare Montparnasse (The Melancholy of Departure)* (Fig. 2.24), from 1914, by Giorgio de Chirico, the perspective gives the painting the fractured space of a dream or a memory. The building with pillars stretches far back to the horizon line, while the striped structure at left seems to plunge into the ground. The silhouette of a train perches precariously on the horizon. The strange lighting and shadows contribute to the sense of unease.

Now let us turn to space in sculpture and architecture, which consists of the footprint occupied by the structure and also the voids and solids within each piece and immediately surrounding it. Look again at the outlined void of the wire *Car* (Fig. 2.19), which might allow the child who plays with it to fill the emptiness by imagining traveling to a fantastic place with friends. The voids and solids in Louise Nevelson's *Mirror Image I* (Fig. 2.10) create a rhythmic dance of dark shapes and even darker voids.

Finally, space in installation or performance art can be particularly significant because part of the meaning comes from the environment. Huang Yong Ping's installation *Bat Project I (Shenzhen)* (Fig. 2.25), from 2001, is a replica of a U.S. spy plane that collided with a Chinese plane in April 2001 and had to land in China, which caused an international furor. Huang's reconstruction

2.25 HUANG YONG PING. *Bat Project I (Shenzhen)*, China, 2001. Replica of an American spy plane from middle of body to tail. Barbara Gladstone Gallery, New York.

The location of an artwork affects what it means.

of the back half of the plane was to be exhibited as part of a major international exhibition amid skyscrapers in the city of Shenzhen. Before the installation was finished, the replica was removed without the artist's permission because officials feared that it might damage international relations among the United States, China, and France (a sponsor of the exhibition). It was later installed (again without the artist's knowledge) as a permanent feature in an amusement park. Thus, the impact of the same piece of art, which was too sensational for a major exhibition, was neutralized by the amusement park location.

Time and Motion

A lot of art is static; it does not move. Yet time and motion can still be important elements. **Time** is the period that viewers study and absorb the message and formal qualities of an artwork. Motion can be implied, as in Marcel Duchamp's *The Passage from Virgin to Bride* (Fig. 2.26), from 1912. Factors that contribute to its illusion of motion are (1) the rhythmic repetition of abstracted forms in a moving pattern and (2) the fading in and out of the image on the left and on the right.

However, motion is integral to film/video, interactive digital art, kinetic sculpture, and performance.

In these works, time and motion are related, as motion cannot exist without time and motion marks the passage of time. Chinese artist Cai Guo-Qiang's *Black Rainbow: Explosion Project for Valencia, Spain* (Fig. 2.27), from 2005, is one of a series that occurs in cities such as Edinburgh and Beijing. These black rainbows were intended as omens of international unease, and although violence and explosive materials are frightening, they can also attract with their power and beauty. In a matter of mere minutes, the loud explosions are set off, and black smoke appears in the sky, spreads into a rainbow-like arc, and then dissipates.

With architecture and large sculpture, we cannot grasp all their features in an instant, from a single point of view. These works unfold in time as we move through them or around them. For example, a traveler first sees the twenty-nine Ajanta Caves as doorways and porches carved

2.27 CAI GUO-QIANG. *Black Rainbow: Explosion Project for Valencia, Spain*, 2005.

Some artwork moves and changes in time and is not in fixed form. In this case, the change was rapid.

2.26 MARCEL DUCHAMP. *The Passage from Virgin to Bride*, 1912. Oil on canvas, 1′ 11½″ × 1′ 9″. The Museum of Modern Art, New York.

Motion is implied by the repetition of similar shapes.

into a curving hillside in west central India. This modest outside view does not prepare the viewer for the amazing *Ceiling of Cave 26* in a darkened, columned hall with a shrine to Buddha, all cut out of the living rock (Fig. 2.28). Yet even more unfolds in time and with the viewer's motion. To one side in Cave 26 is *Parinirvana* (Fig. 2.29), or a sculpture of the death of Buddha, behind a row of columns.

Chance/Improvisation/Spontaneity

Many artists purposely allow for chance, improvisation, or spontaneity to add something unexpected in their work or to make it unique each time it is seen. Some aspects of chance are created by uncontrollable factors, such as atmospheric conditions at the moment that

2.28, *right* View of the *Ceiling of Cave 26*, one of the many caves at Ajanta dating back to 700 CE, Maharashtra, India.

See Figure 2.29 for another view of the cave interior. Art can be spatially complicated, which requires viewers to walk around to see it all.

2.29, *below* A second view of *Cave 26* at Ajanta Caves, *Parinirvana* between the columns in Chaitya Hall, late fifth century, Maharashtra, India.

Looking up gives one view of the cave; looking to the side is a completely different experience.

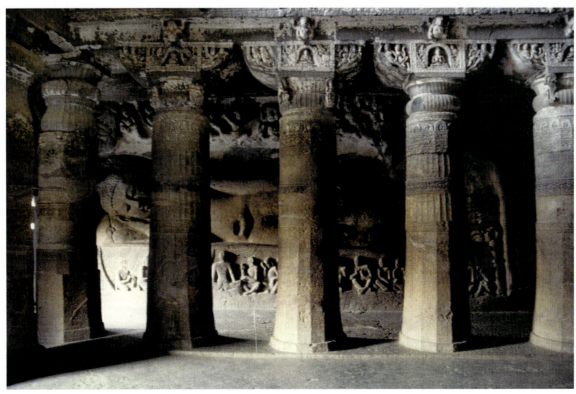

Cai Guo-Qiang's *Black Rainbows* exploded into the sky. Some artists embrace chance and weave it into the very form of the work.

CONNECTION Allan Kaprow's *Household* (Fig. 14.23) was a Happening performed by several men and women, who worked from a simple premise but were free to improvise as the performance unfolded.

Engaging All the Senses

Although we tend to think of art in visual terms, many artworks appeal to other senses as well. Cai Guo-Qiang's explosions are one obvious example. The Ajanta Caves stimulate sound, smell, tactile, and visual sensations. Film, video, interactive digital art, and performance have sound components to accompany the visual.

African masquerades are art forms that incorporate art objects, singing, dancing, and community celebrations and rituals. The performances of the *Bwa Masqueraders* of Burkina Faso (Fig. 2.30) bring spirits among the people, promote community well-being, and ensure good crops and other necessities. Masks are not considered static sculptures but are integral parts of the larger masquerade art form. The masks and raffia costumes also disguise the performers' identities.

ART EXPERIENCE Make a visual diary of the formal elements that you see around you.

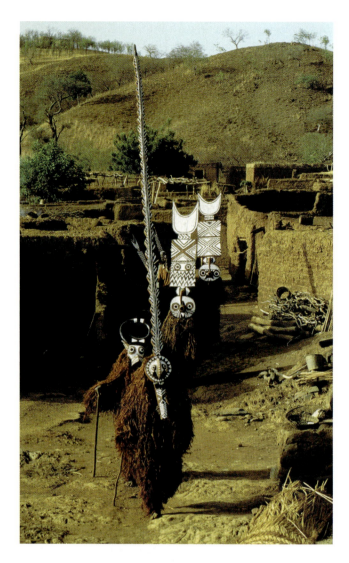

2.30 *Bwa Masqueraders*, Burkina Faso.

Art forms such as performances, masquerades, and film engage more senses than just vision.

PRINCIPLES OF COMPOSITION

The arrangement of the formal elements in a work of art is called its **composition.** The principles of composition are balance, rhythm, proportion and scale, emphasis, unity, and variety.

Balance

Balance in an artwork results from placing the elements so that their visual weights seem evenly distributed. *Weight* generally means the amount of attention an element commands from the viewer. For example, large shapes demand more attention than small ones, complex forms have greater visual weight than simple ones, and vivid colors are visually weightier than faded colors. In **symmetrical balance,** visual weight is distributed evenly throughout the composition. If an imaginary line were to be drawn through the center of the work, one side would mirror the other, as in the Chilkat *Blanket* (Fig. 2.17). **Asymmetrical balance** is achieved by the careful distribution of uneven elements. In *Gare Montparnasse (The Melancholy of Departure)* (Fig. 2.24), the striped building on the left is approximately balanced by the yellow road on the right. **Radial balance** results when all the elements in the composition visually radiate outward from a central point. Radial balance is often an organizing principle in spiritually based art, featured in mandalas, church windows, temple plans, and mosque domes (Fig. 2.1). The magnificent *Angkor Wat* temple in Cambodia is laid out in a modified radial plan (Fig. 2.31).

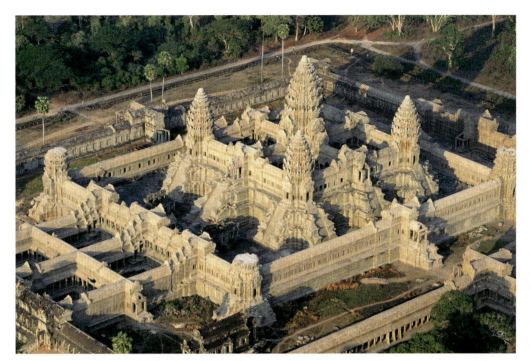

2.31 *Angkor Wat,* Central Temple Complex, Cambodia, c. 1113–1150 CE.

Symmetry and radial balance add to the grandeur of this enormous temple complex.

2.32 *Churning of the Ocean of Milk, Angkor Wat,* Cambodia. Bas-relief.

Rhythm is an organizing principle of composition that repeats elements in regular, alternating, or eccentric arrangements.

Rhythm

In a composition, **rhythm** is the repetition of carefully placed elements separated by intervals. These recurrent visual "beats" move the viewer's eye through the composition in jerky, smooth, fast, or slow ways. Rhythm is related to pattern, but it affects the entire composition.

Regular rhythm is smooth and even, where some visual element is systematically repeated with a standard interval in between. Closely related is **alternating rhythm,** where different elements are repeatedly placed side by side, which produces a regular and anticipated sequence. In architecture, rhythm is often alternating solids and voids. **Eccentric rhythm** is irregular—but not so much so that the visual beats do not connect. In the bas-relief of the *Churning of the Ocean of Milk*, from *Angkor Wat* (Fig. 2.32), we see examples of regular rhythm (the heads), alternating rhythm (the legs), and eccentric rhythm (the dancing

spirits overhead). The relief shows an eternal, cosmic struggle in which demons and gods churn the ocean for precious things that have been lost. The visual repetition is a fitting expression for this rhythmic physical struggle.

Proportion and Scale

Proportion refers to the size of one part in relation to that of another within a work of art or to the size of one part in relation to that of the whole. The small dancers at the top of *Churning of the Ocean of Milk* are proportionally much smaller than the larger figures below. For another example of proportion, return to the *Bwa Masqueraders* (Fig. 2.30) to see how large the masks are in relation to the dancers' bodies and, even within the masks, the size relationship between the face area and the elaborate forms above it.

Scale is the size of something in relation to what we assume to be normal. Figure 2.33 shows a real scale shift upward, with cars driving through *The Binocular Entrance to the Chiat Building* (sculpture by Claes Oldenburg and Coosje van Bruggen; architect, Frank O. Gehry).

Proportion and scale are expressive devices. The *Binocular Entrance* is meant to be dramatic, memorable, and humorous. The tall sculptural forms on the masks of the *Bwa Masqueraders* suggest their otherworldly power. **Hieratic scaling** is a device that points to the highest-ranking person in the scene, as in *Parinirvana* (Fig. 2.29), where the reclining Buddha is enormous compared to all

other figures around him. Scale in architecture is its overall size in relation to the human body, which also has expressive potential. Large-scale buildings dwarf and overwhelm people, whereas small buildings often seem comfortable to the individual.

The scale of art may not be clear if you look at art only in reproductions. Sometimes there are internal clues regarding scale, such as the cars in *The Binocular Entrance* (Fig. 2.33), but often scale can be very uncertain, with no way of knowing how large an artwork actually is. Reading the caption gives you some information, but you have to exert your imagination to really see the piece. This chapter contains several reproductions of three-dimensional works. Can you remember which was the largest: *Untitled (To Donna) 6* (Fig. 2.7), *Mirror Image I* (Fig. 2.10), the *Lion Capital* (Fig. 2.15), or the Chilkat *Blanket* (Fig. 2.17)?

Emphasis

Emphasis is the result of one or more focal points in an artwork. When there are several focal points, lesser ones are called **accents.** In Figure 2.26, *The Passage from Virgin to Bride,* the lightest tones are the most emphasized. Emphasis in architecture means that one part of a building becomes a focal point. Architects often use ornamentation for emphasis. The *Binocular Entrance* is obviously the focal point on that building.

2.33 Claes Oldenburg, Coosje van Bruggen, and Frank O. Gehry. *The Binocular Entrance to the Chiat Building,* Venice, California, 1985–1991.

The binoculars are on a larger scale than everything else around them.

Unity and Variety

Unity is the quality of overall cohesion within an artwork. **Variety** is the element of difference within an artwork. They would seem on the surface to be mutually exclusive qualities, but, in fact, they coexist in all artworks, evoking in viewers a fascination that makes them keep coming back and keep looking. In *The Passage from Virgin to Bride*, unity is achieved with the brown palette and also with the shapes, which are simplified geometric versions of the human body. Variety is introduced with the varying angles of the shapes and the changes in lighting.

In architecture, unity is the quality that makes the disparate architectural parts coalesce, whereas variety adds opposing elements to buildings. It is interesting to see how architects use nature to create variety in their designs. House plants add variety to the interior, while planter beds and gardens relieve the austerity of the exterior. Within neighborhoods, rows of houses are juxtaposed with greenbelts and parks.

CONNECTION An extreme example of variety is the density of Manhattan relieved by the expansiveness of New York City's *Central Park*, designed by landscape architects Frederick Law Olmsted and Calvert Vaux (Fig. 14.8).

STRUCTURAL SYSTEMS IN ARCHITECTURE

So far in this chapter, we have studied formal elements and principles of composition that apply to both art and architecture. Now we turn to structural systems, which apply to architecture only. Structural systems enable buildings to stand up and enclose space, using materials like brick, stone, wood, steel, and concrete. Structural systems and materials strongly influence the design and visual appearance of buildings.

Traditional Building Methods

Load-Bearing Construction

Early architecture was made of shaped earth, bones, wood, or stacked stone. Builders used whatever materials were locally available. The igloo made of ice blocks is one example. Ancient houses in China were dug right out of the earth. In many places, people stacked material to create solid walls that were usually thicker at the bottom to provide stability. Early roofs were often lightweight, impermanent material like reeds or thatch, as in the sun-dried brick structures in the ancient Near East. This kind of architecture is called "load bearing" because all areas of the walls support the structure above them, and the walls have few openings.

An extreme example of a load-bearing structure is *El Castillo*, a Mayan pyramid and temple at Chichén Itzá, in Mexico (Fig. 2.34). The pyramid base is almost solid,

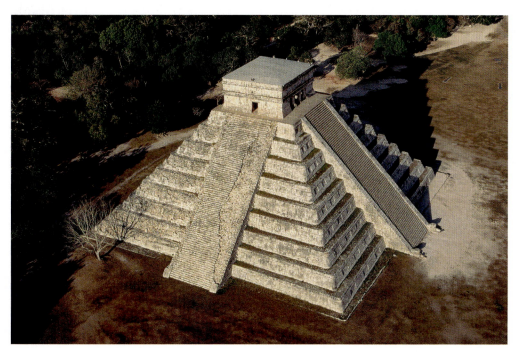

2.34 *El Castillo*, elevated view, Chichén Itzá, Mexico, ninth–tenth centuries.

This structure is nearly solid. The small temple on top is an example of load-bearing construction, with its walls uninterrupted except for a few small doors.

BASIC POST-AND-LINTEL MODULE
Arrows indicate the downward distribution of weight

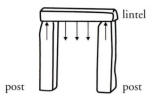

lintel

post post

COLONNADE

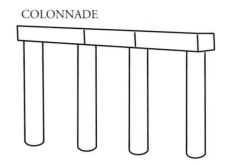

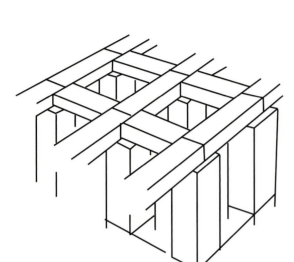

GRID OF POST-AND-LINTEL MODULES,
IN STONE
Many interior posts are needed to support
the stone lintels

GRID OF POST-AND-LINTEL
MODULES, WITH WOOD LINTELS
Fewer posts are needed, and longer
lintels are possible

2.35 Diagram showing post-and-lintel construction.

with only a steep, claustrophobic tunnel inside that runs from the ground to the top. The small stone structure on top has thick walls with small doorways, a necessity given the weight of the roof above. However, since ancient times, people have made the aesthetic decision to have air and light in their buildings. The rest of this section looks at ways to open up structures and to make this possible.

Post-and-Lintel Construction

One ancient method of constructing walls, making openings, and supporting a roof is the **post-and-lintel system.** The basic module is composed of two upright posts supporting a crossbeam or **lintel** (Fig. 2.35). Posts can be either rectangular or cylindrical. Refined and decorated cylindrical posts are called **columns,** and a row of columns

supporting lintels is called a **colonnade.** A grid of posts and lintels can support the roof of a large interior space (Fig. 2.35). This is **hypostyle** construction, marked by rooms filled with columns.

CONNECTION An example of a hypostyle hall is the *First Hypostyle Hall* at the Horus Temple at Edfu, Egypt (Fig. 7.35). The thick columns support a stone roof.

Post-and-lintel structures are often rectilinear, with prominent vertical and horizontal lines, as evident in *The Temple of Athena Nike,* on the Acropolis in Athens,

2.36 MNESICLES. The *Temple of Athena Nike* (right) and the corner of *Propylaea* (left), Athens, 437–432 BCE.

The temple on the right shows post-and-lintel construction in its two porches and load-bearing construction in the solid wall in between.

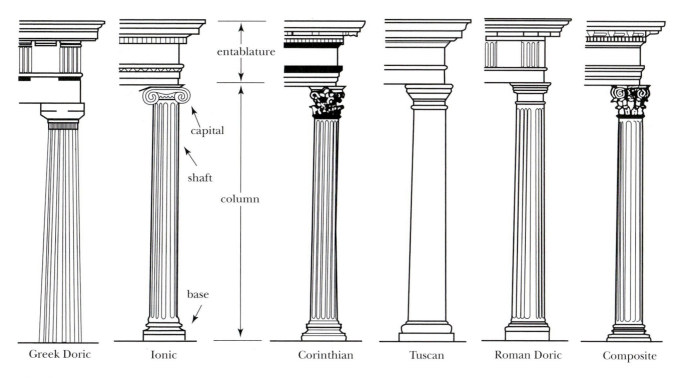

| Greek Doric | Ionic | Corinthian | Tuscan | Roman Doric | Composite |

2.37 Diagram of Greek and Roman orders.

Greece (Fig. 2.36). The side walls of the *Temple* are load bearing. The construction materials are important. Stone is durable but heavy and brittle, so stone lintels need closely spaced supports. Wood, however, is light, flexible, and strong and is able to span great distances, so larger interior spaces can be opened up and the posts can be thinned down. Of course, ancient wood buildings are long gone, while stone ones remain. The relative impermanence of wood and its ability to burn are its greatest drawbacks.

Important subcategories of post-and-lintel architecture are the Classical Greek and Roman architectural orders (Fig. 2.37). An order consists of a specifically designed column with a **base,** a **shaft,** a **capital,** and an **entablature**, all exhibiting standardized proportions and

decorative ornamentation. The oldest is the **Doric Order**, originating in the Greek Archaic period (650–500 BCE). The simple design is geometric, heavy, and relatively without ornamentation. Its column has no base, and its capital is a simple cushion. The ancient Greeks considered the Doric Order to exhibit masculine qualities. The temple porch on the *Propylaea*, to the left in Figure 2.36, is a Doric structure. The second order to appear was the **Ionic Order,** which is taller, more slender, and more decorative than the Doric and was considered feminine. It has a stepped base and a scrolled, carved capital. It originated during the Greek Classical (Hellenic) period (500–323 BCE). *The Temple of Athena Nike,* to the right in Figure 2.36, is Ionic. Later still was the **Corinthian Order,** which is the most complex and organic, with delicately carved acanthus leaves on its capital, dating from the Hellenistic period (323–100 BCE). Roman variations on those orders are Tuscan, Roman Doric, and Composite.

Wood Frame Construction

Wood frame architecture is very common in the East and the West. Wood frames have been used in the West especially for houses and small apartment buildings, and many feature load-bearing walls and trusses (see page 53).

The Chinese developed a distinctive wood frame architecture, based on the post-and-lintel model. This is the **complete frame system,** which contained these innovations: (1) totally non-load-bearing walls, (2) brackets, and (3) cantilevers. All the weight of the entire building was borne by large upright posts. Walls could be completely eliminated.

In the fifth century BCE, the Chinese developed **brackets,** which are clusters of interlocking pieces of wood shaped like inverted pyramids at the tops of upright posts, directly beneath the roof (Fig. 2.38). With brackets, fewer posts are needed, allowing for more spacious interiors. Two centuries later, the Chinese developed half-cylinder, overlapping roof tiles. Their considerable weight adds stability to the wood frame structure below, and they can be glazed in different colors.

Beginning in the eighth century CE, Chinese architects first used the **cantilever,** a horizontal beam anchored to and projecting out from an upright post (Fig. 2.38, and see Fig. 2.41). Cantilevers support deep roof eaves

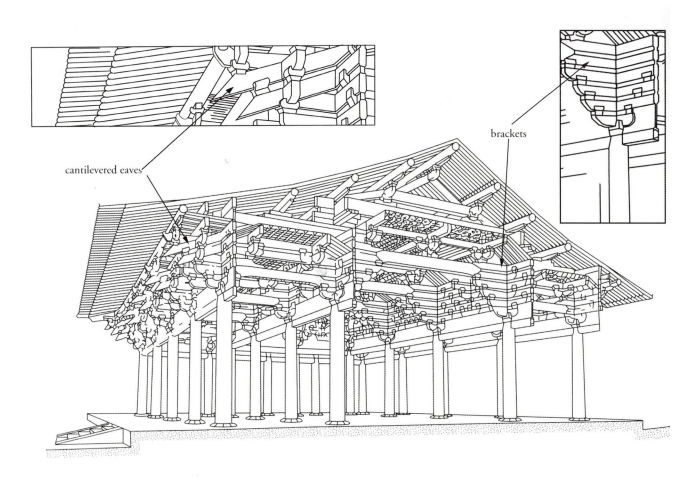

2.38 Chinese wood frame structural system showing brackets and cantilevers.

and balconies. The roof design is often the most important and distinctive feature of significant historical Chinese buildings. Supported by cantilevers, the roofs often project far beyond the edges of the building proper, with shapes that incorporate very complex curves. Brackets are outlined and painted in bright colors.

Arches, Vaulting, and Domes

Stone would have limited use as a building material because of its weight and brittle nature were it not for the **arch** (Fig. 2.39), a structural innovation that dates back to ancient Egypt. The arch is made of wedge-shaped stones, or **voussoirs,** that are constructed from bottom to top, using a wooden scaffold for support. When the final **keystone** is placed in the center, the arch can support itself, and the scaffolding can be removed. Arches can rest either on rectangular **piers** or on cylindrical columns, as we saw in the *Great Mosque of Cordoba* (Fig. 2.18).

Arches can be either round or pointed (Fig. 2.39). With a round arch, the distance between the supports determines the height of the arch because the arch is a semicircle.

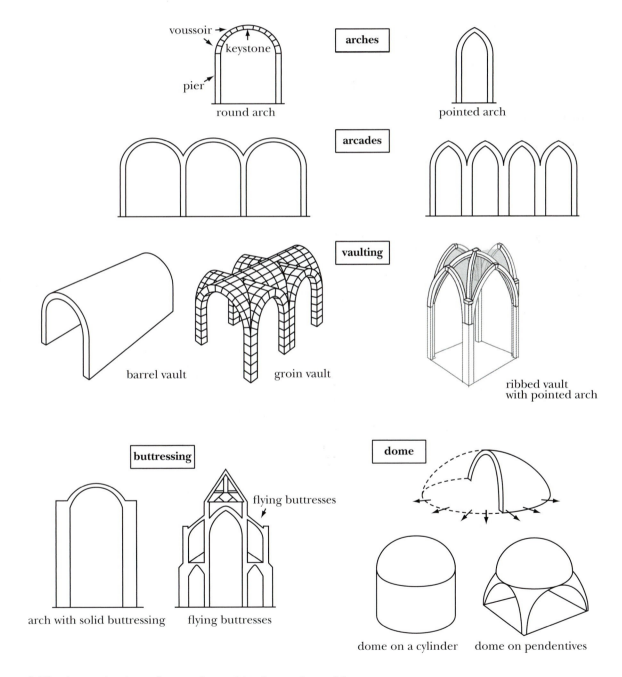

2.39 Diagram showing arches, arcades, vaulting, buttressing, and domes.

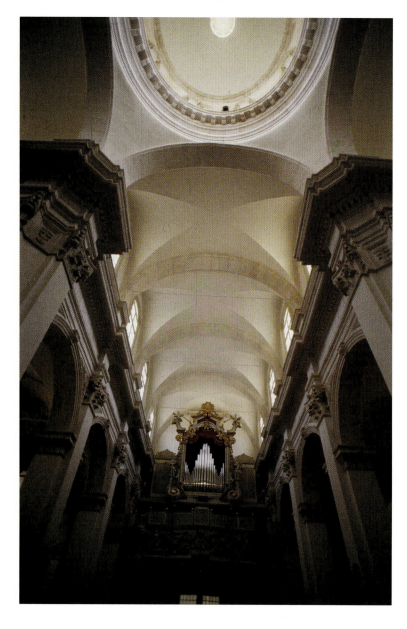

2.40 ANDREA BUFFALINI. *Cathedral of Dubrovnik: Nave Groin Vault,* Croatia, construction finished in 1713.

Groin vaults cover the ceiling, except for the dome at the top.

A pointed arch is actually a round arch with some of the center removed. Builders can make a pointed arch higher or lower, regardless of the distance between its supports. A straight row of arches placed side by side is called an **arcade.**

Unlike in post-and-lintel structures, in which the weight of the roof and lintel presses down equally on all parts below, the weight of the arch is directed outward and then downward to the load-bearing columns or piers. There is no downward pressure over the void of the arch, so higher and larger spaces can be spanned without the need for additional support posts. Arches can be constructed of stone, brick, or concrete. Arches, however, do have to be supported from the outside to prevent lateral movement that would cause them to collapse. That support is called **buttressing** (Fig. 2.39), which is additional exterior masonry placed at key points to keep the arch stable. Buttresses can be solid masonry, or they may be opened up with their own internal arches, called **flying buttresses.**

Builders can expand and multiply the arch in several ways to create entire roofs made of stone. These stone roofs are called **vaults,** or **vaulting,** and are very durable and fireproof (Fig. 2.39). A **barrel vault** is an arch extended in depth from front to back, forming a tunnel-like structure. Barrel vaults have the disadvantage of creating rather dark interiors, as there are no windows in the vault area (Fig. 2.39). **Groin vaults,** sometimes called **cross vaults,** are barrel vaults positioned at 90-degree angles to cross or intersect one another. This innovation allowed light to enter vaulted spaces and gave variation to the interior space, as seen in the *Cathedral of Dubrovnik: Nave Groin Vault* (Fig. 2.40).

A **ribbed vault** (see Fig. 2.39) is a variation of the groin vaulting system in which arches diagonally cross over the groin vault, forming skeletal ribs. Pointing the arch in the ribbed vault creates a **gothic vault.** Used commonly in the Gothic era in Europe, this innovation allowed builders to eliminate large wall areas under arches and to fill the resulting space with gleaming stained glass.

A **dome** theoretically is an arch rotated on its vertical axis to form a hemispheric vault. Domes can rest on a cylinder or a circular **drum,** or they can be placed on **pendentives,** which are the triangular concave sections created when a dome is placed on arches. Domes may also be placed on a square or a polygonal base, in which case the spaces created between the dome and its base are called **squinches.** Domes can be oval; the oval dome of the *Cathedral of Dubrovnik* is visible at the top of Figure 2.40. Domes can also be ribbed and scalloped in shape, as seen in the *Great Mosque of Cordoba* in Figure 2.1.

Vaulted or domed buildings are generally quite massive because of the material used to make them—stone, brick, or concrete. Vaults are very heavy structures and require thick supports. In many cases, architects disguise the massiveness of vaulted structures by placing buttresses on the exterior, out of sight of those enjoying the view of the interior. In the *Cathedral of Dubrovnik,* the plain, bright, airy vaults above contrast with the gray, heavy-looking arcade below.

Recent Methods and Materials

Modern buildings differ from older structures in many ways. New materials, especially steel and steel-reinforced concrete, have resulted in structures taller than anything ever built before the nineteenth century. Like the human body, many modern buildings feature an internal skeletal support system. The outer surface of the wall is like a skin stretched over the bones.

Our expectations of basic comforts have changed, too, so now buildings have a variety of operating systems, such as heating and cooling systems, electricity, plumbing, and telephone and computer wiring, as well as appliances, intercoms, and surveillance systems. Two hundred years ago, this was all unknown.

Steel Frame Construction

High-strength structural steel was developed in the late nineteenth century and, with the invention of the elevator, made very tall buildings possible for the first time.

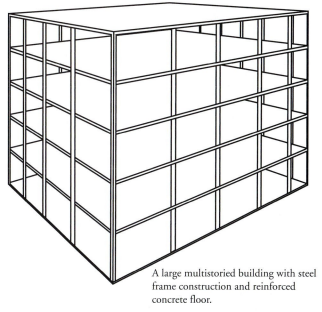

A large multistoried building with steel frame construction and reinforced concrete floor.

Diagram of reinforced concrete showing a metal bar embedded in concrete. This diagram shows a reinforced concrete floor with a cantilevered balcony.

2.41 Diagram of steel frame construction and reinforced concrete.

Steel frame construction essentially expands the post-and-lintel grid vertically as well as laterally, using steel (instead of wood or stone), which can function as a skeleton that will support multistoried buildings (Fig. 2.41). Floors are usually poured concrete with embedded metal reinforcing bars.

At first, steel frame construction was disguised with stone facings so that buildings looked traditional, rugged, and durable. By 1900, however, the simple horizontal and vertical lines of steel frame construction were emphasized and apparent. Windows became big, reaching from framing member to framing member. Steel frame construction has been widely used ever since for all kinds of structures, but especially the high-rise office buildings that filled the downtowns of major cities all over the world from the mid-twentieth century to the present day, like the *Seagram Building at Night*

2.42 *Seagram Building at Night*, New York City, 1954–1958.

Steel frame construction made possible the gleaming modern skyscraper.

(Fig. 2.42), designed by Ludwig Mies van der Rohe and completed in 1958. Representative of what is called the **International Style,** these stripped-down, glass-covered, rectangular-box buildings were enormously popular throughout the world. This image shows the *Seagram Building* nearing completion, and the appeal of the style is immediately apparent: the building is luminous and dramatic compared to the older structures around it. The skeletal structure is visible, and both horizontality and verticality are emphasized.

International Style buildings generally had no ornamentation at all. Some critics have argued against the widespread, homogenizing use of the International Style in cities across the world because many older structures that had given civic centers their distinct character were demolished.

Reinforced Concrete

Another building innovation that resulted from the development of high-strength structural steel was **reinforced concrete,** also known as ferroconcrete. The ancient Romans used concrete, but it is brittle and cracks easily. With ferroconcrete, the steel reinforcing bars embedded in the wet concrete give the concrete tensile strength, while the concrete provides a durable surface. Reinforced concrete was used for the floors of skyscrapers from their early days.

Gradually, architects began using reinforced concrete as an external building material for the finished surfaces of buildings. Concrete can be poured over steel reinforcing rods or mesh that can be shaped into any form the architect wishes. It makes possible free-form architecture, which places no limitations on the shape and mass of a structure.

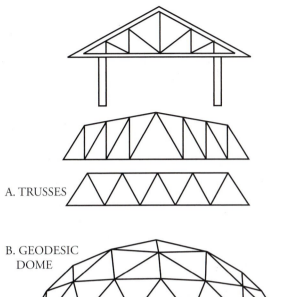

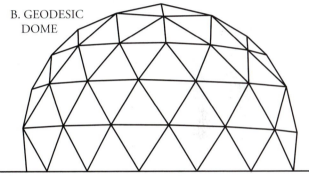

2.43 (A) Truss structural system and (B) geodesic dome structural system.

CONNECTION Three famous examples of reinforced concrete structures appear in this book: Le Corbusier's *Notre Dame du Haut* (Fig. 7.29), the Solomon R. Guggenheim Museum (Fig. 14.5), and the Sydney Opera House (*above;* see also Fig. 14.4).

Truss and Geodesic Construction

Another skeletal structure, the **truss,** is based on a frame made of a series of triangles constructed in steel or wood (Fig. 2.43A). Trusses are very rigid because of the triangle and can be used to span great spaces or to support other structures. Steel trusses are common on railroad bridges, and wooden trusses can be found in the attics of most frame homes in the United States.

The geodesic dome (Fig. 2.43B) is a skeletal frame based on triangles that are grouped into very stable, strong polyhedrons. Polyhedrons are geometric forms with many faces and are found in nature. Geodesic domes can be very large, and they require no interior supports. Builders can easily assemble the skeletal frame from prefabricated modular parts. The framework can be sheathed in glass, plastic, plywood, or a variety of other materials.

The triangles of truss or geodesic structures may be left visible when buildings are finished. In these cases, the buildings have a pronounced geometric appearance. Thus, the linear network of the truss skeleton becomes an important visual feature.

CONNECTION R. Buckminster Fuller's *U.S. Pavilion* (Fig. 5.37) was an enormous example of a geodesic dome.

Suspension and Tensile Construction

Suspension and tensile construction consists of steel cables attached to vertical pylons or masts that can support structures like bridges, exhibition tents, or sport arenas.

2.44 GUNTER BEHNISCH with OTTO FREI. *Olympic Stadium, Munich*, Germany, 1972.

Suspended steel cables hold up the roof mesh, efficiently providing shade over a large area.

The *Olympic Stadium, Munich* (Fig. 2.44), designed by Gunter Behnisch with Otto Frei, was part of a vast sports complex with peaked roofs that recall the mountains of the nearby Alps. Computers were used to assist in designing roof shapes and supports and in determining how the structure would react in weather conditions. Nothing before had been undertaken at this scale with this type of construction. In this case, a cable net attached to vertical masts holds up the PVC-coated polyester roof. Otto Frei was a pioneer in lightweight design.

3

MEDIA

In the previous chapter, we studied the elements and principles of art and architecture. Now we turn to the media used to make artworks. Media for drawing, painting, printmaking, sculpture, and craft making have existed since prehistory. More recent inventions include film or digital imaging. The human body has always been used in artistic performance.

PREVIEW

A medium is the actual material substance used to make a work of art. This chapter covers various media, starting with those used in drawing, painting, and printmaking and then moving to three-dimensional media and processes.

Media can be natural materials, such as stone, shell, straw, and clay. Synthetic art media include acrylics, fiberglass, and neon, as seen in Figure 3.1, Nam June Paik's Electronic Superhighway: Continental U.S., Alaska, Hawaii, *1995. As technology has progressed, photography, film, recordings, videos, and digital imaging have provided new media for artists.*

Going beyond the art supply store, some artists also use materials from theater, industry, construction, and advertising. Others salvage materials from dumpsters and resale shops. Artists use any media that best express their idea or subject matter.

In this chapter, we will see examples of artworks made from clay, bronze, natural fibers, found objects, wood, oil paint, acrylic paint, tempera, fresco, ink, charcoal, silverpoint, colored pencils, pastels, cloth, glass, gems, embroidery, photographs, neon lights, jade, steel, printmaking materials, human teeth, old tires, and more.

For your Art Experiences, try drawing on unusual surfaces, or weaving with discarded materials, or creating an exquisite cadaver drawing with a group of friends.

THE IMPORTANCE OF MATERIALS

It is easy to think that the idea is all that matters in a work of art, but the physical embodiment of the idea is important as well. When artists choose the best medium for their ideas, their art is stronger. The chapter-opening image, Nam June Paik's *Electronic Superhighway: Continental U.S., Alaska, Hawaii*, is a large, forty-nine-channel, closed-circuit video installation, composed of neon, steel, and electronic components. All of those materials speak of advertising, signage, and televised imagery, which reinforce the idea that we know the United States in snippets, through bits of travelogues or passing scenes flashing through the car window. It would not be the same if Paik had made a painting of this idea.

Damien Hirst is an artist known for shocking or controversial works, an effect that is compounded by the materials he used in *For the Love of God* (Fig. 3.2), which is a platinum cast of an eighteenth-century human skull with original human teeth but covered with 8,601 diamonds (1,106.18 carats).

Skulls often symbolize mortality as well as *vanitas*, or the ultimate emptiness and impermanence of earthly things. In this case, there is an extreme contrast between the death skull and a lavish, rich lifestyle suggested by the diamonds. The asking price for this artwork was $50 million, a sensational price that is within the means only of the very wealthy, who are mortal like anyone else.

CONNECTION An example of a painting with a vanitas theme is Jan Davidsz. de Heem's *A Table of Desserts* (Fig. 5.14).

We tend to think of media solely as the materials that the artist manipulates, but equally important is the **support,** which underlies the artwork. Figure 3.3, *Royal Profile*, from Egypt in the sixteenth–thirteenth centuries BCE, was drawn in paint on a fragment of limestone. Although the rock surface is rough and unforgiving, the artist rendered a clear and precise profile with pristine contour lines. Artists have made artwork on rocks, the earth, walls, paper, metal surfaces, and so on.

ART EXPERIENCE Make a drawing on some surface besides drawing paper. Try to make the content of the drawing fit with the surface on which it appears.

MEDIA IN TWO-DIMENSIONAL ART

Drawing

Drawing is one of the oldest forms of art making, and it also seems to be innate. The first marks a toddler makes are scribbles, which are primary to the act of drawing. A wide range of materials are used in drawing.

Dry Media

Dry media for drawing often come in some kind of stick form. Pencil, sanguine chalk, pastel, and silverpoint are examples of dry media used in drawing.

One of the most common drawing tools is the **pencil,** a graphite rod in a wood or metal holder. The graphite comes in varying degrees of hardness, with the hardest creating thin, controlled lines. Robert Gober's *Untitled* (Fig. 3.4), from 1995, resembles a common, quick pencil sketch. His work deals with memory, childhood, religion, and sexuality. Pencils can also be used for large, incredibly detailed studies. Judith Baca's colored-pencil drawing *Las Tres Marias* (Fig. 3.5), from 1976, contains two tightly rendered, life-size drawings of women that look very much

3.2 DAMIEN HIRST. *For the Love of God*, 2007. Platinum life-size cast of a human skull, human teeth, and diamonds, 6¾″ × 5″ × 7½″.

The materials used to make this work of art add to its sensationalism.

3.3, *top left* *Royal Profile*, Ramesside period, Egypt. Painted limestone. Louvre, Paris.

Ancient Egyptian artists did practice sketches on small pieces of rocks. Today the support for drawing and painting is more often canvas or paper.

3.4, *left* ROBERT GOBER. *Untitled*, 1995. Pencil on paper, 8″ × 4⅞″. Gift of Sarah-Ann and Werner H. Kramarsky (159.1997). The Museum of Modern Art, New York.

The pencil is probably the most familiar art medium—and also one of the most versatile.

3.5, *top right* JUDITH BACA. *Las Tres Marias*, 1976. Colored pencil on paper mounted on panel with upholstery backing and mirror, 5′ 8¼″ × 4′ 2¼″ × 2¼″. Smithsonian American Art Museum, Washington, D.C.

Pencil and colored pencil are capable of producing near-photographic detail, shown here in two life-sized drawings.

3.6 Douglas Schlesier. *Stone God Forbidden City*, 2002. Charcoal on paper with gold leaf and color, 2′ 1″ × 3′ 2″.

The rich blacks of charcoal create visual drama in this drawing.

3.7 Edgar Degas. *At the Milliner's*, c. 1882. Pastel on paper, 2′ 3⅝″ × 2′ 3¾″. Gift of Mrs. David M. Levy. The Museum of Modern Art, New York.

Pastels are sticks of almost pure pigment, and because of that, pastel drawings have an intensity that surpasses most other media.

3.8 Hans Holbein the Elder. *Portrait of a Woman*, 1508. Silverpoint, brush, black and brown ink with white on white prepared paper; 5¾″ × 4″. Woodner Collection, National Gallery of Art, Washington, D.C.

Silverpoint drawings are known for their delicacy and precise lines.

like photographs. The drawings and the mirror in the middle invite viewers to "try on" different identities.

Douglas Schlesier's *Stone God Forbidden City* (Fig. 3.6) was rendered in **charcoal,** a carbon stick created from burnt wood, with added touches of color and gold leaf. Charcoal is capable of producing rich, deep, dark areas and a range of lighter tones as well.

Chalk and **pastels** are colored materials held together by wax or glue and shaped into sticks. Sticks with more colored material and less wax produce soft, smudgy lines, whereas those with more wax or glue render precise, controlled lines. Pastels and chalks can be used both precisely and expressively. Edgar Degas was a master of pastel drawing, as seen in *At the Milliner's* (Fig. 3.7), which contains expressive lines, colors, patterns, and textures.

A **silverpoint** drawing is produced by a thin stylus made of silver that leaves marks on paper or wood coated with layers of gesso as a ground. A **ground** is a fluid brushed onto a support to change its surface quality. **Gesso** is a common ground made of very fine powdered white chalk suspended in glue (the traditional method) or an acrylic medium (modern gesso). In this case, the gesso makes the paper better able to accept the silverpoint line. The metallic lines in silverpoint drawing will eventually tarnish and darken with age. This technique is seen in Hans Holbein the Elder's 1508 *Portrait of a Woman* (Fig. 3.8). Because silverpoint holds a point longer than other media, silverpoint drawings are distinguished by very delicate lines made with precision and control.

Wet Media

In drawing, wet media are in liquid form. Ink is the most common wet medium, and it can be used with either brush or pen. The combination of lines made by pen marks and washes applied by brush makes visually fluid imagery. This is seen in Mi Wanzhong's *Tree, Bamboo and Rock* (Fig. 3.9), with calligraphy by Chen Meng. Pen and brush each leave distinctive marks, with a wide range of effects resulting from diluting the ink. Drawing and painting overlap in artworks done in ink; *Tree, Bamboo and Rock* could be classified as a drawing or as a monochromatic painting.

Today ink is most commonly found in felt-tipped pens and markers. Artists frequently grab any convenient writing tool for sketches. Yoshimoto Nara is a Japanese artist whose *Puffy Girl/Screen Memory* (Fig. 3.10), from

3.9, *left* Mi Wanzhong. *Tree, Bamboo and Rock*, calligraphy by Chen Meng. Ink, 3′ 7⅓″ × 1′ 2¼″. Musée National des Arts Asiatiques-Guimet, Paris.

Ink is a versatile medium. It can be applied to paper with a pen for controlled lines or with a brush for gray washes or bold, dramatic lines.

3.10, *below* Yoshitomo Nara. *Puffy Girl/Screen Memory*, 1992–2000. Felt-tipped pen on postcard, 5⅞″ × 4⅛″. Fractional and promised gift of David Teiger in honor of Agnes Gund. The Museum of Modern Art, New York.

When making sketches or drawings, artists frequently use whatever is available among their ordinary pens and pencils.

3.15 ALBRECHT DURER. *Knight, Death, and the Devil*, 1513. Engraving, $9^5/_8'' \times 7^1/_2''$. Musee du Petit Palais, Paris.

The amazing wealth of detail in this print is possible because fine tools were used to engrave thin lines into the printing plate.

3.16 JAMES MCNEILL WHISTLER. *The Doorway*, 1880. Etching. Rosenwald Collection, Accession No. 1943.3.1886, National Gallery of Art, Washington, D.C.

Etching produces a variety of line qualities, while gray tones are created using aquatints.

The ink is then rubbed into the scratches, and the plate and paper are put through the press. The results can resemble a pencil drawing.

Engraving entails cutting or incising lines into a laminated woodblock or a polished metal plate. The ink is rubbed into the recessed lines, and the block or plate is put through the press. An example of a metal engraving is Albrecht Durer's *Knight, Death, and the Devil* (Fig. 3.15), from 1513. Engraving produces thin, precise lines that create both detail and rich values, as seen in this print. It is worth looking though a magnifying glass at an original Durer engraving to see the wealth of details unfold.

In an **etching,** a metal plate is coated with a sticky protective ground, into which the artist scratches a design. The plate is then placed in an acid bath, which eats away or etches the exposed metal surface. The etched areas hold the ink during the printing. An example of an etching combined with aquatint is seen in James McNeill Whistler's *The Doorway* (Fig. 3.16). In this work, Whistler was able to achieve a rich variety of lines and values that evoked the murky water tones in the canals of Venice, Italy.

Aquatint is a process related to etching used to create flat tones or softly shifting values. With aquatint, areas of the metal plate are partly covered with a powder of acid-resistant resin. Heat is applied to the plate, which melts the resin and makes it adhere to the plate surface. The non-resin areas are totally covered with a protective substance. Then the plate is placed in an acid bath, where the exposed areas between flecks of resin powder are eaten away. After the plate is cleaned, it is inked and printed in the same way as other intaglio processes.

Lithography

Lithography starts with a drawing created with an oily crayon, pencil, or liquid on either a limestone slab or a metal surface. Gum arabic, which is a water-based liquid,

3.17 KIKI SMITH. *Born*, 2002. Lithograph, composition and sheet, 5′ 8$\frac{1}{16}$″ × 4′ 8$\frac{1}{8}$″. Publisher and printer: Universal Limited Art Editions, West Islip, New York. Edition: 28. Gift of Emily Fisher Landau (369.2002). The Museum of Modern Art, New York.

Lithography is the printmaking process that produces results that most resemble drawings.

is then applied to the entire surface, except where the oily marks resist it. Next, the stone or plate is inked with an oil-based ink, which adheres only to the greasy marks drawn on the surface (Fig. 3.13C). The plate or stone is then put through the press, where the inked areas transfer to the paper. Figure 3.17 shows Kiki Smith's lithograph, *Born*, from 2002. Smith's work often uses folk tales and mythologies as subject matter; life, death, and resurrection are frequent themes.

Serigraphy

Serigraphy, also called screen printing, is a process in which a stencil is attached over a piece of finely woven fabric stretched over a frame, which supports and gives strength to the stencil (Fig. 3.13D). Ink is then squeezed through the open areas of the stencil and deposited on the surface below, which could include sheets of paper, T-shirts, or cardboard boxes. **Photo silk screens** are variations on the regular screen printing process. Instead of using stencils, photographs are used with special chemicals to block the ink in certain areas from being squeezed through to the paper.

Andy Warhol popularized screen printing with his multiple images of celebrities such as Jacqueline Kennedy. *Marilyn Monroe* (Fig. 3.18), from 1967, is a portfolio of ten screen prints on paper. Repeating images in serigraphy is easy, and Warhol uses repetition to allude to mass production and commercialism.

Monotype

Unlike the previous printmaking processes we have looked at, this process makes only one impression of an image, hence the name **monotype.** A drawing or painting is done with printing ink on a sheet of Plexiglas or metal. Paper is placed on top of the rendering and hand rubbed or put through a press to make the transfer. In Paul Gauguin's *Two*

3.18 ANDY WARHOL. *Marilyn Monroe*, 1967. A portfolio of ten screenprints on white paper, 3′ × 3′. Kupferstichkabinett, Staatliche Museen, Berlin.

With silkscreen, it is possible to get broad areas of intense color.

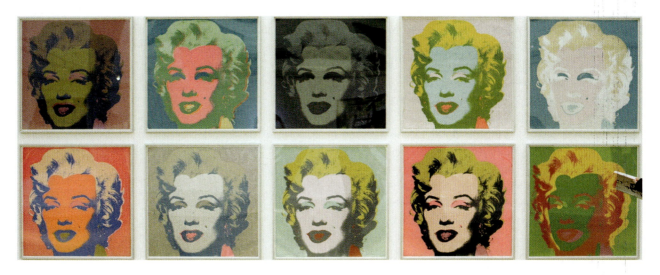

3.19 PAUL GAUGUIN. *Two Marquesans*, 1902. Monotype, 1′ 1½″ × 1′ 8″. British Museum, London.

With monotypes, only one image can be produced from a single working of the plate. Some artists produce a second ghost image from an inked monotype plate, but usually the ghost image needs to be finished in some other medium.

Marquesans (Fig. 3.19), we see the original and only print, which looks like a combination of both drawing and painting.

Painting

Painting media generally consist of two basic components: pigment and binder. **Pigments** are intense colors in powder form, derived from animals, plants, minerals, and synthetic chemicals. They are blended in the **binder,** the substance that holds the components together once it dries. Binders include egg yolk, wax, glue, drying oils, and acrylic liquid mediums, among others.

Although all paints contain colored material, some forms use no binders. Sand painting is a traditional art form in Navajo rituals, used especially for healing. Different natural elements, such as colored sand, crushed stone, charcoal, and pollen, are carefully sprinkled onto a clean, swept earthen floor. Artist priests chant and pray while they create their designs in sand. The sand paintings are then destroyed at the end of the ritual. Figure 3.20 shows

3.20 Natural pigments similar to those used by the Navajo people to prepare ritual sand paintings. From left to right, the pigments are cornmeal, pulverized charcoal, brown sand, red ochre, ground gypsum, yellow ochre, gray sand, pollen, and brown clay.

Pigments in undiluted form can have amazing color intensity.

3.21 Douris. *Red Figure Kylix*, 490 BCE. Slip on clay, 1′ 1″ diameter. Kunsthistorisches Museum, Vienna.

The images produced with colored clays on Greek vases are among the few records of ancient Greek painting that have survived to the present day.

3.22 A Chinese opera performer making up his face in front of a mirror.

The human body has always been used as a "canvas" for painting.

a selection of dry natural pigments that can be carefully poured through the fingers onto the ground to create a sand painting.

Paintings are all made on some kind of support—usually stone, clay, plaster, wood panel, paper, or fabric but sometimes including even found objects. We just saw that sand paintings use the earth itself as the support. Some of the oldest surviving paintings were made on clay vessels, as in the *Red Figure Kylix* by the Greek painter Douris

(Fig. 3.21), from the fifth century BCE. **Slip,** a liquid clay, has been applied to the clay vessel before firing to create both the black background and the delicate black details. The red clay of the vessel shows through where no slip has been applied. Also, the human body is and has been a surface for painting. The Chinese opera performer in Figure 3.22 is painting his face in preparation for his character. His painted face, the text, costumes, music, and singing are all components of the genre.

3.23 JASPER JOHNS. *Flag*, 1954–1955. Encaustic, oil, and collage on fabric mounted on plywood, 3′ 6¼″ × 5′ ⅝″. Gift of Philip Johnson in honor of Alfred H. Barr Jr. The Museum of Modern Art, New York.

Encaustic paint is a mixture of wax and pigment, and it can be somewhat transparent if the ratio of wax to pigment is very high.

Encaustic

Encaustic is one of the most ancient forms of painting media. Because pigments are mixed into hot beeswax, the paints can be blended until they cool. Some encaustic paintings thousands of years old retain their colors and lustrous surfaces. The medium is still used today. The top layer of Jasper Johns' *Flag* (Fig. 3.23) is translucent encaustic over a layer of newspaper scraps and photographs, allowing the viewer to see the imagery embedded in the flag.

Fresco

Fresco is often used for large murals painted directly on walls. There are two kinds of fresco. In **fresco secco,** paint is applied to a dry plaster wall. In **buon fresco,** or true fresco, the plaster on the wall is wet, and wet pigment suspended in water is applied to and soaks into that surface, which results in a very durable painting. The artist must work quickly in small areas before the plaster dries. Buon fresco is remarkably durable, as evidenced by *Glass Bowl with Fruit* (Fig. 3.24), a Roman painting from the first century CE that survived 2,000 years despite being buried by the eruption of Mount Vesuvius in 79 CE.

Tempera, Gouache, and Watercolor

Tempera, gouache, and watercolor are three water-based paint media. Traditional **tempera** paint consists of pigments mixed with egg yolk, which is the binder. Egg tempera is a very strong, quick-drying medium that is excellent for rendering sharp lines and details. Figure 3.25 is Piero Della Francesca's *Portrait of Federico da Montefeltro, Duke of Urbino, and His Wife Battista Sforza*, from approximately 1465. Even after 550 years, the colors and details remain clear and bright. Today the term *tempera* may also refer to a completely different kind of paint, which is commercially available and uses synthetic binders.

Watercolors are pigments suspended in a gum arabic binder, which is a natural water-soluble glue. Watercolors are usually applied to paper in transparent layers of thin stains and are distinct because of their flowing quality. **Gouache** is watercolor with white chalk added to create an opaque paint. Its thicker consistency makes it easier to control. Gouache was often used for Persian miniatures, like *The Reader (frontispiece)* (Fig. 3.26), from the sixteenth century, because of the fine lines, great detail, and bright colors possible with the medium.

3.24 *Glass Bowl with Fruit,* Roman, first century, found in the Mt. Vesuvius region of Italy. Fresco wall painting. Museo Archeologico Nazionale, Naples.

Fresco is a very durable painting medium because the pigment is embedded in plaster.

3.25 Piero Della Francesca. *Portrait of Federico da Montefeltro, Duke of Urbino, and His Wife Battista Sforza,* c. 1465. Tempera on wood, each portrait 1′ 6½″ × 1′ 1″. Uffizi, Florence.

Traditional tempera was made by grinding dry pigments into raw egg yolk, which, when dried, produces a tough and durable film.

3.26 *The Reader* (frontispiece), Bukhara, Iran, first quarter of the sixteenth century. Gouache, gold highlights. Louvre, Paris.

Gouache is opaque watercolor that produces bright, matte color areas. When artists use fine brushes for gouache, they can make delicate lines and intricate details.

3.27 WANGECHI MUTU. *One Hundred Lavish Months of Bushwhack*, 2004. Cut-and-pasted printed paper with watercolor, synthetic polymer paint, and pressure-sensitive stickers on transparentized paper, 5′ 8½″ × 3′ 6″. The Museum of Modern Art, New York.

Watercolor and gouache work well when combined with other media. Here, watercolor is combined with polymer paint and collaged printed papers.

Both watercolor and gouache are ideal for mixed-media work. Figure 3.27 is Kenyan artist Wangechi Mutu's *One Hundred Lavish Months of Bushwhack*, a collage and watercolor piece from 2004. The watercolor is evident in the red stains around the large woman's face. In Mutu's work, the seemingly aggressive, fantastic woman is actually injured and supported by the smaller person below. Mutu believes that women's bodies, whether injured or well cared for, are barometers of the health of any given society.

Oil and Acrylic Paint

Both oil and acrylic paints are notable for their wide range of intense colors. They can be applied as **glazes,** which are nearly transparent layers of paint that leave a hint of color on the underpainting. Glazes can be built up, one layer over the other, to create a rich, subtle color effect. Oils and acrylics can be applied **alla prima** as well, a technique of painting in a direct style without layers, in which the painter often finishes a work in a single sitting. Both oil and acrylic paintings are most often executed on paper, wood, or stretched canvas. Usually, these supports have been coated with a gesso ground to keep the paint from soaking in and, thus, looking dull.

Oil paint has been in common use since the fifteenth century. The powdered pigments are ground into a slow-drying oil (usually linseed), most often on a support of wood or canvas, and are soluble in turpentine or mineral spirits. Slow-drying paint allows artists to easily blend colors and paint details. Glazing with oil paints can result in intense colors with lustrous, glowing surfaces, evident in Titian's *Venus of Urbino* (Fig. 3.28). Oil-based paints are also used for body painting, like that of the Chinese opera performer in Figure 3.22.

Acrylic paint is made with pigment that has been ground with a synthetic polymer liquid binder that quickly dries into a flexible film and can be applied to almost any support. David Hockney's *A Bigger Splash* (Fig. 3.29), from 1967, shows acrylic paint applied primarily alla prima, resulting in large areas of flat, bright color. Because acrylics are water-soluble, artists can also pour acrylic paint, glaze acrylics, and draw fine lines with it. All of these applications are evident in Margaret Lazzari's 2007 painting *Aqueous* (Fig. 3.30). Pouring gives a fluid quality to large areas of the background, while the center drawing, which is a radically enlarged copy of a Leonardo study of water movement, is done in thin, precise lines of acrylic paint. The rich color is the result of glazing.

Sprayed Paint

Thanks to current technology, paint can be sprayed in many ways. An **airbrush** is a small spray gun that is about the size of a pen. Compressed air is forced through the airbrush, which atomizes the liquid paint, allowing it to be sprayed onto a surface. An airbrush can render both large areas and fine details. Not limited to fine art, airbrushes also make their mark in illustration work, murals, signage, custom car finishes, and painting on the human body.

3.28 TITIAN (TIZIANO VECELLIO). *Venus of Urbino*, 1538. Oil on canvas, 4′ × 5′ 6″. Uffizi, Florence.

This oil painting started as an opaque monochrome underpainting, which then had many layers of jewel-like glazes applied to the surface.

3.29 DAVID HOCKNEY. *A Bigger Splash*, 1967. Acrylic on canvas, 8′ × 8′. Tate Gallery, London.

Acrylic paint can produce large areas of flat color, similar to the effect of latex wall paint.

3.30 MARGARET LAZZARI. *Aqueous*, 2007. Acrylic on canvas, 6′ 8″ × 6′ 3″. Collection of the artist.

Acrylics can be poured, glazed, or painted alla prima. They can be thinned and applied with a fine brush to produce lines.

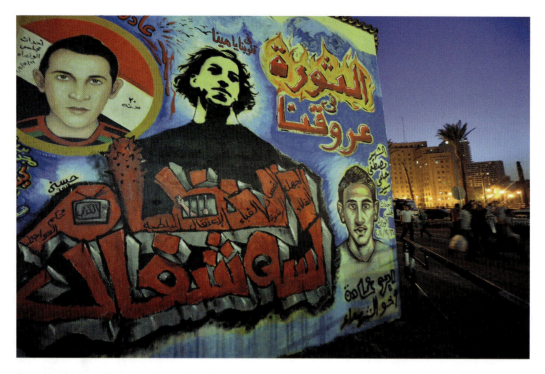

3.31 Egyptians walk past Arabic graffiti that reads "Revolution is in our veins" on the wall of Mohamed Mahmud Street in Cairo's landmark Tahrir Square on September 26, 2012.

Spray paint is the medium of choice for most graffiti artists.

Spray paint is a commercial product in aerosol cans containing compressed air and quick-drying permanent paint, often used by graffiti artists (Fig. 3.31). Spray paint allows for broad areas of color and gradual transitions but will not do fine detail work. As a result, most graffiti artists work on a large scale. Graffiti that is done on public walls without the approval of civil or military powers frequently has political overtones (see also the example of graffiti by Banksy in Fig. 15.12).

Fabrics, Needlework, and Weaving

This category of art makes an ideal transition from the two-dimensional art disciplines and media we have just seen to the upcoming discussion of three-dimensional works. It covers an enormous range of art objects, including tapestries, quilts, rugs, embroidery, and other woven objects. We will look at only a few examples here.

CONNECTION An example of a tapestry is *The Unicorn in Captivity* (Fig. 13.3).

Faith Ringgold used the craft of quilting as an art medium to express her views on African American culture. She did a series of quilts about her "tar beach," the tarred roof of the New York City building she lived in as a child, and this quilt story became a famous children's book. In Figure 3.32, *The Bitter Nest, Part II: The Harlem Renaissance Party*, from 1988, Ringgold creates a gathering of some of the luminaries of African American culture in the 1920s and 1930s.

The *Summer Robe* (Fig. 3.33), from the Qing Dynasty, is an example of incredibly intricate and detailed work, all executed in embroidery. Silk fabric forms the support for the needlework, which contains complex designs such as the imperial dragon. The robe belonged to a eunuch of the court of the Empress Dowager, who reigned in the nineteenth century.

Moving further into three dimensions is *Sasa* (Fig. 3.34), from 2004, woven by Ghana artist El Anatsui from salvaged bits of copper wire and aluminum. The source for the aluminum is the metal foil wrapped around the necks of discarded liquor and wine bottles. El Anatsui is a firm believer in creating artwork from any materials readily available in the environment. Working with found or salvaged materials is something many artists do, as we will see in the next section when we turn in earnest to three-dimensional work. However, more than other found-object artists, El Anatsui has managed to transform

3.32 FAITH RINGGOLD. *The Bitter Nest, Part II: The Harlem Renaissance Party*, 1988. Acrylic on canvas with printed, dyed, and pieced fabric, 7′ 10″ × 6′ 11″. Smithsonian American Art Museum, Washington, D.C.

Ringgold used quilting to tell stories of her childhood in Harlem.

3.33 *Summer Robe*, China, nineteenth century. Embroidered silk. Private collection.

Embroidery is an example of fabric and needlework art.

3.34 EL ANATSUI. *Sasa*, 2004. Aluminum and copper wire, 21′ × 27′ 6″. Musee National d'Art Moderne, Centre Georges Pompidou, Paris.

Discarded strips of metal foil are woven into a sumptuous wall hanging.

salvaged waste into an intricate, fabulous, and glowing object.

METHODS AND MEDIA IN THREE-DIMENSIONAL ART

Three-dimensional art ranges from traditional to new media and includes freestanding work and relief sculpture.

It can be site-specific and even kinetic. **Freestanding** sculptures are objects that are meant to be seen from all sides and could conceivably be placed in many different settings, like the *Monumental Heads* (Fig. 3.35) from Easter Island. A **relief** sculpture is meant to be seen only from the front, like the *Relief Carving* (Fig. 3.36) at Banteay Srei, Cambodia, from the latter part of the tenth century. Relief sculptures are usually carved out of a single face of a stone or wood block. An example of a **site-specific** sculpture is Richard Serra's *The Matter of Time* (Fig. 3.37), from 2005. Made of steel, this sculpture was specifically designed for that particular room, creating passages throughout the space that alternate between

3.35 *Monumental Heads*, Moai statue, c. fifteenth century. Volcanic tufa. Easter Island (Rapa Nui), Polynesia.

Freestanding sculptures can be seen from all sides.

3.36 *Relief Carving*, Hindu, Banteay Srei, Cambodia, second half of the tenth century. Detail of red sandstone carving.

Relief carvings are seen only from one side. Frequently, they are produced by carving into a flat surface plane of wood or stone.

3.37 Richard Serra. *The Matter of Time*, 2005. Eight steel sheet sculptures, each 12 to 14 feet in height and weighing 44 to 276 tons. Guggenheim Museum, Bilbao, Spain.

This is a site-specific work, which means that it has been designed and arranged for this space in such a way that the space becomes part of the experience of the artwork.

3.38 Alexander Calder. *Crinkly with a Red Disk*, 1973. Steel and paint. Konigstrasse, Stuttgart, Germany.

Kinetic artworks are designed to move, and that movement is part of the piece.

spacious and tight or between compressed and elongated. The slightly tilting walls of the sculpture make the space seem to move. The title references in part the time required to move through and experience this large sculptural installation. In **kinetic** works, actual movement is part of the piece, as in Alexander Calder's "mobiles." *Crinkly with a Red Disk* (Fig. 3.38), from 1973, is made of steel and paint, and the top section moves randomly in the natural airflow. Let us now look at media within specific sculptural disciplines.

Carving

One technique for creating three-dimensional work is **carving**, in which artists remove unwanted material from a large block of stone or wood or, more recently, synthetic products like Styrofoam. This is a **subtractive process** because the material is taken away. Stone sculpting goes back to the Paleolithic era and appears across cultures. We have just seen two examples of carving: in solidified volcanic ash, the *Monumental Heads* (Fig. 3.35), and in red sandstone, the *Relief Carving* (Fig. 3.36).

Wood has been carved by artists over the centuries, but because it decays, wooden artworks are much more recent works than the oldest stone carvings. Wood has been used to carve representational sculptures, architectural decorations, furniture, and functional vessels. Figure 3.39 is the *Entrance Doorway of a Maori Meeting House Called Te Mana O Turanga*, opened in 1883 and carved by Raharuhi Rukupo and others. Artists find wood to be a versatile medium for carving, allowing them to achieve deeply rounded forms

and exact surface detail. In this case, the carving was done by a Maori ruler, and the details of the sculpture symbolize the clan's history.

Modeling

Sculptural forms can also be created by **modeling,** which is the pushing and pulling of a malleable substance, such as clay or wax. Modeling is often considered an **additive process** because material is built up to create the final sculptural form. Clay is a common modeling material that becomes hard and permanent after firing. Figure 3.40 shows an Aztec *Eagle Knight*, a ceramic sculpture of earthenware clay and plaster, from Mexico. As a sculptural material, clay is capable of extremely fine detail, as in Marilyn Levine's *Golf Bag* (Fig. 3.41), made of rolled and modeled clay slabs. The ceramic sculpture is an example of **trompe l'oeil** ("fool the eye") artwork because it seems so convincingly to be an actual leather bag. Viewers want

3.39 RAHARUHI RUKUPO AND OTHERS. *Entrance Doorway of a Maori Meeting House Called Te Mana O Turanga*, opened 1883. Carved and painted wood. New Zealand.

A carved work starts from a large block of wood, stone, Styrofoam, or other synthetic materials. See also Chapter 9 for more information on Maori meeting houses.

3.40 *Eagle Knight*, Aztec, c. fifteenth century. Earthenware and plaster, 5′ 6⅞″ × 3′ 10½″ × 1′ 9⅝″. Museo Templo Mayor, Mexico.

The artist shaped this sculpture by pushing and pulling clay until the final form was realized. Sometimes clay is also pressed into molds to create forms.

3.41 Marilyn Levine. *Golf Bag*, 1981. Ceramic, golf bag dimensions: 2′ 10″ × 10¾″. Private collection.

A high degree of control over the surface and the details is possible with ceramic sculptures.

to touch it in order to believe it is actually made out of clay.

Functional ceramics are also made with the additive sculptural process using clay. Functional pieces can be vessels, platters, cups, pitchers, and so on. Ceramics can be hand molded or pinched into their forms, fashioned out of coils or slabs of clay, or thrown on a potter's wheel. Figure 3.42 shows a pinched black-on-black *Bowl*

3.42 Maria Martinez. *Bowl*, undated. Blackware, 6¾″ × 9½″. Smithsonian American Art Museum, Washington, D.C.

Clay was pinched, smoothed, polished, and worked by hand to achieve the highly polished surface.

1. Start with an original sculpture, usually made of clay.

2. Fashion a cup of clay and attach it to the bottom of the sculpture.

3 Make a mold of the original sculpture. Remove the sculpture. Then press thin sheets of paraffin into the mold to create a hollow paraffin copy of the original.

4. Apply sprues to the paraffin copy. Embed this in a ceramic shell, plus a clay core to fill the hollow inside.

ceramic shell

clay core

5. Turn shell upside down. Apply heat and melt the paraffin out.

6. Invert shell and fill with molten bronze.

clay core

ceramic shell

7. Allow bronze to cool. Break off the shell. Remove sprues.

3.43 Cire perdue, or lost wax, casting process.

3.44 *The Marathon Boy*, Greek, Hellenistic period, 330 BCE. Bronze, 4′ 3″ high. National Archaeological Museum, Athens.

This is a hollow sculpture created using the lost wax (cire perdue) casting process.

made by Maria Martinez, a Native American from the San Idelfonso Pueblo in New Mexico. She and her son perfected this technique and design, which blend both glossy and matte surfaces with decorative abstract symbols. This combination beautifully enhances the vessel's form.

Sometimes a modeled sculpture is cast in bronze or plaster. Very small bronze sculptures are created using simple molds and end up as solid bronze pieces. But for larger bronze sculptures, artists use the **cire perdue** process (**lost wax** casting method). This method produces hollow metal sculptures with thin walls. As illustrated in Figure 3.43, a thin layer of wax is suspended between an interior and exterior mold. The wax is then melted out of the mold and replaced with molten metal. The **Classical** Greek sculpture of *The Marathon Boy* (Fig. 3.44) is a cast bronze work made using the lost wax method. Because of the cost and effort, only important artworks were created with the lost wax casting method.

3.45 *Masai Women Wearing Beaded Necklace.*

Assembly is the process used to create many works of art or personal adornment.

Assembling

Assembled works are made of various parts that are then put together. Assembly in its most fundamental form can be seen in the elaborate neck gear of *Masai Women Wearing Beaded Necklace* (Fig. 3.45). The Masai women of Eastern Africa create elaborate beaded works to indicate their identity and position within their groups. Older beads were made from locally available materials like shells, bone, metals, and stones, but more recently the brightly colored imported beads have been favored.

Assembled artworks are often **mixed media,** which literally means mixing up the methods and their various media in a work. Mixed-media works may contain natural materials like stone or wood, but they may also use manufactured goods, photographs, industrial fixtures, and the like. *Nimba, Goddess of Fertility* (Fig. 3.46) is an example of a sculpture in natural materials that has been carved and also assembled with the addition of the raffia skirt and shell ornamentation. When **found objects** or **ready-mades** (already existing objects) are incorporated into pieces, the resulting works are referred to as **assemblages.** Joseph Cornell created poetic, evocative

3.46, *left* *Nimba, Goddess of Fertility*, Baga, Guinea. Wood, shells, and raffia. Musée du Quai Branly, Paris.

This sculpture was both carved and assembled. The central core was carved from wood, and then the raffia and shells were added.

3.47 JOSEPH CORNELL. *Suzy's Sun (for Judy Tyler)*, 1957. 10³/₄″ × 1′ 3″ × 4″. North Carolina Museum of Art, Raleigh.

This artist is well-known for assembling artwork from cast-off materials. The worn quality of the elements adds to the overall feeling of things lost or remembered.

assemblages in shallow boxes, with fragments of things that were once beautiful. In *Suzy's Sun (for Judy Tyler)* (Fig. 3.47), the sun, cut out from an antipasto tin, implies passing time and life cycles, along with a piece of driftwood and a spiraling seashell. The box is dedicated to a young actress who was killed in a car crash after filming *Jailhouse Rock* with Elvis Presley. In *First Landing Jump* (Fig. 3.48), Robert Rauschenberg combined an oil painting with various found objects, including metal, leather, an electric fixture, cable, an automobile tire, and a wooden plank. The overall effect recalls the bold paint strokes of Abstract Expressionist paintings, but here the strokes and marks are actual objects. Rauschenberg coined the

term **combines** for works that are both painting and sculpture.

CONNECTION Robert Motherwell's *Elegy to the Spanish Republic* (Fig. 10.8) is an example of Abstract Expressionist painting.

Sculptures can be **fabricated** using industrial and commercial processes, such as welding or neon lighting. Nam June Paik's *Electronic Superhighway: Continental U.S., Alaska, Hawaii* (Fig. 3.1) is an example of a fabricated neon sculpture that is also a forty-nine-channel,

3.48 ROBERT RAUSCHENBERG. *First Landing Jump*, 1961.
Combine painting: cloth, metal, leather, electric fixture,
cable, and oil paint on composition board; overall, including
automobile tire and wooden plank on floor, 7′ 5$^1/_8$″ × 6′ × 8$^7/_8$″.
Gift of Philip Johnson. The Museum of Modern Art, New York.

Combines are works that are both painting and sculpture.

3.49 ANN PAGE. *petit homage—Stack VIII*, 2010. Redwood cube
with prototyped, infiltrated, gypsum modules, 1′ 2″ × 4$^1/_2$″ × 4″.

The five modules in this sculpture were modeled using computer-
aided design software and were produced on a three-dimensional
printer.

closed-circuit, digital video installation. Richard Serra's
The Matter of Time (Fig. 3.37) is an example of a work
fabricated with industrial equipment designed to roll and
shape sheet metal.

New Technologies

Artists can make sculptures from computer-aided design
files and then "print" them on three-dimensional print-
ers. For *petit homage—Stack VIII* (Fig. 3.49), from 2010,
Ann Page created a digital model for the spiky, branching
module and then had the printer make five exact copies
by building up thin layer on top of thin layer of gypsum.
She then stacked the modules vertically to recall both the
austere geometry of minimalist art and the growth pat-
terns in plants. The redwood base has a similar tension
between the organic and the geometric. Originally cut into
a perfect cube, it has become distorted and more organic
as it has aged and has been exposed to the weather. Again,
the choice of media and materials supports the basic idea
behind this artwork. The work is like a graft, where the

perfection of machine-made objects meets the individual
artist's touch.

Installation

Installations are usually mixed-media artworks designed
for a specific interior or exterior space. In the Cornaro

3.50 GIANLORENZO BERNINI. Cornaro Chapel with the *Ecstasy of St. Teresa*, 1645–1652, in the Church of Santa Maria della Vittoria, Rome. Marble, stucco, paint, natural light, central figures are marble, 11′ 6″ high. As illustrated by an anonymous eighteenth-century painting from the Italian School. The painting is located in the Staatliches Museum, Schwerin, Germany.

Installations transform the entire space of a room.

Chapel in the Church of Santa Maria della Vittoria (Fig. 3.50), Gianlorenzo Bernini created a dramatic stage for his sculpture, the *Ecstasy of St. Teresa*. The 11′6″-high sculpture of St. Teresa and an angel is the centerpiece of the chapel. The work represents the mystical, religious rapture of St. Teresa as she is pierced by the angel's arrow of divine love. The figures appear to float in midair and are lit by heavenly rays. Bernini used the entire chapel space to amplify the ecstatic mood, blending architecture, sculpture, illusionistic painting, colored marble, bronze, and natural light. Even in the modern era, churches are often designed almost as installations that create a spiritual environment. The artist Henri Matisse designed the interior of the Chapel of the Rosary for the Sisters who cared for him while he was ill. His cut-paper designs were translated into stained glass, as seen in Figure 3.51, *Tree*

3.51 Henri Matisse. *Tree of Life*, 1950–1951. Stained glass. Chapel of the Rosary, Vence, France.

Like installations, religious spaces are often carefully designed to transform the entire interior and, in this case, to provide a spiritual experience.

of Life, and were combined with a spare and light-colored interior.

Almost any material can be used in installations. In some instances, the same material can be used to create both freestanding sculptures and installations. Dale Chihuly is a renowned contemporary glass artist who has created brilliantly colored sculptures in glass that resemble flowers, sea creatures, and patterns from Navajo weavings. He has created installations in glass that are far more ambitious than most undertakings by glass artists. His 2002 installation *Seaform Pavilion* (Fig. 3.52) fills the ceiling on the Bridge of Glass in the Museum of Glass in Tacoma, Washington. Hundreds of individual pieces are combined to create a work that references the fantastic world of an undersea coral reef and seems to float overhead. When lit, glass is a luminous medium that enhances the theme of this artwork.

Creating temporary exterior installations had been the life work of Christo and Jeanne-Claude. They had

3.52 Dale Chihuly. *Seaform Pavilion*, 2002. Bridge of Glass at the Museum of Glass, Tacoma, Washington.

This work is installed in the ceiling of a bridge between two buildings. The installation is composed of hundreds of individual pieces of blown glass.

3.53 CHRISTO AND JEANNE-CLAUDE. *Running Fence*, Sonoma and Marin Counties, California, 1972–1976. Height: 18′; length: 24¹/₂ miles; 240,000 square yards of nylon fabric, steel poles, and steel cables.

The line of fabric transforms the landscape.

installed various materials at specific sites to enhance their natural beauty. In *Running Fence* (Fig. 3.53), fabric was stretched over the rolling countryside of Sonoma and Marin Counties in California. The fabric fence visually emphasized the undulating contours of the land, especially when the sun was low and the land was dark but the cloth reflected the warm-colored rays.

PERFORMANCE

Performance is a live-action event that is staged as an artwork. There are obvious similarities between performance art and theater, but in the sense that performance is art that occupies and transforms a space, it is related to installation. Other examples of performance art appear in Chapter 11, Mind and Body, because performance art often requires the human body. We will look at only one example here. Figure 3.54 shows Suzanne Lacy and Leslie Labowitz in a feminist performance piece called *In Mourning and in Rage*. In this protest performance, ten women dressed in black drove in a hearse to a Los Angeles City Council meeting. They were expressing their grief

and outrage both for the ten victims of the Hillside Strangler and for the overall violence against women that is sensationalized in the news media.

CONNECTION Ana Mendieta's *Arbol de la Vida, No. 294* (Fig. 11.36) is another example of performance art.

TECHNOLOGY-BASED MEDIA

Photography

In **photography,** a light-sensitive surface is exposed to light through a lens, which creates an image from the environment on that surface. Early examples of monochromatic photographic processes are daguerreotypes, such as *Frederick Douglass* (Fig. 3.55), from about 1855.

3.54 Suzanne Lacy and Leslie Labowitz. *In Mourning and in Rage.*

The human body is the prime element in performance art.

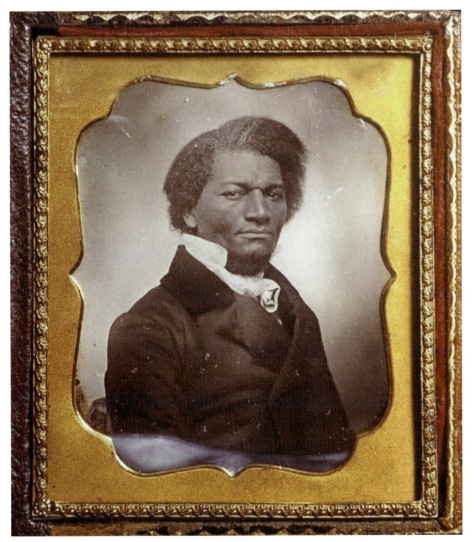

3.55 *Frederick Douglass*, c. 1855. Daguerreotype, $2^3/_4'' \times 2^3/_{16}''$. The Rubel Collection, Partial and Promised Gift of William Rubel, 2001 (2001.756). Metropolitan Museum of Art, New York.

This is an early form of photography and, thus, was precious, as indicated by the elaborate frame. The glass was necessary to protect the fragile surface.

3.56 ANDREAS GURSKY. *99 Cent*, 1999. Cibachrome print, 6′ 9½″ × 11′. Musee National d'Art Moderne, Centre Georges Pompidou, Paris.

Photography has evolved so that very large, durable prints with near-permanent colors are possible.

3.57, right HANS (JEAN) ARP WITH OSCAR DOMINGUEZ, SOPHIE TAEUBER-ARP, AND MARCEL JEAN. *Exquisite Cadaver*, 1937. Collage and pencil on paper, 2′ ¼″ × 9¼″. Musee National d'Art Moderne, Centre Georges Pompidou, Paris.

A collage of photographic and drawn images can have an absurd quality because of disjunctions in the imagery and in the space.

Daguerreotypes were quickly replaced by other photographic innovations because their developing process required the use of toxic chemicals and because the end product was fairly delicate and had to be kept behind glass. Nevertheless, daguerreotypes are beautiful, ghostly silver images of great clarity and detail, representing a medium that evokes a sense of poetry and lost history.

Photography has continued to evolve technologically using film as the light-sensitive surface from which multiple copies on photo paper could be made. Eventually, color photography was also possible. It is beyond the scope of this book to detail photographic history, but we will look at a cibachrome print by Andreas Gursky, entitled *99 Cent* (Fig. 3.56), from 1999. Cibachrome is a photographic color-printing technology invented in the 1960s with vivid, fade-resistant colors and high detail, all on a print on a polyester base rather than paper. Gursky made these very large color prints of the vast interiors of 99-cent stores in order to highlight the amount of low-cost, low-quality consumer goods available in the United States today.

Ever since photographs have become commonly available, artists have experimented with ways to alter or manipulate them. Two examples are **photomontage** and collage, in which many photographs are combined or added to other media to create a new image. Four artists collaborated on *Exquisite Cadaver* (Fig. 3.57), from 1937,

3.58 LORNA SIMPSON. *Easy to Remember*, 2001. Still from 16 mm film transferred to DVD, sound, 2½ minutes.

Artists use new technologies for pieces combining imagery and sound.

using photographs and drawing to create a surreal image. Each artist contributed one section and then covered it so that the next artist added more imagery without knowing what had been drawn earlier. The end result is intriguing but incoherent, like a dream, which is well expressed through the photomontage and collage method.

ART EXPERIENCE Get three friends and make your own exquisite corpse or exquisite cadaver artwork.

In addition to these older photographic technologies, artists today have at their disposal digital cameras and a wide range of printers. Digital images can be easily manipulated with computer software. Output from digital images can be printed on hard copy, displayed on computer monitors, or projected onto a screen. In addition, all kinds of existing imagery and objects can be scanned to become digital information.

The Moving Image

Artists have also worked in film and video, which are essentially photographs shot in sequence to give the illusion of movement. A "movie" is a sequence of still photographs shot in rapid succession on a strip of film. When projected onto a screen, the progression of the still images gives an illusion of movement. Video was originally recorded as both image and sound on magnetic videotape, which was displayed on television monitors. Video cameras first became accessible to the public and, thus, to artists in 1965. We have already discussed Nam June Paik's *Electronic Superhighway: Continental U.S., Alaska, Hawaii* (Fig. 3.1). This is an example of a forty-nine-channel, closed-circuit, video installation.

The digital revolution has also transformed the moving image. Lorna Simpson combines black-and-white film (which has been digitized and now plays as a DVD) with an audio song in *Easy to Remember* (Fig. 3.58). The song, which is softly sung, is intended to

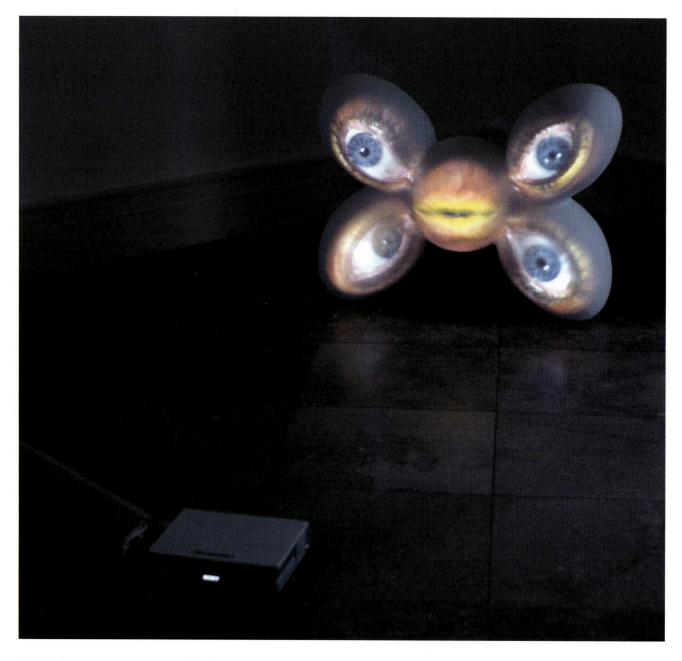

3.59 Tony Oursler. *Junk*, 2003. Fiberglass sculpture and DVD projection. Sculpture 2′ 5″ × 3′ 3″ × 1′ 4″. Sarah Norton Goodyear Fund, 2003. Albright-Knox Art Gallery, Buffalo, New York.

The projected image animates the fiberglass sculpture.

invoke memories of African American childhood. Tony Oursler's *Junk* (Fig. 3.59), from 2003, is a biomorphically shaped fiberglass sculpture with eerie images of rolling eyes and an incessantly speaking mouth projected onto it using a DVD projector. Oursler comments on the modern human condition of neediness, insecurity, and self-centeredness with a work that is funny and annoying at the same time.

4

DERIVING MEANING

Art and architecture have meaning, but how do audiences understand the message? This chapter examines five basic areas in regard to meaning: (1) formal analysis; (2) content analysis; (3) the influence of historical context, physical surroundings, and method of encounter; (4) writings about art; and (5) *you, the viewer*, forming your own interpretation.

PREVIEW

Art communicates complex ideas and emotions, and this chapter looks at the ways this is achieved. We begin with formal analysis, which examines the artist's use of the elements and principles that we saw in Chapter 2. Next is content analysis, dealing with subject matter and systems of symbols.

Historical context and physical surroundings are important in two ways. First, every work of art was created within its own cultural, historical, political, social, or religious context. Knowing about that context deepens our understanding of a work of art. Second, we now live in our own surroundings and historical context, and our situation today influences what we think about any art we see.

Writings about art enrich our experience of it. We will look at several philosophical positions from which art has been analyzed. Sometimes the writers contradict or add to each other's arguments, showing that the meaning of art is not fixed. New interpretations develop over time.

For your Art Experience, we ask you to develop your own interpretation of a work of art.

Iconography

Artists can use metaphors or symbols to convey content. A visual **metaphor** is an image or element that is descriptive of something else. In *Setting Cycles*, the handmade paper is just paper, but it acts as a visual metaphor for the passage of time, as it is piled up one layer upon another and some areas seem to be disintegrating with age.

A **symbol** is an image or element that stands for or represents some other entity or concept. Symbols are culturally determined and must be taught. For example, in the United States today, a dove is a symbol of peace. But people from other cultures would not know by observation alone to connect "dove" and "peace." However, as communications become more global, symbols can more often be understood across cultures. Graphic and environmental designers often use symbols for wayfinding, which is the means people use to orient themselves and navigate unfamiliar spaces. Certain symbols are understood by increasingly large numbers of people, as seen in airport signage (Fig. 4.5). Indeed, contemporary airport signage contains so many symbols that it could be considered iconography.

Iconography is a system of symbols that allow artists and designers to refer to complex ideas. It literally means "image" (*icono-*) and "to write" (*-graphy*). Some cultures and religions developed complex iconographic systems: for example, ancient Egypt, Byzantium, medieval Europe, Buddhism, and Hinduism, to name only a few. In medieval Christian symbolism, the unicorn stands for both Jesus Christ and a faithful husband in marriage (see Fig. 13.3).

Mary, mother of Jesus, was often shown with flowers, symbolizing purity or sorrow.

Figure 4.6 is *Yama* from Tibet and painted around the mid-seventeenth or early eighteenth century. It contains a complex set of symbols, and once we become familiar with this iconography, we know that Yama is the Indian god of death, who later became the protector of the adherents of the Buddhist religion. Dressed in leopard skin and wearing a headdress of human skulls, Yama holds a thunderbolt chopper and skull, while standing on black lotus petals in a sea of blood. This fierce god fights against the inner demons such as hatred and lust. He tramples an agonized creature beneath his feet. Four buffalo-headed Yamas are located near the corners, and various holy figures hover above, while many skulls occupy the space below.

Iconography can be embedded in architecture. We already saw the *U.S. Capitol Building* (Fig. 4.1). Its design reflects Greek and Roman architecture, visually connecting the government of the United States to the ideas of democracy (Greece) and power (the Roman Empire). The building has two wings, instantly conveying the idea of the two houses of Congress and physically containing them. The central dome symbolizes unity.

CONNECTION The *Maori Meeting House* (Fig. 3.39 and Fig. 9.17) contains political and religious iconography that is important to the native Maori people of New Zealand.

4.5 Signs in an airport, Malaga, Andalusia, Spain, 2006.

4.6 *Yama*, Tibet, mid-seventeenth to early eighteenth century. Distemper (pigments mixed with egg yolk, egg white, and/or glue) on cloth, 6′ 3/8″ × 3′ 10⁵/8″. Metropolitan Museum of Art, New York.

This painting has a complex iconography, or system of symbols, that refers to religious beliefs of Buddhism.

immigrated to the United States as a teenager, just as Iran was being transformed into an Islamic state led by clerics. Her subject is Islamic women and femininity in a country where women's actions and rights are limited by religious law. In her photographs, women's hands or faces emerge from beneath veils, often framed by guns or flowers. On the photos, Neshat wrote religious quotes or poetry in Farsi, the language of Iran. The context for Neshat's poignant photos is the political and social climate in a fundamentalist Islamic culture, along with the associated Western reactions.

Physical Surroundings

The location of an artwork also affects its meaning. Many works of art can be moved physically from one location to another, but the location change might have a profound impact on the work. Historical events at a location can also change the meaning of an artwork.

An example of an artwork that takes its meaning from its site is *The New York City Waterfalls* (Fig. 4.9), on view for four months during 2008 along the East River near Lower Manhattan. With the assistance of the Public Art Fund in New York, the artist Olafur Eliasson executed the four artificial "waterfalls," constructed of scaffolding and pumps and ranging from 90 to 120 feet high. Technically, these "waterfalls" could have been built almost anywhere. But Eliasson purposely chose these sites for these works. New York City seems like an enormous and dense urban mass, but in reality it is situated in a mesh of waterways where fresh water meets salt water, an ideal habitat for wildlife. Eliasson wanted to dramatically integrate nature (the falling water) into the city space (the scaffolding) and to draw people back to the New York City waterfronts.

New York is also the site of the World Trade Center (see Fig. 8.30), which was destroyed in the September 11, 2001, attacks. Those historic events will always be attached to the World Trade Center and can deeply affect people who see pictures of the old site or visit the new structures.

Method of Encounter

We encounter art in all kinds of places—in newspapers, in museums, out on the street, at religious sites, in public parks, in government or corporate buildings, in schools, at festivals, and in malls, along with many others. The nature of our encounter adds meaning to the artwork.

We know most works of art through photographs, which communicate only a fraction of the total experience of actually being in the presence of the art. The *Potala Palace* in Lhasa, Tibet (Fig. 4.10), begun in the seventeenth century, is an enormous structure situated high in the

4.9 OLAFUR ELIASSON. *The New York City Waterfalls*, installation along the East River, 2008.

The meaning of this artwork comes in part from the location where it was situated.

Himalaya Mountains. It is the home of the Dalai Lama, the traditional spiritual and political leader of Tibet, although the current Dalai Lama has lived in exile since the Chinese invaded in the 1950s. Looking at photographs at your leisure, you can study the entire palace, seeing it framed against majestic peaks or reflected in a nearby lake. Were you to actually approach and enter the palace, your experience would be quite different: physical exertion while climbing steep stairways, brisk mountain weather,

4.10 *Potala Palace*, the former summer palace of the Tibetan Buddhist leader, the Dalai Lama, Lhasa, Tibet.

If you know this famous palace only through photographs, your experience of it is very limited.

4.11, *right* *Drum*, Dong Son civilization, Thanh Hoa, Vietnam, 3rd–1st century BCE. Bronze, 24.5″ × 31″. Musee des Arts Asiatiques-Guimet, Paris.

In the museum, viewers are limited to visually studying this drum. In the culture for which it was originally made, it provided sound and visuals as part of a larger ritual.

partial glimpses of buildings rather than "the perfect shot," encounters with other pilgrims, and tour buses at the base of the mountain.

Even for artworks that we actually encounter in life, the way we come in contact with them affects how we perceive them. To the people of the first millennium BCE Dong Son civilization (Vietnam), the bronze *Drum* (Fig. 4.11) with a resonating top plate was widely used in rituals related to the community, fertility, and dead warriors. The entirety of the rituals, plus the appearance of the drum and

The final Postmodernist philosophical position is **relational aesthetics,** which focuses on ways that art can augment human relationships in social spaces rather than emphasizing the collection of art objects. French art critic Nicolas Bourriaud has written about relational aesthetics, and perhaps its most famous practitioner is the Brazilian-born Thai artist Rirkrit Tiravanija. Instead of displaying objects, Tiravanija's work in galleries often consists of cooking and serving Thai meals for gallery goers to foster interaction between the artist and the viewers. Tiravanija also created a stainless steel Ping-Pong table called *Untitled 2008 (the future will be chrome)*; rather than being a hands-off work of art, gallery goers play on it (Fig. 4.21). He has also created communal land projects for living, farming, and building in Thailand.

4.21 Rirkrit Tiravanija. *Untitled 2008 (the future will be chrome)*. Polished stainless steel Ping-Pong table, shown here with artists Jay Nelson, right, and Annie Wachmicki, obscured, playing Ping-Pong during a NADA preview at the Ice Palace in Miami, on December 2, 2008.

Relational aesthetics promotes art practices that emphasize social interaction.

Personal Interpretation

In the end, you may develop your own meaning for a work of art. Ultimately, when you interact with art, you produce your own intellectual and emotional response based on your judgment, personal tastes, experiences, and history. In studying art, you learn about yourself now and over time because, as you change, your reaction to an artwork may shift as well. This is related to **phenomenology**, which studies human consciousness and experiences such as judgment and perception.

Applying Theory

Everything we discussed in this chapter can be applied to visuals that you see around you. Let us deconstruct Figure 4.22, the *L&M Cigarette* billboard. Formal analysis (page 88) would point out the large log placed in the center of the composition. Content analysis (also page 88) will show that while the subject is selling cigarettes, the ad is associating masculinity and sexuality with smoking. Regarding context and method of encounter (page 94), cigarette billboards were normal in the 1970s, but are not familiar to younger people because cigarette billboards were banned in 1998. Ideological critics (page 97) would ask who is paying for the ad and who is the target audience. Feminists might analyze the sexuality pervasive in this image and text.

Finally, it is important that you are able to analyze works and determine their meaning for you. For more on evaluating art and visual culture, see the Analysis Guide at the end of Chapter 15.

ART EXPERIENCE Apply theory to an artwork or advertisement of your choice.

4.22 L&M Cigarette billboard in Los Angeles circa 1970s. Art theory can be used to analyze any visual work.

II

WHY DO WE MAKE ART?

Hand, mind, heart, and body are united when a person makes art. Art fulfills basic human pleasures and needs. It is functional and aesthetic. In the next ten chapters, split into four sections, we discuss why humans make art.

Turning vase on pottery wheel in potter's workshop, Manan, Bahrain.
Body, mind, and heart come together in making art.

25,000–6000 BCE

	HISTORY FOCUS		**NEOLITHIC ERA** *Settlements in China and Chile* *Birth of Agriculture in Mesopotamia and Mexico* *Settlements in India* *Domestication of Cattle*	**UNIFICATION OF EGYPT** **MESOPOTAMIA CIVILIZATIONS**	*Irrigated Farming in the Andes* **SHANG DYNASTY—CHINA** **18TH DYNASTY—EGYPT** *Bronze Casting in China*
BEFORE COMMON ERA (BCE) **PALEOLITHIC ERA**	**MESOLITHIC ERA** *Domestication of Sheep*				
25,000 BCE	10,000		8000 7000 6000	3000 2000	1600 1540
Hall of Bulls, Lascaux, France *Bison with Turned Head*, La Madeleine, France			*Çatal Hüyük*, Turkey	*African Rock Painting*, Tassili n'Ajjer, Algeria	

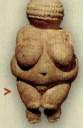
Venus of > *Willendorf*, Austria (6.3)

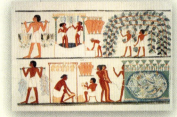
∧ *Bird Hunt and Preservation; Harvest and Wine Making*, Thebes, Egypt (13.32)

AZTEC EMPIRE	**RENAISSANCE (1400–1600)** **INCA EMPIRE** **MING DYNASTY—CHINA**	**MUGHAL DYNASTY—INDIA**	**BAROQUE ERA (LATE 17TH CENTURY–18TH CENTURY)**	**COLONIAL ERA** **INDUSTRIAL REVOLUTION** *Rise in Urban Population* *Steel Frame Structures*
1300	1400	1500	1600	1700 1800
	Silver Representation of a Maize Plant, Inca, Peru DA VINCI. *Last Supper*	*Saltcellar*, Afro-Portuguese PALLADIO. *Villa Rotunda*, Italy, 1552	*Tea Bowl*, Japan DE HEEM. *A Table of Desserts*	*Tipi Cover*, Sioux tribe *Basket*, Pomo tribe *Tyi Wara (or Chi Wara) Dance Headdresses*, Mali *Palm Wine Calabash*, Cameroon

ARCHAIC GREEK ERA (600–480)	ETRURIA, ITALY	COMMON ERA (CE)	MOCHE CULTURE— PERU	MIDDLE AGES IN EUROPE		ANASAZI CULTURE— NEW MEXICO	Spread of Chinese Culture to Japan
	ZHOU DYNASTY— CHINA (1046–221)			**EARLY BYZANTINE STYLE (527–726)**			
	Greek Pottery						
	HAN DYNASTY— CHINA (200 BCE–200 CE)	*Use of Arch and Concrete in Roman Architecture*		*Use of Cantilever in Chinese Architecture, 800 (2.38)*			
	DONG SON CIVILIZATION— VIETNAM						
600	**500 480**	**CE 1**	**200**	**500 800**		**1000**	**1200**
Women at the Fountain House, Greece	*Three-Legged Ting,* Zhou Dynasty, China	*House of Julius Polybius,* Pompeii, Italy	*Tomb Model of a House,* Han Dynasty, China			*Pueblo Bonito,* New Mexico	*Dogon Cliff Dwellings with Granaries,* Mali
		Markets of Trajan, Rome					MU-QI. *Six Persimmons,* Southern Song Dynasty

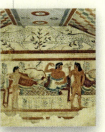

∧ *Banqueters and Musicians,* Etruria, Italy (8.9)

< *Drum,* Vietnam (4.11)

	POP ART				
	Food in Outer Space				
World War I, 1914	**MODERNISM AND POSTMODERNISM (1975–PRESENT)**				*World Population = 6 Billion*
World War II, 1939					
1900	**1960 1970**		**1980 1990 1999**	**2000**	
Toba Batak House, Indonesia	THIEBAUD. *Pie Counter*		TJUNGURRAYI. *Witchetty Grub Dreaming,* Australia	WAMISS. *Halibut Feast Dish*	
SULLIVAN. *Carson Pirie Scott and Company,* Chicago	WARHOL. *Heinz 57 Tomato Ketchup*		COE. *There Is No Escape,* Britain	ZAHID. *Broad Art Museum,* Michigan	
WESTON. *Artichoke, Halved*	SAFDIE. *Habitat,* Canada		PEI. *Bank of China,* Hong Kong		
WRIGHT. *Fallingwater,* Pennsylvania	FULLER. *U.S. Pavilion,* Canada		ANTONI. *Gnaw,* USA		
	CHICAGO. *The Dinner Party,* USA		GURSKY. *99 Cent*		
	MOORE. *Piazza d'Italia,* New Orleans				
	HANSON. *Self-Portrait with Model,* USA				

∧ *Hunter and Kangaroo* (13.26)

MARTINEZ. *Bowl* > (3.42)

∧ *Dyed Rice Sacred Offering,* Bali (1.26)

FOOD

Securing the Food Supply

In prehistoric cultures, hunters, gatherers, and early farmers linked art and ritual to accomplish tasks like bringing rain for crops. This is "sympathetic magic," and the artist/shaman could attain great status in society—and in some cultures still does.

Food, art, and ritual are likely linked in prehistoric cave paintings, like those in the *Hall of Bulls* at Lascaux in southern France (Fig. 5.4), dated c. 15,000–10,000 BCE, with huge woolly mammoths, horses, rhinos, aurochs (wild cattle), and reindeer. The paintings' exact purpose is unknown, but some anthropologists propose that rituals could be performed on the animals' likenesses to ensure a successful hunt. Spears and arrows were painted in or perhaps actually thrown at the image of the prey, ritualistically killing it. However, other scholars argue that the painted "arrows" are few and could be plant forms. They propose that these paintings paid homage to earth and animal spirits. Either way, the current consensus is that these images had a ritual purpose linked to bounty in nature and the human food supply in the Paleolithic era.

The paintings, done from memory, were quite naturalistic, focused on the animals' energy and movements, and used the side view for easy recognition. Color came from naturally occurring materials, such as tar and charcoal for black, colored earth for yellow and brown, and rust for red. Dry pigment could be applied as powder or brushed on with animal fat. Given the crude materials and the rough stone walls, the paintings are especially amazing. Later, Paleolithic hunters and gatherers became Neolithic farmers, as shown in *African Rock Painting* (Fig. 5.3) from Tassili n'Ajjer.

Across the world in Australia up to the present day, we see a similar phenomenon that links food, art, and ritual. Until recently, the Aboriginal people were a Stone Age culture that existed in the twentieth century. The "Ancestor Dreaming" of the Aboriginal people of Australia is a system of beliefs that accounts for the cosmos, from creation to death, and aids in survival, including the location of food for this hunting and gathering culture. Knowledge was passed along through song, chant, dance, and painting. For paintings in the past, Aboriginal artists applied colored dirt on the ground and destroyed the work at the ritual's end. Aboriginal

5.4 *Hall of Bulls*, cave painting, left wall, Lascaux, Dordogne, France, c. 15,000–10,000 BCE. French Government Tourist Office.

These paintings may have been part of ancient rituals linked to the bounty of nature.

5.5 PADDY CARROLL TJUNGURRAYI. *Witchetty Grub Dreaming*, Aboriginal, Papunya, Australia, 1980. Paint on canvas.

The patterns and symbols in this painting are part of the Aboriginal belief system of the origin of life and the sustenance of everyday existence.

5.6 *Tyi Wara (or Chi Wara) Dance Headdresses*, Bamana (or Bambara) people, Mali. Headdresses are generally made of wood, brass tacks, string, cowrie shells, and iron and are between 32″ and 38″ high.

Tyi Wara dancers are wearing headdresses of the mythic antelopes that brought agriculture to their community.

artists have made their paintings with more permanent materials since the 1970s.

Witchetty Grub Dreaming, by Paddy Carroll Tjungurrayi (Fig. 5.5), from 1980, is a kind of contour map with symbols, indicating the location of precious food and water in arid central Australia. The work is strongly patterned, with alternating lights and darks and curving and straight lines, all radiating from a circle in the center that shows the source of the ancestor grub. The small, squiggled lines represent other grubs, an important food source, beneath the ground. Symmetry suggests the balance of the cosmos and the ancestors, providing sustenance for humans.

Compare this with the traditions of the Bamana people of Mali, who use masks, dance, and ritual to help ensure successful crops. While these masks vary from area to area in Mali, predominant mask types can be seen in the *Tyi Wara (or Chi Wara) Dance Headdresses*. These headdresses (Fig. 5.6), from the late nineteenth or early twentieth century, consist of male and female antelope masks, with the female bearing a baby antelope on her back. While the ground is being prepared for planting, young male dancers with masks and costumes perform the leaping movement of the antelope dance, a ritual that causes the return of the

mythical antelope who first gave humans the knowledge of agriculture. Plant life (crops), animal life (antelope), and humankind (ancestors) are united in this ritual. Pattern and rhythm are important visual elements in the headdresses, with interwoven negative and positive shapes.

CONNECTION Many cultures have appealed to a deity spirit for food. One example, from Mesoamerica, is Xilonen, *Goddess of Young Corn* (Fig. 7.6).

In most industrial societies today, few people hunt and process the meat they eat, or gather food, or farm. Instead of religion, technology and business ensure the food supply. To clearly illustrate the change, look at British artist

5.7 Sue Coe. *There Is No Escape*, Britain, 1987. Watercolor and graphite on paper, 1′ 10″ × 2′ 6″.

The stark black-and-white work is a critique of food industries in contemporary industrial societies.

Sue Coe's *There Is No Escape* (Fig. 5.7), from 1987, unmistakably a harsh indictment of the contemporary meat industry. It is part of a large series entitled *Porkopolis*, in which Coe shows living animals being transformed into packaged cuts of meat. Inside a slaughterhouse, Coe emphasizes the carnage and sympathizes with the pigs' fear, while the workers seem sadistic or subhuman. This emotional image is overall very dark, with a few lurid, glaring lights, but Coe wants us to see it as fact and to tie it to the contemporary meat-heavy Western diet.

Storing and Serving Food

The following are examples of the many kinds of vessels created around the world to hold food. They date from the Neolithic era to the twentieth century. Each combines utility with aesthetics and meaning.

Water is essential, so various peoples have developed inventive systems for storing liquids using clay, leather, wood, and straw. Our focus figure for this section is the ceramic hydria *Women at the Fountain House* (Fig. 5.8), dated 520–510 BCE from the **Archaic** Greek era, when figure styles on pottery were evolving from stiff, simplified forms into more fluidly realized bodies. The hydria has a well-designed silhouette, with its body gracefully curving outward to the handles, which accentuate the widest part of the pot. From that point, the "shoulders" move inward dramatically, while the vessel's "neck" echoes but opposes the curves of the body. On this hydria is an example of black figure painting, in which a thin coating of black-firing clay covers the red clay of the vessel itself. Details are scratched in with a needle. Graceful women effortlessly collect water from the fountainhead, reiterating the purpose for the vessel. The scene is framed with floral and geometric designs.

While the Greeks used clay for water storage containers, the ancient Chinese made bronze vessels for storing liquids, such as ritual wine. These vessels may have been placed beside a shrine of deceased ancestors to receive blessings for a successful crop or good health. Some are elaborately and densely patterned over their entire surface, with monster faces at key locations, such as the handles, perhaps to keep away evil. Balance and harmony are important, visually expressing ancient Chinese philosophy and values.

In our example (Fig. 5.9), we see a Zhou *Three-Legged Ting with Cover*, dated c. sixth century BCE. It has a simple shape with bands of patterns, supported by the three legs, or feet. Delicately incised abstract lines complement its overall form. Circles are repeated, even on the ting's cover, decorated with a **quatrefoil** pattern (like a four-leaf clover) and cleverly designed to be used as a serving bowl.

A well-woven container made of natural materials can hold liquid as well. Women of California and Pacific Northwest Coast tribes excelled at weaving baskets using willow and spruce twigs, pine needles, grapevines, and flax plants. The different-colored materials in the basket wall resulted in geometric designs that were symbolic and often referred to nature, such as geese flying or sunlight breaking through stormy skies. These watertight baskets could be used for boiling acorns by placing hot rocks

5.8, *left* PRIAM PAINTER. *Women at the Fountain House*, Greek hydria, 520–510 BCE. Ceramic, 1′ 8¾″ high. Museum of Fine Arts, Boston.

The images on this highly decorated vessel show women carrying water jugs very much like this very hydria.

5.9 *Three-Legged Ting with Cover*, Zhou Dynasty, China, c. sixth century BCE. Cast bronze, 5¾″ high.

The design of this bronze vessel, which was used in rituals to receive blessings from deceased ancestors, features circular details that complement the overall spherical form.

5.10, *above* *Basket*, Pomo tribe, 1890–1910. Clamshell disks, red woodpecker feathers, quail topknots, tree materials, 7″ diameter.

Intricate weaving, precious feathers, and beads mark this vessel, which was made by mothers and given to their daughters.

5.11, *right* *Palm Wine Calabash*, Bamileke people, Cameroon, late nineteenth century. Beads on a cloth foundation, gourd, cowrie shells, 1′ 11½″ high. Collection of The Newark Museum, Newark, New Jersey.

The shape of an ordinary gourd is evident beneath the beaded cloth, but the high quality of handwork and the decorative motifs mark this as an object for a ruler's use.

inside them when filled with water. In *Basket* (Fig. 5.10), dated 1890–1910, from the Pomo tribe, the basic woven design has been covered with feathers and shells, adding layers of pattern. Mothers in California tribes made these special ceremonial gifts to mark significant moments in their daughters' lives, such as birth or puberty. Women treasured the baskets and were cremated with them at death. Though extremely delicate looking, baskets such as this were used in everyday life and developed stains on the inside. The colored feathers represent the bravery and courage of the birds from which they came.

Another highly decorative vessel is the *Palm Wine Calabash* (Fig. 5.11), from Cameroon. While gourds are basic containers for liquids in many traditional African cultures, this bead-covered gourd was for display, ritual, and royal use. It held palm wine, a common social drink in this area, but only the highest quality was stored here. Stoppers on such gourds were often an animal: for example, a leopard, an elephant, or, as here, a bird.

Like water, salt is essential. At times, it has been a form of wealth. The European nobility used elaborate salt-cellars as a status symbol, while medieval Europeans used salt to distinguish the status of guests: prestigious people sat "above the salt," while people of lower rank sat below.

The ivory *Saltcellar* (Fig. 5.12), from the sixteenth century, was carved by African artists for export to Europe. The salt is held in the orb that is topped by an execution scene, showing a victim about to be sacrificed. Alligators serve as vertical supports below. The style reflects both African and Portuguese tastes, and both cultures valued the warmth and luster of ivory and used it for diplomatic gifts. The Portuguese likely drew the original design on paper, but African artists interpreted it, especially the figure proportions, which echo African aesthetics with the large heads, simplified bodies, and short legs (see Chapter 11, Mind and Body). The ivory has been worked very skillfully, with intricate patterning relieved by smooth areas and with solid shapes punctuated by empty spaces.

CONNECTION Can a dish design be an art form or not? Read the discussion in Chapter 1, pages 12–16, on fine art, popular culture, and craft.

So far in this section, the containers are one of a kind and expertly crafted. Andy Warhol's *Heinz 57 Tomato Ketchup* and *Del Monte Freestone Peach Halves* (Fig. 5.13),

5.12, *left* *Saltcellar*, Afro-Portuguese, Sherbro Peninsula (Bulom), Sierra Leone, sixteenth century. Ivory, 1′ 5″ high. Museo Nazionale Preistorico e Etnografico Luigi Pigorini, Rome.

This saltcellar was carved by African artists for export to Europe.

5.13, *below* ANDY WARHOL. *Heinz 57 Tomato Ketchup* and *Del Monte Freestone Peach Halves*, 1964. Silk screen on wood, 1′ 3″ × 1′ × 9½″.

This work blurs the distinction between art and commercial packaging and celebrates the simple colors, bold graphics, and clean layout of advertisements.

dated 1964, are silk-screened wooden sculptures that look like mass-produced cardboard packing boxes for common grocery store items. In the United States, packaged foods are often more familiar than food in its natural condition, and Warhol is celebrating this commercialism, indicating that most people enjoy it and are comfortable with it. To him, the design of a ketchup box is art and, therefore, as meritorious and meaningful as any other work of art. Its formal qualities are bright colors, large type, simple graphics, and an organized layout. Yet there is a sense of irony to the work because whatever is merely comfortable eventually becomes hollow and meaningless. This work was created during the **Pop Art** movement, which was noted for glorifying popular culture items into art icons.

ART EXPERIENCE Look at the eating habits within your own culture. Use video or photographs to describe how art is a part of it.

Art That Glorifies Food

In addition to sustaining us, food is beautiful. Food's shapes and textures are the subject of many sculptures and still life paintings, which also reflect cultural or religious values. Our examples date from many cultures and from the thirteenth century to the present.

Our focus figure is Jan Davidsz. de Heem's *A Table of Desserts* (Fig. 5.14), dated 1640, which reflects cultural and religious beliefs. In Europe, seventeenth-century still life paintings often were lavish displays boasting of wealth and abundance, in which food had become an aesthetic experience for refined taste. This was the **Baroque** era in art, known for exaggeration, artifice, and theatrics. Paintings of food took on almost a fetish

5.14, *below* JAN DAVIDSZ. DE HEEM. *A Table of Desserts*, Netherlands, 1640. Oil on canvas, 4′ 10^7/$_{10}$″ × 6′ 7^9/$_{10}$″. Louvre, Paris.

This glorious display of food has a subtheme about the impermanence of earthy life.

quality, detailed and lovingly painted, like de Heem's sumptuous fruits and sweets on silver platters, laid on velvet. The food is not shown as a person standing or sitting at a table would see it but is elevated to eye level, centralized and formally arranged, and surrounded by heavy draperies and musical instruments. Oil paint made deep, rich colors and textures possible. Yet moral themes are part of *A Table of Desserts*. The tipping trays and half-eaten, soon-to-spoil food allude to the idea of *vanitas*—that is, the impermanence of all earthly things and the inevitability of death.

In contrast to de Heem's work, look at U.S. artist Wayne Thiebaud's 1963 painting of desserts, *Pie Counter* (Fig. 5.15). It deals with food as a visual display and as a popular icon rather than as nutrition for the body. *Pie Counter* shows the plentifulness, standardization, and bright colors in contemporary mass-produced cafeteria food, which is so appealing to many Americans. The thickly textured paint and bright colors are visually seductive and very different from de Heem's style. Thiebaud also alludes to the fact that, for many, the abundance of fattening food has become something to resist rather than something to eat, while mass-media advertising pushes it. Interestingly, Thiebaud's painting and Warhol's *Heinz 57 Tomato Ketchup* (Fig. 5.13) are both from the same era of Pop Art.

In contrast to the sumptuousness of de Heem's painting and the abundance of Thiebaud's, Mu-Qi's *Six Persimmons*

5.15 WAYNE THIEBAUD. *Pie Counter*, 1963. Oil on canvas, 2′ 6″ × 3′. The Whitney Museum of American Art, New York.

Reflecting modern cafeterias, this painting is a colorful display of standardized, mass-produced food.

5.16 MU-QI. *Six Persimmons*, Southern Song Dynasty, Daitoku-ji, Kyoto, thirteenth century. Ink on paper, 1' 2¼" wide. Daitoku-ji, Kyoto, Japan.

The simplicity of this still life reflects the philosophy of Zen Buddhism.

5.17 *Silver Representation of a Maize Plant*, Inca, Peru, 1430–1532. Ethnologisches Museum, Staatliche Museen, Berlin.

Maize was a food staple for the Incans and also was used to make beer, which was used in religious festivals. This silver replica glorifies the food so important to the Incans.

(Fig. 5.16), dated c. 1269, reflects Zen Buddhism, which emphasized the importance of meditation and simplicity in life. This simple arrangement—with contrast between the plump fruits and the angular stems, and the spare richness of their color—is orderly yet irregular. Empty space is an important visual element. Many Zen masters chose to make ink paintings because of the form's spontaneity and simplicity, in contrast to the lushness of oil painting. But with ink, the strokes must be practiced for years to make them confidently, without erasing or correction.

Likewise, the *Silver Representation of a Maize Plant* (Fig. 5.17), c. 1430–1532, reflects the religious, political, and agricultural traditions of its culture—in this case, the Incan civilization of Peru. Maize was integral to Incan life, both sacred and mundane. It was a food staple and was also used for making the most valued *chicha* (beer), which was consumed during religious festivals, such as the important eight-day celebration of the maize harvest. Incans were known to have made life-size replicas of plants and animals from gold and silver, arranging them into elaborate gardens.

Both metals had symbolic significance: gold was believed to be the sun's sweat and silver the moon's tears. Food and feasting were also part of Incan political domination, as subservient peoples would provide food tribute to the Incan rulers and accept feasts from them as a sign of submission. This finely crafted piece is evidence of the key role that maize played in the Incan culture.

Our final example in this section shows yet another reason that food appears in art. In Europe and the United States in the early twentieth century, photographs and paintings of food were often vehicles for abstraction and experimentation with media. During this period, innovation in art and invention in industry were important, as reflected in Edward Weston's *Artichoke, Halved* (Fig. 5.18), from 1930. Weston's photograph reveals the complex design and grace of natural forms, but it also shows off the technical achievement of photography, with the capacity to zoom in close and instantly capture minutely detailed images. There was little interest in this food as sustenance

5.18 EDWARD WESTON. *Artichoke, Halved*, 1930. Photograph. The Museum of Modern Art, New York.

The emphasis in this photograph is more on structure and form than on reflections of morality or philosophy.

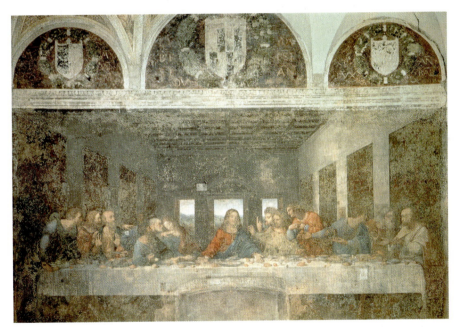

5.19 LEONARDO DA VINCI. *Last Supper*, 1495–1498. Experimental paint on plaster, 14′ 5″ × 28′. Milan.

This image of a ritual meal is also a religious ceremony, and formally it deifies Jesus.

or in its symbolic potential. An interesting comparison can be made with *Six Persimmons*, which reflects inner spiritual beauty, whereas *Artichoke, Halved* looks closely at structure and its inner physical beauty.

CONNECTION Landscapes and images of nature have also glorified food sources. See, for example, the lyrical depiction of *Pear Blossoms* (Fig. 13.17) from China, and *Babur Supervising the Layout of the Garden of Fidelity* (Fig. 13.18), from Mughal, India.

Art and the Act of Eating

We eat for nourishment, but how we eat is full of meaning. Some meals are very formal, like those involved in holiday celebrations or religious rituals. Some meals are very casual. In this section, we look at art that depicts formal or casual meals as well as art objects associated with those meals.

Italian artist Leonardo da Vinci's *Last Supper* (Fig. 5.19), 1495–1498, depicts the ritual meal as a religious ceremony. The composition is very formal and symmetrical, with the most important figure, Jesus, at the center,

5.20 STAN WAMISS. *Halibut Feast Dish*, 2005. Yellow cedar or cypress, 2′ 1″ long × 1′ 1″ wide × 3½″ deep.

Certain animals would be symbols for a specific family. All details have been carved and then painted.

framed by the distant doorway. His hands, arms, and head form a triangle. Six followers are on each side, in groups of three. The one-point perspective lines in the ceiling and wall radiate from Jesus' head. All are on one side of a long table like a head table; this seating arrangement implies that many unseen witnesses are also present at the meal—and we as viewers are among them. Leonardo's formula for depicting the *Last Supper* was so effective that this painting has become the standard.

> **CONNECTION** Review the discussion in Chapter 2 on linear perspective, illustrated in the diagram in Figure 2.20.

Another important ritual feast is the potlatch, from the Native Americans of the Northwest Coast. The potlatch was the formal mechanism for establishing social order among the people. The most powerful people gave the most lavish feasts and gifts, and the guests acknowledged that superior status by eating the food and by accepting the gifts. Some traditional serving dishes were as long as 20 feet and were prized possessions passed down through families. Stan Wamiss' *Halibut Feast Dish* (Fig. 5.20) is a contemporary serving dish for potlatches. Traditionally, carved animal forms were abstracted and rendered as geometric patterns, usually symmetrically around a vertical axis. Certain features, such as eyes, beaks, and claws, were emphasized, and black outlines established the skeletal

framework for the entire design. Contemporary pieces like this are brightly colored because the artists used commercially available paints instead of natural dyes and pigments.

We can extend our comparisons to the Japanese tea ceremony, a formal, ritualized partaking of tea, influenced by Zen Buddhism, the philosophy behind *Six Persimmons* (Fig. 5.16). In Zen, personal meditation leading to enlightenment can include the most common of life's activities, including the making of tea. The host for a tea ceremony would carefully prepare the room, select vessels, and invite guests, guided by the idea that each gathering for a tea ceremony is a supremely intense and precious moment that can never be re-created. Tea bowls were unique, often imperfect in design, to convey the concepts of humility and of beauty embodied in humble things. The *Tea Bowl* (Fig. 5.21), from the seventeenth century, gracefully combines a series of opposites: smooth glazes and textured glazes, round and square shapes, and horizontals and diagonals and verticals.

> **ART EXPERIENCE** Go to your favorite restaurant and have a meal. Make a video of the aesthetic qualities of the exterior architecture, interior design, vessels, and food that you eat.

Some artwork references a ritual meal, although no food is shown. *The Dinner Party* (Fig. 5.22), 1974–1979, is

5.21, *left* *Tea Bowl*, Japan, seventeenth century. Ceramic, Satsuma ware, 4²/₅″ diameter at mouth.

Humble items often embody beauty, and their designs gracefully combine opposites.

5.22, *below* JUDY CHICAGO. *The Dinner Party*, 1974–1979. Painted porcelain and needlework, 4′ × 42′ × 36′. The Brooklyn Museum, Brooklyn, New York.

The design of this dinner arrangement referenced Leonardo's *Last Supper* and reinterpreted it in feminist terms.

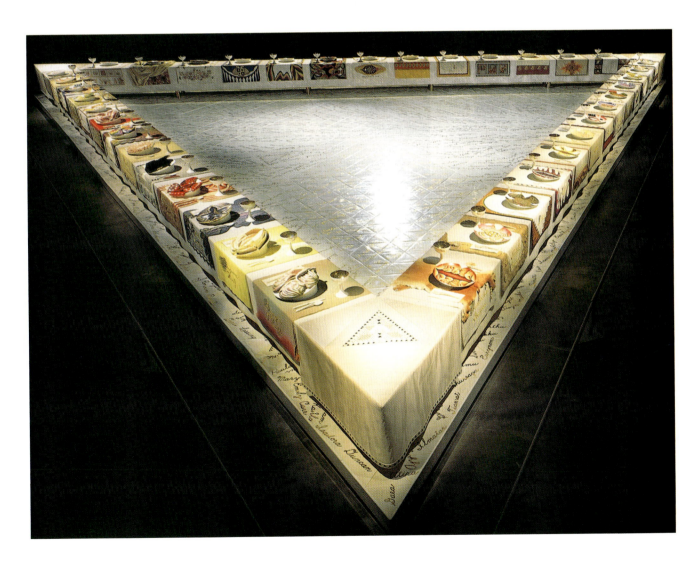

5.26 *Çatal Hüyük*, corner installation in *Building 77*, Anatolia, Turkey, 6000–5000 BCE.

An excavated interior room may have been a shrine, indicated by the installation of bull horns. Note the plastered walls.

urban sprawl housing as well as impersonal high-rise apartments. Safdie created low-cost housing that minimized land use and provided privacy and individualized living within a group setting. The prefabricated units are building blocks that can be stacked and arranged in many unique configurations, providing garden spaces on roofs. The structure was meant to be (1) energy efficient, due to compact design; (2) constructed of available natural resources; and (3) comfortable for many people living in a relatively small space.

Habitat is definitely a product of twentieth-century modernism, with the emphasis on simple geometric shapes, the lack of ornamentation, and the resemblance to abstract sculpture. However, aspects of *Habitat*'s design are taken from older examples of group and community living, when people clustered together in communities to provide protection against danger and to increase their chances of survival. The earliest examples of domestic architecture featured group living, which was begun as long ago as 25,000 BCE, with large circular or oval huts of animal hides covering a framework of light branches and accommodating several families.

The Neolithic town of *Çatal Hüyük* (Figs. 5.1 and 5.26) in Anatolia was an early example of urban life. Its layout was likely an inspiration for Safdie's *Habitat*. The *Çatal*

Hüyük era was notable for the beginning of agriculture, domesticated animals, flourishing crafts such as weaving, and copper and lead smelting. *Çatal Hüyük* consists of one-story, mud-brick and timber houses that were all connected and clustered around a few open courtyards placed near the center of the compound. The interior spaces had plastered and richly painted walls and floors. Intermingled among the houses were many shrines, roughly one for every three houses (Fig. 5.26). There were no streets and no ground-level doors (Fig. 5.1). Entrances were holes in the roofs, which also served as chimney vents. These houses were sturdier and more stable than individual free-standing houses, and the solid exterior wall without openings was an effective defense against human or natural foes. The interior maze of spaces would also thwart invaders. Yet *Çatal Hüyük* was a peaceful town, as there is no evidence of weapons.

In creating *Habitat*, Safdie was also influenced by *Pueblo Bonito* at Chaco Canyon (Fig. 5.27), especially its energy efficiency, location near natural resources, and design for many residences. It was constructed around the eleventh century by the Anasazi people of New Mexico, who were the ancestors of many native peoples of the U.S. Southwest. They were skilled farmers in a dry climate. *Pueblo Bonito* was a ceremonial fortress that may have

5.27 *Pueblo Bonito*, Anasazi, New Mexico, eleventh century.

This finely designed compound featured high-quality masonry work and originally had beamed ceilings.

5.28 *Dogon Cliff Dwellings with Granaries*, Mali, thirteenth century.

These cliff dwellings have been in continuous use since the thirteenth century.

been reserved for the Anasazi elite. It was built all in one piece over the rubble of previous construction, with precisely aligned walls and doors. The structure has sweeping lines, contrasting with the rough vertical cliffs behind it. The walls cover 4 acres, with five-story structures and approximately 660 rooms surrounding dual plazas to accommodate perhaps 1,000 residents. Various clans occupied certain sections of the pueblo. The round underground structures are kivas, centers for ceremony and contemplation.

The Dogon people of Mali live in tightly knit communities (but not group houses) that date from 1300 and are still currently in active use. Clinging to steep cliffs that extend for 125 miles, Dogon villages (Fig. 5.28) are dense collections of adobe houses, mosques, and granaries that are often irregular in shape and built on different levels to use all available space. Lower elevations, where the sparse watersheds are located, are reserved for grazing and farming. The houses and granaries form an aesthetically pleasing pattern of vertical geometric shapes against the cliffs. Horizontal wooden beams project from the outer walls, providing footholds for maintenance as well as a distinctive pattern on the mosques. Unused buildings deteriorate quickly and return to the earth.

5.29 *House of Julius Polybius*, interior looking out into internal garden, Pompeii, Italy, reconstructed, first built in second century BCE.

Airy courtyards, gardens, and artworks distinguished the villas of the wealthy in the ancient Roman Empire.

Individual Homes

We turn now to individual homes, which date back thousands of years. The designs of individual homes embody climate concerns, aesthetic preferences, and cultural choices. Our focus figure is the *House of Julius Polybius* (Fig. 5.29), a spacious and beautiful house for wealthy Romans in Pompeii in the first century CE. (In contrast, average Romans at this time lived in cramped, unheated, multistory apartment buildings with no sanitary facilities.) The villa's exteriors were rather plain, but inside, individual rooms opened onto courtyard spaces that brought fresh air and light into the center of the house. The front atrium in such houses often had a pool, called the impluvium, for collecting rainwater. Paintings and mosaics covered most interior walls and floors. Interior spaces flowed into the courtyard garden, usually furnished with marble tables and fountains.

The Roman house was organized symmetrically around an axis that ran from the entrance to the back of the house, aligning a succession of lovely views and providing illumination throughout the dwelling.

CONNECTION An example of a wall painting for a wealthy Roman residence is *Glass Bowl with Fruit* (Fig. 3.24).

It is interesting to compare the *House of Julius Polybius* with the *Villa Rotonda* (Fig. 5.30), a sixteenth-century

5.30, *below* ANDREA PALLADIO. *Villa Rotonda*, Vicenza, Italy, 1552.

All parts of the *Villa Rotonda* are worked out in mathematical relationships to the whole.

5.31 *Tomb Model of a House*, Eastern Han Dynasty, China, 25–220. Ceramic, 4′ 4″ × 2′ 9″ × 2′ 3″. Nelson–Atkins Museum of Art, Kansas City, Missouri.

The verticality and emphasis on roof design are apparent in this model of Han Dynasty house designs.

Italian house influenced by Greek and Roman designs. This era was the **Renaissance,** known for the rebirth of learning in Europe from the fourteenth through the sixteenth centuries and for the study of Greek and Roman culture. The designer, Andrea Palladio, was the chief architect of the Venetian Republic and wrote books promoting symmetry and stability as controlling elements of architectural design. Centuries later, his writings influenced Thomas Jefferson's design of his home, Monticello (see Fig. 15.1). Palladio's villa has a centralized plan, with thirty-two rooms and four identical porches, united by the central, dome-covered rotunda. The harmonious geometric shapes represent Renaissance philosophical principles of orderliness and hierarchy. Steep flights of stairs lead up to the structure, very much like a Roman temple on a platform.

In contrast, traditional Chinese house design reflects different cultural values and different responses to the environment than the houses we have just seen. Houses for the wealthy were modeled after the palaces of the first emperor of China, Shi Huangdi (ruled 221–206 BCE). No houses from the Han era have survived, but ceramic models of them were buried in tombs. A wealthy person's home typically had several stories, each slightly smaller than the one below it. Capping each level were wide eaves that were both functional and aesthetic, adding horizontal emphasis. Balconies encircled the house. Precious materials, such as gold, jade, and bronze, were used for house ornamentation and accents. Inside, wall paintings would have illustrated Daoist fables and Confucian aphorisms with floral designs in brilliant colors. These features are evident on the relatively modest *Tomb Model of a House* (Fig. 5.31), dating between 25 and 220 CE. It may have served as a watchtower and probably had one or more courtyards, where chores were done. This timber

5.32 *Toba Batak House*, decorated façade, Samosir Island, Sumatra, Indonesia, c. twentieth century.

Traditional houses like this are still found in rural areas, but new housing in urban areas follows Western designs. Traditionally these houses had thatched roofs, but the roofs we see here are metal.

frame house had non-load-bearing walls of compressed earth or mud that the wide eaves protected from rainfall. Elaborate brackets supported the roof.

In Indonesia, distinctive wooden houses were designed in response to the tropical climate, with heavy rainfall, thick vegetation, heat, and insects. The *Toba Batak House* (Fig. 5.32) has a very steep roof that quickly sheds rain to keep it from soaking the thatch. Overhanging eaves shield the generous windows. When seen from the side, the roofline is highest at each end and curves downward at the center. The second and third levels have small sleeping and storage areas, so most people spent the day outdoors. Stilts raise the house to catch breezes, to protect the sleeping people from mosquitoes, and to provide security. Sometimes animals were kept on the ground level. The stilts are made of thick, hardwood tree trunks, necessary to support the heavy thatched roof, and soft wood was used for non-load-bearing walls. The entire house is pegged together instead of nailed, and the stilts sit on rocks, so that the structure flexes during earthquakes.

The parts of the *Toba Batak House* have symbolic meaning, with the internal spaces seen as maternal or womblike. The house is seen as a "transformer [that] tames the terrifying vastness of the universe and at the same time inflates human concerns with cosmic grandeur" (Richter 1994:57). The house echoes the human body, with stilts as legs, the roof as the head, and the trapdoor entrance as the navel. From a cosmic perspective, the three levels are like the upper, lower, and middle worlds of the Indonesian universe; from a social perspective, the three levels of the house are likened to the social hierarchy separating slaves, commoners, and nobility (Dawson and Gillow 1994:14). This house, and others by this clan, is covered with painted patterns and guardian figures for fertility and protection.

Housing can also be shaped by historical necessity. For thousands of years, the Native Americans of eastern and central North America were stable populations who hunted and gathered food. With the coming of the Europeans, these peoples were displaced from their homelands and for a while lived on the Great Plains in movable

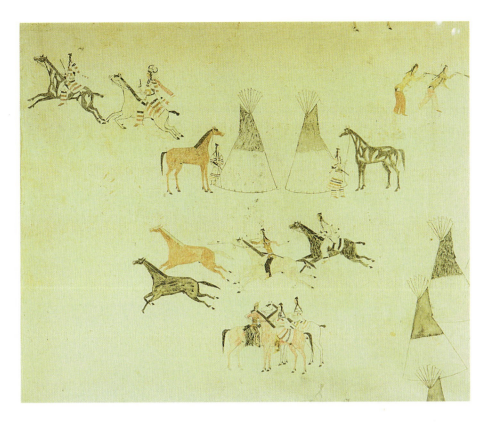

5.33, top *Tipi Cover*, Sioux tribe, c. 1880. Decorated with images of tipis and equestrian warrior figures.

Tipis are portable housing that Native Americans of the Great Plains adopted once they were forced from their original homelands.

5.34, right FRANK LLOYD WRIGHT. *Fallingwater*, Kaufmann House, Connellsville vicinity, Pennsylvania, 1936–1938.

Wright believed that houses should be unified wholes that merge into their natural settings.

houses, or tipis, originally small tents used during hunting season. When later used as year-round housing, tipis were built as large as 25 feet high and were moved by horses. Animal skins, buffalo hide, or canvas covered the framework of slender poles. Adjustable flaps kept out wind or rain and ventilated smoke. Tipi covers and liners were often painted (Fig. 5.33). Before the 1830s, the imagery consisted of stiff figures, whereas later ones often showed the tipi owner's personal adventures in nature or at war.

Our last house for comparison and contrast is *Fallingwater* (Fig. 5.34), 1936–1938, arguably one of the most famous modern houses in the United States. Frank Lloyd Wright designed it for the wealthy Kaufmann family from Pittsburgh as a weekend home in the woods to balance their urban lives. Wright believed that houses should be unified wholes that merge into their natural settings, using local materials. A large boulder is the base

5.35 *Interior of Markets of Trajan*, Rome, 100–112.

Concrete construction, arches, and vaults were exploited by the Romans to construct massive buildings.

of the house's central fireplace, while stones for walls came from nearby quarries. Geometric blocks, some vertical but most horizontal, sit low to the ground. There is no decoration, except the contrasting textures of stone and concrete. The house is arranged to allow maximum sunlight inside. Long, rectilinear windows frame views of the surrounding trees.

ART EXPERIENCE Design your home for a specific site of your choosing. Draw or build a model of it.

Fallingwater has cantilevered porches, which were influenced by Japanese and Chinese architecture where cantilevers were used extensively in roof designs (see Fig. 2.38). Like much of the traditional domestic architecture of Asia, the walls in *Fallingwater* are not load bearing but act as privacy screens. Also from Japan was the idea of a flowing interior space, with few walls and large windows.

CONNECTION Another Wright building is the *Solomon R. Guggenheim Museum* (Fig. 14.5).

Commercial Architecture

Commercial architecture provides shelter for the needs of business and trade. Here are a few examples considered to be important milestones in art. Our focus figure is again from the Roman Empire. The *Markets of Trajan* (Fig. 5.35), 100–112, is a multistoried complex that held

administrative offices and more than 150 shops. This large building on a very steep slope has a paved street cutting through at about mid-level. Its design was likely influenced by the enclosed markets of the Middle East called *souks* or *bazaars*, and it resembles today's shopping malls. There were two levels of shops, called *taberna*, each with a wide doorway and attic storage accessible through a window on top. Although drab today, the interior was once quite decorative and enlivened with vendors, shoppers, and wares of all kinds. A terrible fire destroyed large sections of Rome in 64 CE, so newer construction like the *Markets* used concrete because it was cheap, flexible, and fireproof and could be covered with beautiful veneers of brick, marble, stucco, gilding, or mural paintings. Concrete construction made large, well-lit, multistoried projects feasible. Although the walls are load bearing, the arches channel the tremendous weight of the roof to massive piers, allowing large windows to pierce the walls. This was a remarkable accomplishment architecturally. The massive, muscular Roman style of architecture would have been impossible with only wood construction.

 CONNECTION Romans were known for their ambitious public buildings, such as the *Baths of Caracalla* (Fig. 14.7), the *Colosseum* at left (Fig. 14.11), and the *Pantheon* (Fig. 7.27).

5.36 LOUIS H. SULLIVAN. *Carson Pirie Scott and Company*, Chicago, 1904.

The upper floors of this office building reveal the steel skeleton that supports the entire structure.

In modern industrial nations today, stores and businesses are often located in high-rise buildings. The *Carson Pirie Scott and Company* building (Fig. 5.36), dated 1904, was one of the first innovative tall buildings in the twentieth century. The architect, Louis Sullivan, believed that "form follows function," meaning that buildings should not be shaped according to preconceived ideas but should be an outgrowth of their function and of the materials used. He exploited the new design possibilities of steel frame construction, coupled with the invention of the elevator. Although iron and steel had been used in the past, those buildings were often sheathed in stone or brick or were novelties like the Eiffel Tower. Sullivan's buildings were supported by the steel framework with non-load-bearing walls stretched over it, much like the skin and muscles of the human body over the rigid skeleton. Height was emphasized more than horizontal elements.

On the ground floor, Sullivan introduced the large display windows that have become familiar fixtures in almost every retail store in the United States today. Sullivan saw these display windows as pictures, so he framed them with ornate cast ironwork with organic motifs referencing birth, flowering, decay, and rebirth. In contrast, the upper floors are plain with large horizontal windows that make evident the steel structure underneath. The curved corner provides vertical emphasis, with narrower, taller windows. The roof is deemphasized, with no overhanging eaves or cornices. Rather, the building gives the impression that several more floors, similar in design, could be added right on top of the existing structure.

Late Twentieth- and Twenty-First-Century Public Structures

We conclude this chapter with a discussion of recent public structures. This era is notable for amazing building complexes. Dense urban areas have been constructed across the world from Singapore to Dubai, creating new environments and occupying vast amounts of land. This era has also seen debate about the lack of truly public spaces because these big developments crowd out uncontrolled

5.37 R. BUCKMINSTER FULLER. *U.S. Pavilion*, Expo '67, Montreal. Geodesic dome, diameter 250'.

The geodesic dome is an architectural form that can be scaled to large size, can be distorted to be flat or tall, and can be covered with a variety of materials.

spaces, limit access for the public, or have commercial interest attached to them.

Our first example in this trajectory was a highly innovative design at its time, rivaling Rome's innovative use of concrete and modern architecture's use of steel frame construction. R. Buckminster Fuller was an architectural engineer, inventor, designer, and mathematician with an interest in utopian design. He believed that well-guided technology would get maximum gain for minimum expenditure of energy, giving everyone more affordable shelter with more conveniences. His geodesic domes, which came to be a symbol for twentieth-century innovation and progress, were spherical networks of steel-frame tetrahedrons (a tetrahedron is a three-sided pyramid sitting on a triangular base). Depending on the number of modules used, the domes could be flat or tall and could be made to any size. Fuller even proposed a 3-mile-wide dome to enclose midtown Manhattan in a climate-controlled environment. Domes can be easily assembled and enclose the largest internal volume within the least amount of wall surface, thus saving on materials. They can also be covered with a variety of materials, such as glass, plastic, cloth, wood, or paper.

Fuller's design for the *U.S. Pavilion* (Fig. 5.37) was built at Montreal's Expo '67 World's Fair, a vast complex with ninety pavilions funded by nations and industries on several islands in the St. Lawrence River. (Moshe Safdie's *Habitat* was also there.) The nearly spherical dome, 250 feet in diameter, created a dramatic silhouette and glowed at night like an otherworldly orb. Because the dome is self-supporting, the interior can be configured in any way desired. Although geodesic domes have been used as factories, greenhouses, mobile military living units,

5.38 I. M. PEI AND PARTNERS. *Bank of China*, Hong Kong, 1989.

Triangles form the basis of the visual design and physical structure of this building.

experimental biospheres, and research stations, they have yet to become popular for businesses or homes.

Generally, for mid-twentieth-century office buildings, the rectangle dominated architectural design. The **International Style** featured bare buildings of steel and glass, self-contained and with controlled access, which could be seen in the world's large cities. The unadorned, simple, geometric style was seen as new, modern, heroic, and even utopian as architects sought to transform urban centers with functional forms. One practitioner, Ludwig Meis van der Rohe, summarized this movement with "less is more." (See Meis van der Rohe's *Seagram Building* in Fig. 2.42.)

However, within a few decades, there arose a movement away from the rectangle and toward triangles and diagonals, as seen in the *Bank of China* (Fig. 5.38), dated

5.39 Charles Moore with U.I.G. and Perez Associates. *Piazza d'Italia*, New Orleans, 1975–1980.

The many references to other styles of architecture make the *Piazza d'Italia* like an archeological site, where layer after layer of the past build up.

1989, by the architectural firm of I. M. Pei and Partners. The base is subdivided into four equal triangular sections, and more triangles are created by the diagonal braces that stabilize the skeletal frame, a necessary addition because of earthquakes and high winds. Pei emphasized rather than hid the braces. The skeletal support for this light-reflecting building is innovative. At the corners are four massive columns. Beginning at the twenty-fifth floor, a fifth column at the center supports the load from the upper floors; that load is transmitted diagonally to the corner supports. The lower floors surround a twelve-story-high central atrium, while on top, dining and entertainment establishments boast spectacular views.

Other reactions against the International Style were more radical, like New Orleans' *Piazza d'Italia* (Fig. 5.39), by Charles Moore with U.I.G. and Perez Associates. Moore believed that cities had lost much of their unique character because of new skyscrapers that all looked alike. He favored the **Postmodern** architectural

style in his *Piazza d'Italia*, emphasizing visual complexity, historical references, colorfulness, and even fun. Postmodernists believed that "less is a bore." *Piazza d'Italia* combines elements from the Roman Empire, the Italian Renaissance, and twentieth-century entertainment sites. A map of Sicily sits at the center of the plaza, connected to the larger map of Italy that joins the curved architectural fragments behind it.

The *Piazza d'Italia* suffered severe decline in the 1990s because of the lack of commercial enterprises around it. In order to be adequately supported, urban public spaces need to be completely tax supported or commercially successful for entrepreneurs. The *Piazza* has recently been partly restored with funds from private developers.

Architecture continues to evolve past the Postmodernist *Piazza d'Italia*. **Deconstructivist** architecture, which rejects established conventions and seeks to shake the viewer's expectations, began in the 1980s. Deconstructivist buildings can be disorienting and

5.40 Zaha Hadid. *Broad Art Museum*, University of Michigan, East Lansing, 2012.

The architect often uses stainless steel and glass for her façades and consistently designs beyond common expectations of what a building should look like.

irregular, and outside forms may give no clue to the space of their interiors. Many Deconstructivist buildings resemble abstract sculptures more than traditional architecture, and they generally reject historical notes, as seen in the *Piazza d'Italia*. One example is the *Broad Art Museum* (Fig. 5.40), which was designed by Iraqi-British architect Zaha Hadid beginning in 2007 and opened in 2012 on the campus of Michigan State University in East Lansing. Hadid's buildings often seem to be the result of a gesture,

like a push that created this leaning façade, or to give the impression of frozen movement.

CONNECTION Two more examples of Deconstructivist architecture are Frank Gehry's *Guggenheim Bilbao* at left (Fig. 15.8) and his *Walt Disney Concert Hall* (Fig. 14.6).

6

REPRODUCTION AND SEXUALITY

In addition to food and shelter, human reproduction and sexuality are basic for the survival of the human race. In various cultures, art has aided and pictured human fertility, reproduction, and sexuality, especially with charm-like figures, phallic symbols, fetishes, erotic images, and paintings and sculptures of marriage and children.

PREVIEW

We first examine early ritualistic fertility figures and murals and then compare more recent examples found in the Americas, Africa, and Oceania. We then look at sculptures, paintings, and images within their cultural contexts that have witnessed, documented, and commemorated the coupling and marrying of human beings, along with their lovemaking, birthing, and progeny. In addition, art reflecting sexual preferences and gender relationships will show various cultural attitudes, acceptances, and taboos.

We will see that this primal urge unites art throughout the ages—and even to the present day. Figure 6.1, Draped Reclining Mother and Baby, *from 1983, is an abstracted image that has captured the essence of that close relationship. The sculptor Henry Moore said "the Mother and Child . . . has been a universal theme from the beginning of time" (Hedgecoe 1968:61).*

For Art Experiences in this chapter, make an artwork about primordial couples, sexuality in our culture today, or fertility and offspring.

Connecting Art and History from
6000–2000 BCE

The end of the Stone Age in Europe and the Middle East happened gradually, generally from 6000 to 2500 BCE. Groups of people began to depend increasingly on agriculture for their food in addition to hunting. They continued making stone tools and domesticating animals. All aspects of fertility were important concerns, from human reproduction to successful harvests.

In Chapter 5, we began the discussion of the city of Çatal Hüyük (8000–4000 BCE), an early farming and trading settlement with several thousand people, located in present-day Turkey. The city's residents were among the first to produce pottery and make metal and obsidian objects. They connected their houses for greater protection and built many shrines (see Fig. 5.1). The *Female Fertility Figure* (Fig. 6.2) shows a large, powerful, enthroned woman with attending lions. It is significant that this figure, with its highly accentuated breasts and belly, was found in a Çatal Hüyük grain bin.

Other cultures created female fertility figures as well. For example, the *Idol from Amorgos* (Fig. 6.4), dated 2500–2300 BCE, was found in the Cycladic Islands off the mainland of Greece. She is also connected to fertility and was a probable descendant of the ancient mother goddesses of Greece.

Throughout this period until about 2000 BCE, we see the beginnings of civilizations around the world. The following factors influenced the growth of civilizations:

- Major rivers or bodies of water were necessary for the emergence of civilizations.
- Farming produced surplus food, which allowed for the development of cities and the division of labor within urban areas.
- Cities became political, economic, social, cultural, and religious centers.

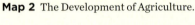

Map 2 The Development of Agriculture.

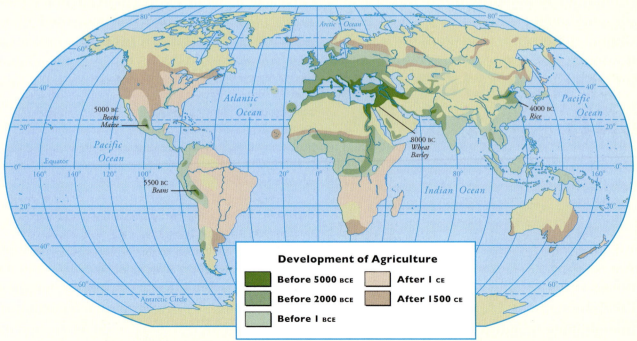

Development of Agriculture

- Before 5000 BCE
- Before 2000 BCE
- Before 1 BCE
- After 1 CE
- After 1500 CE

5000 BC
Beans
Maize

5500 BC
Beans

8000 BC
Wheat
Barley

4000 BC
Rice

- Trade became important among groups of people and between urban centers.
- Formal religions developed, often with many gods and with rulers as stewards of those gods.
- Political and social structures emerged, with hierarchical governments and sometimes bureaucracies. Society was organized around class systems, with priests, warriors, and the wealthy at the top.
- Writing developed in some areas.
- The military or warrior class emerged.
- Independent city-states were gradually merged into larger empires.
- Women were generally made subordinate to men.

In Mesopotamia, around 3000 BCE, several city-states arose along the Tigris and Euphrates Rivers. They included Eridu, Ur, Uruk, Umma, and Lagash, located in an area called Sumer. Surrounded by walls, these cities had political and economic control over the surrounding states. Here, people first scratched cuneiform symbols and other forms of writing into wet clay tablets. Here also is the first evidence of use of the wheel. Around 2300 BCE, the ruler Sargon united several of these city-states into the Akkadian Empire.

Many agricultural communities developed along the Nile River in Egypt. Travel along the Nile was swift and relatively easy, and the upper and lower areas of Egypt were united around 3100 BCE. A series of Egyptian dynasties ruled the area for hundreds of years, and the surrounding desert kept the land relatively free from foreign invasion. The Egyptians developed hieroglyphic writing. The Old Kingdom lasted from 2686 BCE to 2125 BCE; the Middle Kingdom, which saw increased contact with the outside world, especially in Africa and the

6.2 *Female Fertility Figure*, found at Çatal Hüyük, Anatolia (modern-day Turkey), c. 6000 BCE. Terra-cotta, 7¾″ high.

This small, regal figure is enthroned and is attended by lions. She was found in a grain bin, suggesting her role in the success of her culture's fecundity.

Middle East, lasted from 2100 BCE to 1700 BCE.

The Nubian civilization emerged south of Egypt around 3500 BCE. At first, Nubia was a trading partner with Egypt, but later it came under Egyptian control.

Small centers of civilization emerged throughout the Americas. In 3000 BCE, skilled artisans around Lake Superior worked copper into jewelry and tools. Along the Supe River in Peru, the city of Caral flourished around 2600 BCE.

Around 6000 BCE, in the Indus River Valley (in present-day Pakistan), people began growing rice, bananas, sesame, wheat, barley, black pepper, and cotton. In 2500 BCE, the great city of Mohenjo-Daro was established, with a population of 40,000. Many craft

workers, sculptors, and potters lived in the city, which maintained a thriving trade in handcrafted and agricultural products.

In China along the Huang He (Yellow River) Valley, farmers used levees to control floods as early as 3000 BCE. Some researchers believe that as early as 2100 BCE the Xia Dynasty brought centralized rule to a large region of China, although this has not been completely proven historically.

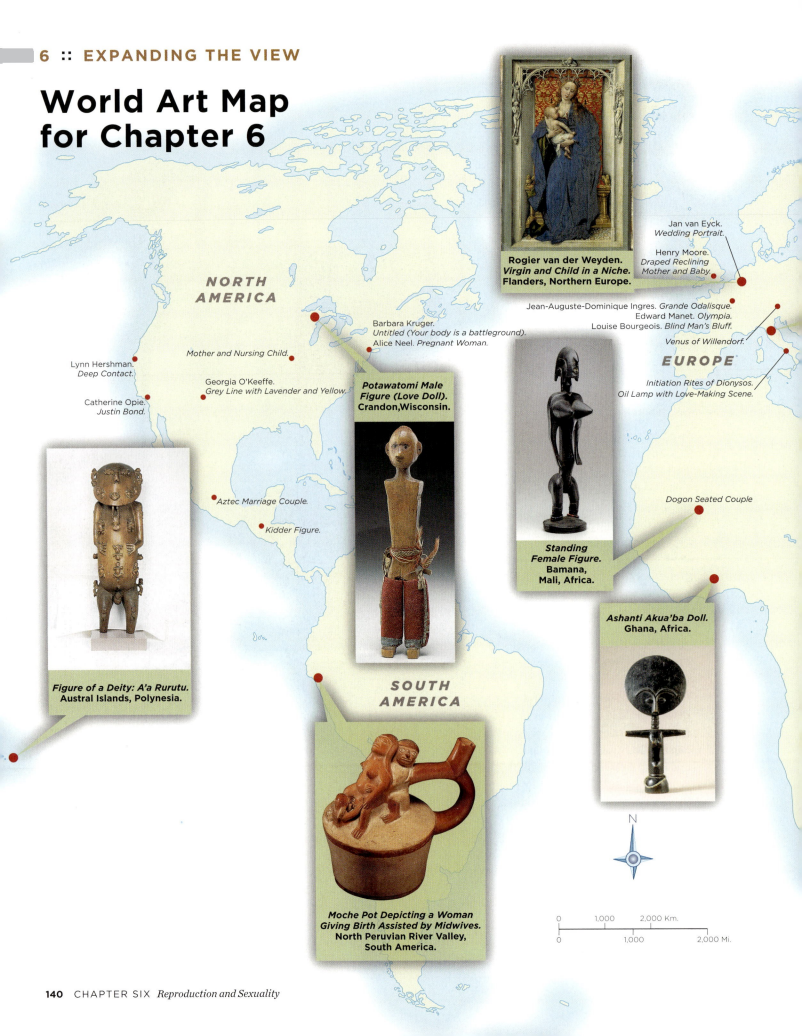

World Art Map for Chapter 6

NORTH AMERICA

Rogier van der Weyden.
Virgin and Child in a Niche.
Flanders, Northern Europe.

Jan van Eyck.
Wedding Portrait.

Henry Moore.
Draped Reclining Mother and Baby.

Jean-Auguste-Dominique Ingres. *Grande Odalisque.*
Edward Manet. *Olympia.*
Louise Bourgeois. *Blind Man's Bluff.*

Venus of Willendorf.

EUROPE

Initiation Rites of Dionysos.
Oil Lamp with Love-Making Scene.

Barbara Kruger.
Untitled (Your body is a battleground).
Alice Neel. *Pregnant Woman.*

Mother and Nursing Child.

Lynn Hershman.
Deep Contact.

Georgia O'Keeffe.
Grey Line with Lavender and Yellow.

Catherine Opie.
Justin Bond.

Potawatomi Male Figure (Love Doll).
Crandon, Wisconsin.

Aztec Marriage Couple.

Kidder Figure.

Dogon Seated Couple

Standing Female Figure.
Bamana, Mali, Africa.

Ashanti Akua'ba Doll.
Ghana, Africa.

Figure of a Deity: A'a Rurutu.
Austral Islands, Polynesia.

SOUTH AMERICA

Moche Pot Depicting a Woman Giving Birth Assisted by Midwives.
North Peruvian River Valley, South America.

N

0 1,000 2,000 Km.

0 1,000 2,000 Mi.

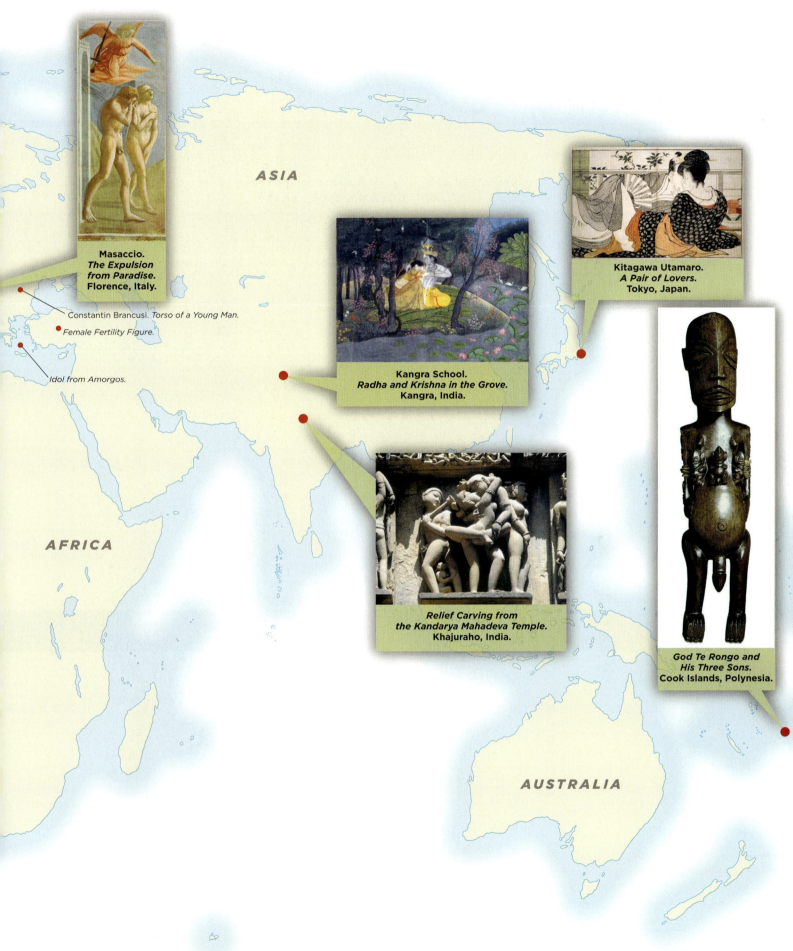

Masaccio.
*The Expulsion
from Paradise.*
Florence, Italy.

Constantin Brancusi. *Torso of a Young Man.*

Female Fertility Figure.

Idol from Amorgos.

ASIA

Kangra School.
Radha and Krishna in the Grove.
Kangra, India.

Kitagawa Utamaro.
A Pair of Lovers.
Tokyo, Japan.

AFRICA

Relief Carving from
the Kandarya Mahadeva Temple.
Khajuraho, India.

*God Te Rongo and
His Three Sons.*
Cook Islands, Polynesia.

AUSTRALIA

6000–2000 BCE

PALEOLITHIC ERA	MESOLITHIC ERA		HISTORY FOCUS			CIVILIZATIONS IN CRETE
	Settlements in China and Chile	NEOLITHIC ERA	Birth of Mesopotamia	UNIFICATION OF EGYPT		Irrigated farming in the Andes
	Çatal Hüyük, Turkey	Settlements in India		OLD KINGDOM—EGYPT		
25,000 BCE	10,000	8000	7000	6000	4000 3100 2500	2000
Venus of Willendorf			Female Fertility Figure, Çatal Hüyük	Idol from Amorgos		

∧ Fowling Scene, Egypt (8.6)

SAFAVID DYNASTY—PERSIA	U.S. Revolutionary War	IMPRESSIONISM	CUBISM, SURREALISM
BENIN KINGDOM—AFRICA	French Revolution	POSTIMPRESSIONISM	World War II
Captain Cook's Voyages in Oceania	ROMANTICISM	Russian Revolution	POSTWAR EXPRESSIONISM
	REALISM	World War I	
1700	1800	1900 1915	1925 1939

God Te Rongo and His Three Sons

Figure of a Deity: A'a Rurutu

Potawatomi Male Figure (Love Doll)

INGRES. *Grande Odalisque*

MANET. *Olympia*

LANGE. ❯ *Migrant Mother* (12.30)

∧ Persian Anatomical Illustration (11.22)

UTAMARO. *A Pair of Lovers*

Radha and Krishna in the Grove

Dogon Seated Couple

Ashanti Akua'ba Doll

O'KEEFFE. *Grey Line with Lavender and Yellow*

BRANCUSI. *Torso of a Young Man*

∧ MARISOL. *The Family* (12.19)

Standing Female Figure, Mali

SHANG DYNASTY—CHINA CHAVIN CULTURE	ROMAN EMPIRE		MOCHE CIVILIZATION ROMANESQUE CAHOKIA CIVILIZATION GOTHIC	RENAISSANCE AZTEC EMPIRE MING DYNASTY—CHINA MUGHAL DYNASTY—INDIA	BAROQUE
1600 1000 200	100	CE 50	100 1000	1400	1600

↗ Sarcophagus with Reclining Couple, Etruscan (8.8)

Kidder Figure

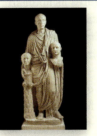

↗ Laocoön and His Sons, Hellenistic (11.18)

Oil Lamp with Love-making Scene

Initiation Rites of Dionysos, Villa of Mysteries

↗ Statue of Togato Barberini, Roman (12.13)

Moche Pottery Depicting Sexual Intercourse

Mother and Nursing Child

Relief Carving from the Kandarya Mahadeva Temple

Moche Pottery Depicting a Woman Giving Birth Assisted by Midwives

van der Weyden. *Virgin and Child in a Niche*

van Eyck. *Wedding Portrait*

Masaccio. *Expulsion from Paradise*

Aztec Marriage Couple

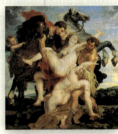

↗ Rubens. *Abduction of the Daughters of Leucippus* (12.9)

Decolonization of Africa	MODERNISM, POSTMODERNISM	First Observation of Breast Cancer Awareness Month	Desert Storm	
1970	1975	1984	1990 2000	

Neel. *Pregnant Woman*

Bourgeois. *Blind Man's Bluff*

Kruger. *Untitled (Your body is a battleground)*

Hershman. *Deep Contact*

Opie. *Justin Bond*

↗ Ngere Girl Prepared for a Festival, Africa (11.35)

Mutu. *One Hundred Lavish Months of Bushwhack* (3.27) ➤

represent ideal procreation roles. Still others represent marriage rituals within cultures. These depictions were rooted in the creation myths of many religions. They also come from marriage rituals that frame procreation in many cultures.

Primordial Couples and Couples' Roles

Our focus primordial couple is Adam and Eve, found in the Jewish, Christian, and Muslim religions and depicted widely in European art. In the Bible, Genesis 1:28, their Creator commanded them to "be fruitful and multiply, fill the earth and conquer it." Later in Genesis, the Fall is described, and Adam and Eve are exiled from the Garden of Eden. A young Early Renaissance artist named Masaccio painted that moment in *The Expulsion from Paradise* (Fig. 6.11) on the wall of the Brancacci Chapel in the Church of Santa Maria del Carmine, in Florence, Italy, in 1427.

In *The Expulsion*, one can almost hear Eve's anguished cry and feel Adam's pain as they shamefully walk from the gate. Their movement is slow, every step more agonizing than the one before. Now God's commandment to "fill the earth" has become a painful burden. The artist paid particular attention to modeling the figures, using soft contrasts of values and color. Only essential details are included along with Adam and Eve, specifically the gate to the Garden of Paradise and the angel with a sword barring their return.

Compare this anguish to the stately and formal couple in Figure 6.12, from the Dogon culture of Africa. *Dogon Seated Couple* shows a male and female symmetrically arranged on a stool supported by four ancestors. Like the Oceanic figures, the sculptures are usually carved from one block of wood. Sometimes naturally occurring features in the wood block, such as a bend or a knot in the wood, are incorporated into the finished sculpture.

While sculptures like this were likely displayed at funerals, they symbolize Dogon concepts of ideal and complementary roles for women and men in fertility and child-rearing. Seated in a frontal position, the *Dogon Seated Couple* are equally exalted in the sculpture, which indicates the harmony and parity of their roles. The male unites the figures with his arm around her neck and his hand resting on the upper part of her breast. His other hand is resting on his penis, symbolizing their sexual union. Their jewelry indicates their sexual power. On their backs are carved representations of the roles they have in life. As hunter, warrior, and protector, he wears a quiver, while she has a child clinging to her.

Other details in the sculpture suggest their high position and perhaps their origin. She wears a mouth ornament

6.11 MASACCIO. *The Expulsion from Paradise*, Brancacci Chapel, Santa Maria del Carmine, Florence, Italy, 1427. Fresco.

Adam and Eve are the first couple of the Jewish, Christian, and Muslim religions. This chapel mural depicts the pair's exile from the Garden of Eden.

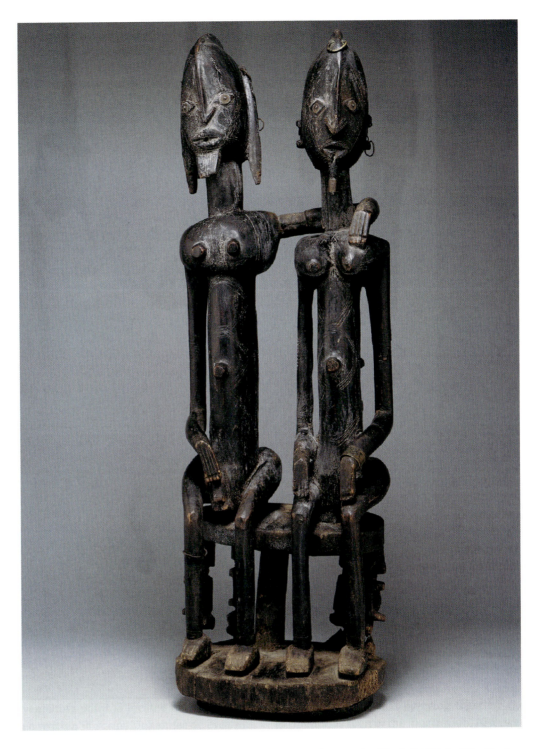

6.12 *Dogon Seated Couple*, Mali, Africa, c. nineteenth–twentieth centuries. Wood, 2′ 5″ high. Gift of Lester Wunderman, 1977. Metropolitan Museum of Art, New York.

These idealized male and female figures are depicted in their defining roles in life, he as the hunter/provider and she as a baby's nurturer. His gestures emphasize their sexual organs.

called a labret, and he wears a chin beard trimmed very much like the beards worn by Egyptian pharaohs. The piece is vertically emphasized by the two elongated figures and by the negative space we see throughout the figures.

Visually, there is a balance between the positive mass and the negative space in the sculpture. For the Dogon, a balanced design is a symbol for an ordered human culture (Roy 1985:31).

tones of oil paint, the *Aztec Marriage Couple* is bright and economically drawn to quickly convey essential ideas.

 CONNECTION *Menkaure and His Wife, Queen Khamerernebty* (Fig. 9.3), are a couple from the Egyptian culture.

ART EXPERIENCE Make a collage that depicts couples today.

ART ABOUT LOVEMAKING

Lovemaking is essential in procreation. Sexuality is a libidinal urge that is gratifying, positive, and even energizing. We will look at five images from various cultures, each of which has its own way of defining and depicting this universal act.

Our first focus is the Roman *Oil Lamp with Lovemaking Scene* (Fig. 6.15), dated to the first century BCE. This clay lamp likely lighted a bedchamber in a home rather than in a brothel, where sexual imagery was found in graphic wall frescoes. It depicts a couple in an intimate gaze while engaging in sexual intercourse on a fine bed. An inscription found in the ruins of Pompeii on the wall of an ordinary house reads "Hic Habit Felicitas" or "here lies happiness" (Mathieu 2003:56), in a place where a lamp like our example would have been found. The figures reflect ideal Classical Greek sculpture in both their artistic style and their composure.

Another example depicting the act of lovemaking is the *Moche Pottery Depicting Sexual Intercourse* (Fig. 6.16). The Moche pot was probably created around 1000–1250, in the desert coast of Peru, in the thriving, artistically active civilization that preceded and was brought down by the Incas. The Moche custom was to bury ceramic pots with the dead that had naturalistic imagery recording their way of life and tribal customs, including lovemaking. The depictions of lovemaking were explicit and candid—and likely were made by the women of the culture, as they

6.15 *Oil Lamp with Love-making Scene*, Roman, first century BCE. Ceramic. Museo Archeologico Nazionale, Naples.

This clay lamp depicts a couple engaged in sexual intercourse, suggesting that it may have been set on a bedside table or hung on a wall in a bedchamber.

6.16, *right* *Moche Pottery Depicting Sexual Intercourse*, Peru, c. 1000–1250. Ceramic. Museo Arqueologico Rafael Larco Herrera, Lima, Peru.

Sexual intercourse is explicitly depicted on a stirrup-handled pot, found in a Moche burial along with others depicting life's daily activities.

6.17 Kitagawa Utamaro. *A Pair of Lovers*, frontispiece from *Poem of the Pillow*, Japan, 1788. Wood block relief print, 9¾″ × 1′ 2¾″. Victoria and Albert Museum, London.

This is a "shunga" print, which depicts lovers engaged in sexual intercourse. This is art depicting the "floating world" (ukiyo), which includes provocative, erotic subject matter.

usually made the pottery. The figures are often lying on or under a blanket with a rolled pillow. Their faces exhibit no emotion. However, the variety of the sexual acts and the positions in which they are sculpted display a wide range of sexual pleasure and preference. Nothing was left to the imagination, as numerous sexual acts besides intercourse between a man and a woman appear. Such sculptures may have been designed as visual aids for sex education, illustrating not only human reproduction but perhaps birth control as well.

Our buff clay and slip-decorated piece was made by pressing clay into a mold. We are looking down on the top of the pot, with the stirrup handle and spout at the right. In addition to showing intercourse, the pot could certainly function very well as a vessel, probably to contain *chicha* (corn beer). The linked limbs of the figures create a circular shape that echoes the stirrup handle. The figures are shown economically, with a minimum of detail.

The next comparison comes from the hand of the famous Japanese printmaker Kitagawa Utamaro, one of the best of Japan's Golden Age (1780–1810) woodblock designers. Utamaro designed *A Pair of Lovers* (Fig. 6.17) as the frontispiece for the book *Poem of the Pillow*. The work reflects the *ukiyo* or "floating world" theme. Chinese and Korean Buddhist missionaries brought the printmaking technique to seventeenth-century Japan as well as the notion of the "floating world," or the Buddhist concept of the transience of life. Nonsamurai classes in Japan translated that concept into the idea of prizing life's fleeting moments of pleasure—in other words, eat, drink, and be merry. These images often centered on female beauty, the theater, and entertainment, and these prints were produced and collected much like movie star posters or baseball cards are today.

A Pair of Lovers is a *shunga* print (translated as "spring pictures") and provocatively depicts erotica. *Poem of the Pillow* contained several prints considered to be Utamaro's finest shunga works. Gently and intimately erotic, this print captures a private moment in the closeness of these lovers. The exquisite interplay of pattern and line of the kimonos with the figures gives emphasis to the intertwining of their bodies as they make love. Even their heads and hands are eroticized, with the closeness of their faces and the strokes of their fingertips. This is a visual poem of line, pattern, and color that composes the floating world image of these lovers' pleasure.

CONNECTION *Komurasaki of the Tamaya Teahouse* (Fig. 12.32) is a ukiyo print depicting a courtesan.

6.20 JEAN-AUGUSTE-DOMINIQUE INGRES. *Grande Odalisque*, France, 1814. Oil on canvas, 2′ 11″ × 5′ 4″. Louvre, Paris.

The nude Turkish harem woman was intended to be an erotic image for European men in the nineteenth century.

Our beginning focus image here is the *Grande Odalisque* (Fig. 6.20), painted by Jean-Auguste-Dominique Ingres in 1814. It is a long, horizontal painting of a nude woman seen from behind. She is an odalisque, a member of a Turkish harem. Blue, gold, and warm skin tones predominate in the painting. The curve of the upper body echoes the curve of the hanging blue drapery. Accents occur at the woman's face and at her hand, holding the peacock-feather fan. Her back is extremely long, creating a sensual flow that complements the curves of her legs, arms, breast, and buttocks. Outline is emphasized, and the flesh is delicately shaded. Its smoothness contrasts with the patterned and textured cloth, feathers, and beads that surround and adorn the woman. Her pose is sensually relaxed.

Nineteenth-century female nudes in Europe and the United States were made for nineteenth-century men. They were the privileged audience for such pictures, as viewers whose gaze completed the sexual exchange implied in the painting. As critic Linda Nochlin wrote:

> As far as one knows, there simply exists no art, and certainly no high art, in the nineteenth century based on women's erotic need, wishes or fantasies. Whether the erotic object be breast or buttocks, shoes or corsets . . . , the imagery of sexual delight or provocation has always been created *about* women for men's enjoyment, by men. . . . Controlling both sex and art, [men] and [their] fantasies conditioned the world of erotic imagination. (Nochlin 1988:138–139)

The fact that only the female is present in a sexual scene is significant. Without a lover in the scene, the odalisque is sexually available for the viewer—presumably the European male—who gazes upon her and "consumes" without being seen or consumed himself. The viewer took the place of the imagined Turkish sultan, with many harem women at his disposal.

Edward Manet's *Olympia* (Fig. 6.21), from 1863, is superficially similar to the *Grande Odalisque*. But *Olympia* scandalized the public, in part because her sexuality and nudity were not of a distant place and time. Olympia's pose is like that of famous Italian Renaissance paintings of heavenly goddesses. In nineteenth-century Europe, the concepts of prostitute, courtesan, and goddess were conflated. Mythological paintings of goddesses or of harem women were an acceptably distant way to present the nude woman for the pleasure of the male viewer. Nineteenth-century wealthy men euphemized their "companions" as embodiments of beauty, like goddesses. Manet's painting shattered those illusions. Olympia's unromantic expression made clear that sex and money would be exchanged in her associations with wealthy men. Her gaze identifies and implicates a viewer, whereas in the *Grande Odalisque* the nature of the viewer is less explicit. The wealthy were horrified that their sexual dalliances could be seen in that light. Manet's painting also reveals the social status accorded different races, with the African woman in the role of maid and the white woman as mistress.

CONNECTION One of the inspirations for Manet's *Olympia* was the *Venus of Urbino* by Titian (Fig. 3.28).

6.21 EDWARD MANET. *Olympia*, France, 1863. Oil on canvas, 4′ 3¼″ × 6′ 2¾″. Musée d'Orsay, Paris.

This painting of a sexual encounter scandalized the public because Olympia was not presented as a mythological or historical figure.

Although Manet's painting was attacked for its content, his defenders praised the work for its innovative paint quality. Manet applied thick paint directly on the white surface of the canvas ground, in a style called "alla prima" painting. His colors were flatter and brighter than the subdued tones of traditional academic painting. The body of Olympia is brightly lit and the background is generally dark, as distinct from most oil paintings since the Renaissance, where midtones predominate. Manet's personal style of brushwork led to many of the painterly innovations of twentieth-century artists, such as gestural mark making, flatness versus illusion of depth, and experiments in applying paint.

Sexuality, Politics, and Consumerism

Here are more examples of imagery that deal with sexuality beyond simply for reproduction.

In the computer-video installation *Deep Contact* (Fig. 6.22), from 1990, artist Lynn Hershman looks at the ways mass media use sexuality in Western culture to attract attention. At the beginning of the piece, the "guide" or hostess, Marion, dressed in sexually seductive clothing, knocks at the window-like surface of the touch screen and asks the viewer to touch different

6.22 LYNN HERSHMAN. *Deep Contact*, 1990. Interactive computer-video installation at the Museum of Modern Art, San Francisco.

Sexuality is used to deliver a range of messages.

parts of her body to start and then to create interactive fictions, enter a paradise garden with various characters, or see video clips on reproductive technologies and women's bodies. Although not all of the content of *Deep Contact* is sexual, everything in the piece has been eroticized, including ideas about technology, self-awareness, and intimacy. The viewer of *Deep Contact* cannot be passive; if you do nothing, nothing happens. Thus, the viewer is dislodged from the position of anonymous, distant voyeur. At times, a nearby surveillance camera flashes the viewer's face on the screen in the midst of a performance.

Sexuality is also politicized, as we can see in *Untitled (Your body is a battleground)* (Fig. 6.23), from 1989, which encapsulates both the shifting attitudes and the heated conflicts that surround women, sexuality, and reproduction. The artist, Barbara Kruger, took a political slogan from the 1960s and combined it with a photograph of a woman's face, split down the middle, positive image on one side and negative on the other. The woman looks like a model from a perfume or makeup ad in a fashion magazine. We viewers become part of the piece, as the staring woman makes us either identify with her or see her as opposite to ourselves. This poster was originally made about abortion rights, but it also alludes to other "battleground" body issues, such as race (black/white) or sexuality (homo/hetero).

> **CONNECTION** Kruger's background is both in fine arts and in the mass media. In the 1980s, she was chief designer for the popular fashion magazine *Mademoiselle*. Her artwork pastes text over images, like magazine covers. For more on the increasingly blurred relationships between fine art and the mass media, see the section "Art within Visual Culture" in Chapter 1.

To whom does "your" refer in Kruger's work—we the viewers or the staring woman? Kruger uses relative pronouns that are gender neutral, with no fixed subject, to imply that attitudes about sexuality (as well as race) are not fixed by nature. Kruger sees these categories as changing entities under social, political, and religious influence.

6.23 Barbara Kruger. *Untitled (Your body is a battleground)*, 1989. Photographic silk screen on vinyl, 9′ 4″ × 9′ 4″. Eli Broad Family Foundation Collection, Los Angeles.

This photographic imagery deals with the shifting attitudes and conflicts that surround women, sexuality, and reproduction in Western culture.

6.24 CATHERINE OPIE. *Justin Bond*, 1993. Chromogenic print, edition of eight, 1′ 8″ × 1′ 4″.

The artist's images of homosexuals, transsexuals, and dominatrices expose the complexities of gender roles and sexuality.

6.25 GEORGIA O'KEEFFE. *Grey Line with Lavender and Yellow*, 1923. Oil on canvas, 4′ × 2′ 6″. Metropolitan Museum of Art, New York.

The image is derived from flower forms, but it visually suggests both female genitalia and sexuality.

Yet Kruger recognizes how harshly divided the rhetoric can be in these areas. The division down the middle, with black and white sides, indicates how polarized societies can be on these issues.

For a last comparison here, we look at Catherine Opie's *Justin Bond* (Fig. 6.24), from 1993. This is a photograph of a cross-dressing male whose attire and hair suggest both "good girl" and sexual potential. Opie's many photographs of homosexuals, transsexuals, and dominatrices make apparent the complexities of gender and sexuality. She is interested in using photographs to catalog and archive the wide range of people and places around her. In addition, the existence of such photographs complicates the idea of the privileged male viewer. *Justin Bond* meets the viewer's gaze with directness and confidence, challenging any attempt by the viewer to see his behavior as pathological. The image is distinct because of the rich colors, near-symmetry, and mixed messages.

ART EXPERIENCE Make an artwork that supports a particular point of view about sexuality in our culture today.

Abstracted Sexual Imagery

Sexual imagery in art can be abstracted. Its forms may allude more or less to the human body, but humans themselves need not be represented.

Georgia O'Keeffe's *Grey Line with Lavender and Yellow* (Fig. 6.25), from 1923, is an enlarged flower image. The simple, near-symmetrical composition is suffused with

subtle color gradations interrupted by occasional lines. Throughout much of her life, O'Keeffe painted natural objects that verged on abstraction, with basic forms and heightened color that increased a sense of beauty and desirability. She used these forms to express emotions rather than copying nature slavishly. The structure of her flower imagery resembles female genitalia (although she denied the association: see Chapter 4, discussion for Fig. 4.12). Feminists have seen in her work a positive, female-based imagery that glorifies and beautifies female sexuality.

Figure 6.26, *Torso of a Young Man* (1924), by the twentieth-century Romanian sculptor Constantin Brancusi, abstracts forms of male sexuality. Influenced by the philosophy of the eleventh-century monk Milarepa, Brancusi sought to understand the universality of all life. With this inspiration, along with the Romanian folk art of his youth and the influence of African tribal art that so strongly affected many European artists, he created works that were intended to capture the essence and universality of pure form, working in related themes such as creation, birth, life, and death. He finished his pieces by hand to a precious perfection, whether using marble, wood, or bronze. Some of his pieces look as if they have been machine tooled. As he developed an idea, his forms became more and more simplified. He is quoted as saying, "Simplicity is not an end in art, but one arrives at simplicity in spite of oneself, in approaching the real sense of things" (Janson 1995:817). *Torso of a Young Man* is 18 inches tall, with three cylindrical forms of highly polished bronze placed on a base composed of several geometric forms. One sculpture seems to be resting on another, contrasting the cylindrical "torso" with rectangular volumes. The simplified torso becomes an obvious phallic symbol.

Louise Bourgeois' abstracted imagery is more explicitly sexual than is O'Keeffe's or Brancusi's. In *Blind Man's Bluff* (Fig. 6.27), from 1984, the "body" is sexual, as the sculpture is like a large phallus covered with ambiguous bulbous forms that are breast-like, penis-like, or similar to sensitive nerves in the tongue or in genital organs. The dichotomy of male versus female is blurred. In its appearance and name, *Blind Man's Bluff* invites touch. The marble at the center is polished to a silky finish, while the top and bottom are left roughly cut. The piece is fetish-like, suggesting a fixation on sexual body parts without necessarily any attachment to an individual as a whole. The plethora of organs has the quality of pleasure overload.

6.26 Constantin Brancusi. *Torso of a Young Man*, Romania, 1924. Polished brass, 1′ 6″ high. Hirshhorn Museum, Smithsonian Institution, Washington, D.C.

Incorporating geometric forms in this work, the artist constructed a simplified torso that also represents a cylindrical phallus, the essence of male sexuality.

With Bourgeois' work, multiple interpretations of the forms are often possible and always subjective. Bourgeois' work stands in contrast to male-based heterosexual imagery like the *Grande Odalisque*.

IMAGES OF PREGNANCY, CHILDBIRTH, AND PROGENY

Images of childbirth are seen in many cultures and have existed for ages. Our first focus figure is a 1971 Western image by Alice Neel. Her painting *Pregnant Woman* (Fig. 6.28) shows us the physical effects of pregnancy on one woman's body and self. Her swollen belly and enlarged nipples contrast with her bony arm and ribs showing through the skin. Her pink, blood-flushed belly makes the rest of her flesh look yellow. Her facial expression seems wooden, passive, dazed, or fearful. The man's portrait behind her may suggest intimacy, distance, possession, or protection. Neel mostly painted portraits, often nude, that created a sense of drama with her unrelentingly realistic images and her ability to capture subtle expressions.

6.27, left Louise Bourgeois. *Blind Man's Bluff*, 1984. Marble, 3′ × 2′ 11½″ × 2′ 1″. Collection of the Cleveland Museum of Art.

The combination of male and female sexual imagery blurs genders as discrete categories in this work.

6.28, *below* Alice Neel. *Pregnant Woman*, 1971. Oil on canvas, 3′ 4″ × 5′.

This painting depicts the physical effects of pregnancy on one woman's body and emotional self.

6.29 *Kidder Figure*, Mayan, Guatemala, 250 BCE–100 CE. Ceramic vessel, 10″ × 7½″ × 6¾″.

This youthful figure shows delight in her pregnancy. She is associated and identified with Mayan female fertility and maternity earth cults.

6.30 *Moche Pottery Depicting a Woman Giving Birth Assisted by Midwives*, Peru, c. 1000–1250. Ceramic. Museo Arqueologico Rafael Larco Herrera, Lima, Peru.

A stirrup-handled pot explicitly depicts the act of childbirth, which may have been a teaching aid to expectant mothers and students of midwifery.

An interesting comparison is the ceramic figurine in Figure 6.29, which depicts pregnancy in the Guatemalan Maya culture and is dated between 250 BCE and 100 CE. She is known as a *Kidder Figure* and is about 10 inches high. The seated female has a baby-like body, and she emphasizes her enlarged abdomen by gently resting her hands on it. The expression on her face seems to be one of contentment and joyous anticipation of the expected event. The Mayas likely identified small sculptures such as this with fertility cults. They linked general procreation with female maternity and fertility and related it to the earth. The figures represent the bearers of human offspring as well as the mother of nature and the progenitor of plant life.

For another comparison, we return to the Peruvian Moche culture to study a ceramic vessel that depicts childbirth in as straightforward a manner as their depiction of sexual intercourse in Figure 6.16. The *Moche Pottery Depicting a Woman Giving Birth Assisted by Midwives* (Fig. 6.30) is another stirrup-handled vessel with small figures connecting the handle with the body of the pot. The figures clearly illustrate the act of childbirth. The mother giving birth shows a bit of a grimace, while the faces of the midwives seem expressionless. The scene seems to be clinically illustrating an event rather than capturing the moment of physical and emotional anticipation or even pain. It records the Moche birthing position and technique and may have taught expectant mothers and students of midwifery. Again, as in our other Moche example, the figures sit on top of the pot, compositionally well-integrated with the stirrup handle. The handle seems to function as the back support to the midwife who holds the laboring woman. The bodies of those two women suggest a curving shape that turns down and concludes at the head of the midwife catching the emerging infant.

There are countless instances of mother and child imagery across many cultures, and we have already seen Henry Moore's archetypal sculpture of the *Draped Reclining Mother and Baby* (Fig. 6.1). Here, we will look at two examples in depth. Interestingly, both have links to death despite depicting the presence of a new life.

Our focus mother-and-child image is a familiar Christian icon of Mary and Jesus. The example was painted by the northern Renaissance Flemish painter Rogier van der Weyden. A student of Jan van Eyck (Fig. 6.13), van der Weyden became the influential master painter of Brussels in 1436, and his work was often copied in the fifteenth century. Although he signed none of his work, his style is distinctive, with linear forms and brilliant color. *Virgin and*

6.31 ROGIER VAN DER WEYDEN. *Virgin and Child in a Niche,* Flanders, c. 1432–1433. Oil on panel, 7¼″ × 4¾″. Kunsthistorisches Museum, Vienna.

This image of Christian beliefs represents the potential of human progeny (Adam and Eve) and the birth of their Savior of Humankind (Virgin and Child).

6.32 *Mother and Nursing Child,* Cahokia, Illinois, Mississippian Period, 1200–1400. Ceramic effigy vessel. St. Louis Science Center, Missouri.

This burial sculpture may have represented a mother and her progeny in life as well as her potential to bear children in the afterlife.

Child in a Niche (Fig. 6.31) was painted in 1432–1433 and is only 7 inches by 4 inches. Despite her size, Mary is majestically enthroned in a delicately carved architectural space, crowned as the Queen of Heaven. Yet she nurses the newborn redeemer, holding him tenderly. The Christian primordial couple, Adam and Eve (see also Fig. 6.11), appear here as carvings on the niche. Adam, who has covered himself in shame, is about to be pushed off his pedestal by a hovering angel, expelling him from paradise. Eve holds the apple under the Tree of Knowledge, while the serpent looks down from the branches. In the center above, God the Father and the Holy Spirit as a dove observe the scene, completing the Trinity. The gentle and loving gaze of Mary on her baby is calm, yet ominous in its understanding of the upcoming crucifixion and the fulfillment of Old Testament prophecies.

The comparison piece is a ceramic human effigy vessel featuring a *Mother and Nursing Child* (Fig. 6.32), from the Mississippian Period (1200–1400), in an agricultural civilization located near the confluence of the Mississippi and Illinois Rivers around Cahokia, Illinois. The Mississippians built large, truncated pyramid mounds topped with temples. Their religion strove to predict and control nature, with much attention paid to death. The *Mother and Nursing Child* was buried in a tomb that likely belonged to a high-ranking person. Tombs contained a quantity of elaborate naturalistic and fanciful funeral pottery, mostly effigies, which captured the spirit of the dead it honored. The *Mother and Nursing Child* is a graceful and serene image of a woman and her baby. Her face is the most detailed area, and triangular shapes describe the rest of the pose, especially in the mother's broad shoulders and folded legs. The simple, geometric form adds to the stability and calm of the figure. Representing a mother and her progeny in life, the effigy vessel may have ensured her potential to bear children in the afterlife.

ART EXPERIENCE Make a sculpture for today that celebrates fertility and offspring.

Section 2 RELIGION

The supernatural realm lies beyond our senses, yet in almost every age and culture, people have created diagrams, symbols, and pictures that express to some extent their understanding of divinity. In the next two chapters, we will look at art from world cultures to see how humans make images of their gods and holy beings as well as diagrams that account for the earth, humanity, the stars, and the cosmos. Also discussed are the places of worship humans have built, where they can feel a divine presence. Finally, we will see the kinds of art that have been made in reaction to—or in preparation for—death.

CHAPTER 7 DEITIES AND PLACES OF WORSHIP

Art that represents deities through images or symbols and art that creates sacred spaces

CHAPTER 8 MORTALITY AND IMMORTALITY

Funerary art, commemorative art, and monuments

7.1 *Transformation Mask*, Kwakiutl, British Columbia, twentieth century. Painted wood.

Through rituals using masks like this one, the Kwakiutl people could access the spirit world.

7

DEITIES AND PLACES OF WORSHIP

By definition, the divine realm is beyond human ability to understand, but humans strive constantly to grasp this other world, to communicate with it, or to be joined with it. Rituals, oral tradition, sacred writings, meditation, prayer, and music are but a few paths used by humans to connect to the Transcendent. Art is another.

PREVIEW

This chapter covers art that pertains to humanity's beliefs in the divine. It will look at how artists and architects have created images of holy beings and fashioned places of worship. It will also show the use of symbols derived from nature, geometry, animals, and humans that allude to the divine. We will see enormous richness and variety in the kinds of art used for rituals, sacred structures, and religious ceremonies. The image that opens our chapter, the Transformation Mask (Fig. 7.1), is but one example.

For Art Experiences in this chapter, you may choose to create an image of the cosmos, design a new temple complex, or discuss the role of art in religion.

Connecting Art and History from
2000–500 BCE

This period saw major civilizations developing in complexity and flourishing all over the world. With them came some early images of deities and prophets and also early places of worship.

Many civilizations in the Middle East continued to grow. Babylon was a center of religious worship, with tall ziggurats topped by temples, not unlike the earlier *Ziggurat at Ur* (Fig. 7.24). In Babylon between 1792 and 1750 BCE, Hammurabi recorded his Code of Law, covering the tax system, fair wages and prices, property rights for women, and criminal punishment (Fig. 7.2). In 1350 BCE, the Assyrians conquered the Fertile Crescent, including Babylonia and, later, Egypt. They built extensive roads, developed a political system of provinces and governors, and established libraries of cuneiform tablets.

The Hebrew people went to Egypt in 1800 BCE because of drought in Canaan, and they were put into bondage. In 1250 BCE, Moses led the Exodus, and by 1000 BCE, the Hebrews conquered the people of Canaan and established Jerusalem. Their religion was monotheistic and became the roots of Judaism, Christianity, and Islam.

The Persians lived east of the Crescent Valley from 550 to 330 BCE, with their capital at Persepolis. Their religion included the teachings of Zoroaster, which were written down in the book *Avesta*.

On the island of Crete, the Minoan civilization flourished through seafaring and trade. The Minoans produced many fertility figures and goddesses, like the *Snake Goddess* (Fig. 7.3). Around 1200 to 800 BCE, another maritime culture, that of the Phoenicians, prospered in small city-states in present-day Lebanon, with colonies in Carthage and North Africa and an active trade economy. The Phoenicians are also known for the phonetic alphabet, based on sounds of the human voice.

Map 3 The Middle East, Asia Minor, and India, showing the locations of empires and the locations of the founding of the religions of Hinduism, Buddhism, and Judaism.

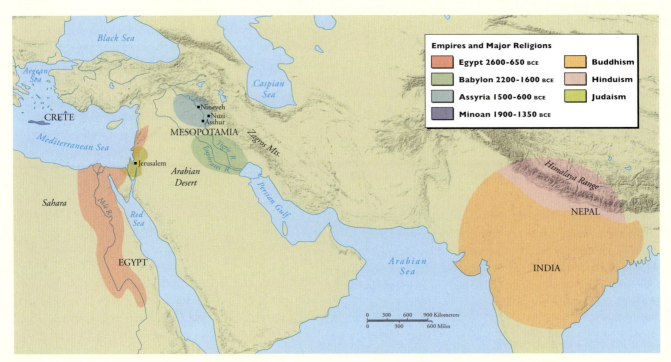

The long-lived Egyptians had three kingdoms. During the Old Kingdom, 2700–2200 BCE, the Great Pyramids and Sphinx were built. From 2100 to 1800 BCE, Egypt was ruled by invaders but later regained autonomy. In the New Kingdom, 1600–1100 BCE, remarkable temples were built that were similar in style to the later *Horus Temple at Edfu* (Figs. 7.34 and 7.35). The Egyptian religion was polytheistic. One goddess, Hathor, is represented as a cow, as seen in Figure 7.5.

The Greek civilizations established city-states, the strongest being Athens and Sparta. The ancient Greeks are credited with developing the early forms of democracy. Around 500 BCE, the Golden Age of Greece began, producing great advances in philosophy, the arts (see *Parthenon*, Fig. 7.32), architecture, writing, crafts, medicine, mathematics, and Olympic sports.

Between 750 and 500 BCE, the Etruscan people ruled central Italy. Beginning in 509 BCE, the Romans chipped away at their power, eventually driving them out and establishing the Roman Republic.

In India around 1500 BCE, nomadic peoples formed a new culture that incorporated Hinduism and the Sanskrit language. Later, the sacred text of the *Rig-Veda* was written. In 563 BCE, Siddhartha Gautama was born. He would later become the Buddha, the Enlightened One, founding the religion of Buddhism (see *Seated Buddha*, Fig. 7.9).

From 2000 to 1500 BCE, China was cultivating millet and wheat, using the potter's wheel to produce black pottery, and domesticating animals. Later, the Shang Dynasty (1500–1122 BCE) was known for developing writing, cultivating silkworms, and producing white pottery, bronze works, and marble, jade,

and ivory artworks. They practiced ancestor worship. Between 1123 and 256 BCE, the Chinese invented the crossbow and perfected lacquer.

In Africa, the Kush people lived in the Sudan between 2000 and 350 BCE. In 732 BCE, they conquered Egypt and ruled for one hundred years. In 600 BCE, they were conquered by the Assyrians.

On the American continent, the Olmec civilization existed on the coast of the Gulf of Mexico between 1200 and 400 BCE. The Olmec built great temples, pyramids, colossal heads, and monuments. They also invented an accurate calendar and a counting system. In northern Peru from 1000

7.2 *Hammurabi Stele*, Susa (modern Shush, Iran), 1792–1750 BCE. Detail showing the king standing before the sun god and god of justice, Shamash, who commanded Hammurabi to record the law. Relief, 2′ 4″ high. Louvre, Paris.

to 200 BCE, the Chavin built temples with stone carvings and produced fine pottery and gold work. Mound builders, farmers, and potters lived in central North America.

Around 2000 BCE, Europe was still in the New Stone Age, with megalithic structures built over a widespread area. Religious rituals were mixed with astronomy and agriculture, as at *Stonehenge* (Fig. 7.26).

World Art Map for Chapter 7

Stonehenge. Wiltshire, England.

Matthias Grünewald.
The Isenheim Altarpiece.

Notre Dame du Haut.

EUROPE

Chartres Cathedral.
Rose Window.

Lorenzo Ghiberti.
Sacrifice of Isaac.

Pantheon. Rome, Italy.

Transformation Mask.
Kwakiutl, British Columbia, Canada.

Michelangelo.
Ceiling of the
Sistine Chapel.
Rome, Italy.

Raphael Sanzio.
Madonna of the Meadow.
Rome, Italy.

NORTH AMERICA

Jimmie Kewanwytewa. *Ahola Kachina.*

Tlalocan Painting.
Pyramid of the Sun.
Retablo of Maria de la Luz Casillas and Children.

Shield Jaguar and Lady Xoc.

Xilonen,
Goddess of Young Corn.
Veracruz, Mexico.

AFRICA

Power Figure.
Kongo, Zaire, Africa.

SOUTH AMERICA

N

| 0 | 1,000 | 2,000 Km. |
| 0 | 1,000 | 2,000 Mi. |

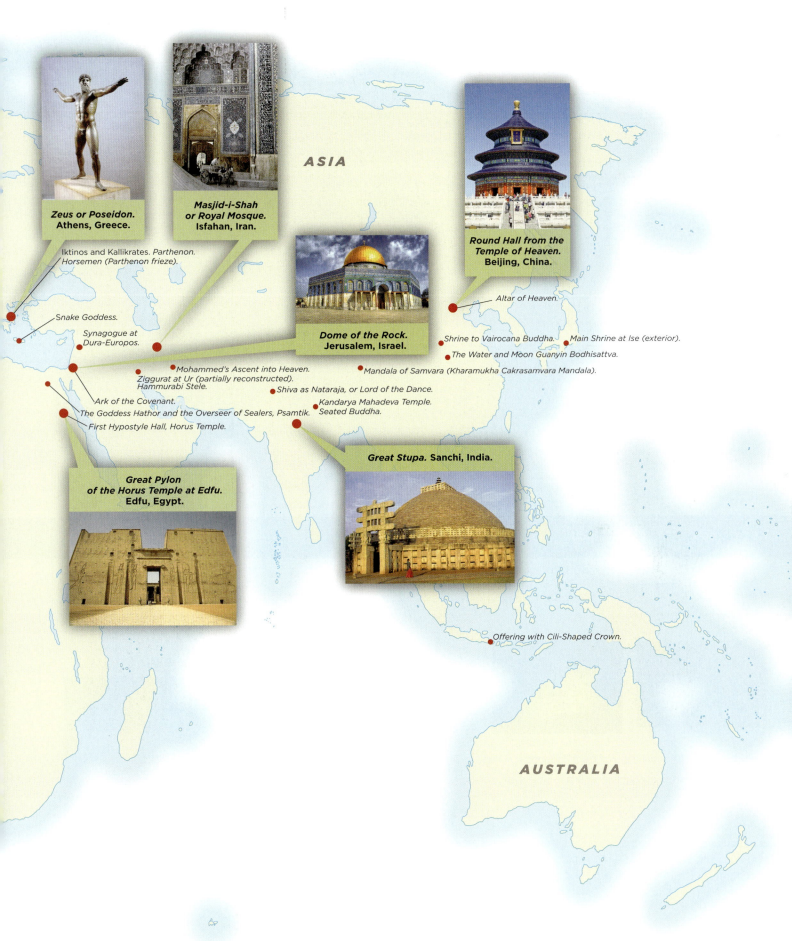

Zeus or Poseidon.
Athens, Greece.

Iktinos and Kallikrates. *Parthenon.*
Horsemen (Parthenon frieze).

Masjid-i-Shah
or Royal Mosque.
Isfahan, Iran.

ASIA

Round Hall from the
Temple of Heaven.
Beijing, China.

Dome of the Rock.
Jerusalem, Israel.

Snake Goddess.

Synagogue at
Dura-Europos.

Altar of Heaven.

Shrine to Vairocana Buddha. *Main Shrine at Ise (exterior).*

Mohammed's Ascent into Heaven. *The Water and Moon Guanyin Bodhisattva.*
Ziggurat at Ur (partially reconstructed).
Hammurabi Stele. *Mandala of Samvara (Kharamukha Cakrasamvara Mandala).*

Ark of the Covenant. *Shiva as Nataraja, or Lord of the Dance.*

The Goddess Hathor and the Overseer of Sealers, Psamtik. *Kandarya Mahadeva Temple.*
Seated Buddha.

First Hypostyle Hall, Horus Temple.

Great Stupa. Sanchi, India.

Great Pylon
of the Horus Temple at Edfu.
Edfu, Egypt.

Offering with Cili-Shaped Crown.

AUSTRALIA

2000–500 BCE

OLD KINGDOM—EGYPT MIDDLE KINGDOM—EGYPT	HISTORY FOCUS BABYLON EARLY GREEK CIVILIZATIONS NEOLITHIC EUROPE	HEBREW CULTURE *Hammurabi's Code*	MINOAN CIVILIZATION	NEW KINGDOM—EGYPT INDIAN CIVILIZATION, HINDUISM SHANG DYNASTY—CHINA
2700 BCE 2100	**2000**	**1800**	**1700**	**1600**
Ziggurat at Ur	*Stonehenge*	*Hammurabi Stele*		*Snake Goddess*

	Crusades: Wars between Christians and Muslims for the Holy Land GOTHIC ERA—EUROPE	MALI EMPIRE—AFRICA *Aztecs Build Tenochtitlan*	Martin Luther and the Protestant Reformation, 1517 Ivan IV (the Terrible) Becomes Tsar of Russia Counter-Reformation
900 1000	**1100**	**1300 1400**	**1500**
Shield Jaguar and Lady Xoc *Shiva as Nataraja, or Lord of the Dance* *Xilonen, Goddess of Young Corn*	*The Water and Moon Guanyin Bodhisattva* *Chartres Cathedral*	GHIBERTI. *Sacrifice of Isaac*	MICHELANGELO. *Ceiling of the Sistine Chapel* *Mandala of Samvara* *Altar of Heaven* *Mohammed's Ascent into Heaven* RAPHAEL. *Madonna of the Meadow* GRÜNEWALD. *The Isenheim Altarpiece*

⋀ *Relief Carving,* Banteay Srei, Cambodia (3.36)

⋀ *El Castillo,* Chichén Itzá, Mexico (2.34)

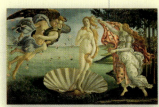

⋀ BOTTICELLI. *The Birth of Venus,* Italy (1.4)

⋀ *St. Basil Cathedral,* Moscow (15.15)

ETRUSCAN CIVILIZATION	*Birth of Buddha* **ROMAN REPUBLIC** **GOLDEN AGE OF GREECE** **PERSIAN EMPIRE**	**ROMAN EMPIRE** *Birth of Jesus*	*Founding of Islam*	*Islam in Africa, the Middle East, and Spain*
1000 700 600	500 400	100 4 CE 200	400 600	700

The Goddess Hathor and the Overseer of Sealers, Psamtik

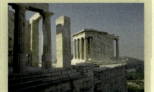

Synagogue at Dura-Europos
Pyramid of the Sun
Tlalocan Painting
Ark of the Covenant mosaic

Seated Buddha
Shrine to Vairocana Buddha
Main Shrine at Ise
Dome of the Rock

Kandarya Mahadeva Temple

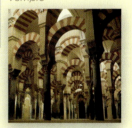

∧ MNESICLES. *Temple of Athena and the Propylaea*, Greece (2.36)
Zeus or Poseidon
Parthenon
Great Stupa
Horus Temple

∧ *Great Mosque of Cordoba*, Spain (2.18)

HEIGHT OF THE ASHANTI EMPIRE—AFRICA	**AGE OF ENLIGHTENMENT** *State of Israel Founded*	*Dalai Lama Exiled from Tibet*
1600	1700 1800 1900	1950 2000

Masjid-i-Shah, or Royal Mosque

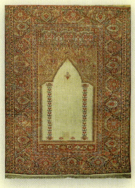

∧ *Grand Mosque*, Djenne, Mali (1.8)

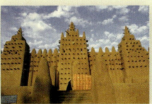

∧ *Nimba, Goddess of Fertility*, Guinea (3.46)

LE CORBUSIER. *Notre Dame du Haut*
Transformation Mask
Retablo of Maria de la Luz Casillas and Children
Offering with Cili-Shaped Crown

∧ MATISSE. *Tree of Life* (3.51)

∧ *Gheordez Prayer Rug*, Turkey (1.20)

RELIGIONS AND THEIR IMAGERY OF DEITIES AND HOLY BEINGS

For some religions, artists make images or sculptures of gods and goddesses and other holy beings to aid people in rituals. The faithful may believe that the deity is actually present in the artwork or just represented by it.

Simple geometric shapes often symbolize God. The sphere and dome are significant in Islamic architecture, as they stand for the heavens and the oneness of God. In the Hindu religion, the circle can symbolize the unknowable Supreme Being. The triangle stands for the Christian Trinity. Words can also be symbols of God, such as in Islamic calligraphy. In many religions, light is a symbol for God.

Animal features or natural phenomena can represent, act as metaphors for, or symbolize deities (see Fig. 7.1). For example, the sun can be a symbol for God and, at other times, can actually be worshiped as a deity itself. In Christian art, Jesus is symbolized by a sacrificial lamb and the Holy Spirit by a dove or by fire. Other religions are animistic, with natural elements or animals as deities or inhabited by spirits. The earth is often understood to be a female force because of its ability to generate life. Other religions depict God anthropomorphically—that is, with human attributes. Gods may be gendered and have human-like personality traits.

In some religions, God is not pictured. Most African religions and the Hindu religion recognize a completely unknowable Supreme Being. In the Islamic religion, Allah is never depicted.

Let us now look at a few ways that deities and holy beings are depicted in artwork.

Animism

A basic belief found in our human legacy is **animism**. Its premise is that all the forces of nature are inhabited by spirits. Although there are no specific images of the spirits, a rock or tree can be carved into an image to bring out the natural force, as seen in the *Venus of Willendorf* (see Fig. 6.3). The small, egg-shaped stone was likely believed to contain the spiritual force of procreation, which would have been an important aid to ancient fertility rituals.

Polytheism

Polytheism is the belief in many gods with distinct and sometimes several functions. Likely the first of the polytheistic gods, the Earth Mother is the original deity in almost all areas of the globe—the giver of life and fertility and the carrier of death. In ancient myths of nomadic cultures—hunters and gatherers—the goddess existed first. Later, she created her male counterpart, with whom she mated to produce the rest of Creation. As agriculture increasingly replaced hunting and gathering as the primary source of food, the importance of paternity increased, along with land ownership, animal breeding, cities, and hierarchical classes. Powerful goddesses continued to be worshiped in many religions—but alongside important male gods.

We begin our focus with two artworks. The first, from an early polytheistic religion, is the *Snake Goddess* (Fig. 7.3), dated 1600 BCE, which probably evolved from the Earth Mother in the Minoan civilization on Crete from 2000 to 1200 BCE. The open bodice and prominent breasts tie this figure to early fertility goddesses. Her intense expression and upraised arms energize this piece. She holds snakes, which may have represented male sexuality because of their shapes. Female fertility and regenerative powers may also have been connected to the snake's periodic shedding of its skin. The leopard-like animal on her head may have symbolized royalty. Her tiered dress and hairstyle likely represented Minoan fashion at that time.

> **CONNECTION** For more on early goddesses, see the section on "Fertility Goddesses and Gods" in Chapter 6.

The ancient Greeks believed that the beginning of all life on earth was Gaia, the Earth Goddess. Her descendants, the Greek gods on Mount Olympus, had distinct personalities and formed alliances and enmities among themselves and with humans. They were responsible for many aspects of the natural world and human life, such as love, warfare, and the seasons. The Greek gods were always in human form, as the Greeks considered themselves superior to followers of religions that worshiped animals or mountains. The earliest images were stiff and frontal, without fluid movement, similar to Egyptian sculpture. Later Classic depictions had convincing anatomy and movement but were entirely idealized and flawless, conforming to Greek standards of beauty. Our focus example, *Zeus*, or possibly *Poseidon* (Fig. 7.4), 460–450 BCE, is from the Classical period. Zeus, chief among the Greek gods, is usually shown as a mature, bearded male with an ideal, godlike physique.

7.3 *Snake Goddess*, Minoan, from the palace at Knossos, c. 1600 BCE. Glazed earthenware, 1′ 1½″ high. Archeological Museum, Heraklion.

This goddess has likely evolved from the Earth Mother deity; she represents male and female regenerative powers of a snake shedding its skin.

7.4 *Zeus* or *Poseidon*, Greece, 460–450 BCE. Bronze, 6′ 10″ high. National Archeological Museum, Athens.

Greek gods appear in the ideal human form according to the Greek aesthetic rule of proportion.

His right hand probably once held a thunderbolt, an attribute of Zeus, who is associated with the sky and storms (if the figure once held a trident, then he likely is Poseidon, God of the Sea). The over-life-size figure appears monumental, muscular, and ideally proportioned. It conveys a sense of action and energy and, at the same time, poise and dignity. Fully extended, Zeus's mighty body is balanced between the backward movement of his arm and its anticipated forward movement as he hurls a thunderbolt.

Now compare the deities of ancient Egyptian religion, who were mostly personifications of natural forces, such as the daily rising of the sun, the ripening of crops, and the annual flooding of the Nile River. These divine beings required worship and sacrifice from humans, who appealed to them for special needs. Most were represented as animals or as animal-human combinations.

The goddess Hathor, associated with the sky, stars, love, mirth, and joy, was depicted as a cow or as a combination of a

7.5 *The Goddess Hathor and the Overseer of Sealers, Psamtik,* Saqqara, Egypt, Late 26th Dynasty, sixth century BCE. Gray stone, base is 11½" × 3' 7¼", height of cow to horns is 2' 7". Cairo Museum.

Egyptian deities were usually personifications of natural forces or animal forms. This image is an offering to Hathor by an official, seeking her guidance in his duties.

woman and a cow. In *The Goddess Hathor and the Overseer of Sealers, Psamtik* (Fig. 7.5), sixth century BCE, Hathor encompasses and hovers protectively over Psamtik, an Egyptian official. Her horns surround the head of a cobra, a sign of royalty, and the sun disk with a crown of feathers. Even in images of Hathor as a woman, her head is usually topped by the same combination of horns and sun disk, which symbolize royalty and divinity. The side view of this piece shows the entire length of the cow striding forward, with bone and muscle beautifully sculpted. In our front view of her calm, majestic face, we see more stylized features, such as the repeated ridges above the eyes and the radiating pattern in the ears. Psamtik keeps pace with Hathor. His standardized face and body show conventional divisions of breast, rib, and belly, while the arms and hands are presented frontally and symmetrically. His official duties are inscribed on his skirt. The work was likely commissioned by Psamtik as an offering that would have been placed in a temple to Hathor.

CONNECTION A hawk representing Horus, the Egyptian God of the Sky, is on the coffin case of the Pharaoh Tutankhamen (Fig. 8.5).

Other cultures connect deities with specific benefits. Much later in time, the Mesoamerican cultures often linked the gods associated with corn and water because water was so essential and corn symbolically stood for all food. Having a special role as the protector of young corn plants, the maize goddess was called *Xilonen* (Fig. 7.6). In our image of her, dating from 1000–1200, the head is rounded, very human-like, and grandly adorned. She wears a headdress with ornamental bands and ears of corn, a collar with sunrays, heavy ear pendants, and a jade necklace that symbolizes crop fertility. Also from Mesoamerica was Tlaloc, the rain deity who made crops flourish (see Fig. 4.2; an image of his goddess consort can be seen in Fig. 7.44). The most worthy of the human dead were received into Tlaloc's heaven. Images of Tlaloc were common, as were temples dedicated to him. This god was traditionally shown with distinctive features—circular

7.6 *Xilonen, Goddess of Young Corn,* Huastec, Tuxpan (Veracruz), Mexico, 1000–1200. Limestone, 2' 7" high.

This goddess's important function was to promote abundant growth of the corn crops.

eyes, twisted serpent nose, fanged mouth, headdress, and large ear ornaments with pendants—and his face was flattened with features rendered as geometric shapes.

Compare how the Mesoamerican artists show the divine status of Tlaloc and Xilonen to the way that divinity is shown in Minoan and Greek gods. All are represented as human. Xilonen is shown naturalistically, yet grandly adorned to establish her divinity. Her staring eyes and down-turning mouth make her a remote, almost unapproachable goddess. The sculpture also has a monumental feel, which adds to the sense of distance. Tlaloc's face is abstractly human, making the deity seem more terrible, powerful, and removed from the experiences of everyday life.

CONNECTION Look again at Figure 7.2, the *Hammurabi Stele*, which shows him standing before Shamash, the powerful Babylonian God of the Sun and Justice.

Pantheism

Pantheism is the belief that a divine spirit pervades all things in the universe.

Hinduism

Although the Hindu religion appears to have numerous gods, it is pantheism rather than polytheism. This is because their "gods" are all manifestations, or "avatars," of a divine universal spirit—in this case, Brahman the Unbounded. Brahman is one—pure being, pure intelligence, and pure delight—and is, therefore, unknowable. Although never pictured, Brahman can be partially known through the human senses because all natural things, humans, and spiritual beings reflect Brahman.

The god Shiva, one of the primary avatars, is the source of good and evil, male and female. He is the unity in which all opposites meet. He is the destroyer of life who also re-creates it—terrible and, at the same time, mild. Since the tenth century, Shiva has often been depicted in Hindu art as *Nataraja*, or *Lord of the Dance*, seen here in a sculpture from c. 1000 (Fig. 7.7). Shiva's body is shown as supple, sleek, and graceful. Cobra heads form the ends of his hair, and he stands in perfect balance. As the lord of the unending dance, he is the embodiment of cosmic energy, yet the balanced pose also contains the concept of eternal stillness. The multiple arms tell of his power, and his divine wisdom is shown by the third eye in the middle of his forehead. His far right hand holds a small, hourglass-shaped drum, the beating of which stands for creation and the passing of time. The second right arm is coiled by a snake that symbolizes regeneration, while the hand forms a

7.7 *Shiva as Nataraja*, or *Lord of the Dance*, Naltunai Isvaram Temple, Punjab, India, c. 1000. Bronze, 2′ 11¼″. British Museum, London.

Shiva is one of the primary avatars of Brahman, the Unbounded, the universal spirit of all things.

mudra, a symbolic gesture that here is a sign of protection. The far left hand balances a flame that symbolizes destruction, while the other left hand points to his feet. The left foot is elevated in the dance, indicating release from this earth, and the right foot crushes the personification of ignorance. The circle of fire that radiates around Shiva shows the unfolding and transformation of the universe and its destruction.

Buddhism

Rooted in Hinduism, the Buddhist religion follows the teachings of Siddhartha Gautama, a prince born in India near Nepal around 563 BCE. He fled from court life to become a homeless holy man and later achieved enlightenment, or Buddhahood. The Buddha, also known as Sakyamuni (meaning "the sage of the Sakya clan"),

continued to teach for the next forty-five years until his death. Buddhists, like Hindus, hold that humans are perpetually reincarnated, most often into lives of suffering, based on the deeds of their past lives. By following the teachings of Sakyamuni, humans can overcome desires and the cycle of rebirth. Then they can attain nirvana, a transformation of their consciousness from the material world to the eternal realm.

For several hundred years after his death, Sakyamuni was represented by a set of symbols but never as a human because he had achieved enlightenment. One symbol for Sakyamuni was the **stupa**, a sign of his death and attainment of nirvana. Originally, a stupa was a mound tomb. It eventually was transformed into a monument that contained the ashes or relics of a Buddha. An example of an early Buddhist stupa is the *Great Stupa* at Sanchi (Fig. 7.8), third century BCE to first century CE, a solid, dome-shaped mound of earth enclosed in brick or stone. The form of the mound represented the cosmos as the world mountain, the dwelling place of the ancient gods and a sacred womb of the universe. The structure is encircled with a low balustrade wall containing four heraldic gates, all highly adorned with rich carvings. The gates, called **toranas**, are located at the four cardinal points in the circular wall (two can be seen at left in Fig. 7.8). The balustrades are also densely carved. Pilgrims would come from all over the world to walk clockwise around the stupa and chant, meditate, and pray as they observed the special meanings of the carvings. The square enclosure on top of the dome symbolized the heavens, surmounted by the mast with umbrellas, called **chatras**, that united the world with the paradises above. The chatras signified the levels of human consciousness through which the human soul ascends to enlightenment. The stupa as a symbol of Buddhahood spread throughout Asia, although there were local variations in its design.

The toranas of *Great Stupa* rise as high as 34 feet. These gates contain many scenes showing episodes from the life of Sakyamuni, presented in symbols such as footsteps, an empty throne, and animals. There are also sensuous images of the nature deities that have been retained from the early Vedic sculptural tradition. Small stupas carved on the gateway reliefs symbolize Sakyamuni in his

7.8 *Great Stupa*, Sanchi, India, third century BCE–first century CE. Dome, 50′ high.

Siddhartha Gautama, whose early teachings founded Buddhism, is represented symbolically in this structure and carvings.

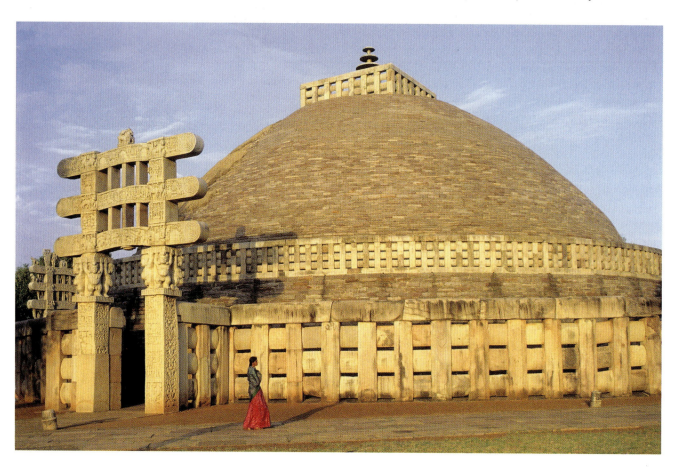

attainment of Buddhahood; they look very much like the *Great Stupa*.

CONNECTION One of the carvings from the *Great Stupa* at Sanchi is the *Yakshi* (Fig. 11.17).

As later sects emphasized a more personal Buddha, images of him in human form were produced, along with the traditional symbols. At first, these figurative sculptures were variations of older Hindu spirits, with certain Buddha-identifying attributes, such as the topknot of hair (a cranial bump indicating wisdom) and a circle between the eyebrows. Earlobes were long, since Sakyamuni was once a bejeweled prince.

In still later images, the emphasis was on the general serenity of Buddhahood. The red sandstone of the *Seated Buddha* (Fig. 7.9), late fifth to early sixth century, has been carved and polished to a smooth, flawless finish. The statue seems to represent a generalized holy being rather

7.9 *Seated Buddha*, Sarnath, Uttar Pradesh, India, late fifth–early sixth centuries. Sandstone, 5′ 3″ high. Sarnath Museum.

Later in Buddhism, its founder is depicted as the Enlightened One, the Buddha.

than a specific person. The body seems almost weightless. The face is rendered as a perfect oval, and the torso and limbs are simplified into graceful lines and elegant shapes. Clothing is sheer and clinging, unworldly in its draping and its perfection. The tall arches of the brow, downcast eyes, and quiet but sensual mouth all speak of a transcendent serenity. The Buddha is seated in lotus position on a throne, under which are carved worshipers around the Wheel of the Law. Abstracted foliage above and around Sakyamuni represents the Tree of Enlightenment. His hands are posed in a preaching gesture.

Over the centuries, Buddhist beliefs became more complex and varied, with some resembling philosophy, others atheism, and still others pantheism. In some variations, Bodhisattvas are living beings who have attained Buddhahood but who have chosen to remain on earth to help others. While Buddhas in their serenity in nirvana may seem remote to struggling humans, the Bodhisattvas are immediate personal intercessors who give aid. *The Water and Moon Guanyin Bodhisattva* (Fig. 7.10), c. 1100, is the most powerful Bodhisattva, with

7.10 *The Water and Moon Guanyin Bodhisattva*, Song Dynasty, China, c. 1100. Painted wood, 7′ 11″ high. Nelson-Atkins Museum of Art, Kansas City.

This image depicts a Buddhist living person who has attained Enlightenment but who has chosen to remain on earth to help others attain it.

a great capacity for salvation. Depictions of *Guanyin* vary radically, with two to twelve arms, often crowned, sometimes with a muscular male body and sometimes with an effeminate body. In our example, the body is graceful and the face beautiful and serene. The elegance of the body and right hand, along with the lavish carving and rich colors, makes this sculpture sensually appealing. The diagonals of the figure's right leg and arm balance the verticals of the torso and the left limbs, while the flowing curves of the drapery unite all.

Monotheism

Monotheism is the belief that there is only one God.

Judaism

Judaism is one of the oldest monotheistic religions of the Western world and also the foundation of Christianity and Islam. The Jews consider themselves the Chosen People and have a special covenant with their God and Creator, Yahweh, who alone is to be worshiped. It was thought by scholars that the making of art images in the Jewish faith was forbidden because of the Second Commandment. However, images have been found in scripture illumination and on the walls of ancient synagogues.

In Figure 7.11, we see the interior of the *Synagogue at Dura-Europos*, dated 245–256 CE, which is covered with paintings depicting Old Testament themes. Dura-Europos was an outpost in Syria and was probably founded around 323 BCE.

The *Synagogue at Dura-Europos*, originally a private home with a courtyard, was transformed into a place of worship in the second century CE. The paintings on the walls were didactic, illustrating stories found in the Hebrew Bible. The figures have stylized gestures; lack expression, mass, and depth; and, for the most part, stand in frontal rows, providing a means to explain a concept or illustrate a story. Action was not depicted. Yahweh was shown as a hand emerging from the top of the panels. Evidently, this kind of image making was not forbidden for the Jews, but the worship of images was.

Christianity

Unlike Judaism, the traditions of **Christianity** have many kinds of images of God. Some Christians understand God as a single being, whereas most conceive of God as a Trinity, with three persons in one: the Father, Son, and Holy Spirit. The Father is usually depicted as an aged patriarch, wise, powerful, and judging. The Son was incarnated as Jesus and founded the Christian religion. He is believed

7.11 *Synagogue at Dura-Europos*, Syria, 245–256 CE. Interior, with wall paintings of biblical themes. National Museum, Damascus, Syria.

Images of the Hebrew deity, Yahweh, were very rare; however, at times his hand appears in Old Testament paintings found on temple walls.

by Christians to be the Savior of souls. Images of Jesus range from a babe in arms to a young man in life, death, and resurrection. The Holy Spirit is represented as a symbol, either a dove or a flame of fire.

As an actual historical figure, Jesus is the most commonly depicted of the Trinity. In early images, he was a youthful, protecting shepherd, a comforting figure to early Christians, who were often persecuted by Romans. Once Christianity became the official state religion of the Roman Empire in the fourth century, Jesus was depicted as a royal ruler. Images of Jesus as miracle worker, judge, and teacher often combine storytelling and symbolism.

In *Madonna of the Meadow* (Fig. 7.12) by Raphael Sanzio, c. 1505, Jesus, the robust, beautiful child in the center, is seen with his cousin, St. John the Baptist, at the left, and Mary, his mother, who towers over both children. Although the children look youthful and sweet, their

solemn composure and the cross they hold portends their roles of savior and prophet. All figures are totally human, but their dignity and serenity seem divine. The blues, reds, and greens add to the sense of harmony. Mary and the two children fit into an implied triangle—a stable, symmetrical, sacred shape recalling the Trinity. Mary's silhouette completely contains the form of Jesus, attesting that she is Jesus' mother and establishing her as a symbol for the Christian church, through which Jesus remains present on earth. The large, sheltered body of water in the background implies a harbor, and Mary was known as the Port of Salvation.

In contrast, the *Crucifixion* from *The Isenheim Altarpiece* (Fig. 7.13) by Matthias Grünewald, c. 1510–1515, shows Jesus at death, which for Christians is a moment both of annihilation and of redemption from sin. The dark, gloomy background obliterates all landscape detail. The grisly

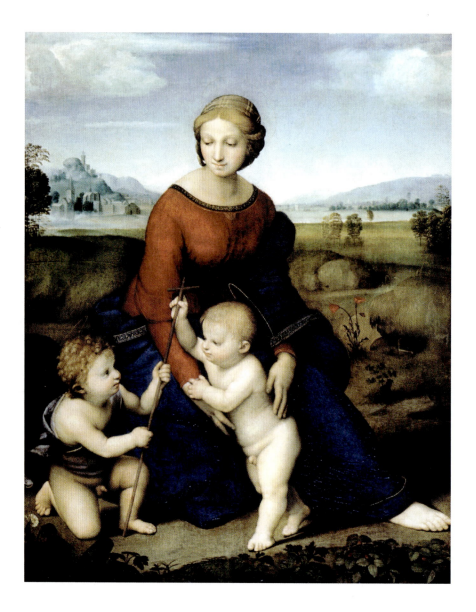

7.12 RAPHAEL SANZIO. *Madonna of the Meadow*, Italy, c. 1505. Panel painting, 3′ 8½″ × 2′ 10¼″. Kunsthistorisches Museum, Vienna.

Jesus Christ is believed to be both divine and human but is often presented in his human form, seen here as a baby.

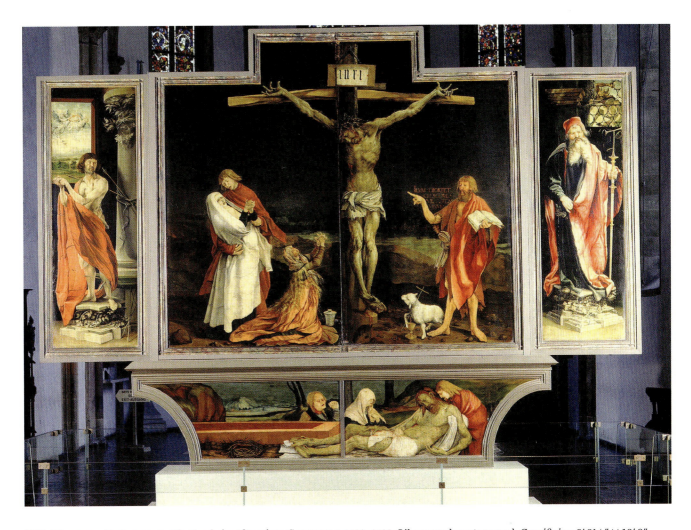

7.13 MATTHIAS GRÜNEWALD. *The Isenheim Altarpiece*, Germany, c. 1510–1515. Oil on wood; center panel: *Crucifixion*, 9′ 9½″ × 10′ 9″. Musée d'Unterlinden, Colmar, France.

Here, the human Christ is depicted in his sacrificial crucifixion, which fulfilled the Christian prophecy of redemption as written in its scriptures.

details of Jesus' sore-ridden and scraped skin, convulsed body, and drooping head are meant to be a realistic picture of a terrible death. At the same time, the *Isenheim Altarpiece* is a conceptual rather than a realistic representation. The bottom panel, which shows Jesus' body being placed in the tomb, would sit directly above the altar, where the body of Jesus is offered at Christian Eucharistic rituals in the form of bread and wine. The lamb in the *Crucifixion* panel, holding a cross and bleeding into a chalice, symbolizes animal sacrifices conducted by Jews in the past and the current offering of bread and wine. People who were present at the Crucifixion, such as Roman soldiers, are omitted from this painting, while St. John the Baptist is shown, although he had already died. Saints on side panels were associated with cures for the sick.

The painting was a form of consolation for patients in a hospital, for they could see the horrendous suffering of Christ and relate it to their own suffering. Also, the dark, suffering-filled *Crucifixion* panel opens in the center, and behind it are three joyful scenes from the life of Jesus—his conception, birth, and resurrection from the dead, all in brilliant colors.

CONNECTION Turn to *The Last Judgment* (Fig. 11.19) to see an image of Jesus as judge.

Islam

Islam was founded by Mohammed in seventh-century Arabia. Islam requires complete submission to Allah, who is seen as the same deity as in the Jewish and Christian faiths. Islam's sacred scriptures, the Koran, contain its articles of faith. Whereas images of Allah were forbidden, the Prophet Mohammed is sometimes shown in religious

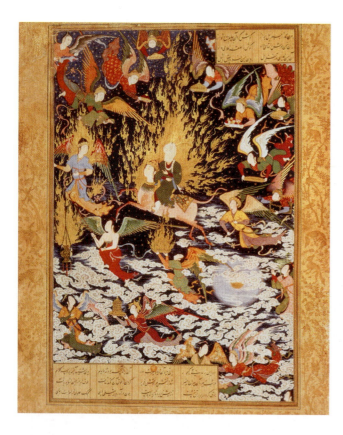

7.14 *Mohammed's Ascent into Heaven*, from Nizami's *Khamsa (Five Poems)*, made for Tahmasp, Safavid Dynasty, Tabriz, Iran, 1539–1543. Ms. Or. 2265, fol. 195a. British Library, London.

In a glorious array of fire and clouds, the veiled Mohammed ascends into heaven accompanied by angels.

manuscript art. Figure 7.14 depicts *Mohammed's Ascent into Heaven*, a royal miniature that illustrates a copy of a collection of poems by the famous Persian poet Nizami Ganjavi. Mohammed's face is veiled, as was customary in such depictions, out of respect for the holy and for fear they could never be rightly portrayed. Prior to Mohammed's ascent into heaven, he embarked on a night journey on Buraq, a white winged horse that carried him through various stages of heaven, where he met several Jewish and Christian prophets and also visited hell. Mohammed's night journey is important in Islamic thought and is seen as symbolizing each man's spiritual journey. The saturated colors, elaborate details, and intricate renderings of clouds and flames mark this as a royal commission. In contrast to the rich center, the margins are covered with monochrome drawings of animals surrounded by vegetation.

HUMANS RESPOND TO GOD

Humans use religious ceremonies, prayers, and rituals to acknowledge God and to request what they need for earthly or spiritual existence. Many religions require humans to make offerings to the gods as outward signs of their devotion. Art frequently is part of this process.

Ceremonies

The Kwakiutl of the Pacific Northwest dwelled in two sites corresponding with summer food gathering and elaborate winter rituals, such as marriages, initiations, feasts, potlatches, and dramatic performances. Special houses were built for the winter ceremonies. Performers in full masquerade told their stories and became the supernatural beings of their masks.

Our example is the twentieth-century *Transformation Mask* (Fig. 7.1). During performance, its character changed from that of an earthly being to that of a supernatural being. At the critical moment in the story-drama, the dancer would turn and manipulate the mask with hidden strings and devices and then turn back in a completely different mask. This surprising transformation might be the changing of a bear or a sea creature into one of the horrendous cannibal spirits. The intent of this magical event was to make humans fear the supernatural. Besides being superbly carved, the mask is exquisitely painted. Bright, bold colors in undulating shapes create overall harmonious compositions that complement the facial contours. This distinct aesthetic with its flowing curvilinear style is visible throughout Kwakiutl art forms, both past and present.

 CONNECTION Figure 5.20 shows a large *Halibut Feast Dish* used in a potlatch.

Offerings

In central Mexico, hundreds of believers leave small votive paintings called *retablos* at certain important religious shrines, as a form of prayer and thanks for a divine favor. Pictures with bright colors and text dramatically record emotional, miraculous events. These artworks also may contain holy cards, pictures of loved ones, diplomas, or legal papers.

Our focus figure here is the *Retablo of Maria de la Luz Casillas and Children* (Fig. 7.15). The translation reads:

> I give thanks to the Holiest Virgin of San Juan de los Lagos for having made me so great a miracle of saving me in a dangerous operation that was performed on me for the second time on the 9th day of October 1960, in Los Angeles, California. Which put me at the doors of death but entrusted to so miraculous a

7.15, above *Retablo of Maria de la Luz Casillas and Children*, central Mexico, 1961. Oil on metal, 7″ × 10″.

This offering is a prayer of thanksgiving to the Virgin of San Juan.

Virgin I could recover my health, which I make apparent [in] the present retablo: in sign of thanksgiving. . . . (Durand and Massey 1995:164)

The Virgin of San Juan de los Lagos is a small statue of Mary, the Mother of Jesus, in a shrine in the central Mexican state of Jalisco. Multiple scenes are common on retablos, and in this example we see Maria twice, both as a helpless and vulnerable patient on the operating table in a foreign land and as the supplicant with her children imploring the help of the Virgin. In the *Retablo*, the Virgin looms large in the bleak, gray room, with golden rays, miraculously intervening in a fearful episode. Extraneous details are omitted to better emphasize the victim's helplessness and the Virgin's power.

Compare the *Retablo* with the crafted offerings of the Balinese people. The Balinese have many days of religious observance, which they commemorate by giving handmade offerings. They regard these offerings as artworks and consider many of their people to be artists. Religion and art are integrated components of everyday life. Often, handmade offerings are modest, but on festival days women make and carry to temples more elaborate offerings, such as the *Offering with Cili-Shaped Crown* (Fig. 7.16), from the mid-1980s. This intricate sculpture of fruit and flowers is cut and woven with palm leaves. An ancient symbol of wealth, fertility, and luck, the cili

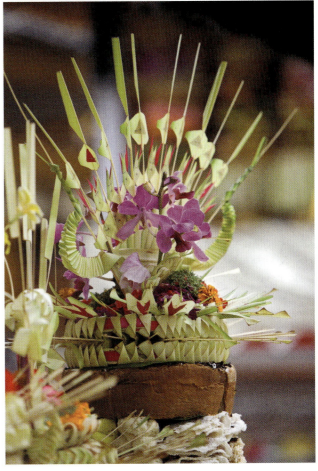

7.16 *Offering with Cili-Shaped Crown*, Bali, c. 1985. Flowers, fruit, and palm leaves, approximately 2′ tall.

This intricately woven cili crown is an ancient symbol of wealth, fertility, and luck.

is a simplified woman's head with a large, fanlike headdress radiating from it. In temple rituals, the gods accept the essence of the offering; afterward, any foodstuff that has not touched the ground is eaten in the temple or by the family making the offering. Offerings in the Balinese sense are meant to give back in thanks and do not have the connotation of sacrificing something.

Sacrifices

Various forms of religious sacrifices have been practiced by humankind throughout the ages.

Judeo-Christian religions recognized the offering of foodstuffs and have a history of blood sacrifice. Cain offered farm produce to God; Abel offered an animal and animal fat; the priest Melchizedek prepared a ritual meal for an offering for Abraham. One famous story of sacrifice concerns Abraham, who prepared to kill his son Isaac at the command of God, but at the last minute he was allowed to substitute the slaughter of a ram. Our focus figure is a detail of a gilded bronze relief panel, *Sacrifice of Isaac* (Fig. 7.17), sculpted by Lorenzo Ghiberti in 1401–1402. It shows the emotionally intense moment when the youthful Isaac is bound on an altar of sacrifice as his fierce-faced father, Abraham, aims the knife at his son's throat. The curves of their bodies echo each other, with Isaac pulling away as Abraham is poised to lunge forward. The nude body of Isaac is idealized and perfect, increasing the merit of the sacrifice. The intervention of an angel halted the sacrifice, and food, in the form of a ram (not visible in our detail), became an acceptable alternative offering. Although blood sacrifices are no longer offered in mainstream Christian religions, the Eucharistic offering of bread and wine may be celebrated (in some cases as the body and blood of Christ).

In other cultures, human offerings to deities also entailed sacrifice, sometimes involving the spilling of human blood. In the various Mesoamerican cultures—Maya, Toltec,

7.17 LORENZO GHIBERTI. *Sacrifice of Isaac* (detail), Florence, Italy, 1401–1402. Gilded bronze, 1′ 9″ × 1′ 5½″. Museo Nazionale del Bargello, Florence.

This relief illustrates the ultimate test of faith in the Jewish and Christian religions.

7.18 *Shield Jaguar and Lady Xoc*, classic Maya, from a palace at Yaxchilan, Chiapas, Mexico, c. 750. Limestone relief, 3′ 7″ × 2′ 6½″. British Museum, London.

This relief depicts a blood sacrifice that was required of the nobility in the Maya religion.

Aztec, and others in Central America—the sun was believed to be ever thirsty for blood to stave off the power of the moon and was symbolized by a fiery tongue. In our comparison figure *Shield Jaguar and Lady Xoc* (Fig. 7.18), dated c. 750, we see an example of a bloodletting ceremony, in which the Mayan ruler holds a torch over his principal wife as she pulls a thorny rope through a hole in her tongue. Those participating in blood sacrifices had to be high ranking, shown by their wrist bracelets, necklaces, crowns, and garb. Their flattened foreheads were signs of beauty, an unnatural effect created by binding boards on the soft skulls of very young children of the nobility. More extreme forms of blood sacrifice were practiced, such as cutting out the hearts of captured warriors or the captains of ball teams. Ballplayers were important members of society, and ball games were important religious rituals in which the ball itself and the opposing teams symbolized the terrible balance between the sun and the moon.

CONNECTION For more on the Mesoamerican ball games and their meaning, see the Mayan ball court in Figure 14.12.

Prayers

Prayer is a vehicle of communication between human beings and the gods, and it may take many forms. Our focus figure is from the Hopi of North America, who make small sculptures that act as a form of prayer. The Hopi believe that *kachinas*, or spirits of dead ancestors, dwell in their community for six months in winter and spring. Kachinas ensure the welfare of the community and sufficient moisture for crops. Male members of the Hopi community perform as kachinas during religious festivals.

7.19 JIMMIE KEWANWYTEWA. *Ahola Kachina*, Hopi, Third Mesa, Oraibi, 1942. Cottonwood, paint, feathers, wool, 1′ 1″ high. Museum of Northern Arizona, Flagstaff.

These doll figures act as a form of prayer for the welfare of the community and as a teaching aid for the young.

7.20 *Power Figure (Nkisi n'kondi)*, Kongo, Zaire, 1998. Wood, nails, blades, medicinal material with cowrie shell, 3′ 10¼″ high. Detroit Museum of Art.

This figure is used as a form of prayer for protection against evil influences from enemies.

Kachina performers also carve dolls that reproduce the costumes of specific spirits. Our example, the *Ahola Kachina* (Fig. 7.19), dated 1942, by Jimmie Kewanwytewa, is the primary spirit at an important celebration. It is identifiable by the dome-shaped mask, yellow on one side and gray on the other, covered with small crosses. Other identifying attributes of the costume include the large, inverted black triangle on the face and the feathers from an eagle's tail that project from the head. The colors on the dolls, which reproduce the costumes, represent sacred directions: north is symbolized by blue or green; west by yellow; south by red; east by white; the heavens by multicolors; and the nadir by black. During ceremonies, children receive the dolls to educate them about the individual kachinas and the elaborate costumes and rituals. Women receive them as symbols of fertility. The dolls are hung from rafters in houses as blessings and as prayers for rain and good crops. Older dolls are stiffly posed, but newer ones are more naturally proportioned and often appear in active poses. Bright acrylic colors are now used, and feathers are often carved as certain birds become endangered.

A comparative example of an art object used as a form of prayer is the African *Power Figure* (Fig. 7.20), a sculpture that would be used to counter the evil influence of enemies, whether human, animal, or spiritual. This example is dated 1998. Sculptors carve the power figure with an open mouth, indicating that the sculpture will "speak out" on behalf of anyone who is beset by evil. Shamans activate them, first, by ritually placing medicines in cavities in the figure's abdomen, back, or head. Then they release the figure's power by driving in one metal nail or blade for each request for help. Once effective, the exact nail representing a particular request must be removed. This *Power Figure* is visually dramatic, with its compact form, expressive face, and bristling nails. Power figures are rarely used now, as African religious practices are evolving and rituals may be abandoned or amalgamated into other beliefs.

The Cosmos

Artists in various religious traditions have created artworks that map the cosmos, showing the origin of the world, the structure of the universe, spiritual beings, the place of humans in relation to the gods, or a diagram of time.

Our focus figure is the images on the *Ceiling of the Sistine Chapel* (Fig. 7.21), painted by Michelangelo from

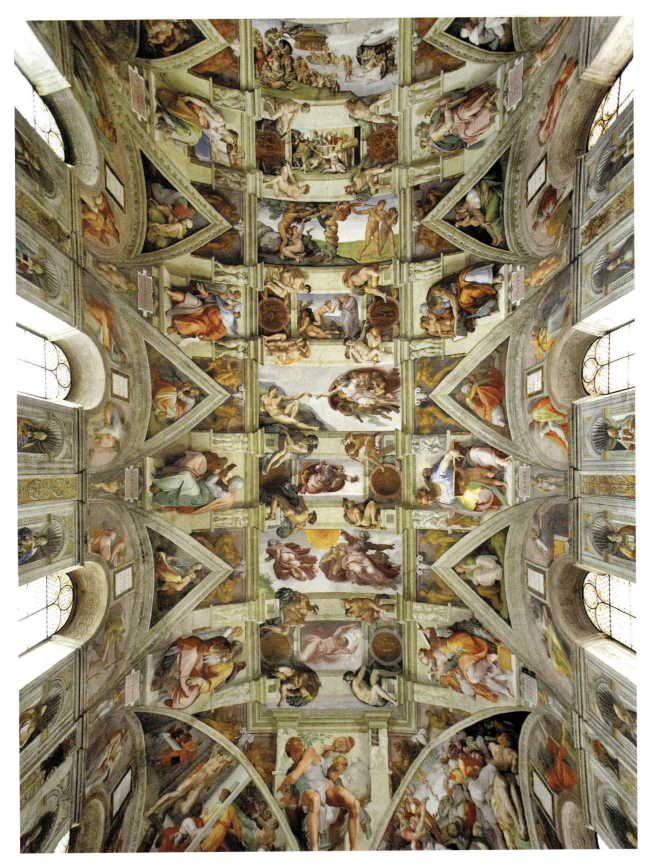

7.21 MICHELANGELO. *Ceiling of the Sistine Chapel*, Vatican, Rome, 1508–1512. Fresco, approximately 128′ × 45′.

These Christian scenes present the origins of the universe, human beings, and sin.

1508 to 1512, which present the origin of the universe, of human beings, and of sin. Pope Julius II commissioned the work; more accurately, the pontiff's strong will triumphed and Michelangelo reluctantly acquiesced. The artist felt that he was a sculptor and that painting was a less noble art form. Originally, the work was to consist only of the twelve apostles with some other ornamentation. But as Michelangelo proceeded, he changed the imagery from the apostles to nine scenes from Genesis, along with seven prophets and five sibyls. Illusionistic marble frames subdivide the broad expanse of the ceiling.

At the center bottom of Figure 7.21 is a panel showing God as a powerful-bodied, older man in pink robes, separating the light in the lower right from the darkness in the upper left. Next, God creates the sun and the moon and then separates the water from land. Following are the creation of Adam, then Eve, and original sin, in which Adam and Eve break God's commandment and are expelled from Paradise. The three center panels at the top are concerned with stories of Noah, the patriarch of the human race after a devastating flood destroyed most life on earth. These cosmic moments are depicted in bright, clear colors against plain backgrounds, emphasizing the bodies' dramatic shapes.

Our comparative example, a mandala, is a radially balanced, geometric diagram augmented by images of deities, humans, and symbols of the universe. Together, they form a map of the structure and relationships among all entities of the cosmos, in accordance with Hindu or Buddhist beliefs. By meditating on the mandala, people can begin to grasp these cosmic relations and understand their place within them.

The mandala begins with the inner circle, which symbolizes the void before all creation. Into this emptiness the image of the God will appear. In our example, the *Mandala of Samvara* (Fig. 7.22), dated c. sixteenth century from Tibet, the deity Samvara (also referred to in this work as Cakrasamvara, who rules and sets into motion the universe) erotically embraces his female Buddha consort, Vajravarahi. Samvara, an angry emanation of the Absolute Being, is shown with blue skin and multiple arms, symbols of his power and divinity. He is pictured here with a donkey face because those meditating on this image learn the illusory nature of the physical body. Radiating from this center are eight paths, which terminate at the sides or corners of a square. These paths refer to rays of light, the cardinal directions, and elements, such as fire, water, wind, and earth. Other fierce deities, combinations of animal and human forms, occupy these paths.

While the inner circles contain deities, the large outer circle encloses charnel fields, where vultures,

7.22 *Mandala of Samvara* (*Kharamukha Cakrasamvara Mandala*), Tibet, c. sixteenth century. Water-based pigments on cotton cloth, 1′ 11″ × 1′ 6″.

This image diagrams a map of the structure and relationships of all entities of the universe.

wild dogs, or cremation fires consume the bodies of the dead (there are generally no graveyards in Southeast Asia). The details are both gruesome and gleeful, vividly depicting harmful forces. Immediately outside the ring of the charnel fields are eight auspicious signs, such as a lotus blossom and a white conch shell, which represent divine gifts offered to Buddha. The outermost areas of the mandala are populated with images of monks, mystics, and more deities.

The underlying geometry makes the mandala both simple and complex. During meditation, it can be followed from the outside inward to the center circle, indicating stages of increasing enlightenment. In reverse, the mandala represents the emanation of the creative force responsible for all life, which originates from Samvara. The mandala reinforces the belief that the cosmos, including the physical and spiritual worlds, is an uninterrupted whole of continually fluctuating energy states. Red is a common color of Tibetan mandalas and predominates here. The brilliant blue comes from lapis lazuli, an expensive pigment derived from grinding

semiprecious stones. Thus, the work was probably commissioned by a wealthy patron.

PLACES OF WORSHIP AND THEIR GENERAL CHARACTERISTICS

Since prehistory, people have set aside special places for religious worship. All of them, from simple to grand, are designed to reveal something of the spiritual realm and to provide an experience beyond the normal and mundane. Across cultures and religions, places of worship may:

- Shelter a congregation
- House sacred objects
- Incorporate elements of nature
- Incorporate symbolic geometry in their dimensions or the determination of their location
- Be sites of sacred ceremonies and pilgrimages

Regarding the first point, it is sufficient to say that places of worship were often designed to house a large group of people, all of whom are participating at the same time in ritual observances. The other four characteristics are explained more fully here.

Housing Sacred Objects

Many places of worship were built specifically to house a sacred image, text, or artifact of a religion. Temples, cathedrals, churches, shrines, and altars may contain a sacred object. For example, in the Jewish religion, the most holy structure is called the *Ark of the Covenant*. It is a special tabernacle that held sacred objects, as depicted in Figure 7.23. Moses constructed the Ark according to instructions from Yahweh so that the prophet could communicate with and receive revelations from him during the exodus from Egypt. Our image is a mosaic from the fourth century CE, which depicts the Ark in the center of the composition. Sanctuary implements, including elaborate seven-branched candelabra, flank the tabernacle.

Other religions also house sacred objects in their places of worship, as we shall see later in this chapter. Often, these are specially constructed buildings, such as temples or churches. In many cases, however, formal structures are not necessary. For example, among many African religions, shrines that hold sacred objects are part of ordinary houses. This is an important aspect of many African religions, as they weave spiritual forces with everyday life.

7.23 The *Ark of the Covenant* and sanctuary implements, Hammath, near Tiberias, fourth century. Mosaic. Israel Antiquities Authority, Jerusalem, Israel.

The tabernacle (enclosure) houses the Hebrew sacred scriptures of the Torah.

Incorporating Elements of Nature

Places of worship can be natural sites: mountains, springs, and sacred trees or groves. Mountains have been meeting places between heaven and earth or dwelling places of divine beings. Rocks can be seen as containers or symbols for spirits and deities. The earth and water are the sources or sustainers of life. Trees may be seen as sources of truth and symbols of the cosmos, existing simultaneously in the underworld, the earth, and the heavens. Fire, light, and the sun are divine symbols or sometimes spirits themselves.

The focus figure is the *Ziggurat at Ur* (Fig. 7.24), dated c. 2150–2050 BCE. It is a sacred artificial mountain erected by the Sumerians of the city of Ur to honor their special deity from among the Sumerian pantheon of gods. Its corners point toward the four points of the compass, reflecting the movement of the sun. The word *ziggurat* means "mountain" or "pinnacle." Surrounded by flat land, this terraced tower of rubble and brick seemed to reach into the heavens. The *Ziggurat at Ur* has three broad staircases, each with one hundred steps, leading to a temple-shrine 40 feet above the ground, dedicated to protective gods and goddesses and attended to by special orders of priests and priestesses.

The Shinto religion in Japan teaches that forests and enormous stones are sacred dwellings of the gods of nature, who are called the **Kami**, all connected to growth and renewal. Our comparison example, the *Main Shrine at Ise* (Fig. 7.25), is located in a forest, on a holy site. Only the roof is visible above a high, protecting fence. Through ritual, the Kami are prevailed upon to enter the shrine, where their powers are worshiped and their aid solicited. A mirror placed inside facilitates their coming into the shrine.

The *Main Shrine at Ise* is made of natural materials, primarily wood and thatch. It is rebuilt every twenty years to exactly the same specifications, so what we see in Figure 7.25 is both a new building and a structure that dates from c. 685. With each rebuilding, the builders observe careful rituals and express gratitude as they take wood from the forest. Boards taken from the same tree are placed together in the building of the shrine. The wood is left plain and unpainted to retain its natural character, and it is carefully fitted and joined with pegs. Nails are not used. The golden color of the wood and the simple but striking geometry are dramatic and impressive.

CONNECTION Compare the basic design of the Shinto shrine to the *Toba Batak House* (Fig. 5.32).

7.24 *Ziggurat at Ur* (partially reconstructed), Third Dynasty of Ur, Iraq, c. 2150–2050 BCE.

This structure was built to house and honor the Sumerian deity of the ancient city of Ur.

7.25 *Main Shrine at Ise* (roofline), Japan, c. 685, rebuilt every twenty years.

Careful rituals are observed as this structure is ritually rebuilt.

Using Geometry Symbolically

Many cultures use geometry and symmetry to symbolize divinity, all-encompassing totality, perfection, and time-lessness. Such geometry may determine the placement or orientation of religious sites, or a building's plan, layout, or elevation.

Our focus is on *Stonehenge* (Fig. 7.26), dated c. 2000 BCE, located in Wiltshire, England. It was built at a time when religion and science were not separate but were a single unified means of understanding natural forces. Thus, *Stonehenge* is likely an altar for religious rituals as well as an astronomical device that maps solar and planetary movement upon the earth. The stone arrangement marks the midsummer solstice, essential to an agrarian civilization dependent on successful crop planting.

7.26, *right* *Stonehenge*, Wiltshire, England, c. 2000 BCE. Diameter: 97′, upright stones with lintel approximately 24′ high.

It is likely that the stone arrangement marks the midsummer solstice, needed for planting cycles.

Other Neolithic stone arrangements in the area align with *Stonehenge*, creating a larger network that may have mapped force fields within the earth.

The first building phase of *Stonehenge* was a gigantic circular ditch, with rubble piled to create an outer bank. The later core of *Stonehenge* consists of a 97-foot-diameter ring of colossal sarsen stones, 24 feet high with their capping lintel. An inner ring of bluestones in turn surrounds a horseshoe-shaped stone arrangement and, finally, an altar stone in the center. A heel stone, separate from the circle, marks the solstice. Builders dragged the stones twenty-four miles, pounded and rubbed them to shape, and likely set them in place using ropes and earthen ramps. *Stonehenge* includes several large rings of holes dug into the ground that conceptually connect the center stones to the surrounding earth.

For comparison, we see centuries later how simple geometric shapes formed the basis of a Roman building that alluded to divine qualities of perfection and completion. The *Pantheon* (Fig. 7.27), dated 118–125, is a shrine to the chief deities of the Roman Empire. A 142-foot-diameter sphere fits into the interior space, making the width of the building equal to its height. The dome, a perfect hemisphere, is the top half of that sphere. A 30-foot circular opening at the top (the **oculus**, or eye) creates a shaft of sunlight that dramatically illuminates the interior. Squares are inscribed in the dome and wall surfaces and are the basis of the pattern on the marble inlay floor.

7.27 *Pantheon*, Rome, 118–125. Concrete and marble, 142′ from floor to opening in dome.

This structure was designed using geometric shapes to which the Romans attributed divine qualities of perfection and completion.

7.28 *Shrine to Vairocana Buddha*, Longmen Caves, Luoyang, Valley of the Yellow River, China, c. 600–650. Natural rock carving, 50′ high.

The colossal statue represents the universal principle dominating all life and phenomena.

The entire structure is symmetrical, both inside and out, and creates the impression of loftiness, simplicity, and balance.

In fact, throughout this chapter, we will see the circle and square and verticality in many religious structures, and geometry was important for their placement and orientation.

Providing Sites for Sacred Ceremonies and Pilgrimages

Places of worship can be sites where sacred ceremonies are performed and destinations for pilgrimages. Sometimes there is no special architecture, only the use of the arts— music, dance, singing, literature, or the visual arts. In the U.S. Southwest, the making of sand paintings has constituted an essential part of Navajo religious ceremonies for centuries. These impermanent paintings are made directly on clean-swept floors of houses and are destroyed in the course of the ceremony. Very few have ever been photographed or documented; however, the rituals are fixed, and certain symbols must be repeated each time. To cure illness, ensure success in hunting, or promote fertility, the artist-priest chants and prays while making the painting using the natural elements of colored sand, crushed

stones, charcoal, and pollen. The person in need sits in the center of the painting to receive the supernatural power. Sometimes ceremonies are performed for the earth itself.

CONNECTION The cave paintings at Lascaux and Aboriginal paintings were essential parts of rituals (see Figs. 5.3 and 5.4).

A pilgrimage is a journey to a shrine or sacred place for believers hoping to receive special blessings or deepening of faith. The concept of journey is both metaphoric and actual, as the soul's spiritual search for understanding has been likened to a physical journey. Almost all major religions incorporate the concept of pilgrimages into their belief systems—Muslims journey to Mecca, Jews to Jerusalem, Catholics to various sites such as Lourdes, Hindus to shrines dedicated to various deities, and so on.

Our first example is from the Longmen Caves in China, a huge complex of cave-shrines housing thousands of sacred statues, which is a Buddhist pilgrimage destination. At Longmen, 1,352 caves have been carved into the limestone mountains, with more than 97,000 statues and 3,600 inscriptions dedicated to Buddha. The largest of these is the monumental *Shrine to Vairocana Buddha* (Fig. 7.28),

7.29 Le Corbusier. *Notre Dame du Haut*, Ronchamps, France, 1950–1955.

The church's design recalls praying hands, dove wings, and a boat hull, Christian symbols of divine generosity.

dated c. 600–650, who is the universal principle dominating all life and all phenomena. He is attended by demons and lesser Buddhas who govern their own worlds, a model used by tyrant emperors in China to justify their rule. In fact, the carvings at the Longmen Caves were supported by imperial patronage. The Buddha at the center is serene, massive, and volumetric, with drapery defined with a few simple curves to enhance the colossal scale of the carving.

Another pilgrimage destination is the small church of *Notre Dame du Haut* (Fig. 7.29), a Catholic chapel in the Vosges Mountains of France, built between 1950 and 1955. The design recalls praying hands, the wings of a dove, and the shape of a boat, all Christian symbols of divine generosity to humans. The structure itself looks like it could be a sculpture. To accommodate very large crowds on holy days, the church was fitted with an outdoor altar and pulpit (visible toward the right in this photograph) so that services could be conducted for twelve thousand pilgrims on the lawn. Then, the building's exterior becomes a monumental sculptural backdrop for the religious event. The interior of *Notre Dame du Haut* is a relatively small space with limited seating, almost mystically dark and cave-like, with deep-set, square, colored-glass windows piercing the walls.

7.30 *Dome of the Rock*, Jerusalem, Israel, 687–692.

This pilgrimage shrine marks the site of the triumph of Islam in Jerusalem.

Another site for comparison is the *Dome of the Rock* shrine (Fig. 7.30), which was built in Jerusalem in 687–692. This historic place is a sacred pilgrimage destination for Jews, Christians, and Muslims. This oldest example of great Islamic architecture was built by the caliph Abd al-Malik as a monument to the triumph of Islam over the land of the Jews and Christians in 638. Built on a rock platform, it occupies the site believed to be the burial place of Adam, the altar on which Abraham's son Isaac was saved by the angel, the Hebrew Temple at Jerusalem destroyed by the Roman Emperor Titus in 70, and finally the stone from which Mohammed ascended to heaven and thereafter returned to his home in Mecca. The monumental shrine's design was influenced by the geometric characteristics of Roman and Byzantine architecture. Its structure is a highly ornamented octagonal platform topped with a gilded dome.

TEMPLE COMPLEXES AND LARGE-SCALE SACRED ARCHITECTURE

Some religious sites are more grand, extensive, and complex than what we have already seen. They are some of the most famous works of art in the world. Although they all incorporate the general characteristics of sacred sites that we saw at the beginning of this chapter, all go far beyond them. When a religion has become firmly established and tied to political power, these expensive, labor-intensive, long-term projects are possible. Thus, grand places of worship are expressions of temporal power, religious power, and broad cultural values. With imposing size and lavish detail, these structures are spectacles, amazing to see. In ceremonies, the individual is reduced to spectator, part of

A. HORUS TEMPLE
pylon façade 118' high

pylon

courtyard

pylon

hypostyle hall

B. ACROPOLIS
Parthenon approximately 60' high

to marketplace

Parthenon

slopes of the plateau

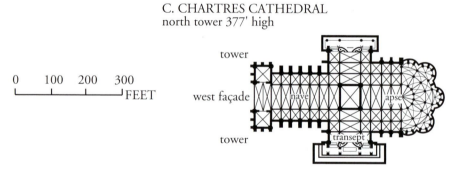

C. CHARTRES CATHEDRAL
north tower 377' high

0 100 200 300
FEET

tower

west façade nave apse

tower

transept

7.31 Comparison of the plans of various places of worship. Notice that all plans are drawn to the same scale and vary tremendously in size. Heights vary tremendously also; they are indicated next to each plan. (A) *Horus Temple* (top left), (B) *Acropolis* (middle left), (C) *Chartres Cathedral* (lower left), (D) *Pyramid of the Sun* (top center), (E) *Kandarya Mahadeva Temple* (right), (F) *Masjid-i-Shah* (lower center).

See Figure 7.37 for the plan of the Buddhist temple compound, the *Altar of Heaven*, which is too large to be shown to scale here.

the throng that adds to the religious importance of the site.

First, compare the plans of six of the seven major sites we will study (Fig. 7.31). All are drawn to the same scale. Even the smallest, the *Kandarya Mahadeva Temple*, is imposing with its 130-foot height. The largest, the *Pyramid of the Sun* in central Mexico, is truly enormous. The plans also reveal how important geometry is in these designs to suggest perfection, completion, balance, and formality. Symmetry is an excellent visual metaphor for political power and divinity.

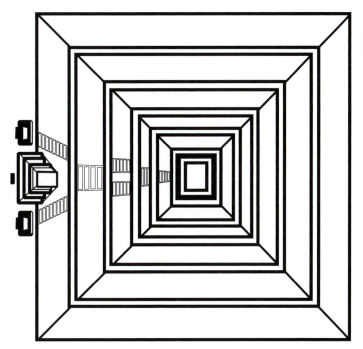

D. PYRAMID OF THE SUN
215' high

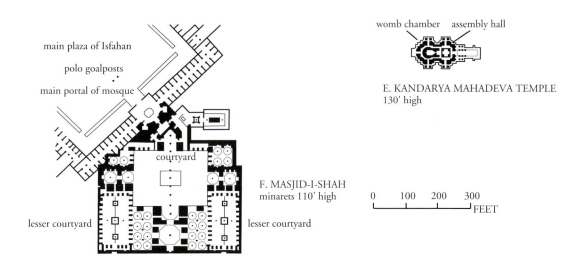

main plaza of Isfahan

polo goalposts

main portal of mosque

courtyard

lesser courtyard

lesser courtyard

womb chamber assembly hall

E. KANDARYA MAHADEVA TEMPLE
130' high

F. MASJID-I-SHAH
minarets 110' high

0 100 200 300
FEET

The plan of the seventh major site, the Buddhist *Altar of Heaven*, is shown in Figure 7.37. The temple compound is integrated into the design of a quarter-mile-wide park and will be discussed in that context. Let us begin our study of religious compounds and large-scale sacred architecture with the Greeks.

The Greek Temple

In studying Greek temple design, we will use the Parthenon in Athens as our focus example. Athens is situated on a plain surrounded by mountains, with a high plateau in the center dedicated to the city's patroness, Athena. This plateau, the Acropolis, forms a dramatic setting for temples and is a mountain to climb in the pilgrimage journey. Smaller buildings, clustered along the steep approach, contrast dramatically with the large temples and open space at the top (see the plan in Fig. 7.31B). It is visually impressive from many surrounding viewpoints.

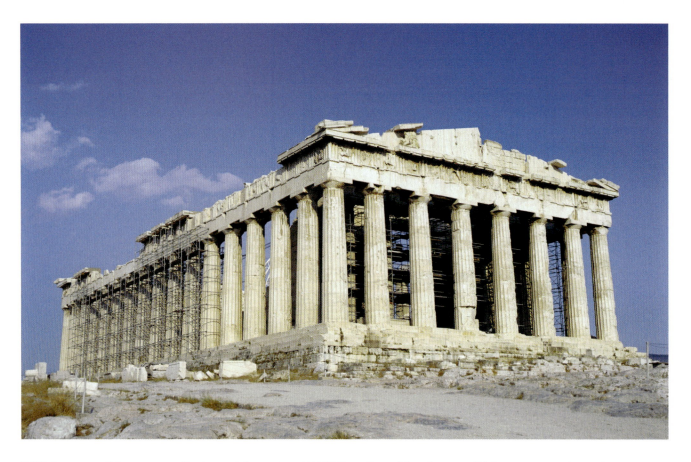

7.32 IKTINOS and KALLIKRATES. *Parthenon*, Athens, 447–432 BCE. Pentelic marble, columns 34' high, structure 228' × 104'.

This structure is the standard Classical Greek temple using the post-and-lintel construction and the Doric Order.

Temple Design

The *Parthenon* (Fig. 7.32) is a good example of a standard Classical Greek temple. Following a three-hundred-year precedent, it is a two-room structure with pediments above the short sides and a colonnaded porch all around. It is more graceful and refined than older temples, but, like them, it was covered using the post-and-lintel system. This particular style (or "order") of temple was called Doric and could be easily identified by its column. The Doric column had no base, a simple cushion capital, and a shaft that was fluted, or carved from top to bottom with thin, vertical channels. High-quality marble blocks were carefully stacked and finished so that the columns originally appeared seamless.

In designing the *Parthenon*, the architects Iktinos and Kallikrates often treated it more like a piece of sculpture than architecture. Like a pedestal, the steps form the base for the structure. They are higher at the middle of each side and lower at the corners, to counteract the illusion of sagging in the middle. Thus, the *Parthenon* contains optical illusions. The corner columns are thicker and placed closer to neighboring columns to compensate for the

glaring bright sky behind them that would make them seem thinner. Outer columns lean slightly toward the middle of the building to make the *Parthenon* more visually cohesive. The shaft of the Doric column has a slight swelling at the middle, called an *entasis*, to give the column a feeling of organic flexing.

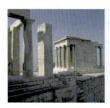

CONNECTION Near the Parthenon are the Propylaea and the Temple of Athena Nike (Fig. 2.36). See also Figure 2.37 for diagrams of the Doric, Ionic, and Corinthian orders.

Sculpture and Relief Carving

The *Parthenon* had two interior rooms for housing sacred objects, rooms that only a few priests entered. Religious ceremonies took place outside, so originally the exterior was richly adorned with sculpture and brightly painted. Large sculptures of the gods stood in the pediment and near the roof, and a long band of sculpture (3 feet 6 inches

7.33 *Horsemen* (from the *Parthenon* frieze), Athens, c. 440 BCE. Marble, 3′ 6″ high.

The relief is located in an upper band around the structure, representing some of the participants in the Panathenaic Festival procession.

high and 524 feet long), called a **frieze**, girded the top outside walls of the *Parthenon*'s two inner chambers. Carved c. 440 BCE, the frieze shows a long procession of Greek worshipers climbing up to the *Parthenon*, including marshals, youths, maidens, musicians, jar carriers, horsemen, and charioteers, some bringing animals for sacrifice. At the beginning of the procession, the worshipers are raucous and unorganized, like the *Horsemen* in Figure 7.33. Gradually, the worshipers become solemn and orderly as they approach the gods. This is a depiction of the special Panathenaic Festival procession, which occurred only once every four years to bring a new ceremonial tunic to robe an ancient wooden statue of Athena.

The carving on the sculptural frieze is very high quality, an especially amazing feat given that the sculpture is almost twice the length of a football field and was completed in less than a decade. Overlapping, crisscrossing diagonals—horses' legs, waving hands, drapery—communicate the bustle early on. Gods and humans are similarly rendered as rounded and lifelike, with carefully carved muscles. They are dignified, composed, well proportioned, and idealized. The frieze is carved more deeply at the top and more shallowly at the bottom to make it clearer to viewers below.

Mathematical Proportions and Greek Philosophy

In their science, geometry, art, religion, and philosophy, the Greeks were engaged in a search for perfection.

For example, they believed that certain geometric ratios and certain musical intervals resonated with the cosmic order and were in tune with the heavens. Thus, builders used a consistent set of proportions to determine the length and width of parts within the *Parthenon*, and they balanced horizontal and vertical elements to give the structure a quality of self-containment. By not being overwhelming in size, the *Parthenon* also reflects the Greek idea of the value of the individual. Now compare this Classic Greek temple with the following examples of worship places.

The Egyptian Temple

Egyptian temple design remained relatively constant for three thousand years, so the study of one will illustrate the qualities of many.

Setting and History

Protected by the desert, ancient Egyptians had an unusually stable existence. Natural cycles, such as night and day and the annual flooding of the Nile River, provided powerful symbols for the Egyptian religion. The Egyptians used symbolic geometry to demarcate sacred alignments in the landscape. East-west marked the path of Re, the Sun God, symbolizing life, death, and resurrection. The north-south axis paralleled the Nile River. Generally, cult temples, which were used to worship gods, were located on the east bank of the Nile, like the rising sun, while funerary

7.34 *Great Pylon of the Horus Temple at Edfu*, Egypt, c. 237–57 BCE. The pylons are 118′ high, and the façade is 230′ wide. Unlike most Egyptian cult temples, this one is located on the west side of the Nile River.

These "geometric" mountains flank the entrance to the temple, functioning both as a gate and as a social barrier blocking the lower classes from entry.

temples were on the west. Cult temples were often parts of large sacred cities. Successive pharaohs would add new temples to the complex or expand existing ones.

CONNECTION Other than cult temples, much Egyptian architecture, such as the *Mortuary Temple of Hatshepsut* (Fig. 8.7), consists of tombs and funerary temples.

Temple Design

The *Horus Temple at Edfu* housed the sacred cult image of the sun falcon, Horus. Because cult temples were believed to be the actual dwellings of the gods, they were modeled after the residences of nobles and pharaohs (see the plan in Fig. 7.31A). Courtyards and halls were like reception rooms, leading to the sanctuary that corresponds to the private family bedrooms. For purity, amulets protected the temple's foundations, and its outer edges were walled.

The *Great Pylon of the Horus Temple at Edfu* (Fig. 7.34), built c. 237–57 BCE, is a temple front entrance, with two large, symmetrical, geometric "mountains" flanking the large doorway. The image may have been derived from the Nile River flowing between cliffs. Visually, the pylons both define the entrance and act as barriers; indeed, the lower classes of the Egyptian population were forbidden

to enter. Statues and carvings animated the great surfaces, and they were painted to make the temple façade very colorful. The four vertical niches once held tall poles with flying banners.

All doorways and open areas were aligned to create a straight-line path that continues throughout the temple, suggesting the flow of the Nile River and echoing the Egyptians' sanctified experience of nature. The temple floor was painted to depict a river, and the ceiling was decorated with sunrays and the stars of the night sky. Two covered rooms are located beyond the entrance courtyard at Edfu (see the plan in Fig. 7.31A). They were hypostyle halls, with parallel rows of columns that supported the ceiling. In the *First Hypostyle Hall* at Edfu (Fig. 7.35), the columns are huge and closely spaced, clogging the interior space. The stone roof necessitated closely spaced supports. The concept of the passageway is again emphasized, as the space is not really usable as a room. The shapes of the columns and capitals were probably derived from the bundles of reeds used to build the very early Egyptian buildings. To express divine permanence and power, Egyptians translated that original organic material into massive and monumental granite and limestone. The stone capitals often resemble lotus buds, blossoms, or palm fronds. The shafts of the columns swell like the flexing of organic materials.

7.35 *First Hypostyle Hall, Horus Temple at Edfu*, Egypt, c. 237–57 BCE. The roof slabs are 50′ from the floor.

Huge, closely spaced supporting columns resemble lotus buds, blossoms, or palm fronds.

At Edfu, the columns of the hypostyle hall are 50 feet tall; at another temple site, Karnak, the central columns in the hypostyle hall are 66 feet high, and the capitals at the top are 22 feet in diameter, large enough to hold one hundred people. The massive stones are held in place solely by their tremendous weight.

The temple became darker with each succeeding room, and rooms became smaller, with lower ceilings. To help protect its purity, the sacred image of Horus was kept in the sanctuary at the very back, sealed by heavy doors covered with bronze or silver and decorated with precious stones. The holiest areas were opened only on special occasions and could be approached by only a very few. The sacred image of Horus did not always reside in darkness, however. On certain special feast days, such statues were taken out and rejoined with the sun to recover their vigor.

The Hindu Temple

Theology and Temple Design

Hinduism is based on two belief systems. The first is nature based and venerates the various spirits responsible for the incredible abundance of plant and animal life in India. From this came the concept of reincarnation, an infinitely repeating cycle of death and life. Around 1500 BCE, invaders brought the second belief system—an understanding of the cosmos in symbolic, geometric terms. For them, the circle stood for the totality of the universe; the square was that divine force made physical in life on earth; a vertical pole was the pillar between heaven and earth, a link that also ensured their separation. A good person would eventually break the cycle of rebirth and death and move into a changeless, timeless union with the Supreme Consciousness, Brahman.

7.36 *Kandarya Mahadeva Temple* (at left), Khajuraho, India, tenth–eleventh centuries. Main tower is 130′ high. The small Mahadeva Temple is at center, and in the distance is the Devi Jagadamba Temple.

This temple is dedicated to Shiva and is seen as an artificial mountain that surmounts a small, dark, womb-like chamber.

Temple architecture gives form to these spiritual beliefs. The earliest temples were cave temples carved into mountains, like opening the earth's womb to find the divinity enshrined inside. Other temples were free-standing, thick-walled cubes, containing a womb-chamber that housed the cult image or symbol of the deity. A heavy tower, like an abstract mountain, covered it, and a few relief sculptures adorned the exterior. Worshipers brought offerings, meditated, and made sacrifices indi-vidually but remained outside. Priests tended to the dei-ties housed inside and acted as intermediaries for the worshipers. Thus, the Hindu temple was more like sculp-ture with a small interior. There is no collective service in the Hindu religion, and the temple is the dwelling of the deity.

Later Hindu temples and precincts became much more elaborate, but the same basic formula of womb-chamber and mountain remains. In now-deserted Khajuraho, an important political capital in the tenth and eleventh cen-turies, was a grouping of thirty temples, symbolizing abun-dance and proliferation. One was the *Kandarya Mahadeva Temple* (Fig. 7.36), dedicated to Shiva in his manifesta-tion as Mahadeva, who maintains all living things. The *Kandarya Mahadeva Temple* is still an artificial mountain that surmounts the small, dark womb-chamber. The basic shapes are symbols of male and female sexuality, repre-senting sexual energy and the procreative urge. Then, almost lifelike, they break down into multiplying, cascad-ing forms that are fantastic in their variety and number. Several attached porches and a front assembly hall add to the proliferating forms.

Despite the elaborate details and forms, visual unity is maintained because of the basic mountain-like form and because of the simple umbrella shape (which represents

the Unbounded) that surmounts the tallest tower, above the womb-chamber. Thus, the temple exterior was an instrument of meditation on reincarnation. Up close, the relief carvings become more readable, with images of deities and of smaller shrines. Many are openly erotic because the Hindu religion believes that carnal bliss reflects divine union with the Unbounded.

> **CONNECTION** Figure 6.19 shows an erotic scene from the *Kandarya Mahadeva Temple.*

Geometry and Its Significance

The plan of the temple (Fig. 7.31E) is a mandala, a geometric drawing that symbolizes the universe, which we saw in Figure 7.22. Four porches on the temple pointing in the cardinal directions mark the four sides. Then the squares and circles, which have cosmic meaning, are repeated, rotated, and overlaid and finally expanded into space to create the fantastic compilation of shapes proliferating to become the outer layer of the temple, which still relates to the inner sanctum.

The Buddhist Temple

Distinct versions of Buddhist temples sprang up in India, Southeast Asia, Indonesia, China, Japan, and Korea. For now, we will confine our discussion to just one Buddhist temple compound from China, the *Altar of Heaven*, and to one temple within it, the *Temple of Heaven*.

The *Altar of Heaven* (Fig. 7.37), constructed over the fifteenth and sixteenth centuries, is a large, tree-filled temple compound located in Beijing, south of the palace core. Surrounded by a four-mile wall, the compound is square at its southern end and semicircular at its northern end. To the Chinese, the round shape symbolized the heavens, while the square represented the earth.

The major structures and roadways of the complex are laid out on a north-south axis. Altars and temples face south, the source of temperate weather and abundance, while the north was the source of evil influences. Temple complexes were also carefully sited relative to the forces of wind and water (*fengshui* means "wind and water") because wind disperses the breath of life and must be stopped by water. All structures are symmetrical and enclosed by walls, railings, terraces, or gates, expressing the Chinese values of seclusion and order.

⊢———⊣ 1/4 mile

The Altar of Heaven, Beijing
A Altar of Heaven
B Imperial Lofty Throne
C Temple of Heaven
D Palace of Fasting

7.37 *Altar of Heaven*, Beijing, fifteenth–sixteenth centuries. Plan and artist rendering.

This diagram shows the grounds of the altar and temple complex.

7.38 *Temple of Heaven*, Round Hall, Beijing, begun 1420, restored 1754. Wood with tile roof.

This is a three-tiered pagoda where the emperor officiated at religious and political ceremonies outside of the Forbidden City.

Three or four times a year, the emperor used the *Temple of Heaven* (Fig. 7.38), built in 1420 and restored in 1754, to officiate at religious-political ceremonies, mostly dedicated to the earth and crops. The temple is a lofty, three-tiered pagoda, a cone-shaped structure distinguished by its layers of eaves and gilded orb on top. Its shape is a geometrically simplified mountain form, like the Hindu temple. The entire structure is 125 feet high and nearly 100 feet across. The wide eaves provide shelter from bright sun and rain. The colors and patterns in this wooden building are brilliant. It has a gently curving, violet-blue tile roof, similar to the color of a dark blue sky. The outside walls are deep red, offset with bands of gleaming gold. The interior is red lacquer with foliage patterns in gold and blue and contains green and white beams. Twenty-eight tall posts on the interior entirely support the roof. There are no walls, only door-like partitions pierced with latticework. The four central posts represent the four seasons, while other columns represent the

months of the year and the division of day and night. In the center of the stone floor is a marble slab with a design incorporating the dragon and phoenix, symbols of the emperor and empress.

The *Temple of Heaven* sits atop three terraces surrounded by richly carved, lace-like, white marble balustrades. Worshipers circumnavigate the round structure at different levels to symbolize the achievement of wisdom. The temple's symmetry and order contrast strikingly with expanses of wooded areas.

The Hebrew Temple

Because the ancient Hebrew peoples seldom had a permanent homeland in the early years of their history, a tent was likely their early place of worship as well as a temporary temple. In approximately 957 BCE, King Solomon built the first Temple in Jerusalem, a grand structure that replaced the portable sanctuary of old. It was destroyed in 586 BCE, and the second Temple was begun and dedicated in 515 BCE. Today the Western Wall in Jerusalem is believed to have been a part of the remaining ruins of that Temple and is now the site where Jews from all over the world still go to pray. The wall is one of the foundations for the platform of the *Dome of the Rock* (Fig. 7.30). In more recent centuries, the synagogue has evolved for Jews as a community house of worship, assembly, and study, and it houses their sacred objects: an Ark, scrolls of the Law, an eternal flame, and a candelabra. This modern temple may be designed in various architectural styles.

CONNECTION Earlier in this chapter, we saw examples of art from Hebrew places of worship. Review the wall painting at the *Synagogue at Dura-Europus* (Fig. 7.11) and the *Ark of the Covenant* mosaic (Fig. 7.23).

The Gothic Cathedral

The imposing, mystical **Gothic** cathedral is one of the most famous forms of a Catholic church. Medieval Christians believed that the body and earth were profane and sinful, while the soul was sacred. They saw the church building as the heavenly Jerusalem on earth. Abbot Suger, a leading cleric during this era, remarked upon entering a Gothic church, "I see myself existing on some level . . . beyond our earthly one, neither completely in the slime of earth nor completely in the purity of Heaven." Gothic cathedrals were all funded by and built in cities, indicating the rise of cities and monarchies and

7.39 *Chartres Cathedral*, Chartres, France. The oldest western parts date from 1145–1170; most of the exterior of the structure was built between 1194 and 1220. The south tower is 344′ high and the north tower 377′ high; the cathedral itself is 427′ long. A rose window is visible at the middle of the church.

The tall vertical design emphasized by its spires symbolizes the Roman Catholic Church's role of linking heaven and earth.

a decline in feudalism. The modern humanist view that values the individual was beginning to develop at this time. Gothic churches are remarkable human achievements. While they evoke the spiritual realm, they do so by giving pleasure to the senses.

Plan and Design

Gothic cathedrals towered over the towns around them, which is evident with *Chartres Cathedral* (Fig. 7.39), mostly built between 1194 and 1220. The spires symbolized the church's role linking heaven and earth. Flat, blank walls are almost nonexistent. Large windows are filled with tracery, a lacy stone framework that holds sections of glass in place. Blank spaces are covered with figurative sculptures or decorative carvings, showing Jesus, saints, rulers, and sometimes demons. Flying buttresses create a visual pattern of forms that jog in and out, as can be seen at the right in Figure 7.39. Towers, arches, buttresses, and arcades create vertical lines that continue from ground to roof. The plan of *Chartres* is symmetrical, while its shape (Fig. 7.31C) is a cross, symbolizing Jesus' crucifixion as the act of salvation that redeemed sinful humanity.

The emphasis on verticality continues inside. Long lines rise from the floor, continue up the piers and between the windows, and flow gracefully up the pointed groin vaults. The vaults seem to billow overhead rather than being stone structures that weigh tons. There is also

7.40 *Rose Window*, from the north transept of *Chartres Cathedral*, Chartres, France, 1233.

The stained glass filled the church with light. In the center are Mary and Jesus, surrounded by Old Testament prophets.

a strong horizontal pull toward the altar, with the large windows at the apse end that are like bright beacons.

Window Design

The large stained-glass windows were not only incredible technical achievements but also powerful symbols of heavenly radiance. Previously, churches tended to be very dark, but these windows fill the Gothic church with muted light. The flying buttresses on the outside make the enormous windows possible because the buttresses and not the walls are holding up the vaults above.

The *Rose Window* (Fig. 7.40), from 1233, on the north transept of *Chartres*, shows rings of Old Testament prophets and kings surrounding Mary with her child Jesus. This illustrates the Christian concept that the Old Testament culminated in the birth of Christ. Mary's central location indicates the raised status of women. (In fact, the church is dedicated to Mary.) The female model was now Mary, mother of the savior Jesus, rather than sinful Eve.

Geometry was used to locate the various small scenes in this window by inscribing and rotating squares within a circle. The window is shaped like a blooming rose, a symbol of Mary.

CONNECTION For an example of the English style of Gothic architecture, see the *Chapel of Henry VII* (Fig. 8.19).

The Islamic Mosque

The religion of Islam requires that its adherents pray five times a day while bowing toward Mecca, the birthplace of the prophet Mohammed. On Friday, men are required to attend collective prayer services in mosques, a word derived from the Arabic **masjid**, which means "prostration." The faithful ritually cleanse themselves and then assemble on beautifully patterned rugs facing Mecca for prayer, sermons, and readings from the Quran (or Koran), the Islamic book of sacred texts.

It is thought that the plan of Mohammed's house in Medina influenced the design of early mosques, which were simple courtyards with shaded areas. On the wall facing Mecca was the **mihrab**, a special marker niche.

A stepped pulpit called the **minbar** was usually located next to the mihrab. The tall minarets could be seen from afar, as a beacon to travelers. There are no icons, statues, or images in Islamic worship or in mosques.

Later Developments in Mosque Design

One of the most beautiful mosques ever constructed is located in ancient Persia (present-day Iran). Shah Abbas I (the Great) sought to make Persia an important center and undertook an ambitious urban renewal program in the capital city, Isfahan. With the *Masjid-i-Shah*, or *Royal Mosque* (Fig. 7.41), dated 1612–1637, the individual parts of the mosque became elaborate and were given separate identities. The portals, for example, became separate, large structures distinguished by elaborate decoration and pattern to awe and draw in the viewer. The once-simple courtyard evolved into a two-story arcade covered with blue-patterned tiles, with four huge, porch-like portals, where schools of Islamic theology could be assembled. The covered prayer hall is physically and conceptually separate from the open courtyard (see Fig. 7.31F). Worshipers move through a series of interlocking areas to leave the profane world and enter the sacred realm. The single minaret has multiplied to four.

7.41 *Masjid-i-Shah*, or *Royal Mosque*, Isfahan, Iran, 1612–1637. The arch of the main portal, to the left in this picture, is 90′ high; the minarets are 110′ high.

Worshipers moved through various spaces to leave the profane world and enter the sacred realm.

The *Masjid-i-Shah* has a very rough exterior finish, contrasting with the lavishly decorated interior. The spaciousness and symmetry of the mosque represent the infinity and completeness of Allah.

Pattern

Ornamentation is profuse and serves several purposes: (1) it symbolizes Allah in its suggestion of infinity and creation; (2) it enhances the sacred character of the mosque; (3) it identifies and makes visually distinct the various parts of the mosque, so that portals, porches, windows, domes, and the mihrab are easily recognizable; and (4) it disguises the mosque's mass, although not its form. The mosque walls seem to be merely thin screens of incredible color and delicate pattern rather than thick, heavy, massive brick walls.

Other elements add more pattern. Windows are covered with decorative screens that break up the light into patterns as it reflects off the patterned tiles. Reflecting pools are common, and this mosque has one in the courtyard that mirrors the buildings around it. Disturb the water, and the image vanishes. Text passages on mosque walls are a favored form of decoration. Calligraphic lettering was stylized to become very elegant and, in some instances, almost indistinguishable from geometric or foliage patterns, as seen above the doorway. The panels on either side of the doorway in Figure 7.42 resemble Persian weavings and tapestries. In the Islamic world, weavings serve utilitarian functions in the home, palace, and mosque, but they are also high aesthetic achievements and signs of favor. As treasured portable objects, they recall the early nomadic Arabs and the founding of Islam. The **mukarnas (muqarnas)**, or vaults above the door, are also pattern elements. The hanging quarter-domes break up the structure and disguise the mass of the building.

The entire complex is unified by the enormous, patterned turquoise dome that dominates the Isfahan skyline. The circular dome stands for the heavens and symbolizes the oneness of Allah.

7.42 *Masjid-i-Shah*, or *Royal Mosque*, main entrance portal, Isfahan, Iran, 1612–1637.

This photo shows the intricate ornamentation of pattern and calligraphy meant to draw in and awe the viewer.

CONNECTION The *Taj Mahal* (Fig. 8.20) is an Islamic funerary structure decorated with carved and inlaid stones.

The Mesoamerican Temple

Mesoamerican temples often took the form of a pyramid with a small structure on top. Indeed, the pyramid or the mound was a frequent holy site throughout the Americas, from Illinois to Peru.

History and Setting

Thirty miles north of today's Mexico City, the Teotihuacános, a pre-Aztec people, built a vast religious center in a large city high on a plateau surrounded by mountains, a center that reached its peak from 100 to 400 CE. Teotihuacán, or "Place of the Gods," had 200,000 residents, enormous temples, and numerous and lavish palaces and governed a wide area. Unlike in previous rambling Mesoamerican cities, the streets of Teotihuacán were rigidly laid out on

a grid oriented to north, south, east, and west, and even a river through the town was channeled to conform to that grid. The main north-south corridor, the Avenue of the Dead, formed the religious center of the city, with more than one hundred temples in two miles. The incredible scale of the Avenue of the Dead dwarfs any of the places of worship we have seen so far (see Fig. 7.31D). Still, the style of architecture is remarkably consistent throughout, and the overall design emphasizes both space and mass: the pyramids as solid mass, with plazas as voids that were often the same size as the bases of the pyramids. Ball courts were also included.

The very building and growth of Teotihuacán directly led to its decline, as forests were leveled to fire plaster kilns, resulting in soil erosion, along with the failure of rains and the decline of the city.

Temple Designs

In the middle of the Avenue of the Dead was the *Pyramid of the Sun* (Fig. 7.43), begun before 150 CE and probably dedicated to sun worship. It was aligned east-west and along the rising of the star cluster Pleiades on the days of the equinox and once had a temple atop it. The pyramid is quite simply staggering in size, covering 7.5 acres and rising 215 feet. The Teotihuacános did not use the wheel and had no beasts of burden, so people carried the 2.5 million tons of earth, stone, and rubble to the site. Probably three thousand laborers worked thirty years to complete the pyramid. The ledges, tiers, vertical insets, and square corners visually separate the pyramid from the rounded mountains that surround it. To prevent erosion, it was built with a relatively low profile, with embedded stone walls set perpendicular to the outer face. The design features **talud** and **tablero** construction, alternating slopes and inset platforms.

The entire earthen mound was once covered with huge clay bricks faced with stone and finished with a coat of smooth, white, polished lime plaster. It must have looked like a gleaming white mountain, with certain parts painted in color. Ceremonies with splendid pageantry were likely held on the steps and ledges.

CONNECTION There are many similarities between the *Pyramid of the Sun* and the *Ziggurat at Ur* (Fig. 7.24), seen earlier in this chapter.

7.43 *Pyramid of the Sun* (background), with smaller pyramids lining the Avenue of the Dead in the foreground, Teotihuacán, Mexico, begun before 150 CE. The pyramid is 768' along one side of the base.

This huge pyramidal temple is part of an expansive complex of temples and courtyards.

7.44 *Tlalocan Painting*, from Tepantitla compound, Teotihuacán, Mexico. Copy by Agustin Villagra; original: pigment on stucco.

This frontal image represents the water goddess with water droplets springing from her hands.

Temple Painting

Early temples had sculptural ornamentation, but after the third century, paintings were used, like the restored copy of the *Tlalocan Painting* (Fig. 7.44), from a palace in Teotihuacán. Tlalocan was paradise ruled by the rain god, Tlaloc, and his goddess consort. A large frontal figure at the center is a water goddess with green water droplets springing from her hands. Plants populated with butterflies and spiders grow from her head, while two priests, shown symmetrically and smaller in scale,

attend and make offerings. The colors in this restored version are bright, with an especially intense red background. The deity is distinguished by her larger size and frontality and by the profusion of symmetrical patterns that ornament her. In fact, the entire piece shows the Teotihuacános' fondness for elaborate symmetrical patterns, both in framing and in depicting characters.

ART EXPERIENCE Ponder this question: Are the arts necessary for us to grasp the divine realm at all?

8

MORTALITY AND IMMORTALITY

Our awareness of our mortality and the quest for immortality seem to be a strictly human phenomena. Life, death, and the afterlife have always been and will continue to be intertwined with art making.

PREVIEW

From ancient times to the present, the living have made both tombs and commemorative art to serve various purposes. These purposes may be to (1) express a culture's ideas and values about death and the afterlife; (2) closely tie religion to ritual burials; (3) promote political and social intentions; (4) visually establish power; and (5) guarantee honor, fame, and/or glory. The artwork covered here ranges from the awesome grandeur and ambition of the Pyramids to the bright and personal quality of the Coca Pod Coffin by Kane Kwei (Fig. 8.1).

For Art Experiences, you are invited to design a variety of memorials for loved ones or for a celebrity or political leader.

Connecting Art and History from
500 BCE–500 CE

Major civilizations and empires flourished around the world at this time (see Map 4). The great wealth and power of these empires produced elite classes who commissioned amazing works of art, among which were monumental tombs and funerary art that preserved their fame.

In Greece, which consisted of independent city-states, 500–338 BCE is considered the Classical period. In Athens, artworks reflected Greek humanism with their idealized yet naturalistic representations of the human figure, as seen in the *Grave Stele of Hegeso* (Fig. 8.15). Athens also developed an early but short-lived form of democracy. In the fourth century BCE, the Macedonians conquered the Greeks and, under Alexander the Great, invaded Persia and defeated King Darius. Alexander's empire, stretching as far as India and the Middle East, further spread Greek influence.

The Etruscan civilization, consisting of city-states, occupied much of central Italy. What we know about the Etruscans comes largely from excavations of their tombs and funerary art. Tomb paintings of lively people feasting, dancing, or enjoying outdoor sports are common, as in the *Banqueters and Musicians* from the Tomb of the Leopards (Fig. 8.9). The *Sarcophagus with Reclining Couple* (Fig. 8.8) indicates that Etruscan women enjoyed considerable independence. They attended symposia and sporting events, were equals at banquets with their husbands, owned property independently, and likely had a high rate of literacy. Beginning in 509 BCE, the Romans began chipping away at Etruria, and they completely overwhelmed the Etruscans by 273 BCE.

Map 4 The Assyrian and Persian Empires.

Rome was founded as a city in 753 BCE, but by 100 CE its influence had spread into Europe, Asia Minor, and North Africa. At first a republic, Rome became an empire in 27 BCE when Caesar Augustus came to power. His reign was the beginning of the Pax Romana (Roman Peace), which lasted for two hundred years and saw the construction of many amazing Roman monuments, including the *Pantheon* (Fig. 7.27), the *Colosseum* (Fig. 14.11), and the *Ara Pacis Augustae* (Fig. 9.33). In Rome, an individual's or a family's pedigree was important, evidenced by the many busts of ancestors or funerary monuments, as in the *Statue of Togato Barberini* (Fig. 12.13) and the *Funerary Relief of a Circus Official* (Fig. 8.16).

Early Christian art developed within the influence of Roman art, although Christians were subject to periodic persecutions. In 312, Emperor Constantine made Christianity legal, and, eventually, it became the religion of the empire. The fragments of the *Colossal Statue of Constantine* (Fig. 8.2) clearly indicate that he was a powerful ruler, but others found it difficult to hold the huge expanse of the empire together, and it was subdivided periodically. The *Mausoleum of Galla Placidia* (Fig. 8.17) is an excellent example of late Roman and early Christian art. Nomadic tribes from northern Europe overran the western part of the Roman Empire by 476 CE. The eastern portion survived for another thousand years as the Byzantine Empire.

In India, the Mauryan Empire united most of the country with a central government between 321 and 185 BCE. The major rulers were Chandragupta and Asoka. The empire included northern and central India (modern Pakistan and part of Afghanistan). The Golden Age of India occurred between 330 and 500 CE during the Gupta Empire, begun by Chandragupta I. During this time, India prospered, and the arts were highly developed (see the *Lion Capital*, Fig. 2.15).

In China during the Zhou Dynasty, which ended in 256 BCE, Confucianism and Daoism were practiced, and the art of lacquering was developed. From 221 to 206 BCE, Shi Huangdi destroyed rival states and unified China, establishing the Qin Dynasty. To consolidate his power, he had all historical books burned and scholars burned or buried alive to eradicate old traditions. He established a civil service and bureaucratic government that continued for centuries in China. He built *The Great Wall* (see Fig. 9.22), highways, and canals and standardized weights, measurements, axle widths, currency, and script styles for trade. The life-size ceramic army, the *Soldiers from Pit 1* (Fig. 8.10), that guarded his extravagant tomb is an eloquent visual monument to a ruthlessly ambitious ruler.

Shi Huangdi's dynasty ended quickly after his death and was succeeded by the Han Dynasty (202 BCE to 222 CE). Arts included wall painting and sculpture. There was a major expansion of both domestic and foreign trade.

8.2 *Colossal Statue of Constantine*, fragments, c. 330 CE. Palazzo dei Conservatori, Rome.

Constantine was the first Roman emperor to legalize Christianity in the empire.

During this period, Egypt was dominated by foreign powers, but Egyptians' funerary art practices continued. Farther south in Africa, the Great Empire of Ghana was established in 300 CE. The Ghanaians set up trade routes and controlled trade in gold and salt. South of Egypt, the independent state of Kush thrived as a result of vigorous trade. In 400, the Bantu people settled in South Africa.

In Mesoamerica, the Maya developed writing, a calendar, sophisticated architecture, painting, and sculpture between 250 and 900. In Peru, the Chavin culture flourished between 1000 BCE and 200 CE and developed agriculture and art. Later, the Moche, whose culture dates from 200 to 800, built pyramids, buried their dead in elaborate tombs, and made fine pottery (see Figs. 6.16 and 6.30). Their leaders were warrior-priests whose regalia likely inspired awe and fear (see the artifacts in Fig. 8.12 and the *Peanut Necklace* in Fig. 8.13 from the *Royal Tombs of Sipán*).

World Art Map for Chapter 8

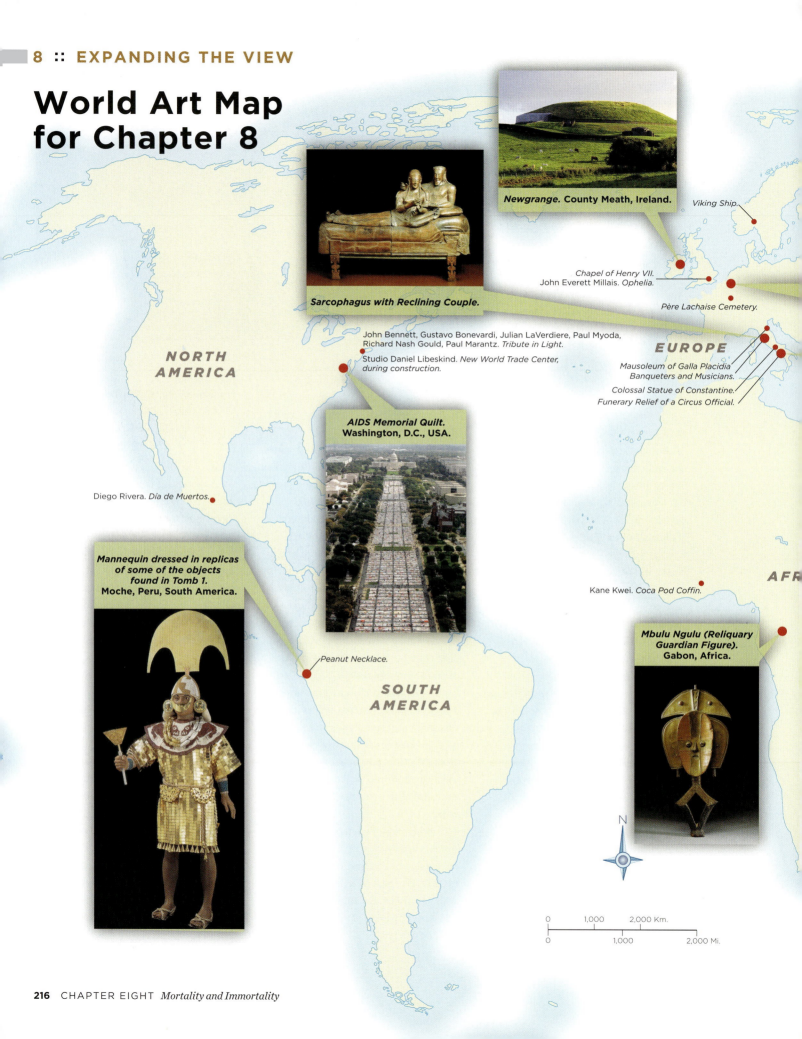

Newgrange. County Meath, Ireland.

Viking Ship.

Chapel of Henry VII.
John Everett Millais. Ophelia.

Père Lachaise Cemetery.

Sarcophagus with Reclining Couple.

NORTH AMERICA

John Bennett, Gustavo Bonevardi, Julian LaVerdiere, Paul Myoda, Richard Nash Gould, Paul Marantz. *Tribute in Light.*

Studio Daniel Libeskind. *New World Trade Center, during construction.*

EUROPE

Mausoleum of Galla Placidia
Banqueters and Musicians.

Colossal Statue of Constantine.
Funerary Relief of a Circus Official.

AIDS Memorial Quilt. Washington, D.C., USA.

Diego Rivera. *Día de Muertos.*

Mannequin dressed in replicas of some of the objects found in Tomb 1. Moche, Peru, South America.

Kane Kwei. *Coca Pod Coffin.*

AFR

Mbulu Ngulu (Reliquary Guardian Figure). Gabon, Africa.

Peanut Necklace.

SOUTH AMERICA

N

| 0 | 1,000 | 2,000 Km. |

| 0 | 1,000 | 2,000 Mi. |

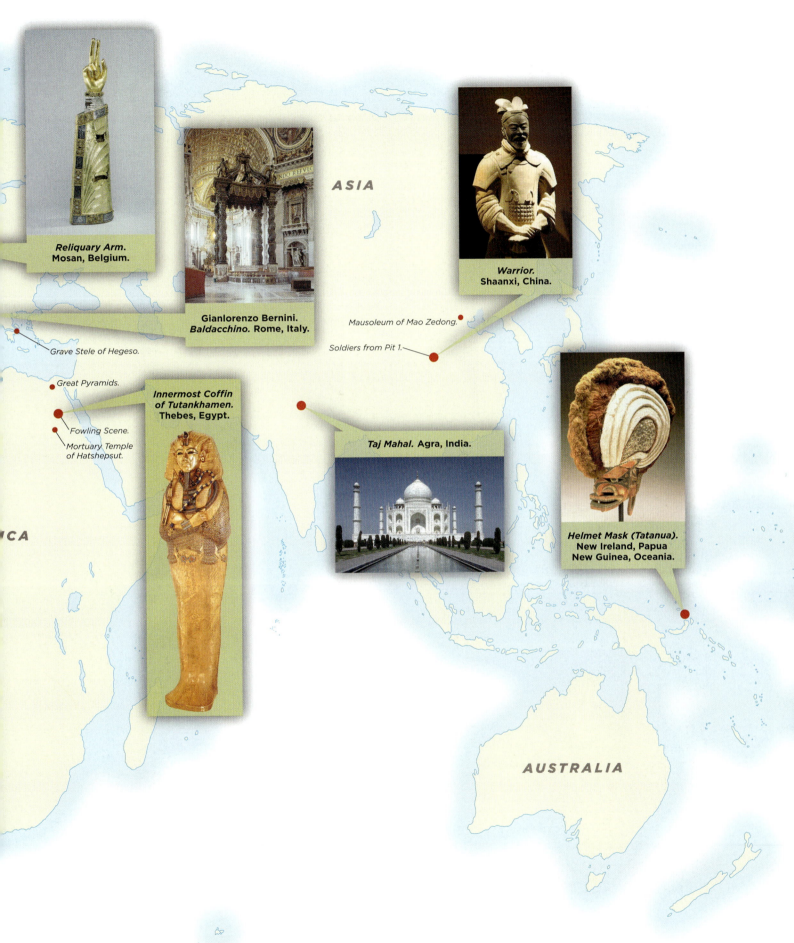

Reliquary Arm. Mosan, Belgium.

Gianlorenzo Bernini. *Baldacchino.* Rome, Italy.

ASIA

Warrior. Shaanxi, China.

Mausoleum of Mao Zedong.

Soldiers from Pit 1.

Grave Stele of Hegeso.

Great Pyramids.

Innermost Coffin of Tutankhamen. Thebes, Egypt.

Fowling Scene.

Mortuary Temple of Hatshepsut.

Taj Mahal. Agra, India.

Helmet Mask (Tatanua). New Ireland, Papua New Guinea, Oceania.

ICA

AUSTRALIA

500 BCE-500 CE

		MIDDLE KINGDOM— EGYPT	HISTORY FOCUS	PERICLES' GOLDEN AGE OF GREECE
				Parthenon Restored
				ROMAN REPUBLIC ESTABLISHED
		NEW KINGDOM— EGYPT	**CHAVIN CULTURE—PERU**	**QIN DYNASTY— CHINA**
UNIFICATION OF EGYPT	**OLD KINGDOM— EGYPT**		**ETRUSCAN CIVILIZATION**	*Peloponnesian War*
			NEO-ASSYRIAN EMPIRE	*Alexander Invaded Persia*

4000 BCE	3000	2000	1000	500	400

Newgrange burials	Great Pyramids, Gizeh	Mortuary Temple of Hatshepsut	Sarcophagus with Reclining Couple		Soldiers from Pit 1 Warrior
		Innermost Coffin of Tutankhamen	Banqueters and Musicians		
		Fowling Scene, Egypt	Grave Stele of Hegeso		

∧ Temple of Ramses II, Abu Simbel (12.22)

Royal ＞ Profile (3.3)

∧ Ashurbanipal II Killing Lions (13.9)

AGE OF ENLIGHTENMENT

Colonization of the Americas and Africa
Industrial Revolution
American Revolution
French Revolution
South American Revolutions

ROMANTICISM

Mexican Independence from Spain

1700	1750	1800	1850

Père Lachaise Cemetery

MILLAIS. *Ophelia*

Helmet Mask (Tatanua), Papua New Guinea

∧ GOYA. *The Executions of May 3, 1808* (10.3)

∧ RED HORSE. *Battle of Little Big Horn* (9.26)

∧ BRADY or STAFF. *Dead Confederate Soldier with Gun* (9.25)

ZHOU DYNASTY—CHINA

Daoism and Confucianism

Birth of Jesus Christ

Constantine Legalized Christianity

ROMAN EMPIRE

MOCHE CIVILIZATION—PERU

GOLDEN AGE OF INDIA—GUPTA EMPIRE

RENAISSANCE BEGINS IN EUROPE

FIRST EMPEROR, QIN DYNASTY—CHINA

GREAT AFRICAN EMPIRE OF GHANA

BYZANTINE EMPIRE

Islam Religion Founded

GOTHIC ERA

MALI EMPIRE AT HEIGHT

BAROQUE ERA BEGINS IN EUROPE

| CE 100 | 200 300 425 | 500 | 1000 | 1500 1600 |

Funerary Relief of a Circus Official

Royal Tombs of Sipán

Colossal Statue of Constantine, Rome

Mausoleum of Galla Placidia, Ravenna, Italy

Viking Ship

Reliquary Arm

Chapel of Henry VII

BERNINI. *Baldacchino*

Taj Mahal

GHIBERTI. ›
Sacrifice of Isaac (7.17)

World War II

PEOPLE'S REPUBLIC OF CHINA

Vietnam War

Russian Revolution

Death of Mao Zedong

World War I

Desert Storm

September 11 Terrorist Attacks

| 1900 | 1940 | 1970 | 2000 2002 2012 |

RIVERA. *Día de Muertos*

Mbulu Ngulu (Reliquary Guardian Figure)

Mausoleum of Mao Zedong

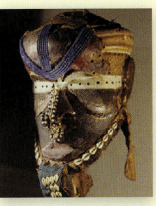

˄ *Ceremonial Mask*, Zaire (1.6)

˄ HOCKNEY. *A Bigger Splash* (3.29)

KWEI. *Coca Pod Coffin*

AIDS Memorial Quilt

˄ SMITH. *Born* (3.17)

Tribute in Light

New World Trade Center

EARLY TOMBS: MOUNDS AND MOUNTAINS

The very earliest tombs in many cultures are shaped like hills or mountains. The Egyptians built pyramids, which were geometric mountains. Others built funeral mounds that look like naturally occurring grass-covered hills, some small and others quite large. They contain hidden burial chambers, usually for elite members of a society. Some were lavishly furnished. The locations of mound graves were often tied to a natural phenomenon, such as the movement of the sun. Mound graves can be found in Europe, Asia, the Middle East, and the Americas.

Ancient Burials

Funerary practices, religion, agriculture, and astronomy were often interrelated among early peoples. Among the oldest tombs are the New Stone Age mounds in western Europe. In Ireland, the New Stone Age tomb of *Newgrange* (Fig. 8.3), from 3200 BCE, is part of a complex of tombs and monolithic rock structures. It contains 220,000 tons of loose stone with a white quartz rock facing on one side. Inside a long passageway leads to a cross-shaped interior chamber with five burials. The passageway has forty-ton

stones, some decorated with spirals and geometric patterns, perhaps indicating stars and planets. It is sealed to prevent water seepage. *Newgrange* is oriented so that for about two weeks around the winter solstice, a burst of brilliant morning sunlight radiates down through the entire passage, illuminating one patterned stone in the burial chamber. Over time, like other mounds, *Newgrange* eroded and blended into the natural landscape. *Newgrange* ceased to be used for any ritual activity after the fourth century CE and remained undisturbed until 1699 CE, when it was rediscovered by men quarrying for building stone.

CONNECTION *Stonehenge* (Fig. 7.26) is an example of a monolithic rock structure, dating from the same era as *Newgrange*.

The *Great Pyramids* of Egypt are perhaps the most famous ancient burial sites, and they serve as the focus

8.3 *Newgrange*, Neolithic, County Meath, Ireland, 3200 BCE.

This ancient mound is oriented so that, during the winter solstice, sunlight radiates through a passage that illuminates a patterned stone.

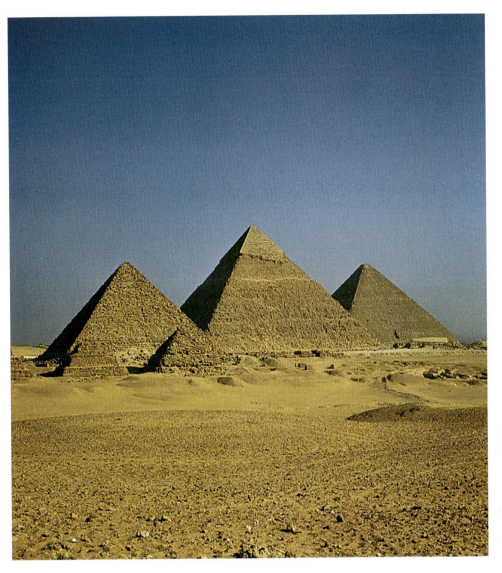

8.4 *Great Pyramids*, Gizeh, Egypt. From left, *Menkaure*, c. 2525–2475 BCE; *Khafre*, c. 2575–2525 BCE; *Khufu*, c. 2600–2550 BCE.

Oriented to the sun, these are the tombs of the pharaohs, who were believed to be sons of Re, the Sun God.

figures for this section. Like *Newgrange*, the *Great Pyramids* are very old, very large, very influential in style, and oriented to the sun. They are the tombs of the pharaohs, the rulers of Egypt who were believed to be the sons of the most powerful of all the gods, Re, the Sun God. The pyramids, standing dramatically on the edge of the Sahara Desert, are artificial mountains on a flat, artificial plane. They are part of a necropolis, composed of tombs and mortuary temples, that extends for fifty miles on the west bank of the Nile. The pyramids of pharaohs *Menkaure* (built c. 2525–2475 BCE), *Khafre* (built c. 2575–2525 BCE), and *Khufu* (built c. 2600–2550 BCE), shown in Fig. 8.4, are the largest among all the pyramids. The numbers associated with the very largest, the pyramid of *Khufu*, are often recited but still inspire awe: 775 feet along one side of the base; 450 feet high; 2.3 million stone blocks; average weight of each block, 2.5 tons.

The *Great Pyramids* have interior chambers that are quite small and, when opened in modern times, contained only empty stone crypts. The tombs may have contained provisions, but they were robbed shortly after they were sealed. In an effort to thwart grave robbing, which was rampant in ancient Egypt, later pharaohs stopped building enormous, expensive, ostentatious tombs like the pyramids. Instead, later rulers were buried in less costly chambers cut deep into the sides of mountains, with hidden entrances.

FURNISHED TOMBS

Many cultures believed that the afterlife was similar to this life and that the dead continued to "live" in the tomb and needed furnishings like those used when they were alive, such as furniture, clothing, utensils, and precious items.

Egyptian Tombs and Mortuary Temples

One thousand years after the *Great Pyramids*, the Egyptians provided the supreme examples of furnished tombs, which were the meeting places between earthly life and eternity. According to Egyptian beliefs, a human soul possessed both a **ba** and a **ka**. The *ba* is the part of the soul whose seat was the heart or abdomen in the body. It is depicted as a human-headed bird. When humans take their last breath, the *ba* flies from the body. Seventy days later, after the body has been mummified and buried, the *ba* returns, hungry and thirsty. A well-prepared tomb is filled with provisions to satisfy the needs of the *ba* in the afterlife, including water, wine, grains, dates, cakes, and even dehydrated beef and fowl.

The *ka* is the mental aspect of the human's soul. It is symbolized by two outstretched arms or by an attendant figure that represents the double of the personality. The *ka* dwells in a lifelike statue of the deceased, which is placed in the tomb. It was important for both the statue and the sarcophagus to have a strong likeness of the dead person so that both the *ba* and the *ka* could easily recognize their destinations. The *ba* and the *ka* were thought to enter the tombs through a small chimney or an air vent. Provisions for the *ka* would include chairs, beds, chariots, models of servants, kitchen utensils, dishes, and simulated food (unlike the real food the *ba* required). Combs, hairpins, and ointments were also included, along with games for entertainment. Rich treasures of gold and silver as well as carriages and boats for the *ka*'s journey to heaven have also been found in the more elaborate tombs.

These richly furnished tombs have been targets for robbers since early times. Despite later pharaohs' efforts to hide their tombs, almost all were robbed long ago, except that of King Tutankhamen, which was only partly plundered. Ironically, while stealing treasures from a nearby tomb, robbers happened to heap more debris on the entrance to Tutankhamen's tomb, so it remained undisturbed until 1922. Among the amazing treasures found in Tutankhamen's tomb was his *Innermost Coffin* (Fig. 8.5), dated c. 1325 BCE. It is beaten gold, weighing nearly three-quarters of a ton, and is inlaid with semiprecious stones. Two other, larger coffin cases of gold fit over it, and together they encased the mummy. To preserve bodies and make them recognizable, they were mummified with **natron**, a mineral mixture found in the desert. Portraits also were placed in the tomb as substitute spirit receptacles in case something happened to the mummy. Pharaohs had several stone statues or effigies in gold, like the *Innermost Coffin*. The wings of the god Horus protectively encircle the coffin, and Tutankhamen holds insignia of his rank.

8.5 *Innermost Coffin of Tutankhamen*, Thebes, Egypt, c. 1325 BCE. Gold inlaid with enamel and semiprecious stones, 6′ 1″ long. Egyptian Museum, Cairo.

Unlike many of the pharaohs' tombs, this one was only partly plundered, leaving a vast amount of funerary treasure.

8.6 *Fowling Scene*, wall painting from the tomb of Nebamun, Thebes, Egypt, c. 1400–1350 BCE. Paint on dry plaster, approx. 2′ 8″ high. British Museum, London.

This is a depiction of an Egyptian noble in the afterlife hunting in the abundant Nile River.

Certain features are standard on Tutankhamen's face: the distinctive eye makeup; the false beard, a symbol of power; the striped head-cloth; and the cobra head to frighten enemies. Nevertheless, it is indeed a portrait of Tutankhamen.

The tomb also contained inlaid chests, gilt chairs, and other wooden items covered with gold. These items included carved watchdogs, life-size guardian statues, and jewels, among many others. To provide for the comfort of those of high rank, clay statues of servants were included in the tombs. Because Tutankhamen died unexpectedly before the age of twenty, there was little time to prepare his tomb, as mummification, funerary rites, and burial had to be completed in seventy days. Archaeologists believe that his tomb was surely less lavishly furnished than those of pharaohs with long reigns. It is small and its walls were painted, whereas other rulers' tombs were large, barrel-vaulted chambers with relief carvings.

In Egyptian tombs, wall paintings and carvings re-created the pleasures and labors of earthly existence. The *Fowling Scene* (Fig. 8.6), a wall painting from the tomb of Nebamun, c. 1400–1350 BCE, shows an Egyptian noble hunting in the marshes along the Nile River. The air is filled with birds that are painted with care and distinction, and the water is teeming with fish. Pattern is important, as seen in the water ripples and the repeated image of birds in the nobleman's hand. The marsh grasses fan out in a beautiful but rigid decoration. Depth is rarely shown in ancient Egyptian paintings, so everything is distributed vertically or horizontally. Pattern elements are visual metaphors for the seasonal cycles of the Nile, the unchanging culture, and the vast desert that surrounds the river valley.

In this wall painting, humans dominate the scene. The noble is shown in the formal manner reserved for exalted persons: head, shoulders, legs, and feet in profile; eyes and shoulders frontal. Size was an important indicator of rank, so the nobleman is larger than his wife and daughter, indicating their lower status.

When high-ranking Egyptians began to hide tombs in hillsides, the funerary temples that formerly were appendages to pyramids were enlarged and emphasized.

The *Mortuary Temple of Hatshepsut* (Fig. 8.7), c. 1490–1460 BCE, shows this later development. Hatshepsut was a woman pharaoh in the Eighteenth Dynasty, and the temple was the monument to her greatness. It once housed two hundred statues of her and many brightly painted reliefs showing her divine birth, coronation, military victories, and other exploits. In the years after her death, Hatshepsut's portraits were defaced, and records of her rule were obscured until they were rediscovered in the nineteenth century.

This large temple has an open, light design, without the mass and weightiness of the earlier pyramids. The simple vertical columns echo the cliff's rock formations. A quarter-mile-long forecourt contained a garden with a

8.7 *Mortuary Temple of Hatshepsut*, Deir el-Bahri, Egypt, c. 1490–1460 BCE.

This funerary temple was a monument to the greatness of Egypt's woman pharaoh.

pool and papyrus and with rows of frankincense trees. The garden was a pleasure in Egyptian life and, thus, was prominent in their afterlife imagery. An inscription from another tomb says: "May I wander around my pool each day for evermore; may my soul sit on the branches of the grave garden I have prepared for myself; may I refresh myself each day under my sycamore."

ART EXPERIENCE Notable natural landforms were often associated with burials. Where would such a place be where you live?

Etruscan Tombs

It is interesting to compare Egyptian funerary practices with those of other cultures. The Etruscans were another ancient people who buried their dead in earthen mounds furnished for the afterlife. The Etruscan civilization was a loose band of city-states in west-central Italy. It developed in the eighth and seventh centuries BCE, flourished, and then was overtaken by the expanding Roman Empire in the fifth and fourth centuries BCE. Around the city of Cerveteri, the

Etruscans buried their dead under row after row of earthen mounds arranged along "streets" in a necropolis. The Etruscan tombs often had several modest-sized rooms, laid out much like houses. These tomb chambers were carved directly out of the soft bedrock, called **tufa**. Furnishings, such as chairs and beds and utensils, were sometimes carved in relief on the underground rock surfaces. They simulated a domestic interior. In contrast to those of other civilizations, the Etruscan tombs are not grand monuments to powerful rulers but reminders of a society that emphasized sociability and the pleasures of living.

The freestanding terra-cotta sculpture *Sarcophagus with Reclining Couple* (Fig. 8.8), c. 520 BCE, comes from a tomb in Cerveteri. The clay sarcophagus, with life-size figures, was molded in four pieces. The wife and husband are shown at the same scale, reclining together at a banquet, sharing the same couch. This reflects the fact that Etruscan women had more rights than women in most

8.8 *Sarcophagus with Reclining Couple*, from a cemetery near Cerveteri, Etruria (Italy), c. 520 BCE. Painted terra-cotta, 3′ 9½″ tall. Museo Nationale di Villa Giulia, Rome.

A couple enjoys a banquet on their coffin in this freestanding sculpture.

other cultures. The facial features are similar and standardized on both figures, and their hair is represented as a geometric pattern. Their bodies are somewhat flattened and unformed from the waist down. Despite these unnatural features, the wife and husband still give the impression of alert liveliness, health, and vigor. Their gestures are very animated.

Etruscan tomb art emphasizes pleasure. In tombs carved into cliffs near the Etruscan city of Tarquinia, the walls were often covered with paintings. One example is *Banqueters and Musicians* (Fig. 8.9), c. 480–470 BCE, from the Tomb of the Leopards, so named for the leopards painted on the wall near the ceiling. To the left, banqueters recline on couches while servants bring them food and drink. The women are shown with light skin and the men with dark, according to conventions of representation at that time. One man holds an egg, a symbol of rebirth.

To the right, musicians dance across the wall. Gestures are lively and animated and are made more visible by the oversized hands. Golds, reds, and greens predominate, and the circle and checkerboard patterns on the ceiling add to the general colorfulness of the scene.

Funeral Complex of Shi Huangdi

Our next comparison shows one of the most extensive tombs ever constructed. In 259 BCE, at age thirteen, Ying Cheng became the ruler of the Qin state. By 221 BCE, he had subdued the rival neighboring states to unify China and founded the Qin Dynasty. A brutal ruler, he assumed the title *Shi Huangdi*, the "First Emperor." Shi Huangdi accumulated amazing power, ruthlessly homogenizing Chinese culture and eradicating all opposition to his rule (see *History Focus* on page 215). Shi Huangdi built for

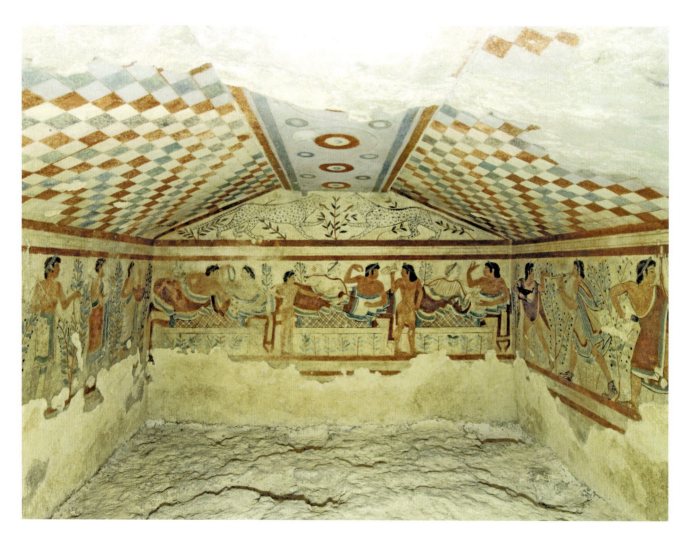

8.9 *Banqueters and Musicians*, mural painting from the Tomb of the Leopards in a cemetery near Tarquinia, Etruria (Italy), c. 480–470 BCE.

The pleasures of Etruscan life included feasting, music, and dancing.

8.10, *above* *Soldiers from Pit 1*, near the tomb of Shi Huangdi, Shaanxi, China, 221–206 BCE. Painted ceramic; average figure height, 5′ 9″.

This terra-cotta army is only part of the funerary complex built for the First Emperor of China.

8.11, *right* *Warrior*, from the tomb of Shi Huangdi, Shaanxi, China, 221–206 BCE. Painted ceramic, life-size. Cultural Relics Publishing House, Beijing.

Each of the warriors is made from a combination of standardized and handcrafted parts.

himself a large, lavish underground funeral palace. In 1974, peasants digging a well uncovered pieces of a huge, buried army of 6,000 life-size clay soldiers guarding the afterlife palace complex. Since then, archaeologists have concentrated on excavating and restoring the terra-cotta army; the tomb is mostly untouched.

The *Soldiers from Pit 1* (Fig. 8.10), from 221–206 BCE, are arranged in eleven columns, with four soldiers abreast in nine of the columns. In this image, only a small percentage of the life-size sculptures are visible! The torsos are hollow, while the solid legs provide a weighty bottom for support and balance. The bodies are standardized: frontal, stiff, and anatomically simplified. Certain features, such as hands, were mass-produced in molds. However, every face is different and sculpted with great skill and sensitivity, like the *Warrior* (Fig. 8.11). He is one of four kinds of soldiers—cavalry,

archers, lancers, and hand-to-hand fighters—all sculpted at least 4 inches shorter than the commanders. The hair is shown with detailed, individualized knotting and braiding, typical of Chinese infantry of the time.

The clay soldiers were outfitted with bronze spears, swords, or crossbows, or all three, and were originally painted in vivid colors. The army stood on brick "streets" that were 15 to 20 feet below ground level. Separating the columns were rows of pounded earth that supported wood beams that once covered the entire pit. Fiber mats and plaster were placed over the beams to seal the pits and prevent water seepage. All were hidden under a low, flat mound of dirt.

Royal Tombs of the Moche Civilization

From 150 to 800 CE, the Moche civilization extended for more than four hundred miles along the Pacific Ocean in modern Peru (see *History Focus* on page 215). Moche society was stratified from rich to poor, which is reflected in their burials, ranging from elaborate burial chambers on pyramids to simple shallow pits. Warrior-priests apparently ruled the Moche civilization, judging by their richly furnished graves. The primary reason for warfare in Moche society was to capture prisoners for sacrificial ceremonies. A class of skilled artisans worked full-time to create gold and silver metalwork for elite burials as well as pottery for all classes.

For our next comparative tomb complex, we look at the Royal Tombs of Sipán from c. 300 (recently discovered in 1980). Similar to the treasures found in the other tombs we have looked at, Tomb 1 contained several sets of warrior-priest ceremonial gear, including many layers of jewelry, breastplates, weapons, and ornamental feathers. The mannequin in Figure 8.12 is dressed in replicas of just some of the objects that were found in that tomb, believed to be that of the Lord of Sipan. He is wearing a cloth covered with gilded platelets, shell beads over his wrists and shoulders, and a truly striking helmet on his head. A nose plate is suspended from a hole in the nasal septum. This one is plain gold; others are elaborately decorated. From his waist hang crescent-shaped bells that would have jangled with every step. Figure 8.13 shows the magnificent *Peanut Necklace*, with ten gold and ten silver "beads." The peanut may have been a ceremonial food or a food of honor. The Moche used gold and silver symmetrically. An identical pair of weapons was found in one tomb, one in gold and

one in silver. In another tomb, a gold ingot was found in the deceased's right hand and a silver one in the left. Some nose plates are symmetrically half gold and half silver.

CONNECTION Like the Moche people, the Inca represented a treasured food in silver. See *Silver Representation of a Maize Plant* (Fig. 5.17).

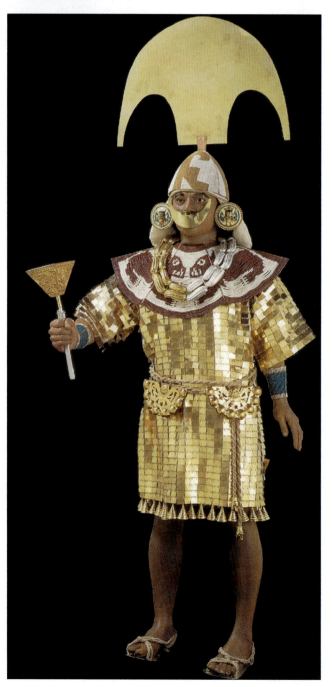

8.12 Mannequin dressed in replicas of some of the objects found in Tomb 1, Royal Tombs of Sipán. Moche civilization, Peru, c. 300. Fowler Museum of Cultural Heritage, University of California at Los Angeles.

This figure shows the elaborate gear worn by a warrior-priest.

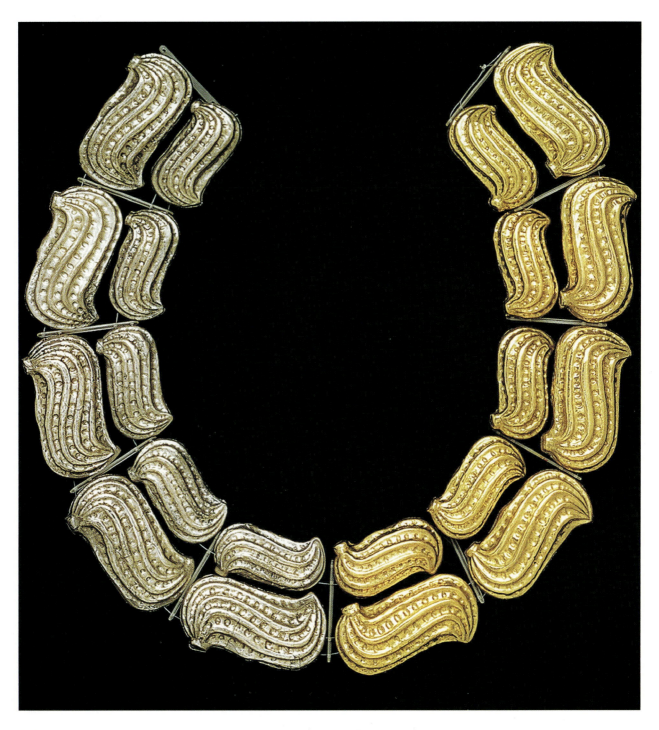

8.13 *Peanut Necklace*, from Tomb 1 of the Royal Tombs of Sipán, Moche civilization, Peru, c. 300. Gold and silver necklace, 1′ 8″ diameter. Museo Arqueológico Nacional Bruning de Lambayeque, Peru.

This fine necklace was worn in life by a warrior-priest and later buried with him.

Viking Ship Burial

The Vikings were maritime raiders from Scandinavia with settlements in Iceland, England, northern France, and Russia in the ninth and tenth centuries. Their tombs reflect how important sea travel was to their civilization.

The Oseberg ship burial, located under a mound approximately 20 feet high and 130 feet long and excavated in 1904 near Oslo, Norway, was the tomb of a high-ranking Viking woman. The ninth-century tomb had been robbed centuries ago, but large wooden items were left behind. Our last

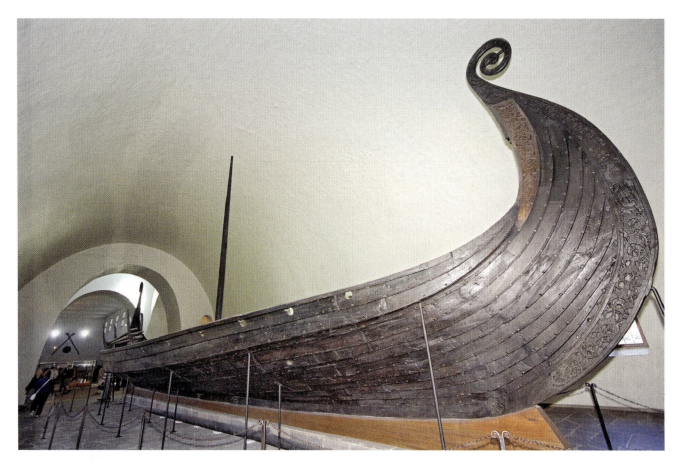

8.14 *Viking Ship*, from the Oseberg ship burial, Norway, early ninth century. Oak, 65′ long. Viking Ship Museum, Oslo.

This ship burial was the tomb of a high-ranking woman.

comparison is the *Viking Ship* (Fig. 8.14), which was probably the private vessel of a wealthy family, intended for use near the coast and on inland waterways. It had a mast and sail plus rowlocks for thirty oarsmen. The graceful curves of the low, wide ship culminate in tall spiral posts at stem and stern; the one at the front is carved like a coiled snake. Rising up each post are relief carvings of elongated animal forms interlocked in complex, lace-like patterns. In these intricate carvings, each animal is composed of a layered network of crisscross lines. Other wooden objects were found in the burial, including beds, carts, and sledges, with carvings of imaginary birds or totally unidentifiable beasts. All convey a feeling of wild agitation, firmly contained within the margins of the carving.

DEVELOPMENT OF CEMETERIES AND GRAVE MONUMENTS

During the first millennium BCE, mound tombs were gradually replaced by other funerary art and architecture. Tombs became commemorative structures instead of furnished homes for the afterlife.

The ancient Greeks developed the earliest commemorative funerary architecture in Europe and the Middle East. Although large, magnificent mausoleums were the privilege of the wealthy, the merchant and working classes near Greek (and, later, Roman) cities were buried in cemeteries. As populations in cities grew, cemeteries with small plots marked by upright monuments became practical. In ancient Greece, the most common monuments were (1) small columns that supported vases, urns, or small statues; (2) life-size freestanding figures of young men or women; and (3) relief carvings on stone slabs, like the *Grave Stele of Hegeso* (Fig. 8.15), c. 410–400 BCE, which is our focus figure. Hegeso is the seated woman, whose servant has brought her jewelry. Quiet, everyday moments were often depicted on Greek grave markers. A simple architectural frame encloses the scene. Its straight edges contrast with the curve of the chair and complex drapery folds. The bodies are rounded and naturalistic, but they also are idealized in their proportions and in their serenity and composure. Grave markers such as this were once colorfully painted. *Hegeso*'s combination of idealism and naturalism echoes the Greeks' emphasis on humanism, as seen in the *History Focus* (page 214).

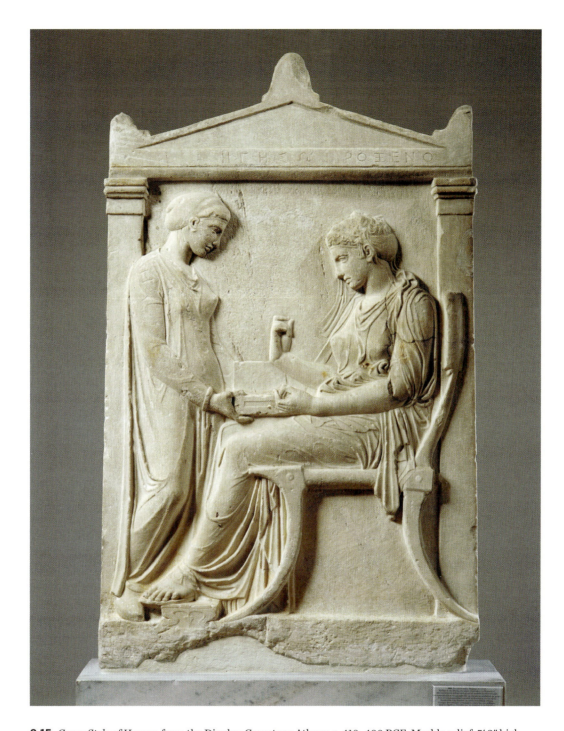

8.15 *Grave Stele of Hegeso*, from the Dipylon Cemetery, Athens, c. 410–400 BCE. Marble relief, 5′ 2″ high. National Archeological Museum, Athens.

This stele depicts the deceased woman with a servant bringing her jewelry.

In ancient Rome, the dead were buried outside the city walls, along roadways entering the city, in highly visible funerary monuments to preserve an individual's fame, family honor, and standing in society. These tombs were the meeting place for the living and the departed, and families would hold feasts at the tombs, putting out food and drink for the dead to enjoy.

Roman family tombs and mausoleums were built in several styles: altar-tombs, towers, modified Greek temples, and diminutive Egyptian pyramids—or combinations of these. Almost all featured inscriptions and relief carvings that announced the fame of the individual or family interred there. Tombs of the wealthy had lavish sculpture in dignified, idealized Greek styles. In contrast,

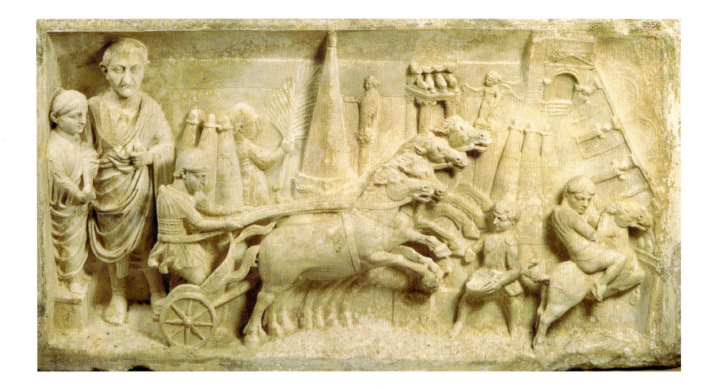

8.16 *Funerary Relief of a Circus Official*, Ostia, 110–130. Marble relief, approx. 1′ 8″ high. Vatican Museum, Rome.

Details crowd together in this relief depicting a working-class man at his job, with his family.

CONNECTION Realistic portraiture was important because respected ancestors raised the status of the living Romans, as discussed in *History Focus* (page 215). For an example of nonidealized Roman portraiture, see *Statue of Togato Barberini* (Fig. 12.13).

the *Funerary Relief of a Circus Official* (Fig. 8.16), dated 110–130 CE, was produced for a working-class person's tomb and is very cramped in style, is full of details, and has numerous characters. The largest figure is the official himself, holding hands with his wife at the far left. In Roman art, the handshake symbolized marriage. The wife is smaller, as she is of lesser status, and she stands on a pedestal as a sign that she died before him. The faces of the official and his wife are frank, unflattering portraits. The Romans often produced nonidealized likenesses— in this case, with forehead wrinkles, protruding ears, and a drooping nose and mouth. The official and his wife are crowded to the side to give space for the Circus Maximus. Only one team of horses is shown, but their leaping stance communicates the speed and competitiveness of all the chariot races. The racecourse is tilted up and diminished in size behind the chariot, while the charioteer is shown twice, once driving the team and again holding a palm branch of victory. The deceased may be a race official, or he may be the charioteer himself, shown in his younger days.

BURIAL IN PLACES OF WORSHIP

In some cultures, a preference arose for being buried in holy sites. This practice could be a sign of either religious devotion or the desire for prestige. The most sanctified places for burial were reserved for those with the greatest wealth, power, or religious standing.

Christian Burials

Early Christians buried their dead rather than cremating them because they believed the body would be resurrected and rejoin the soul at the end of time. Around Rome, vast underground networks called *catacombs* were dug out of tufa, as were the Etruscan burial chambers. They were used from the second through the fourth centuries, and some were five levels deep. From floor to

8.17 *Mausoleum of Galla Placidia*, interior, Ravenna, Italy, c. 425. The early Christian mosaics show the influence of Roman secular art.

ceiling, passageways were lined with openings for bodies, which were sealed after burial and decorated with painted plaster or carvings. The catacombs became sanctified places during times of persecution from 249–251 and 303–306: martyrs were buried there, fugitives hid from the Romans, and occasionally worship services were conducted. Christians refused to recognize the divinity of the emperor or pay token tribute to Roman gods; therefore, the Romans considered them destabilizing to civil order.

Later, after Christianity was accepted in Rome and became the official religion in 313, large churches were constructed and tombs located inside them. The *Mausoleum of Galla Placidia* (Fig. 8.17), in Ravenna, from c. 425, was originally attached to a church, now in ruins. The original purpose of this building is not known, but its mosaics give us a good idea of the style of imagery and decoration at this time. The deep-colored and elaborate mosaics show figures that were done in a style very similar to Roman secular paintings of noble servants. On one panel, sheep represented the flock protected by Jesus, the

Good Shepherd. Pattern motifs also come from Roman secular paintings.

CONNECTION Later Christian art became much more formalized, rigid in design, and awe-inspiring in size, as seen in the detail of the *Deesis Mosaic* (Fig. 2.16) from the Hagia Sophia in Istanbul.

One of the most famous early Christian churches, St. Peter's in Rome, was built over the tomb of St. Peter, the follower of Jesus. Old St. Peter's, which was begun in 318, marked the tomb by six twisting marble columns and four brass candelabra, each 10 feet tall and finished in silver. By the sixteenth century, Old St. Peter's, a deteriorating timber church, was no longer a fitting symbol for the expanded Catholic Church, so a newer, grander St. Peter's was constructed in stone.

8.18 GIANLORENZO BERNINI. *Baldacchino*, St. Peter's, Rome, 1624–1633. Gilded bronze, 100' high.

This tall canopy is mounted over the tomb of St. Peter.

The saint's tomb continued to be the focal point of the new church, marked by a new canopy in bronze, called a *Baldacchino* (Fig. 8.18), designed by Gianlorenzo Bernini between 1624 and 1633. This grand, lavish structure, taller than an eight-story building, recalls the cloth canopies that originally covered the tombs of early martyrs, and its curving columns recall those from Old St. Peter's. The vine-covered, twisting columns seem to leap up and support the canopy as if it were weightless, instead of tons of bronze (the bronze was stripped from the nearby *Pantheon* (see Fig. 7.27) and melted to make the *Baldacchino*). Compare the grandeur of the *Baldacchino* with the modest, yet ornate, and simple *Mausoleum of Galla Placidia*. That comparison makes evident the growth of the Catholic Church from an outlawed fourth-century sect to a major religious and political power in the sixteenth century.

Over the centuries, Christian church burials were periodically banned, as tombs rapidly overtook church interiors. However, the rich and powerful continued to enjoy church burials, partly because many churches depended on the donations that accompanied the burials. (The poor and working classes were buried outside in cemeteries and in rural churchyards.) The *Chapel of Henry VII* (Fig. 8.19), dated 1503–1519, is a large chapel, almost a separate church on the back of London's Westminster Abbey, built to house the tomb of Henry VII and his wife and to honor his deceased uncle, Henry VI. To help atone for his acts of war and royal intrigue, Henry VII gave money to various charities and to the abbey. The tomb established the abbey's fame, making it a destination for pilgrims.

The chapel is built in the **English Perpendicular** style, a variation of the **Gothic** style. The ceiling seems to rise up on slender piers between the windows and then fan out gracefully and drape downward into lacy vaults. Window tracery and carvings add to the overall effect. Sculptures of saints fill the remaining wall space. The height and delicate patterning make a fitting symbol of royal power at the end of the age of chivalry. A carved wooden screen encloses the tombs of Henry VII and his wife, Elizabeth of York, which have bronze effigies atop them. The tombs are directly behind the altar, the most venerable location in the chapel. Westminster Abbey continued to be used for royal burials until the eighteenth century, and it houses tombs of illustrious statesmen, military leaders, artists, and poets as well.

CONNECTION Compare the French Gothic emphasis on verticality in *Chartres Cathedral* (Figs. 7.39 and 7.40) with the elaborate Perpendicular style of the *Chapel of Henry VII*.

Islamic Mausoleums

The wealthy and powerful among Islamic societies were sometimes buried in mausoleums adjoining mosques. For example, Shah Abbas the Great, a seventeenth-century Persian ruler, was buried in a mausoleum attached to the *Masjid-i-Shah* (see Figs. 7.41 and 7.42).

Possibly the most famous Islamic mausoleum is the *Taj Mahal*, the final resting place of Mumtaz Mahal and a monument to the greatness of her husband, Shah Jahan, ruler of the Mughal Empire in India. The emperor apparently loved her dearly; she may have been his trusted advisor.

8.19 *Chapel of Henry VII*, interior (toward east), Westminster Abbey, London, 1503–1519.

Built in the English Perpendicular style, this chapel houses the tombs of royalty.

8.20 *Taj Mahal*, Agra, India, 1632–1654.

This famous Islamic shrine is a memorial to the wife of a great shah.

The *Taj Mahal* (Fig. 8.20), built between 1632 and 1654, is an imposing and impressive structure, comparable in ambition to the *Baldacchino* in St. Peter's and the *Chapel of Henry VII*. The *Taj Mahal* sits at the north end of an expansive walled and gated garden, like some in Turkey and Iran. Such gardens symbolized Paradise and were earthly recreations of it. Canals divide the thirty-five-acre garden into four equal squares, with a large reflecting pool in the center. Those four squares are further subdivided into fours. The canals symbolize the four rivers of Paradise, from the Quran. An inscription on the garden's main gate reinforces the link between the garden and Paradise:

> *But O thou soul at peace,*
> *Return thou to the Lord, well-pleased, and well-pleasing unto Him.*
> *Enter thou among my servants,*
> *And enter thou My Paradise.*

> (The Quran Sura 89)

CONNECTION In the manuscript painting *Babur Supervising the Layout of the Garden of Fidelity* (Fig. 13.18), we see an example of a walled garden from Persia.

The *Taj Mahal* symbolizes the throne of Allah, a celestial flowering rising above the Paradise garden, buffered from the outside world. A red sandstone mosque and guesthouse flank the white mausoleum. The *Taj Mahal* is a compact, symmetrical, centrally planned structure, constructed on a raised platform and surrounded by four minarets. The huge dome dominates and unites the entire building, but the various parts, from arched portals to windows to porches, maintain their own identity. The *Taj Mahal* seems billowing and light, and, combined with its reflection in the pool, it seems to float. The walls throughout the *Taj Mahal* are decorated lavishly with inlaid or carved floral designs, with onyx, red sandstone, agate, jasper, cornelian, lapis, coral, jade, amethyst, green beryl, and other semiprecious stones.

RELIQUARIES

In some religions, bones, tissues, and possessions of deceased holy persons are kept and venerated. Since the time of the Roman Empire, Christians have sought out the relics of saints and martyrs as they prayed to God. The practice continued in medieval Europe, where pilgrims would visit prominent medieval churches to ask special favors in the presence of a saint's relics. Fragments of clothing or body parts were kept in *reliquaries*, small

precious shrines like the *Reliquary Arm* (Fig. 8.21), c. 1230. Frequently, these shrines were sculptures in the shape of the body part contained within. Our focus example was built to hold pieces of arm bone from an unknown holy person. Clergy used it to bless the faithful or heal the ill. Reliquaries were expensive to produce, as was appropriate because relics were precious. In addition to decorations in silver, gold, and gemstones, this reliquary has scenes from the lives of Saints Peter and Paul. Reliquaries were related as much to the jeweler's craft as to sculpture.

In contrast, reliquaries from Africa often held the remains of venerated ancestors. Most African religions honor ancestors through ritual and sculptures because they are believed to affect the welfare of the living in many ways. *Mbulu Ngulu (Reliquary Guardian Figure)* (Fig. 8.22), from Gabon in west-central Africa, was placed on a bag

8.21 *Reliquary Arm*, Mosan (Belgium), c. 1230. Silver over oak; hand: bronze-gilt; appliqué plaques: silver-gilt, niello, and cabochon stones, 2' 1½″ × 6½″ × 4″. The Cloisters Collection, Metropolitan Museum of Art, New York.

Reliquaries contained items or body parts of Christian holy people—in this case, an arm bone fragment.

8.22 *Mbulu Ngulu (Reliquary Guardian Figure)*, from the Kota region of Gabon, likely nineteenth or twentieth century. Wood, metal.

This sculpture was placed over a container with the skulls and long bones of ancestors that founded a clan.

or basket that contained the skulls and long bones of the ancestors who founded a clan. The guardian protected the relics from evil and helped obtain food, health, or fertility from these ancestors. The sculpture, combined with the relics, was considered the image of the spirits of those dead ancestors. Offerings were made to them.

This *Mbulu Ngulu (Reliquary Guardian Figure)* and others like it were constructed over flat wooden armatures and then covered with sheets and wires of brass or copper. The faces were oval and usually concave, with projections to show the elaborate hairstyles traditionally worn in the area. The guardian figure probably evolved from figurative sculptures with hollow torsos in which bones were originally placed, a practice that became impractical as more bones were accumulated. In their present form, these figures could also be used in dances. These sculptures were extremely influential in the development of twentieth-century European modern art.

> **CONNECTION** Pablo Picasso was influenced by African sculpture. See *Les Demoiselles d'Avignon* (Fig. 1.5).

> **ART EXPERIENCE** Make a special container to hold a small memento of an older member of your family.

8.23 *Père Lachaise Cemetery*, Paris, opened 1804.

This cemetery's design was influenced by nineteenth-century European Romanticism.

MODERN COMMEMORATIVE ART

Commemorative art from the past two centuries is varied and includes monuments that deal with personal loss, memorials for groups, and monuments for important political leaders. They express loss, preserve memory, or transform the experience of death. Elements are drawn from fine art, architecture, popular culture, folk art, and craft.

Modern Cemeteries

From the middle of the eighteenth century and into the nineteenth century, cemeteries within cities in Europe reached a crisis point. Expanding cities began to overtake neglected churchyards, which were overcrowded with graves that were seen as unhealthy and sources of pollution. As a result, civil authorities gradually removed control of burial practices from the churches and established new, large, suburban cemeteries that buried the dead, regardless of their religion.

In Italy, the new cemeteries were rigidly organized in tight grids. In contrast, we will focus on the northern Europeans, who favored the picturesque cemetery, like the *Père Lachaise Cemetery* (Fig. 8.23), which opened on the outskirts of Paris in 1804. Its design was influenced by **Romanticism**, a major art and cultural movement of the nineteenth century that emphasized a return to a

simpler, rural way of life, just as the Industrial Revolution was creating increasingly packed cities, greater pollution, and mechanization of life. The cemetery was laid out with meandering paths on a hilly site, with massive trees overhead. As families could own plots in perpetuity, they often constructed elaborate and fantastic structures, running the gamut from Egyptian, Greek, Roman, Byzantine, and Gothic to modern art nouveau styles. Urns, columns, and obelisks abound. Their exotic qualities are further manifestations of Romanticism. The famous and the obscure are buried together here, making the cemetery a national tourist attraction, like many burial places in this chapter.

Now compare *Ophelia* (Fig. 8.24), painted by John Everett Millais in 1852, which is contemporary with some of the monuments in *Père Lachaise Cemetery*. Ophelia, a character in the Shakespearean play *Hamlet*, becomes incapacitated from grief and later drowns. This painting exhibits the same feeling toward picturesque nature that is apparent in *Père Lachaise Cemetery*, with deep color, lushness, accurate detail, and extraordinary delicacy. *Ophelia*'s pose and flower-strewn dress already suggest the casket. The whole scene is lacking in the grisly details of madness

8.24 John Everett Millais. *Ophelia*, England, 1852. Oil on canvas, 2′ 6″ × 3′ 8″. Tate, London.

This painting depicts a romantic image of death within a lush landscape.

and death by drowning; rather, it is permeated with tragedy and poetic feeling. At *Père Lachaise Cemetery*, many monuments echo the sensibilities expressed in this painting, with sculptures of family members reaching for each other or lying together in death.

Contemporary Memorial Art and Practices

Today's art and rituals of death serve a broad array of social, political, and personal needs. On the personal end of the spectrum is Kane Kwei's *Coca Pod Coffin* (Fig. 8.1), which we saw at the beginning of this chapter. Kwei's workshop has produced personalized coffins primarily for Ghana locals but also for people all around the world. His coffins are designed to reflect the lifework and values of the deceased. The bright colors and almost startling design honor the deceased, whose body would be placed in the long pod. The horizontal ridges echo the horizontal axis of the pod, which is balanced by the vertical diminutive tree to the left.

While the *Coca Pod Coffin* celebrates the lifework of a person, the rest of the funerary structures and traditions we examine in this section have a more social dimension. One famous tradition is the Day of the Dead, a popular celebration mixing Christian and Aztec beliefs. It is celebrated, with local variations, in Mexico and parts of the

8.25 DIEGO RIVERA. *Día de Muertos*, detail showing the city fiesta, Mexico, 1923. Fresco. South wall, Court of the Fiestas, Ministry of Education, Mexico City.

Christian and Aztec beliefs are mixed together in Mexican celebrations of the dead.

United States. During the day, marketplaces become sites for parades and spirited celebrations. In private homes, altars commemorate the family's dead, with burning incense and pictures of the departed placed next to their favorite foods to welcome their returning spirits. Families may spend the night at the graveyard with the deceased, decorating the gravesites and burning hundreds of candles.

Diego Rivera depicted this important ritual celebration in a series of murals about Mexican history and culture in the Ministry of Education building in Mexico City, which is our focus figure here. The painting *Día de Muertos* (Fig. 8.25), executed in 1923, shows the urban observance of the feast day; two other panels depict more traditional rural observances. Great crowds fill the marketplace in a raucous celebration. In the foreground are food vendors and children in skull masks. Hanging under the awning in the background are satirical skulls and skeletons of various characters, including a priest, a general, a capitalist, and a laborer. In Mexico, the carnival atmosphere of Day of the Dead invites political satire and commentary. Rivera painted his figures in a simplified, rounded, monumental style. He insightfully recorded different individuals' personalities, and he captured the crush and excitement of the crowd and the spirit of the event.

For comparison, we go to New Ireland and nearby islands in Papua New Guinea, where villagers hold memorial festivals to commemorate recently deceased clan members. Both the festivals and the sculptures carved for the occasions are called *malanggan*. Planning takes several months, as special crops must be planted, pigs raised for the feast, and sculptures carved for the occasion. Honoring the dead requires a great expenditure of effort and wealth, which stimulates the local economy and creates stronger alliances among villages and clans. *Malanggan* also include initiation rites for young men. Although they have evolved as a result of foreign influence, *malanggan* rituals continue to be enacted.

Some *malanggan* carvings are narrative sculptures with intricate openwork carving. Humans and various animals transform into one another or merge ambiguously, but the exact meanings are clan secrets. Less complex, but visually impressive, is the *Helmet Mask*, or *Tatanua*, shown in Figure 8.26, which is used most

8.26 *Helmet Mask (Tatanua)*, Northern New Ireland, Papua New Guinea, nineteenth century. Wood, paint, natural fibers, and opercula shells; 1′ 3¼″ × 9½″ × 1′. Museum of Fine Arts, Houston.

Great feasts were prepared and many carvings made for *malanggan* rituals, which commemorated recently deceased clan members.

8.27 *Mausoleum of Mao Zedong*, Tiananmen Square, Beijing, latter half of the twentieth century.

This is a monument to both the power of Communism and its leader.

frequently in dances. Combined with rituals, the fierce and dramatic masks provide an opportunity for spirits to be present in the villages. They are made of painted wood, vegetable fibers, and shells, and the top crest resembles men's traditional hairstyles. The traditional colors for *malanggan* are red, black, white, and yellow, which have symbolic meaning; for example, red usually means danger.

The Day of the Dead and *malanggan* rituals commemorate the dead as well as serve social needs. Our next work functions commemoratively and politically. The *Mausoleum of Mao Zedong* (Fig. 8.27) not only houses the body of the leader of the Communist revolution in China but also asserts the authority of the Communist government after centuries of imperial rule. Mao's historical accomplishments included helping to restore Chinese independence and redistributing land to the peasants.

The major axis of Beijing, the Chinese capital, runs north–south, and official buildings, palaces, public grounds, and city gates were placed along this axis, along with the Forbidden City and the Imperial Palace (see Fig. 9.1). This alignment signifies the authority of the imperial dynasties. In front of the Forbidden City is Tiananmen Square, a large, important ceremonial space. The *Mausoleum of Mao Zedong* is deliberately located in the square, on the north–south axis, as the Communist leaders claim to be rightful successors to the emperors.

CONNECTION See the discussion in Chapter 9 of the elaborate Forbidden City and the *Imperial Throne Room* (Fig. 9.13), in the Hall of Supreme Harmony.

CONNECTION Like the *Mausoleum of Mao Zedong*, the *Vietnam Veterans Memorial* (Fig. 9.30) stands on politically significant ground, the Mall in Washington, D.C.

 ART EXPERIENCE Memorialize a recently departed celebrity or political leader who is important to you.

Another powerful art project to compare is the *AIDS Memorial Quilt*, shown here in 1996 (Fig. 8.28), a commemorative work with a personal and political impact. The quilt is composed of thousands of individual 3- by 6-foot panels, approximately the size of a twin-bed blanket, which would cover the body of one person who died from AIDS. Friends or family make each panel and decorate it, sometimes only with initials but often more elaborately, with photographs, memorabilia, or details of a life story. The work is organized by a group called the Names Project in San Francisco, and most people contributing quilt pieces have no art training. The format of a quilt is especially appropriate for this collaborative, grassroots product of loving remembrance. Begun in the mid-1980s, the *AIDS Memorial Quilt* had become a vast public spectacle in only a few years, which communicates the enormity of the epidemic and its toll in the United States alone. The quilt changes every time it is displayed. In Figure 8.28, its proximity to the White House and government buildings means that the disease was recognized publicly as a crisis and a tragedy by the U.S. government.

The tragedies of September 11, 2001, have been memorialized in several ways. For one month in 2002, *Tribute in Light* (Fig. 8.29), designed by three architects, two artists, and a lighting consultant, projected two powerful beams of light into the night sky where the twin towers of the World Trade Center once stood. *Tribute in Light* has been re-created each year since 2002 for the anniversary of the attacks. These temporary "towers" of light appeared architectonic because each was composed of forty-four high-powered lamps that, combined, resembled a three-dimensional column with fluting. As light, the beams referenced hope and aspiration, but because they were immaterial, they also recalled the transitory nature and vulnerability of earthly things.

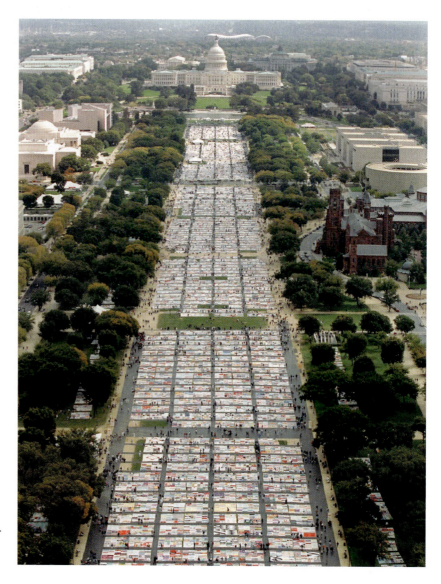

8.28 *AIDS Memorial Quilt*, displayed on the Mall in Washington, D.C., October 11, 1996. Organized by the Names Project, San Francisco.

This huge, collaborative work commemorates the loss of loved ones to a deadly disease.

8.29 JOHN BENNETT, GUSTAVO BONEVARDI, RICHARD NASH GOULD, PAUL MYODA, JULIAN LaVERDIERE, and PAUL MARANTZ. *Tribute in Light*, New York City, 2002. High-power lamps. World Trade Center Memorial at Ground Zero.

Two vertical beams, composed of eighty-eight search lights, are lit in memory of the 9/11 tragedy.

Meanwhile, the World Trade Center is being rebuilt according to a design from Studio Daniel Libeskind (Fig. 8.30), which includes a ring of lower office buildings and one large Freedom Tower, a tapering, twisting skyscraper, topped by an openwork cable superstructure and a spire. The Freedom Tower, 1,776 feet tall, commemorates the year of the Declaration of Independence and symbolizes the spirit of the United States, while being extremely safe and secure and not competing with the design of the old World Trade Center.

The area in the middle of the ring of buildings contains a tree-covered plaza and permanent memorial and museum dedicated to those who died at the site on September 11, 2001. Michael Arad and Peter Walker's design was chosen for that permanent memorial, *Reflecting Absence*, consisting of two sunken reflecting pools that mark the footprints of the old towers and feature inscriptions of the victims' names. The memorial officially opened on September 12, 2012.

8.30 STUDIO DANIEL LIBESKIND. *New World Trade Center*, during construction, expected completion in 2015. In the foreground is *Reflecting Absence*, part of the *National September 11 Memorial and Museum*, designed by Michael Arad and Peter Walker, 2012.

A group of five towers, plus a sunken memorial in the middle, contains symbolic attributes that recall the spirit of the United States as well as memorialize the September 11 attacks.

Section 3 THE STATE

Rulers and governments use art to celebrate and spread their earthly power. Art is also used in war, either in creating weapons and armor for it or in making images that promote it. In addition, it gives us images of peacemaking and monuments for peace. Art can be an equally strong voice of protest against a government or against a social practice. People who are not in power can use art to affirm their ideas and to protest against warfare, oppression, or political policy.

CHAPTER 9 POWER, POLITICS, AND GLORY

Art made in the service of political rulers or as records of war or peace

CHAPTER 10 SOCIAL PROTEST/ AFFIRMATION

Art as a vehicle for affirming the rights of oppressed groups or protesting injustice

9

POWER, POLITICS, AND GLORY

Throughout human history, a vast amount of artwork has promoted, popularized, or propagandized governments as well as those who lead them. Art has depicted war and helped shape our reaction to it. Art has also celebrated peace.

PREVIEW

Art has played a tremendous role in glorifying the state and its rulers' authority, prestige, and achievements. Portraits, sculptures, paintings, and special objects denote supremacy or status. The state is made magnificent in art, especially in monuments, seats of government, and palaces, as in the Imperial Palace (Fig. 9.1).

We will also see how art can glorify war and document its impact on those involved. A warrior's paraphernalia raises the owner's status, and artistry enhances the spirit and function of the weapon. War scenes can exalt the drama, give alternate views of battle, or emphasize its horror. War memorials may evoke deep patriotism or private mourning and contemplation. Peace itself is given an image in painting, and beautifully crafted art objects may become peace offerings. Peace memorials may glorify the abundance possible when there is no war.

The Art Experiences invite you to design a palace and a coin or paper currency for a contemporary state and to consider whether a democratic government produces different art from a totalitarian government.

Connecting Art and History from
500–1300 CE

World history from 500 to 1300 witnessed the rise and fall of many kingdoms, with rulers using art to increase their prestige. Civilization centers flourished throughout the Americas. The Moche civilization (200–800) of coastal Peru produced great temples of sun brick and had elaborate burials filled with metal, jewels, and ceramic treasures. The Inca civilization in the Andes Mountains was shortly to emerge. North American centers included the Mississippian culture (c. 800) and the Anasazi (1000–1300), who built the famous cliff dwellings in the southwestern United States.

Map 5 The Expansion of Islam, the Byzantine Empire, and the Migration of Germanic People into Southern Europe.

Central America saw the succession of many great empires with ambitious architecture and advances in learning, especially in mathematics and astronomy. All were hierarchical societies, governed by a supreme ruler with warrior and priest classes. Teotihuacán reached its height around 600. The old Maya Empire in the Yucatan Peninsula thrived until around 900, with grand temples and palaces, like the *Palace at Palenque* (Fig. 9.12). From the Toltec culture (900–1200) around Veracruz came the *Tula Warrior Columns* (Fig. 9.20). Beginning in the thirteenth century, the Aztec built a powerful empire in central Mexico, with engineering feats that included irrigation and drainage systems and road building.

During this period, the Byzantine Empire and the expansion of Islam dominated eastern Europe, the Middle East, central Asia, and northern Africa. One of the great rulers of the Christian Byzantine Empire (476–1453) was Justinian, whose notable churches featured mosaics such as the *Emperor Justinian and His Attendants* (Fig. 9.4). Wealthy Byzantium had many centers for learning and for preservation of ancient knowledge. It began to decline around 1100, due to warfare with Muslims.

The prophet Mohammad founded the Islamic religion in the early seventh century. Islam spread quickly, often through open acceptance and sometimes through warfare. Muslim armies conquered northern Africa, Spain, and the Middle East within one hundred years and advanced on India beginning in 1000. Important Muslim kingdoms were established in today's Spain, Iraq, and Turkey. The Muslims were known for their accomplishments in algebra, geometry, astronomy, optics,

Legend:
- Byzantine Empire
- Islamic territory at Muhammad's death
- Islamic expansion 632–661
- Islamic expansion 661–750
- Arrows indicate expansion

and literature, as well as for creating great universities and libraries.

This was the Middle Ages in Europe, beginning with the dissolution of the Western Roman Empire and concluding with the early forms of the modern European nation-states. Until 600, Europe experienced upheaval as Germanic peoples migrated south and east. Once they settled, they founded Christian kingdoms with architecture and art influenced by Rome and Byzantium. Large monasteries and the Catholic Church in Rome were more powerful than any other European government. Almost all art was religious. The Crusades (1095–1291), a series of wars for control of the Holy Land, brought the Germanic Europeans into further contact with Byzantium and the Muslim Empire. Feudalism was the main form of social and economic organization. The Black Death (1347–1351) ravaged Europe, killing one-third of the population. By 1200, a distinctive art form, Gothic, developed in Northern Europe.

Africa also saw the emergence of several early empires. Northern empires were Islamic, while southern empires followed native African religions. Powerful and wealthy Ghana (c. 700–1200) controlled the area's trade in salt and gold. Its ironworks produced powerful weapons. Later in the same area, Mali became a large Islamic empire. Farther south, in Ife, the twelfth century saw the founding of the Yoruba civilization, with its famous *Crowned Head of an Oni* (Fig. 9.5). Also in the south, the Zanj people thrived on trade with China, Arabia, and India from 1200 to 1500, and the kingdom of Zimbabwe flourished, with its great stone buildings.

India experienced a resurgence of Hinduism beginning in the sixth century, and many huge temple complexes were constructed. After 1000, Muslims invaded and established the Mughal Empire in northern India. In the south, strong Hindu dynasties continued, with ambitious building

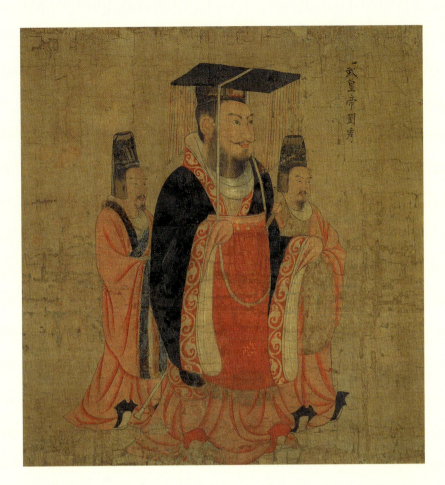

9.2 YAN LIBEN. *Portraits of the Emperors* (detail), China, seventh century. Ink and colors on silk, 1′ 5½″ high.

Chinese emperors were believed to be Sons of Heaven. Their lavish attire, serene expression, and relatively large size all attested to their brilliance.

programs. Indian art and architecture spread to Southeast Asia and Indonesia throughout this period. In Cambodia, the Khmer people developed a culture noted for its amazing architecture and sculpture, like *Jayavarman VII* (Fig. 9.6).

The imperial court in China promoted the arts throughout this era, with accomplishments in poetry, literature, music, ceramics, and painting, like the *Portraits of the Emperors* (Fig. 9.2). The dynasties were the Tang (618–906), Song (960–1279), and Yuan (1279–1368). The Yuan was founded by invading Mongolians under Kublai Khan. Inventions included the magnetic compass, paper money, book printing, and gunpowder. After 1368, the Ming Dynasty began an ambitious building program, which included the structures in the Forbidden City

(Figs. 9.1 and 9.13) and *The Great Wall* expansion (Fig. 9.22), and China became an international naval power.

Japanese recorded history begins around the year 600, when the Japanese culture changed as a result of foreign influences. It imported the Buddhist religion, mathematics, architecture, the arts, and agricultural methods from the Chinese but eventually modified them. Shinto is the native Japanese religion. Japan produced the world's first novel, *The Tale of the Genji*, by Lady Murasaki Shikibu, illustrated in the hand scroll *Heiji Monogatari* (see Fig. 9.24). From the eighth through the nineteenth centuries, Japan was essentially a feudal state, with a hierarchy of military leaders under the shogun, and it experienced periods of internal strife.

World Art Map
for Chapter 9

Red Horse. *Battle of Little Big Horn.*
Crow Agency, United States.

Presentation Pipe Tomahawk.

Mesquakie Bear Claw Necklace.

NORTH AMERICA

Edward Hicks. *The Peaceable Kingdom.*

Felix W. Weldon. *USA Marine Corps War Memorial.*
Maya Ying Lin. *Vietnam Veterans Memorial.*

Mathew B. Brady (or Staff).
Dead Confederate Soldier with Gun.

Cloak and Feather Hat.

Moctezuma's Headdress.

Palace at Palenque.
Chiapas, Mexico.

Tula Warrior Columns.
Hidalgo, Mexico.

SOUTH AMERICA

Leni Riefenstahl. *Triumph of the Will.*

Charles Barry and A. W. N. Pugin. *Houses of Parliament.*

Jules Hardouin Mansart and Charles Le Brun. *Hall of Mirrors.*

Andrea del Verrocchio. *Equestrian Monument of Bartolomeo Colleoni.*

Emperor Justinian and His Attendants.

EUROPE

Arch of Titus.
Ara Pacis Augustae.

Pablo Picasso. *Guernica.* **Madrid, Spain.**

Olowe of Ise. *Palace Sculpture.*
Crowned Head of an Oni.
Plaque with Warrior and Attendants.

N

| 0 | 1,000 | 2,000 Km. |
| 0 | 1,000 | 2,000 Mi. |

ASIA

Sergei M. Eisenstein.
The Battleship Potemkin.

**The Great Wall.
Northern China.**

*Imperial Palace.
Imperial Throne Room.*

**Lamassu.
Khorsabad, Iraq.**

Yan Liben. *Portraits of the Emperors.*

Menkaure and His Wife, Queen Khamerernebty.
Persepolis.

Palette of King Narmer.

**Burning of the Sanjo Palace.
Heiji Monogatari, Japan.**

AFRICA

**Jayavarman VII.
Siem Reap, Angkor Region,
Cambodia.**

Eddie Adams. *Brigadier General . . . executing . . .*

**Te Papaiouru Marae.
Ohinemutu Maori Village,
Rotorua, North Island,
New Zealand.**

AUSTRALIA

500–1300 CE

			ACHAEMENID EMPIRE—PERSIA			
PALEOLITHIC ERA	UNIFICATION OF EGYPT	ASSYRIAN EMPIRE	UNIFICATION OF CHINA ROMAN REPUBLIC			ROMAN EMPIRE
15,000 BCE	3200 BCE	1500 1000 720	500	100 BCE	100 CE	

Palette of King Narmer

Lamassu

Persepolis

Ara Pacis Augustae

Arch of Titus

∧ Great Pyramids, Egypt (8.4)

Menkaure and His Wife, Queen Khamerernebty

∧ Soldiers from Pit 1, China (8.10)

The Great Wall

∧ Colosseum (14.11)

INCAN EMPIRE

RENAISSANCE IN EUROPE

MING DYNASTY—CHINA

MUGHAL DYNASTY—INDIA

Forbidden City Begun

SAFAVID DYNASTY—PERSIA

BAROQUE STYLE

BENIN KINGDOM—AFRICA

U.S. Revolutionary War

1400	1500	1600	1700

Imperial Palace, Forbidden City, Beijing

Imperial Throne Room, Hall of Supreme Harmony

VERROCCHIO. *Equestrian Monument of Bartolomeo Colleoni*

MANSART and LE BRUN. *Hall of Mirrors*

< *Nobles at the Court of Shah Abbas*, Persia (11.1)

Cloak and Feather Hat

Plaque with Warrior and Attendants

∧ *U.S. Capitol Building* (4.1)

Taj Mahal (8.20) >

Teotihuacán	**HISTORY FOCUS**			**YORUBA CULTURE FOUNDED**				**YUAN DYNASTY— CHINA**		

HISTORY FOCUS

Teotihuacán

German Migration in Europe

BYZANTINE EMPIRE BEGINS

TANG DYNASTY—CHINA

MAYAN CIVILIZATION

JAPAN—HISTORIC ERA

Islam Founded

YORUBA CULTURE FOUNDED

MAYA—TOLTEC CULTURE

SONG DYNASTY— CHINA

ROMANESQUE ERA

ANASAZI CULTURE

GOTHIC ERA

YUAN DYNASTY— CHINA

AZTEC EMPIRE

Black Death

200	400 500	600	700	800	900	1000	1100	1200	1300

Emperor Justinian and His Attendants

Palace at Palenque

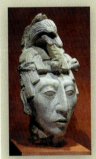

< Head from the Tomb of the Temple of Inscriptions, Mexico (11.34)

YAN LIBEN. Portraits of the Emperors.

Tula Warrior Columns

Crowned Head of an Oni

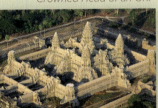

∧ Angkor Wat, Cambodia (2.31)

Jayavarman VII

Burning of the Sanjo Palace

Moctezuma's Headdress

French Revolution

ROMANTICISM

REALISM

IMPRESSIONISM

POSTIMPRESSIONISM

Russian Revolution

World War I

CUBISM

SURREALISM

World War II

MODERNISM

Vietnam War

POSTMODERNISM

Fall of the Berlin Wall

9/11

War in Afghanistan

War in Iraq

1800	1860	1900	1930	1950	1960	2000

Presentation Pipe Tomahawk

HICKS. The Peaceable Kingdom

∧ DAUMIER. The Legislative Belly (10.29)

BARRY and PUGIN. Houses of Parliament

Mesquakie Bear Claw Necklace

BRADY (or STAFF). Dead Confederate Soldier with Gun

RED HORSE. Battle of Little Big Horn

Te Papaiouru Marae

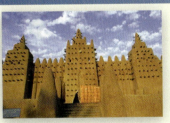

∧ Grand Mosque, Djenne (1.8)

OLOWE OF ISE. Palace Sculpture.

EISENSTEIN. The Battleship Potemkin

RIEFENSTAHL. Triumph of the Will

PICASSO. Guernica

Hiroshima Peace Memorial Park

WELDON. USA Marine Corps War Memorial

∧ SAARINEN. St. Louis Gateway Arch (15.3)

ADAMS. Brigadier General . . . executing . . .

LIN. Vietnam Veterans Memorial

THE GLORY OF THE RULER

The following artistic devices are often used to glorify a ruler's image:

- *The idealized image*: The ruler's face and/or body is depicted without flaw and often with youthful vigor; the idealized image often includes a wise or dignified demeanor.
- *Symbols*: Details are included that indicate omnipotence, authority, or divine blessing; some symbols show military or religious power.
- *Compositional devices*: The ruler often occupies the center of a picture and may be shown larger than attendants or other figures; the ruler's clothing may attract attention.

Divine Rulers, Royalty, and Secular/Religious Leaders

Many heads of state throughout history have considered themselves not only royalty but also religious leaders or members of a divine or mythic family. Images helped them to spread and communicate that idea.

We begin our focus here with an early example of a royal portrait, *Menkaure and His Wife, Queen Khamerernebty* (Fig. 9.3), dated c. 2600 BCE. The royal couple stand side by side, united by the queen's embrace, placing the same foot forward. Young, strong, and confident, they display the Egyptian ideal of beauty and maturity. Khamerernebty is shown as large as Menkaure, as pharaonic succession was traced through the female line. The compact pose makes the sculpture more durable and permanent, befitting the pharaohs as divine descendants of the Sun God, Re.

The sculpture was carved from a block of slate, a very hard stone. One view was likely sketched on each side, according to the Egyptian canon of proportions, and then carved inward until all four views met. Traces of paint were found on the piece. Menkaure was the pharaoh who built the third and smallest of the *Great Pyramids* at Gizeh (see Fig. 8.4). This shrine-like statue was found in his valley temple.

> **CONNECTION** Chinese emperors were considered to be divine Sons of Heaven. See the detail of Yan Liben's *Portraits of the Emperors* in Figure 9.2.

Compare another royal portrait, *Emperor Justinian and His Attendants*, from the Church of San Vitale in Ravenna, Italy, built in the sixth century (Fig. 9.4). Justinian dominates this image, just as he dominated the

Byzantine Empire, an outgrowth of the old Roman Empire that grew in power from the sixth century onward (see the *History Focus* on page 246). A devout Christian, he occupies the center spot between clergy to the right and military and state leaders to the left. As emperor-priest, Justinian wears a purple cloak and a magnificent jeweled crown and carries a golden bowl with bread used in Christian ritual. The solar disk or halo behind his head indicates divine status, a device used in Egyptian, Persian, and late Roman art.

9.3 *Menkaure and His Wife, Queen Khamerernebty*, Fourth Dynasty, Gizeh, Egypt, c. 2600 BCE. Slate, approximately 4′ 6½″ high. Museum of Fine Arts, Boston.

This early portrait of the royal couple displays the equal status of Menkaure's wife Khamerernebty, who passes on the pharaonic succession through her offspring.

9.4 *Emperor Justinian and His Attendants*, Church of San Vitale, Ravenna, Italy, c. 547. Mosaic on the north wall of the apse.

This devout Christian emperor dominates the center of the composition, which represents his power over both the military and the church.

The emperor is flanked by twelve figures, alluding to Christ and the twelve apostles. The clergy hold sacred objects: the crucifix, the book of Gospels, and the incense burner. Even a soldier's shield displays the **Chi-Rho,** an ancient symbol of Christ. A similar mosaic (not pictured here), *Empress Theodora and Her Attendants*, faces the Justinian mosaic in the church's sanctuary. Theodora, Justinian's wife, was an able and effective co-ruler, and her image indicates her equal rank and power.

In the next comparison, the head alone carries the exalted qualities of a ruler. In west-central Africa, several superb portrait heads were made in the twelfth to fifteenth centuries, each very much like the *Crowned Head of an Oni* (Fig. 9.5). This head cast in precious bronze represents a

9.5 *Crowned Head of an Oni*, Yoruba, Wunmonije Compound, Ife, Nigeria, twelfth–fifteenth centuries. Zinc, brass; smaller than life-size. Museum of the Ife Antiquities, Ife, Nigeria.

This delicately detailed portrait of an early African ruler expresses a sense of calm, security, and poise.

high ruler in one of the many early empires emerging in Africa at this time (see *History Focus* on page 247). The delicately detailed portrait is in a naturalistic style that contrasts with the more abstracted art from much of Africa. The face has a remarkable sense of calm and serenity, with beautiful flowing features, making it an outstanding example of an idealized royal portrait. Scholars still debate the exact identity and use of these portrait heads, but many believe each head represents one of the Yoruba or Benin rulers, who traced their rule back to the mythic first human ancestor. The crown was likely a royal insignia. The lines on the face may indicate scarification or perhaps strings of a beaded veil. Also visible are neck rings that are similar to those worn today among the Yoruba. In many areas, rings indicate fat, which is a mark of prosperity.

Also from the twelfth century is the portrait head of *Jayavarman VII* (Fig. 9.6), the last great king of the Angkor Empire of the highly civilized Khmer people (in present-day Cambodia). He was a mighty military leader who conquered invaders and fought back rival states; one campaign lasted twenty years. Jayavarman VII was also well known for his amazing building projects, including the great *Temple of Bayon at Angkor Wat*, which boasts fifty towers, each side with a large face of Buddha. Yet in this portrait, Jayavarman chose to be represented almost as a mystic, and, in fact, his own conversion from Hinduism to Buddhism spread that religion in the area. His face is softly modeled with eyes downturned in meditation, and his gentle smile became famous in Khmer art.

CONNECTION Jayavarman's likeness may have been the model for the Buddha faces on the *Temple of Bayon*, complex of Angkor Thom (Fig. 15.19).

CONNECTION To see the range of styles in African art, contrast the naturalistic quality of the *Crowned Head of an Oni* with the more abstracted style of the *Reliquary Guardian Figure* (Fig. 8.22).

CONNECTION Yoruba leaders today are identified by such headgear as the *Great Beaded Crown of the Orangun-Ila*, in Figure 12.26. These contemporary crowns are ancient forms that may date back to those worn by the early Onis.

9.6 *Jayavarman VII*, Bayon style, province of Siem Reap, Angkor region, Cambodia, late twelfth or early thirteenth century CE. Sandstone head, 1′ 4″ × 9″ × 1′. Musée des Arts Asiatiques-Guimet, Paris.

The portrait of the last and most powerful king of the Angkor Empire and the Khmer people displays his contemplative mysticism after his conversion from Hinduism to Buddhism. His turned-down eyes and gentle smile became known in Khmer art.

9.7 *Cloak and Feather Hat*, Hawaii, eighteenth century. Museo de America, Madrid.

Only monarchs were allowed to wear the woven red and gold feathers that represented royalty and prosperity.

Many royal portraits from various cultures use similar attributes that convey an exalted quality: the idealized face/body, symbolic details, centralized composition, and dignified demeanor.

> **ART EXPERIENCE** Imagine yourself as an absolute ruler of an empire. How would you commemorate your power and glory to your public? Design your own portrait, palace, or monument.

Objects of Royalty and Prestige

Royalty have been exalted with elaborate thrones, garments, dazzling jewelry, or objects of power. We have two examples here to compare.

Hawaiian royal objects were made of materials that were taboo to all others in the society, unlike the gold and gems in a European crown, which any wealthy individual could possess. Hawaiians considered feathers sacred and connected with the gods, so only royalty could own or wear them. The *Cloak and Feather Hat* (Fig. 9.7) is magnificent apparel made of red and gold feathers. Although feather work is common in many Pacific islands, the Hawaiian work is the most developed and intricate. Colors have symbolic value, with red representing royalty and yellow signifying a prosperous future. Hawaiian royalty also enjoyed large, elaborate feathered fly whisks called *kahili*, which were common objects transformed into luxury items and used for special occasions.

CONNECTION See *Moctezuma's Headdress* in Figure 9.34 to compare Hawaiian and Aztec feather work.

9.10 *Lamassu*, Khorsabad, Iraq, 720 BCE. Limestone, 14' high. Louvre, Paris.

Two of these huge sculptures dominated the palace gate to Khorsabad, the Assyrian capital. It was meant to terrify and intimidate all those who entered.

CONNECTION We will look at other fantastic animals, and the reasons humans invented them, in Chapter 13, Nature, Knowledge, and Technology.

An outstanding early example of a palace comes from the Achaemenid civilization in ancient Persia, which produced a body of monumental art of outstanding splendor. The palace of *Persepolis*, begun by Darius I in 518 BCE and destroyed by Alexander the Great in 331 BCE, took fifty years to build (Fig. 9.11). The heavily fortified palace citadel was located on an elevated, terraced platform measuring 1,500 feet by 900 feet, with mud walls reaching 60 feet high and sometimes faced with carved stone slabs and glazed brick. Interior spaces were large, wide **hypostyle** halls, with many carved columns supporting the roofs. The windows were made of solid blocks of stone with cutout openings. Stairs were also chiseled from stone blocks and then fitted into place.

The Royal Audience Hall was an impressive room in the palace. It was 200 feet square and 60 feet high and may have held up to 10,000 people. One hundred tall columns (some visible in the left background of Fig. 9.11) supported a massive wood-beam ceiling. On top were elaborate capitals with curving scrolls and foreparts of bulls or lions. Some had human heads. A grand staircase, cut directly from natural rock formations, was covered with reliefs depicting subjects presenting tribute to the king. Gates at *Persepolis* had guardian figures like the *Lamassu* (Fig. 9.10).

Like the Persians, the Mayans of Central America created large palaces with high platforms and relief sculpture. Occupied from 514 to 784, but abandoned before the Spanish conquest, Palenque remained completely hidden by tropical flora until it was rediscovered in modern times. Palenque was the center of one of several successive empires in Central America (see *History Focus* on page 246). It had the living quarters for the Mayan royalty, a center for religious rites, facilities for astronomical studies, and an administrative precinct.

The *Palace at Palenque* (Fig. 9.12) featured four courts, each surrounded with rooms and galleries, likely used for administrative purposes. Several thrones were found within the galleries. Built on a 30-foot-high platform, the complex measures 250 feet long by 200 feet wide. Large, painted stucco masks of human faces once adorned the ends of the terraces. Nearby, a vaulted underground aqueduct brought water to the *Palace*. The 72-foot-high tower adds important verticality to the horizontal design. Large tower windows facing the four cardinal points may have had both astronomical and defensive uses. The profusely

Our introduction to palace art is the mighty *Lamassu* (Fig. 9.10), from 720 BCE, an enormous sculpture from Khorsabad, capital of the Assyrian Empire. The Assyrians, known for their ruthlessness and brutality, dominated the Near East for more than three hundred years. With enormous size and glaring stare, two large *Lamassu* guarded the palace gate, intended to terrify and intimidate all who entered. A form of a divine genie, the winged creature is part lion or bull, with the head of a human being. The horned crown symbolizes the king's divine power. Notice the five legs that show movement and stability at the same time. From the side, the *Lamassu* appears to be striding forward. The front view, however, shows the beast at a stalwart standstill, blocking the viewer's forward movement. Stylized and natural elements are combined, with hair and wings depicted with linear and repetitive patterns, while the strong, muscular legs and facial features are more naturally rendered.

9.11 *Persepolis*, general view, Persia (Iran), 559–330 BCE.

This awesome palace complex consisted of many structures, including hypostyle halls with many carved columns that supported their roofs.

9.12 *Palace at Palenque*, Maya, Chiapas, Mexico, 514–784.

This complex featured four courts, each surrounded by rooms and galleries, which were likely used for administrative purposes.

decorated interior was covered by parallel rows of **corbel** vaults and arches. This allowed for thin inner walls and airy rooms that countered the fierce tropical heat. The outer walls were pierced with T-shaped windows and doorways.

Magnificent Chinese royal architecture helped sustain the emperor's rule because historically Chinese emperors claimed to be the Son of Heaven, the father of the people, and the one who maintained Heaven on Earth. Compare now the Forbidden City, an enormous palace compound that once had 9,999 rooms and resembles a city unto itself within Beijing. No commoners were allowed to enter. The major structures have gleaming yellow tile roofs and rich vermilion walls. Pure white marble staircases connect one courtyard after another. There were also mansions of princes and dignitaries, lush gardens, artificial lakes, theaters, and a library, laid out in a symmetrical plan. The city's major axis is north-south, with most structures facing south, the source of fruitfulness (north brought evil influences). The *Imperial Throne Room* (Fig. 9.13), part of the *Imperial Palace* shown in Figure 9.1, is one example of the interior decoration. The majestically high ceiling is covered with elaborate patterns subdivided by grids. The focus of the room, the throne, is framed by columns and elevated on a stepped platform.

CONNECTION Other Chinese examples of ambitious royal building projects are the *Soldiers from Pit 1* (Figs. 8.10 and 8.11), from the tomb of Qin emperor Shi Huangdi, and *The Great Wall* of China (Fig. 9.22).

9.13 *Imperial Throne Room*, in Hall of Supreme Harmony, Forbidden City, Beijing.

The grandeur of this royal room helped sustain the emperor's rule because its magnificence supported his claim to be the Son of Heaven and the father of the people.

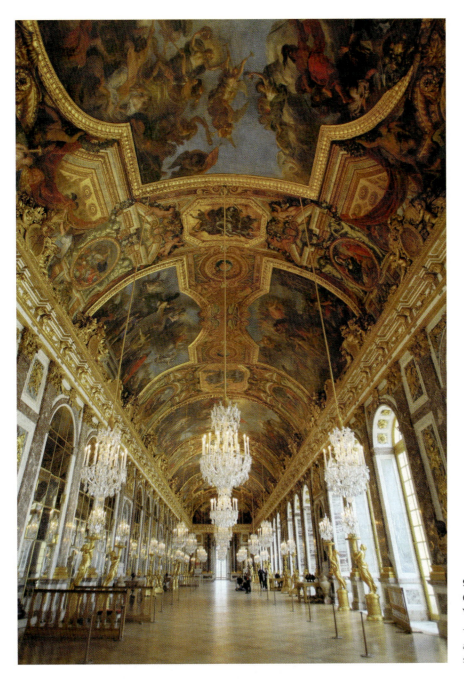

9.14 JULES HARDOUIN MANSART and CHARLES LE BRUN. *Hall of Mirrors*, Versailles, France, c. 1680.

The grand spaces, dramatic embellishments, and theatrical display of this palace were signs of Louis XIV's power.

Like the Forbidden City, the palace complex at Versailles was both a sign of power and an instrument for maintaining that power. It was built by King Louis XIV of France, the Sun King who identified himself with Apollo. Louis moved his entire court from Paris to Versailles in 1682 in order to better control them. Originally Louis' grandfather's hunting lodge, Versailles was extensively enlarged and remodeled. Approximately 36,000 workers took twenty years to complete it to Louis' liking, with grand spaces, dramatic embellishment, and theatrical display in the **Classical Baroque** style. The connected buildings measure 2,000 feet wide and are surrounded by seven square miles of parks. Its scale is tremendous, as indicated by just one detail: more than four million tulip bulbs were planted in the parks' flower beds.

Inside, the *Hall of Mirrors* (Fig. 9.14), 240 feet long, connects the royal apartments with the chapel. The ceilings were covered with marvelous frescoes, and the long, mirrored room was embellished with gilded bronze capitals, sparkling candelabra, and bejeweled trees. Just as Louis XIV dominated the French church, nobility, and peasants, he also controlled the arts, fashion, and manners.

He established the French Royal Academy of Painting and Sculpture to ensure a steady supply of works that would glorify his person and reign.

 CONNECTION At Versailles, Louis XIV stripped the nobility of their power, so they occupied their time in games of romance and intrigue, as in Fragonard's *The Swing* (Fig. 12.25).

The Palace at Ikere, the residence of a Nigerian ruler, provides another example for comparison of artwork that symbolizes kingly power. Olowe of Ise carved the *Palace Sculpture* (Fig. 9.15), showing the senior wife, the queen, standing behind the enthroned king. Women are revered for their procreative power, so the royal female towers over the king while crowning him because she is the source of his power. His conical crown is topped by a bird, a symbol for the reproductive power of mothers, female ancestors, and deities. The interlocking forms of king and queen visually convey monumentality and elegance. Details, such as the pattern of body scarification, add authenticity to the sculpture. Yoruba aesthetic values are evident: "clarity, straightness, balance, youthfulness, luminosity and character" (Blier 1998:85).

Yoruba kings would seek the best artists to make artwork for their palaces as a way to increase their prestige. Olowe of Ise spent four years (1910–1914) at Ikere producing around thirty pieces (see Fig. 1.2 for another example). Songs or poems of praise (**oriki**) were composed about him:

> *Handsome among his friends.*
> *Outstanding among his peers.*
> *One who carves the hard wood of the iroko*
> *tree as though it were as soft as a calabash.*
> *One who achieves fame with the proceeds of his carving.*

(Blier 1998:85)

Thus, across several continents and several centuries, we have seen palaces built with certain distinguishing features: large size, height, and terraces and/or platforms, embellished with decorated interiors and symbolic sculptures.

Seats of Government

Seats of government visually symbolize a nation (evident in the *U.S. Capitol Building*, Fig. 4.1). It is important to realize that social and political pressures help determine which styles of architecture are used in government

9.15 OLOWE OF ISE. *Palace Sculpture*, Yoruba, Ikere, Nigeria, 1910–1914. Wood and pigment, 5′ × 1′ 1¼″. Art Institute of Chicago.

The senior wife stands behind the enthroned king, giving her high status for her procreative power.

9.16 CHARLES BARRY and A. W. N. PUGIN. *Houses of Parliament*, London, 1840–1860. 940′ long.

This seat-of-government structure was designed in the Gothic Revival style, breaking away from the popular Neoclassical style at the time.

buildings, as seen in the designing of England's *Houses of Parliament* (Fig. 9.16), our focus figure. In 1836, the old Houses of Parliament burned. A new design was sought that would reinforce England's desires to create a "national identity" and express patriotic spirit. Architect Charles Barry designed the general plan in the **Gothic Revival** style, while A. W. N. Pugin was responsible for suitable ornamentation. They felt that the style of the soaring medieval cathedrals of the thirteenth through the fifteenth centuries appropriately represented a Christian nation. New building materials, such as cast iron, enabled the Gothic Revival style to flourish on a grand scale in the 1800s.

Pugin and Barry were hotly criticized for breaking away from **Neoclassic** architecture, which was widely used for public and government buildings in western Europe and the United States, like the *U.S. Capitol Building*. The painter John Constable argued that the new Gothic Revival design of Parliament was a "vain endeavor to reanimate deceased art, in which the utmost that can be accomplished will be

to reproduce a body without a soul" (Honour and Fleming 1995:621). Pugin, however, felt that Gothic art never died or lost its soul. He believed that Gothic was a principle rather than a style, "as eternally valid as the teaching of the Roman Church" (1995:621). He also reasoned that contemporary Greek temples were mere imitations and had no integrity.

The long, horizontal buildings are topped with Victoria Tower on one end, while the famous clock tower, with Big Ben, is on the other. Ironically, the building's plan is clearly symmetrical with repetitive ornamentation, qualities of Classical architecture. However, the building resembles a medieval church or a castle-fortress, visually housing Parliament in a metaphor of the church's strength and the government's power.

CONNECTION *Chartres Cathedral* (Figs. 7.39 and 7.40) and the *Chapel of Henry VII* in Westminster Abbey (Fig. 8.19) are two examples of Gothic architecture that inspired the design of the *Houses of Parliament*.

9.17 *Te Papaiouru Marae*, Maori meeting house, Ohinemutu Village, Rotorua, North Island, New Zealand, late nineteenth century.

This important structure was an elaborate version of the chief's house and a site for reaffirming tribal values and clan ties.

Just as a new architectural style was developed for the *Houses of Parliament*, a new form of architecture evolved in New Zealand in response to political and social needs. In the nineteenth century, the Maori nation was undergoing tremendous change as a result of European colonization. The Maori meeting house, like *Te Papaiouru Marae* (Fig. 9.17) in Ohinemutu, developed from an elaborate version of a chief's home and was a site for reaffirming old tribal values and clan ties. It represented the body of a powerful ancestor, and, once inside, the living became one with their ancestor. The porch is considered to be the ancestor's brain, the **bargeboards** are the ancestor's arms and hands, and the roof's ridgepole represents the ancestor's backbone, terminating at the front with a face mask. Inside, the rafters and wall slabs represent the ancestor's ribs and are covered with carved and painted vines that symbolize the clan's generations.

The sculptures on Maori meeting houses are visually overwhelming. These profuse carvings, swirls, lines, and frightening imagery empower clan members, while intimidating any outsiders. (See Fig. 3.39 for an interior view of a meeting house.) The carvings represent mythical first parents and the tribe's history—in this case, Tamatekapua, who was the captain of the canoe that first brought the tribe's ancestors to New Zealand. Inspirational stories about clan heroes, told in the presence of these images, pass on clan history, traditions, and values to the young.

Monuments

A final category of government art is the commemorative monument. These structures are often very large, with architectural elements, sculpture, and inscriptions. Although we are looking at only one monument in this section, later in this chapter are examples that relate to war and peace. In addition, you can find many monuments in cities around the world that commemorate past events, civic leaders, and military heroes.

9.18 *Arch of Titus*, Rome, 81 CE. Marble on concrete, 50′ × 40′.

This monument both illustrates and commemorates Titus' victories and his apotheosis (becoming a god).

CONNECTION The *Portrait of George* (Fig. 10.30) is a monument to slain San Francisco mayor George Moscone. Another example is the *Monumental Heads* from Easter Island (Fig. 3.35).

ART EXPERIENCE A state's currency reveals a lot about the image of the country. Imagine yourself to be a currency designer. Design a new dollar that reflects the United States today.

Roman triumphal arches commemorate military victories or major building projects. The *Arch of Titus* (Fig. 9.18) was built along the Via Sacra (the Holy Road) in Rome, by Titus' brother Domitian, to record Titus' **apotheosis.** The inscription at the top reads roughly ". . . dedicate this arch to the god Titus, son of the god Vespasian."

This single-passageway arch (others have three) is a small **barrel vault.** Engaged columns have both Ionic and Corinthian elements, a Roman synthesis of Greek **orders.** The **attic** is the uppermost section with the inscription. "Winged victories" in the **spandrels** symbolize Titus' military successes. Under the vault, one relief depicts Titus being carried up to heaven on the back of an eagle, giving a visual image of his deification. Other relief carvings show his military victories.

WAR

War is part of the history of most civilizations and cultures, and it is part of the story of power, politics, and glory.

Warriors, Weapons, and Fortifications

Warriors have been depicted in art since 8000 BCE. Warrior images can be found in almost every culture since then. Frequently, fierceness is shown in the following ways:

- Large size of warriors
- Emphasis on armor, weapons, or regalia of power
- Menacing or aloof facial expressions

Our focus figure is a soldier mounted on his horse. Before the modern era, the warrior on horseback was

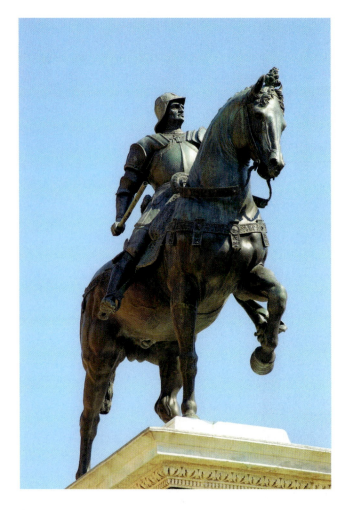

9.19 Andrea del Verrocchio. *Equestrian Monument of Bartolomeo Colleoni*, Italy, c. 1483–1488. Bronze, 15' high. Campo Ss. Giovanni e Paolo, Venice.

The warrior mounted on horseback represents fearsome victorious power.

9.20 *Tula Warrior Columns*, Toltec, Mexico, 900–1000. 16' to 20' high.

These tall and stable totem-like guardian figures supported the roof on an elevated temple base.

greatly feared. Andrea del Verrocchio's colossal bronze *Equestrian Monument of Bartolomeo Colleoni* (Fig. 9.19) joins the horse's power with the rider's strength and determination. Colleoni was a **condottiere,** or mercenary soldier, who fought many campaigns for the city-state of Venice during the fifteenth century. The 15-foot-tall statue is raised on a high pedestal, so that viewers are vulnerably placed under the horse's raised hoof. The animal's tense, bulging muscles and Colleoni's twisted pose and scowling face are the very embodiment of aggression.

For comparison, we see in the Toltec city of Tula in central Mexico the colossal *Tula Warrior Columns* (Fig. 9.20), which stand on a temple platform atop a pyramid dating between 900 and 1000. These 16- to 20-foot-tall figures once held up the temple roof; figuratively, they "supported" the religion. Stiff, blocky, and frontal, they are carved in low relief from four basalt drums attached with dowels and

originally painted in bright colors. They wear Toltec garb with elaborate headdresses, and each holds an **atlatl**—spear-thrower—at his side. Thus, the warriors' attire is more than functional; it is also aesthetic to increase their power and prestige. The warriors' uniformity gives the impression of a formidable army that could crush anything. Stylized butterflies, carved on their chests, represent the souls of past warriors.

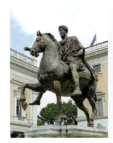

CONNECTION Compare the *Equestrian Statue of Marcus Aurelius* (Fig. 1.3) for a nonwarrior image of a ruler on horseback.

Another comparative example here is a brass *Plaque with Warrior and Attendants* (Fig. 9.21), which depicts an impassive Nigerian warrior king from the seventeenth or early eighteenth century. Larger than his two attendants, the king displays classic African figurative proportion, approximately three heads high. His apron and shield have leopard imagery, a regal symbol made more important because of the artistic attention given to it.

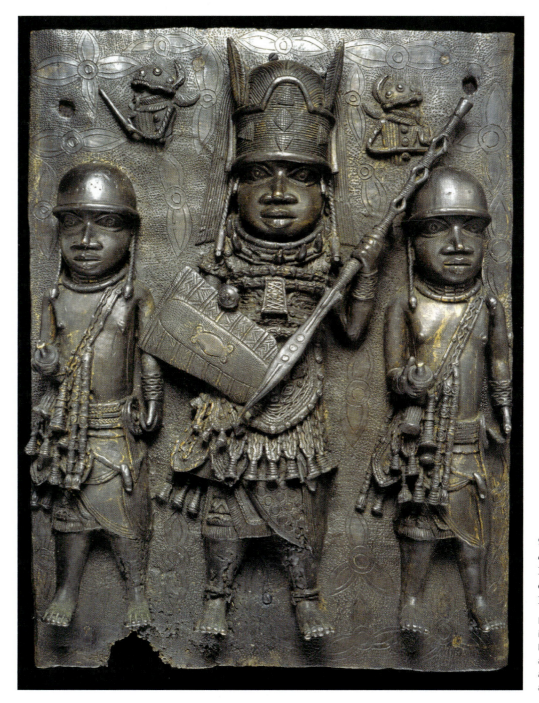

9.21 *Plaque with Warrior and Attendants*, Benin, Nigeria, seventeenth or early eighteenth century. Brass, 1′ 7¼″ high.

In the center of this plaque is an impassive warrior king, flanked by his two attendants. It conveys his absolute authority, power, and strength.

9.22 *The Great Wall*, China. Construction began during the Qin Dynasty in 206 BCE, with major work occurring during the Ming Dynasty, 1368–1644 CE. Brick faced, average height 25′, 1,500 miles long.

This enduring war fortification is considered a "wonder of the world."

Dominating the composition are the warrior's spear, helmet, and shield. Often, armor and weapons were protection for both the body and the spirit. The frontal, symmetrical composition of the *Plaque* conveys absolute authority, power, and strength; the face is aloof. These plaques were documents of kings, warriors, and famous events and were displayed prominently in Benin palaces. The plaques represented the king's power and literally were his image among his people because he rarely appeared in public except to wage war and to officiate at religious ceremonies.

And, finally, outstanding among war architecture is *The Great Wall* of China (Fig. 9.22). Begun in 206 BCE during the Qin Dynasty, with major additions during the Ming Dynasty (1368–1644 CE), this 1,500-mile-long wall is a "wonder of the world." New pieces of it are still being discovered, and the section near Beijing has been restored. The brick-faced wall averages 25 feet in height and width, and it creates a light-colored, undulating line on the brown and green hills. Strategically placed watchtowers provide points of visual emphasis. The towers contained embrasures for cannons and were used as signal stations, with smoke by day and fires by night.

War Scenes

Art can present war as a memorable, even glorious, action-filled event. Or art can document battles from various points of view. Finally, art can emphasize the horrors of war.

Glorifying War

Here, we begin our focus in Egypt with the *Palette of King Narmer* (Fig. 9.23), from 3000 BCE, which was used

9.23 *Palette of King Narmer*, Egypt, c. 3000 BCE. Slate, 2′ 1″ high.

The relief carvings both depict and commemorate the unification of Upper and Lower Egypt and the glory of its victorious pharaoh.

for mixing black eye makeup worn by ancient Egyptian men and women. The carving records the forceful unification of Egypt, when Narmer (also called Menes), king of Upper Egypt, was victorious in war over Lower Egypt. At top center, the horizontal fish and the vertical chisel below it are pictographs for "Narmer." Flanking Narmer's name are two images of Hathor, the cow goddess of beauty, love, and fertility, who was the king's protector. Like *Menkaure* (Fig. 9.3), Narmer is shown in the formal, standardized pose typical of Egyptian art, but here he is larger than those around him because of his status. Horizontal divisions (or **registers**) separate scenes.

On the right, a large King Narmer, wearing the tall white crown of Upper Egypt, is about to administer a deadly blow to the enemy he grasps by the hair. Behind him is a servant who is carrying his sandals, his bare feet suggesting that this is a divinely predisposed event. The falcon represents Horus, the god of Upper Egypt, standing triumphantly on a head and papyrus, both representing Lower Egypt. In the bottom register are dead prisoners. On the left, the triumphant Narmer wears the cobra crown of Lower Egypt. Preceded by standard-bearers, he inspects the beheaded enemies lined up in rows with their heads tucked between their feet. The intertwined necks of beasts may represent unification of Egypt.

Compare the battle depictions in the *Palette of King Narmer* with a painting of a battle that occurred during the Kamakura era in medieval Japan. The country was convulsed by civil war and two invasions by the

Mongol emperor Kublai Khan (see the *History Focus* on page 247). Warfare and artistry were particularly interwoven at this time. The martial arts were elevated to a precise art form, and literature featured long tales of war and battle, unlike the courtly love tales from the period immediately preceding. The *Heiji Monogatari* is an illustrated scroll nearly 23 feet long, telling the tale of two feuding clans in the twelfth century. It was to be unrolled one scene at a time and viewed by two or three people. One scene, the *Burning of the Sanjo Palace* (Fig. 9.24), shows the tumult and disorder of warfare. As flames and smoke erupt dramatically, the raiders dash away to the left, trampling their victims or leaving them trapped in the burning rubble. Strong visual contrasts heighten the sense of chaos. Jumbled shapes differ from the clean lines of the palace roof. Groups are juxtaposed with single figures to build and then diffuse dramatic moments.

Nineteenth-Century Battle Scenes

In the preceding examples, the artists had license to exaggerate or even fantasize about the battles and warriors. The nineteenth-century invention of the camera changed that. Along with romanticized photographs of war heroes came horrific battlefield scenes, such as *Dead Confederate Soldier with Gun* (Fig. 9.25), by Mathew B. Brady (or staff), from 1865. We begin our focus here. The first to photograph war, Brady made 3,500 photographs covering both sides of the U.S. Civil War. Brady often arranged props, such as the rifles, to enhance both the composition and the sense of tragedy. Rough textures fill the image, except for the smooth planes of the soldier's face and rifle stock. The fallen tree forms a horizontal barrier separating the dead soldier from the living. His fallen body parallels the guns and rubble in the background behind him.

Compare here another point of view in the *Battle of Little Big Horn* (Fig. 9.26), painted in 1880 by the Sioux

9.24 *Burning of the Sanjo Palace*, detail, from the *Heiji Monogatari* (hand scroll), Kamakura period, Japan, late thirteenth century. Ink and color on paper, 1′ 4¼″ × 22′ 9″.

This long scroll tells the tale of two feuding clans in medieval Japan.

9.25 Mathew B. Brady (or Staff). *Dead Confederate Soldier with Gun*, 1865. Civil War photograph.

This photograph is one image of many taken during the U.S. Civil War, the first war to be documented in photographs.

9.26 Red Horse. *Battle of Little Big Horn*, Sioux, 1880. National Anthropological Archives, Smithsonian Institution, Washington, D.C.

The depiction is a Native American's version of this historic battle.

artist Red Horse, which presents the Native American's version of Custer's last stand. The Sioux had been given land in a treaty with the U.S. government, but gold prospectors, settlers, and the railroads wanted it revoked. The flamboyant Lt. Col. George Custer attacked the Sioux and their leader, Sitting Bull, thinking this would help Custer to be elected U.S. president. In the painting, Sioux warriors advance from the right in their last victory as a nation. Custer was defeated, and the dead and wounded from both sides occupy the bottom of the image. Red Horse stacked figures above each other to show both the chaos and the detail of battle.

Twentieth-Century Images of War

Although war is still glorified in twentieth-century art, as we saw in Riefenstahl's *Triumph of the Will* (Fig. 9.9), more and more images present the horrific side.

After the revolution of 1917 in Russia, Communist leader Vladimir Lenin saw the advantages of film as a new medium. Sergei M. Eisenstein was commissioned to glorify the collective heroism and martyrdom of the Soviet people in his masterpiece film, *The Battleship Potemkin* (Fig. 9.27), made in 1925. A great admirer of U.S. filmmaker D. W. Griffith, Eisenstein used many cinematic devices: full views; extreme close-ups; panned shots; iris (blurred edges); traveling (moving from front to back or back to front); flashbacks; and crosscutting (two events interwoven for dramatic effect).

Eisenstein's strength, however, was his editing. He used a rapid form of **montage** that allowed the viewers to piece together the narrative from fleeting images. The Odessa Steps Massacre sequence in *The Battleship Potemkin* shows the horrendous conclusion of a failed 1905 uprising. It lasts four minutes and twenty seconds but contains 155 separate shots, all from different camera angles, showing Czarist soldiers firing on unarmed people, a mother holding a dead child, the bloodied face of a beaten woman, a baby in a carriage that careens down the steps, a horrified student, and the dreadful aftermath of the dead lying on the stairs of the port. The quick-cut images capture the feeling of terror, panic, and chaos.

Compare now one of the greatest twentieth-century paintings, *Guernica* (Fig. 9.28), by Pablo Picasso, which dramatized the 1937 destruction of the Basque capital during the Spanish Civil War. German Nazi planes bombarded the city, which burned for three days and left more than 1,000 people dead. In Paris, shocked and outraged, Picasso immediately set down sketches for the painting, blending the nightmarish aspects of **Surrealism** with his

9.27 SERGEI M. EISENSTEIN. *The Battleship Potemkin*, Russia, 1925. Film stills.

This film was commissioned to show the collective heroism and martyrdom of the Soviet people after the Russian revolution of 1917.

9.28 PABLO PICASSO. *Guernica*, Spain, 1937. Oil on canvas, 11′ × 28′ 8″. Museo Reina Sofia, Madrid.

This work dramatized the 1937 destruction of the Basque capital by Nazi fire bombs during the Spanish Civil War.

own style of **Cubism.** The bull represents Fascist Spain, doomed to be tortured and suffer a slow, inevitable death. The gored, dying horse is the Spanish Republic, while the fallen soldier holding the broken sword represents the spirit of resistance against tyranny. Other heads represent shocked witnesses to the suffering and carnage. The electric lightbulb shaped like an eye suggests that the world is being shown its inhumanity. A sense of agony pervades. Picasso experienced a conversion after the attack on Guernica. In earlier work, he was more concerned with the formalistic elements in art. Subsequently, he said, "Painting is not done to decorate apartments. It is an instrument of war for attack and defense against the enemy" (Rubin 1972:166).

CONNECTION Turn to Chapter 10 for examples of protest art against war.

War Memorials

An entire book could be devoted to monumental art dedicated to war victories, battles, and the dying. In this chapter, we have already seen the *Arch of Titus* (Fig. 9.18), which both enhanced the emperor's fame and memorialized his battle victories.

The *USA Marine Corps War Memorial* (Fig. 9.29), sculpted by Felix W. Weldon and dedicated in 1956, commemorates the 6,800 U.S. soldiers who died in the victorious battle for Iwo Jima in World War II. This sculpture

9.29 FELIX W. WELDON. *USA Marine Corps War Memorial*, Arlington, Virginia, 1954. Cast bronze, over life-size.

These statues commemorate the soldiers who died during the battle for Iwo Jima in World War II.

9.30 MAYA YING LIN. *Vietnam Veterans Memorial,* Washington, D.C., 1982. Black granite, 492′ long, height of wall at center is 10′ 1″.

A reverent and quiet space, the shrine wall contains the names of 58,000 men and women who died in the Vietnam War.

is a copy of an Associated Press photograph that captured the re-creation of the flag raising after the Marines charged up Iwo Jima's Mt. Suribachi. Weldon's bronze sculpture is larger than life-size, grand, and dramatic. The soldiers form a triangle to indicate strength and solidity, while the numerous diagonals suggest tumbling haste. The past blends with the present, as every day a real American flag is raised and lowered on the memorial.

For contrast in design, we look at another commemoration for Americans lost in war. The *Vietnam Veterans Memorial* (Fig. 9.30), 1982, by Maya Lin, is located on the Mall in Washington, D.C. The names of nearly 58,000 men and women who died in the Vietnam War, from 1959 until 1975, are carved in chronological order on its black granite face. Its polished surface reflects the faces of the living and superimposes them on the names of the dead, which forces a personal connection between the two. Family and friends make rubbings of the names and leave all kinds of remembrances, such as poems or childhood mementos. Visitors meditate or mourn rather than celebrate. This lack of glory made the *Memorial* very controversial, so figurative sculptures of heroic soldiers and nurses were added later near the site. Taken all together, these monuments create a powerful memorial to the Vietnam War.

The long, V-shaped memorial is set into the ground with one end pointing to the Washington Monument, a symbol of national unity, and the other end pointing to the Lincoln Memorial, remembering a nation divided by civil war. This reflects the national anguish over soldiers who died in a war about which the general population was ambivalent. Magazine and newspaper coverage had brought the blunt

realities of the war into U.S. homes, as evident in *Brigadier General Nguyen Ngoc Loan summarily executing the suspected leader of a Vietcong commando unit* (Fig. 9.31), a war photograph from 1968 by Eddie Adams. Its harshness contrasts severely with romanticized images of war.

PEACE

Winged allegorical figures, doves, women, and pastoral landscapes have symbolized peace in Western art. Gardens, bells, and temples serve as monuments to peace in Asia, Europe, and the Americas.

CONNECTION

Ambrogio Lorenzetti's *Allegory of Good Government* (Fig. 10.20) contains a personification of peace and shows the prosperity that comes with peace.

Art about Peace

Edward Hicks' *The Peaceable Kingdom* (Fig. 9.32), painted between 1830 and 1840, is based on the following biblical passage:

> The wolf also shall dwell with the lamb, and the leopard shall lie down with the kid; and the calf and the young lion and the fatling together; and a little child shall lead them. (Isaiah 11)

9.31 EDDIE ADAMS. *Brigadier General Nguyen Ngoc Loan summarily executing the suspected leader of a Vietcong commando unit*, Saigon, South Vietnam, February 1, 1968.

This brutal and blunt photo showed a reality of the Vietnam War in U.S. publications.

9.32 EDWARD HICKS. *The Peaceable Kingdom*, United States, 1830–1840. Oil on canvas, 1′ 5⁷/₁₆″ × 1′ 11⁹/₁₆″. Brooklyn Museum of Art.

A passage from the Bible (Isaiah 11) inspired the Quaker artist to express a message of peace in this work.

9.33 *Ara Pacis Augustae*, Rome, 13–9 BCE. Marble, outer wall 34′ 5″ × 38′ × 23′.

This structure was built to commemorate Emperor Augustus' stopping the war between Spain (Hispania) and France (Gaul).

Hicks was also inspired by the Quaker William Penn and his treaty with the Indians, which is visible in the background as a copied detail from a famous painting by U.S. artist Benjamin West. This moment came to signify a utopian new world. Hicks' visual metaphors have become standard language for expressing the concept of peace. A luminous sky glows in the background, while lush vegetation frames the foreground figures. The animals are rendered in a flat, decorative, imaginative style. There is a feeling of innocence and peace, without strife and turmoil.

Peace Monuments and Peace Offerings

An example of a peace monument is the *Ara Pacis Augustae* (Fig. 9.33), from 13–9 BCE, built to commemorate Emperor Augustus' stopping of the civil wars between Spain and France. It sits on a podium with twelve steps, enclosed by walls covered with reliefs of the Earth Mother, Tellus; Aeneas, the legendary founder of Rome; and two long processions led by Augustus. Carved foliage and fruit garlands symbolize the golden age of plenty as well as fecundity, ripeness, and peace, all under the rule of Augustus. Sacrificial offerings of animals and humans are indicated. The whole piece was probably brightly painted. Although the *Ara Pacis Augustae* celebrates the peace of the Roman Empire, it can also be seen as a victory monument that glorifies the emperor Augustus.

When peace treaties are signed, art and gifts are often exchanged to seal the agreement. Precious objects might also be offered to show submission or to avoid further confrontation. *Moctezuma's Headdress* (Fig. 9.34) is believed to have belonged to the last Aztec ruler, Moctezuma, who may have given it to the Spanish leader Cortés as a peace offering or as a desperate last measure to avoid his own demise. Objects made of feathers are frail, and not many survive long periods. This one is exceptional. The 4-foot-high headdress features iridescent green feathers from the quetzal bird's tail and has blue feathers from the cotinga

9.34 *Moctezuma's Headdress*, Aztec, Mexico, c. 1519. Quetzal and cotinga feathers, gold plaques. Kunsthistorisches Museum, Vienna.

This object was believed to be given to Hernán Cortés by the Aztec ruler as a last resort for peace before his own demise.

9.35 *Presentation Pipe Tomahawk*, Ottawa, United States, c. 1820. Wood, inlaid metal; 1' 11½" × 8".

Ironically, this weapon was superbly crafted only to be given as a peace offering, never for use in battle.

interwoven with small gold disks. Three hundred workers staffed the royal aviaries that produced these feathers. Moctezuma's wives and concubines probably made the piece.

Native Americans created tomahawks and pipes used exclusively for peaceful exchange. The *Presentation Pipe Tomahawk* (Fig. 9.35) is an aesthetically beautiful work meant to be presented as a ritual peace offering.

It is made of hickory wood, silver, iron, and lead. The name "Ottokee," a member of the Great Lakes Ottawa tribe in 1820, is engraved in silver inlay on the handle, along with naturalistic fish and an abstract curvilinear pattern. On the head and blade of the tomahawk are engraved an acorn, a heart, and a half moon. The style of the engravings suggests European influences. The pipe tomahawk may have been crafted by European, American, or Ottawan metalsmiths.

Recently in the twentieth century, memorials to peace were constructed in Hiroshima, Japan, and in Los Angeles, California. These peace parks, not shown here, were built to heal wounds of war. It is hoped that such memorials will become a more prominent part of human history.

ART EXPERIENCE Discuss the following: The art you have studied in this chapter has largely come from authoritarian states. What differences, if any, can be found in the artistic and architectural expressions of power within democratic governments?

10.1 CILDO MEIRELES. *Insertions into Ideological Circuits: Coca-Cola Project*, Brazil, 1970. Screen print on Coca-Cola bottles.

This work was created as a response to Brazil's military government in 1970, which supported itself by "selling" the country to foreign investors, including the United States.

10
SOCIAL PROTEST/ AFFIRMATION

Many artists protest injustice with their artwork. They identify villains, honor heroes, and promote causes with emotional and visual impact unequaled by the written word. Protest art is a form of affirmation because it is based on respect for human dignity and the belief that change is possible. Two other chapters contain related images. Chapter 9 has artworks about war, and Chapter 12 contains art that examines race and gender.

PREVIEW

This chapter begins with art that depicts the cruelty and destruction of war and exposes cynical military leaders. Realist, abstract, and conceptual art can express the human struggle for liberty against totalitarian forces.

Artists have protested many forms of oppression, such as the exploitation of laborers, acts of betrayal, repressive governments, colonialism, and pollution. They have used all kinds of media, as with the modified Coke bottles in Figure 10.1, both to protest and to affirm opposing values. "Normal" conditions are reexamined by artists and, in many cases, found wanting. Half-truths, stultifying bureaucracies, police states, and upper-class greed and mindlessness are all targets for artistic critique. Other artists look at consumerism, oppressive patriarchy, the status of women, and institutionalized discrimination.

For your Art Experiences in this chapter, you may choose to make your own protest art, alter an existing mass-produced product item to change its meaning, or have a debate about which form of protest art is most effective.

Connecting Art and History from
1300–1550 CE

The world in 1300 was still a patchwork of relatively autonomous, relatively isolated regions. Within 250 years, much of that changed. Many conditions in the modern world have their roots in this era.

Many areas of the world were ruled by strong centralized governments. China during this period was ruled by two dynasties: the Yuan dynasty of the Mongolian invaders, which ended in the mid-1300s, and the native Ming dynasty, known for its territorial expansion as well as its amazing building program, which included rebuilding the Great Wall and constructing the Forbidden City.

Wealth was distributed to lower classes through the civil service and land ownership. This was a period of stability, prosperity, religious tolerance, and a high standard of living. Chinese ships traveled to India and Africa, and the Portuguese landed at China's ports in 1514.

Islam continued to expand in Asia, Africa, and southeastern Europe. Around 1280, the mighty Ottoman Empire was established with Turkey as its center, and it expanded its territories in North Africa and the Middle East. Many Ottoman rulers were art patrons, great builders, and conquerors. They generally tolerated

other religions. Likewise, the Mughal Empire in India was known for its ambitious building program, its humane rulers, and its illuminated manuscripts. The Safavids ruled Persia after 1500.

At this time, Europe saw the end of the Middle Ages and the beginning of the Renaissance. The rise of Christian humanism in the fourteenth and fifteenth centuries brought an emphasis on reason, human abilities, and intellectual achievement, as exemplified by scholars and leaders such as *Jean de Dinteville and Georges de Selve ("The Ambassadors")* (Fig. 10.21). This humanistic tradition has

Map 6 Patterns of World Trade.

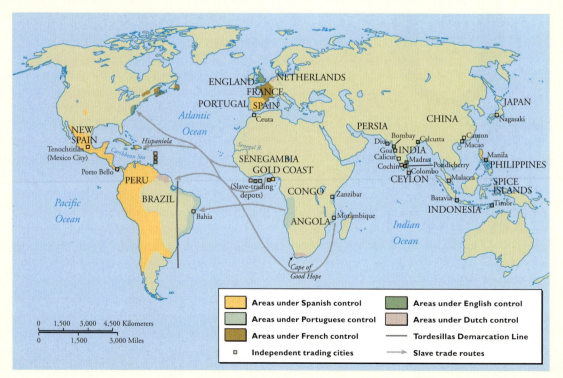

continued to grow, and because it promotes the inherent worth and dignity of all human beings, it is the basis for much social protest art. Small areas of Italy—notably Florence and Siena—had republican governments, as shown with the *Allegory of Good Government* (Fig. 10.20). In Italy, the era brought increased prosperity and the rediscovery of Greco-Roman culture.

Beginning in 1300, the secular power of the Catholic Church slowly declined in Europe. The Church's religious authority was challenged in the 1500s when the Protestant Reformation divided European Christians between the Protestants and Catholics.

This was the beginning of the age of exploration and expansion. European sailors undertook amazing voyages of discovery, most notably in the Americas in 1492. Advanced civilizations, especially the Toltec and Maya cultures, had flourished earlier in Central America, with hieroglyphics, ball courts, and palaces. In 1500, the Aztecs dominated central Mexico and had a complex society with accomplishments in painting, architecture, astronomy, and cosmology. The Aztec *Coatlicue* (Fig. 10.2) is a colossal freestanding sculpture of a deity representing sacrificial death as well as the potential for new life. The *Codex Borbonicus* (Fig. 10.22) is an example of Aztec bookmaking and painting accomplishments that also shows the culture's calendar system. In 1519, the Spaniards conquered the Aztecs and attempted to wipe out their culture; later, they also conquered the Incas of Peru and established a large colonial empire in the Americas.

Other adventurers circled the globe, visiting ports in Asia and India. Trade expanded greatly in the 1500s and reached many parts of the world. For Europe, the spice trade with Southeast Asia and the slave trade with Africa were

10.2 *Coatlicue*, Aztec, Tenochtitlán, Mexico, c. 1487–1520. Andesite, 11′ 6″ high. Museo Nacional de Antropología, Mexico City.

This colossal freestanding statue is an example of the art style of the Aztecs of Central America. It depicts a deity who represents sacrificial death as well as the potential for new life.

important. Other traded commodities included fur, fish, timber, tobacco, rice, silver, gold, sugar, cacao, coffee, diamonds, tea, silk, cotton, and ivory.

The Kingdom of Zimbabwe flourished from 1300 to 1450 in Africa. Other central areas of Africa remained free of Europeans, but African slaves from coastal areas were brought to Europe and the Americas beginning in the 1500s. England, Portugal, and France as well as Spain established American colonies. Spain and Portugal divided South America along the Tordesillas Demarcation line. In still-isolated Australia, the Aboriginal peoples were

growing in population and developing long-distance trading among themselves.

Thus, we have seen the beginnings of slavery, the expansion of Islam and changes to Christianity, and European colonization taking hold as long as seven hundred years ago. The injustices and conflicts resulting from the slave trade are still the subjects of contemporary artworks, such as Yinka Shonibare's *Mr. and Mrs. Andrews without Their Heads* (Fig. 10.18), Kara Walker's "*They Waz Nice White Folks While They Lasted*" (Says One Gal to Another) (Fig. 10.19), and William Kentridge's *Drawing from Mine* (Fig. 10.31).

World Art Map
for Chapter 10

NORTH AMERICA

Kara Walker. *"They Waz Nice White Folks While They Lasted." (Says One Gal to Another)*

Ester Hernandez. *Sun Mad.*
Robert Arneson. *Portrait of George.*

Edward Kienholz. *The State Hospital.*

Leon Golub. *Mercenaries I.*
Robert Motherwell. *Elegy to the Spanish Republic XXXIV.*
Lewis Hine. *Leo, 48 Inches High, 8 Years Old, Picks Up Bobbins at 15¢ a Day.*
Jenny Holzer. *Untitled (Selected Writings).*
Hans Haacke. *MetroMobiltan.*
Jacob Lawrence. *No. 36: During the Truce Toussaint Is Deceived and Arrested by LeClerc. LeClerc Led Toussaint to Believe That He Was Sincere, Believing That When Toussaint Was Out of the Way, the Blacks Would Surrender.*

David Alfaro Siqueiros. *Echo of a Scream.*
Codex Borbonicus.
Coatlicue.

EUROPE

George Grosz. *Fit for Active Service.*
John Heartfield. *Goering the Executioner.*
Käthe Kollwitz. *The Outbreak ("Losbruch").*

Yinka Shonibare. *Mr. and Mrs. Andrews without Their Heads.*
William Hogarth. *Breakfast Scene.*

Honoré Daumier. *The Legislative Belly.*

Hans Holbein the Younger. *Jean de Dinteville and Georges de Selve ("The Ambassadors").*

**Francisco Goya.
The Executions of May 3, 1808.
Prado, Spain.**

**Ben Shahn.
The Passion of Sacco and Vanzetti.
Massachusetts, United States.**

**Miguel Antonio Bonilla. *The Knot.*
El Salvador, Central America.**

**Pepón Osorio.
The Scene of the Crime (Whose Crime?).
Puerto Rico.**

SOUTH AMERICA

Cildo Meireles.
Insertions into Ideological Circuits: Coca-Cola Project.

N

| 0 | 1,000 | 2,000 Km. |
| 0 | 1,000 | 2,000 Mi. |

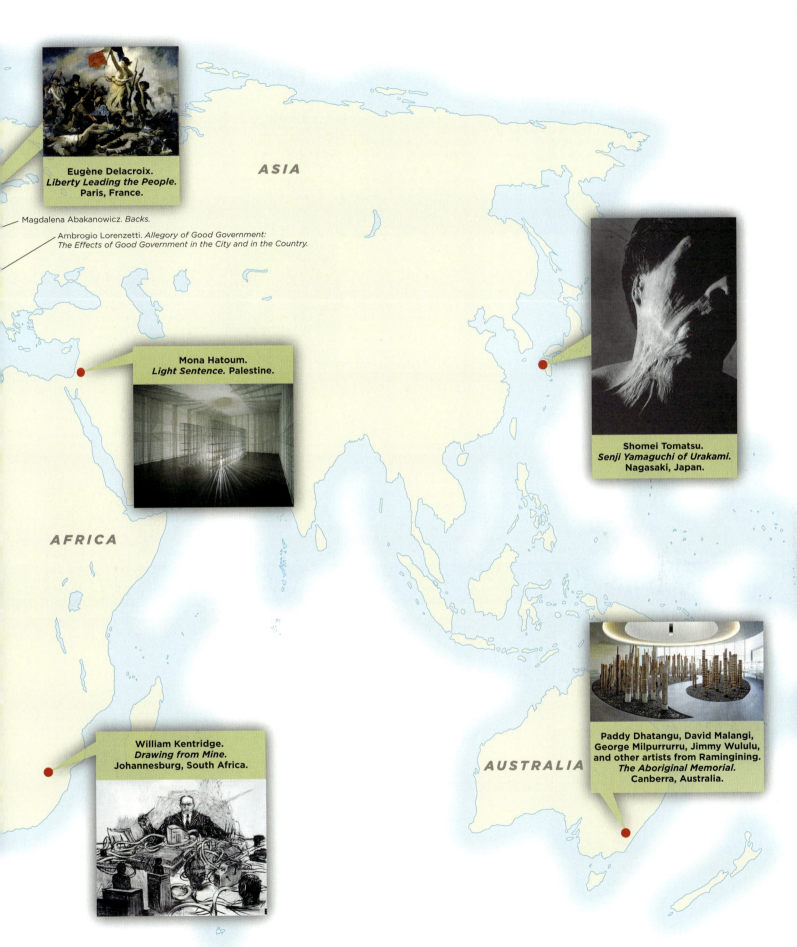

Eugène Delacroix.
Liberty Leading the People.
Paris, France.

ASIA

Magdalena Abakanowicz. *Backs.*

Ambrogio Lorenzetti. *Allegory of Good Government:*
The Effects of Good Government in the City and in the Country.

Mona Hatoum.
Light Sentence. Palestine.

Shomei Tomatsu.
Senji Yamaguchi of Urakami.
Nagasaki, Japan.

AFRICA

William Kentridge.
Drawing from Mine.
Johannesburg, South Africa.

Paddy Dhatangu, David Malangi,
George Milpurrurru, Jimmy Wululu,
and other artists from Ramingining.
The Aboriginal Memorial.
Canberra, Australia.

AUSTRALIA

1300–1550 CE

HISTORY FOCUS

ROMANESQUE ERA	KAMAKURA PERIOD— JAPAN	GOTHIC ERA CHOLA KINGDOM— INDIA YUAN DYNASTY— CHINA MAYA/TOLTEC CULTURE IN MESOAMERICA	Black Death in Europe MING DYNASTY— CHINA Great Wall of China Rebuilt	RENAISSANCE IN EUROPE OTTOMAN EMPIRE IN TURKEY, NORTH AFRICA, AND MIDDLE EAST AZTEC CIVILIZATION Christopher Columbus	
CE 1000	1192	1200	1300	1400	1500
			LORENZETTI. *Allegory of Good Government*		*Codex Borbonicus* HOLBEIN. *Jean de Dinteville and Georges de Selve ("The Ambassadors")*

∧ *Eagle Knight* (3.40)

Coatlicue

REALISM Colonial Rule Established in Africa U.S. Civil War End of Slavery in U.S.	IMPRESSIONISM POSTIMPRESSIONISM	FAUVISM, CUBISM, FUTURISM, DADA	SURREALISM, FANTASY, SUPREMATISM	World War I Harlem Renaissance	Great Depression Stalin and the U.S.S.R. Spanish Civil War World War II
1850	1875	1900	1907 1910	1914 1920	1930
		KOLLWITZ. *The Outbreak ("Losbruch")*	HINE. *Leo, 48 Inches High . . .*	GROSZ. *Fit for Active Service*	SHAHN. *The Passion of Sacco and Vanzetti* HEARTFIELD. *Goering the Executioner* LAWRENCE. *No. 36: During the Truce Toussaint Is Deceived . . .* SIQUEIROS: *Echo of a Scream*

∧ *Frederick Douglass* (3.55)

∧ MANET. *Olympia* (6.21)

∧ *Dogon Seated Couple* (6.12)

Portuguese Arrive in China

Spanish Conquest of the Aztecs and Incas

Martin Luther and the Reformation

European Colonies in the Americas

Slave Trade Begins: Africa, Europe, and the Americas

Spice Trade—Dutch East Indies and Southeast Asia

MUGHAL EMPIRE— INDIA

BAROQUE ERA

ROCOCO STYLE

Japan Closed to Westerners

Rise of Merchant Class in Japan

ROMANTICISM

Displacement of Native Americans from Western U.S.

Aboriginal Decline in Australia

| 1550 | 1600 | 1612 | 1700 | 1800 | 1819 |

HOGARTH. *Breakfast Scene*

GOYA. *The Executions of May 3, 1808*

DELACROIX. *Liberty Leading the People*

DAUMIER: *The Legislative Belly*

∧ ARTEMISIA GENTILESCHI. *Judith and Holofernes* (4.19)

ABSTRACT EXPRSSIONISM

PEOPLE'S REPUBLIC OF CHINA

POSTWAR EXPRESSIONISM

U.N. Universal Declaration of Human Rights

Cold War, 1950–1990

Civil Rights Movement in U.S.

Cesar Chavez and the United Farm Workers

Six-Day War— Israel

MODERNISM

POSTMODERNISM

Islamic Revolution in Iran

Nicaraguan Civil War

Iraqi Invasion of Kuwait

Apartheid Ends—South Africa

World Conference on Global Warming

U.S. Patriot Act

| 1940 | 1948 | 1950 | 1960 | 1962 | 1970 | 1975 | 1980 | 1990 | 1993 | 2010 |

MOTHERWELL. *Elegy to the Spanish Republic XXXIV*

TOMATSU. *Senji Yamaguchi of Urakami*

KIENHOLZ. *The State Hospital*

MEIRELES. *Insertions into Ideological Circuits: Coca-Cola Project*

GOLUB. *Mercenaries I*

ABAKANOWICZ. *Backs*

HERNANDEZ. *Sun Mad*

ARNESON. *Portrait of George*

HAACKE. *MetroMobiltan*

The Aboriginal Memorial

HOLZER. *Untitled (Selected Writings)*

KENTRIDGE. *Drawing from Mine*

HATOUM. *Light Sentence*

BONILLA. *The Knot*

∧ HAMPTON. *Throne of the Third Heaven . . .* (1.22)

∧ BACA. *Las Tres Marias* (3.5)

∧ *AIDS Memorial Quilt* (8.28)

SHONIBARE. *Mr. and Mrs. Andrews without Their Heads*

OSORIO. *The Scene of the Crime (Whose Crime?)*

WALKER. *They Waz Nice White Folks . . .*

SALCEDO. *Shibboleth*

PROTESTS AGAINST MILITARY ACTION

For thousands of years, artists have depicted war, sometimes glorifying the victors, sometimes showing the defeated and those killed or wounded. Not until two hundred years ago, however, did artists begin to make art that protests a particular war or the idea of warfare altogether. One likely reason is that a sizable percentage of past art was made for victorious political or religious leaders. Warfare was one means to gain power, and art was a way to display that power. Especially since World War II, however, growing numbers of artworks have protested full-blown war, police actions, covert operations, and guerrilla activity.

Our beginning focus is on a pivotal piece in the history of protest art: *The Executions of May 3, 1808* (Fig. 10.3), from 1814. The artist, Francisco Goya, based his painting on sketches he had made of the actual event as it happened six years earlier. The citizens of Madrid unsuccessfully rose up against Napoleon Bonaparte's occupational army in 1808. The soldiers captured many of the rioters and executed them a short distance outside the city. Goya individualized the Spaniards trembling, praying, or protesting as they face the firing line, so that we identify with their horror. We particularly focus on the man in white

with outstretched arms who is posed like the crucified Jesus, surrounded with light colors against the pervasive gloom. In contrast, Goya has dehumanized the soldiers, with repeated poses and hidden faces. The barrels of their pointing rifles are rigidly organized, like a war machine. Goya's painting goes beyond partisanship and could stand for any mass execution.

We have several examples to compare, beginning with Kathe Kollwitz. This artist dedicated her work to ending war and poverty. She lived in Germany through the two world wars, losing a son and a grandson in the fighting. In her artwork, however, she frequently turned to past conflicts to show the destructive energy of war. *The Outbreak* (*"Losbruch"*) (Fig. 10.4), dated 1903, is the fifth in a series of seven prints that tell of the Peasant War in Germany in the early sixteenth century. In the first four prints in the series, we see the causes for the peasant revolt: abuse by the ruling class, poverty, crushingly hard work, and rape of

10.3 FRANCISCO GOYA. *The Executions of May 3, 1808*, Spain, 1814. Oil on canvas, 8′ 8¾″ × 11′ 3¾″. Prado, Madrid.

Painted from sketches the artist made at the actual event, this work was a pivotal protest against Napoleon's occupational army in 1808 Madrid.

10.4 KATHE KOLLWITZ. *The Outbreak ("Losbruch")*, Germany, 1903. Etching, 1′ 8″ × 1′ 11¼″. British Museum, London.

This work, which depicts an uprising in the sixteenth-century Peasant War in Germany, is one of seven prints etched by the artist to show the destructive energy of war.

the women. In the fifth image, *The Outbreak ("Losbruch")*, the peasants revolt, propelled by their wretched living conditions.

The composition of the work is remarkable. The peasants group at the right, while already at the left they rush at deadly speed to attack their oppressors with crude weapons and farm tools. The dark woman in front becomes the leader and the conscience for the group. Her upraised arms incite them to action, while her bony, twisted hands and arms are documents to the incredible harshness of the peasants' life. Stark blacks and whites flash across the image, visually conveying the emotional moment.

Kollwitz shows a woman leading the revolt, breaking old stereotypes about women's passivity. This also attests to the misery of the peasants' lives—in the end, the women rose up. The uprising was unsuccessful, as the forces of the ruling class suppressed the peasants with brutality. The last

two prints of the *Peasant War* series show a mother searching for her dead son among piles of bodies and peasant prisoners bound together awaiting execution.

Fit for Active Service (Fig. 10.5), a 1918 pen-and-ink drawing by George Grosz, exposed the bloated doctors

10.5 GEORGE GROSZ. *Fit for Active Service*, Germany, 1918. Pen and ink, 1′ 2½″ × 1′ 1½″. The Museum of Modern Art, New York.

In this drawing, the artist exposes well-fed doctors and self-absorbed officers who were sending elderly, sick, and very young men to the front lines to fight for Germany near the end of World War I.

and self-absorbed officers, secure in their bureaucratic assignments, who sent elderly, sick, or very young men to the front lines to fight for Germany near the end of World War I. (All able-bodied men had been sent out much earlier.) With grim wit, the artist's pen outlines the smug, laughing faces of the officers in the foreground. Farther back, two mute soldiers stand at attention. The seams in their uniforms line up with the floor and the window frames. They are conformists subsumed into the structure, without independent conscience. The doctor at the center seems almost happy, since he has found another body for the front lines. Outside, factories contentedly belch out the machinery of war. In contrast to the spare and flattened manner in which the other figures are portrayed, the skeleton seems the most human, as it is rounded, detailed, and adorned with rotting organs and tufts of hair.

John Heartfield dedicated much of his art to exposing and condemning the horrors of Nazi Germany. He was born in Germany as Helmut Herzfelde but later anglicized his name. *Goering the Executioner* (Fig. 10.6), dated 1933, is a **photomontage,** in which news photographs are combined and manipulated with drawing. It appeared on the front page of the Prague newspaper *AIZ* (*Arbeiter-Illustrierte-Zeitung*). The subject is Field Marshal Hermann Goering, one of the major leaders of the Nazi Party. Heartfield pulled Goering's head forward, increasing the thickness of the neck and emphasizing the aggressiveness of his bullying face. Behind him burns the Reichstag, the German parliament building, destroyed in 1933 by an act of terrorism that was likely perpetrated by the Nazis but officially blamed on Communists. The Nazis used this excuse to seize absolute power and end any democratic government. Black-and-white elements give the image an unvarnished, blunt quality. Goering's meat cleaver and stained apron have the quality of factual truth, even though the artist added those props. Heartfield's warnings of Nazi bloodshed proved to be prophetically true. Heartfield was forced to leave Germany and spent much of the 1930s and 1940s in England.

In the mid-1930s, Spain was engulfed in a civil war that in many ways was a prelude to World War II. In 1937, David Alfaro Siqueiros painted *Echo of a Scream* (Fig. 10.7) in response to the horror of the Spanish Civil War. Siqueiros symbolized all of humanity with the screaming, helpless, pained child sitting amid the debris and destruction of modern warfare. The sky is filled by the large, detached head—the child's head repeated—emitting a massive cry that symbolizes the combined pain of all the victims we do not see. The dark tones and blue-gray colors of the painting add a somber note to the ugly surroundings. The painting also alludes to urbanization and industrialization and to the endless piles of waste that are the result of "progress" and "innovation." Siqueiros knew his subject matter firsthand. He was a Mexican citizen who fought in Spain in the International Brigade, composed of volunteers from fifty countries who fought for the Spanish Republic against the Fascists and their German Nazi backers. He was also a political activist and social reformer.

CONNECTION See Pablo Picasso's *Guernica* (Fig. 9.28) for another artwork that deals with the Spanish Civil War.

Later, between 1953 and 1954, Robert Motherwell painted the *Elegy to the Spanish Republic XXXIV* (Fig. 10.8), part of a series of more than 150 paintings that mourned the loss of liberty in Spain after the Fascist forces were victorious. Although the paintings do not tell a story, Motherwell believed that abstraction communicated, in universal terms, the struggle between life and death and between freedom and oppression. The large size of the painting makes these struggles seem monumental. Motherwell was **influenced by Surrealism**'s process of expression called

10.6 JOHN HEARTFIELD. *Goering the Executioner*, Germany, 1933. Photomontage cover for *AIZ* newspaper.

The artist depicts the Nazi field marshal as a butcher to forewarn the public of the bloodshed the party would cause in Germany.

Automatism, which incorporates intuition, spontaneity, and the accidental when creating artworks, similar to **Abstract Expressionism**'s style. His black-and-white forms suggest several Spanish motifs, according to Robert Hughes (1997:496). They are bull's testicles, the patent leather berets of the Guardia Civil, and living forms (represented by the large, ovoid shapes) being crushed by the black bands.

10.7, *left* DAVID ALFARO SIQUEIROS. *Echo of a Scream*, Mexico, 1937. Enamel on wood, 4′ × 3′. Gift of Edward M. M. Warburg (633.1939). The Museum of Modern Art, New York.

Painted in response to the horrors of the Spanish Civil War, this work symbolizes all of human suffering through the screaming, pained child sitting amid the debris of modern warfare.

10.8, *below* ROBERT MOTHERWELL. *Elegy to the Spanish Republic XXXIV*, United States, 1953–1954. Oil on canvas, 6′ 8″ × 8′ 4″. Albright-Knox Art Gallery, Buffalo, New York.

This work was part of a series that contained 150 paintings in which the artist expresses his mourning over the loss of liberty in Spain after the Fascist forces were victorious during that country's civil war.

10.9 SHOMEI TOMATSU. *Senji Yamaguchi of Urakami*, 1962. Gelatin silver print, 1′ 15/16″ × 8 13/16″.

This powerfully disturbing photograph is one of a series that exposes the mutilation of victims who survived the atomic bombing of Nagasaki, Japan, at the end of World War II.

From the other side of the world, Tomatsu Shomei's *Senji Yamaguchi of Urakami* (Fig. 10.9) is one of a series of photographs of victims of the atomic bombing of Nagasaki, Japan, at the end of World War II. The blast was so powerful that it vaporized the victims who were nearest the center of impact. Those farther away suffered terrible injuries and deformities. Tomatsu's photograph is technically beautiful, with a full range of deep blacks contrasting with the bright light casting shadowing textures of the scared skin of the man's face. This powerful view of his twisted neck gives us a lasting impression of Senji's lifelong suffering. Tomatsu made this series to document past horrors and to protest against U.S. troops stationed in Japan for decades. Since World War II, some Japanese have pushed for complete, permanent demilitarization of the country.

Leon Golub's painting *Mercenaries I* (Fig. 10.10), from 1976, shows two "guns for hire" dangling a bound victim between them, using brute power to bolster a repressive government. These professional fighters are devoid of any ideological stance; they are simply paid thugs. The mercenaries are flattened figures against the flat background. They are pushed aggressively to the foreground, and we, the viewers, are dwarfed by the nearly 11-foot height of the painting. Looking up, we share the same view as the victim, who has no identifying traits and could be anyone, even us. The paint, applied thickly at first, has been scraped repeatedly so that the surface seems raw and nasty. The flesh looks particularly repulsive, both on the cruel faces of the mercenaries and on the tortured victim. The colors are jarring and acidic.

Golub worked from news photographs and insisted that his images realistically report atrocities occurring regularly in the world. His images have an immediacy to

10.10 LEON GOLUB. *Mercenaries I*, United States, 1976. Acrylic on canvas, 9′ 8″ × 15′ 6½″. The Broad Art Foundation, Los Angeles.

This work shows two "guns for hire," exposing thugs who use brute force to bolster a repressive government.

them because of the news and because of entangled global politics and economies.

FIGHTING FOR THE OPPRESSED

Artists who fight for the rights and affirm the values of economically or politically repressed peoples use several strategies to make their points most forcefully. These include beauty, illustration, narrative, humor, and shock. Most social protest works are designed generally to affect public consciousness rather than to prescribe specific changes.

Strategies for Protesting Oppression

Interestingly, beauty and excitement can be very effective elements in protest art, as our focus figure displays. In Eugène Delacroix's *Liberty Leading the People* (Fig. 10.11), painted in 1830, Liberty has been personified as a partially nude woman—apparently flesh and blood—but reminiscent of a Greek goddess in her profile and in her idealized body. Energized and oblivious to danger, she carries a rifle and the flag of the French Revolution. She forms the peak of a triangle made up of merchants, students, laborers, soldiers, and even young boys who emerge from the smoke, debris, and dead bodies to move toward the light that surrounds Liberty.

The lower and middle classes revolted many times against European ruling classes in the late eighteenth and early nineteenth centuries. This painting is an homage to the Paris revolt in 1830. Delacroix's painting mixes realistic, idealistic, and romantic elements. Realistic are the faces of the men, who look like Parisians of the day, and the details of the clothing, weapons, and the Paris skyline in the background. Idealistic elements include the glowing, goddess-like figure of Liberty and the belief that revolution will lead to a better way of life. The work is romantic in its portrayal of fighting as thrilling, dangerous, and liberating. Compare this work to Siqueiros's *Echo of a Scream* (Fig. 10.7), where warfare is not romanticized.

10.11 EUGÈNE DELACROIX. *Liberty Leading the People*, France, 1830. Oil on canvas, approximately 8′ 6″ × 10′ 8″. Louvre, Paris.

This is an homage to the 1830 Paris Revolt in France in which the artist personifies liberty's fight against oppression of the people.

We again have several figures for comparison here. One of the most direct ways to make social protest art is to illustrate the oppressive situation. At the beginning of the twentieth century, sociologist and artist Lewis Hine photographed miserable labor conditions and slum housing in the United States. He was particularly known for exposing child labor in mines and textile mills, where children were doing the lowest-paying, most tedious jobs. *Leo, 48 Inches High, 8 Years Old, Picks Up Bobbins at 15¢ a Day* (Fig. 10.12), from 1910, shows a young boy who dodges under textile looms to pick up loose thread spools. Children in these jobs ran the risk of injury or death from moving machinery. They typically worked ten- to twelve-hour shifts in the mills, six days a week, making schooling impossible. Child laborers were destined to remain illiterate, poor, and overworked. Hine fully documented the youthfulness of the child laborers by giving his photos long titles, yet in some ways these titles were unnecessary. Hine's composition emphasizes the large scale of the weaving machines—their great length and height—that dwarf the child. Leo seems very young and apprehensive. The factory is gloomy, littered, and staffed by women, another underpaid group. Hine's pictures are more difficult to forget than wordy ideological arguments, pro or con, on labor conditions.

Hine worked with the National Child Labor Committee, a private group dedicated to protecting working children, and the loosely organized Progressive Movement of the early twentieth century, which sought reform for many problems resulting from urbanization and industrialization.

He lectured and his images were published in magazines, making his work unusually successful in changing both public opinion and public policy. Child labor was eventually outlawed in the 1930s.

Ben Shahn used narrative as a protest strategy in *The Passion of Sacco and Vanzetti* (Fig. 10.13), dated 1931–1932, to tell the story of Nicola Sacco and Bartolomeo Vanzetti, Italian immigrants who were active in labor organizations, avoided the draft in World War I, and were political anarchists. They were arrested and convicted of robbery and murder, despite several witnesses who testified that they were elsewhere at the time of the crime. Many claimed that Sacco and Vanzetti were convicted because of their politics, as the judge allowed the prosecution to make inflammatory statements about their political beliefs during the trial. In his painting, Shahn collapses time, showing simultaneously the courthouse steps, the framed portrait of the judge who presided over the original trial, and the ashen faces of Sacco and Vanzetti as they lie in their coffins. Prominent in the middle are three commissioners who declared the trial to have been legal, thus allowing the executions to take place. The commissioners are dour and righteous, bolstered by institutional rigidity. The harsh colors express Shahn's distress at the death of the two men, whom Shahn and many others felt were heroes.

Jacob Lawrence also used narrative to recount the accomplishments, challenges, and oppressions of the African community uprooted to the Western Hemisphere by slavery. He made thirty-one paintings about Harriet

10.12 Lewis Hine. *Leo, 48 Inches High, 8 Years Old, Picks Up Bobbins at 15¢ a Day*, United States, 1910. Photograph, 8½" × 11". University of Maryland Library, College Park, Maryland.

This artist was known for exposing child labor in mines and textile mills, where children were working at the most tedious, most dangerous, lowest-paying jobs, as seen in this photo.

Tubman and twenty-two about John Brown. The paintings reconstruct the past with lengthy narrative titles to make the story clearer and to inspire African Americans today. Our example is *No. 36: During the Truce Toussaint Is Deceived and Arrested by LeClerc. LeClerc Led Toussaint to Believe That He Was Sincere, Believing That When Toussaint Was Out of the Way, the Blacks Would Surrender* (Fig. 10.14). It is one of forty-one paintings made from 1937 to 1941 about François-Dominique Toussaint-L'Ouverture (or "Louverture"), a slave who led a revolt in Haiti that resulted in the abolition of slavery there in 1794. Toussaint then established a semiautonomous black government, resisting French, English, and Spanish attempts to control Haiti. He was eventually captured by French forces and died a year later in a French prison. Haiti finally overcame

10.13, *left* BEN SHAHN. *The Passion of Sacco and Vanzetti*, United States, 1931–1932. Tempera on canvas, 7′ 1/2″ × 4′. Whitney Museum of American Art, New York.

This painting tells the story of the unjust conviction and execution of Italian immigrants who were active in labor organizations, avoided the draft in World War I, and were political anarchists.

10.14, *below* JACOB LAWRENCE. *No. 36: During the Truce Toussaint Is Deceived and Arrested by LeClerc. LeClerc Led Toussaint to Believe That He Was Sincere, Believing That When Toussaint Was Out of the Way, the Blacks Would Surrender*, United States, 1937–1938. Tempera on paper, 11″ × 1′ 7″.

This work is one of forty-one paintings about a slave who led a revolt to abolish slavery in Haiti.

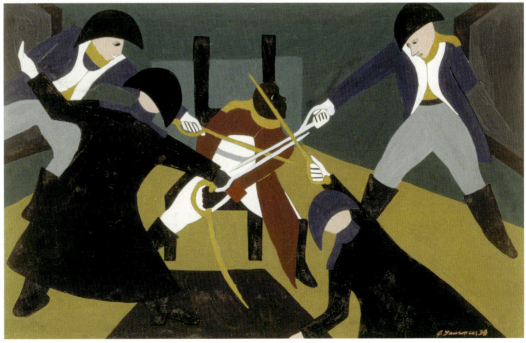

the French in 1804 and became the first black-governed country in the Western Hemisphere.

Lawrence completed forty-one preliminary drawings and then worked on all of the paintings simultaneously, so that the series has formal cohesion with its bold, flat, simplified style. Colors are limited, with black and white punctuating the images, giving them strength and starkness. *No. 36* shows the French soldiers' crossed swords that pin Toussaint in the center. The floor tilts up, and the walls of the room trap him at the intersection of colors. The black chair reads like bars of a prison. Broad sections of yellow and green in the background unify the image, while the center, with its greatest density of detail, provides a forceful focal point. In his use of space and color choices, Lawrence was influenced by Cubism as well as the bright patterns of handmade rugs.

> **CONNECTION** Lawrence trained in Harlem during the Harlem Renaissance and was influenced by the vibrant community of artists, writers, and performers, as shown in Faith Ringgold's *The Bitter Nest, Part II: The Harlem Renaissance Party* (Fig. 3.32).

Hans Haacke's *MetroMobiltan* (Fig. 10.15), 1985, is art designed to raise social consciousness. Haacke was advocating for native Africans in South Africa who were politically and economically repressed under *apartheid*, a system of legal racial separation. In the 1980s, many nations, including the United States, denounced apartheid. However, some corporations profited from apartheid

enforcement, including U.S.-based Mobil Oil, which sold supplies to the South African police and military. To counter negative publicity, Mobil provided major financial backing to the Metropolitan Museum in New York City to mount a blockbuster exhibition entitled "Treasures of Ancient Nigeria." *MetroMobiltan* raises awareness of the often-hidden ways that one country's culture and economy can profit from an unjust situation halfway around the world.

Formally, *MetroMobiltan* is like a stately altar. The elaborate frieze echoes the Metropolitan Museum façade, but the inscription is from the museum's 1980s pamphlet advising corporations to sponsor museum shows as "creative and cost effective answers" if the corporation is experiencing difficulties in "international, government or consumer relations." The three silk banners indicate Mobil's policies. Hidden behind is a black-and-white photomural of a funeral procession for black South Africans shot by police. *MetroMobiltan* links the museum, the oil company, and apartheid, but the layering shows that people might be unknowingly involved in an oppressive situation that they condemn.

> **CONNECTION** Compare *MetroMobiltan* to works that memorialize past events, like the *USA Marine Corps War Memorial* (Fig. 9.29). Both have monumental presences and realistic elements. However, *MetroMobiltan* combines different points of view about a situation, while the *War Memorial* represents a single perspective.

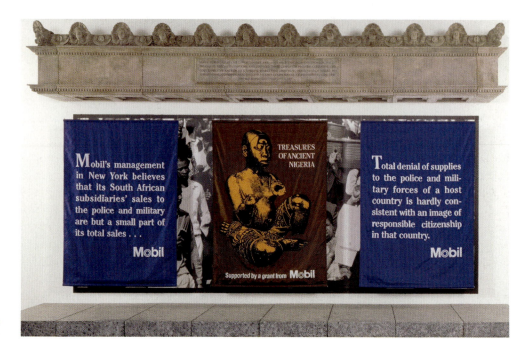

10.15 HANS HAACKE. *MetroMobiltan*, 1985. Glass fiber, fabric, photograph, 11′ 8″ × 20′ × 5′. Musee National d'Art Moderne, Centre Georges Pompidou, Paris.

Haacke showed that three apparently different phenomena are actually intertwined: the oppressive policies of apartheid in South Africa, the profits of an oil company, and artwork shown at a major museum.

10.16 EDWARD KIENHOLZ. *The State Hospital* (detail), United States, 1966. Mixed media, 8′ × 12′ × 10′. Moderna Museet, Stockholm.

To protest against society's treatment of people it deems incompetent, the artist made this installation, which exposes the neglect and filth he found in a state mental hospital.

Shocking ugliness can be used in the service of protest art. In *The State Hospital* (Fig. 10.16), from 1966, artist Edward Kienholz criticizes the way society deals with people it deems incompetent. The outside of this work, not shown here, is a grim, boxlike cell with a locked, grimy door. Inside, a naked mental patient is strapped to his bed. His mattress is filthy, and the bedpan is streaked with excrement. His head is replaced by a fish bowl with two black fish swimming aimlessly inside. Encircled in neon is the cartoon balloon above his head that shows another image of himself. The patient is completely isolated and has no life beyond this room. Kienholz's props are actual institutional objects: the bed frame, the urinal, the rolling table (barely visible at left). The strongest impact, however, comes from the pathetic body of the patient—his bony knees; his sagging, exposed genitals; his leathery skin. The realism makes the sculpture seem more immediate to the viewer.

To look inside, one has to peer through a barred window, which makes everyone on the outside part of "normal" society that supports such institutions in which the powerless are mistreated. Looking through the window,

viewers take on the role of guards or surveillance cameras. Kienholz drew on his experiences as an employee in a mental hospital, where he saw, for example, a staff member repeatedly hit a patient in the stomach with a soap bar wrapped in a towel, so there would be no surface bruises.

Cildo Meireles made *Insertions into Ideological Circuits: Coca-Cola Project* (Fig. 10.1) in the 1970s in response to Brazil's military government, which supported itself by "selling" the country to foreign investors, mostly from the United States. Much of the natural environment as well as the cultures of indigenous peoples in Brazil was being destroyed because of such policies. Meireles and others wanted to affirm Brazil's autonomy and resist becoming a market for foreign goods, but art that was openly critical of the government was repressed. So Meireles took empty Coca-Cola bottles, screen-printed subversive messages on them, and then returned them for refilling. The added writing on the bottles is almost invisible when they are empty. Only the person holding the bottle close while drinking the soda can easily read the message. Using Coca-Cola bottles as vehicles for political messages was clever in many ways: first, because Coca-Cola is

everywhere; second, because Meireles took advantage of the already existing system of reusing bottles; and third, because Coca-Cola is a popular symbol for U.S. culture.

CONNECTION Some would say that printing "Yankees go home!" on Coca-Cola bottles is not art. Others would argue that an artist's job is to increase the viewer's awareness. For more on this topic, see Chapter 4, Deriving Meaning.

ART EXPERIENCE Make your own protest art that addresses a social, political, or economic issue that is important to you.

Humor is another strategy for effective protest. In *Sun Mad* (Fig. 10.17), dated 1981, Ester Hernandez takes familiar imagery from popular, commercial culture and subverts it. For decades, the raisin growers around Hernandez's hometown heavily used insecticides that contaminated the groundwater the local population used for drinking and bathing. Hernandez took the packaging of the best-known raisin producer, Sun Maid, and changed the usual image of healthy eating into a message of death. Her grimly humorous work is effective because the raisin industry advertising is so successful and we know the original image.

Hernandez chose an art form that allows her to reach many people, just as advertising does. This work is a color screen print that has been reproduced and widely disseminated on T-shirts and postcards. Even though Hernandez was reacting to a specific instance of contamination, her work reaches out to everyone who ingests pesticide residue or to farm workers who were sprayed with pesticides while working in the fields.

Yinka Shonibare uses historical quotes, clothing, and humor to protest the colonial past and to show the complexity of world trade and culture in his *Mr. and Mrs. Andrews without Their Heads* (Fig. 10.18), from 1998. A contemporary British artist of Nigerian origin (Nigeria was a British colony), Shonibare has created a three-dimensional parody of the famous eighteenth-century painting in which the landed gentry show off their estate. In his version, Shonibare has beheaded the aristocrats, recalling the fate of the ruling class during the French Revolution. The most complex aspect of the piece, however, is the printed cotton cloth, the kind associated with idealized African culture, which Mr. and Mrs. Andrews are wearing. The cloth is not African at all but is made in the batik method that the Dutch and English manufacturers learned in Indonesia and then sold in West Africa. Shonibare shows that all cultures are intertwined and hybridized and that while many people may like the idea of cultural purity, it does not exist.

10.17 ESTER HERNANDEZ. *Sun Mad*, United States, 1981. Color serigraph, 1′ 10″ × 1′ 5″.

This work exposes the dangerous chemical pesticides that are used in vineyards to grow grapes that eventually become raisins. These poisons leach into the public drinking water.

CONNECTION Shonibare based his sculpture on the eighteenth-century painting by British artist Thomas Gainsborough, *Mr. and Mrs. Andrews* (Fig. 2.11).

Some art dealing with past injustices and oppressions is met with mixed responses, even art by those who are descendants of the oppressed. Kara Walker is an African American artist who creates life-size, cutout silhouette figures based on racist imagery of the slave era in the United States. Petticoated plantation mistresses, slaves with their masters' heads under their skirts, bastard children, black women squeezing out multiple babies between their legs, slaves being tortured or murdered—all are depicted as elegant flat shapes, both humorous and shocking. The imagery is based on fact and fantasy, primarily from pulp fiction sources dealing with subjugation and titillation. In works like *"They Waz Nice White Folks While They Lasted" (Says One Gal to Another)* (Fig. 10.19), from 2001,

10.18 YINKA SHONIBARE. *Mr. and Mrs. Andrews without Their Heads*, 1998. Collection of the National Gallery of Canada, Ottawa. Wax-print cotton costumes on mannequins, dog mannequin, painted metal bench and rifles, 5′ 5″ × 18′ 8″ × 8′ 4″.

Historical quotation, clothing, and humor are used here to protest the colonial past and to show the complexity of world trade and culture.

10.19 KARA WALKER. *"They Waz Nice White Folks While They Lasted" (Says One Gal to Another)*, United States, 2001. Cut paper and projections on wall, 14′ × 20′.

The cutout life-size figures based on literature about the slave era in the United States have had both positive and negative responses.

Walker's cutouts are enhanced with projections in darkened galleries, so that viewers participate in the action by casting their own shadows on the wall, joining the animated and raucous silhouettes hung there. Walker has received many letters of protest from black people who believe that she should refrain from presenting negative images of African Americans. Walker responds that she makes these images because they are controversial and should be discussed.

Affirming the Values of the Oppressed

When a group of people is oppressed, that group's way of life tends to be discounted or ridiculed. Art is an especially effective tool for affirming the lifestyles and values of downtrodden groups.

We begin with our focus figure, from Italy. When Ambrogio Lorenzetti painted the fresco *Allegory of Good Government: The Effects of Good Government in the City and in the Country* (Fig. 10.20), dated 1338–1339, Italy was a patchwork of city-states regularly thrown into turmoil by civil strife, unstable governments, and petty tyrants. In contrast, Lorenzetti showed how common citizens prosper when Justice, Prudence, Temperance, and Fortitude reign, represented by hovering allegorical figures (one is partly visible at upper right). In our detail here, businesses

flourish and culture thrives in the secure city. Not shown here is the rest of the mural to the right, which depicts fruitful farms. This late-Gothic painting is full of delightful details of everyday life in fourteenth-century Italy. The sweeping panorama was a remarkable achievement in Italian painting of the era.

Likewise in Northern Europe, power was concentrated in religious and secular rulers, but their absolute authority was being questioned (see *History Focus*, page 280), while the idea developed of the worth of the ordinary individual. In 1533, Hans Holbein the Younger painted the portraits of *Jean de Dinteville and Georges de Selve ("The Ambassadors")* (Fig. 10.21). De Dinteville was a political leader and de Selve a religious leader, but both were fervent humanists, as indicated in the various items on the table between them, reflecting their worldly interests in culture, arts, mathematics, astronomy, and so on. The emphasis on learning rather than authority is very significant, and Holbein paints the two men with intelligent eyes and gravitas that go beyond the pomp of their robes. However, symbols of discord are present, with a broken lute string alluding to tensions between church and secular authorities as well as the long, stretched shape at the bottom that becomes a skull, or symbol of death, when viewed from a severe oblique angle. This painting is famous for its fine detail, monumental figures, and rich colors.

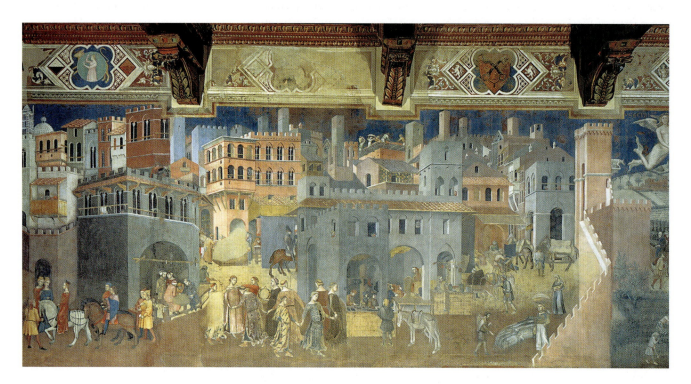

10.20 AMBROGIO LORENZETTI. *Allegory of Good Government: The Effects of Good Government in the City and in the Country* (detail), Italy, 1338–1339. Fresco. Sala della Pace, Palazzo Publico, Siena, Italy.

The artist shows how common citizens prosper when Justice, Prudence, Temperance, and Fortitude reign.

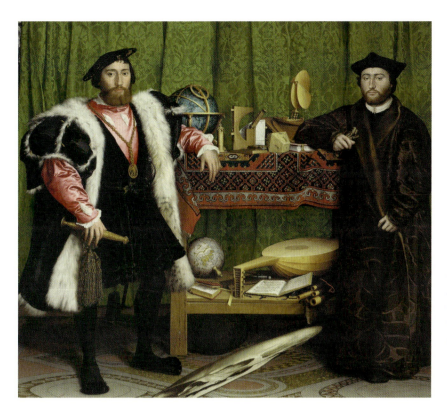

10.21 HANS HOLBEIN THE YOUNGER. *Jean de Dinteville and Georges de Selve ("The Ambassadors")*, 1533. Oil on oak, 6′ 9½″ × 6′ 10½″. National Gallery, London.

De Dinteville (left), a French nobleman serving as ambassador to London, and his friend, Bishop de Selve (right), exemplify the humanistic influence in active and contemplative life.

In contrast, a different form of art can affirm the history and culture of a people even as that culture is being attacked and eradicated. The Aztec *Codex Borbonicus* (Fig. 10.22) is a religious calendar that was made during the period of the Spanish conquest, either just before or just after the fall of the Aztec empire (see *History Focus*, page 281). The *Codex Borbonicus* and the handful of other manuscripts that have survived from this era preserve the pre-Columbian culture. This image depicts calendar **glyphs** surrounding the large image of two gods, Quetzalcoatl (light and sun) and Tezcatlipoca (moon and destruction), who are devouring a man. Many remnants of Aztec culture survive in Central America to the present day.

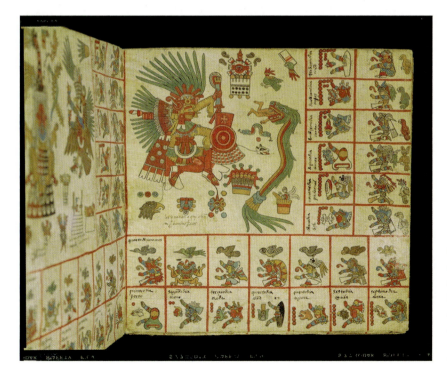

10.22 *Codex Borbonicus*, detail depicting Quetzalcoatl and Texcatlipoca, Aztec, early sixteenth century. Paint on vellum, 1′ 3½″ × 1′ 3¾″.

This religious calendar was made close to the time of the Spanish conquest in Mexico. Its preservation affirms the history and culture of the Aztec people.

We can also see how Aboriginal artists have used art to affirm their cultural values, which have been suppressed by Australians of European descent. Because of colonization, many Aborigines lost their land or were killed. While the rest of the country was celebrating the two-hundredth anniversary of Captain Cook's "discovery" of Australia, the Aboriginal population commemorated Invasion Day. Forty-three artists collaborated to make *The Aboriginal Memorial* (Fig. 10.23), installed in 1988. The work is composed of two hundred logs, one for each year of settlement, hollowed out as traditional Aboriginal coffins. They are memorials to all the native peoples who died as a result of European settlement and were never given proper Aboriginal mortuary rites. Artists painted the logs with their important clan **Dreamtime** symbols, affirming traditional Aboriginal culture, which was undermined and, at times, outlawed. Poles reach as high as 10 feet and seem like living growths springing up with vibrating patterns and vigorous animal imagery (Caruana 1993:206).

CONNECTIONS For more on Aboriginal culture and Dreamtime imagery, see *Witchetty Grub Dreaming* (Fig. 5.5). Like the Australian Aboriginal artists, many contemporary Native American artists continue to reference traditional imagery and art processes in the work they produce today, as in the late-twentieth-century *Bowl* by Maria Martinez (see Fig. 3.42).

Puerto Rican–born Pepón Osorio's mixed-media installation *The Scene of the Crime (Whose Crime?)* (Fig. 10.24), 1993–1999, affirms the worth of Puerto Rican culture in New York, while protesting how the people are depicted in mass media. He has re-created a typical Puerto Rican house, cluttered with kitsch statuettes, inexpensive religious objects, plastic plants, sentimental family photos, trophies, covers of *TV Guide*, and so on. Police tape and bright lights indicate a crime has happened, and a mannequin corpse lies face down at the back of the installation, but everything is remote, and no details are given. A welcome mat in front reads: "Only if you can understand that it has taken years of pain to gather into our homes our most valuable possessions; but the greater pain is to see how in the movies others make fun of the way we live." Because much is obscure or just out of sight, viewers' reactions are based on stereotypes or narratives from mass media, including assumptions of drugs and crime in the culture, or on class-based condemnations of the décor. Like Kara Walker (see Fig. 10.19), Osorio at times has received negative responses, some from Latino viewers who want to distance themselves from these cultural stereotypes.

Mona Hatoum is an artist of Palestinian descent who has lived in London since 1975. Her work deals poetically with personal identity, the body, surveillance, and control. *Light Sentence* (Fig. 10.25), from 1992, is an installation of wire mesh lockers in a dark room, stacked to human height. In the middle, a bare lightbulb swings around, casting wildly rocking shadows so that the cell-like room seems to sway.

10.23 PADDY DHATANGU, DAVID MALANGI, GEORGE MILPURRURRU, JIMMY WULULU, AND OTHER ARTISTS FROM RAMINGINING. *The Aboriginal Memorial*, Australia, 1988. Natural pigments on 200 logs, heights 1′ 4″ to 10′ 8″. National Gallery of Art, Canberra.

This installation affirms the survival of the Aboriginal culture and commemorates the dead after the impact of the Europeans in Australia.

10.24 PEPÓN OSORIO. *The Scene of the Crime (Whose Crime?)*, Puerto Rico/United States, 1993–1999. Mixed-media installation, dimensions variable. Bronx Museum of the Arts, New York.

The artist affirms the worth of Puerto Rican culture in New York, while protesting how the people are depicted in mass media.

10.25 MONA HATOUM. *Light Sentence*, Palestine/England, 1992. Mixed media, dimensions variable. Musée National d'Art Moderne, Centre Georges Pompidou, Paris.

This artist's work deals poetically with personal identity, the body, surveillance, and control. The swinging light alludes to the instability that those without power endure.

The swinging bulb is like a sometimes-blinding prison searchlight, implying surveillance. Lockers should hold private possessions safely, but here everything is exposed. The piece suggests animal cages in an experimental laboratory and connotes the oppressively uniform high-rise housing for low-income people. *Light Sentence* reveals the instability that those without power endure.

ART EXPERIENCE Alter an existing mass-produced item to change its meaning.

QUESTIONING THE STATUS QUO

The status quo is the existing state of affairs, which appears natural or inevitable instead of constructed and evolving. In this section, artists take a critical look at the "normal," at all those underlying and ingrained systems, beliefs, and ways of operating within a culture.

The Social Environment

Our focus here begins with artist William Hogarth. He satirized the English upper classes in a series of six paintings called *Marriage à la Mode*, dated c. 1745, a comedy mixed with criticism and condemnation. In the second of the six images, *Breakfast Scene* (Fig. 10.26), the wall

10.26 WILLIAM HOGARTH. *Breakfast Scene* (from the series *Marriage à la Mode*), England, c. 1745. Oil on canvas, 2′ 4″ × 3′. National Gallery, London.

In a series of comedic paintings, this artist satirized the English upper classes in the eighteenth century.

10.27 MAGDALENA ABAKANOWICZ. *Backs*, Poland, 1976–1982. Eighty pieces, burlap and glue, each over life-size.

This installation suggests the modern malaise of uniformity and the loss of self and individuality.

clock indicates past noon, but the couple is just meeting over the breakfast table in their lavish mansion. The disheveled, bored husband has been out all night. The puppy sniffs at his pocket where another woman's lingerie hangs. The young wife stretches after a night of cards and music at home. The overturned chairs indicate that the evening became a bit raucous. The paintings on the walls indicate a taste for sexual intrigues, despite the presence of classical busts and religious images for propriety. At left, a servant rolls his eyes, clutching unpaid bills.

The young man is a penniless nobleman whose father arranged this marriage to the daughter of a wealthy merchant. For her part, the arranged marriage brings status and a title, Lady Squanderfield. She casts a flirting glance at her husband, but he is completely unresponsive. A vacuum of unconcern separates them. The series ends miserably with infidelity, scandal, and

death by duel. Hogarth's paintings were turned into inexpensive prints that were enormously popular and received widespread distribution among the English middle class.

Compare now Magdalena Abakanowicz's *Backs* (Fig. 10.27), dated 1976 to 1982. Her composition consists of eighty slumping, hollow backs that are more than life-size—but without legs, heads, and hands. They hunch forward, immobile, in lines all facing the same direction. *Backs* alludes to the human condition in times of great distress. Abakanowicz lived in Poland during World War II, saw her mother's arm shot off at the shoulder, and witnessed death, pain, and destruction. In postwar Soviet-dominated Poland, she encountered many hardships in her struggle to make artwork.

Backs suggests the modern malaise of uniformity and of loss of self and individuality. Organic fibers were pressed into the same plaster mold to make all eighty backs, so that

each is very similar to the others. However, small degrees of individuality emerge in the twist of the fiber and in the slight variations created as each back was removed from the mold. The thick, matted fibers resemble wrinkled skin, knotted muscles, and visceral tissue. Their organic quality emphasizes our physicality and our ties to the natural world. The weary backs also suggest endurance, strength, and survival.

Contrast now another installation, this one by Jenny Holzer, who focused on the mass of implicit beliefs that are widely accepted in the United States today, in *Untitled (Selected Writings)* (Fig. 10.28), dated 1989. Holzer wrapped electronic signs around the spiral interior of the Solomon R. Guggenheim Museum in New York City and placed a circle of red granite benches below. The stream of words jumps out from the darkened interior of the museum, starting at the bottom and then swirling up until they disappear at the top of the spiral. The phrases seem familiar, but as a whole, they sound contradictory or even a little idiotic. As Holzer herself says, "They're about how we drive ourselves crazy with a million possibilities that are half correct" (Auping 1992:55). "A sincere effort is all you can ask" is countered with "Enjoy yourself because you can't change anything anyway." Another example is "Protect me from what I want," written in

10.28 Jenny Holzer. *Untitled (Selected Writings)*, United States, 1989. Extended helical LED electronic signboard, with selected writings, and 17 Indian red granite benches. Installation view at Solomon R. Guggenheim Museum.

Holzer's work focuses on the mass of implicit beliefs that are widely accepted in the United States today. The quickly flashing words show how a million possibilities of half-truths contradict each other and can drive us crazy.

10.29 HONORÉ DAUMIER. *The Legislative Belly*, France, 1834. Lithograph, image 11^1/$_8$″ × 1′ 5^1/$_8$″, sheet 1′ 1^{11}/$_{16}$″ × 1′ 8^3/$_{16}$″. Bibliothèque Nationale de France, Paris.

Daumier was particularly known for his political cartoons with his pointedly satirical caricatures in nineteenth-century France.

a culture where money can buy almost anything. The electronic signs flash words like a mass-media attack, and then they quickly slip away almost before we can grasp them. In contrast, the words carved in the stone benches below are permanent—but just as conflicting. The sheer number of phrases, the speed at which we see them, and their contradictory messages destroy thought, although we normally think of words as the carriers of meaning.

Art versus Politics

In Chapter 9, Power, Politics, and Glory, we saw art that promoted the personal glory of a ruler or the power of a state. In this section, we will see art that pokes at the political status quo.

The political cartoon has a long history of challenging politics and society in Western nations. In France, Honoré Daumier was especially known for his pointedly satirical **caricatures** until an 1835 government crackdown outlawed works like our focus figure, *The Legislative Belly* (Fig. 10.29), from 1834. Here, members of the French legislature are mean-spirited, sleeping, or arrogant. The curving walls echo their fat bellies. Although Daumier depicted specific politicians (who would have been recognized by the French public at that time), his great composition and caricatures are an indictment of corrupt lawmakers at any time, in any place.

Portrait of George (Fig. 10.30), dated 1981, by Robert Arneson, is a bust portrait of George Moscone, a popular mayor of San Francisco in the late 1970s. Moscone's smiling face is distinct and lively, animated by splattered colors. The bust sits on a column casually covered, graffiti-like, with phrases recalling Moscone's background, some of his more memorable sayings, and events from his life and death. Moscone and Harvey Milk were assassinated in 1978 by a disgruntled San Francisco city supervisor named Dan White, who had disagreed with Moscone on most political points, including issues concerning homosexuals.

The bust was made for a new civic center in San Francisco. Arneson's *Portrait of George* departs from the status quo of bland, bronze portrait heads of political leaders that are common in parks and in lobbies of public buildings. This sculpture is irreverent, colorful, and very large. Marks that suggest bullet holes pierce the pedestal, and a yellow, phallic Twinkies snack cake is prominent. At his trial, Dan White received a light sentence for his crimes because his lawyers argued that he was depressed at the time of the shooting, evidenced in many ways including his abandoning healthy eating for junk food. Many San Franciscans protested the sentence, and there was a night of rioting. Because Arneson's sculpture was a vivid reminder of the murder and riots, *Portrait of George* was officially removed from the civic center after one week because the pedestal was deemed crude and inappropriate. The work was later sold to a private collector.

In South Africa for many years, the economic and political status quo was based on apartheid, a system of laws and social standards that repressed the native population. William Kentridge created charcoal drawings and film animations based on the causes and injustices of apartheid. Kentridge's work, however, goes beyond the specifics of the South African situation. The *Drawing from Mine* (Fig. 10.31), from 1991, shows the white businessman with tangled financial tapes wrapped around sculptural heads of Africans, very much like the *Crowned Head of an Oni* (Fig. 9.5). Kentridge's art points out the moral difficulties that attend all instances of power, ownership, and oppression on a grand scale. This charcoal drawing and others were photographed repeatedly, while Kentridge drew and erased, to create the short film sequence called *Mine*.

A contemporary El Salvadoran artist, Miguel Antonio Bonilla, painted *The Knot* (Fig. 10.32) in 1994. The two ominous figures represent the country's police and politicians, who conspired in the 1980s to create an oppressive regime in El Salvador. The knot that connects them

10.30 ROBERT ARNESON. *Portrait of George*, United States, 1981. Glazed ceramic, 7′ 10″ × 2′ 5″ × 2′ 5″. Private collection.

This piece is a memorial to San Francisco's mayor, who was assassinated in 1978 by a disgruntled city supervisor who disagreed with most of his political points, including homosexuality.

10.31 WILLIAM KENTRIDGE. *Drawing from Mine*, South Africa, 1991. Charcoal. *Mine* is a 5-minute, 49-second film.

This artist created drawings and film animations based on the causes and injustices of apartheid in South Africa.

10.32 MIGUEL ANTONIO BONILLA. *The Knot*, El Salvador, 1994. Acrylic on canvas, 4′ 3″ × 6′ 6″. Museum of Latin American Art, Long Beach, California.

The two ominous figures represent the country's police and politicians who conspired in the 1980s to create an oppressive regime in El Salvador.

seems to be made of two extended, elongated phalluses. In this way, Bonilla referred to the chauvinism in his culture that allows factions to oppress others and also causes domestic violence. Bonilla took a political risk in this painting because of its criticism of the political status quo. He also took artistic risks, making the painting purposefully ugly and shocking. The style of this work was contrary to prevailing El Salvadoran aesthetics for painting at that time.

10.33 DORIS SALCEDO. *Shibboleth*, 2007–2008. Installation in the Turbine Hall of the Tate Modern, London.

A long crack in the floor represents divisions between races and between rich and poor as well as the experience of Third World immigrants coming into Europe.

Our final artwork of protest and affirmation is *Shibboleth* (Fig. 10.33), an installation in the Tate Modern in 2007–2008. The Colombian artist Doris Salcedo created a 548-foot-long crack in the floor of a huge exhibition hall, very thin at first but opening up to several inches wide and 2 feet deep. *Shibboleth* refers to a word that only insiders know, so the work is about belonging versus outsider status, with all the accompanying social and political implications. Salcedo has said that the work was about the divide between races and social classes, which can start quite small but eventually become a chasm that can bring down institutions and cultures. Indeed, the cracked floor that Salcedo created made the entire structure seem unstable. At the end of the run of the installation, the crack was filled in, but a visible scar remains permanently in the floor.

ART EXPERIENCE Debate which form of protest art is most effective.

Section 4 SELF AND SOCIETY

Self and society include our physical bodies, our minds, and the larger world we inhabit. Art is a great mirror that we hold up to see ourselves and to help understand our surroundings.

CHAPTER 11 MIND AND BODY

The nature of humans in general and individuals in particular, as seen through art

CHAPTER 12 RACE, GENDER, CLAN, AND CLASS

Art that reflects the larger social structures within which each person operates

CHAPTER 13 NATURE, KNOWLEDGE, AND TECHNOLOGY

Art that reveals the shifting relationship of humans to animals, to the land, and to the knowledge systems and technology that we create

CHAPTER 14 ENTERTAINMENT AND VISUAL CULTURE

The examination of the visual components of some forms of entertainment and the way that art relates to these forms

11.1 *Nobles at the Court of Shah Abbas*, Persian School, Safavid Dynasty, Reign of Abbas I, Chehel Sotun, Isfahan, Iran, 1588–1629. Detail of a fresco wall painting.

This palace wall painting shows idealized human forms from seventeenth-century Persia.

11

MIND AND BODY

The body is very personal: this is my body, this is me. The body is very social: we watch each other, and the ways we dress and walk are meaningful to the group. Mind and body are completely intertwined. Through art, different cultures show their concept of mind and body as well as human nature in general and larger social trends.

PREVIEW

A portrait can show the mind and spirit of a unique individual, or it can represent ideas about human beings in a given historical moment.

Art can idealize the human face and body. Just one example is Nobles at the Court of Shah Abbas *(Fig. 11.1). Other artwork emphasizes the tragic or the debased in human nature. In yet other examples, the body is measured and studied like a machine.*

Physical and psychological pressures can distort the body and affect the mind. In artwork that deals with sickness and death, the horrible and the beautiful often are mixed. Art can represent states of mind, including transcendent states, fantasy, nightmares, or surreal dreams. Art can also be psychologically active and influence the people who use or display it.

The body also can be either art material or an art tool. It is malleable and can be scarred, sculpted, or painted. It is a primary element in performance art.

With the Art Experiences, try creating a psychological portrait, designing a tattoo, or planning a performance art piece that focuses on your body.

Connecting Art and History from
1550–1750 CE

Cogito ergo sum. "I think, therefore I am," wrote René Descartes, French philosopher and mathematician, at the beginning of the Enlightenment in Europe (roughly 1640–1789). This period saw advances in philosophy, science, literature, and human rights. Increasingly, learned people believed that men were entitled to life, liberty, the pursuit of happiness, property ownership, and individual rights.

Interest in the human mind and body was strong during this period. The founding principle of the Enlightenment was that human reason was the primary authority in science and in politics. Anatomies of the human body were written or republished across Europe as well

Map 7 The Ottoman Empire, the Safavid Empire, the Mughal Empire, and the Qing Dynasty, in 1650.

as seen in examples from Japan and Persia (see *Persian Anatomical Illustration*, Fig. 11.22; another example is by Andrea Vesalius, Fig. 13.24). The emphasis on reason also eventually fostered an interest in its opposite, as seen metaphorically in Giovanni Battista Piranesi's fantastic *Prison* series (Fig. 11.31).

In some areas of the globe, the rising support for human rights in time led to the curtailing of the power of kings. The beliefs of the Enlightenment contributed to the power and prosperity of the Dutch middle class during this period, which Rembrandt depicted in many paintings (Fig. 11.10). The Netherlands was Calvinist Protestant, a religion that believed industriousness and spirituality were the measures of an individual. Humanist philosophy flourished in leading Dutch universities, and learning was valued in the upper and middle classes. Power in

the country was distributed among wealthy bourgeois families rather than being concentrated in a monarchy. In addition to the political situation in the Netherlands, Enlightenment principles influenced the American Revolution in 1776 and the French Revolution in 1789.

However, across most of the world, this era saw the increased development of centralized states with powerful leaders. Suleyman the Magnificent (or Suleiman) (Fig. 11.2) ruled during the Golden Age of the Ottoman Empire (centered in modern Turkey), when it was the greatest power in the world. During his reign of 1520–1566, the arts flourished, including painting, ceramics, poetry, and architecture, and he supported expanded education and reformed the law for greater justice for all, including lower classes and non-Muslims. Militarily adept, he conquered areas of eastern Europe and dominated the Middle East.

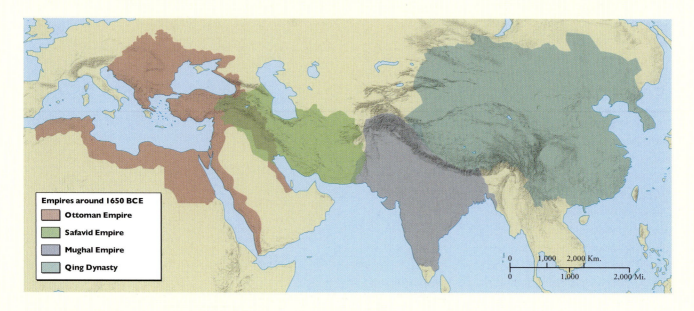

Empires around 1650 BCE
- Ottoman Empire
- Safavid Empire
- Mughal Empire
- Qing Dynasty

Shah Abbas I led Persia's rise in power, and that country became a rival to the Ottoman Empire in the late 1500s. Abbas excelled at both war and diplomacy, and he patronized the arts, especially in Isfahan, his new capital, which he undertook to make into one of the most beautiful cities in the world. *Nobles at the Court of Shah Abbas* (Fig. 11.1) is a detail from a series of large paintings from one of his palaces. He also funded the construction of the famous *Masjid-i-Shah* (Figs. 7.41 and 7.42).

The Mughal Empire continued in India, and Akbar (1556–1605) oversaw a period of humane rule, peace, and prosperity. Mughal artists excelled at miniature painting (for example, Akbar's grandfather is shown in *Babur Supervising the Layout of the Garden of Fidelity*, Fig. 13.18). The empire subsequently weakened throughout the eighteenth century.

Turning to Asia, after a long peasant uprising ended in 1644, China also saw a period of remarkable tolerance, prosperity, and unity, especially under the reign of Kangxi (1661–1722). Japan continued to be ruled by local warlords until 1603, when Tokugawa Ieyasu unified Japan under his command and closed the country to foreigners. The Japanese merchant class grew in number and wealth for the next few hundred years. Japanese art was distinguished by painted scrolls, screens, and gardens.

Europe had already embarked on a period of global expansion. With the exception of limited access to a few ports, Europeans were kept out of China, Japan, and India. However, the English, French, and Spanish quickly divided the Americas into colonies. Spanish rule was the most extensive, covering western North America, Central America, and most of South America, except for Portuguese Brazil. Latin American societies were multiracial, reflecting intermarriage among native populations, Europeans,

and Africans since the 1500s. Because Latin America was more remote, European rulers exercised less direct control, and local landowners amassed large holdings and developed extensive power. In contrast, the population in the English colonies continued to be mostly European, both racially and culturally.

Africa's heartlands continued to be self-ruling and relatively isolated, although the coastal regions were engaged in the slave trade with Europe. The Asante Kingdom was established in western Africa in 1680. Likewise, in Southeast Asia, Dutch and English traders continued in the lucrative spice trade, but the inland areas were generally unaffected and self-ruled.

In Europe, 1560–1650 was a period of crisis because of religious wars between Catholics and Protestants, competition for colonial lands, and hardship caused by crop failures. In response to the unrest, new centralized powers emerged after 1650. In some cases, these were absolute rulers who governed all aspects of their country with tight control—for example, Louis XIV of France, Peter the Great

11.2 Haydar Ra'is (often known as Nigari). *The Sultan Suleyman the Magnificent as an Old Man with Two Dignitaries*, Ottoman miniature, c. 1560. H. 2134, fol. 8. Topkapi Palace Museum, Istanbul.

Suleyman was the greatest leader of the Ottoman Empire, which was the strongest world power of its time.

of Russia, and the rulers of Prussia. The Habsburgs ruled Austria, but the nobility maintained considerable power. England developed a constitutional monarchy. The Baroque style of art dominated European art at this time. One strong influence on the Baroque era was the heroic sculptures and paintings of Michelangelo, as seen in *David* (Fig. 11.20).

Also, beginning in 1700, the world population grew dramatically for four reasons: (1) better immunity to diseases that had been spread by the first explorers; (2) a period of climate warming, which improved agricultural conditions; (3) new food sources through trade; and (4) the invention of gunpowder, which allowed rulers to control larger areas with their armies and to create more stability.

World Art Map for Chapter 11

Edvard Munch. *The Scream.*

Mask of the Swan and the White Whale. Alaska, Northwest Pacific.

Eadweard Muybridge. *Handspring, a Flying Pigeon Interfering.*
Lucian Freud. *Leigh under the Skylight.*
Richard Hamilton. *Just What Is It That Makes Today's Homes So Different, So Appealing?*

Chuck Close. *Fanny (Fingerpainting).*

Vincent van Gogh. *Portrait of Dr. Gachet.*
Gislebertus. *The Last Judgment.*
Umberto Boccioni. *Unique Forms of Continuity in Space.*

NORTH AMERICA

Bill Viola. *Dolorosa* (Production Stills from the Video Installation).
Cindy Sherman. *Untitled Film Still 53 (Blonde: Close-Up with Lamp)*
Hannah Wilke. *Intra-Venus.*
Mark Rothko. *Green, Red, Blue.*
Jackson Pollock. *Lucifer.*
Marina Abramovic. *The Artist Is Present.*

EUROPE

Giovanni Battista Piranesi. *Prison.*

Michelangelo Buonarroti. *David.*
Agesander, Athenodorus, and Polydorus of Rhodes. *Laocoön and His Sons.*

Nancy Burson. Untitled Image from *Faces.*

Frida Kahlo. *Self-Portrait with Monkey.*

Ana Mendieta. *Arbol de la Vida, No. 294.*

AFRICA

Manual Alvarez Bravo. *Striking Worker Assassinated.*

Head from the Tomb of the Temple of Inscriptions.

Ngere Girl Prepared for a Festival.

Male Torso, Ghana, Africa.

SOUTH AMERICA

Matta. *Listen to Living.* Santiago, Chile, South America.

N

| 0 | 1,000 | 2,000 Km. |
| 0 | 1,000 | 2,000 Mi. |

ASIA

Rembrandt van Rijn.
Self-Portrait.
The Netherlands.

The Sultan Suleyman the Magnificent as an Old Man with Two Dignitaries.

Polykleitos. *Doryphoros (Spear-bearer).*

Nobles at the Court of Shah Abbas.
Isfahan, Iran.

Mariko Mori. *Star Doll.*

Shimomura Kanzan.
Study for the Portrait of Okakura Tenshin.

Torso.

Nefertiti.
Egypt.

Persian Anatomical Illustration.
Anonymous Drawing from the *Tibb al-Akbar (Akbar's Medicine).*
Iran or Pakistan.

Yakshi. Sanchi, India.

Double Mask.
Ejagham People,
Cross River, Cameroon.

AUSTRALIA

Tomika te Mutu of Coromandel.
Motuhoa Island,
New Zealand.

1550–1750 CE

INDUS RIVER CIVILIZATIONS	EGYPT, EIGHTEENTH DYNASTY	OLMEC CIVILIZATIONS	CLASSICAL ART—GREECE HELLENISTIC ART—GREECE **MAURYAN DYNASTY FOUNDED IN INDIA**		EARLY CHRISTIAN ART
3000 BCE	1350	900	400	100 CE	350

Torso (Harappa)

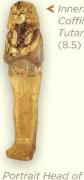

< Innermost Coffin of Tutankhamen (8.5)

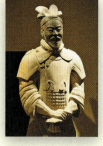

∧ Warrior, Tomb of Shi Huangdi (8.11)

POLYKLEITOS. Doryphoros

Laocoön and His Sons

Yakshi

Portrait Head of Nefertiti

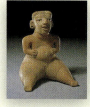

∧ Kidder Figure (6.29)

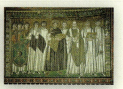

∧ Emperor Justinian and Attendants (9.4)

VICTORIAN ERA—ENGLAND	IMPRESSIONISM POSTIMPRESSIONISM *Freud and Psychoanalysis*	*FAUVISM, CUBISM, FUTURISM, DADA*	*World War I*	END OF THE OTTOMAN EMPIRE *SURREALISM, FANTASY, SUPREMATISM*
1850	1875	1890 1900	1914	1917

Tomika Te Mutu of Coromandel

MUYBRIDGE. *Handspring*

VAN GOGH. *Portrait of Dr. Gachet*

MUNCH. *The Scream*

Double Mask

Male Torso (Ancestor figure)

Mask of the Swan and the White Whale

BOCCIONI. *Unique Forms of Continuity in Space*

∧ Frederick Douglass (3.55)

< Wearing Blanket, Navajo (4.18)

MAYAN CIVILIZATION	ROMANESQUE ART GOTHIC ART RENAISSANCE ART			REIGN OF AKBAR—INDIA	TOKUGAWA SHOGUNATE— JAPAN BAROQUE ART Thirty Years' War—Europe, 1618-1648	Louis XIV of France Kangxi of China ENLIGHTENMENT	ROCOCO ART ROMANTIC ART Latin American Independence Movement
600 CE	1100	1200	1400	1500	1600	1650	1700 1750 1800

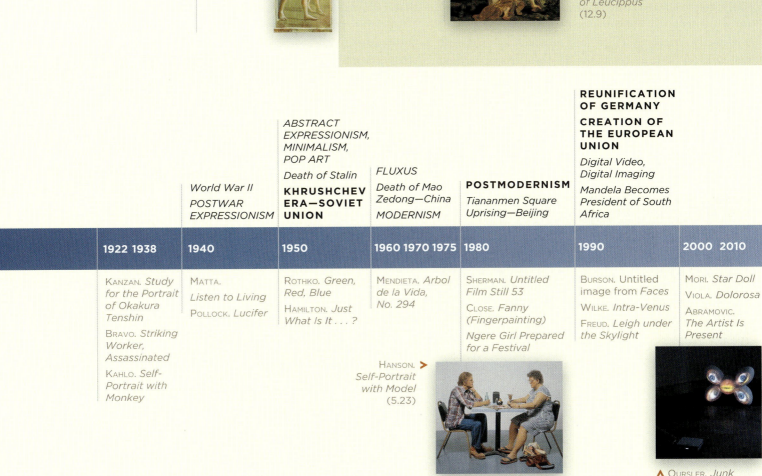

Head from the Tomb of the Temple of Inscriptions

GISLEBERTUS. *The Last Judgment*

MASACCIO. > *Expulsion of Adam and Eve from Paradise* (6.11)

MICHELANGELO. *David*

HAYDAR. *The Sultan Suleyman the Magnificent as an Old Man with Two Dignitaries*

Nobles at the Court of Shah Abbas

< RUBENS. *Rape of the Daughters of Leucippus* (12.9)

REMBRANDT. *Self-Portrait*

Persian Anatomical Illustrations

PIRANESI. *Prison*

	World War II POSTWAR EXPRESSIONISM	ABSTRACT EXPRESSIONISM, MINIMALISM, POP ART Death of Stalin KHRUSHCHEV ERA—SOVIET UNION	FLUXUS Death of Mao Zedong—China MODERNISM	POSTMODERNISM Tiananmen Square Uprising—Beijing	REUNIFICATION OF GERMANY CREATION OF THE EUROPEAN UNION Digital Video, Digital Imaging Mandela Becomes President of South Africa	
1922 1938	1940	1950	1960 1970 1975	1980	1990	2000 2010

KANZAN. *Study for the Portrait of Okakura Tenshin*

BRAVO. *Striking Worker, Assassinated*

KAHLO. *Self-Portrait with Monkey*

MATTA. *Listen to Living*

POLLOCK. *Lucifer*

ROTHKO. *Green, Red, Blue*

HAMILTON. *Just What Is It . . . ?*

MENDIETA. *Arbol de la Vida, No. 294*

SHERMAN. *Untitled Film Still 53*

CLOSE. *Fanny (Fingerpainting)*

Ngere Girl Prepared for a Festival

BURSON. *Untitled image from Faces*

WILKE. *Intra-Venus*

FREUD. *Leigh under the Skylight*

MORI. *Star Doll*

VIOLA. *Dolorosa*

ABRAMOVIC. *The Artist Is Present*

HANSON. > *Self-Portrait with Model* (5.23)

< HUNG LIU. *Trauma* (12.12)

^ OURSLER. *Junk* (3.59)

DEPICTING THE BODY

Artists depict individuals through portraits and body images. These reveal both a physical likeness and hints of character or mental state. At the same time, portraits and body images reflect social concepts that were commonly held about humans and human nature at the time they were made.

Portraits

First, we examine portraits that show individuals in ways that mirror their sociopolitical milieu. Second, we look at portraits that reveal character or inner state of mind.

Our focus figure for portraits that mirror the sociopolitical milieu is the famous bust of Queen Nefertiti (Fig. 11.3), from the Egyptian New Kingdom's Eighteenth Dynasty, likely sculpted by the artist Thutmose c. 1350 BCE. Her features are definitely individualized but also idealized, with a perfectly symmetrical face, long nose, full lips, flat ears, and graceful neck, all below the tall royal crown. Beyond her likeness, however, *Nefertiti* displays the new aesthetic canon, which is relaxed and naturalistic and which differed from the rigid, more abstract style found in prior Egyptian art, as seen in the *Fowling Scene* (Fig. 8.6). The change in portrait styles was concurrent with a change in religion and occurred during the Amarna period in Egypt.

11.3 *Nefertiti*, Egypt, c. 1350 BCE. Portrait bust, approximately 1′ 8″ high. Aegyptisches Museum, Staatliche Museen, Berlin.

This idealized portrait of Nefertiti embodies the ancient Egyptian concept of female beauty.

Nefertiti's beauty as rendered in this painted limestone portrait has influenced the Western aesthetic of feminine beauty, in both the past and the present. Her name reflects this, as it translates to "The Beautiful One has come." *Nefertiti* is also a portrait of a ruler, and the idealized qualities in the portrait reflect that. Compare *Nefertiti* with an idealized portrait of another ruler, Suleyman the Magnificent, whose likeness we have already seen in Figure 11.2. Both have a presence and composure that is emblematic of their political status.

CONNECTION Another ancient head modeled with refined, portrait-like sensitivity is the *Jayavarman VII* (Fig. 9.6).

Now let us turn to another example of a portrait that reflects profound cultural and political change. The *Study for the Portrait of Okakura Tenshin* (Fig. 11.4), painted in 1922, records a face that emphasizes inner character and reveals a shrewd, intelligent individual. Additionally, the portrait mirrors the social, political, and aesthetic controversies in Japan during his time. Okakura (1862–1913) was a writer, aesthete, educator, and art curator who lived when rulers of Japan were ending three hundred years of isolation and embarking on a period of rapid Westernization. Eastern-influenced music, literature, religion, and medicine were suppressed, and Western modes were introduced. The one exception was the visual arts, in which traditional and Western styles—and mixtures of the two—flourished. Traditional Japanese paintings and prints were popular and sold well not only in Japan but also in the West. They influenced many Western artists, such as Vincent van Gogh (see Fig. 11.5).

Okakura co-authored the first Western-style history of Japanese art and established a Japanese museum, an academy of art, and art appreciation societies, which were essentially Western cultural institutions. Before this, the Japanese aesthetic tradition did not include these concepts and institutions. Later, Okakura wrote *The Ideals of the East*, in which he created the concept of Asia as the East in contrast to the West. Eventually, he moved to the United States and became an assistant curator in the Japanese and Chinese Department of the Boston Museum of Fine Arts.

The very style of *Study for the Portrait of Okakura Tenshin* reflects this time of change. Japanese-style contour lines and flat shapes are apparent here, especially in Okakura's left hand and sleeve, but the face and hat are rendered with Western chiaroscuro—that is, by dark and light shading. Okakura smokes a Western cigarette, while wearing traditional Japanese garb. Okakura believed that only the combination of modernism and tradition meant progress in art. His face is the focal point of the composition, sitting atop the triangular shape of his body, and his features make a great study of shrewdness, toughness, and perception.

CONNECTION For an example of a face rendered in traditional Japanese style, with outlines only, see *Komurasaki of the Tamaya Teahouse* (Fig. 12.32).

Next, we see an extreme example of a portrait that focuses on a person's inner mental and emotional state, yet even here there are also social dimensions to the image. In the *Portrait of Dr. Gachet* (Fig. 11.5), dated 1890, Vincent van Gogh painted a free-thinking, eccentric, homeopathic doctor with the foxglove flower to symbolize his profession. With a melancholy face and pose, Gachet leans on two nineteenth-century novels about tragic and degenerate life in Paris.

Gachet's portrait is also a vehicle for van Gogh to make observations about modern urban life in general, which van Gogh found to be full of suffering. In this case,

11.4, *left* SHIMOMURA KANZAN. *Study for the Portrait of Okakura Tenshin*, Japan, 1922. Pigment on paper, 4′ 5½″ × 2′ 2″. Art Museum, Tokyo National University of Fine Arts and Music.

This drawing combines Japanese and Western art styles. It was made at the historical moment when both Japanese art and European art were profoundly influenced by each other.

11.5, *below* VINCENT VAN GOGH. *Portrait of Dr. Gachet*, Netherlands, 1890. Oil on canvas, 2′ 2¼″ × 1′ 10″. Private collection.

Portraits can be visual records of inner emotional states.

the artist may have revealed as much about himself as he did about his subject. Van Gogh found life in Paris to be unhealthy and miserable, and he took refuge in his art, in the countryside, and in medical help. At this time, van Gogh was painting at a feverish pace, but he was less than two months away from his death. Thick paint animates the entire surface, with emphatic dashes and tight swirls that model form, increase color saturation, and indicate van Gogh's own agitation and intensity. Thus, Gachet's likeness was also a reflection of van Gogh's own inner state.

In *Fanny (Fingerpainting)* (Fig. 11.6), dated 1985, artist Chuck Close has used the portrait not so much to reveal inner personality as to create an amazingly detailed record of the structure, ridges, pores, and wrinkles of an elderly woman's head. The scale is enormous. Her head is more than 9 feet high. Her face fills the foreground space of the painting, pushing toward us her lizard-like eyelids, her watery eyes and cracked lips, and the sagging skin of her neck. With this painting, we can stare curiously at a person's face, an action considered impolite in U.S. culture.

The pose is ordinary, like that on a driver's license. Her nonidealized features are lit unflatteringly from both sides, leaving darker shadows at the center of her face. But the scale and surface make her face forceful and imposing. Copying his photographic sources, Close has the painting in sharp focus in certain areas, such as the tip of the nose, and soft focus in more distant points, such as the hair, base of the neck, and shoulders. The expression on the woman's face also makes evident the photographic source: her eyes are focused on the camera, which is close to her nose, and she seems both tolerant of and slightly affronted by it.

In the 1992 series called *Faces*, Nancy Burson also gave us the opportunity to indulge our curiosity about other people's faces. She used a cheap plastic camera to make grainy, fuzzy photographs of children with unusual faces due to genetic conditions, accident, or disease. The low-quality lens produced surprisingly beautiful images, with blurred edges, softened highlights, and grainy but luminous shadows. Burson's photographs reveal some aspects of the children's personalities, such as friendliness, dreaminess,

11.6 CHUCK CLOSE. *Fanny (Fingerpainting),* United States, 1985. Oil on canvas, 10′ × 7′. Donation of Lila Acheson Wallace. National Gallery of Art, Washington, D.C.

This is a large portrait with an amazing amount of textural detail.

caution, concern, curiosity, and boldness. Our untitled example (Fig. 11.7) shows the boy at the left obligingly posing and encouraging the other to do so as well, while the other boy remains reluctant and suspicious of manipulation. Framing makes the child at the left seem to be moving, while the other appears more pinned at the center.

Burson's photographs act as a mirror to the viewers, who reveal themselves in their reactions to the images. Burson noted that people who dwell on disaster see these children as disasters, whereas others react to them as they would to other children. Thus, degrees of normal and abnormal are more the viewers' judgments than objective standards.

<table>
<tr><td>⊿ ART EXPERIENCE Draw or photograph a psychological portrait of yourself or someone close to you.</td></tr>
</table>

We now compare full-body portraits, which often reveal more about the sitter's personality than just a face rendering. *Leigh under the Skylight* (Fig. 11.8), painted in 1994, is one of Lucian Freud's many full-body portraits. During the long process of sitting for a painting in Freud's studio, the sitters unintentionally reveal clues about their most intimate selves, primarily through their poses and facial expressions. The figure of Leigh is massive, and from

11.7 NANCY BURSON. Untitled image from *Faces*, United States, 1992. Silver gelatin print, 1′ 3″ × 1′ 3″. Twin Palms Publishers, Santa Fe, New Mexico.

The artist used a cheap camera with a bad lens to create a blurry but evocative double portrait.

11.8 LUCIAN FREUD. *Leigh under the Skylight*, Britain, 1994. Oil on canvas, 7′ 6″ × 4′. Acquavella Contemporary Art, New York.

Freud's portraits are known for exhibiting an amazing range of paint applications and for revealing the inner being of his sitters.

11.9 BILL VIOLA. *Dolorosa*, United States, 2000. Production stills from the video installation.

This work is high-resolution video replayed slowly, so that the viewers have a chance to study the intense emotions presented on the screen.

the low point of view assumed by the artist, he appears to be almost gigantic. Yet the flesh is soft. The crossed legs, deeply lined face, and furrowed brow communicate a sense of tightness. The figure appears almost stuffed up against the space of the skylight, wary and exposed. The paint is thick and buttery below the knees and the top of the belly but congealed and clotted around the jaw, nipples, navel, and genitals. The excess of texture is both fascinating and repulsive. This full-size nude is definitely a portrait of an individual man, in contrast to the full-size nude *Doryphoros* (see Fig. 11.14), which is a depiction of "Man."

Video allows artists to make moving portraits. Bill Viola's *Dolorosa* (Fig. 11.9) consists of two flat-panel monitors arranged like a diptych or a double-frame portrait showing a weeping man and woman. At first glance, the videos look like paintings because the color is so saturated, the picture so sharp, and the movement so excruciatingly slow. Only after a few minutes of study do we see the subtle changes in their faces, expressing a deep, almost unbearable sorrow. Viola made this study of emotional states and more than twenty others in a series titled *The Passions*, based on **Renaissance** and **Baroque** paintings of figures in sorrow, ecstasy, or astonishment. Rather than restage the old paintings, Viola sought to expand their emotional and spiritual dimensions. Viewers can examine faces as never before.

Self-Portraits

We will look at four artists who have made many pictures of themselves. Rembrandt van Rijn made at least sixty-two self-portraits. Frida Kahlo painted herself fifty-five times,

which represents almost one-third of the artwork she did in her entire lifetime. Cindy Sherman has photographed herself hundreds of times in various guises and settings. Likewise, Mariko Mori has made multiple images of herself that cross the boundaries separating fine art, consumer culture, and kitsch.

Our focus figure is by Rembrandt van Rijn, who recorded his face as strong, vulnerable, cloddish, or sophisticated and at stages ranging from youth through old age. The paintings are emotional barometers as well, showing happiness, worry, sorrow, humor, or resignation. In *Self-Portrait* (Fig. 11.10), painted in 1669, Rembrandt records both a human face and a human soul. His lit face emerges from the void of the background. Light seems both to reflect off the surface of his face and to emanate from inside his head. His dark, piercing eyes express gentleness, pain, and knowledge. The left side of his face is in soft shadow, a fitting visual metaphor for a man of wisdom facing his own death. In fact, Rembrandt died later that year. Earth tones, blacks, dull reds, and luminous yellows predominate in this painting. The paint surface is rich and thick. Rembrandt studied himself in a country where both religion and the state promoted individualism (see *History Focus* on page 310).

Compare the subtle emotions of Rembrandt's face with the fiercely unblinking expression in our next example. In her fifty-five self-portraits, Frida Kahlo conducted a long inquiry into her inner and her outer being as well as the broader social and political forces that had influenced her life. Yet her face stays almost the same in all her paintings: distinctive and unemotional, with an unrelenting gaze that looks back at the viewer. She surrounds

11.10 REMBRANDT VAN RIJN. *Self-Portrait*, Netherlands, 1669. Oil on canvas, 1′ 11¼″ × 1′ 8″. Mauritshuis, The Hague.

Rembrandt's self-portraits, which he painted over many decades of his life, are a profound record of the pleasures and sorrows in the life of this man.

herself with signs and images of the different factors that shaped her very self, such as her ancestry, her physical body, her nearly fatal accident and chronic pain, the indigenous Mexican culture, the landscape, the Christian religion, and her relationship with Diego Rivera, a prominent Mexican artist. In *Self-Portrait with Monkey* (Fig. 11.11), painted in 1938, Kahlo's face is central, studying us as we study her. Her long hair is braided and pulled on top of her head in traditional Mexican style, to show her identification with the peasant culture. Lush foliage from the Mexican landscape surrounds her head. For Kahlo, the monkey was her animal alter ego. In other self-portraits, Kahlo uses such symbols as hummingbirds, which stood for the souls of dead Mayan warriors, and blood, which alludes to the crippling injuries she suffered in a bus accident, to Mayan bloodletting ceremonies, and to the Christian crown of thorns.

11.11 FRIDA KAHLO. *Self-Portrait with Monkey*, Mexico, 1938. Oil on masonite, 1′ 4″ × 1′. Albright-Knox Art Gallery, Buffalo, New York.

Kahlo painted her face many times, almost always with the same impassive expression. She surrounded her image with symbols of her personal history and of Mexican history that were significant in her life.

11.12 CINDY SHERMAN. *Untitled Film Still 53 (Blonde: Close-Up with Lamp)*, United States, 1980. Gelatin silver print, 8″ × 10″.

Sherman's work asks the question of whether a person's very self emanates from inner impulses or is molded from culturally given models.

CONNECTIONS For an example of a work by Kahlo's husband, Diego Rivera, see *Día de Los Muertos* (Fig. 8.25). A Mayan relief depicting a bloodletting ritual, *Shield Jaguar and Lady Xoc*, appears in Figure 7.18.

Kahlo's and Rembrandt's self-portraits show the inner self of a unique, deeply feeling person. In contrast, Cindy Sherman photographed herself hundreds of times, but the cumulative effect is one of fragmentation, not of piecing together a unique individual. Each image of Sherman reflects a socially prescribed or media-disseminated role. Our example, *Untitled Film Still 53* (Fig. 11.12), is one of a series of sixty-nine fake film stills she made between 1977 and 1980. They were all black and white, and 8 by 10 inches, the exact format of B-movie stills. She wears a wide range of costumes and poses in all kinds of settings, with a vast array of props, as if unaware of the camera. Often, the shutter release cable that Sherman operates is visible in this series of photographs.

In the photos, Sherman is sometimes almost unrecognizable as she reenacts roles for women that are given to us by the media, such as the sweetheart next door, the hardened woman, the girl left behind, or the vulnerable hitchhiker from a slasher film. In *Untitled Film Still 53 (Blonde: Close-Up with Lamp)*, Sherman appears to be a type of film character, an attractive, comfortably middle-class young woman perhaps inside a ranch-style home. We may be catching a character in one moment stopped in a film, but we have no clue about this person, who evades our encounter. Through this image and her other film stills, Sherman suggests that no one has a built-in sense of identity, but rather we compose ourselves from pieces of popular culture. The *Film Still* self-portraits are collectively a portrait of familiar female stereotypes, as represented through the media.

CONNECTIONS To read what critics have said about Sherman's work, turn to pages 99–100 and Figure 4.17.

Japanese-born Mariko Mori is an artist who was formerly both a fashion model and fashion designer living in New York and Tokyo. She creates photographs and performances starring herself in various roles, such as geisha or cyber-chick, which she sees as total fabrications. Embracing the commercial world that uses models to sell messages, she sees her artwork as part of pop culture and wants to connect art with movies and fashions. In *Birth of a Star*, she photographed herself as a teen rock star in a shiny, plastic, plaid skirt and spiked purple hair, surrounded by computer-manipulated floating bubbles. Afterward, she translated that same image into *Star Doll* (Fig. 11.13), in 1998, an edition of ninety-nine dolls. Because her identity is a totally fabricated hybrid, her work raises the question "What is 'self'?" Mori's work collapses distinctions among the categories of art, toy, fashion, kitsch, frivolity, and serious inquiry.

The Physical Body

Artists use the body to address ideas about the essence of humanity as well as cultural ideals.

11.13, *above* MARIKO MORI. *Star Doll*, 1998 (edition for Parkett 54, 1998–1999). Multiple of doll, 10¼″ × 3″ × 1⁹⁄₁₆″ (irregular). Publisher: Parkett, Zurich and New York. Manufacturer: Marmit, Tokyo. Edition: 99.

Mori's self-portrait is a commercially packaged version of herself as artist, model, and fashion designer.

11.14, *right* POLYKLEITOS. *Doryphoros (Spear-Bearer)*, Rome, c. 450–440 BCE. Marble after a bronze original, 6′ 11″ high. Museo Nazionale, Naples.

Polykleitos developed a canon of proportions, in which each part of the ideal body was in carefully controlled proportion to all other parts.

The Idealized Body

Our first examples present the human body in ideal terms, although that varies from culture to culture. The Greek philosopher Protagoras said, "Of all things, the measure is man." The democratic government, although limited, meant that individuals were self-governing. Athlete, philosopher, scientist, statesman, playwright, and warrior were all ideal occupations for men. The Greeks believed that humans were capable of near per-fection, defined as a fit body guided by a keen mind. Emotions were generally considered less important than the intellect and should be properly contained. Nudity was common in art and in athletic events, both of which glorified the unclothed, idealized human form. The focus figure for this section is *Doryphoros (Spear-Bearer)* (Fig. 11.14), dated 450–440 BCE. This slightly larger-than-life-size nude male by Polykleitos idealized the human form in several ways: (1) in the

balanced pose; (2) in the internal proportions; (3) in the restrained emotions; and (4) in the roles depicted—youth, athlete, and warrior. This work was executed in the Greek **Classical** art style.

The pose is simple, balanced, and understated. The statue's straight leg and arm create a vertical line on the left, balanced by the bent leg and arm on the right. Balance is also expressed across the body. The straight leg and bent arm are tensed, while the hanging arm and flexed leg are relaxed. The action is minimal and at the same time complex in its subtleties, with small twists, stretches, and compressions. This **contrapposto** (counterbalanced) stance is the way many people stand, so the sculpture re-creates an image of a living, flexing body.

Polykleitos invented and applied a now-lost system of mathematical and geometric proportions, called the Canon, which harmonized one body part with another in his sculptures. *Doryphoros* was originally conceived as a sculpture that would illustrate and demonstrate the Canon. A few of the simpler proportions of the Canon are still known; for example, the length of the longest finger equaled the length of the palm of the hand, and together they were used as a measure for the length of the arm. The breast nipples are one head-length below the chin, and the navel is another head-length below the nipples. This system also determined the placement of all the muscles. Polykleitos and the Greeks of his era believed that mathematical proportions resulted in a harmonious figure that was morally and aesthetically good. (In fact, the body is blocky, the result of the application of the Canon.) Polykleitos' total combination of balance, proportion, restraint, and youthful heroism made *Doryphoros* one of the most famous nudes of its time as well as of the Roman era and the Italian Renaissance.

CONNECTIONS See *Zeus* or *Poseidon* (Fig. 7.4) to compare the similarity between images of gods and humans in Greek Classical art. The original *Doryphoros* was executed in bronze, using the lost wax process. For more information, see Figure 3.43.

It is interesting to compare *Doryphoros* with the *Male Torso* (Ancestor figure) in Figure 11.15, which was likely carved in the twentieth century in the Baule area of Africa. Internal proportions, idealized character, harmony of parts, and restraint are important elements here as in *Doryphoros*, but the visual result is very different. In most traditional African sculpture, the front view of the human figure was sculpted symmetrically; arms are in parallel positions, legs both on the ground, head facing forward.

11.15 *Male Torso* (Ancestor figure), Baule, Africa, c. nineteenth–twentieth centuries. Wood, 1' 8½" high. British Museum, London.

In African art, ideal proportions for the human body were usually divided vertically, with one-third for the head, one-third for the torso, and one-third for the legs.

This formal, frontal pose contributes to the dignified, almost solemn aspect of the sculpture. In contrast, the side view features counterbalanced curves: the abdomen and knees project forward, balanced by the buttocks to the back. The straight neck and back interrupt the curves. The distinctive silhouette of the head is the focus for the

entire work. This sculpture is likely the depiction of an ancestor.

In some African traditions, the head and neck were considered the most important parts of the body and thus were apportioned one-third the height of the entire figure. The torso occupied another third and the legs the last third. The sculptor's first cuts set these proportions. The major forms were sculpted next, and, finally, decorative patterns enlivened the surface. The patterns represent scarification and carefully combed, braided, twisted, or beaded hair. The pattern elements are all confidently carved without mistakes or reworking because African sculptors generally were well trained as apprentices. The *Male Torso* combines naturalistic and abstracted features; for example, the chest and arms are relatively naturalistic compared to the stylized hands. This echoes tendencies in African sculpture as a whole, which runs the gamut from realistic to very abstract.

We continue with our comparisons of ideal figures by turning to two examples from ancient India. *Torso* (Fig. 11.16), dated c. 3000 BCE, is a carving from the ancient Harappan civilization that was centered on the Indus River in what is now Pakistan. The sculpture is an idealized version of the human body, with a supple, rounded form. The arm sockets suggest that the figure originally included several arms, possibly representing a youthful deity. The somewhat distended stomach suggests a yogic breathing posture. The stone has been so sensitively shaped that it gives the impression of living flesh, smooth muscle, and a little pad of fat. In contrast to the crisply articulated forms in *Doryphorus* and in the *Male Torso* from Baule, here the outlines and forms are smooth and curving, suggesting grace, flexibility, sensuality, and even vulnerability.

Yakshi (Fig. 11.17), dating from the first century BCE in India, continued the rounded form and sensuality of the *Torso*. Yakshi is a nature spirit who represents fertility; her breasts are exaggerated to emphasize her powers—her touch caused trees to flower. Her nearly nude body is curving and rounded and can be seen through her transparent skirt with the hemline draping across her shin. *Yakshi* twists with incredible flexibility, looking natural in a pose that would leave a human totally off balance. Jewelry adorns her lower arms and legs, giving interest to the less-curving features of her body. Her belt visually emphasizes her broad hips in contrast to her small waist. For the next several centuries, India produced an enormous amount of splendid figurative sculpture, and the twisting pose and voluptuous form appear often. Thus, in India, sensuality is an important and central characteristic of human nature.

11.16 *Torso*, India (Harappa, Pakistan), c. 3000 BCE. Red sandstone, 3½″ high. National Museum, New Delhi.

In ancient India, the ideal body had a soft, supple, fluid quality.

11.17 *Yakshi* (detail of East Gate, Great Stupa), early Andhra period, Sanchi, India, first century BCE. Sandstone, approx. 5′ high.

The ideal female body in ancient India was very well rounded and remarkably limber.

Many cultures do not have a tradition of depicting nudes in art, yet even these cultures have representations of ideal human forms. Return to Figure 11.1, *Nobles at the Court of Shah Abbas*. Note the graceful tilt of the head, the elegant hands, the serene facial expression, and the relaxed pose. This beautiful couple represents ideal qualities of youth in early-seventeenth-century Persia.

Flawed Humanity

Having looked at idealized human forms, we turn now to art in which human flaws are part of the content of the work.

At first glance, our focus figure seems to completely fit into the category of art that shows idealized human bodies. But *Laocoön and His Sons* (Fig. 11.18), dated 300 to 100 BCE, was created during the centuries that followed the idealized image of *Doryphoros*, when Greek art turned to depicting humans engaged in violent action, vulnerable to age, injured, diseased, and subject to feelings of pain, terror, or despair. Two cults were particularly influential in this era known as Hellenistic Greece: *Stoicism*, in which individuals were urged to endure nobly their fate and state in life; and *Epicureanism*, which advocated intelligent pleasure-seeking in life because death was the end of existence. Both philosophies imply a kind of resigned

11.18 Agesander, Athenodorus, and Polydorus of Rhodes. *Laocoön and His Sons*, Hellenistic (Roman patronage), Greece, early first century BCE. Marble, 7′ 10″ high. Vatican Museums, Rome.

The dramatic display of emotion in this sculpture stands in contrast to *Doryphorus*, which represents a balance between mind and body and emphasized restrained emotions.

acceptance of fate and a withdrawal from the Classic Greek ideal of the active, heroic, involved person. The **Hellenistic** Greek art style then emerged.

Laocoön and His Sons shows these changing concepts of the human body and human nature. In *Laocoön*, the human bodies are impressively muscular, an inheritance of the Classical Greeks, but the balance of mind and body, and the contained emotion, has here burst apart in a scene of high drama and sensationalism. Laocoön was a Trojan priest who tried to warn his fellow citizens against accepting the Trojan Horse as an apparent token of surrender from the Greeks who had been warring against them. Greek warriors hid in the horse, and they overcame the Trojan forces once the horse was inside the fortifications. The gods, who sided with the Greeks against the Trojans, sent sea serpents to strangle and kill Laocoön and his sons, even as they were making offerings at an altar. The story seems to be one of great injustice, as a virtuous man helping his fellow citizens is cruelly crushed by the gods. Human vulnerability and lack of control of one's fate are well demonstrated.

The figures are like a group of actors on a stage, all facing forward as if performing for an unseen audience (which is common in Hellenistic sculpture). Their struggles are theatrical. Their bodies are idealized, but the father's is overdeveloped and muscle-bound, more spectacular than heroic. Emotionality is increased by the deeply cut sculpture and Laocoön's dramatic reach into the surrounding space. The textures and surfaces vary from skin to hair and from cloth to serpent.

Compare now a representation of the body when human nature was held in low esteem. In Europe, medieval Christians saw a great split between the purity of God's divine realm and the natural world, a transitory place of sin and corruption. The mortal body was given over to appetites and lusts that led humans into sin and endangered their immortal souls. Salvation with God was possible only through the Church. We have another example of art depicting flawed humanity in *The Last Judgment* (Fig. 11.19), dated c. 1130 and sculpted in the **Romanesque** style, from the main entrance of the Church of St. Lazare. Unlike the muscular body of *Laocoön*, here the human

11.19 GISLEBERTUS. *The Last Judgment* (West Tympanum of the Church of St. Lazare), Autun, France, c. 1130. Stone carving, 21′ × 12′.

The bottom band shows humans raised from the dead on the last day, while Heaven is shown at center left, and the scales of Judgment and Hell are at center right. Body styles differ between holy and evil characters.

bodies are depicted as miserable, frail, and pitifully unattractive. The scene illustrates the end of time, when every person rises from the ground to be judged forever as worthy of heaven or condemned to hell. In the lower section of this carving, the cowering humans rise from their box-like graves and huddle in line until a pair of large hands, like oversized pliers, clamps around their heads. All are then plucked up and deposited on the scales of Judgment, where they risk being snatched by demons and stuffed in hell for eternity. The saved souls clutch fearfully at the robes of the angels.

Because human nature was considered so base, the idealized Greek nude was inconceivable, and the concept of a naturalistic body as beautiful and good had long since disappeared. The body in medieval art was distorted to communicate moral status. Thus, naked humans are puny. Good angels are elongated and serene, their anatomical distortions emphasizing their distance from earthly beings. The demons, however, seem to have been modeled on a flayed human corpse, with the exposed ribs and muscles of a tortured body, while their faces grimace horribly. Their claw feet are beast-like, and indeed the human body was associated with animals, which were seen as even more distant from God. Jesus is depicted in a grand manner reigning over heaven and earth, frontal and symmetrical, and much larger than all others.

It is interesting to compare the medieval depiction of the human form with an example from the Renaissance. Attitudes about human nature had shifted again. Humanistic philosophy of this time celebrated the glory of humanity: Italian philosopher Giovanni Pico della Mirandola declared in the fifteenth century, "There is nothing to be seen more wonderful than man," reflecting an attitude very similar to the Greeks'. Michelangelo Buonarroti, the famous painter, sculptor, and architect of the Italian **Renaissance,** believed that the human form was the most perfect and important subject to depict. He believed that his work was an echo of God's divine creation of humanity. Like most other Italian artists of that time, he was strongly influenced by Hellenistic and Roman sculptures that were being excavated in central Italy—for example, *Laocoön and His Sons* (Fig. 11.18). The nude as an ideal form became popular again.

But Renaissance nudes were different from Classical nudes. On the one hand, the body was seen now as a work of God and deserving of respect and honor. Yet the medieval beliefs persisted regarding the enduring soul versus the corruptible body. *David* (Fig. 11.20), dated 1501 to 1504, represents the Israelite youth who fought the giant warrior Goliath, saved his people, and later became the greatest king of the Old Testament. Michelangelo chose the moment that the young David first faces Goliath. Tension is apparent in his frown, tensed muscles, and protruding veins.

11.20 Michelangelo Buonarroti. *David*, Italy, 1501–1504. Marble, 14′ 3″ high. Galleria dell'Accademia, Florence.

The youthfulness of David is expressed in the oversized hands and in the tension on his face.

The sculpture is not self-contained, in contrast to *Doryphoros* (Fig. 11.14); the turning figure of David is "completed" by the unseen Goliath. The head and hands are oversized, indicating youthful potential still maturing and a greater potential violence, all attributes that differ from the restrained, relaxed *Doryphoros*. David's inner tension speaks of the core of being, the soul, that is separate from

the body. The body is ennobled and emphasized, but only as a vehicle for expressing the soul.

David reflects some broad trends. During the Renaissance, there was also a growing interest in scientific inquiry and the study of human anatomy. Michelangelo, Leonardo da Vinci, and other Italian artists performed dissections to assist them in rendering muscles. Also, David versus Goliath was a popular story in the republic of Florence, the city-state in central Italy for which this sculpture was made. Florence was ruled by a group of wealthy families rather than by a single leader, and Florentines saw themselves as much more self-determining than citizens of areas that were ruled by tyrants.

Our final comparison within the category of less-than-perfect humanity is the 1956 collage by Richard Hamilton, *Just What Is It That Makes Today's Homes So Different, So Appealing?* (Fig. 11.21). In an era of consumerism, people often gauge their worth by the purchases they can make, not by character, deeds, fate, or karma. Body shape becomes something that can be bought, too. In this **Pop Art** collage, we see the aestheticized body ideals of the late twentieth century: the buff, muscular man of amazing sexual prowess (the Tootsie pop) and a super-thin, sexy woman with a fashion-model pout on her face. The faces and bodies have been molded through implants, plastic surgery, and the latest abdominal workout machine. In addition, the couple's attractiveness is enhanced by their acquisition of trendy props, which in the 1950s included modern furniture, the latest appliances, and new media products. Hamilton took his imagery from popular magazines and billboards. The rug is a designer version of a Jackson Pollock action painting, which we will see at the end of this chapter. The cluttered composition, with all things new and chic, makes everything seem arbitrary and faddish. Hamilton's lampoon of modern consumer culture reveals the effectiveness and ridiculousness of advertising because it projects ideal body images that are so extreme, images to which we can never (but must always try to) measure up.

> **CONNECTION** Hamilton's work is fine art with mass-media imagery, and he is critical of both. For more, see "Fine Art" and "Popular Culture" in Chapter 1.

The Body as the Subject of Scientific Study

Starting with the Renaissance and moving toward the modern era, religious models for human nature held less sway in Europe and were increasingly challenged and displaced by concepts of humans based on scientific inquiry, whether physical anatomy, medicine, or psychiatry. This shift was also apparent in artwork.

In the discussion of *David* (Fig. 11.20) and also in the *History Focus* section (page 310), we have mentioned that anatomical studies were written or republished

11.21 RICHARD HAMILTON. *Just What Is It That Makes Today's Homes So Different, So Appealing?* England, 1956. Collage, 10¼″ × 9¾″. Kunsthalle Tubingen, Germany.

This work mocks the notion that status can be acquired by purchasing consumer products or by manufacturing an ideal body type for oneself.

in many parts of the world throughout the second millennium, most for medical or artistic reasons. This growing interest in anatomy resulted in body depictions that differ from those designed to reveal religious truths, philosophical positions, or inner emotions. The *Persian Anatomical Illustration* (Fig. 11.22), from Iran or Pakistan around 1680–1750, shows a pregnant female. She draws back the skin of her chest and abdomen to reveal inner organs, including her heart, stomach, and uterus. Around her are detailed drawings of other organs, including two hearts and lungs. She holds a plant in her hand, which may have been symbolic of her fruitfulness.

CONNECTION Another famous anatomical study is Andreas Vesalius' *De Humani Corporis Fabrica*. His *Fourth Plate of Muscles* (Fig. 13.24) is an example of European Renaissance scientific studies of anatomy.

Moving closer to our present era, new technologies changed the understanding of the human body. For artists, the invention of photography meant that human movement could be stopped and examined as never before. *Handspring, a Flying Pigeon Interfering, June 26, 1885* (Fig. 11.23) is a study of the human body in action made by Eadweard Muybridge and subsequently published with other such studies in the book *Animal Locomotion*. Muybridge invented a special camera shutter and then placed twelve cameras so outfitted in a row. When the athlete performed the handstand, his movements broke the series of strings stretched across his path, thus progressively triggering each of the twelve cameras.

For Muybridge, the human body was an object of detached, scientific study and not a powerful presence like *David* or the *Male Torso* from Baule. With Muybridge, the concept of the human body was altered and was recognized as being modified by time and space. Muybridge made similar studies for all kinds of human and animal movement. He also developed a cylindrical device that allowed his images to be mounted, rotated, and viewed to give the illusion of motion. In this respect, his work was a precursor of cinema.

The Limits of the Self

Is the individual person a discrete entity? What are the boundaries between the self and the environment, between the self and the spiritual realm, or between the self and technology?

Many Oceanic cultures of the South Pacific conceive of the person as an amalgam of life forces, physical substances, and ritual knowledge that come from many sources. That amalgam, which is at this moment a particular person, is, in fact, constantly changing and transforming and also in danger of coming apart.

Ritual tattooing was one way of strengthening the individual and was used throughout the more eastern islands of the South Pacific. Extra eyes, for example, gave the tattooed person more power and decreased vulnerability. Tattooing is often part of initiation rites that gradually harden the human body for adulthood. Extensive tattooing subjected a person to severe pain for a long time, but the result was generally seen as a kind of ritual empowerment. On the Marquesas Islands, the entire body was tattooed, while tattooing was confined to the buttocks and thighs of the women of Fiji and of the men of Samoa, Tahiti, and Tonga.

11.22 *Persian Anatomical Illustration*, anonymous drawing from the *Tibb al-Akbar (Akbar's Medicine)*, by Muhammad Akbar, known as Muhammad Arzani, Iran or Pakistan, c. 1680–1750. Ink and pigment on paper.

The body has been the subject of scientific study in many cultures around the world.

11.23 EADWEARD MUYBRIDGE. *Handspring, a Flying Pigeon Interfering, June 26, 1885*, England/Scotland/United States, 1887. Print from an original master negative, Plate 365 of *Animal Locomotion*. International Museum of Photography at George Eastman House, Rochester, New York.

The photograph allows artists and scientists to study the mechanics of human movement.

The tattoos of *Tomika Te Mutu of Coromandel* (Fig. 11.24), a nineteenth-century Maori tribal chief, were seen as an extra protective shell and a new ritual skin. Tattooing was effective in war, as it distracted and confused opponents. The tattoos also identified the individual. Among the Maori, facial tattoos were often considered more memorable than the person's natural features, which is true of Tomika Te Mutu. The chiseled whorls emphasize his scowl, piercing vision, hot breath, and fierce mouth. Traditional Maori tattooing is done with chisels, which gouge deep grooves in the skin. Curves and spirals are similar to the patterns in Maori woodcarving.

ART EXPERIENCE Design a tattoo for yourself or for a famous person or celebrity.

CONNECTION Turn to Figure 9.17 to see Maori woodcarving on a traditional meeting house.

11.24 *Tomika Te Mutu of Coromandel*, Maori chief, New Zealand, nineteenth century.

Tattoos applied to the body were believed to provide a ritual protective skin to rulers of the Maori people.

11.25 Umberto Boccioni. *Unique Forms of Continuity in Space*, Italy, 1913. Bronze (cast 1931), approx. 3′ 7″ high. Acquired through the Lillie P. Bliss Bequest. The Museum of Modern Art, New York.

This artwork presents the human figure distorted by external forces—and thus continuous with all other forms and energy in space.

If ritual beliefs can shape the concept of the human being, then scientific discoveries and technological advances can do so as well. A vast range of environmental factors influence the living body. The human being is seen now as permeable and as an integrated part of the total world.

In *Unique Forms of Continuity in Space* (Fig. 11.25), created in 1913 and cast in 1931, the artist Umberto Boccioni dissolves the conventional belief that the skin layer defines the body's outer edge. To him, the body is a mass of wave energy defined by its movement through a fluid atmospheric medium. Significantly, the body is considered less as a human and more as a form that is continuous with others in space. Muscle and bulk are implied, but the sculpture resembles a map of aerodynamic turbulence and the distorting effects of air currents on forms. Boccioni was part of an art movement called **Futurism,** which celebrated violence, speed, energy, motion, force, and change, which reflected his contemporary world.

Sickness and Death

Human illness and death are topics that are also addressed in art. *Intra-Venus*, dated from 1992 to 1993, is a series of large-scale photographs that the artist, Hannah Wilke, made with her husband, Donald Goddard, as she struggled with and eventually succumbed to cancer. In this series, both cancer and its medical cures transform and ravage Wilke's body. The frequently larger-than-life photographs present her body to us as it weakened, bloated, and bled. The size makes the physical reality of sickness apparent; it is "in your face." In one bust-length portrait, we see her bald scalp, mottled skin, and bleeding, pus-filled tongue, all resulting from her cancer treatment. Yet many of the images show that her body possessed a kind of monumental beauty and that Wilke was still a person of humor and strength.

In three panels from *Intra-Venus* (Fig. 11.26), Wilke assumes three poses derived from images of sexually attractive nudes taken from fine art and from magazines, such as *Playboy*. Her glance implies the presence of a sexual partner, as she poses herself as the object of voyeurism. Her posture speaks of narcissistic pleasure. She is Venus, the goddess of love and beauty, even with the ravages of disease and surgery. Wilke reclaims sexuality for herself in sickness and, thus, challenges conventional ideas of attractiveness. In doing so, her last work continued her earlier art. Before the onset of cancer, her body conformed to "fashion model" looks, and she frequently used her body in her artwork to undermine or critique how female beauty is currently defined and consumed in the United States.

11.26 Hannah Wilke. *Intra-Venus*, United States, 1992–1993. Chromogenic supergloss photographic prints (13), each panel 2′ 2″ × 3′ 3½″.

This artist examines the beauty of her body even when ravaged by disease.

11.27 MANUAL ALVAREZ BRAVO. *Striking Worker, Assassinated*, 1934. Gelatin silver print, $7^9/_{16}'' \times 9^3/_8''$. The Museum of Modern Art, New York.

Photographs of death are often less idealized than paintings of death.

CONNECTION For more about the sexual meaning of gaze and gender roles in images, see *Olympia* by Edward Manet (Fig. 6.21).

Striking Worker, Assassinated (Fig. 11.27), from 1934, is a close-up view of death by Manual Alvarez Bravo, one of Latin America's most important artistic photographers. His photographs are almost all of ordinary people shown with unvarnished realism, as exemplified in his image of the murdered worker. In painting, death can be glorified or idealized. In this photograph, formal qualities can be carefully arranged (note the alignment of stripes and the way that diagonals all converge on the victim's head). But these aesthetic fine points coexist with details of appalling gore. *Striking Worker, Assassinated*, is a disturbing image, not only for its content but also because this death is close up and immediate.

CONNECTION Compare this image of death with those from war, such as Mathew Brady's *Dead Confederate Soldier with Gun* (Fig. 9.25).

THE PSYCHOLOGICAL DIMENSION IN ART

Much art is related to the mental or emotional state of humans. We have already seen this in some portraits in the beginning of this chapter. Now we turn to work that functions psychologically in one of three ways. First is an example in which the body is affected by a host of internal emotional and mental forces. Second, we see two works that are intended to be psychologically potent and affect the mental states of those who view or use the art.

11.28 EDVARD MUNCH. *The Scream*, Norway, 1893. Oil painting, $2'\,11^3/_4'' \times 2'\,5''$. National Gallery, Oslo, Norway.

Inner emotional forces have distorted and deformed the head into almost a skull-like form.

Finally, we examine three examples of art that act as records of a mental or emotional state.

Illustrating the first kind of art is our focus figure, *The Scream* (Fig. 11.28), painted by Norwegian artist Edvard Munch in 1893. In this work, the distorted body is the

vehicle for expressing inner terror, anxieties, and pressures. Realism has been abandoned to give form to these internal emotions. At this time, Sigmund Freud had propagated his theories of repression and neurosis as both social and personal ills, which influenced Munch and other artists. The central character glances back at distant figures, but it is unclear whether they are part of the scene or disinterested bystanders. Whatever the situation, the foreground figure is overcome by fear that has twisted the body and reduced the face to a near skull. The figure stands in complete physical and emotional isolation, cupping its hands over its ears and screaming at a pitch that reverberates in the landscape and in the sky. The colors are emotionally distorted and heightened.

Let us turn now to art that is intended to be psychologically active when used, worn, or displayed. The *Double Mask* (Fig. 11.29), from the Ejagham people of the Cross River area of Cameroon, is an example of masks that in many African cultures are intended to be psychologically potent, either by giving the wearer extra power or by intimidating the audience witnessing a performance with the mask. This *Double Mask*, which is just one example of the great variety of African masks, was carved and then covered with fresh antelope hide, which when dried gives

the mask a startlingly lifelike finish. The masks were used by associations whose members had achieved notable feats or had mastered important skills. They were part of rituals and celebrations that promoted group cohesion. People of rank within the associations had the right to wear the masks. The double face looking forward and backward likely suggested heightened spiritual powers.

Compare the *Double Mask* with the *Mask of the Swan and the White Whale* (Fig. 11.30), from the North American Inuit (Eskimo) culture. According to Inuit beliefs, the swan leads the white whale to the hunter. Traditionally, the Inuit culture has depended on whale hunting to provide many necessities, so during rituals the wearer of this mask would receive added powers in whale hunting. The mask is visually striking. It is asymmetrical and eccentric, with a grinning half-face. Its shape suggests whale fins, and it is adorned with bird feathers. This mask was produced by the Yup'ik people of western Alaska, who created masks that are noteworthy for their amazing inventiveness.

In our final category of art in this section, we look at works that are meant to be records of an inner emotional state.

11.29 *Double Mask*, Ejagham People, Cross River, Cameroon, nineteenth–early twentieth centuries. Wood, hide, pigment, rope, beads; 1′ 1¾″ high. Ethnologisches Museum, Staatliche Museen, Berlin.

This artwork is intended to be psychologically potent for those who use it.

11.30 *Mask of the Swan and the White Whale*, Inuit, early twentieth century. Wood, 1′ 7¼″ high. Musée du Quai Branly, Paris.

The Inuit people of Alaska are known for their inventive masks that are intended to increase the power of those who wear them in rituals.

Italian artist Giovanni Battista Piranesi's *Prison* (Fig. 11.31), from 1745, does not focus on the human form like Munch's *Scream*; rather, the complicated, dreary spaces of the dungeon act as a metaphor for the darker, twisted side of the human mind. The fantastic gloominess of this prison is pervaded by hopelessness and a lack of meaning, and exit seems impossible. Small humans are dwarfed as they move through the oppressive space. These complex, dark chambers are the exact opposite of sunny landscapes, but each can be seen as a metaphor for a human state of mind.

Our next example depicting an inner emotional state is Chilean artist Matta's painting *Listen to Living* (Fig. 11.32).

11.31, *left* GIOVANNI BATTISTA PIRANESI. *Prison*, from *Le Carceri*, No. XIV (first state), 1745. Etching.

Although this image shows a gloomy architectural interior, it is a visual metaphor for the dark side of the human mind.

11.32, *below* MATTA. *Listen to Living*, 1941. Oil on canvas, 2′ 5½″ × 3′ 1⅞″. Inter-American Fund.

Surrealist paintings like this one are often intended to be reflections of the unconscious mind and to allude to cosmic forces in life, such as creation and destruction.

His work is an example of **Surrealism,** a movement that emphasized absurd or dream states. Matta's paintings are called "inscapes," as he sought to create in pictorial space an image of the workings of the human mind. His work is marked by vivid colors, luminous patterns, and bold lines, all against a vague, unspecific background. Although he does not depict realistic scenes, Matta's work is often preoccupied with primordial creation and cycles of destruction. During and after World War II, his surrealistic abstractions also reflected the horrors of war. His painting technique was marked by spontaneity; he smeared and splotched the paint on the canvas until he arrived at shapes that resonated with the unconscious.

Our last example of an artwork meant to record a mental state is by U.S. artist Mark Rothko, who started as a figurative painter but eventually abandoned imagery that depicted the physical world for abstractions that hint at a sublime moment or transcendent state of being. He created a series of paintings that contained large rectangles, sometimes only vaguely defined, against a field of other colors. Shapes and background emerge, float, and glow, as in *Green, Red, Blue* (Fig. 11.33), from 1955. Rothko first applied thin "veils" of paint that soaked into and stained the canvas. He then applied many layers on top to create shapes that seem present and yet hard to define, hovering in a space that is real and yet not wholly knowable.

Rothko used abstraction as a means to address these broad and fundamental feelings and ideas because figurative or narrative imagery was too specific and too limiting. In addition, Rothko's abstractions were meant to provide a kind of direct physical experience to the body.

THE BODY IN ART AND AS ART

The body is not only depicted in art but also used in making art or transformed to become artwork.

The Body as Art Material

The human body is material for art making. It can be painted or sculpted, or it can be part of a performance or spectacle. In all of these instances, the living body energizes, personalizes, or adds emotional content to the artwork. We have already seen an example of body art in the tattooed face of *Tomika Te Mutu* (see Fig. 11.24), where his skin is the canvas on which the artwork is made. The marks on the face of the *Male Torso* (Ancestor figure) from Baule (see Fig. 11.15) may be like the scarification patterns that the Baule people created on their own bodies. In both cases, the body art has great cultural significance.

Modifying the living human body has a long history. The Mayan *Head from the Tomb of the Temple of Inscriptions* (Fig. 11.34), dated mid- to late seventh century, shows how the human body is plastic and moldable, a kind of raw material from which works of art can be made. To the Mayans, a flat, sloping forehead was beautiful and aesthetically pleasing, so they bound and compressed infants' heads to deform the shape as they were growing. Hair was bluntly cut at different levels and woven with jade ornaments, cotton threads, and flowers. The stair-step cut on the sides and the top plume of hair were common designs. The resulting human head was a living artistic creation, the image of which is reproduced in this stucco sculpture in the round, which was once brightly painted. This portrait sculpture of a ruler known as Pacal or Pakal (Mayan for "Shield") was found next to his tomb.

Body ornamentation is an art form in many traditional African cultures, as we have seen, where rituals are the supremely important events for the community, governing all aspects of life, death, everyday survival, and interaction with the spirit world. But not all body art involves scarification. In many of these cultures, body painting is equivalent to wearing masks or costumes. Among the Ngere people in the late twentieth century, girls paint their torsos white and their faces in brilliant colors after initiation, as in *Ngere Girl Prepared for a*

11.33 MARK ROTHKO. *Green, Red, Blue*, United States, 1955. Oil on canvas, 6′ 9½″ × 6′ 5¾″. Milwaukee Art Museum, Wisconsin.

By painting glowing colors and hovering shapes, the artist hoped to allude to a sublime, transcendent state of being.

11.34 *Head from the Tomb of the Temple of Inscriptions*, Maya, Palenque, Chiapas, Mexico, mid- to late seventh century. Stucco, 1' 5" high. Museo Nacional de Antropología, Mexico City.

The human body is malleable and can be changed for aesthetic purposes. Mayan rulers often flattened the foreheads of their offspring, and hair was cut and sculpted in a dramatic way.

11.35 *Ngere Girl Prepared for a Festival*, Africa, late twentieth century. Body painting.

Body painting is an important art form among some African people.

Festival (Fig. 11.35). The patterns of color are similar to the way the face can be abstracted and broken down into parts in sculpture, while the parallel lines in the white paint echo both chisel marks and sculptural hair patterns. Body painting, like tattooing, makes the living body into a work of art, expands its power and its protection, and announces the status of the person in the community—in this case, an initiated girl.

Cuban artist Ana Mendieta created several outdoor performances that dealt with her body directly or the trace of her body on the earth. Individual works in the series, called *Silueta* (*Silhouette*), were performed in Iowa and in Mexico from 1973 until 1980 and exist now only as documentary photographs. In *Arbol de la Vida, No. 294* (Fig. 11.36), dated 1977, Mendieta made herself into a body

11.36 ANA MENDIETA. *Arbol de la Vida, No. 294*, from the series *Arbol de la Vida/Silueta* (*Tree of Life/Silhouette*), Cuba/United States, 1977. Color photograph documenting the earth/body sculpture with artist, tree trunk, and mud, at Old Man's Creek, Iowa City, Iowa.

This artist covered her body in mud and assumed distinct poses to represent primal female forces with her own personal body.

11.37 MARINA ABRAMOVIC. *The Artist Is Present*, March 14–May 30, 2010. 736-hour performance. The Museum of Modern Art, New York.

The human body is often a primary element in performance art.

sculpture covered with mud and straw. She posed against a tree in a manner reminiscent of ancient fertility goddesses, leaving traces of mud on the bark. The site of her performance was very dramatic, with a massive tree growing at the edge of a deeply cut creek bed. In other works in the *Silueta* series, Mendieta sculpted the mud or used stones or flowers to trace the outline of her body on the earth. It was important to use her living body in these performances because they became like rituals in which the energy of her living being was joined with that of the earth, which she believed was a force that was omnipresent and female.

CONNECTION Review the discussion of ancient fertility goddesses, such as *Idol from Amorgos* (Fig. 6.4).

Contemporary performance art almost always involves the body. There were a number of early practitioners who

defined the medium, including Yoko Ono, Chris Burden, and Bruce Nauman. Marina Abramovic, a leader in this visual art form, has work that dates back to 1970, which involves pushing the mental and physical limits of her being. Time, actual lived experience, and her own body are her materials. Her work has involved self-inflicted and other-inflicted pain, near death, and exhaustion, all to produce moments of spiritual or emotional transformation in herself. One recent feat of endurance was *The Artist Is Present* (Fig. 11.37), from 2010. This 736-hour-long piece (executed over several weeks) involved Abramovic sitting immobile in the atrium of the Museum of Modern Art in New York, while museum guests were invited to sit opposite of her for a span of time. The two looked at each other in silence until the guest left. Rather than being represented by her work, the artist herself was indeed present through the run of the exhibition. The performance created a space of stillness in the crowded, noisy

11.38 Jackson Pollock. *Lucifer*, United States, 1947. Oil, aluminum paint, and enamel on canvas, approx. 3′ 5″ × 8′ 9″. Collection of Harry Ward and Mary Margaret Anderson.

The poured and dripped paint is a permanent record of the actions of the artist's body as he bent his back, lunged forward, and swung his arm to make this painting.

museum and a sense of slowed-down time that was completely discontinuous with the surroundings. Videos of the work make clear how taxing the performance was for the artist, who had to remain still and attentive for hours on end, and how curious and unusual it was for the guests.

The artist's body and the actions of the audience are the art piece, not the photo document we see in this book. The physical presence of real bodies, the quality of spectacle, the uncertainty, and the palpable experience of time passing are potent elements that still photography cannot convey.

CONNECTION For another example of an artist who uses his body as art material, see James Luna's *The Artifact Piece* (Fig. 12.6).

ART EXPERIENCE Produce a brief performance piece using your body as an art material.

The Body as an Art-Making Tool

The first and most important tools of artists are their bodies: their fingers, hands, and arms, guided by their minds. In making works of art, artists continually touch the entire surface of their works. This is obvious with sculptors who model clay with their hands, but even

painters work the entire surface of their images with sensitive brushes and often adjust or finish their work with their fingertips. Although the touch of photographers and computer artists may leave no mark on their works, their hands are nonetheless essential and present. In *Fanny (Fingerpainting)*, which we saw in Figure 11.6, artist Chuck Close created the woman's enormous head in detail, showing the texture of her hair, her skin wrinkles, her watery eyes, and the cloth of her dress. The entire work was painted with the artist's hand and fingerprints. Although it looks like a photograph, the face, in fact, is a mass of finger smudges, a record of everywhere the artist touched. The mark of the hand relates to fossils and the handprints in prehistoric cave paintings and to the first marks we made as children.

When Jackson Pollock painted *Lucifer* (Fig. 11.38) in 1947, the motion of his entire body was very significant. This style of painting is called "gestural abstraction" or **action painting.** The "action" came from the movement of the artist. The canvas was laid down on the ground, and Pollock poured, dripped, and flung paint upon it as he stood at the edges or walked across the surface. He lunged and swirled about in furious outbursts, which were followed by periods of reflection. His body movements were fixed and recorded in the paint surface, which is a rhythmic mesh of drips, congealed blobs, and looping swirls.

Pollock's act of painting and the painting itself were frequently described in quasi-combat terms. He saw the

11.39 Jackson Pollock at work in his Long Island studio, 1950.

Making large-scale action paintings requires the movement of the artist's entire body.

canvas on the ground as a plane of action, but when hanging on the wall in front of the viewer, it became a plane of confrontation. Pollock believed his spontaneous, energetic painting style fit the mood of the United States immediately after World War II. He also believed that the power of his unconscious mind was being released in action painting and that his painting style was a burst of primal energy and a release from civilized constraints. The action painter was seen as being an isolated genius, almost always male, whose work had no moral message and no narrative, just pure paint and pure body action.

Do women have to be naked to get into the Met. Museum?

Less than **5%** of the **artists** in the Modern Art sections are women, but **85%** of the **nudes** are female.

GUERRILLA GIRLS CONSCIENCE OF THE ART WORLD
www.guerrillagirls.com

12.1 GUERRILLA GIRLS. *Do women have to be naked to get into the Met. Museum?* United States, 1986. Street poster.

Art can point out inequities between genders within a culture.

12

RACE, GENDER, CLAN, AND CLASS

All persons are born with race and gender characteristics, class standing, and genealogy that will affect their lives. These characteristics contribute to personal identity, but on the downside they may also trigger prejudice and discrimination. Art reflects these issues.

PREVIEW

Art can forge racial identity and preserve the history and values of an ethnic group. Art can also expose racial oppression.

Gender roles are reinforced or challenged in artworks. Some works are intended to strengthen the status quo in the gender relationships, while others protest inequality such as our chapter opener, Do women have to be naked to get into the Met. Museum? *(Fig. 12.1), by the Guerrilla Girls. We also see art in which gender is tied to ideas of beauty and heroism within a culture.*

Artwork preserves clan identity and traditions, and it documents clan history. Some clans place great importance on venerated ancestors, and art helps to maintain the presence of the ancestors. Art also reflects the way some cultures are organized around clans and some around the nuclear family. We also see the shifting definitions of family.

Lifestyles of social classes are reflected in art. Often, class rank and distinction are evidenced by the size of the architecture and the quality of the art objects used by the wealthy versus those used by the poor. Classes also develop art that is unique to their group. In this chapter, we see images in which poverty marks the figures from the lowest classes, while the middle and upper classes enjoy leisure and comfort.

In this chapter, you can make an artwork about contemporary gender roles, about family relationships, or about food as an indicator of class.

Connecting Art and History from
1750–1850 CE

The period 1750–1850 brought major changes in the history of humankind. In 1760, the Industrial Revolution was beginning in Europe—power machinery replaced hand labor, and steam engines replaced water wheels and spinning mills. Many important inventions were developed in the late eighteenth and early nineteenth centuries, including the steam engine (1775), the cotton gin (1793), the telegraph (1836), and the sewing machine (1844). Workers formed the first trade unions to fight for their rights, and Karl Marx and Friedrich Engels wrote the *Communist Manifesto*, published in 1848. People moved to the cities to work in factories, and a middle class grew and gained power, while working classes struggled for rights. This was also the Age of Enlightenment, which fostered ideas of personal liberty. All of this tremendously affected ideas of race, gender, clan, and class.

The middle of Africa during the 1700s remained mostly isolated,

Map 8 Independence Movements in North and South America.

THE UNITED STATES
Independence from England 1776

FLORIDA
Ceded to the U.S. 1821

TEXAS
Ceded to the U.S. 1845

HAITI
Independence from France 1804

MEXICO
Independence from Spain 1810

VENEZUELA
Independence from Spain 1811 and Great Columbia 1830

CENTRAL AMERICA
Independence from Mexican Empire 1823

THE GUIANAS
Split into French Guiana, British Guiana, Dutch Guiana, and the Guayana Region

COLUMBIA
Independence from Spain 1810

ECUADOR
Independence from Spain 1809 and Great Columbia 1830

EMPIRE OF BRAZIL
Independence from Portugal 1822-1889

PERU
Independence from Spain 1821

BOLIVIA
Independence from Spain 1825

CHILE
Independence from Spain 1810-1826

PARAGUAY
Independence from Spain and Buenos Aires 1810-1811

UNITED PROVINCES
Independence from Spain 1816

URUGUAY
Independence from Brazil 1825

0 1,000 2,000 Km.
0 1,000 2,000 Mi.

although Europeans established trading ports on the coast. During the 1800s, the need for raw materials to fuel the Industrial Revolution drove the Dutch, Portuguese, English, and other Europeans to colonize the entire continent. Toward the latter part of this period, the empires of Zimbabwe and Asante came to an end.

Europeans also divided the Americas through colonization. The French claimed land from Canada through the Great Lakes and down the Mississippi River. Britain controlled the thirteen colonies, and Spain claimed Florida, Texas, New Mexico, Arizona, and California as well as vast territories in Central and South America. In India, Great Britain set up colonial rule, and, later, Queen Victoria would become the empress of India. The British also claimed eastern Australia in 1770.

Also during this time, Japan saw the continued rise of its merchant class, and color woodblock prints called *ukiyo-e* were made that appealed to their tastes and financial means. One example is *Komurasaki of the Tamaya Teahouse* (Fig. 12.32). The Japanese middle class also developed theatrical forms that were distinct from those of the ruling class. Japan was ruled by the Tokugawa Shogunate, which held military power, whereas the emperor was the political and religious leader.

The Qing (or Manchu) Dynasty ruled in China during this period, reaching its height throughout the 1700s. China continued to be ruled through the bureaucratic system of government. Emblems were worn on robes to distinguish members of the enormous Chinese court, like the *Rank Badge with Peacock* (Fig. 12.2). Wars, internal unrest, natural disasters, and an outdated bureaucracy eventually led to the Qing Dynasty's decline in the mid-nineteenth century. Between 1839 and 1842, the Opium Wars broke out between China and Britain.

Britain had smuggled opium from India into China, causing mass addiction to the drug, which in turn greatly affected China's economy. Britain won the war and gained Hong Kong plus five ports in China for trade.

A series of political revolutions occurred during this era that had enormous impact on the modern world. In 1775, England's thirteen colonies in North America began a revolution that eventually resulted in an independent United States (see Map 8). George Washington became the first president of the United States in 1789. In France, the nobility enjoyed great wealth and leisure, exemplified by the frivolity in *The Swing* (Fig. 12.25). Eventually, the disparity in wealth and lifestyles between the rich and the poor led to the French Revolution in 1789, in which the monarchy was overthrown. Many French, both aristocrats and citizens, were executed on the guillotine during the Reign of Terror

12.2 *Rank Badge with Peacock*, Qing Dynasty, China, late eighteenth–early nineteenth centuries. Silk, metallic thread on silk; 1′ 1/8″ × 1′ 1/8″. Metropolitan Museum of Art, New York.

Richly embroidered badges distinguished among groups in the Chinese court. The Imperial Family badges had dragons and phoenixes, while those of military officers featured lions or tigers and civil officials wore birds. Peacocks were worn by civil officials who had attained the third rank among nine possible ranks.

following the uprising. In art, the revolutionary spirit was presented in **Neoclassical** terms, as seen in *Oath of the Horatii* (Fig. 12.10). In 1804, Napoleon took control of France and conquered a vast but short-lived empire. In 1812, in South America, revolutionary leaders such as Simón Bolívar of Venezuela and José de San Martín of Argentina fought for independence from Spain. By 1825, all of the Spanish colonies in South America had thrown off colonial rule (see Map 8).

World Art Map
for Chapter 12

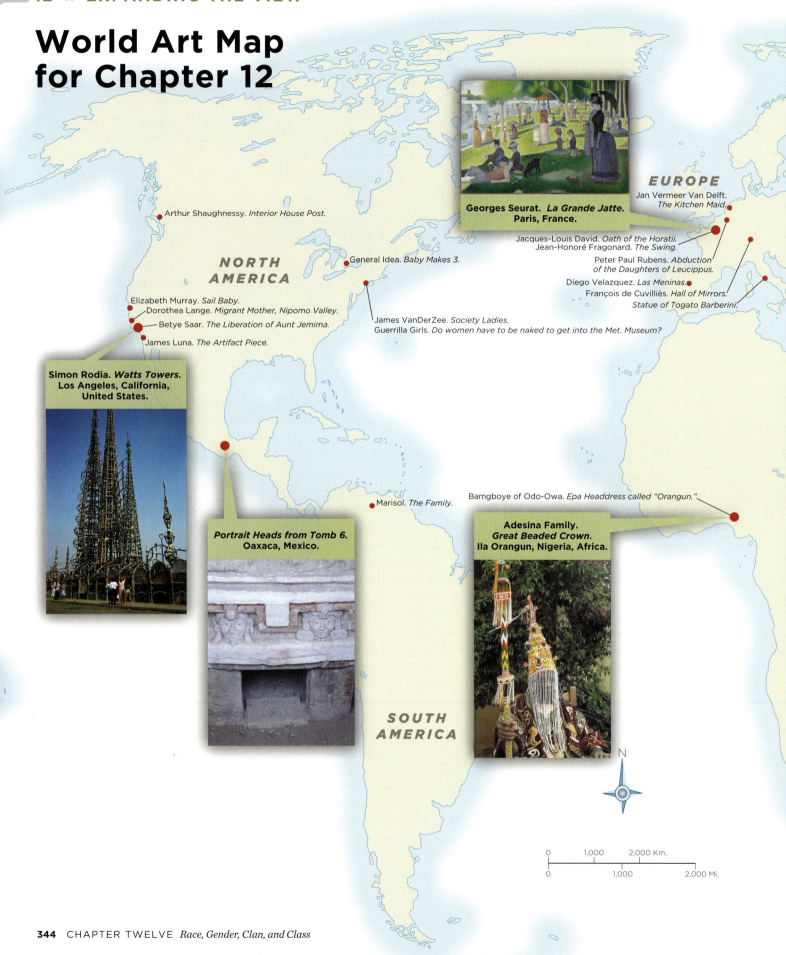

NORTH AMERICA

SOUTH AMERICA

EUROPE

Arthur Shaughnessy. *Interior House Post.*

Georges Seurat. *La Grande Jatte.* Paris, France.

Jan Vermeer Van Delft. *The Kitchen Maid.*

General Idea. *Baby Makes 3.*

Jacques-Louis David. *Oath of the Horatii.*
Jean-Honoré Fragonard. *The Swing.*
Peter Paul Rubens. *Abduction of the Daughters of Leucippus.*
Diego Velazquez. *Las Meninas.*
François de Cuvilliès. *Hall of Mirrors.*
Statue of Togato Barberini.

Elizabeth Murray. *Sail Baby.*
Dorothea Lange. *Migrant Mother, Nipomo Valley.*
Betye Saar. *The Liberation of Aunt Jemima.*
James Luna. *The Artifact Piece.*

James VanDerZee. *Society Ladies.*
Guerrilla Girls. *Do women have to be naked to get into the Met. Museum?*

Simon Rodia. *Watts Towers.* Los Angeles, California, United States.

***Portrait Heads from Tomb 6.* Oaxaca, Mexico.**

Marisol. *The Family.*

Bamgboye of Odo-Owa. *Epa Headdress called "Orangun."*

Adesina Family. *Great Beaded Crown.* Ila Orangun, Nigeria, Africa.

N

0 1,000 2,000 Km.

0 1,000 2,000 Mi.

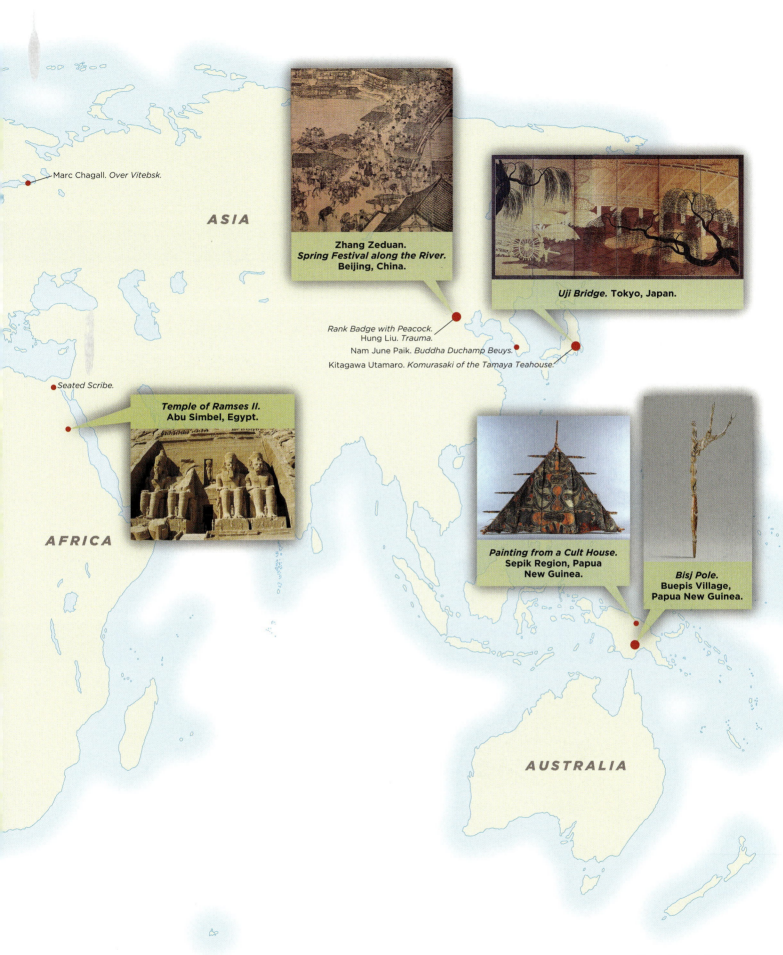

Marc Chagall. *Over Vitebsk.*

ASIA

Zhang Zeduan.
Spring Festival along the River.
Beijing, China.

Uji Bridge. Tokyo, Japan.

Rank Badge with Peacock.
Hung Liu. *Trauma.*
Nam June Paik. *Buddha Duchamp Beuys.*
Kitagawa Utamaro. *Komurasaki of the Tamaya Teahouse.*

Seated Scribe.

Temple of Ramses II.
Abu Simbel, Egypt.

AFRICA

Painting from a Cult House.
Sepik Region, Papua
New Guinea.

Bisj Pole.
Buepis Village,
Papua New Guinea.

AUSTRALIA

1750–1850 CE

OLD KINGDOM, EGYPT			ACHAEMENID CIVILIZATION	ROMAN EMPIRE	TANG DYNASTY— CHINA HISTORIC ERA— JAPAN	Teotihuacán— Mexico		ROMANESQUE ERA
2700 BCE	2500	2000	500	100 75	600 CE	640	700	1000
	Seated Scribe Temple of Ramses II			Statue of Togato Barberini		Portrait Heads from Tomb 6		Zhang Zeduan. Spring Festival along the River

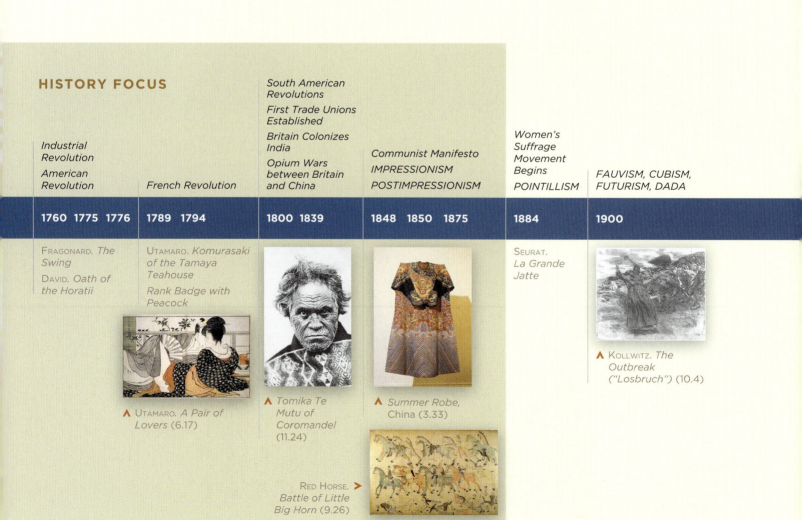

∧ Persepolis (9.11)

HISTORY FOCUS

Industrial Revolution American Revolution			French Revolution	South American Revolutions First Trade Unions Established Britain Colonizes India Opium Wars between Britain and China	Communist Manifesto IMPRESSIONISM POSTIMPRESSIONISM			Women's Suffrage Movement Begins POINTILLISM	FAUVISM, CUBISM, FUTURISM, DADA
1760	1775	1776	1789 1794	1800 1839	1848	1850	1875	1884	1900
Fragonard. The Swing David. Oath of the Horatii			Utamaro. Komurasaki of the Tamaya Teahouse Rank Badge with Peacock		Seurat. La Grande Jatte				

∧ Utamaro. A Pair of Lovers (6.17)

∧ Tomika Te Mutu of Coromandel (11.24)

∧ Summer Robe, China (3.33)

∧ Kollwitz. The Outbreak ("Losbruch") (10.4)

Red Horse. > Battle of Little Big Horn (9.26)

AGE OF ENLIGHTENMENT

ROCOCO STYLE

England, France, and Spain Colonize the Americas

Dutch and Portuguese Establish Trading Ports in Africa

GOTHIC ERA	RENAISSANCE BEGINS	BAROQUE ERA			
1200	1400　1500	1600	1617　1656　1660	1700	1734　1750

Uji Bridge

RUBENS. *Abduction of the Daughters of Leucippus*

VELAZQUEZ. *Las Meninas*

VERMEER. *The Kitchen Maid*

DE CUVILLIÈS. *Hall of Mirrors*

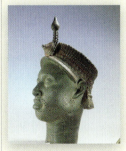

ᐱ *Crowned Head of an Oni* (9.5)

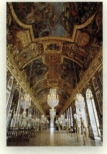

ᐱ *Hall of Mirrors, Versailles* (9.14)

SURREALISM, FANTASY, SUPREMATISM	World War I Harlem Renaissance	World War II	POSTWAR EXPRESSIONISM Feminist Movement	POSTMODERNISM	End of Apartheid in South Africa
1907　1908	1914　1921　1927　1936	1940	1950　1962	1972　1974　1975　1979	1983　1984　1986　1989　1991

SHAUGHNESSY. *Interior House Post*

Painting from a Cult House

CHAGALL. *Over Vitebsk*

RODIA. *Watts Towers*

VANDERZEE. *Society Ladies*

LANGE. *Migrant Mother, Nipomo Valley*

Bisj Pole

MARISOL. *The Family*

ADESINA FAMILY. *Great Beaded Crown of the Orangun-Ila*

SAAR. *The Liberation of Aunt Jemima*

BAMGBOYE OF ODO-OWA. *Epa Headdress Called "Orangun"*

MURRAY. *Sail Baby*

GENERAL IDEA. *Baby Makes 3*

LUNA. *The Artifact Piece*

GUERRILLA GIRLS. *Do women have to be naked to get into the Met. Museum?*

PAIK. *Buddha Duchamp Beuys*

HUNG LIU. *Trauma*

ᐸ KAHLO. *Self-Portrait with Monkey* (11.11)

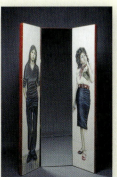

ᐱ BACA. *Las Tres Marias* (3.5)

RACE AND ART

This section contains several artworks that deal with race. Some help form a cohesive identity for a racial group, whereas others challenge negative attitudes.

Art That Promotes Ethnic History and Values

These works of art examine or illustrate the history or values of a certain ethnic group. In Russia in the 1800s and early 1900s, Jews were considered outsiders because of laws and traditions originated and maintained both by the Jews and by the Russians. Jews were allowed to live only in certain areas and were restricted from attending universities. That separateness was often passively accepted, but at times Jews suffered from anti-Semitic terrorism. Even so, Russian Jews were often cultural innovators and, in many cases, were known throughout Europe as artists, musicians, and writers.

Our focus figure was created by Marc Chagall, a prominent Jewish artist who grew up in Russia but spent most of his long life in Paris. Many of his paintings imaginatively re-created Jewish village life at the turn of the twentieth

century in Russia, which was in fact disintegrating as a result of political, religious, and economic pressures. Chagall's imagery was a personal (sometimes incoherent) reordering of bits and pieces of his experiences, which included folktales, festivals, marriages, funeral practices, and finally suffering and death caused by anti-Semitism. In *Over Vitebsk* (Fig. 12.3), dated 1915–1920, Chagall painted a large solitary figure floating over his own village, representing thousands of eastern European Jewish refugees who fled to Russia, displaced by World War I. In Yiddish, "passing through" is expressed as wandering "over the village," which Chagall painted literally by means of the "refugee" floating figure in the composition. A sense of being rootless and in a state of upheaval pervades the picture. The space in the foreground of the picture appears fractured, which Chagall devised from **Cubism** to represent instability. The colors are from **Fauvism**, an art movement that originated in Paris in which color was exaggerated in paintings for greater power and expression.

Compare Chagall's lyrical scene with the frank, forthright portraiture of James VanDerZee, a commercial studio photographer whose works are a record of the Black Renaissance of Harlem, generally dating from 1919 to 1929 (he continued to photograph Harlem residents through

12.3 Marc Chagall. *Over Vitebsk* (after a painting of 1914), Russia/France, 1915–1920. Oil on canvas, 2′ 2½″ × 3′ ½″. Acquired through the Lillian P. Bliss Bequest, 1949. The Museum of Modern Art, New York.

Chagall's painting re-creates and memorializes the experiences of Jewish people in Russia at the end of the nineteenth century.

the 1940s). VanDerZee's photographs contrast strongly with the two kinds of images of African Americans from that time. The most common were crude racial caricatures of African Americans from postcards, comics, magazines, picture books, and greeting cards. On the other hand, a few photographers depicted African Americans as helpless victims of racism and their situation as a problem to be solved.

In contrast, VanDerZee's African Americans are autonomous, healthy, and self-aware. They were the black middle class, like the women pictured in *Society Ladies* (Fig. 12.4), photographed in 1927. His subjects were intellectuals, merchants, and writers who demanded full participation for blacks in U.S. politics and culture. The furniture and trappings of comfort surround his well-dressed sitters. Their poses convey a variety of emotions, including confidence, humor, directness, and dreamy wistfulness. VanDerZee was influenced by movies of the 1920s and 1930s and encouraged sitters to take poses from the films. At times, VanDerZee provided costumes and props that allowed his sitters to expand their personalities.

CONNECTION Another artist of the Harlem Renaissance, Jacob Lawrence, painted the history of African Americans in the Western Hemisphere. For more, see *No. 36, During the Truce Toussaint . . .* (Fig. 10.14).

Art That Criticizes Racism

Unflattering images of African Americans have been common in popular culture over the past 150 years—for example, the pickaninny, Little Black Sambo, and Uncle Tom. Another is Aunt Jemima, a domestic servant whose title of "aunt" was a commonly used term for African American domestic servants, nannies, and maids. Aunt Jemima is a caricatured jolly, fat woman who has been used for years to sell commercially prepared pancake mix. In the 1972 mixed-media piece *The Liberation of Aunt Jemima*

12.4 JAMES VANDERZEE. *Society Ladies*, United States, 1927. Black-and-white photograph.

Art can promote the status and create a positive perception of a racial group. In this case, the portraits show the confident, affluent people of the Harlem Renaissance in the United States.

(Fig. 12.5), Betye Saar uses three versions of Aunt Jemima to question and turn around such images. The oldest version is the small image at the center, in which a cartooned Jemima hitches up a squalling child on her hip. In the background, the modern version shows a thinner Jemima with lighter skin, deemphasizing her Negroid features. The older one makes Jemima a caricature, while the new one implies she is more attractive if she appears less black. Look for Aunt Jemima's pancake mix in the supermarket or online, and compare the latest image of her on the package with Saar's images.

The middle Jemima is the largest figure and the most emphasized. Her patterned clothing is very bright and colorful. Her black skin makes her white eyes and teeth look like dots and checks, too. This Jemima holds a rifle and pistol as well as a broom. A black-power fist makes a strong silhouette shape in front of all the figures, introducing militant power to the image. The idea of Aunt Jemima,

12.5 Betye Saar. *The Liberation of Aunt Jemima*, United States, 1972. Mixed media, 11¾″ × 8″ × 2¾″. Purchased with the aid of National Endowment for the Arts funds. University Art Museum, University of California, Berkeley.

This work illustrates, and therefore protests, the ways that African Americans were often depicted in folk art and in commercial imagery.

in any of its forms, can no longer seem innocuous. Saar enshrined these images in a shallow glass display box to make them venerable. Symmetry and pattern are strong visual elements.

In *The Artifact Piece* (Fig. 12.6), performed in 1986, Native American artist James Luna challenged the way contemporary American culture and museums have presented his race as essentially extinct and vanished. In this performance piece, Luna "installed" himself in an exhibition case in the San Diego Museum of Man in a section on the Kumeyaay Indians, who once inhabited San Diego County. All around were other exhibition areas with mannequins and props showing the long-lost Kumeyaay way of life. Among them, Luna posed himself, living and breathing, dressed only in a leather cloth. Various personal items were displayed in a glass case, including contemporary ritual objects used currently on the La Jolla reservation where Luna lives, recordings by the Rolling Stones and Jimi Hendrix, shoes, political buttons, and other cultural artifacts. Around Luna were labels pointing out his scars from wounds suffered when drunk and fighting. The mixture of elements revealed a living culture.

In this striking piece, Luna challenged the viewer to reconsider what museums teach about cultures and what constitutes a cultural artifact. Museum artifacts may be simply the things that, by chance, happened to survive. In other cases, some objects are kept, whereas others are ignored or destroyed. Thus, we learn less about Native American cultures than we learn about the current culture's ideas about Native American cultures. In addition, museums and museum visitors often discount living cultures of today and are interested only in preconceived ideas of "cultural purity." "Authentic Indians" are those who are long dead. Native Americans who are alive today are less interesting to museums because they are cultural mixtures who may wear athletic shoes rather than moccasins. Luna sees himself in a new way. Although he still considers himself a warrior, he is a new one who uses art and the legal system to fight for Native Americans. In *The Artifact Piece*, Luna also touches on the effects of alcohol on Native Americans.

12.6 JAMES LUNA. *The Artifact Piece*, United States, 1986. Installation/performance at the Museum of Man, San Diego.

The purpose of art is often to make simple stereotypes more nuanced and accurate. Luna's work is intended to debunk a simplistic image of Native Americans.

Who Is Looking at Whom?

In the United States, hundreds of images are produced every day dealing with other cultures, so we develop ideas about foreign or ethnic groups from the mass-media images we consume. But who makes those images of others, and why? Are the viewers in a privileged position because they "consume" the images of others without directly interacting with them? Chapter 6 covered the gaze in reference to sexuality. Now we return to it to see how art can both reflect and undermine racial relationships in the world.

Look back to *Society Ladies* (Fig. 12.4) and *The Artifact Piece* (Fig. 12.6). In both, viewers are made self-conscious about looking rather than being able to enjoy what is viewed from an isolated, privileged position. In *Society Ladies,* the older woman gazes out with an appraising look, which makes the viewers aware of their own gaze. This kind of frank return of the gaze also marks the work of Frida Kahlo (see Fig. 11.11), whose work affirms and identifies with indigenous people in Mexico, especially the underclass. In *The Artifact Piece,* the sheer presence of a living being in a museum display interrupts the viewers' un-self-conscious gaze and their consumption of easy, stereotypical ideas about a long-ago culture.

In his 1989 video installation *Buddha Duchamp Beuys* (Figure 12.7), Nam June Paik takes on the gaze in relation to East and West. The title, the Buddha statue, and the television reference various parts of the world and the consumption of culture through media, without direct contact. This seems to reinforce the detached, privileged viewer, but what is interesting here is that this viewer lives in cultures other than Western industrialized nations, undermining Western domination. In addition, Paik's artworks generally emphasize collaboration, humor, and the new world models coming from cultural interaction. In this work, Paik makes references to both Joseph Beuys and Marcel Duchamps

12.7 NAM JUNE PAIK. *Buddha Duchamp Beuys*, 1989. Video installation with Buddha sculpture, as seen at the September 2010 exhibition at the Kunst Palast Museum in Düsseldorf, Germany.

Paik's work brings together opposites, sometimes humorously, in ways that suggest new potentials for cultural interaction.

12.8 *Painting from a Cult House*, Slei, Middle Sepik Region, Papua New Guinea, c. twentieth century. Palm leaves on a bamboo frame, painted with earth pigments; 3′ 8″ × 5′ 1½″. Museum der Kulturen, Basel, Switzerland.

Within the Sepik culture, art is used along with rituals to pass male power on to the next generation.

(see Fig. 2.26), two artists whose works strongly influenced the direction of twentieth-century Western art. So Paik turns around cultural dominance and replaces it with a potentially confusing but also open playing field of cultures meeting cultures. The video camera loops images, suggesting that we are only meeting ourselves.

GENDER ISSUES

Every culture sets up standards that define and limit acceptable behavior for women and for men. Artwork from different eras and cultures often gives us clues about those social restrictions and, in some cases, is actually part of making them.

Art and Ritual Perpetuating Gender Roles

In the early twentieth century, before the disruption of foreign influences, men dominated women among the Sepik people of Papua New Guinea, and art and rituals reinforced and dramatized this relationship. Sepik art also made men powerful in war.

The rituals, called *Tambaran*, took place in large, decorated cult houses. Men saw their rituals as creating men from infants, usurping women's procreative

power. Unlike the Western notion that an individual exists from birth, many South Pacific peoples believed that a person's very being was built through a lifetime of ritual experiences. Men invested their vigor into the paintings and carvings that hung in the cult house, in order to pass their spirits on to younger men at lower stages of initiation. *Painting from a Cult House* (Fig. 12.8), at Slei, is an artwork associated with Tambaran rituals from the early twentieth century. The curvilinear designs create multiple faces, with gaping, tooth-filled mouths, large noses, and numerous eyes. Faces can be read stacked or superimposed on each other. The curves and spirals fill the triangular shape of the painting—cramped and small at the edges, swelling into large, aggressive forms in the middle. The colors—black, red, and off-white—are bold, with high contrast from dark to light. Major forms, such as mouths and eyes, are outlined repeatedly in alternating black and white lines, resulting in vibrating patterns that express the idea of fearsome vigor.

Gender Reflected in Art and Architecture

Gender roles are often revealed in art and are reflected in architecture and fashion. Our focus figure, *Abduction of*

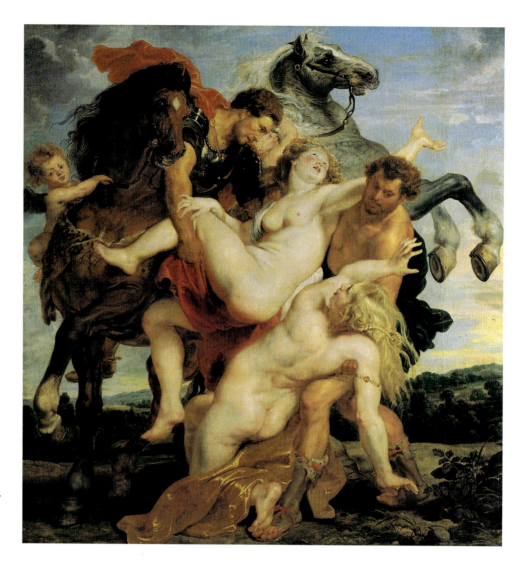

12.9 PETER PAUL RUBENS. *Abduction of the Daughters of Leucippus*, Flanders, 1617. Oil on canvas, 7′ 3″ × 6′ 10″. Alte Pinakothek, Munich, Germany.

Rubens' painting reflects his culture's ideals about femininity and masculinity.

the Daughters of Leucippus (Fig. 12.9), painted by Peter Paul Rubens in 1617, is another example of European painting dealing with sexual exotica, like the *Grande Odalisque*, which we saw in Figure 6.20. The scene comes from Greek mythology. Castor and Pollux, twin sons of Zeus, capture a philosopher's two daughters as they were out horseback riding. Aided by Cupids, the two immortals lower the women, who resist with dramatic but ineffective, fluttering gestures. Interestingly, this painting is also commonly referred to as *Rape of the Daughters of Leucippus*, as an old meaning of *rape* was "the carrying away of someone by force."

Blue skies, shimmering cloth, and a variety of textures add to the rich surface and the sensual color harmonies. The composition places all figures in a compact diamond shape, which suggests movement because of its instability. On the left, dark tones act as a foil to the lighter areas in the center. Various textures, such as armor, satin, flesh, and hair, are all expertly painted.

The painting indicates what was considered masculine and feminine during that era. All figures represent ideal body types. The women's voluptuous, soft fleshiness was considered sexually attractive and a sign of health and wealth. Outdoor activity was appropriate for the darker-skinned, muscular men versus the pale women who occupied the domestic interiors. The painting also represents current ideas of gender behavior. Men had privilege over women's bodies. Women learned to be helpless, and they relied on social structures to protect their virtue. The expressions of the men are subdued and determined, while the women are much more emotional. The men are at least partially clothed—one is in armor—while the women are unclothed and displayed. Western art history has numerous examples of the female nude providing pleasure for male viewers, legitimized because it was "art."

All kinds of trappings can serve as indicators of masculinity or femininity. In *Oath of the Horatii* (Fig. 12.10), painted in 1784, Jacques-Louis David represents a scene

12.10 JACQUES-LOUIS DAVID. *Oath of the Horatii*, France, 1784. Oil on canvas, 10′ 10″ × 14′. Louvre, Paris.

While this painting illustrates an event from Roman history, it also shows the kinds of behavior that reflected femininity and masculinity in eighteenth-century France. The Neoclassical architecture was associated with masculinity and revolution.

from the early history of ancient Rome, in which three brothers vow to represent the Roman army in a fight to the death against three representatives of an opposing army. Their father hands them their swords, reminding them of the manly virtues of courage and patriotism, while their sisters and wives swoon at the right, in dread and sorrow at the anticipated killing (one of the sisters was to marry a representative of the opposing army). Heroic actions are a mark of masculinity, reinforced by the women's passivity. In a moment of male bonding, forged in the face of danger, the three brothers become a single force, a part of each other, and each is willing to die for the others and for an external cause.

There are other gender indicators. The male dress is rendered in angular lines that contrast with the soft curves of the female attire. The men hold weapons as their job is war, while women's jobs are concerned with children.

The architecture's symmetry and the composition's over-all balance suggest the orderliness of this world. The images both reflect the "reality" of gender roles and create that "reality." They spring to some extent from existing social conditions, but they also entrench those conditions and make them seem natural, not just social conventions.

In this painting, one indicator of masculinity is the background of classical architecture, which was popular during the French Revolutionary era when this painting was executed. The use of classical elements in art and architecture at this time formed a style called **Neoclassicism**, which was a revival of Greek and Roman aesthetics after the ruins of Pompeii were discovered. Also at this time, French citizens were about to overthrow the oppressive, parasitic French monarchy and aristocracy. The nobility favored decorative architecture called **Rococo**, such as that seen in the *Hall of Mirrors* at the Amalienburg hunting lodge in Munich,

12.11 FRANÇOIS DE CUVILLIÈS. *Hall of Mirrors*, Amalienburg Hunting Lodge, Germany, 1734–1739. Nymphenburg Park, Munich, Germany.

The Rococo architectural style was associated with the aristocracy and also thought to have feminine qualities.

Germany (Fig. 12.11), dated 1734–1739, by François de Cuvilliès. Rococo architecture was seen as feminine, with its emphasis on delicate, curving, colorful decoration. Square walls and ceilings dissolve in curves, and these curves dissolve under the abundance of nature-based decoration and the reflecting mirrors, crystal, and silver. The ceiling appears to be an open sky, with birds flying from branch to branch of gold-leafed stucco trees. All elements—the architectural shell; the precious materials; the detailed, graceful decorations—contribute to the entire exquisite effect. The members of the French middle class, on the verge of revolt, chose the clean, simple, austere, Roman-inspired architecture that we see in the background of *Oath of the Horatii* to distinguish themselves from the aristocracy and to serve as an appropriate symbol for their ideas.

Indeed, in Western culture, architecture is gendered; that is, different styles come to be associated with certain qualities, and those qualities in turn are associated with masculinity or femininity. This goes back at least as far as the ancient Greeks, who saw the Doric Order as masculine and the Ionic as feminine. Although the architecture behind the *Horatii* was considered manly, while the *Hall of Mirrors* was considered feminine and elegant, nothing inherent in these styles requires them to be understood in this way. In another situation, the *Horatii* background might be seen as bare and oppressive and the *Hall of Mirrors* considered uplifting and stirring to the imagination. The gendered associations of Western architectural styles continue, as writers commonly associate the modern, bare, high-rise skyscrapers of the late 1960s and 1970s with masculinity.

CONNECTION The Doric and Ionic Orders are illustrated in Figure 2.37. *The Swing* (Fig. 12.25) is a **ROCOCO** painting by Jean-Honoré Fragonard and reflects the same sensibilities as the *Hall of Mirrors*.

Critiquing Gender Roles

Gender roles are often widely accepted and seem quite natural within a culture at any one time, but when there are deep political or social changes, the roles can become very controversial.

People change their bodies to enhance their femininity or masculinity, usually by dieting, plastic surgery, implants, scarification, and various bindings that mold body parts. In her work, artist Hung Liu has examined foot binding, practiced in China from the Song Dynasty (960–1279) until the beginning of the twentieth century. Many Chinese women's feet were bound from birth to artificially confine their growth, distorting them into small, twisted fists that were sexually attractive to men. With bound feet, walking was extremely difficult, but the mincing steps were considered delicate and lovely. Bound feet left women handicapped, which also ensured that they remained subservient. When imperial rule ended in China and the Communist government came to power and mandated physical labor for all able-bodied people, many foot-bound women resorted to prostitution.

Liu ties oppressive gender practices to broader political repression. In *Trauma* (Fig. 12.12), dated 1989, the woman at the center publicly shows her bound feet. Although bound feet were considered erotic in private, public exposure was a shameful act. Below her is an image of a dead Chinese student, killed by Chinese government forces when they violently crushed the demonstrations for freedom in 1989 in Tiananmen Square. Liu sees the killings in Tiananmen Square as a shameful event for China. Behind the woman's head, the outline map of China is upside down, whereas its reflection below, cut out of red felt, becomes a bloodstain on the floor below the student. The bowl on the floor is a vessel often emptied and filled—but never in exactly the same way. Poetically, the empty bowl represents China and the artist herself, emptied and then refilled by the cycles of history. Because of their long history, the Chinese commonly make associations between contemporary events and events of the distant past, a habit of thought that is evident in Liu's work.

The next work, the Guerrilla Girls' *Do women have to be naked to get into the Met. Museum?* (Fig. 12.1), seeks to correct a specific kind of gender discrimination. In 1986, when the poster was made, high-profile art exhibitions in prestigious museums often included very few women artists. In other words, a naked woman painted by a man might be shown in a museum, but a painting by a woman artist was not likely to be. On the poster, the woman's body is that of the *Grande Odalisque* (see Fig. 6.20 in Chapter 6, Reproduction and Sexuality), whose aesthetically pleasing

12.12 HUNG LIU. *Trauma*, China/United States, 1989. Ink on plywood cutouts, acrylic on wall, felt cutout, and wooden bowl, 9′ × 4′ 4″ × 2′ 2″.

Foot binding, a tradition from Imperial China, is here associated with a massacre of student protestors that happened in 1989 in Beijing.

elongated torso reclines on cushions, on display for male viewers to enjoy and "consume." However, her head has been obscured by a gorilla mask, like those the Guerrilla Girls wear in public appearances to maintain their anonymity and to liken themselves to revolutionary guerrillas who seek to overthrow a dominant power.

The Guerrilla Girls is a collective of anonymous women artists and arts professionals whose mass-produced, inexpensive posters feature text, image, and humor combined with strong graphics. They protest the fewer exhibitions, fewer jobs, and lower pay for women artists and the underexposure of their work. The masked Guerrilla Girls show up at galleries and museums hosting high-profile art events where women are underrepresented. The purpose of their work is to cause exposure, embarrassment, and, eventually, change.

Later Guerrilla Girls posters have been concerned with racial imbalances in the art world.

ART EXPERIENCE Make an artwork about contemporary gender roles.

CLAN

A clan is a group of people joined by blood or marriage ties. It could be as small as two people or extend to groups of families who share a common ancestor and recognize one member as leader.

The Extended Family

Art helps solidify extended families in three ways: (1) art makes major ancestors available to the living clan members, (2) art depicts important events in the clan's history, and (3) art is an important element in rituals that bring the entire clan together.

Ancestors

For many, the founding members of a clan have a major impact on the prestige of the living people and on their ability to function with power and authority. Our focus figure is from ancient Rome, whose people believed their ancestry was tremendously important. They preserved portraits of their ancestors and venerated their memory as a way of establishing their own importance as they went about the business of living. At first, these ancestor portraits were simply death masks, made by pressing soft wax on the face of a deceased family member shortly after death. However, the wax masks deteriorated after a few years and looked like death, with sagging tissue and sunken eyes. Around the first century BCE, affluent Romans began having copies of the death masks made in marble for permanence, and so the face could be sculpted to appear energetic or even monumental.

The *Statue of Togato Barberini* (Fig. 12.13) is an excellent example of Roman portrait sculpture made to worship an ancestor and to glorify the lineage. Here, Togato Barberini is holding portrait busts that boast of his lineage. All three faces are factual, unflattering records of appearance. Personality also comes through in the expressions. Ancestor portraits were treated with respect and were frequently copied for various family members; having a unique art object was not important. For large sculptures like this, the portraits were individually made and often were inserted into mass-produced and standardized marble bodies, echoing the process for making the *Soldiers*

12.13 *Statue of Togato Barberini*, Rome, early first century CE. Marble, 5′ 5″ high. Palazzo Barberini, Rome.

Genealogy was important to the ancient Romans, and people of rank were expected to display busts of their ancestors.

from Pit I (Fig. 8.10), from the ceramic army of the First Emperor of Qin. Prominent Romans kept sculptures and busts in a shrine in the family home and brought them out at funerals and family ceremonies as status symbols.

Compare the Roman busts with the *Portrait Heads from Tomb 6* (Fig. 12.14). Among the Zapotec people of Oaxaca in southern Mexico, ancestors were so important that the living interred the dead in tomb chambers under their houses and consulted them on pressing problems. By displaying their ancestors' leg bones, the rulers ensured their right to rule. These underground tombs were lavishly decorated, houselike crypts, with sculpture and painting to make ancestors available to the living. Tombs were reopened when a clan leader died, and

12.14 *Portrait Heads from Tomb 6*, Lambityeco, Oaxaca, Mexico, 640–755. Stucco, each head 10½″ × 11½″.

Ancestors provided legitimacy for rulers in this ancient culture and were consulted on difficult matters.

important rituals were held there to transfer that leader's power, wealth, and energy to the living. Figure 12.14 shows two *Portrait Heads* from a tomb in the town of Lambityeco, in Oaxaca. They are life-size heads sculpted in stucco that date from 640 to 755. The heads seem very lively and create a strong presence. The male head, on the left, has a goatee, a beaded necklace, and earrings, and his hair is pulled up and tied in a bun above his forehead. Lines through his eyebrows and below his eyes are ancient symbols or glyphs that identify him. The wife's head, to the right, is lined with age. Her hair is styled with ribbons very much like that of Zapotec women today. The faces have individualized features and are definitely portraits.

They likely represent the founding parents of a clan. Both were important, as lineage was traced through the male and female sides. These portrait heads are located on the lintel above the tomb entrance and may represent the first ones buried within.

CONNECTION Among the present-day Zapotec, belief in the power of the dead continues. They celebrate *Día de Los Muertos*, as in Diego Rivera's painting (Fig. 8.25).

Clan History

Art is also instrumental in preserving clan history, which helps ensure clan cohesion and thus increases a clan's power.

The *Interior House Post* (Fig. 12.15), dated c. 1907, is our focus figure for this section. It was one of four posts carved by Arthur Shaughnessy for the Raven House of the John Scow clan of the Northwest Coast of North America. The Raven House was a lineage house; such structures were built when a new lineage was being founded because of death or marriage. When first opened, these houses were used for festivities when the new leader assumed his ceremonial name. Guests would be invited to several-day celebrations called potlatches, with elaborate singing and masquerades. Later, the interior was subdivided to create living quarters for several clan families.

The carvings in lineage houses were visual aids that accompanied the telling of clan legends and history and were concentrated in significant areas—specifically, around doorways, on interior posts, and on exterior totem poles. The intention of the Northwest Coast artist is not to invent new forms but to re-create old ones invested with new life and energy. The carvings might represent specific ancestors (like animals in European family crests) or important deities or humans in animal form. House posts

12.15 ARTHUR SHAUGHNESSY. *Interior House Post*, Kwakiutl, Gilford Island, British Columbia, Canada, c. 1907. Carved and painted red cedar, 15′ × 11′ × 2′ 10″. Seattle Art Museum.

Art is a vehicle for clan cohesion. Sculptures like these were featured in lineage houses and were prominent in ritual feasts when the leadership of the clan changed.

both physically support the house and symbolically represent the spiritual and mythical foundation of the clan. The top of our *Interior House Post* has a mythical thunderbird with imposing, spread wings, representing a chief. Its powerful curved beak and curved ears suggest supernatural powers. Extra eyes are placed on the wings and torso, again to imply power. The feathers are examples of formline design, typical of much Northwest Coast art. The formline (Fig. 12.16) divides and merges, creating a continuous flowing grid that beautifully unifies the overall decoration. The ovoid is always convex on its upper side, while the lower side is slightly concave; the shape possibly was inspired by the elliptical spots on a ray fish. We also see two examples of the "U form" (Holm 1995:29, 37–41). Black emphasizes the major shapes, while red, white, green, and yellow are added for brightness and high contrast. For this *Interior House Post*, Shaughnessy used newly available commercial paint for brighter colors. Older works were painted with natural pigments, so their color is less saturated.

The figure below the thunderbird is a bear, a common figure on family crests, often associated with an elder or a high-ranking person. It has bared teeth, an upturned nose with circular nostrils, and compact arms and legs. Bodies were usually compressed, but heads were oversized, often one-third the total figure. Essential features were emphasized in a highly stylized manner, whereas less important features were understated or even omitted. In this example, the bear's claws are given prominence—an extra face is painted on each paw—while the torso is generalized, without musculature or surface detail. The claws and muzzle were separate pieces added to the trunk, again increasing the dynamism of the carving.

CONNECTION For more on Northwest Coast rituals, see *Halibut Feast Dish* by Stan Wamiss (Fig. 5.20).

Art Used in Clan Rituals

Clan ties are strengthened through rituals, and art is often an essential part of those rituals. Among the Asmat people of Papua New Guinea, the living engaged in elaborate rituals to pass on the life force of the deceased clansmen to the rest of the group. They carved and erected tall poles from wild nutmeg trees called *Bis* or *Bisj Poles* (Fig. 12.17), which

A.

B.

C.

12.16, *above* Examples of formline design in Northwest Coast art: (A) ovoid form; (B) typical U complex with semiangular curves; (C) split U with outline (after diagrams by Bill Holm).

This diagram illustrates the kinds of outlines that are basic to the design of Pacific Northwest art.

12.17, *right* *Bisj Pole*, Asmat, Papua New Guinea, mid-twentieth century. Wood, paint, fiber, 17′ 8″ × 3′ 3″ × 5′ 3″. Metropolitan Museum of Art, New York.

Large sculptures such as these are associated with rituals that enhance male power and fertility.

could reach up to 25 feet high. These pole sculptures were named to represent deceased clansmen, now called ancestors. The large openwork projections on the top figures are phalluses, representing power in warfare and in fertility. The height and intricate carving make the poles impressive. The negative and positive shapes and grim faces speak of bristling warlike energy. Sometimes poles were painted in high-contrast colors. As recently as the 1950s, the Asmat were headhunters, and part of their rituals involved avenging a clansman's death, as they believed that death is not natural but caused by enemy warfare or magic. After the men carved and painted the Bisj Poles, the ritual feast prepared them for actual headhunting. Warriors stood before the poles and bragged about their power and received the strength of the ancestors for success in headhunting. These rituals were also tied to fertility, as successful warriors were rewarded with sexual favors. After the rituals, the poles were traditionally left to rot in groves of sago palms, where they would pass their vitality on to the plants that provide a staple food for the Asmat. The headhunting practice ended in 1970; however, the carving of the Bisj Poles is still an important part of Asmat rituals today.

Art, ritual, and clan identity are intertwined among the Yoruba people of west-central Africa. The Epa Festival is held every other year for three days in March to promote fertility and the well-being of the community. The *Epa Headdress Called "Orangun"* (Fig. 12.18), sculpted by Bamgboye of Odo-Owa, was

12.18 BAMGBOYE OF ODO-OWA. *Epa Headdress Called "Orangun,"* Yoruba, Erinmope, Nigeria, 1974. Wood and paint.

The *Epa Headdress* contains an image of the founder of the clan and is used in rituals to promote fertility and the well-being of the community.

used in masquerades to honor the family. The base of an Epa headdress is a helmet that fits on top of the performer's head, and it is carved with grotesque Janus-like faces, front and back. Above the helmet is a large structure with an equestrian figure, the nomad warrior chief who founded several towns. Other characters represent important members of the household. Although such masks weigh more than fifty pounds, young dancers would perform athletically in them.

12.19 MARISOL. *The Family*, Venezuela, 1962. Painted wood and other materials in three sections, overall 6′ 10″ × 5′ 5½″ × 1′ 3½″. The Museum of Modern Art, New York.

The relationships among members of a nuclear family are investigated in this sculpture.

The Nuclear Family

In highly industrialized societies, where individuals have great mobility, the extended family has lost much of its strength, and the clan has dwindled to the nuclear family. These artworks about the nuclear family do not emphasize unifying rituals or shared ancestors, in contrast to the art for large clans that we have just seen. Rather, artists examine the nuclear family to find its strengths, its changes, and its points of tension.

Our focus figure, *The Family* (Fig. 12.19), dated 1962, by Marisol, presents us with a mother and her children arranged as if sitting for a photographer. Feelings of both mutual affection and personal awkwardness emanate from the three older children as they present themselves to the world as family members and as individuals. The mother in the center is dignified, solid, and thoughtful—but

12.20 Elizabeth Murray. *Sail Baby*, United States, 1983. Oil on three canvases, 10′ 6″ × 11′ 3″. Walker Art Center, Minneapolis, Minnesota.

The formal elements of this painting allude in an abstract way to bouncy, energetic children.

not elegant. She links all the figures and elements. The doors and decoration behind suggest the domestic setting, but they seem generally poor. Marisol's figures are blocks of wood, drawn on and minimally carved, each maintaining its own separateness while interlocking with the group. The shoes and doors are real, found objects that Marisol incorporated into her work. *The Family* contrasts with the uniformity and affluence of the nuclear family as it was commonly presented on U.S. television in 1962, with shows like *Leave It to Beaver*.

Compare the literal representation of Marisol's *The Family* with *Sail Baby* (Fig. 12.20), dated 1983, by Elizabeth Murray, which is an abstract painting about family life. Three rounded canvases suggest the bouncy energetic bodies of infants or children. The bright colors recall the palette of childhood. The yellow shape becomes a cup, referring to the role of parents, the domestic sphere, and feeding. The grouping of the three shapes suggests the closeness of siblings, all with similarities and, at the same time, each a unique individual. The ribbon of green reflects their relatedness and the intimacy of their lives. The artist in fact has said that this painting is about her own siblings and her children. Other of her abstract paintings refer to different family relationships, such as mother-daughter and husband-wife.

As the twentieth century drew to a close, the definition of family had been expanded. *Baby Makes 3* (Fig. 12.21), from the late 1980s, is by General Idea, a Canadian collective of

12.21 General Idea. *Baby Makes 3*, Canada, 1984–1989. Lacquer on vinyl, 6′ 6¾″ × 5′ 3″.

The nuclear family is reconfigured in this artwork.

three artists, A. A. Bronson, Felix Partz, and Jorge Zontal, who had been working together since 1968. General Idea presented a homosexual approach to the nuclear family, showing three men in bed in the clouds, looking tranquil and impish. The work both pokes fun at the idea of the happy nuclear family and also shows how gays and lesbians re-create such family and social structures. *Baby Makes 3* also alludes to recent discoveries in science that suggest methods other than heterosexual reproduction to generate a biological family. The image appeared on the cover of *File*, which was General Idea's parody of *Life* magazine. General Idea critiqued many aspects of popular culture that so heavily promote the heterosexual nuclear family. They created their own versions of TV dinners, postage stamps, boutique items, videos with commercials, and so on.

CLASS

A group of people sharing the same economic, social, or ruling status comprises a class. Class boundaries are rigid in some cultures, whereas, in others, people can easily move up or down the social ladder. Class becomes like a very large extended family, where individuals often find their identity and their social circle.

Art and class structure can be linked in several ways: (1) members of different classes may be depicted with distinctive body styles and poses; (2) artwork can show the environment, accoutrements, and activities that mark members of a certain class; and (3) a work of art can be a status item, the possession of which indicates the class of the owner.

Class Status and Body Styles

Our focus figure is from ancient Egypt, where the human body was sculpted in different ways, depending on the person's class. Upper classes, consisting of the pharaoh and his family, the nobility, and the priests, were depicted in formal, highly standardized ways that indicated immediately their importance in the social hierarchy. The four gigantic statues at the *Temple of Ramses II* at Abu Simbel (Fig. 12.22), dated c. 1275–1225 BCE, are examples of

12.22 *Temple of Ramses II*, 19th Dynasty, Abu Simbel, Egypt (now relocated), c. 1275–1225 BCE. Each colossal statue is 65′ high.

In ancient Egypt, members of the ruling class were depicted in art in a formal, compact, frontal, idealized way.

official images of the pharaoh. Befitting his semidivine status, he is enormous. The repetition of the image reinforces the idea of his imposing grandeur and divinity. Another eight standing statues of Ramses II are just inside the doorway, each standardized, each 32 feet high. The seated pose is frontal, composed, and symmetrical, according to the Egyptian aesthetic, with few breakable parts. The expressionless face and staring eyes look outward in timeless serenity. The body of Ramses II is well developed and flawless, frozen forever in idealized, youthful prime. Smaller figures at Ramses' knees and feet are members of his family, their smaller size indicative of their lesser rank. Enormous projects of this kind were very costly and demanded the skills of the best carvers, reinforcing the status of the very highest classes.

The colossal statues of Ramses II were intended to be permanent memorials to him, as befitting his rank. In 1968, the statues were moved to higher ground and affixed to artificial cliffs to avoid their being submerged in the back pools of the new Aswan Dam. Their permanence remains.

By contrast, the *Seated Scribe* (Fig. 12.23), dated c. 2500–2400 BCE, is a portrait of an Egyptian court official of much lesser rank than the pharaoh. The sculpture is limestone, a relatively soft, inexpensive stone considered to have an unattractive finish, so the work was painted. The result is more lifelike and thus less eternal and permanent than the monumental stone image of Ramses II at Abu Simbel. As befitting those of a lower class, there is much less formality and idealization in the portrait of the scribe. His pose is more relaxed, and the figure is cut away from all backing stone. His face is expressive and personalized rather than eternally calm and divine. He seems intelligent, alert, and aware. His body shows the effects of age, with sagging chest muscles and a potbelly, attributes that would be considered disrespectful in a portrait of a pharaoh.

CONNECTION The Egyptians were not the only people to create idealized images of their leaders. See the images of rulers in Chapter 9, such as *Emperor Justinian and His Attendants* (Fig. 9.4).

Class Activities and Lifestyles

Art records not only the lifestyles of the rich and famous but also the more mundane existence of the lower classes. We will look at a cross-cultural selection of images that reflect class activities and class lifestyles. It is important to remember that the great majority of these images are made by the ruling class or the middle class, often of themselves and of classes below them.

The Ruling Class

In many cultures, art is used to define people of high rank. In Europe in the last millennium, portraits were often records of those in high positions, as only the wealthy could afford to commission or own an oil painting.

Our focus figure is *Las Meninas* (Fig. 12.24), painted by Diego Velazquez in 1656. The title means "Maids of Honor," which by itself marks the upper class. At the center of the composition is the blond Infanta Margarita, the daughter of King Philip IV and Queen Mariana of Spain, the focus of considerable attention and energy. She is shown almost casually in the painter's studio. This informal image was meant not for public display but for the king's private office. Although the Infanta is not painted in a throne room or with a crown, we can understand her exalted position through many elements in the painting. Her location at the center of the picture, the light that floods her, and her glowing white dress all mark her as the most important figure.

12.23 *Seated Scribe*, 5th Dynasty, from a mastaba tomb at Saqqara, Egypt, c. 2500–2400 BCE. Painted limestone, approx. 1′ 9″ high. Louvre, Paris.

Members of the Egyptian lower classes were depicted more naturally than were the members of the ruling class.

12.24 Diego Velazquez. *Las Meninas,* Spain, 1656. Oil on canvas, approx. 10′ 5″ × 9′. Museo Nacional del Prado, Madrid.

This painting depicts the family of the Spanish monarch. In addition, because the painting is a large and costly item, possessing it is another indicator of status.

As the presence of servants is also a sign of rank, she is attended by two young ladies in waiting, two dwarfs, and two adult chaperones, male and female, in the shadowy right background. Her royal parents are reflected in the mirror against the back wall; presumably, they are standing where the viewer of the painting would be.

The space of the painting is majestic: light floods the foreground; the room is grand; the deep space extends back in the distance. The space is also made complex by mirrors. One we see, but the other we cannot, although its presence is implied by the fact that Velazquez peers outward, presumably into a mirror, to paint himself. Velazquez is the standing figure at the left of the painting, working on a large canvas, perhaps this very picture.

Size is important. This painting is 10½ feet by 9 feet. A physical object this large is a sign of rank and a mark of distinction, as is owning, possessing, or commissioning such an artwork. Diego Velazquez was a celebrated and famous artist. His prestige is an important addition to the royal commissions.

Sometimes class was indicated by its members' activities. *The Swing* (Fig. 12.25), painted by Jean-Honoré Fragonard in 1766, shows the frivolous sexual escapades

12.25 JEAN-HONORÉ FRAGONARD. *The Swing*, France, 1766. Oil on canvas, 2′ 11″ × 2′ 8″. Wallace Collection, London.

In a pre–French Revolution painting, the upper class is engaged in frivolity.

of the members of the French aristocratic class in the mid-eighteenth century. During that period, they enjoyed tremendous wealth and privilege and had few responsibilities, as most of their power had been assimilated by the French king and most of their duties assumed by an ever-growing middle class. They were effectively transformed into a leisure class, with little to do but become embroiled in their own intrigues.

In *The Swing*, a young, aristocratic woman enjoys a moment of swinging, assisted by the bishop in the shadows who pulls the ropes. Hidden among the bushes in the lower left is a young nobleman, enjoying a peek up the woman's skirt as she playfully kicks off her pink shoe at a statue of Cupid. All details speak of the wealth and the lack of purpose of the aristocracy: the lush parks of their beautiful estates sprinkled with statuary, their rich clothing, the complete frivolity of their days' activities, and their interest in sexual intrigues. Fragonard's rich colors, delicate details, and sensual textures lend sweetness to the scene as well as a sense of fragility. In fact, the aristocratic class was shortly to be brutally eliminated by the French Revolution, which began in 1789 (see *History Focus*, page 343).

Dress and other paraphernalia are often a sign of rank, as already illustrated with the *Rank Badge with Peacock* (Fig. 12.2) and as seen in the attire of nobility above. (Members of the military and even the Boy or Girl Scouts today dress to show rank. Priests of most religions also dress distinctively to show their status.) Here, we will focus on one example, the *Great Beaded Crown of the Orangun-Ila* (Fig. 12.26),

12.26 BEADWORKERS OF THE ADESINA FAMILY OF EFON-ALAYE. *Great Beaded Crown of the Orangun-Ila*, Yoruba, Ila Orangun, Nigeria, twentieth century.

Rulers in many cultures are often distinguished by crowns and elaborate dress.

from the Yoruba people of Nigeria. The image shows not only the crown but also the robe and staff that are signs of rank. Crowns such as this one are worn by high-ranking territorial chiefs and are similar to the headgear worn by priests and the supreme ruler. Rank is made apparent through dress in a number of ways: (1) the shape of the clothing or headgear, (2) the materials used, and (3) the meaning of the decorative symbols. The conical shape of the crown is a highly significant Yoruba symbol. It represents the inner self, which, in the case of those of rank, is connected with the spirit world. The cone shape is repeated in the umbrella that protects the chief from the sun and in the peaked-roofed verandas where he sits while functioning as the ruler.

According to Michael Roth, a noted collector of African art, beads have been used in Yoruba crowns at least since the 1550s and likely even earlier, and they have two important functions: to protect the identity of the wearer and to symbolize wisdom. The bead strands are removed when the piece is taken out of use. The birds on the chief's crown and robe represent generative power, closely associated with women's reproductive abilities and the life-giving, stabilizing structure of Yoruba society. The long, white feathers at the top of the crown are from the Okine, called the royal bird by the Yoruba people.

CONNECTION For an example of the conical-shaped crown in Yoruban art, see the *Palace Sculpture* by Olowe of Ise (Fig. 9.15).

The Working Class and Middle Class

In cities, dense populations provide opportunities for commercialization and specialization for merchants, skilled workers, laborers, restaurateurs, entertainers, household workers, and others. This new class was distinct from the nobility and from traditional farm laborers.

We begin our discussion with *The Kitchen Maid* (Fig. 12.27), painted by Jan Vermeer in 1660, showing a maid in a modest home in the Netherlands of the seventeenth century. In this painting, the working class is elevated in dignity. The mundane tasks of pouring milk and arranging bread seem almost sacred. The gentle light bathes, outlines, and gives a strong sense of the physical presence of a humble woman, an image with such simplicity and directness that she almost personifies virtue. Her work seems healthy and life sustaining. The woven basket, the crust of the bread, the earthen jug, and the texture of the wall seem glowing and burnished with age. The color harmonies of cream, gold, and rust are earthen versions of the strong primary colors of red and yellow.

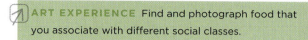

ART EXPERIENCE Find and photograph food that you associate with different social classes.

Vermeer often painted ordinary scenes from everyday life, a category of paintings called **genre painting**. This was part of an overall tendency in the Netherlands of the seventeenth century to emphasize and elevate middle-class domestic life, where music, reading, and culture flourished and basic needs were met. The maid, from an even lower social level, is treated with the same respect. The sphere of women was the home, and *The Kitchen Maid* reflects the ideals of womanhood at that time: virtue, modesty, and hard work. As a country with a strong middle class, the Netherlands focused on the family and family life and on the individual. Portraits were common, as were moralizing genre scenes that criticized such vices as laziness, drunkenness, and lust.

CONNECTION *The Self-Portrait* (Fig. 11.10) by Rembrandt van Rijn reflects the same sense of individual worth and the sacredness of a modest life as does Vermeer's *The Kitchen Maid*.

Compare the quiet of *The Kitchen Maid* with the bustle of our next image. Kaifeng, the longtime capital of China, had 260,000 households in the year 1105. Scenes of its urban culture are recorded in the scroll painting *Spring Festival along the River* (Fig. 12.28), by Zhang Zeduan, from the late eleventh or early twelfth century. A painting this size was undoubtedly commissioned by a member of the aristocracy, so this image represents an upper-class concept of ideal middle-class life, animated with crowded, bustling activity. Details show merchants selling goods in booths, people eating in restaurants, farmers delivering produce, and so on. Friendly neighbors were helpful and involved with each other. For example, onlookers shout advice and gesture from the bridge and banks as boatmen steer their vessel under the Rainbow Bridge. Each small scene is rendered with the same amount of detail and similar color, and the accumulated scenes give a picture of busy, contented, unassuming middle-class life.

A later painting records the increased affluence and leisure of the middle class in Western countries.

12.27 Jan Vermeer Van Delft. *The Kitchen Maid*, Netherlands, 1660. Oil on canvas, approx. 1′ 5″ × 1′ 3″. The Rijksmuseum, Amsterdam.

She is only pouring milk, but this working-class woman appears dignified within a glowing space.

12.28 Zhang Zeduan. *Spring Festival along the River* (detail), China, late eleventh–early twelfth centuries. Handscroll, ink on silk, 10″ × 17′ 3″. The Palace Museum, Beijing.

The wealth of details speaks of the bustle and hard work of the merchant class in China.

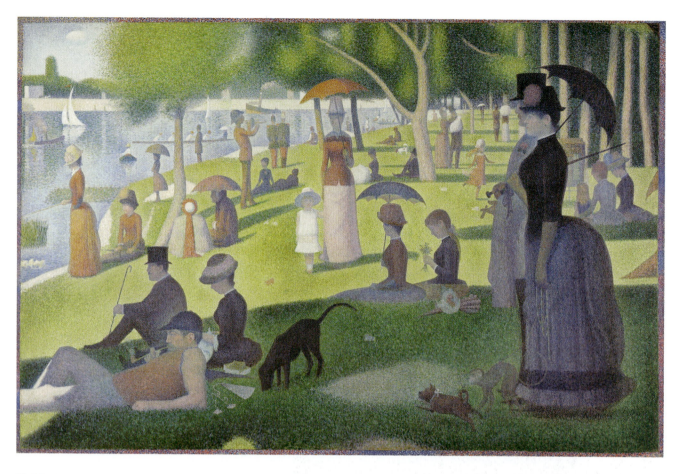

12.29 GEORGES SEURAT. *La Grande Jatte* (also called *A Sunday on La Grande Jatte—1884*), France, 1884–1886. Oil on canvas, approx. 6′ 9″ × 10′. The Art Institute of Chicago.

Art shows that the middle class enjoyed increased leisure time in Europe at the end of the nineteenth century.

Georges Seurat's *La Grande Jatte* (Fig. 12.29), dated 1884–1886, is a park scene. In an era of increasing industrialization, the very creation of parks was the result of the affluent middle class's desire to reintroduce nature into increasingly crowded cities. The painting shows a collection of strangers outdoors on a modern holiday. Unlike villagers attending a local festival, the groups do not know each other. The figures are proper, composed, and orderly. Details of middle-class dress are carefully recorded. Almost all figures are shown rigidly from the side, front, or back. Diagonals are reserved for the left side of the painting and are stopped by the orderly verticals on the right. Shadows mass in the foreground and light in the background.

The painting reflects the growing emphasis on and awareness of science. The woman in the right foreground holds a monkey on a leash, and the similarity between the monkey's curved back and the bustle on her dress shows an awareness of Charles Darwin's theories of evolution and the resulting social Darwinism, which placed women closer on a continuum to the rest of nature than men were placed. Also, Seurat was influenced by the science of color and optics, especially the works of the scientist Eugène Chevreul, as he painted with small dots of intense colors laid side by side in a style called **Pointillism**. Chevreul theorized that contrasting colors applied that way could intensify each other. The dots of bright colors eliminated muddy mixtures, and, in fact, this painting up close is a somewhat dizzying and disorienting mass of small colorful dots. So labor intensive was this process that it took Seurat more than two years to complete the work.

The Poor

Art provides us a record of the poor, their way of life, and their struggles. Art itself, however, is sometimes an upper- or middle-class luxury, so in some cases artworks

represent how the more affluent classes saw the very destitute.

CONNECTION Turn to Chapter 10 for art that protests oppression of lower classes by those in power. Two examples are Kathe Kollwitz's *Outbreak* (Fig. 10.4) and Lewis Hine's *Leo, 48 Inches High* . . . (Fig. 10.12).

Migrant Mother, Nipomo Valley (Fig. 12.30), photographed by Dorothea Lange, shows one of many workers who were starving at a migrant camp Lange visited in 1936. Lange's field notes tell us about the woman: "Camped on the edge of a pea field where the crop had failed in a freeze. The tires had just been sold from under the car to buy food. She was 32 years old with seven children." The woman's face and pose express both strength and desperation. Skin, clothes, and hair show signs of poverty and hard times. Fear and uncertainty permeate the scene, made more acute because we also see the emotional ties of the family and the fear of the children. *Migrant Mother, Nipomo Valley* is an example of documentary photography, which purports to record facts objectively and in a straightforward manner. In reality, we know that this family posed for Lange, that she made several exposures of them, and that she edited her prints for the most effective image. Nevertheless, it is important that we understand the photograph to be factual, whether or not it was staged or manipulated.

Lange was a New York commercial photographer who was hired by California and federal agencies to document migrant farm workers during the Great Depression in the United States. Her photographs were especially effective because she made her subjects so human and so immediate. Her photographs were credited with improving conditions for migrant workers in California. The black-and-white photograph was an especially effective medium to use to express conditions of poverty, to concentrate on the facial expression, and to lend the aura of truth.

CONNECTION Many other U.S. artists took up the cause of the poor or laboring classes throughout the nineteenth and twentieth centuries. Turn to Ester Hernandez's memorable print *Sun Mad* (Fig. 10.17).

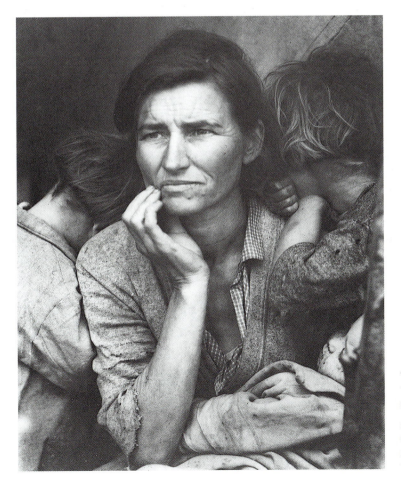

12.30 DOROTHEA LANGE. *Migrant Mother, Nipomo Valley*, United States, 1936. Gelatin silver print. Collections of the Library of Congress.

One of the most famous images of the Great Depression, this photograph appeared originally in a San Francisco newspaper and created an outpouring of food donations for the migrant workers.

Art Objects That Indicate Class Status

Finally, different kinds of art are often indicators of class. Art objects are made for and reflect the needs and tastes of specific classes. We could have chosen from many examples to illustrate this concept, but we will focus first on two from the era of the Tokugawa Shogunate (1573–1868) in Japan. We will conclude with an example from the United States of the twentieth century.

Historically in Japan, classes were kept rigidly distinct. The ruling class consisted of the imperial family and the warriors, who divided the land and were its feudal rulers, led by the shogun. The very poorest class consisted of the peasants, who farmed the land that belonged to the warrior class. In addition, a middle class of urban dwellers began to emerge, starting in the mid-1600s and continuing into the twentieth century. This class was composed primarily of merchants, manufacturers, and laborers, and the largest concentration of them was in the city of Edo, known today as Tokyo. As these groups were kept separate and distinct, each class developed its own cultural spheres and its own art styles.

The warrior-rulers (or **samurai**) built for themselves splendid stone castles that were both fortresses and self-aggrandizing monuments. Because of the stone construction, rooms in these castles were large, gray, and dimly lit. The warrior-rulers commissioned large screens, sliding doors, and wall paintings to lighten and decorate the dark, drab interiors. For example, *Uji Bridge* (Fig. 12.31), from the sixteenth or seventeenth century, is a large screen more than 5 feet tall. The bridge arcs across the top of the screen, partly obscured by mists. In the foreground, the river rolls past a water wheel. Dramatic willow branches contrast with budding leaves. The dark branches stand in stark contrast to the golds and reds of the background. The painting expresses qualities of simplicity and beauty, perishable with the passing of the moment. The gold leaf background reflected light in the dim castle interior.

The artwork of the middle class was often the *ukiyo-e* print (see *History Focus*, page 343). These prints were modest in size and produced in large numbers, so that the cost of each was within the reach of the middle-class merchant. They were kept in drawers and, therefore, did not require a castle to house them. The *ukiyo-e* prints were eclectic in style, combining Japanese, Chinese, and, later, Western styles. Because they were inexpensive to produce, the artist who drew the original design was able to be innovative. For lavish screens like the *Uji Bridge*, artists had much less latitude in the designs they produced.

12.31 *Uji Bridge*, Momoyama period, Japan, sixteenth–seventeenth centuries. Six-fold screen, color on paper; 5′ 2″ high. Tokyo National Museum.

Large golden screens were used to decorate the castles of warrior-rulers in Japan.

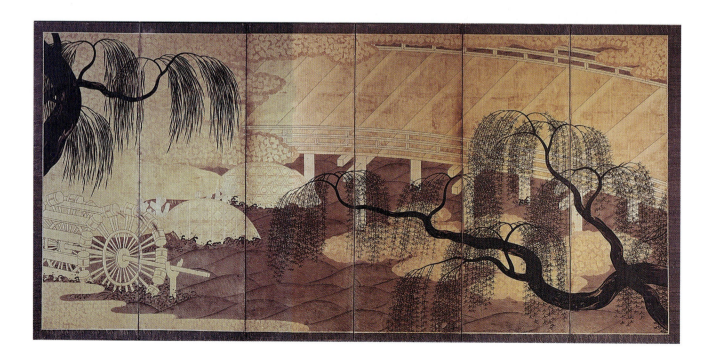

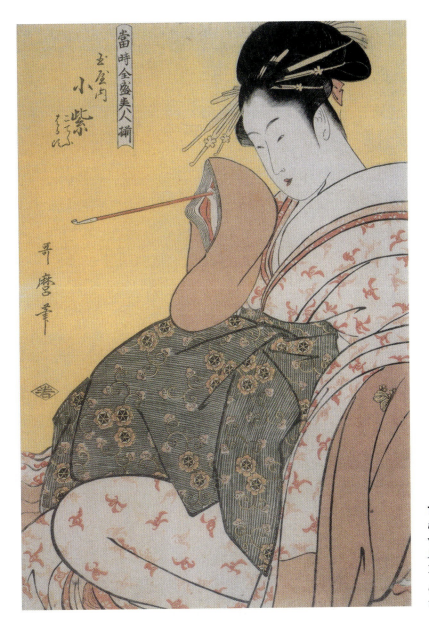

12.32 KITAGAWA UTAMARO. *Komurasaki of the Tamaya Teahouse*, Japan, 1794. Multicolor woodblock print from the series *A Collection of Reigning Beauties*, 1′ 3″ × 10″. Tokyo National Museum.

Color woodblock prints were a favored art form of the Japanese merchant class.

Ukiyo-e prints showed generally one of three subjects: famous Kabuki actors, beautiful young women, and landscapes. *Komurasaki of the Tamaya Teahouse* (Fig. 12.32), designed by Kitagawa Utamaro in 1794, is an example of the beautiful woman theme, showing the courtesan Komurasaki. The woman is charming, but human existence is fleeting and transitory; thus, the beautiful can add a melancholy note, making humans ache all the more for life's passing. This wistfulness is a quality of many Japanese images, as we saw even with the *Uji Bridge* screen. The colors are exceedingly delicate, with yellow ochres, olive tones, dull reds, grays, and blacks—not blazingly bright. The line quality of the prints was splendid—elegant, fine, curving, and graceful here (or, in the case of prints of the energetic Kabuki actors, vigorous and even wild).

The lines in the face and hair are especially refined, while the folds of the drapery are expressed in bold marks and curves. Geishas and courtesans were depicted in ways that would make them outlets for male desires; the market for these pictures was married men, who would see in these women for hire a fleeting beauty and an erotic perfection that they desired. Especially famous courtesans and geishas would be depicted in popular prints and their images circulated and collected.

CONNECTION You can read more about Japanese prints with *A Pair of Lovers* (Fig. 6.17). The production of such prints is discussed in Chapter 3, Media, on pages 60–61 and with Figure 3.14.

Our last example, *Watts Towers* (Fig. 12.33), was made by a working-class man for a working-class neighborhood in Los Angeles. Beginning in the 1920s when he was in his late forties, Simon Rodilla (also called Simon or Sam Rodia) labored for more than thirty years in his backyard to erect a nine-part sculpture, more than 100 feet high. It was an amazing artistic and physical effort. The tower forms rise dramatically against the sky, while the openwork pattern adds an element of rhythm. The *Watts Towers* are constructed of rods and bars shaped into openwork sculptures. The concrete coating on the *Towers* was encrusted with ceramic pieces, tiles, glass, seashells, mirror pieces, and other shiny or broken castoffs, creating a glittering mosaic-like surface. An immigrant from Italy, Rodia wanted to construct a monument to pay tribute to his adopted land.

Rodia was not academically trained as an artist, and his work does not reflect the major art trends of his day.

His work was not made for an upper-class audience. As a result, many critics place *Watts Towers* in categories outside of fine art. It has been variously described as folk art, outsider art, or naive art. The dense and shimmering surfaces have caused some to relate his work to crafts and decorative arts. Some have even called it "kook" art, claiming that Rodia was trying to make a transmitter to contact aliens. Some of these descriptors ("naive," "kook," "decorative," etc.) have more or less pejorative connotations, while "folk" suggests an art category of less value than fine art. But there is no denying the visual power of the *Watts Towers*.

CONNECTION Another work of "folk art" is the *Retablo of Maria de la Luz Casillas and Children* (Fig. 7.15). Read about that work, and then review the discussions of "Fine Art" and "Popular Culture" in Chapter 1, pages 12–16.

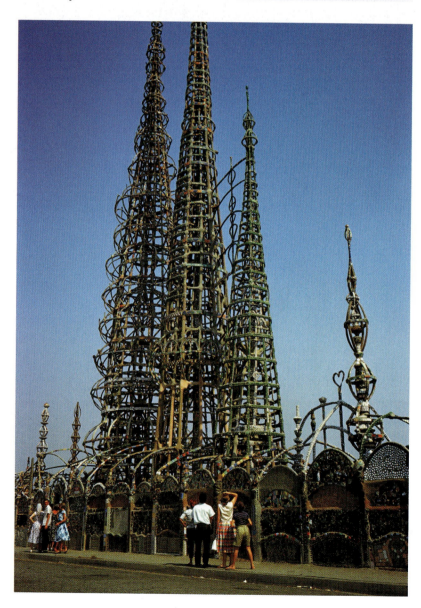

12.33 SIMON RODIA. *Watts Towers*, United States, 1921–1954. Reinforced concrete with mixed media and found materials, 100′ high. Los Angeles.

These towers were built by a working-class man in his spare time, over a span of thirty-three years.

13

NATURE, KNOWLEDGE, AND TECHNOLOGY

Art can imitate, praise, or criticize the world around us. That world consists of animals, plants, and the earth. It also contains the things that humans build, such as knowledge systems, technology, and cities.

PREVIEW

The first artworks in this chapter deal with animals, as we consider what humans find to be ideal or powerful in nature. These works with animals reflect desirable or despicable qualities in humans. The chapter opener, Shaman's Amulet (Fig. 13.1), is just one example of animals that are combined with each other and with human forms to indicate superhuman powers. We will also look at the various meanings behind landscape imagery.

The next artworks either promote or spread human knowledge about the world or critique human knowledge for its insufficiencies. Finally, we will see that artists examine technology to see how it is helping us or hurting us.

The Art Experiences invite you to make a photomontage from observations of nature, to invent a fantastic animal, and to debate the merits of recent technologies.

Connecting Art and History from
1850–1950 CE

Three major trends marked this period: industrialism, modernization, and nationalism. Before we begin that discussion, it is important to note that even at this time, many areas of the world remained unindustrialized. For example, in central Australia, artists in the Aboriginal culture produced works such as *Hunter and Kangaroo* (Fig. 13.26). Within industrialized nations, artworks such as Ansel Adams' *Clearing Winter Storm, Yosemite National Park, California, 1944* (Fig. 13.15) glorified the beauty of untouched nature.

Nevertheless, industrialism was transforming the world. Western European nations continued to build their colonial empires in Africa and Asia. The years from 1850 to 1914 marked the high point of colonialism, even with increased resistance and colonial independence movements. Because they generally had more undeveloped land, the colonies provided raw material for industrialized nations. The Industrial Revolution, which had already begun in Great Britain, spread to other areas of western Europe and the United States. The Industrial Revolution brought amazing advances in technology as well as profound social changes, including the development of a large middle class and an industrial working class, the creation of factories, great increases in population, and mass migration into urban areas, as reflected in Fernand Léger's *The City* (Fig. 13.31). Scientific advances were important, especially in medicine and physics. Science also influenced art, especially Impressionism and Futurism. Claude Monet's style of water lily paintings, seen in *The Japanese Footbridge* (Fig. 13.14), is based in part on optics.

The newly powerful middle class enjoyed greater educational opportunities and leisure time. Many new leisure activities took place in nature, as seen in Renoir's *The Luncheon of the Boating Party* (Fig. 13.2). The working class continued to suffer with poverty, long hours, and political oppression. Karl Marx co-authored the *Communist Manifesto* in 1848, and the labor movement was agitating for fair wages, safe working conditions, and reasonable hours for workers.

Map 9 World Map Showing Colonial Empires.

Civil rights movements for racial and gender equality grew in power throughout this period.

Nationalism is devotion to one's country, especially promoting that country's interests and culture above all others. Nationalistic fervor saw the formation of modern nations in South America, central Europe, and the Balkans. In the United States, the Civil War (1861–1865) both split and then reinforced the national identity.

In Japan, this was a period of nationalization, industrialization, and modernization. In 1868, the old shogun rulers of Japan were overthrown. Emperor Meiji rose to power and began the rapid industrialization of Japan and modernization of its society. In 1874, Japan began a period of expansion in Asia, following the model of Western colonial empires. Japan envisioned itself as the dominant power in Asia.

The Great War (World War I) broke out in 1914 and lasted until 1918. Its causes were many, including increased friction among European nation-states, entangling alliances, internal conflicts caused by ethnic groups that had not yet achieved nationhood, and competition for colonies and trade. The war and the terms of the peace treaty embittered Germany, one of the losing nations. Art movements such as Dada and Surrealism developed in response to the horrors of World War I, the crumbling social order, and increased industrialization, as seen in Salvador Dalí's *The Persistence of Memory* (Fig. 13.28). Other artworks were more pointedly critical, like José Clemente Orozco's *Gods of the Modern World* (Fig. 13.29).

Imperial rule was beginning to crumble. The 1912 revolution in China ended centuries of dynastic rule. The Russian Revolution of 1917 created a Communist state and ended the rule of the czars. The centuries-old Ottoman Empire, centered in Turkey, was broken up in 1919. Unfortunately, totalitarianism in other forms was on the rise. In Stalinist Russia and Nazi Germany in the 1930s, the state had absolute power, and dictatorships arose in Latin America. Fascism dominated in Spain and Italy as well.

The 1930s and 1940s were periods of great hardship and destruction. The Great Depression was a decade of severe financial difficulty for industrialized nations, and many people suffered. The Depression's unemployment and homelessness, coupled with extreme nationalism and the rise of totalitarian regimes, led to World War II. A bloody prelude to that war was the Spanish Civil War, waged by Fascists and Republicans/Communists from 1936 to 1939, each side heavily aided by foreign countries. Beginning in 1931, Japan, Italy, and Germany began seizing lands around them until war was declared in Europe in 1939 and in the Pacific in 1941. When

13.2 Pierre Auguste Renoir. *The Luncheon of the Boating Party*, France, 1881. Oil on canvas, 4′ 3″ × 5′ 8″. Phillips Collection, Washington, D.C.

The European middle class enjoyed greater leisure time in the late nineteenth century, including pleasurable outings in nature.

the horrendous destruction of World War II finally ended in 1945, at least 17 million soldiers and perhaps as many as 40 million civilians were dead, including the millions who died in German concentration camps.

The years immediately following World War II saw the founding of the United Nations, the destruction of old European colonial empires, and the establishment of Communist China (1948). Also established was the modern state of Israel, which displaced the Palestinians.

Thus, many issues that we see in today's world had their roots back a century or more as the foundations were laid for the global economy, global trade and resources, and global political entanglements.

World Art Map for Chapter 13

Shaman's Amulet.
Alaska/British Columbia,
Northwest Pacific.

Anselm Kiefer. *Breaking of the Vessels.*

Andreas Vesalius of Brussels. *The Fourth Plate of Muscles.*
Jan Bruegel. *A Stoneware Vase of Flowers.*
The Unicorn in Captivity.

Jean Tinguely. *Homage to New York:*
A Self-Constructing, Self-Destructing
Work of Art.

John Constable. *The Haywain.*
Bridget Riley. *Current.*
Chris Ofili. *Monkey Magic—Sex, Money and Drugs.*
Joseph Mallord William Turner.
The Fighting Temeraire Tugged to Her Last Berth to Be Broken Up.
Pierre Auguste Renoir. *The Luncheon of the Boating Party.*
Claude Monet. *The Japanese Footbridge.*
Fernand Léger. *The City.*

NORTH
AMERICA

EUROPE

Robert Smithson. *Spiral Jetty.*
Serpent (or Snake) Mound.

Mierle Laderman Ukeles. *The Social Mirror.*

Salvador Dalí. *The Persistence of Memory.*

Ansel Adams.
Clearing Winter Storm,
Yosemite National Park, California, 1944.

George Rickey. *Cluster of Four Cubes.*

Julie Mehretu. *Grey Space (distractor).*
John James Audubon. *Carolina Paroquet.*

Walter De Maria.
The Lightning Field.

Rock Art.
Acacus Mountains, Libya.

José Clemente Orozco. *Gods of the Modern World.*

Relief Depicting
a Priest . . .
La Venta, Mexico.

Vessel in the Form of a Monkey.
Veracruz, Mexico.

SOUTH
AMERICA

Spider.
Nazca, Peru, South America.

N

0 1,000 2,000 Km.

0 1,000 2,000 Mi.

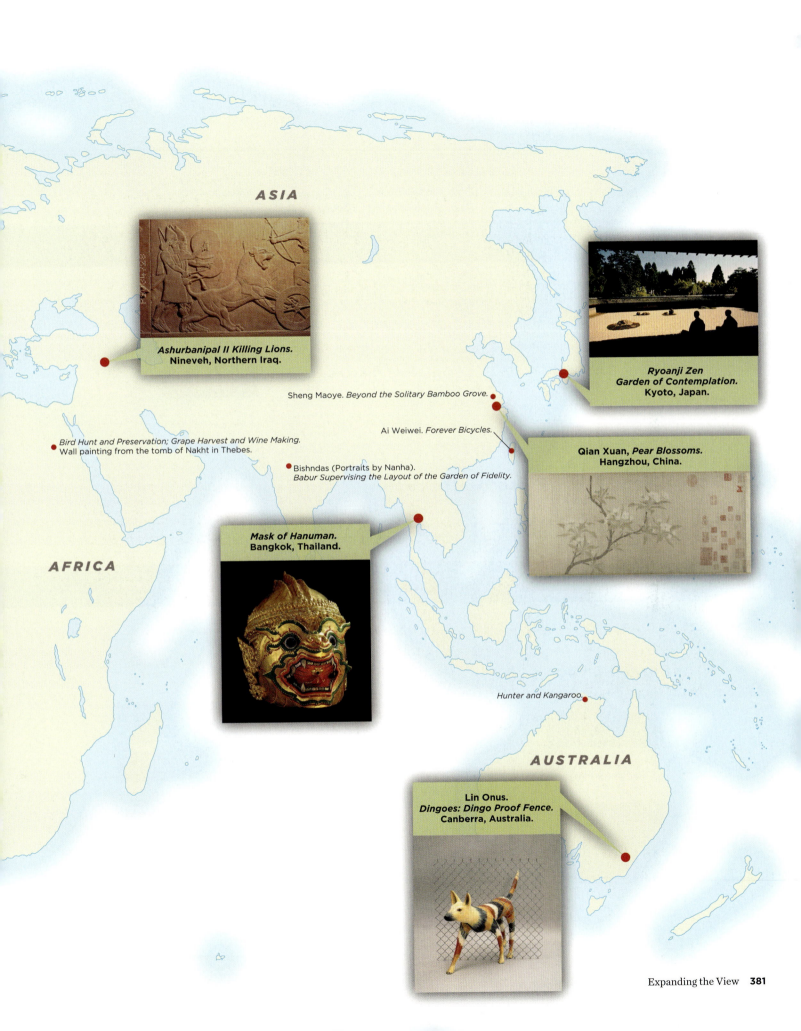

ASIA

Ashurbanipal II Killing Lions.
Nineveh, Northern Iraq.

Sheng Maoye. *Beyond the Solitary Bamboo Grove.*

Ai Weiwei. *Forever Bicycles.*

Ryoanji Zen
Garden of Contemplation.
Kyoto, Japan.

Qian Xuan, *Pear Blossoms.*
Hangzhou, China.

Bird Hunt and Preservation; Grape Harvest and Wine Making.
Wall painting from the tomb of Nakht in Thebes.

Bishndas (Portraits by Nanha).
Babur Supervising the Layout of the Garden of Fidelity.

AFRICA

Mask of Hanuman.
Bangkok, Thailand.

Hunter and Kangaroo.

AUSTRALIA

Lin Onus.
Dingoes: Dingo Proof Fence.
Canberra, Australia.

1850–1950 CE

	Wheel Appears— Mesopotamia					Printing Invented in China
	Bronze Casting in Sumeria			Paper First Used in China	Islamic Libraries Established Irrigation Developed in Moche Civilization, Peru	
Domestication of Horse and Camel	First Library in Sumeria	First Libraries in China	China: The Silk Trade Library at Alexandria	Elephants First Used in Warfare	Temple Libraries in Japan	
10,000 BCE	**3500 2000**	**1700**	**600 300**	**100 CE**	**200**	
Rock Art, Libya		Bird Hunt and Preservation; Grape Harvest and Wine Making, wall painting from the tomb of Nakht in Thebes	Ashurbanipal II Killing Lions Relief Depicting a Priest . . . (Olmec)		Spider (Nazca)	

∧ Bison with Turned Head (5.2)

∧ Peanut Necklace (8.13)

	Invention of Dynamite				
	Edison and the Lightbulb				
	Labor Movement	**HISTORY FOCUS**			
	IMPRESSIONISM		World War I	World War II	
	POSTIMPRESSIONISM		Great Depression		
Early Experiments in Photography	Women's Rights Movement	First Flight, Wright Brothers	Early Experiments with Computers	Establishment of Communist China	POP ART
1821 1827 1838	**1840**	**1900**	**1914 1932 1934**	**1940 1950**	**1960 1964 1965 1970**
CONSTABLE. *The Haywain* AUDUBON. *Carolina Paroquet* TURNER. *The Fighting Temeraire . . .*	RENOIR. *The Luncheon of the Boating Party* MONET. *The Japanese Footbridge*	Hunter and Kangaroo	LÉGER. *The City* DALÍ. *The Persistence of Memory* OROZCO. *Gods of the Modern World*	ADAMS. *Clearing Winter Storm, Yosemite National Park, California, 1944*	TINGUELY. *Homage to New York . . .* RILEY. *Current* SMITHSON. *Spiral Jetty*

∧ HINE. *Leo, 48 Inches High . . .* (10.12)

MILLAIS. > *Ophelia* (8.24)

UTZON. *Opera* > *House*, Sydney, Australia (14.4)

RENAISSANCE IN EUROPE

Moslem Paper Mills in Spain

*Inca Empire Develops
Elaborate Accounting
Systems*

BAROQUE ERA

*ROMANESQUE
ERA*

GOTHIC ERA

Medieval Universities

Gutenberg's Press

*Industrial
Revolution
Begins*

*Steam
Locomotive—
Europe*

800	1000 1300	1400	1500	1600	1800

*Vessel in the
Form of a
Monkey*

Serpent (or Snake) Mound
QIAN XUAN. *Pear Blossoms.*

*Ryoanji Zen Garden of
Contemplation*

*The Unicorn in
Captivity*

VESALIUS. *The
Fourth Plate of
Muscles*

BISHNDAS. *Babur
Supervising
the Layout of
the Garden of
Fidelity*

BRUEGEL. *A
Stoneware Vase
of Flowers*

SHENG MAOYE.
*Beyond the
Solitary
Bamboo Grove*

*Shaman's
Amulet*

*Mask of
Hanuman*

∧ *Relief Carving,*
Cambodia (3.36)

RUKUPU. *Entrance* ❯
*Doorway for a
Maori Meeting
House (3.39)*

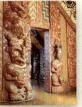

∧ *Eagle Knight,*
Aztec (3.40)

∧ *Silver
Representation
of a Maize
Plant (5.17)*

Desktop Publishing

POSTMODERNISM

Digital Imaging

The Internet

Reunification of Germany

Social Networking

*Global Warming Debated
in Governments around
the World*

1971 1980 1989	1990 1995	1999	2005	2010

DE MARIA. *The Lightning
Field*

UKELES. *The Social Mirror*

ONUS. *Dingoes: Dingo
Proof Fence*

KIEFER. *Breaking of the Vessels*
RICKEY. *Cluster of Four Cubes*

OFILI. *Monkey
Magic—Sex,
Money and
Drugs*

MEHRETU. *Grey
Space (distractor)*

AI WEIWEI. *Forever Bicycles*

∧ OURSLER.
Junk
(3.59)

NATURE

The relationship of humans to the natural world is very complex. We fear, love, and eat animals. They are part of industry, as we breed some and extinguish others. We identify with animals and project our highest aspirations and deepest fears onto them. Likewise, humans use landscape imagery, both the wild and the cultivated, to project their own ideals.

Animals

Animals appear in art in every culture, in forms both real and imagined. Animals were likely the subjects of humans' first drawings. They figure in myths and religious narratives, such as "Noah and the Ark" and the *Ramayana*. Humans have recorded animal likenesses and have invented bizarre creatures from parts of other living beings.

CONNECTION The cave drawings at Lascaux (Fig. 5.4) are among the oldest existing drawings made by humans.

Fantastic Creatures

Fantastic creatures are the product of human imagination, fear, and desire. Because they really do not exist, their human creators can assign a meaning and purpose to them.

The ancient Greeks invented several fantastic creatures that usually were threats to humans or represented degraded human nature. Harpies were woman-headed birds who lured and fed on men. Centaurs were man-headed horses known for their lustfulness. Satyrs, men with goat or horse attributes, were prone to drunkenness and sexual excess. Medieval Europeans were especially interested in fantastic animals from antiquity and also made up several of their own. Medieval beasts, however, often acted like humans in narratives that had a moralizing purpose or were demons in warnings about hell. Fantastic creatures still feed popular imagination today, as mermaids, giant insects, vampires, and werewolves thrive in film and popular fiction.

Our focus figure for this section is *The Unicorn in Captivity* (Fig. 13.3), from the late fifteenth century. Originally described in ancient times, the unicorn is a horse with some goat features and a long, single horn that was an expensive, prized possession capable of purifying water or removing poison (it was actually the spiral tusk of a narwhal, an arctic whale). Another common belief was that the unicorn could elude all hunters. However, when it saw a virgin, it put its head on her lap and could easily be caught.

The Unicorn in Captivity is the last image in six Netherlandish tapestries. Captured in a paradise garden, this unicorn has a lively and soulful expression on its face. It is surrounded by a fence, wears a jeweled collar, and is chained to a pomegranate tree. In these tapestries, this may symbolize Jesus, believed to be the source of spiritual life, who was hunted by men, was brutally killed, and then rose back to life. Or the image may represent true love in the Age of Chivalry, with the unicorn (man) enduring terrible ordeals to win his beloved. The collar represents a chain of love, mentioned in medieval allegories as a sign that a gentleman submits to his lady's will. The pomegranates dripping red juice onto the unicorn may symbolize Christ's sacrifice or human fertility. Multiple meanings were common in the medieval era as a way to acknowledge the complexity of life.

Fantastic creatures can express various forms of power. The limestone *Relief Depicting a Priest Making an Offering, and a Snake behind Him* (Fig. 13.4), dated to the sixth century BCE, comes from the Olmec culture of ancient Mexico, which produced many instances of animal imagery that combine natural and fantastic elements. Here, a warrior or priest is seated and wearing an elaborate jaguar-serpent helmet with the extended jaw of the creature forming the chinstrap. Towering over him is a large serpent with heavy brows and a crest like some sort of imaginary bird. Undoubtedly, the animal attributes protect the man as well as combine with him to create heightened powers.

Compare the *Relief* with the *Shaman's Amulet* (Fig. 13.1), dated c. 1820–1850. Like the *Relief*, the *Amulet* shows the combination of animal forms as a source of power and protection, here among the peoples of the Northwest Coast of North America. A shaman was a person with supernatural powers, believed to be a bridge among the human, animal, and spirit worlds. The amulet was a visible sign of the shaman's power, and it extended that power. The most prominent animal is the sea serpent, whose head is to the right, swallowing a human. This indicated that the shaman could take on the forms of certain animals and could operate in both the animal and the human realms. Other animals include a bear, for its strength, and a bird, for its ability to fly. The smooth, arching outline is echoed in interior details such as the folded arms, lines of feathers, and serpent's mouth. A dark patina gives depth to the work.

Another example of fantastic creatures comes from Thailand, a country with monsoon rains, thick jungles, and abundant animal life. Plants, birds, and beasts abound in

13.3, *above* *The Unicorn in Captivity,* South Netherlandish, 1495–1505. Wool warp, wool, silk, silver, and gilt wefts; 12′ 1″ × 8′ 3″. Gift of John D. Rockefeller Jr., 1937. Cloister Collection, Metropolitan Museum of Art, New York.

The unicorn had various symbolic meanings for medieval Europeans.

13.4, *right* *Relief Depicting a Priest Making an Offering, and a Snake behind Him,* Olmec, La Venta (Mexico), sixth century BCE. Basalt, 3′ 2½″ high. Museo Nacional de Antropología, Mexico City.

The combination of animal features protected the man and perhaps extended his power.

traditional Thai art, and many have more than one meaning. Monkeys, for example, are common wild animals in Thailand, and they are metaphors for humans, who aspire to be gods. In many Hindu and Buddhist tales, they also indulge in behavior unfit for humans or gods, such as lust and drunkenness, and, thus, present the realistic side of human nature in contrast to the idealized.

The *Mask of Hanuman* (Fig. 13.5) is a headpiece representing the white monkey-hero and loyal follower of the deity Rama in the Thai story *Ramakien* (called the *Ramayana* in India). Performers wear this mask when representing this fantastic creature, a divine monkey with white fur, jeweled teeth, and a white crest of hair that shone like diamonds. His heroic exploits were many, including helping rescue Rama's wife from a demon and bringing a mountain of medicinal plants to cure the wounded in battle. The *Mask of Hanuman* is equally fantastic, covered with gleaming metal and enamel. Red, black, and green dramatically outline his fierce, bulging eyes and snarling mouth. Gold serpents curl at his ears. Hanuman is modeled from an actual monkey, the leaf-eating langur from India (Taylor 1994:35–38).

Compare the Thai monkey with that in the contemporary painting by Chris Ofili, *Monkey Magic—Sex, Money and Drugs* (Fig. 13.6), 1999. The monkey is again a stand-in for human behavior, and, here, it holds an empty turquoise vessel and tries to capture three powerful elements of life: sex, money, and drugs, represented by three clumps of dried elephant dung attached to the canvas. The surface is colorful and shiny with thick beads of paint and layers of glitter, which emphasizes the imagined rather than the real. A British artist of Nigerian descent, Ofili uses dried elephant dung to reference the African ritual use of it. His paintings often rest on balls of dung, seeming to come up from the earth rather than hang on the wall.

In some cases, a group of people feels such an affinity with an animal that the group members use it to represent themselves and their interests, as in Lin Onus' *Dingoes: Dingo Proof Fence* (Fig. 13.7). The fantastic dingo of this sculpture is a wild dog that has a coat in colors representing the native Aboriginal people and has the ability to pass through fences. This work upholds the wild animals'

13.6 CHRIS OFILI. *Monkey Magic—Sex, Money and Drugs*, Great Britain/Nigeria, 1999. Acrylic, collage, glitter, resin, pencil, map pins, and elephant dung on canvas, 8′ × 6′. Museum of Contemporary Art, Los Angeles.

Animals act as stand-ins for humans, as this monkey reaches for sex, money, and drugs.

13.5 *Mask of Hanuman*. Enamel inlay, gilt, gems, and other materials; fits over a human head. National Museum of Bangkok, Thailand. Early nineteenth century.

This mask represents a mythical monkey who seems even more fantastic because of the rich materials and exaggerated facial features.

right to the land in Australia as well as supporting the aboriginal way of life, which leaves the natural environment intact. It protests the fencing, farming, and grazing of Australian land, a practice brought by European settlers that aggressively altered the land. In this artwork, the dingo-proof fence turned out to be ineffective against natural forces.

ART EXPERIENCE Create a fantastic animal in a collage.

CONNECTION Examples of fantastic creatures appear in previous chapters. They include human-headed winged bulls, at left (*Lamassu*, Fig. 9.10); serpents (*Laocoön and His Sons*, Fig. 11.18); and totem animals (*Interior House Post*, Fig. 12.15).

Observed Animals

Animals are magnificent creatures, and in many instances their likenesses—without embellishment—are sufficient justification for a work of art.

Our focus figure shows that from the very earliest times, humans have recorded the likenesses of animals they encountered. Figure 13.8 is one of hundreds of ancient rock art images from the Acacus Mountains in

13.7 LIN ONUS. *Dingoes: Dingo Proof Fence* (detail from the series *Dingoes*), Aboriginal, Australia, 1989. Synthetic polymer on fiberglass, wire, metal, 3′ 1½″ high. National Gallery of Australia, Canberra.

The dingo, a wild dog in Australia, is here shown as able to walk right through fences constructed by humans.

13.8 *Rock Art* from the Acacus Mountains, western Libya, c. 10,000 BCE.

This is an ancient rendering of an elephant scratched into a rock that is graceful, beautiful, and accurate.

western Libya. Now the Sahara Desert, the area supported vegetation and large animals in 10,000 BCE, like the elephant shown in our example. There are also paintings and carvings of humans, giraffes, antelopes, and domesticated animals. This *Rock Art* drawing depicted the elephant with great accuracy and sensitivity, in a work that is memorable even for our modern eyes.

Compare the *Rock Art* with the next work, a relief that was part of extensive carvings from a palace in Ancient Assyria that shows how people admire animals and, at the same time, desire to destroy them. In the detail entitled *Ashurbanipal II Killing Lions* (Fig. 13.9), c. 650 BCE, the lion's muscles, veins, and bones show its tremendous strength, fierceness, and agility. It was precisely because they admired these qualities that the Assyrian elite slaughtered the animals in a public spectacle, the royal lion hunt. Lions in cages were released in an enclosed arena, where the king, Ashurbanipal, accompanied by bowmen and spearmen, would face them to show his courage. Other scenes show a large number of lion carcasses piled behind the king or wounded lions slowly dying. Assyrians believed that the longer a man or beast took to die, the higher the layer of heaven that was attained in the afterlife. The Assyrians covered the mud-brick palace walls with many such relief carvings that boasted of the king's power not only in hunting lions but also in waging battle campaigns and in the company of the gods.

Contrast the degree of detail in the Assyrian *Lions* with the large animal drawings produced by the Nazca culture, a pre-Incan civilization in southwestern Peru. The drawings are located on a rocky, arid plain, with no wind and essentially no rainfall. A casual footprint or scrap of litter will remain undisturbed for years. The Nazca drawings were made at least 1,400 years ago by scraping the brown surface of the desert floor, revealing lighter-colored sand beneath. The earliest drawings were of animals, such as birds, whales, monkeys, or dogs. Our example, *Spider* (Fig. 13.10), dates from around 200–600. Later drawings consisted of large geometric shapes, spirals, and long, straight lines that extend for miles or radiate from center points. Many drawings were made right on top of previous ones.

The Nazca drawings are remarkable for their regularity, simplicity, and lack of detail. All lines are a standard width and executed as a continuous path. The Nazca people probably used rudimentary surveying instruments and

13.9 *Ashurbanipal II Killing Lions*, Palace of Ashurbanipal, Nineveh, Assyria (northern Iraq), c. 650 BCE. Limestone relief, approx. 5′ high. British Museum, London.

By fighting and killing fierce lions, Assyrian rulers affirmed their own bravery and fitness to rule.

13.10, *above* *Spider*, Nazca, Peru, c. 200–600.

This large drawing was created when brown surface rocks were scraped away to reveal yellowish surface below. The humans who made the drawing never saw the entire work because of its huge size.

13.11, *right* *Vessel in the Form of a Monkey*, late Classic period, Veracruz, Mexico, 800–900. Clay, 8½″ high. Indiana University Art Museum, Bloomington.

When shaken, the cup makes a rattling noise like the chattering of monkeys.

string to plot the paths. The drawings are so large and the plain so flat that most drawings can be seen only from the air. Some long, straight lines may have been used for astronomical sightings, while others may have been paths that connected the plain's various shrines. In this arid area, the animal drawings may have been messages or offerings to water gods residing in mountains. Even today in areas of Peru and Bolivia, the spider is highly regarded because it predicts weather changes and may foretell rainfall.

Another instance of carefully observed animals can be seen in the *Vessel in the Form of a Monkey* (Fig. 13.11), made between 800 and 900 in the pre-Columbian Veracruz culture in Mexico. Animal-shaped vessels were common in many Mesoamerican and South American cultures. This is

a spider monkey, squatting with its arms overhead grasping its own tail and exhibiting a naturalistic facial structure. The artist has captured the animated expressions and energy of the animal. In addition, small rocks sealed inside in hollow pockets rattle when the vessel is shaken, mimicking the monkey's chatter. Monkeys were kept as pets and were featured in Mesoamerican mythology. They were also linked to dancers, because of their quick, agile movements, or to uninhibited sexuality (Pelrine 1996:75). The monkey in this example has pierced ears, like humans. On the formal side, the vessel can be enjoyed for its design. The rounded belly contrasts with the angular forms of the arms, as do the concentrated facial details with the smooth abdomen. The belly and expanded back provide the space to hold liquids; the opening is behind the monkey's head.

The Land

This section contains landscapes, flowers and gardens, and earthworks, which are gigantic sculptures using the earth as their base.

Landscape Imagery

A landscape image is different from the actual outdoors. Landscape images are carefully created translations of reality that often have deeper social or religious meanings.

Landscape paintings were particularly common in the United States and in Europe in the nineteenth century. Landscapes tended to have a nationalistic look. For example, German landscapes sometimes were marked by melancholy or morbidity. English landscapes, however, tended to emphasize the open-air expansiveness of farm scenes. Our focus figure for this section is John Constable's *The Haywain* (Fig. 13.12), from 1821, which shows a broad meadow in the distance, with a farm scene in front. The composition seems casual, direct, natural, and unstudied, but Constable carefully observed everything, especially the clouds. Tranquility pervades all, as a warm mellow light washes over the land, and brilliant clouds play against the blue sky.

Constable's work appealed especially to Europeans who had migrated in large numbers to industrial cities

13.12 JOHN CONSTABLE. *The Haywain*, England, 1821. Oil on canvas, 4′ 3″ × 6′ 2″. National Gallery, London.

This scene of the broad English countryside emphasized an open-air quality, but the painting was made in the studio from sketches the artist had executed outdoors.

and missed contact with nature. Before painting large canvases, Constable made numerous outdoor studies that he saw as being scientific (meteorology was his avocation). His work also grew from **Romanticism,** which elevated nature and immediate experience. In his works, he used stippling, in which small dabs of bright color and white are applied to reproduce shimmering light. His method was important later to **Impressionism.**

Compare Constable's landscape with Sheng Maoye's *Beyond the Solitary Bamboo Grove* (Fig. 13.13), from the seventeenth century, which also was a reaction to city life. In China and Japan, landscape paintings were especially popular among upper- and middle-class urban populations, especially in noisy and polluted areas. The booming city of Suchou, wealthy from the European silk trade and tourists, had one park that was so overcrowded that a local artist called it "squalid," with "visitors [who] flock there like flies swarming on meat" (Cahill 1966: 87). Paintings like *Beyond the Solitary Bamboo Grove* made pristine nature once again available. Landscapes were displayed in homes on large, hanging silk scrolls; fans or smaller albums were made for private viewing. Our example shows the soft blur of misty mountains, an isolated hut, and the distinctive silhouettes of various trees, all rendered by subtle washes of ink and light color. Inspiration for paintings often came from poetry or the beliefs of Daoism (or Taoism), which held that nature was a visible manifestation of the Absolute Dao, the ultimate substratum from which all things come. Nature also reflected Daoism in its rhythms, changes, and transformations. Chinese landscapes are carefully composed imaginary scenes. Artists practiced their brushwork for years to achieve a sense of effortlessness and spontaneity, qualities valued in Daoism.

In comparison, the Impressionist landscape painter Claude Monet was motivated by a desire to capture the subtle qualities of light and reflection. Unlike Constable or Maoye, Monet executed his finished paintings almost exclusively outdoors. In his later years, he planted his own water garden at his home in Giverny, France, to

13.13 SHENG MAOYE. *Beyond the Solitary Bamboo Grove*, China, c. 1625–1640. From a six-leaf album of landscapes inspired by Tang poems; ink and color on silk; 11¼" × 1'. Metropolitan Museum of Art, New York.

This landscape painting has a quality of poetic reverie.

provide himself with inspiration close at hand. In *The Japanese Footbridge* (Fig. 13.14), from 1899, the colors are dazzling; by mixing vivid strokes of pure color, Monet achieved the effect of sunlight upon water. In Monet's later career, his paintings approached abstraction as brushstrokes became more important than imagery. The Impressionists' emphasis on observation paralleled the ideas of scientists and philosophers of the day, who posited that reality was only that which could be sensed, measured, and analyzed.

These three landscape paintings all depict the actual or implied presence of humans. In contrast, painters and photographers in the United States produced more images of pristine, untouched nature, where one could imagine that humans had never been. Ansel Adams was particularly well known for grand and romantic photographs of remote landscapes, like *Clearing Winter Storm, Yosemite National Park, California, 1944* (Fig. 13.15). In our example, the mist- and cloud-covered mountains are the focal point, while the textures of clouds and trees balance each other. The center seems to recede into infinite space.

Adams worked very hard exploring, studying, and waiting for just the right moment for his shot. In this case, the light caught the waterfall, while the surrounding cliff was in dark shadow. Adams used filters while shooting, and manipulated his prints in the darkroom to achieve the full range of tones, from brilliant white to darkest black. His splendid photographs raised public support for national parks and for the environmental movement in general.

ART EXPERIENCE Make a photomontage of a natural site.

Flowers and Gardens

Art gives us framed, composed, distilled, and transcendent images of flowers. And gardens are living sculptures, exotic refuges arranged for human enjoyment. Water is frequently a central motif in a garden of any size. Paintings of gardens attempt to capture that same sense of pleasure and release.

Flowers are sources of beauty and are often used symbolically. This section's focus figure is Jan Bruegel's *A Stoneware Vase of Flowers* (Fig. 13.16), 1607–1608. This joyful display of vitality is filled not only with the fresh flowers but also with insects that abound. Bruegel layered his paint to create bright, subtle mixtures that captured the silkiness and translucency of petals. He claimed that they were lovelier than gold and gems, proving it with rings and

13.14 CLAUDE MONET. *The Japanese Footbridge*, France, 1899. Oil on canvas, 2′ 8″ × 3′ 6″. National Gallery of Art, Washington, D.C.

Monet worked outdoors on his paintings in an effort to capture the color and brilliance of natural light.

13.15 ANSEL ADAMS. *Clearing Winter Storm, Yosemite National Park, California, 1944*, United States.

Landscapes can imply the presence of humans or can suggest a pristine space where no one has been before, as with this photograph.

jewels at the lower right. Bruegel's flower arrangements never existed in real life. He combined local meadow flowers and exotic varieties in a single vase and included specimens that bloom in different climates and in different seasons. Yet he painted only from life, using a magnifying glass, sometimes waiting months for a certain bloom. Since medieval times, flowers had been sacred symbols: the iris, for example, represented Jesus, while the rose stood for Mary. The symbolism may have enriched the meaning of the painting for Bruegel's patrons.

Flower paintings were particularly popular in both China and Japan. (In Japan, flower arranging is considered an important art form, on the level of painting, calligraphy, and pottery.) An example from China is *Pear*

13.16 JAN BRUEGEL. *A Stoneware Vase of Flowers*, c. 1607–1608. Oil on panel, 1' 11¾" × 1' 4½". Fitzwilliam Museum, University of Cambridge, United Kingdom.

This bouquet is realistic in its detail but not in the grouping of flowers because the blossoms shown here come from various places and different seasons.

Blossoms, from c. 1280 (Fig. 13.17), by Qian Xuan, a scholar and court official who retired from the court when he did not advance in rank. He devoted his life after 1276 to painting and became one of the first to combine poetry, painting, and calligraphy. The poem that accompanies *Pear Blossoms* is:

> *All alone by the veranda railing,*
> *teardrops drenching the branches,*
> *Although her face is unadorned,*
> *her old charms remain;*
> *Behind the locked gate, on a rainy night,*
> *how she is filled with sadness.*
> *How differently she looked bathed in golden waves*
> * of moonlight, before the darkness fell.*

Both poetry and painting were believed to have the capacity to express ineffable beauty. Ink wash paintings look simple, but they require long practice. Qian Xuan's brushwork is refined. The blossoms are outlined in elegant curves, playing off against the gray shapes of the leaves. The entire composition is off-balance and irregular, capturing the unexpected forms of nature. The beauty of the blossom is simple and timeless, but the flowers last only a short time. Qian Xuan's poetry captures the melancholy nature of the fading bloom, and reflects his personal feelings. It is interesting to compare the kinds of painting skills required of Qian Xuan and of Jan Bruegel.

Gardens also often carry symbolic and philosophical meaning, just as paintings of flowers do. For example, gardens were very popular among the Islamic ruling classes of Persia, central Asia, and Mughal India (these areas are modern-day Iraq, Iran, Afghanistan, Pakistan, and northern India). In the painting *Babur Supervising the Layout of the Garden of Fidelity* (Fig. 13.18), c. 1590, water is shown being channeled in four directions, representing the rivers of Paradise. The four resulting squares can be repeated or subdivided and yet maintain the integrity of the original layout. The proliferation of squares represents the abundance of Allah's creation. The outer wall provides privacy and protects the trees and birds

13.17 QIAN XUAN. *Pear Blossoms,* Yuan Dynasty, China, c. 1280. Handscroll, ink and color on paper, 1' 1½" × 3' 2". Metropolitan Museum of Art, New York.

This painting was done not from direct observation but from memory after the artist had repeatedly practiced the necessary brushstrokes.

13.18 BISHNDAS (PORTRAITS BY NANHA). *Babur Supervising the Layout of the Garden of Fidelity*, Mughal, India, c. 1590. Manuscript painting, gold and gouache on paper, 8¾" × 5¾". Victoria and Albert Museum, London.

Mughal gardens have great religious and political symbolism.

from surrounding desert. The English word *paradise* comes originally from ancient Persian words for "walled garden."

Babur Supervising the Layout of the Garden of Fidelity is a book illumination from the memoirs of Emperor Babur, a botanist who took great interest in planning many gardens throughout the lands that he ruled to secure his identity. Here, he is dressed in gold and is directing engineers and workmen. Originally a minor prince, he conquered much of central Asia and northern India, claimed to descend from Genghis Khan and Tamerlane (Timur), and established gardens, which was a prerogative of princes. In addition, Babur believed his rule created order

out of the chaos, and the garden's symmetry was a sign of that.

 CONNECTION Review the discussion of the Taj Mahal (Fig. 8.20) for more on Islamic gardens symbolizing Paradise.

In comparison, the Japanese have different traditions for gardens. One kind of Japanese garden is planned around a pond or lake and features rocks, winding paths, and bridges to delight the viewers with ever-changing vistas. A second tradition is exemplified in the *Ryoanji Zen*

Garden of Contemplation (Fig. 13.19), c. 1488–1499, located in a courtyard of a Buddhist temple in Kyoto. The rock garden reflects Zen Buddhist beliefs that the world is full of change and disorder but that meditation can lead to an understanding of the oneness of the universe. Visitors do not walk through the garden but rather sit along the edge meditating on the raked quartz gravel that represents the void both of the universe and of the mind, while the dark rocks represent material substances and worldly events that float through those voids. The garden also represents an ocean journey, with gravel raked to signify waves and boulders now standing for mountains. The fifteen large rocks, each of a distinctive shape and outline, are arranged such that visitors can see only fourteen at once from any angle. The fifteenth can be seen through the mind's eye after spiritual enlightenment. The *Ryoanji Zen Garden of Contemplation* is small, but because the largest boulder is at the front and the smallest at the back, there is an optical illusion of greater depth.

Earthworks and Site Pieces

The earth itself and natural phenomena can become sculptural materials. *The Lightning Field* (Fig. 13.20), 1971–1977, by Walter De Maria, is this section's focus figure. The work consists of a large, flat plain surrounded by mountains in New Mexico and four hundred stainless steel poles arranged in a rectangular grid measuring one kilometer by one mile. *The Lightning Field* requires some effort and endurance on the part of viewers. It is remotely located, and to see it, a visitor must get permission from the Dia Foundation, which commissioned the work. Once on-site, the viewer waits for whatever happens. On clear days, the shiny, pointed poles catch the sun and glow against the natural vegetation. On stormy days, an occasional bolt of lightning may strike a pole, creating a fleeting, but dramatic, visual effect. *The Lightning Field* is better known through photographs that document it in different conditions than it is by actual experience. In this respect, the work is also a conceptual piece, existing primarily in the mind of the viewer, who contemplates the contrast between constructed and natural elements, the slow passage of time in the desolate environment, and the imagined experience of the work as known through various photographs.

Contemporary **earthworks** are large-scale environmental pieces in which the earth is an important component. Earthwork artists not only use natural materials but also are responsive to their sites. The monumental scale of their work is an attribute of both ancient and modern art. There is a minimalist emphasis on simple shapes. Robert Smithson's *Spiral Jetty* (Fig. 13.21), 1970, was made

13.19 *Ryoanji Zen Garden of Contemplation*, Japan, c. 1488–1499. Walled garden, 99′ wide × 33′ deep. Daijuin Monastery, Kyoto.

This garden is not meant to be entered but to be contemplated from the side.

13.20 WALTER DE MARIA. *The Lightning Field*, United States, 1971–1977. Four hundred stainless steel poles, average height: 20′ 7″; land area: 1 mile × 1 kilometer in New Mexico.

This work of art incorporates the ground, the sky, and weather activity.

of rocks, dirt, salt, and water, extending into the flat, still surface of the Great Salt Lake. Smithson thought the spiral suggested an incredible potential force, like a dormant earthquake or a raging cyclone immobilized. Located in a remote site, *Spiral Jetty* was seen by few people and now is often invisible because of the fluctuating lake level.

Smithson was interested in moving his art outside of the gallery and away from traditional art materials. He saw his earthworks as unifying art and nature. Human design is, of course, evident in this work. Less evident is what went into making the piece, which involved heavy earth-moving equipment, engineering skills, and many workers.

Smithson was also influenced by the mound builders of native North American cultures, who used dirt to construct large ceremonial sites. Mounds and pyramids were relatively common in the ancient world, but the North

13.21 ROBERT SMITHSON. *Spiral Jetty*, United States, 1970. Earthwork; black rocks, salt crystals, earth, red water (algae); 1,500′ long × 15′ wide × 3½′ high. Great Salt Lake, Utah.

Rocks were moved and dirt shaped to create this massive earthwork.

American mounds are unique in being animal-shaped, like the *Serpent* (or *Snake*) *Mound* (Fig. 13.22), c. 900–1300, in Ohio. The serpent's body follows a natural ridge near a small river. The distended jaw of the 1,400-foot-long serpent is pointing to the upper right. Its body is rhythmically curved and ends with its spiraling tail. In 1846, the snake's body was 5 feet high and 30 feet wide, but it has since eroded to 4 feet by 20 feet. An oval shape inside the serpent's jaw, measuring almost 79 by 158 feet, encircles a plateau topped with what may have been a stone altar. The builders must have had a great admiration for the snake to stamp its form so dramatically on their landscape, especially since they never enjoyed an aerial view of it. Like Smithson's *Spiral Jetty*, the *Serpent Mound* required the labor of many workers to dig and carry earth to the site.

Ecological Concerns

Artists who deal with the land and with landscape often have ecological concerns as part of their motivation to make art. We already saw this with Ansel Adams' *Clearing Winter Storm, Yosemite National Park, California, 1944* (Fig. 13.19). And very possibly the creators of the *Serpent Mound* (Fig. 13.22) believed that the land was sacred.

Today, however, ecological concerns are clearly political and social issues. *The Social Mirror* (Fig. 13.23), 1983, by Mierle Laderman Ukeles, focuses on the problem of waste caused by growing populations and consumerism. Ukeles had a clean New York City garbage truck fitted with gleaming mirrors, which transform it into a piece of sculpture. *The Social Mirror* also has a performance element, as in this photograph taken when the truck was part of a parade. The mirrors reflect the faces of the public, making them aware that they make trash and are responsible for its impact. The mirrors also glamorize the garbage truck and raise the status of sanitation workers, whose labor is not respected but is absolutely necessary. All of Ukeles' work since the mid-1970s has focused on ecological issues of maintenance, recycling, waste management, and landfill reclamation.

KNOWLEDGE

Humans systematically study and examine the world in an attempt to understand (and often control) its course. Although all art is a kind of knowing, this section focuses on art that deals directly with a body of knowledge. The first group consists of informative images, in which art helps explain a specific body of learning. The second group

13.22 *Serpent* (or *Snake*) *Mound*, Native American, near Locust Grove, Ohio, c. 900–1300. Earthen sculpture, 1,400′ long.

Ancient earthworks were mounds or, in this case, were shaped into animal forms.

provides glimpses into areas of intuited knowing. Finally, art critiques what we consider knowledge.

These same ideas—scientific knowledge, intuited knowledge, and critiqued knowledge—are found in other fields of knowledge and artistic disciplines. And like artists, many in these fields came to question the use of knowledge for destructive purposes after the horrible wars of the twentieth century (see *History Focus*, page 379).

Informative Images

There are numerous examples of art that illustrate a specific body of knowledge. Our focus figure is from the Low Countries. There, in 1543, Andreas Vesalius of Brussels published *De Humani Corporis Fabrica*, a study of bones, muscles, and internal organs based on the dissection of human bodies, which is considered the beginning of modern science. Before that time, Western knowledge of the human body was based on ancient Greek, Roman, and medieval Arabic writings. Vesalius' studies corrected errors in old sources and added a tremendous amount of new knowledge. Important here, however, is that Vesalius created a major work of Western science and art.

The Fourth Plate of Muscles (Fig. 13.24), dated 1543, shows that Vesalius gradually stripped the cadaver's

13.24 ANDREAS VESALIUS OF BRUSSELS. *The Fourth Plate of Muscles*, from *De Humani Corporis Fabrica*, Flanders, Belgium, published in 1543. Engraving.

This is a work of anatomical science and a work of art. It also reflects attitudes about human nature that were prevalent at that time.

(Fig. 13.28), 1931, by Salvador Dalí. For example, watches are devices of knowing and a means of maintaining external order. However, here the watches are limp and useless. The landscape stretches out, vast and empty. The sky glows in splendid blues and golds, while the still water reflects the sun-bathed cliffs like a flawless mirror. Nothing makes sense, but Dalí has painted everything with rigorous detail and convincing realism, so that book-learned knowledge fades in importance and we enter the eerie scene with a kind of intuited knowing. Swarming ants and a fly allude to the horror dimension in dreams.

CONNECTION For more on artwork that is inspired by mental and emotional states of mind, see Chapter 11, Mind and Body, especially the sections entitled "Portraits" and "Self-Portraits" (pages 316–322) as well as "The Psychological Dimension in Art" (pages 333–336).

The Critique of Learning

Gods of the Modern World (Fig. 13.29), 1932–1934, painted by José Clemente Orozco, is the focus figure for this section on art that looks critically at human knowledge. This

13.28 SALVADOR DALÍ. *The Persistence of Memory*, Spain, 1931. Oil on canvas, 9½″ × 1′ 1″. The Museum of Modern Art, New York.

Surrealism presents dreams, intuition, and visions as a kind of knowledge.

13.29 JOSÉ CLEMENTE OROZCO. *Gods of the Modern World*, twelfth panel in a cycle of murals entitled *An Epic of American Civilization*, Mexico, 1932–1934. Fresco, 10′ 6″ × 14′ 8″. Baker Memorial Library, Dartmouth College, Hanover, New Hampshire.

The artist Orozco presents the argument against the pursuit of sterile knowledge.

painting is a warning against the academic who is completely occupied with sterile research or learning that has no value outside of academia. The black-clad university scholars line up like midwives to watch a skeleton give birth to miniature scholar-skeletons and stacks of obscure books. Orozco believed that sterile education passes for knowledge, but it actually keeps the young busy without giving them any real wisdom or understanding. The lurid red background suggests urgency, as if the world is on fire, but no guidance or concern can be found among the learned. Their posture is aloof, frontal, stiff, and unresponsive. The style of the work is very striking. The rhythm of the lines is strong, from the verticals of the academic robes, to the black and white of the skeleton's ribs, to the swaying parade of book spines below. Significantly, this painting is in the library of a prestigious U.S. college, to be seen by all students and professors.

Compare Orozco's painting with *Breaking of the Vessels* (Fig. 13.30), 1990, through which artist Anselm Kiefer looks at knowledge on many different levels. The piece consists of a three-tiered bookshelf filled with massive volumes whose pages are made of sheets of lead. The books sag perilously, some about to fall from the shelf. Glass shards from the books have fallen, and their shattering has covered the floor all around. Above, written on a half-circle of glass, are the Hebrew words *Ain Soph*, meaning "the Infinite." Dangling copper wires connect thick stumps projecting from the sides. The piece is 17 feet high and weighs more than seven tons. The shattered glass covers several square yards of floor all around.

The piece contrasts the infinity and clarity of the spiritual realm with the thick, dull, ponderous containers of human knowledge. Human knowledge, as contained in and symbolized by the books, is limited and sagging under its own weight. Visually, the heavy lead pages are like the blackened pages of burned books. The knowledge contained within them seems inaccessible to most people; the book format hides knowledge rather than exposing it. The books seem as though they might even be rotting away, ready to crash to the floor. The sheer mass of the sculpture becomes a metaphor for the accumulated struggles to acquire and preserve human knowledge, but books and their contents disintegrate. The work alludes to the fact that all human endeavor is cyclical like nature; it is subject to periods of decline and entropy that eventually lead to regeneration.

The title *Breaking of the Vessels* refers to mystical Hebrew writings (the Kabbalah) that tell of the awesome, uncontainable Divine essence whose power filled and shattered the fragile vessels of the universe upon Creation. The title symbolizes the introduction of evil into the world. It could also refer to the atrocities of *Kristallnacht* (the "Night of Crystal" or the "Night of Broken Glass"),

13.30 ANSELM KIEFER. *Breaking of the Vessels*, Germany, 1990. Lead, iron, glass, copper wire, charcoal, and aquatec, 17' high. St. Louis Art Museum, Missouri.

Old books are not always storehouses of knowledge. They may make knowledge inaccessible, or they may rot and fall apart.

when the Nazis vandalized and terrorized Jewish neighborhoods in Germany and Austria in November 1938.

TECHNOLOGY

Technology is the last component of the outside world in this chapter. First, we will see three artworks that regard technological advances as good, healthy, exciting, and even

Art and History in Context,
1950 CE-PRESENT

The contemporary era is marked by international tensions that create great rifts in the world fabric, while at the same time advances in information technology begin to make a global community possible.

At the end of World War II, the United States and the Soviet Union emerged as competing superpowers. The Cold War (1950–1991) saw a massive arms buildup, pitting the United States and western Europe against the Soviet Union and its eastern European satellites. Communist China was the third major force. Tensions among the major powers spawned protracted regional wars in Korea and Vietnam. Television brought these world conflicts directly into people's homes in industrialized nations.

Cold War competition also centered on technology and culture. Technological superiority was sought in the arms race and the race for space (moon landings, satellites, and space stations). On the culture front, the United States emphasized art of individual self-expression over art made in service of the state, such as the social realism of the Soviet bloc and China. Some key qualities in U.S. art at this time can be seen in Barnett Newman's *Broken Obelisk* (Fig. 14.2), with its abstraction, simplified form, grand scale, and tension in balance that seems so perfect and at the same time so precarious.

With its oil riches, ethnic conflicts, and religious wars, the Middle East has been another major source of global unrest (see Map 10). The Arab-Israeli conflict is ongoing, dating from 1947. The independence of Hindu India and the creation of Moslem Pakistan produced tensions that are still present. An Islamic revival and resistance to Western culture have resulted in the mixing of religion and civil government, seen, for example, in the fundamentalist revolution in Iran. The unrest has spread, causing such events as the destruction of the World Trade Center, bombings and violence in Indonesia, and the wars in Iraq and Afghanistan.

The 1950s and 1960s brought big political changes to Africa and Latin America. In Latin America, dictatorships were common throughout the 1950s and 1960s; some were replaced later with democracies. Revolutions, coups, and civil wars occurred in many countries, including Cuba, Chile, El Salvador, and Argentina. The 1960s

Map 10 Location of the World's Oil Reserves.

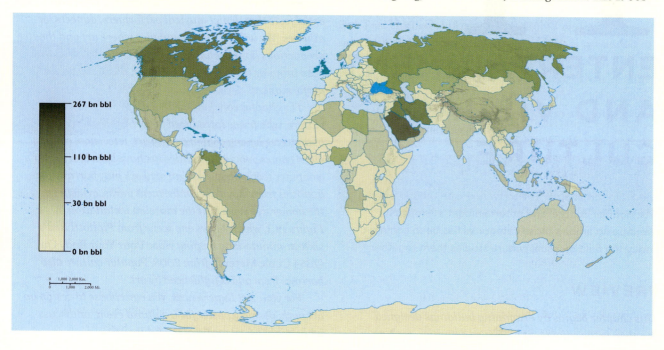

267 bn bbl

110 bn bbl

30 bn bbl

0 bn bbl

0 1,000 2,000 Km.
0 1,000 2,000 Mi.

14.2 BARNETT NEWMAN. *Broken Obelisk*, 1963–1969. Cor-Ten steel, 24′ 10″ × 10′ 11″ × 10′ 11″. Given anonymously. The Museum of Modern Art, New York.

This is an example of the large, bold artworks produced in the United States during the Cold War era. The theme of this work is the balance between life and death forces, which is symbolically expressed through the pyramid and the obelisk.

saw the founding of modern African states.

This era also brought economic changes. In 1975, China began a program to become a major manufacturer of goods and electronics and became an important economic force in the world. Meanwhile, after 1991, the Soviet bloc disintegrated, and the Communist system was discarded or modified. Elsewhere, open-trade agreements, such as the European Union and the North American Free Trade Agreement (NAFTA), exist in many areas. The World Trade Organization (WTO), created in 1994, is an international body that enforces trade treaties and laws. The global trade community has created opportunities as well as conflicts, economic hardships, and environmental problems.

For nations like the United States, this is the postindustrial era. While most traditional industrial production is overseas, other forms

of capitalism, like the entertainment industry, are growing in importance, starting as long ago as early movies as well as television productions like *I Love Lucy* (Fig. 14.30). Tourism supports many art, cultural, and entertainment sites around the world. Las Vegas, Nevada (Fig. 14.10), perhaps panders most blatantly to tourists.

The trend toward globalism continues, with events in one part of the world often having profound effects everywhere. Culture now can be and is exported globally, as with Miyazaki's *Spirited Away* (Fig. 14.32). By 1980, anthropologists could find no group of people on the entire planet who did not listen to radio. Nevertheless, older art forms continue, although modified, as with the *Eastern Iatmul Hand Drum* (Fig. 14.25), Locke's *Open Circle Dance* (Fig. 14.26), and the *Kanaga Masked Dancers* (Fig. 14.27). In fact, older art forms often influence newer productions,

such as the Broadway play *The Lion King* (Fig. 14.21). Blockbuster exhibitions have brought the superstar phenomenon to art. Communication and computing technologies are converging. Digital technologies are the basis for writing, information access, sound mixing, video editing, and still-image manipulation.

The global culture has brought changes to the natural world. AIDS and other new, quick-spreading diseases have caused alarm. With melting ice caps and destruction of rain forests and coastal habitats, the earth's environment is changing.

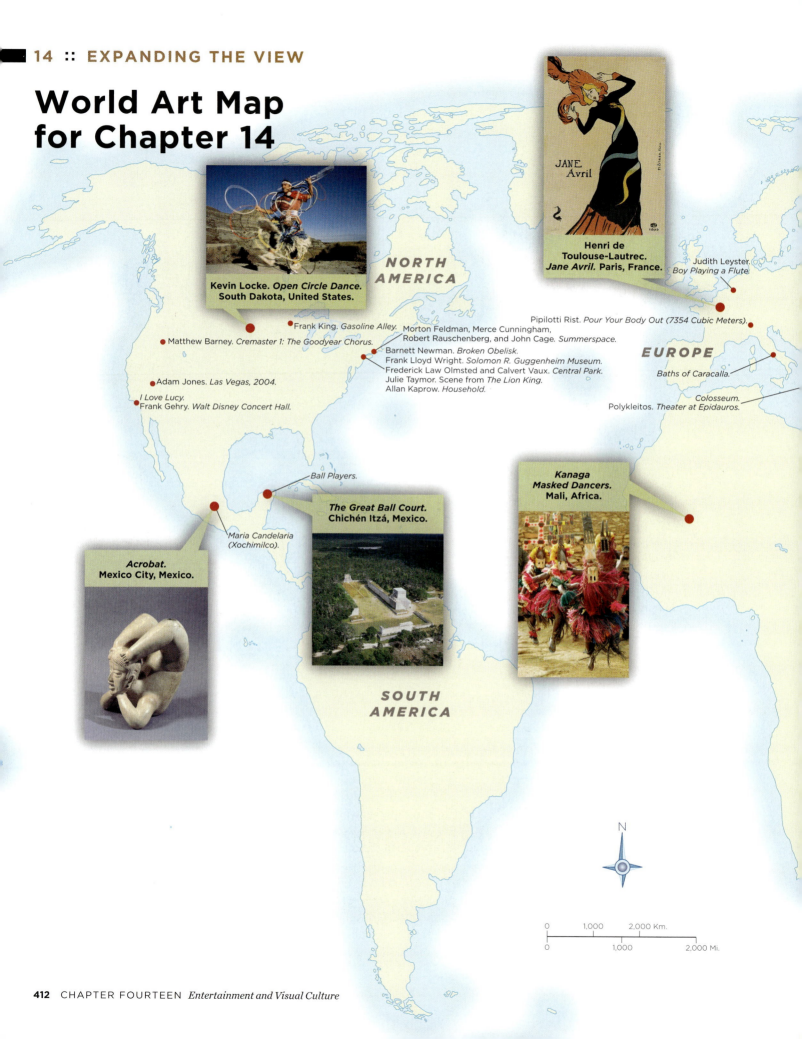

World Art Map for Chapter 14

Kevin Locke. *Open Circle Dance.* South Dakota, United States.

NORTH AMERICA

Frank King. *Gasoline Alley.*

Matthew Barney. *Cremaster 1: The Goodyear Chorus.*

Morton Feldman, Merce Cunningham, Robert Rauschenberg, and John Cage. *Summerspace.*

Barnett Newman. *Broken Obelisk.*
Frank Lloyd Wright. *Solomon R. Guggenheim Museum.*
Frederick Law Olmsted and Calvert Vaux. *Central Park.*
Julie Taymor. Scene from *The Lion King.*
Allan Kaprow. *Household.*

Adam Jones. *Las Vegas, 2004.*

I Love Lucy.
Frank Gehry. *Walt Disney Concert Hall.*

Henri de Toulouse-Lautrec. *Jane Avril.* Paris, France.

JANE Avril

Judith Leyster. *Boy Playing a Flute.*

Pipilotti Rist. *Pour Your Body Out (7354 Cubic Meters).*

EUROPE

Baths of Caracalla.

Colosseum.
Polykleitos. *Theater at Epidauros.*

Ball Players.

The Great Ball Court. Chichén Itzá, Mexico.

Maria Candelaria (Xochimilco).

Acrobat. Mexico City, Mexico.

Kanaga Masked Dancers. Mali, Africa.

SOUTH AMERICA

N

| 0 | 1,000 | 2,000 Km. |
| 0 | 1,000 | 2,000 Mi. |

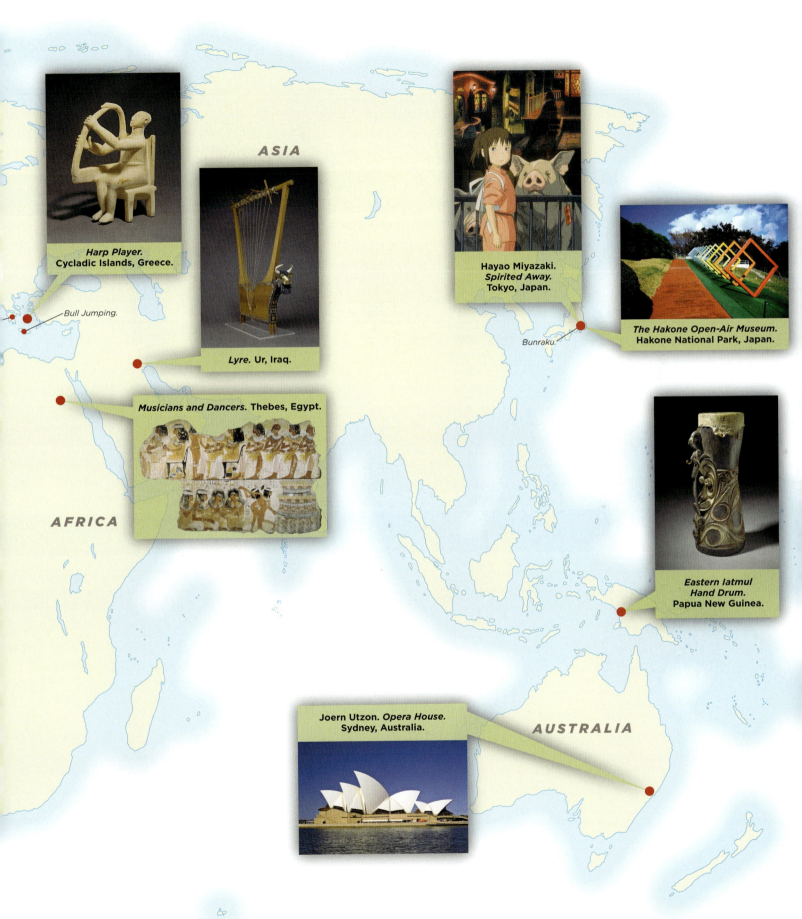

ASIA

Harp Player.
Cycladic Islands, Greece.

Bull Jumping.

Lyre. Ur, Iraq.

Musicians and Dancers. Thebes, Egypt.

AFRICA

Hayao Miyazaki.
Spirited Away.
Tokyo, Japan.

Bunraku.

The Hakone Open-Air Museum.
Hakone National Park, Japan.

*Eastern Iatmul
Hand Drum.*
Papua New Guinea.

Joern Utzon. *Opera House.*
Sydney, Australia.

AUSTRALIA

1950 CE-PRESENT

Roman Art Placed in Baths, Temples, Gardens, Villas, and Forums

Early Theater in India Based on Sanskrit Epics

CLASSICAL GREEK ERA

Early Museum—Alexandria

Three Orchestras/829 Members—Han Dynasty

Chinese Opera in the Tang Dynasty

Pipes and Chimes in Chinese Tombs

ETRUSCAN CIVILIZATION

2685 BCE	2500	1400	1000	400 100	70 CE 100	200 900

Lyre

Harp Player
Bull Jumping

Musicians and Dancers

Acrobat

POLYKLEITOS. *Theater at Epidauros*

Colosseum

Baths of Caracalla

Lamassu, > Assyria (9.10)

∧ Tomb of the Leopards (8.9)

∧ Spring Festival along the River (12.28)

Cold War

ABSTRACT EXPRESSIONISM

Color Television and Color Movies

Korean War

Space Programs Begin in United States and Soviet Union

End of European Colonies in Africa

MINIMALISM

FLUXUS

Vietnam War

The First Mega-Resorts Open on the Las Vegas Strip

HISTORY FOCUS

Isaac Asimov Coins the Term "Robotics"
Television Broadcasting Begins

1940	1950	1960

WRIGHT. *Solomon R. Guggenheim Museum*
Maria Candelaria (Xochimilco)

I Love Lucy
FELDMAN, CUNNINGHAM, RAUSCHENBERG, *and* CAGE. *Summerspace*

UTZON. *Opera House,*
NEWMAN. *Broken Obelisk*
KAPROW. *Household*
Kanaga Masked Dancers
The Hakone Open-Air Museum

∧ FULLER. *U.S. Pavilion* (5.37)

Shakespeare, the Globe

Precolonial Masquerades in Africa

BAROQUE ERA

Bunraku and Kabuki Theater—Japan

Beginnings of Modern Museums

First Art Museums in West

IMPRESSIONISM

POSTIMPRESSIONISM

Telephone Lines Installed in New England

First Film Screenings

SURREALISM

Hollywood—Film Capital

First Commercial Radio Broadcast

Beginning of Global Music Culture

GOTHIC ERA

Noh Theater— Japan

RENAISSANCE

Opera at High Point in Europe

Peking Opera

Zoetrope—Precursor to Film

Telegraph Invented

| 1200 | 1600 | 1800 1850 | 1870 | 1900 1939 |

The Great Ball Court

Ball Players

LEYSTER. *Boy Playing a Flute*

OLMSTED and VAUX. *Central Park*

TOULOUSE-LAUTREC. *Jane Avril*

Eastern Iatmul Hand Drum

KING. *Gasoline Alley*

∧ FRAGONARD. *The Swing* (12.25)

Operation Desert Storm

Expansion of the Las Vegas Strip

Digital Video

Internet

POSTMODERNISM

Technological and Industrial Revolution—China

War on Terrorism

iPod Introduced

Nintendo DS First Sold in North America

| 1970 | 1980 | 1990 | 2000 2008 |

TAYMOR. *The Lion King*

BARNEY. *Cremaster 1: The Goodyear Chorus*

LOCKE. *Open Circle Dance*

MIYAZAKI. *Spirited Away*

GEHRY. *Walt Disney Concert Hall*

RIST. *Pour Your Body Out (7354 Cubic Meters)*

∧ LIN. *Vietnam Veterans Memorial* (9.30)

∧ Bwa *Masqueraders* (2.30)

< ISOZAKI. *Nara Convention Hall* (3.12)

< OLDENBURG, BRUGGEN, and GEHRY. *Binocular Entrance—Chiat Building* (2.33)

ARCHITECTURE FOR ENTERTAINMENT

Art and architecture give visual form to cultural, athletic, and entertainment events. Structures must function well and comfortably accommodate their audiences. In addition, these spaces must meet the aesthetics, expectations, and values of the audience for the activities that happen inside. Sports, arts, and entertainment often have political or religious implications or have meaning beyond one of simple leisure or game playing. Often, the structures that house them make these meanings clear.

"Houses" for the Arts

Our focus figure for this section is also the oldest because it contains precedents for all auditoriums and **amphitheaters** that follow. Ancient Greek comedies and tragedies were originally part of ritual festivals dedicated to the deity Dionysos. They were first performed in natural settings, in the hollows of hills. Eventually, magnificent theaters were designed to add visual significance to these dramas, like the *Theater at Epidauros* (Fig. 14.3), designed

by Polykleitos the Younger around 350 BCE. It is a theater of great size (387 feet in diameter) and formal grandeur that suggests the Classical Greek ideal shape, the circle. The *theatron*, or seating area, could accommodate 12,000 spectators on its fifty-five tiers of stone benches, which rise at a high angle for clear views and good acoustics for all. Stairs connect each section for easy access. At the very center was the orchestra platform, a circle in which the chorus would dance near or around the altar of Dionysos. Behind the orchestra is a long, rectangular structure used for the stage, backed by the **skene,** a building that provided a backdrop for the plays and contained dressing rooms and scenery. These ritual plays included music and dance, with actors wearing elaborate costumes with oversized masks to emphasize the characters' emotions and amplify their voices through megaphone-like mouths.

The stage and audience structure of the *Theater at Epidauros* has been used through the ages for the interior design of Western houses of the performing arts. However, the outside structure of these buildings reflects the values of their eras. Nineteenth-century houses for the arts often had ornate exteriors to emphasize their importance or to link them to the Classical heritage. Today houses for the arts often reflect modern values of innovation, bold movement, or future potential. The *Opera House* (Fig. 14.4) in Sydney, Australia, stands on the harbor's edge to greet visitors arriving by air, land, or sea. The Danish architect Joern Utzon thought of it as "functional sculpture." Called **organic architecture,** this style was rooted in the work of Frank Lloyd Wright (see Fig. 14.5). Utzon was also influenced by the platform architecture of Mesoamerica. The cascading vaults suggest the billowing of the sailboats in Sydney Harbor, and they are faced with gleaming ceramic tile, adding jewel-like reflections to the fluid forms. Windows are covered by two laminated layers of amber glass, creating a quiet interior with spectacular views of the surrounding harbor. The concert halls, theaters, auditoriums, and recording studio are all lined with rich natural woods, both for aesthetics and for acoustics.

CONNECTION *The British Museum* (Fig. 15.7) is an example of a nineteenth-century house for the arts built to resemble a Greek temple.

14.3 Polykleitos. *Theater at Epidauros*, Greece, c. 350 BCE.

The arrangement of the stage and the audience's seating has set the standard for most Western theaters and auditoriums.

14.4 Joern Utzon. *Opera House*, Sydney, 1959–1972. Reinforced concrete, highest shell 200′ high.

The structure resembles billowing sails, like the ships in Sydney Harbor.

Frank Lloyd Wright's *Solomon R. Guggenheim Museum* (Fig. 14.5) is another example of organic architecture, here designed to exhibit art. Its rounded form encloses a ramp that spirals around an empty center that is 90 feet wide. Certainly, the museum creates a striking visual image. The viewer takes an elevator to the top and then walks down past individual bays with paintings, allowing closer focus on small groups of artworks. The design is memorable, but the space does not work well for showing paintings and sculptures. Artwork can be seen only up close or from all the way across the central open well. There is no in-between vantage point, and some works suffer. Rather than choosing their own course, viewers must see the works in the predetermined order. Because the floor slopes, the exhibition space does not work well for sculptures, and paintings appear askew against the curved wall.

14.5 Frank Lloyd Wright. *Solomon R. Guggenheim Museum*, New York City, design begun in 1943, structure completed in 1959.

This museum resembles a modern, abstract sculpture.

14.6 FRANK GEHRY. *Walt Disney Concert Hall*, Los Angeles, 2003.

There is no single focal point in this concert hall design.

CONNECTION For a view of the inside of the Solomon R. Guggenheim Museum, see Jenny Holzer's installation *Untitled (Selected Writings)* in Figure 10.28.

Frank Gehry's *Walt Disney Concert Hall* (Fig. 14.6), 2003, in Los Angeles, is a recent entry among world-class music centers. Trained as a sculptor, Gehry creates buildings that are often irregular, colliding, sculptural, and perhaps even disorienting because they are asymmetrical or have no apparent central point. The concert hall's structural systems are disguised under the curving stainless-steel surface. Such architecture is called **Deconstructivist** because its many unique viewpoints do not coalesce into a unified whole and there is a disconnection between inside form and outside structure. It is also **Neo-Modernist,** with its emphasis on abstract form.

Other Visual and Performing Art Environments

Throughout the ages, art spaces have been combined with structures that serve other uses. Ancient Greeks had art galleries near their temple complexes. In medieval churches in Europe, treasuries held precious artworks from nearby and far-off lands. Today government buildings all over the world may contain galleries highlighting the artwork of the nation.

In the Roman Empire, many rulers spent public funds to build bathhouses, theaters, amphitheaters, circuses, arenas, and stadiums for the pleasure of their subjects, and they adorned those structures with art. At one time, Rome had more than nine hundred bathhouses, ranging from imperial baths to no-frills public baths, where Romans improved their health and socialized. Features included workout rooms, steam rooms, massage rooms, swimming pools, and warm, hot, and cold baths. Imperial baths boasted libraries, art galleries, restaurants, bars, gymnasiums, and shady walkways. They also offered theater performances, public lectures, athletic contests, and other entertaining features. Excavations of bathhouse sites have revealed much ancient sculpture.

Our focus figure for this section is the *Baths of Caracalla* (Fig. 14.7), built between 211 and 217 by the emperor of the same name, which could serve 1,600 clients. Once covering fifty acres, even its ruins are still amazingly impressive. The baths had brick-faced concrete walls 140 feet high supporting the huge vaulted ceiling. It was an imperial bath, so the interior was palatial, decorated lavishly with stucco ceilings, marble facing, mosaic floors, and colossal statuary, as reconstructed in this drawing. The water for the baths came from the aqueduct, another brilliant Roman invention. Heated air circulated through hollow floors and walls to warm the rooms.

CONNECTION In the sixteenth century, the Greek sculpture *Laocoön and His Sons* (Fig. 11.18) was discovered buried in the ruins of an imperial Roman bath.

In the United States from the nineteenth century to today, the large city park offers a variety of diversions. *Central Park* (Fig. 14.8), in the middle of Manhattan, is a retreat from bustling New York City. With its artwork, performing spaces, and green setting, it is like the Roman *Baths of Caracalla*—but without the spa. The long, narrow park is considered an outstanding example of landscape architecture, and in 1965 it was declared a National Historic Landmark. Designers Frederick Law Olmsted and Calvert Vaux worked with the natural setting rather than completely reshaping it. Hog farms, open sewers, and hovels had to be removed before millions of flowers, trees, and shrubs could be planted. Trails, roads, and bridges were added within the natural rolling terrain.

14.7, *left* *Baths of Caracalla*. As reconstructed in the hand-colored engraving of a nineteenth-century illustration, *Citizens of Ancient Rome Enjoying the Baths of Caracalla*.

This lavish and grand structure was the site for many relaxing, sporting, and cultural activities.

14.8, *below* Frederick Law Olmsted and Calvert Vaux. *Central Park*, New York City, 1857–1887.

The visual arts, performing arts, and other leisure activities find a home in this oasis in the middle of the dense city.

The park today features all kinds of entertaining places and events:

- Metropolitan Museum of Art
- Sheep Meadow, now used for free musical concerts
- Delacorte Shakespeare Theater (free)
- The Ramble (wilderness area trails)
- Zoo and the Children's Zoo
- Wollman Rink and Lasker Rink and Pool
- Chess and Checker Pavilion
- Harlem Meer, a small lake with a boathouse
- Fort Fish and Fort Clinton, blockhouses from the Revolutionary War and the War of 1812
- Sculptures honoring statesmen, writers, children, animals, birds, and military events
- Tennis courts, baseball diamonds, football and soccer fields, children's playgrounds, a cafeteria, bike and bridle paths, and many gardens

CONNECTION The formal gardens that surrounded European palaces like Versailles (Fig. 9.14) and Nymphenburg (Fig. 12.11) were one inspiration for large urban parks in the United States.

The Hakone Open-Air Museum (Fig. 14.9), opened in 1969, is a museum set in nature, located in Japan's scenic Hakone National Park. Like the *Baths of Caracalla*, it is a special environment for appreciating the arts. The exquisitely manicured lawns, woods, and gardens complement the many contemporary outdoor sculptures displayed there, all against the breathtaking beauty of the Hakone Mountains. Indoor galleries feature sculptures and paintings by famous twentieth-century Japanese and European artists.

The mixed-use features of the *Baths of Caracalla* can be seen again in *Las Vegas* (Fig. 14.10), Nevada, where art mixes with gambling, tourism, sports, and entertainment. The casino areas of Las Vegas are dense with reproductions, including Paris's Eiffel Tower, the Sphinx and pyramids of Egypt, the Venetian waterfront, the New York City skyline with the Statue of Liberty, and a medieval castle. Original and copied art is featured in galleries and in the casinos. Major boxing events are held here. Neon art and illuminated signs glow throughout the night. A huge visual spectacle, Las Vegas is a site of tourists' fantasies and desires for glamour and wealth, often satisfied through copies and representations.

ART EXPERIENCE Design an art park.

Sports Arenas

Architecture provides a framework and an appropriate setting for the drama and spectacle of sports events. Our focus figure for this section is again from Rome. In its original condition, the *Colosseum*, or the Flavian Amphitheater (Fig. 14.11), was a feast for the eyes. This huge structure covering six acres was faced with rich veneers of marble, tile, plaster, and bronze. The 160-foot-high outer wall is encircled by four horizontal bands, three with arches flanked

14.9 *The Hakone Open-Air Museum*, Hakone National Park, Japan, opened in 1969.

Cultural treasures and natural treasures mix in this park-museum.

by Greek Classical columns—a monumental celebration of Greco-Roman architecture. Emperors who succeeded the infamous tyrant Nero built it between 70 and 82 CE on the site of an artificial lake in Nero's private park where his colossal statue once stood (hence, the name *Colosseum*).

Inside, a complex design of ramps, arcades, vaults, and passageways efficiently moved more than 50,000 spectators. Admission was always free to all; however, the seating was reserved by rank. The hot sun was blocked by a huge cloth canopy managed by a special detachment of the navy. The center area could be covered with sand for hunting sports and gladiator games or filled with water to enact mock sea battles. Complex underground passages, rooms, and elevators were added later so that animals, scenery, and prisoners could make dramatic entrances to the spectacles. The *Colosseum* was dedicated to blood sports, and thousands of humans and animals perished in the gruesome games, which continued until 523.

14.10, *left* *Las Vegas*, 2004. Sunset, elevated view.

The casinos are lavish visual experiences of brilliant lights, historical replicas, and original art.

14.11, *below* *Colosseum*, Rome, 70–82 CE.

This sport site was lavishly decorated and ambitiously engineered, in part because of the political importance of the building and the events staged in it.

14.12 *The Great Ball Court*, Maya-Toltec, Chichén Itzá, Mexico, eleventh–thirteenth centuries. Stone, 567′ × 228′, I-shaped.

This large, imposing structure housed games that had great ritual significance.

On the North American continent, the Maya culture developed a ball sport that was a form of ritualistic entertainment. *The Great Ball Court* in Chichén Itzá, Mexico (Fig. 14.12), from the eleventh to the thirteenth century, measures 567 feet by 228 feet. Compared to the *Colosseum*, its basic shape is an I-shaped court rather than an oval amphitheater. However, both the *Colosseum* and *The Great Ball Court* have an architectural grandeur because they were ritually or politically important. *The Great Ball Court* has 27-foot-high walls with two stone rings mounted near the top. In a game similar to contemporary soccer, the players used their heads and bodies to project the hard ball, which took much strength and skill through the long, arduous game. The Mayan people saw the ball game as a metaphor for the epic journey through the Underworld taken by the hero twins, the Sun and the Moon, with underlying meanings about the conflict between good and evil and the cycles of heavenly bodies. The game ended when the ball passed through the stone ring, and then one player (or perhaps one team) became a human sacrifice to the gods.

The dramatic ball court is a fitting setting for the ritualistic game. It features the Temple of the Jaguar on the long east wall and another temple at the far north end. Phenomenal decorative reliefs cover the walls. The acoustics of the court are also amazing. A person standing in one temple can hear a conversation taking place in the temple at the other end. Similar ball courts existed at most major urban centers of the Maya and other Mesoamerican peoples, with some variations in the designs. Many still stand.

CONNECTION The same qualities of grandeur and spectacle seen in the *Colosseum* and *The Great Ball Court* are present in many sports arenas today, including the *Olympic Stadium, Munich* (Fig. 2.44).

ART THAT ILLUSTRATES LEISURE ACTIVITIES

Throughout history and across cultures, artists have recorded the spectacles, leisure activities, and forms of entertainment in their cultures.

Images of Athletes

The focus figure for this section comes from the Minoan culture on the island of Crete. The fresco wall painting *Bull Jumping* or *Toreador Fresco* (Fig. 14.13), dating from c. 1550–1450 BCE, is part of a group of murals with bulls as the subject matter, located in the ruins of the palace at Knossos. It may refer to the mythical Minotaur, a half-man and half-bull beast, to whom young men and women were sacrificed. The bull also symbolizes fertility and strength.

The contestants are trim, youthful, and idealized. They demonstrate their courage with every leap and tumble, as they face the fury of the bull and all he stands for. The overall forms are flowing, undulating, and floating, as if referring to the ocean that surrounds the islands. The massive bull seems graceful, and the figures seem weightless, as if suspended in water. In ancient Mediterranean civilizations, gender was often indicated by dark (male) and light (female) skin tones.

Athletes are often depicted in an ideal manner, as in the *Bull Jumping* fresco and again in the vase painting of *Ball Players* (Fig. 14.14), which shows some of the very ballplayers who would have competed on the Maya ball court in Figure 14.12. Team members are covered with elaborate dress and heavy padding, especially on the chest and knees. This was eye-catching attire that also provided necessary protection from the hard ball. Patterns and insignia cover the players' clothing, and they are adorned with earrings and a large animal headdress, showing that ballplayers enjoyed considerable status in Mayan society. In usual Mayan fashion, the painting combines outlined, dark silhouette forms and patterned areas. The figures, though stylized, seem powerful and lithe.

14.13 *Bull Jumping*, palace complex at Knossos, Crete, c. 1550–1450 BCE. Wall painting, 2′ ½″ high.

Youthful acrobats leap over the back and the horns of a bull.

14.14 *Ball Players*, Maya, Mexico, eleventh–thirteenth centuries. Vase painting.

Elaborate padding and costumes were worn by Mayan ballplayers.

14.15 *Acrobat*, Early Pre-Classical, Mexico, 1200–600 BCE. Light clay, 10″ × 6½″. National Museum of Anthropology, Mexico City.

The ancient contortionist is the inspiration for the clever composition of this small sculpture.

Also from Mexico comes the *Acrobat* (Fig. 14.15), from the ancient village of Tlatilco located outside Mexico City, discovered in 1940. Like the *Bull Jumping* figures, this *Acrobat*, from 1220–600 BCE, is rendered in a simplified way, with smooth outer lines and relatively few anatomical details. He has a relatively naturalistic face framed with a stylized, incised hair treatment and articulated toes. The head is disproportionately large, with a concentrating, straining expression. Compositionally, the bent arms and legs create diagonals that frame the face. Graves contained burial offerings that included figurines of females, ballplayers, musicians, dancers, and acrobats. Clearly, these artifacts indicate that these ancient peoples prepared for an afterlife full of entertainment.

Music and Dance Imagery

Artworks that depict music and dance can tell us about the musical forms of cultures now long lost and about the social, political, and religious framework into which music fits. The sculpture and two paintings in this section give visual form to performing events.

The focus figure is from seventeenth-century Holland; it is a painting of a young boy engrossed in playing his flute by Judith Leyster, a prolific artist whose work was well known at the time, a rare accomplishment for a woman in a predominantly male art world. *Boy Playing a Flute* (Fig. 14.16), 1630–1635, is considered her masterpiece. Leyster captures the pride and the enthusiasm of the young musician as he glances at his audience, likely looking for their approval. The mellow tones of the painting suggest the soft tones of the flute. In the shallow space, the boy is balanced compositionally with the instruments hanging on the wall.

Holland at the time was predominantly middle class and Protestant, so music was not written for grand productions for the nobility or for elaborate rituals for the Catholic Church but was often performed in the middle-class home. Leyster painted the boy as an ordinary child, playing for his own pleasure and that of his family, in a home graced with several musical instruments.

In contrast to the detail and individuality shown in *Boy Playing a Flute*, our next sculpture is a more abstracted work, where the smooth curves of the musician and instrument almost become as one. In the Cycladic Islands off Greece, sculptures of male musicians were found buried

14.16 JUDITH LEYSTER. *Boy Playing a Flute*, Netherlands, 1630–1635. Oil, 2′ 4½″ × 2′ ¼″. National Museum, Stockholm.

This painting documents the presence of music in ordinary middle-class homes in the Netherlands in the seventeenth century.

in graves along with plank marble goddess figures like that in Figure 6.4. The *Harp Player* (Fig. 14.17), from c. 2500–1100 BCE, is smoothly carved with clear, simplified forms. Close attention was given to the hands and fingers, as in his thumb that plucks invisible strings. The upper torso, arms, and head are exaggerated or stylized. The proportions of the musician figures appear standardized, with a fixed ratio of height to width, perhaps reflecting the mathematical relationship of musical intervals. The *Harp Player* is better viewed in profile rather than from the front.

Just as the *Boy Playing a Flute* reflects the northern European Protestant middle class from which it came, the Egyptian wall painting of *Musicians and Dancers* (Fig. 14.18) reflects its culture's style of entertainment and its fixation with funerary rituals and the afterlife. Traditionally, living relatives celebrated the anniversaries of the dead in their

14.17 *Harp Player*, Cycladic culture, c. 2500–1100 BCE. Marble, approx. 1′ 2″ × 3″. Rogers Fund, 1947 (47.100.1). Metropolitan Museum of Art, New York.

Musician and instrument seem almost combined in the simplified, smooth forms.

14.18 *Musicians and Dancers*, from the tomb of Nebamun, Thebes, Egypt, c. 1400 BCE. Fresco, 1′ × 2′ 3″. The British Museum, London.

In the bottom area of this painting, the style of depicting the human form is unusually free, relaxed, and unstructured when compared to the more typical, formal style, seen at the top.

tombs, some of which were quite large and elaborate and featured fresco wall paintings. In *Musicians and Dancers*, from the tomb of Nebamun, dated c. 1400 BCE, four finely dressed women sit casually in the bottom part of the image, with one playing an oboe-like instrument while others clap in rhythm. The cone on top of each woman's head was made of perfumed animal tallow, which would melt and run down their bodies, covering them with fragrant oil. To the right are barely clad dancers and stacked wine jars.

The painting style at the bottom of this fresco is relaxed as well, which contrasts with the formal depictions of higher-ranking Egyptians at the top. The ladies' hair is loose, the soles of their feet are shown, and two face the viewer head-on rather than in the typical Egyptian profile. The lively dancers are smaller, indicating their lesser rank. The whole scene gives the feeling of levity and pleasure meant both for the spirit of the deceased and for the living.

ART IN ENTERTAINMENT

This section contains works that straddle the borders dividing art, popular culture, and entertainment. In addition to their striking visual elements, most of these artworks have components of sound, music, movement, or dance. Many works in this section are often-repeated performances or mass-produced images or objects. Also, many are included here as indicators of new trends. This is in contrast to one-of-a-kind artworks that are valued for their uniqueness, which we have frequently seen earlier in this book.

Art and Dramatic Productions

The visual arts have long been part of dramatic productions, especially in masks, puppetry, set design, costumes, and graphics. Theater has in turn influenced the visual arts, particularly performance art.

Our focus figure is by Henri-Marie-Raymond de Toulouse-Lautrec, who lived in the cabaret and theater district of Montmartre, Paris, in the 1880s. There he became friends with artists, entertainers, street people, and prostitutes, many of whom were depicted in his work. Other visual artists have produced graphics for the performing arts, but Toulouse-Lautrec is well known for his street posters of Paris nightlife, which reached a wide audience consisting of people who probably did not attend art galleries and salons. A favorite subject was *Jane Avril* (Fig. 14.19), a singer and dancer at the famous cabaret Moulin Rouge. This 1899 poster captures the provocative essence of the cabaret. Avril's sensuous silhouette is composed of simple, fluid shapes filled with bright, flat colors. The coiling snake emphasizes her curves and suggests that

she is a temptress, like Eve to Adam. Her written name balances the negative space and at the same time visually supports her exaggerated back bend. Toulouse-Lautrec was influenced by shallow space, decorative color, and the fluid contour line of Japanese prints. His work strongly influenced later graphic designers.

In addition to producing posters, artists have created objects used in live performances, including props, backdrops, and puppets. In many cases, like Toulouse-Lautrec's posters, these visual elements are essential for conveying the theme and mood of the performance.

Puppetry is an art form at least four thousand years old. Japan has a traditional form of "doll drama" called *Bunraku* (Fig. 14.20), which was originally performed by traveling troupes. Doll dramas continue today. The naturalistic puppets are one-half life-size with articulated hands, heads, eyes, brows, and mouths. Only male characters have articulated legs because female puppets wear long robes. Wearing elevated sandals, the master

14.19 HENRI DE TOULOUSE-LAUTREC. *Jane Avril*, Paris, 1899. Lithographic poster, 1′ 10″ × 1′ 2″.

Artists have often provided imagery for theater or dance that captures the essence of the performance.

14.20 Bunraku performance on stage, Japan, c. twentieth century.

Ancient doll dramas are preserved in Japan as national treasures.

puppeteers, whose faces we see, hold the puppets up and work their head and facial features with one hand and their right hand with the other. Assistants covered in black control the left hand and the feet. Lengthy practice and discipline are required to get all actions precisely synchronized, as they work in full view of the audience. The puppeteers are accompanied by a singer-narrator and a musician playing a three-stringed instrument called a samisen. The singer describes the scenes, voices all the roles, and makes comments to enhance the drama. All the elements, including the voices, the puppets, the movements, and the music, combine to create an art form that Japan recognizes as a national treasure.

Puppetry took a new form in the mid-1990s on the Broadway stage with Disney's *The Lion King* (Fig. 14.21), which featured a unique combination of human-puppet characters, created and directed by Julie Taymor. Her background includes Indonesian masked dance, Bunraku

14.21 JULIE TAYMOR (designer and director). Scene from *The Lion King*, New York City, opened mid-1990s.

Elements of art, theater, and popular culture mix in the design and performance of this Broadway play.

puppetry, and Western opera. Because the puppeteer-actors are visible, both the story and the process of telling the story unfold simultaneously. This is especially appropriate because the animal characters endure human-like rites of passage and a search for identity. In our example, the dancers perform high, graceful leaps, mimicking antelopes' movements, and their costumes are coordinated with those of the puppets. Again, the striking visuals add to the dramatic performance.

Set design is another area of significant overlap between the visual arts and the performing arts—but, of course, in a different way than the Toulouse-Lautrec poster of *Jane Avril*. In 1958, U.S. artist Robert Rauschenberg, choreographer Merce Cunningham, and composer Morton Feldman created an innovative and provocative work entitled *Summerspace* (Fig. 14.22); with John Cage as musical director, it was first performed at the American Dance Festival. All components were performed together but were also independent of one another, with aspects of improvisation and chance. Cunningham conceived of space as a continuum, without a focal point for the dancers. Conceptually, this was like some abstract painting in which there is no figure that is more important than the background. Cunningham was also influenced by Albert Einstein's theory of relativity, which posited that there are no fixed points in space. Rauschenberg designed the sets

and costumes to echo the dance that had no center point but that moved from all points on the stage. The dancers' costumes were covered with dots (or points) like the set, giving each element equal visual importance.

In recent years, the performing arts have had a great influence on the visual arts, especially in **performance art,** a visual art form that incorporates live action and mixed media and is presented before an audience. The first performances were 1960s *Happenings* organized by Allan Kaprow, who believed that art, like life, should be unstable, transitory, and ambiguous. What *happened* was what was important. This opposes much previous Western thought, which regarded artworks as pure, transcendent, universal objects meant to endure. Kaprow felt that art should mesh with life rather than interpreting life experience. During Happenings, participants and audience were often one and the same.

For *Household*, Kaprow set the Happening to begin at a specific time in a dump area in Ithaca, New York, close to Cornell University. It began as male participants built a tower of garbage while women built a nest of twigs and string, suggesting the traditional domain of each gender. From inside the nest, the women began screeching at the men, who brought a wrecked car and smeared it with strawberry jam. The women left their nest and began licking the jam off the car (Fig. 14.23) while the men destroyed

14.22 *Summerspace.* Music by Morton Feldman, choreography by Merce Cunningham, set and costumes by Robert Rauschenberg; John Cage, Musical Director of the Cunningham Dance Company. Premiered at the American Dance Festival at Connecticut College, New London. Dancers: Viola Farber (standing) and Carolyn Brown.

A visual artist provided the design of the costumes and backdrops in this experimental dance production.

14.23 ALLAN KAPROW. *Household*, May 1964. Performance Happening. Commissioned by Cornell University, New York.

Happenings were events that began with a simple premise but progressed in unexpected ways through spontaneity and improvisation.

14.24 *Lyre*, sound box from the tomb of Queen Puabi, Ur (Iraq), c. 2685 BCE. Wood, gold and shell inlay, lapis lazuli, 5′ 5″ high. University of Pennsylvania Museum, Philadelphia.

Beautiful design and expert craftsmanship distinguish this lyre, which was part of an ancient royal burial.

the nest. Afterward, the men wiped the jam off the car with white bread and ate it while the women retaliated by decimating the men's tower. The event continued with violence until the men demolished the car and set it on fire. In silence, all participants watched the car burn and then departed without words. *Household* was bizarre, surreal, and ambiguous like a dream, and Kaprow welcomed individual interpretations.

ART EXPERIENCE Design a poster for a theater, music, or dance event.

Musical Instruments and Dance

The visual arts and music also overlap—but in ways different from visual art and theater. Historically, artists have made musical instruments and continue to do so today. Aspects of dance recall the visual arts, and artists have provided props for dancers.

The focus figure is an artwork that is also a musical instrument. The *Lyre* (Fig. 14.24), beautifully crafted of wood, lapis lazuli, and gold and shell inlay, was found in the royal Mesopotamian tomb of Queen Puabi, dated c. 2685 BCE. The instrument, similar to a harp, has a

14.25 *Eastern Iatmul Hand Drum*, East Sepik province, Papua New Guinea, c. 1900. Wood, fiber, shell, animal hide, red and white pigment 1' 11¾" × 9". Los Angeles County Museum of Art.

To make this drum, the center of a log was hollowed out. The exterior, along with the handle, was then shaped and carved from that same piece of log.

wooden sound box and body composed of clean rectangles and subtle curves, with decorative sculpture and scenes as accents. The stunning blue-bearded bull is made of gold and lapis lazuli, an imported semiprecious stone. It is naturalistic with highly stylized details, such as the outlined eyes and patterned beard. Bearded bulls were symbols of royalty.

Beneath the bull's head are four scenes made of shell inlaid in bitumen. They may depict a fantastic banquet, fables, or the myth of Gilgamesh. These scenes are typical on the many lyres and royal standards found in burials that have been excavated. Such a grandly made lyre is both a visual and a musical work of art.

Just as fables or myths are important components of the *Lyre*, ritual is an important dimension for the *Eastern Iatmul Hand Drum* (Fig. 14.25). In both cases, it is not

enough that the drum or lyre functions musically; they are also beautifully crafted works of art. In Melanesia, men make and use very large as well as small drums in ceremonies for a boy's initiation, to placate ancestor spirits who died because of an enemy raid, and for magical rites. This midsized drum is carried in one hand while the lizard skin head is struck with the other. The slender, hourglass-shaped drums were usually decorated with ancestral and head-hunting symbolism, represented in the figures on the handles.

Turning to dance, the North American Sioux *Open Circle Dance* (Fig. 14.26) was part of the annual celebration of the springtime rebirth of nature. The dancer performs to a rapid rhythm, using twenty-eight hoops made of wood or reeds. All movements have spiritual significance and together are visualizations suggesting the unity of all things in the universe as well as individual growth, change, and metamorphosis. Some parts of the dance re-create the image of an eagle soaring in flight, suggesting that parts of nature (including human beings) belong to the spiritual world in the heavens. Another configuration represents the caterpillar, which, during the dance, will become a graceful butterfly. The rigorous performance climaxes with the "Hoops of Many Hoops," when all things of the universe come together as part of a hopeful Sioux prophecy for peace among all people. This dance is an elaborate variation of older forms that has been developed because of the interest of tourists. Once again, entertainment, art, and ritual mix.

The Dogon people in Mali connect the dance, costume, and Kanaga mask (Fig. 14.27). The performers are members of a male masked society called the *awa*, who, in their dance, tell their culture's story about how death entered the world. The masking and the red color of the costumes are believed to catch, manipulate, and rechannel vital forces that could pose potential danger to the community if unleashed. Kanaga masks are worn three days after a death in the community, when the spirit of the deceased is believed to leave the body. The masks, carved by the performers, may represent various beings, such as a mythological crocodile, birds in flight, an ancestor who is re-created in the ritual dance, or a rabbit with tall ears commemorating the changing of generations, as seen in our example.

ART AND VISUAL CULTURE

The last several decades have been unique in human history because of the impact of mass media. In Chapters 1 and 4, we introduced the idea of **visual culture** as the totality of images and visual objects produced in industrial and postindustrial nations and the ways that those images

14.26 KEVIN LOCKE. Performing the *Open Circle Dance*, Sioux, United States, twentieth century.

Hoop dances are performed by one dancer with many hoops; the dancer spins the hoops to create shapes that are symbolically important for the story being told through the dance.

are disseminated, received, and used. Visual culture is also the field of academic study that researches these phenomena.

As discussed in the section on "Art within Visual Culture" (page 11), an almost constant barrage of images comes to us today from art, advertising, information design, gaming, news organizations, science, and education. Researchers in biology, medicine, and astronomy are making visualizations of things that are not visible. Surveillance is part of the public space. Ordinary people are constantly making and circulating images with cell phones and camcorders. Visual culture scholars study visual media of all sorts as well as the "centrality of vision and the visual world in producing meanings, [and] establishing and maintaining aesthetic values, gender stereotypes and power relations within cultures" (Rogoff 1998:14). Image competes with word as our main mode of communicating and of understanding the global culture. Scholars also maintain that our eager consumption of images fills our lives with virtual experiences that replace real life. These images generate emotions related to pleasure, anxiety, power, and fantasy. Vision is associated with the **gaze** (discussed on page 157 in relation to sexuality and on page 352 in relation to race) because power relationships are embedded in "who is looking at whom."

Visual culture is also concerned with **spectacle,** or any kind of public show on a grand scale. This event could be the opening ceremonies for the Olympic Games, the miles of neon lights on the Las Vegas strip, a celebrity making an entrance, a grand immersive video installation

14.27 *Kanaga Masked Dancers*, Dogon, Mali, twentieth century.

In Africa, the masquerade is the art form that combines dance, music, and carving (masks).

14.30 *I Love Lucy*, United States, 1951–1957. Television video, situation comedy (sitcom).

This series is considered one of the all-time classics of American television.

which were the many floating gardens that once produced most of the food and flowers for Tenochtitlan (now Mexico City). Xochimilco is one of the last areas where these gardens and their surrounding canals still exist, as many have been filled in. Today both Mexicans and tourists still float down and enjoy this area's beautiful canals, flowers, and landscape, as seen in the film's frame.

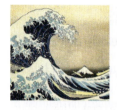

CONNECTION Before the era of inexpensive book illustrations, film, and broadcast television, printmaking helped circulate images more broadly than was possible with painting. See Hokusai, *The Great Wave Off Kanagawa*, page 1, and other examples in this book.

During this era, television came into its own as an important and almost omnipresent medium, adding more layers to our complex visual culture. Television in essence shrank the world, as people could witness events from far-off places right in their living rooms on the small screen. Television became broadly popular in the 1950s. Most of the early television shows evolved from radio programs, such as the quiz show, talk show, travelogue, and sitcom (situation comedy). Later programming expanded to investigative reporting, political coverage, educational programs, music videos, reality TV, and makeover series.

One icon of American family humor is *I Love Lucy* (Fig. 14.30). Performed and filmed before a live audience, this sitcom was rated number one in its time. Even the 1953 inauguration of President Dwight D. Eisenhower drew fewer viewers than the episode on the birth of little Ricky, the child of the two main characters in the sitcom. Although the scripts were undoubtedly effective, much of the humor was communicated visually, through facial expression, gesture, and body language. Notice how clearly the ideas of conflict and outraged surprise are conveyed in Figure 14.30. Still in syndication, *I Love Lucy* remains a popular favorite.

Television and movies have borrowed from art and vice versa. From 1995 through 2003, U.S. artist Matthew Barney created the *Cremaster* cycle of films, juxtaposing historical and autobiographical imagery with bizarre creatures, bodily orifices, and so on. Rather than presenting a narrative, the ravishing imagery promotes personal, free-associative meanings. Much of the films' content deals with gender identity, and many characters have mutant, ambiguous, or partially formed genitalia. Audiences are either repulsed or fascinated. All *Cremaster* films borrow from Hollywood types; for example, *Cremaster 1* references the Busby Berkeley musical extravaganza. Barney also creates individual artworks related to his films, such as *Cremaster 1: The Goodyear Chorus* (Fig. 14.31), a color print based on a film still.

14.31 MATTHEW BARNEY. *Cremaster 1: The Goodyear Chorus*, United States, 1995. Color print in self-lubricating plastic frame, 3′ 7¾″ × 4′ 5¾″.

Art films may borrow from popular movies. In this case, the artist has mimicked some qualities of Busby Berkeley films.

Animation grew out of flip books, in which a series of drawn images seems to move as book pages are flipped rapidly. Early animation features gained a wide following beginning in the 1930s. Animation is labor-intensive if completely hand-drawn; for example, an average of 14,000 drawings is required for a ten-minute animation sequence. **Traditional animation** is drawn on transparent sheets so that foreground action figures can be separated and moved across an unchanging background. **Claymation,** a relatively early form of animation, uses clay sculptures that are photographed while being moved in tiny increments. **Computer animation** is a new form that allows characters to be plotted as a series of points and vectors and made to move with mathematical computation. Disney and Warner Brothers were two pioneers in the animation industry, but other studios and independent producers now exist.

Hayao Miyazaki's *Spirited Away* (Fig. 14.32), 2002, is considered to be an animation movie masterpiece. The story concerns Chihiro, a ten-year-old girl separated from her parents in a fantastic and sometimes frightening land.

14.32 HAYAO MIYAZAKI. Still from *Spirited Away*, Japan, 2002. Feature-length animated movie.

Making drawings move is the great appeal of animation.

In the process of reuniting with them, she grows up. Miyazaki created scenes with fantastic structures and broad vistas that are amazingly beautiful, are often vast and ornate, and draw from a variety of historical and global sources. Likewise, lush landscapes abound. Miyazaki is known for his elaborate hand-drawn architectural interiors and diverse characters.

Games and Toys

Games have existed since at least 5000 BCE. They are appealing combinations of social interaction, competition, skill, and chance. Games also please the eye and hand if they feature sculpture-like pieces or rich colors, textures, and patterns. Figure 14.33 shows ancient *Egyptian Board Game Pieces*, c. 3000 BCE, for a game called Mehen with a game board shaped like a coiled snake and three pieces each of lionesses and lions. The lions are appealing to players because they are little touchable works of art.

Video games are a newer addition to the game world, although they will never replace the physicality and social experience of traditional board games. In addition to video games for entertainment, some artists are experimenting with games to deliver an artistic experience, while educators are working to see if games can be effective teaching tools. Interactive video games can be completely absorbing to adults and very young children (Fig. 14.34), at times replacing the real world in people's lives.

Other electronic toys and games populate our living spaces with innovations combining artistry, engineering, and computer programming. The robotic toy staged in Figure 14.35, *Girl Reaching Out to a Robot*, is just one example of remote-controlled electronic versions of traditional stuffed animals, model cars, dolls, and warriors, and character-like robots.

14.34 Five-year-old boy playing with his Nintendo DS game console, 2013.

Video games deliver screen after screen of interactive images, which are very absorbing.

In the years to come, the evolution of technology and media-based art will bring more complex and exotic forms of entertainment, coexisting with previous traditional forms. Art, design, technology, and entertainment will be integrated in new ways and will include functionality and educational purposes as well. The future is almost here.

14.33 *Board Game Pieces*, Abu Roash, Egypt, early Dynastic period, c. 3100–2890 BCE. Ivory. Egyptian National Museum, Cairo.

Board games can be like small works of art.

14.35 *Girl Reaching Out to a Robot*, 2010.

Art, design, technology, and entertainment are integrated in new ways in the twenty-first century.

III

MAKING ART PART OF YOUR LIFE

Art is all around you, and so are beautifully designed objects, immersive environments, and artistic experiences. Here are three examples of public art along the Charlotte, North Carolina, Blue Line. Like these, there are many opportunities to see art where you live and wherever you travel. This section shows the many ways that art and visual culture are in your life.

Three artworks from the Charlotte, North Carolina, Blue Line. Susan Brenner, *BLE Elevator Tower*, 2017 (top); Dennis Oppenheim, *Reconstructed Dwelling*, 2011 (bottom left); Alice Adams, *Intervention*, 2011 (bottom right).

Find art in your city or town.

CHAPTER 15 ART IN YOUR LIFE

This chapter is a challenge for you. Find, enjoy, and engage in art in the world that is both around you and part of you. Connect art to your own personal life and the artistic expression of all humanity.

15

ART IN YOUR LIFE

Put into action what you have learned in this book. Have art in your life. Participate in art events where you live. Make art. Bring art and design to your community.

PREVIEW

Thomas Jefferson's parlor at his home in Monticello (Fig. 15.1) was filled with art, crafts, and furnishings. You also live everyday surrounded by art, design, craft, and visual culture. From the moment you wake and throughout your day, you see images inspired by art, use objects that designers created, gather information visually, and move through spaces shaped by architects. In this chapter, we will show you even more ways to get art into your life.

EXPERIENCING ART IN PERSON

In person, art is richer than seeing it on your phone or in a book, where everything is the same small-sized flat image.

If you only saw Kehinde Wiley's 2016 painting *The Lamentation* (Fig. 15.2) on your phone, you would miss out on so much. Seeing the sixteen-foot-wide painting in person is more stunning than seeing a three-inch-tall version on your phone. In person, you would also see three more paintings and six large stained-glass windows by Wiley showing contemporary African Americans as saints and martyrs done in Baroque painting styles. If it were possible for you to have seen the Wiley exhibit in the Petit Palais in Paris, you would have seen his work next to original eighteenth- and nineteenth-century paintings like those that inspired him.

So get out and immerse yourself in the real thing. Go see art.

Public Art

Public art is a good way to see art in person. About 50 years ago, public art started to change from something you looked at, like a statue in the park, to something you experience, with multiple components. The *St. Louis Gateway Arch* (Fig. 15.3), designed by Eero Saarinen and Associates and constructed from 1963 to 1965, consists of a park, a museum, and a 63-story stainless-steel monument with trams in the legs that transport visitors to the top for a great view. The arch has become the emblem of St. Louis. Recent public art is often linked to local history, regreening cities, and urban renewal. The arch and park replaced several blocks of urban blight (ironically the oldest and most historic core of the city).

One recent Philadelphia public artwork used social media to be interactive. The 2012 temporary piece *Open Air* (Fig. 15.4) by the Mexican-Canadian artist Rafael Lozano-Hemmer consisted of 24 powerful searchlights that changed brightness and position based on voice messages that the public could send from their cell phones. The shout-outs, songs, rants, poems, and proposals could be heard by everyone with the proper app while they watched the lights. The work changed moment to moment, and low clouds or clear skies transformed its appearance. Temporary, interactive, accessible, and constantly changing—these features allow for a whole new set of possibilities for art.

15.2 Visitor taking a photo of *The Lamentation,* 2016, by Kehinde Wiley at a 2017 exhibition in the Petit Palais, Paris.

Use your phone to capture images, but don't mistake those images for the real thing.

15.3 EERO SAARINEN AND ASSOCIATES. *St. Louis Gateway Arch*, constructed 1963–1965. Stainless-steel exterior, 630′ high. St. Louis, Missouri.

While it is a sculpture to be seen, the Gateway Arch also is an artwork, a ride, a park, a museum, and a frame for the river.

15.4 RAFAEL LOZANO-HEMMER. *Open Air*, September 20–October 14, 2012. Robotic searchlights and interactive website. Benjamin Franklin Parkway, Philadelphia.

Some recent public art is interactive, accessible, and temporary.

15.5 *Millennium Park,* completed 2004. Twenty-four and a half acres including the Jay Pritzker Pavilion, *Cloud Gate*, and the Crown Fountain. Chicago.

This city park is filled with interactive artworks that are very popular with locals and tourists.

15.6 Anish Kapoor. *Cloud Gate* (detail), completed 2006. Stainless-steel plates, 33′ × 66′ × 42′, 100 tons. Millennium Park, Chicago.

This sculpture invites people to come close and touch it.

Public art can exist on a very large scale. *Millennium Park* (Fig. 15.5), 2004, along Lake Michigan in Chicago, is a 24.5-acre public–private partnership on top of a parking garage and train station, making it the world's largest green roof project. The large park contains a performance space, the Crown Fountain, the Lurie Garden, and the *Cloud Gate* (upper center in Fig. 15.5) by Indian-born British artist Anish Kapoor. The *Cloud Gate* (Fig. 15.6) resembles a large, shiny, metal bean, and visitors enjoy its reflective beauty and crazy distortions. It changes the "Do not touch the art" rule to "Please touch and enjoy."

Museums

Of course, another place to see art is in **museums**. The largest museums are national museums, like The British Museum, the Louvre Museum in Paris, and the Smithsonian Institution in Washington, D.C. They have massive collections of art, design works, cultural objects, and historical artifacts, often from all over the world. You can lose yourself for days and still not see everything. The nineteenth-century *British Museum* (Fig. 15.7) has a Greco-Roman façade and traditional galleries inside because at the time it was built, the prevailing European attitude was that ancient Greek, Romans, and Renaissance artworks were the supreme human achievements.

In contrast, the sweeping lines and reflective surfaces of Frank O. Gehry's 1997 *Guggenheim Bilbao* (Fig. 15.8) tells you to expect modern and contemporary art inside. The interior galleries at Bilbao are also large, brightly lit, and spacious.

Find out what art museums are in your area. Go see art in person.

Art Collections in Universities and Other Institutions

Many universities, colleges, churches, religious shrines, large corporations, libraries, and hospitals have **art collections** open to the public. The entirety of some churches, such as the twelfth-century Chartres Cathedral (see Figs. 7.39 and 7.40), are museums unto themselves.

Some colleges and universities have museums of their own, such as the University of California's Los Angeles Fowler Museum, which once featured a travelling exhibit of ancient Peruvian art (see Fig. 8.12). Others have permanent art collections, like the 19 major installations of public art

15.7 SIR ROBERT SIDNEY SMIRKE. *The British Museum*, portico, south façade, London, 1823–1847.

Museums like this have huge collections of art from the past.

15.8 FRANK O. GEHRY. *Guggenheim Bilbao*, Bilbao, Spain, 1997.

Museums built in modern architectural styles often specialize in contemporary art.

15.9 Do Ho Suh. *Fallen Star,* 2012. Permanent sculpture and garden on the roof of the seventh floor of Jacobs Hall. Stuart Collection, University of California, San Diego.

Many universities have art collections that are open to the public.

in the Stuart Collection at the University of California, San Diego. A 2012 installation is *Fallen Star* (Fig. 15.9) by Korean artist Do Ho Suh in which a small cottage seems to have crashed, Wizard-of-Oz-like, onto the roof of the modern engineering building. This piece is about the leaving home and cultural displacement, a fitting theme both for students away from home and for the large immigrant population in southern California. Another Stuart Collection sculpture is Tim Hawkinson's *Bear* (see Fig. 1.19).

Almost every college and university with an art department has student galleries where you can see stimulating artwork in person (Figure 15.10). Go support the work of emerging artists!

Art Galleries, Art Fairs, Craft Fairs

Commercial venues like art galleries, art fairs, and craft fairs are still more places to see art. In these venues, the work is for sale. Art galleries are often clustered together in arts districts, and you can see the work on exhibition for free. Art fairs are week-long events in major urban areas like Miami, Basel, New York, or Beijing. Large commercial galleries from all over the world rent booths in art fairs to show work by their featured artists. Generally there are admission fees for art fairs. Art fairs are intensely immersive, with an almost overwhelming amount of artwork in a relatively small space.

15.10 Students hanging artwork in a student gallery. Check out the student galleries to see some excellent work.

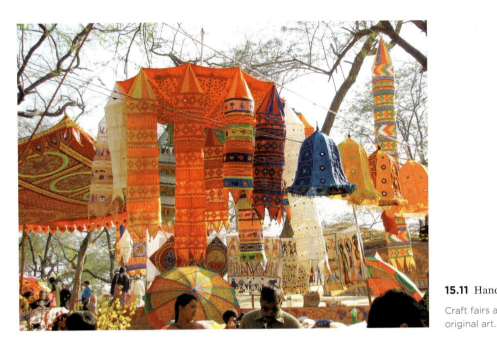

15.11 Handicrafts at Surajkund Mela, India.

Craft fairs are excellent places to see original art.

You can see more art in one day at a fair than would otherwise be possible, even if you had a lot of travel and viewing time. Craft fairs are usually local, casual, open-air events that you can find in almost all cities or state fairs (Fig. 15.11).

Street Art

Often you can see art on the street spray-painted directly on walls. **Street art** emphasizes imagery, unlike tagging and some graffiti that is text heavy. Street art can be political, as in Egypt at the time of the 2011 Arab Spring upheavals (Fig. 3.31) or when paintings covered the western side of the Berlin Wall in the late twentieth century. Some street art can simply be whimsical or lovely drawings and paintings, like the large rooster drawing in Puerto Rico (Fig. 1.14). Some street art is created with the permission of the property owner, while some is unsanctioned.

Most street artists work outdoors to communicate directly with the public without the filter of curators who choose what art is shown in museums. The work of famous street artist Banksy (which is the pseudonym for a British political activist) deals with economic and political oppression, sexuality, war, peace, and power. In Figure 15.12, Banksy's unnamed painting shows a graffiti-removal worker obliterating what seems to be prehistoric cave painting. Banksy believes that street painting is as valuable as art in museums.

What do you think of it?

15.12 BANKSY. Street art depicting a worker removing prehistoric cave paintings, 2008. Painted for the Cans Festival Graffiti Exhibition in an unused London Underground tunnel.

Banksy precuts stencils to make his street art quickly and stealthily.

15.13 GIORGIO VASARI. *Studiolo of Francesco I de' Medici*, 1570–1572. Palazzo Vecchio, Florence.

Private collections were often housed in special rooms in palaces, which were precursors to museums.

Private Collections

People often collect art and use their home or office as a gallery. Private collections go back for centuries. The 1570–1572 *Studiolo of Francesco I de' Medici* (Fig. 15.13) is a chamber where Francesco I stored his collection of rare items such as relics or antiquities, and experimented with alchemy. The cabinets for the curios are long gone, but wall paintings indicate what they once contained. Another example of collections in a home is the parlor at *Monticello* (Fig. 15.1). Do you have your own collection in whatever category of art you like? If not, go for it.

> **ART EXPERIENCE** Go to non-art places in your town and photograph images, objects, or spaces that seem art-like to you. In what ways are your photographs like any of the artworks in this book?

Archeological Sites

Traveling to **archeological sites** will give you an experience that cannot be duplicated by reading about them in a book. The *Nohoch Muul Temple* pyramid at Coba (Fig. 15.14) is the tallest pyramid in the Yucatan Peninsula from the pre-Columbian Maya civilization. Visitors climb to the top of the 14-story structure using only a rope handhold. If you can make it happen, there is no substitute for the actual experience.

15.14 *Nohoch Muul Temple*, Coba archaeological site, Quintana Roo, Mexico, 200–600 CE. 138′ high.

The pyramid rises from a dense tropical jungle.

15.15 *Cathedral of St. Basil the Blessed,*
1555–1561. Moscow.

This church is now a secularized World
Heritage Site and a destination for tourists.

YOUR CULTURAL HERITAGE

Your **cultural heritage** includes all the works of art made
by past generations that are still present today. Now your
involvement with art can add to culture and increase the
legacy of art, wonders, and monuments that will be passed
on to future generations after you.

Cultural heritage is not to be taken for granted. While
some is preserved, other parts are ignored, lost, deterio-
rating, or purposely destroyed. Consider the *Cathedral of
St. Basil the Blessed* in Moscow (Fig. 15.15), a sixteenth-
century church made up of several small chapels that the
Communist government threatened to demolish in the
1930s because it represented the power of the Czarist and
the Russian Orthodox religion. Incredibly, at that time,
some people did not appreciate the historical significance
and fantastic design of St. Basil. Eventually it was spared
and restored, and today is a cherished part of the Russian
cultural heritage.

Look around where you live. Some of your cultural
heritage may be in museums, but other things may be
neglected or overlooked. You can get involved in local
groups that recognize and develop the art resources in their
communities. For example, in Dubuque, Iowa, a moder-
ate-sized city, ordinary citizens banded together with the
county historical society to create the *National Mississippi
River Museum & Aquarium* (Fig. 15.16), which celebrates
the art, technology, and history of the Mississippi River.
Historic warehouses, boats, and waterfronts were saved
thanks to the efforts of citizens who cared about the merit
of things in their "backyards." What started from almost
nothing is now a popular tourist destination affiliated with
the Smithsonian Institution. What a gift to the city!

15.16 *National Mississippi River Museum & Aquarium,*
Dubuque, Iowa.

People working together can preserve their cultural heritage.

Should every artwork, building, and scientific artifact be saved? First, it is important to realize that some things are meant to be temporary. For example, traditional Navajo sand paintings were made during rituals and then destroyed. Navajo attitudes about beauty, art, and permanence are expressed in the following:

A Navajo experiences beauty most poignantly in creating it and in expressing it, not in observing it or preserving it. The experience of beauty is dynamic; it flows to one and from one; it is not in things, but in relationships among things. Beauty is not to be preserved but to be continually renewed in oneself and expressed in one's daily life and activities. (Witherspoon 1977: 178)

Open Air (Fig. 15.5) was always meant to be temporary. Andy Goldsworthy's *Dandelion Line* (Fig. 15.17) from 2000 was an outdoor installation intended to

CONNECTION Hopi and Zuni men perform sacred ceremonies, part of which involves the distribution of Kachina dolls they make, like the *Ahola Kachina* at left (Fig. 7.19). These works are not as temporary as traditional Navajo sand paintings.

create a special moment in nature. The flowers rotted or blew away shortly after completion, and the photographs taken of the work are its only permanent aspect.

In your city or in your home, you can help decide what artwork should be saved. Should the art be accessible (and therefore more vulnerable) or heavily protected? At one extreme, some artworks become so precious that museums set up barriers that make it hard to see, like the dimly lit *Mona Lisa* (Fig. 15.18) by Leonardo da Vinci (c. 1503–1506). This lack of access is the opposite of the interaction that excites so many people about the *Cloud Gate* in Chicago (Fig. 15.6).

As you think about the artwork around you, you will notice that sometimes access is in opposition to preservation. Consider again the *Nohoch Muul Temple* at Coba (Fig. 15.14). Tourists can indeed climb it, but the stones are being worn down by their feet. Air pollution is also bad for stones. If an artwork or structure gets cleaned, harsh chemicals may do undetected damage. For example, centuries-old temples in Southeast Asia covered with vegetation, roots, and fungus are often sprayed with modern detergents and herbicides to remove mold and retard new plant growth, like the enormous sculptures at Angkor Thom in Cambodia (Fig. 15.19).

War and cultural conflicts are also grave threats to art. Much artwork has been lost during armed conflicts over the centuries. In World War II, for example, the Nazis stole millions of works of art, and many are still missing or are in dispute. Conquerors also often

15.17 ANDY GOLDSWORTHY. *Dandelion Line,* 2000. Storm King Sculpture Park, Cornwall, New York.

This outdoor piece lasted a very short time.

CONNECTION Performance art is another form of temporary work. Examples include Suzanne Lacy and Leslie Labowitz's *In Mourning and Rage* (Fig. 3.54) and James Luna's *The Artifact Piece* (Fig. 12.6).

15.18 LEONARDO DA VINCI. *Mona Lisa,* Italy, c. 1503–1506. Oil on wood, 2′ 6¼″ × 1′ 9″, currently displayed behind bulletproof glass. Louvre, Paris.

Preservation measures can sometimes make art inaccessible and difficult to enjoy.

15.19 *Buddha Face Carved in Stone,* Temple of Bayon, complex of Angkor Thom, Angkor, Cambodia.

Harsh chemicals have been used to clear forest growth off ancient temples in tropical areas, but the potential damage has not been studied.

purposely destroy art of the vanquished; vast amounts of Aztec, Mayan, and Incan art and architecture were burned or demolished by the sixteenth-century Spanish conquerors. Medieval Europeans destroyed many ancient Roman monuments. Religious imagery is often vulnerable in conflict; for example, the former Taliban regime in Afghanistan declared the large fourth-century *Bamiyan Stone Buddha* (Fig. 15.20) to be an idol. They completely demolished it in 2001.

In conclusion, not everything can be saved, but you can help preserve your heritage and add to the legacy for those people who inherit from you. You can be an advocate for the **preservation** of art in your own neighborhood or around the world.

Finally, consider making your living space an aesthetic experience. Make choices about the shapes and colors with which you surround yourself. Notice the quality of light in your room or the ceramic mug that

15.20 *Bamiyan Stone Buddha*, Bamiyan, Afghanistan, fourth or fifth century CE, demolished March 2001. 165′ high.

Artworks may be destroyed when they represent cultural or religious beliefs that are in conflict with the current ruling government.

CONNECTION Much of Baule sculpture, like the *Seated Female Figure* (Fig. 1.27), is commissioned by ordinary individuals for their personal shrines. Because the patrons perform the rituals for the piece, they are considered the creator as much as or more than the actual artist.

15.21 Nao Bustamante. *Soldadera*. Video and sculptural installation, 2015. Vincent Price Art Museum, Los Angeles.

The artist combined research and reenactment to create an immersive installation that resembled those found in history museums.

holds your coffee. Add art, whether it's done by family members, students, artists, or craftspeople. Use social media to find out about and participate in art activities. Bring art into your life and into your community.

TECHNOLOGY IN VISUAL CULTURE AND THE CREATION OF NEW WORLDS

Technology creates new possibilities for (1) immersion, (2) interactivity, and (3) sharing. As a result, technology has changed visual culture, including art, entertainment, and advertising and marketing.

Let's take a look at some ways that technology has affected art. *Soldadera* (Fig. 15.21), 2015, by Nao Bustamante, is a collection of hybrid works put together in a single installation that created an immersive experience where the artist controlled all aspects of the space. *Soldadera* was based on research, but added fictional elements to help viewers imagine the women who fought, or supplied food for other fighters, in the Mexican Revolution (1910–1920), a national conflict with many warring sides. Historically accurate dresses were made of Kevlar, a modern protective combat material used for helmets and vests (Fig. 15.21). Bustamante shot at the dresses to show the violence of conflict and the vulnerability of the body. Videos and performances reenacted the *soldadera*, reinstating them in history, which often left them out. Artwork like this is a very different experience from viewing a single painting or an isolated sculpture.

Other examples of art affected by technology are the infinity rooms by Japanese artist Yayoi Kusama, such as *Aftermath of Obliteration of Eternity* (Fig. 15.22). These small rooms become illusionistic, vast, almost magical environments, created with mirrors, lighting technology, sculptures, and other elements. You can walk into some of Kusama's infinity rooms, while others are seen through a small window, but all are filled with shimmering lights that change as you view them.

15.22 Yayoi Kusama, *Aftermath of Obliteration of Eternity*, Japanese, 2009. Wood, metal, glass mirrors, plastic, acrylic paint, LED lighting system, and water. Edition 3/3, 13' 7½" × 13' 7½" × 9' 5¼".

Viewers stand on a platform in the room as lights are gradually illuminated, reflected hundreds of times, and then fade.

15.23 Shinjuku, Tokyo, Japan, cityscape.

Lights and technology can define an area of a city.

15.24 Immersive promotional event for *Blade Runner 2049*, 2017. San Diego.

The sets are from the movie, but the overhead lights reveal their use as an immersive promotional event.

15.25 *Video Game.* Playing a video game is an immersive experience made possible by good art, design, and technology.

The use of technology to create environments is not limited to art. Lit signs, electronics, and new plastics create illuminated advertisements that can transform an entire city area. Commercial urban centers with color saturation, brilliance, and density are immersive environments made possible by technology (Fig. 15.23).

Technology-driven immersive environments are used in entertainment and marketing. Movie sets combined with computer-generated imagery (CGI) result in films that create amazing new worlds that are especially immersive when seen on a big screen. After filming, movie sets can be repurposed for immersive promotional events, as was the case with the set of *Blade Runner 2049*, which was set up in San Diego and opened to fans, reviewers, or members of the public who entered and interacted with actors on the set as if they were part of the movie (Fig. 15.24). A huge amount of free marketing for the movie was generated when participants shared the event on social media. The same social media phenomenon happens in art; for example, visitors constantly photograph and share Kusama's infinity rooms all over social media.

All immersive, interactive, and shared experiences exist in multiple forms in time. The first experiences are made by the people who participate, like *Open Air* (Fig. 15.4), where visitors controlled lights and sounds with their phones. Nothing happens without participation. And then, because they are widely shared, these art, marketing, and entertainment experiences exist again as events in the virtual, shared space of social media.

Video games also are interactive and immersive. Many games emphasize a visually breathtaking artistic vision for the games' environments. As they play, gamers move through elaborate landscapes, cityscapes, and futuristic environments that are truly like new worlds. Sophisticated color palettes, atmospheric conditions, space, and lighting all combine to give a particular vibe to each part of each game. In Figure 15.25, we can look over the shoulder of a video game player and get a sense of how some games resemble the rich, painterly colors and textures of oil painting.

All of the examples we have just seen share this: They are the products of artistic vision used to create new worlds. Creative firms put the artist and designers front and center, and emphasize design thinking to create good user experiences. Using painting, sculpture, and digital technology, artists and designers bring these new places and experiences to life, inventing every detail to make them convincing.

Truly new potentials in art are being explored every day.

VISUAL LITERACY

Anyone can look at a visual work and say "I like it" or "I don't like it." But you are visually literate. After taking this course, you should be able to scrutinize and evaluate visuals more deeply. Visual literacy applies to any work of art, design object, form of visual entertainment, advertising, or image you see on social media.

Let's try this. Imagine you encounter a group of baskets (Fig. 15.26) in a museum, commercial gallery, book, or in someone's house. Next to the baskets is this information:

Hsig Di Baskets, woven in Panama by the women of the Wounaan Tribe of the Darien Rainforest

Review the Analysis Guide below and use it to analyze these baskets:

1. What do you notice first?
2. Describe what you see in terms of line, shape, color, and material. Write about the contrast between the background and the imagery. Would you describe the colors as bright? Talk about areas where outlining is used. Describe the overall shape of the baskets.
3. Focus on subject matter. What is depicted in the woven material of the basket? Make a list of all the entities you recognize. Describe abstract patterns.
4. Use the Internet and library to do research on Hsig Di baskets, the Wounaan Tribe, and the Darien Rainforest in Panama, then write a paragraph on what you learned. Compare the baskets to other vessels that you have seen in the book, such as Figure 3.42, *Bowl* by Maria Martinez; Figure 5.10, *Basket from the Pomo*; and Figure 5.11, *Palm Wine Calabash*. Identify similarities/differences and the purposes that each serve.
5. What do you think about the work? Give details about your reaction beyond "I like it" or "I don't like it."

CONNECTION Art is all around you and is not necessarily expensive or remote. For a historic example of accessible art, look at *Basket Ferry* by Ando or Utagawa Hiroshige, a nineteenth-century Japanese print that was created specifically for merchant-class and working-class collectors (Fig. 1.23).

Analysis Guide

Visual literacy is the ability to analyze a work using these prompts:

1. FIRST GLANCE: What do you notice first?

2. DESCRIPTION: Describe any visual image, object, or experience you see in front of you using the art and media vocabulary from Chapters 2 and 3.

 ▪ *Line, light and value, texture and pattern, shape and volume, space, and color*
 ▪ *Composition: balance, rhythm, emphasis, unity, and variety*
 ▪ *Materials used*

3. INTERPRETATION: What is the meaning of what you have just described in front of you, as laid out in Chapter 4?

 ▪ *Subject matter, content analysis, context, writings about art*

4. RESEARCH: Compare the work to other items you have seen in this book (Chapters 5–14). Look up the work or the artist on the Internet for more information.

5. EVALUATION: Assess the impact of the work from your point of view and background, and also understand how the work may be viewed by others from different backgrounds.

15.26 *Hsig Di Baskets*, Panama. Woven by women of the Wounaan tribe, twenty-first century. Palm fibers and natural dyes, various sizes. Collection of Gayle Garner Roski.

Research the background of these baskets and use your visual literacy skills to analyze them.

15.27 Exterior of the Louis Vuitton store wrapped in the distinctive dot motif of Yayoi Kusama, 2012. Fifty-seventh Street, New York.

Art meets commerce.

Now, finally, you try it. Figure 15.27 is an image of the exterior of the Louis Vuitton store on 57th Street in New York City in 2012 wrapped with a dot pattern by artist Yayoi Kusama (the same artist who produced *Aftermath of Obliteration of Eternity*, Fig. 15.22). The dots wrapped the store for a month to celebrate the Yayoi Kusama x Louis Vuitton collection.

1. What do you notice first?
2. Describe what you see in terms of line, shapes, colors, textures, and materials. Look up more images on the Internet to see the installation from various points of view.
3. Research Yayoi Kusama and Louis Vuitton.
4. What does it mean to wrap a building in dots? Is it art or is it a promotional event? How is this like

using the set of *Blade Runner 2049* for an immersive promotional event (Fig. 15.24)?
5. What do you think about this combination of high-end commerce joined with art?

You now have a solid foundation in art, and throughout your life you can build on this knowledge. Make art happen in your community. Start making art. Be an art advocate in your area, an art educator, or a local museum volunteer. Live with art wherever you dwell.

Congratulations! You have finished this book. The authors wish you well as you go out and continue your exploration into the art world, which is *your* world.

GLOSSARY

A

Abstract Expressionism An art movement that emerged after World War II that emphasized spontaneous artistic self-expression, non-representational imagery, and distinct paint application; most abstract expressionist works were paintings.

abstracted texture A distortion, a simplification, or an exaggeration of an actual texture.

Abstraction Visual imagery in art that does not copy reality. This might be achieved by simplifying, distorting, or exaggerating objects from nature.

academy An institution developed in various cultures to educate artists and to set strict standards and guidelines for art works.

accent Special attention given to any element of a composition in order to attract the viewer's eye to it. This may be done by giving an element a brighter color, isolating it, or enlarging it in order to accent it. Any visual device may be used in an accent.

achromatic value scale (ak-ruh-MAT-ik) A chart indicating tonal variations, without color, consisting only of grays.

acropolis (ah-KRAH-pul-us) The highest ground in an ancient Greek city; originally fortified and, later, the site of temples.

acrylic A water-soluble, permanent synthetic paint that was developed in the 1960s.

action painting A process used in creating a non-objective painting whereby the artist makes gestural movements to produce expressive brush strokes, drips, and splashes.

actual line Physical lines made with material that have more length than depth.

additive color system Color that is created by mixing light rays. When the three primary colors (red, blue, and green) are mixed, a white light is produced. Cyan, yellow, and magenta are the secondary colors in this system.

additive process Any art-making process in which materials are built up to create the final product.

adobe (ah-DOH-bee) Sun-dried brick made of straw and clay.

aerial perspective The blurring of forms, colors, and values as they recede into the background. This is sometimes referred to as *atmospheric perspective*, as receding forms in space take on the colors and tones of the natural atmosphere.

Aesthetics (es-THET-iks) A branch of Western philosophies that is concerned with the critical reflections on art, on beauty, and on taste.

afterimage A phenomenon that occurs after staring at an area of color for a while, then glancing at a white ground. The eye will see the complementary color.

airbrush A small spray gun attached to a compressed air source that atomizes liquid paint, allowing it to be sprayed onto a surface.

akua'ba A female doll used as a fertility aid by young Asanti women in Ghana.

alla prima (ah-la PREE-mah) A technique in painting in which pigment is laid directly on the surface without any underpainting.

alternating rhythm Two or more different visual elements are repeatedly placed side by side or in a grid, which produces a regular and anticipated sequence.

altar A specifically prepared area or platform designed for a worship place.

ambient light The light all around us in the world.

amphitheater (am[p]-feh-THEE-et-er) An oval, semi-circular, or circular arena surrounded by tiers of seats.

amulet (AM-yoo-let) A charm worn to protect one from evil.

analogous colors Colors (**hues**) that are placed next to one another on the **color wheel.**

Ancestor Dreaming A system of spiritual beliefs for the Aboriginal people in Australia that accounts for creation and the cosmos.

animation A series of drawings that vary slightly from one to the next, so that the figures within the drawings appear to move.

animé A contemporary style of animation that originates in Japan.

animism The belief that all things in nature contain a spiritual force or soul.

anthropomorphic Giving human characteristics and attributes to a nonhuman being.

apotheosis (ah-poth-ee-OH-sus) The raising of human beings to a divine level, or to be deified.

aquatint A printmaking process related to etching in which the metal plate is covered with a powder of acid-resistant resin to create a tonal area.

arabesque (ar-ah-BESK) Intricate interlocking surface decorations usually of spiral forms, knots, and flora. There is no suggestion of human forms in the designs.

arcade A line of arches placed side by side on piers or columns that may be freestanding or attached to a wall.

arch A curved structure made of stone or brick that supports weight over an opening.

Archaic A period in Ancient Greece when artwork shifted from featuring primarily abstract decoration to emphasizing more nature-based or figurative work; roughly 700-500 BCE.

archeological site A place where art and architecture occurred in the past, and which is now being studied, excavated, or preserved.

architecture The science and art of designing buildings and other structures that are both aesthetic and functional.

armature The underlying framework on which clay, wax, or plaster is placed; used in making sculpture.

art collection A group of artworks owned by an individual, by a foundation, or by a government agency.

artifact An object made by one or more human beings and usually categorized by time and culture.

assemblage (ah-sem-BLAHZH) Sculptures made from various found objects or prefabricated parts that are put together.

asymmetrical balance Balance that is achieved in a composition by arranging dissimilar elements so that they exist in groupings of equal visual weight and attention.

Athena Greek goddess of war, wisdom, and crafts.

atlatl (AHT-[uh]-lat-[uh]l) A stick thrower, or a device that aids the throwing of a stick or spear.

atmospheric perspective *See* **aerial perspective.**

atrium (AY-tree-um) The entrance room with an open skylight in a Roman house. Also, the attached, open-colonnaded court at the entrance of a Christian basilica.

attic The uppermost story in a structure.

Automatism A process for artmaking that incorporates intuition, spontaneity, unconscious behavior, and the accidental.

avant-garde (av-an[t]-GAR) Late-nineteenth- and twentieth-century artists who develop new concepts in their work.

avatar (av-uh-TAR) In Hinduism, the manifestation of a deity, or an aspect of a deity.

B

ba Part of the human soul, in ancient Egyptian beliefs. *See also* **ka.**

balance Visual equilibrium in a composition; achieved by organizing the weight and attention of all elements in an artwork. Types of balance are **symmetrical, asymmetrical,** and **radial.**

baldacchino (bal-dah-KEE-no) A canopy placed over a throne or an altar, sometimes resting on columns.

balustrade (BAL-us-trade) A railing supported by short pillars.

bargeboards Boards that conceal roof timbers projecting over gables; often decorated.

Baroque (bah-ROHK) A style of architecture and art in seventeenth- and eighteenth-century Western cultures (specifically in Europe) characterized by exaggeration, overstatement, and a flare for artifice and the theatrical.

barrel vault *See* **vaulting.**

bas relief (bah reh-LEEF) *See* **relief.**

base The lowest part of an Ionic or a Doric column.

binder A liquid, gel, or wax that holds pigment particles together and dries or hardens to create a paint layer.

biomorphic shape An irregular shape that resembles living forms.

bitumen A natural, tar-like substance.

black figure A style of Greek pottery that has been decorated with dark figures placed on a lighter background of red clay.

bodhisattva (boh-dih-SAHT-vah) In Buddhist beliefs, those humans who have attained the level of Buddhahood but choose to postpone their achieving Nirvana to remain on Earth to help others.

brackets In traditional Chinese architecture, clusters of interlocking pieces of wood shaped like inverted pyramids at the tops of upright posts, directly beneath the roof.

Buddha A person who has achieved a state of complete spiritual enlightenment; one who has attained Nirvana; the Buddha is Siddhartha Gautama, the spiritual leader from India who founded Buddhism.

Buddhism An Asian religion with the belief that the rejection of personal desires will lead to complete spiritual enlightenment.

buon fresco (true fresco) A form of fresco painting in which wet pigment is applied to a wet plaster wall, with very durable results.

burin A sharp pointed tool used to incise or engrave a plate or block in the printmaking process.

bust A sculpture of a human being that includes only the head and shoulders.

buttressing A mass of brick or stone that supports a wall or an arch; a *flying buttress* is a buttress placed some distance from the structure it is supporting, and it is connected to the main structure with an arch.

Byzantine A cultural style dating from 527 to 1453 CE and associated with Byzantium (especially Constantinople, now Istanbul, Turkey).

C

caliph A successor of Mohammed in the Islamic faith and recognized as their religious leader.

calligraphy (keh-LIG-reh-fee) Handwriting that is considered exceptionally beautiful.

canon (KAN-on) A rule of proportion that meets the requirements of a specific cultural aesthetic.

cantilever (kant-el-EE-ver) A structure in architecture that extends or protrudes horizontally beyond its support.

capital Uppermost element on a column, serving as a transition from the shaft to the lintel.

caricature The exaggeration of natural features usually seen for comic or satirical effect.

carving A type of sculpture in which unwanted materials are removed from a large block of material like stone, wood, or Styrofoam.

caryatid (kar-ee-AYT-id) A supporting element, like a column, that is carved to represent a female figure. A male supporting figure is called an *atlantid*.

cast, casting A process in which a mold of a form is made, then a liquid material is poured in and allowed to harden. The mold is then removed, leaving a sculptural replica of the original form.

catacombs (KAT-eh-kohmz) Subterranean chambers used for the burial of the dead.

cathedral (keh-THEE-drel) A church that is the official seat of a bishop.

centaur (SEN-tar) A half-man, half-horse creature, from fables.

ceramic Pottery and objects made of clay.

chalk A soft, white form of limestone, shaped into sticks and used for drawing; colored pigments can be added for colored chalk.

charcoal A carbon stick created from burnt wood, used for drawing.

chatras Stacked stone disks on a pole, seen on the top of Hindu temples.

Chi-Rho (ki roh) The initials of Christ's name in Greek.

chiaroscuro (kee-ar-eh-SK[Y]OOR-oh) In a drawing, the use of various tones (black, white, and grays) to create the illusion of volume.

chroma (KRO-ma) Brightness or dullness of a hue, or intensity.

chromatic Of or relating to color

Christianity Religions founded on the life and teachings of Jesus.

cili An ancient symbol of wealth, fertility, and luck. It appears in the shape of a woman's head with a large, fanlike headdress radiating from it.

cire perdue (seer per-DOO) *See* **lost wax.**

city-state An autonomous political entity, consisting of a city and its surrounding territory.

civilization A highly structured society, with a written language or a very developed system of communication, organized government, and advances in the arts and sciences.

Classical The art of ancient Greece during the fifth century BCE, based on ideal proportion grounded in the human figure. The term also refers to a style that is clear and rational. Western art aesthetics are heavily influenced by Classical Greek art, seen in Roman, Romanesque, Renaissance, and Neoclassical styles.

Classical Baroque The Baroque style that also contains classical characteristics, especially in architecture. *See* **Baroque style.**

claymation A method of animation using clay figures moving in small increments in place of drawings.

clerestory (KLEER-stor-ee) An area of wall that contains windows and that rises above roof areas that surround it.

codex (codices) Early books made of parchment, vellum, deerskin, or bark paper, which were bounded on one side, or folded into fan-like pleats.

collaboration Arrangement in which two or more artists work together on one artwork.

collage (kuh-LAZH) A two-dimensional composition in which paper, cloth, or other materials are glued to a surface.

colonnade (kol-uh-NADE) A row of columns that supports an entablature or lintel.

color wheel A circular arrangement of the hues of the spectrum.

column A cylinder consisting of a base, shaft, and capital (top element) that usually supports a roof. However, freestanding columns sometimes function as monuments. *See* **Orders.**

combine Works that are both painting and sculpture.

complementary colors Hues that are located directly opposite each other on the color wheel.

complete frame system A structural system originated in China, with brackets, cantilevers, and totally non-load-bearing walls.

composition The organization of the elements of an artwork in such a way that harmony, balance, unity, and variety are achieved.

computer animation Totally digital animation; in some forms, characters can be plotted as a series of points and vectors and made to move with mathematical computation.

conceptual Artwork whose primary purpose is to convey an idea or a concept in any medium. Printed text is often included.

condottiere Mercenary soldiers who fought for various city-states during the European Renaissance.

contained style In a sculpture, all the forms are kept within the overall outer shape.

content An artwork's themes or messages, conveyed through subject matter, symbols, or iconography.

context Consists of the external conditions that surround a work of art, such as historical events, religious attitudes, social norms, and so on.

contour line The outline of a shape.

contrapposto (kon-trah-POS-toh) A standing position in which the body weight rests on one straight leg, with the other leg relaxed and bent, giving the torso an s-shaped curve.

cool [colors] Generally, blues, greens, and purples.

corbel (KOR-bul) Stones or bricks stacked so that each new layer projects beyond the layer below it; corbels can be arranged to create a corbeled arch or corbeled vault.

Corinthian Order (kuh-RIN-thee-en) *See* **Orders.**

cornice (KOR-niss) A projecting horizontal element that crowns a structure.

cosmos A systematic, orderly, harmonious universe.

craft A category of art that requires special manual skills and is often functional in origin.

crayon A small stick used as drawing material, with pigment held together by a wax binder.

cross-contours Repeated lines that go around an object or a form to express its three-dimensionality.

cross-hatching *See* **hatching.**

cross vault *See* **vaulting.**

crypt An underground chamber usually located in a church below the altar, sometimes used for burials.

Cubism An art style in which multiple viewpoints or facets are represented within one point of view. Analytical Cubism broke down forms, while Synthetic Cubism used collage and assemblage to represent parts of objects in order to visually play with illusions and reality.

cultural heritage The accumulated mass of customs, traditions, visual art, other arts, and architecture (and their meaning and values) that a community or a nation develops and passes on from generation to generation.

cultural style The recurring and distinctive features in many works of art emanating from a particular place and era, which allow them to be seen as a distinct and coherent group.

culture The totality of ideas, customs, skills, and arts that belong to a people or group; or a particular people or group, with their own ideas, customs, and arts.

cuneiform (kyoo-NAY-uh-form) A system of writing with wedge-shaped characters, used in the ancient Near East.

curvilinear Consisting of visual elements that are made up of or allude to curved lines.

D

Dada, Dadaist Of or relating to an art movement characterized by works with fantastic or incongruous imagery.

daguerreotype (deh-GARE-[e]-o-type) A photographic process invented in the nineteenth century for fixing an image on a silver-coated metal plate.

deconstruction A method for analyzing works of art developed in the late twentieth century, in which artworks are treated as texts that can have a variety of meanings, based on the person who perceives them, emphasizing subjectivity.

Deconstructivist A contemporary architectural style in which building parts are disassembled and reassembled in an almost sculptural fashion, without regard to the function of the building.

decoration An adornment or an embellishment on an object or structure intended to give visual pleasure.

direction The course of movement, as in horizontal, vertical, diagonal, or meandering.

digital art Art that is made with the assistance of electronic devices, or intended to be displayed on a computer.

diptych (DIP-tik) A two-paneled painting, often hinged.

disciplines Branches of art-making activity, such as painting or sculpture.

distemper A painting process using pigments mixed with egg yoke, egg white, glue, or size.

distortion The changing of an accepted perception of a form or object so that it may be barely or not at all recognizable.

dome A hemisphere used to cover an open interior space, made of an arch rotated 360 degrees on a vertical axis.

Doric Order *See* **Orders.**

drum A solid cylindrical stone that is stacked with others to create the shaft of a column, or a hollow cylinder base that supports a dome.

drypoint An etching, which is a kind of printmaking, in which the design is scratched into the surface of a metal plate.

dynasty A powerful group or family that rules a territory or nation for an extended period.

E

earthenware Ceramic ware made of slightly porous clay fired at a low temperature.

earthworks In art, the earth itself as sculptural material.

eccentric rhythm A perceived pattern that has irregular repetition of elements or irregular spacing between elements.

eave, eaves The edge of the roof that overhangs the wall.

edition A number of **prints** made from a specific printing process in one single batch. Each batch is then numbered, i.e., first edition, second edition, etc.

egg tempera Paint created by grinding dry pigment into egg yolk, which is the binder.

embroidery Sewing a design or image with colored threads into a fabric.

emphasis A device in art that draws the attention of the viewer to one or more focal points in an artwork.

encaustic (en-KAH-stik) A paint medium in which pigments are mixed into heated beeswax.

engaged column A column partly embedded in a wall.

English Perpendicular *See* **Gothic.**

engraving The process of incising or scratching lines on a hard material, such as wood or a metal plate.

entablature (in-TAB-leh-chur) In classical Greek architecture, the part of the building that is above the capital of the supporting columns. It consists of three parts: the architrave, the frieze, and the pediment.

entasis (EN-teh-sis) An apparent swelling or bulging in the shaft of a Doric column.

Epicureanism (ep-i-kyoo-REE-en-izm) An ancient Greek philosophy that advocated intelligent pleasure-seeking in life, because death was the end to existence.

equestrian An artwork that depicts a figure mounted on a horse.

etching The creation of lines or areas on glass or a metal plate, using acid that eats into the exposed surface but leaves coated, protected areas unchanged. When etched plates are inked, they can be used in printmaking.

Eucharist (YOO-keh-rist) The Sacrament of Holy Communion in the Christian faith. The ritual involves the transformation of bread and wine into the sacrificial body and blood of Jesus Christ (believed by some to be symbolic only).

Expressionism (Expressionist) An art movement in early-twentieth-century Europe that focused on capturing the subjective feeling toward objective reality. The movement developed a bold, colorful, and vigorous style, especially in painting.

F

fabricated, fabrication Artworks created with industrial and commercial processes or materials, such as welding or neon lighting; often fabricated works are designed by the artist but made by a professional in the fabrication process.

façade (feh-SAHD) The front facing of a building.

Fauvism (FOH-vizm) An early-twentieth-century art movement in Europe led by Henri Matisse that focused on bright colors and patterns. The term comes from the French word *fauve*, meaning "wild beast."

Feminism, Feminist Criticism Artwork or art criticism based on the idea that women should have political, economic, and social rights that are equal to those of men.

fengshui (FUNG-shway) The science and art of arranging architecture and furnishings to allow for a good flow of energy. The term comes from the Chinese words for *wind* and *water*.

fetish An object that is empowered with supernatural powers.

feudalism (FYOOD-el-izm) An economic and political system in rural societies in which the land is owned and controlled by a few warrior-rulers, and the rest of the people work the land as peasants.

finial (FIN-ee-el) A crowning ornament or knob.

flute, fluting Narrow vertical channels carved from top to bottom into the shafts of columns.

Fluxus A late-twentieth-century art movement that sought to create a kind of anti-art or non-art; art was conceived as an artist-initiated experience rather than an object.

flying buttress *See* **buttressing.**

focal point Main area of visual concentration in an artwork.

Foreshortening In a two dimensional artwork, creating a sense of space by enlarging areas of an object that are close to the viewer, and shrinking the parts that are farther away.

form The total appearance and organization of an artwork; also, a shape or structure in an artwork.

formal analysis The study of artwork that focuses on the elements of the language of art and the principles of composition.

formal qualities All that makes up an artwork, such as the formal elements (line, value and light, color, shape, space, texture, volume and mass, time, and motion), the medium, proportion, size, and subject matter.

formalism Artworks based solely on formal qualities.

formalist criticism The analysis and critique of an artwork based on its composition and the arrangement of its elements and principles.

found objects Already existing objects incorporated into a sculpture or assemblage. Ready-mades refer to found objects that are presented almost in their original form as finished sculptures.

freestanding Sculpture in the round, intended to be seen from many viewpoints.

French Gothic *See* **Gothic.**

fresco A painting made on plaster; in *true fresco*, water-based pigments are painted directly on a wet lime plaster ground and bind with the plaster when dry; in *dry fresco*, the paint is applied to dry plaster.

fresco secco (dry fresco) A form of fresco painting in which paint is applied to a dry plaster wall.

frieze (freez) A decorative band in the central section of the entablature in classical Greek architecture, or a decorative band on a building.

frontal A quality of sculpture in the round when it is meant to be viewed from one side only.

Futurism An art movment in Italy around 1910 that celebrated the speed, energy, change, and upheaval of the machine age.

G

gaze An analysis in artwork of who is looking at whom, and the often-implied power relationship of autonomous subject (who gazes) and subservient object (the object of the gaze)

genre painting (ZHAH[n]-reh) Paintings that contain subject matter of everyday life.

geodesic dome (jee-oh-DEES-ik) A dome shape made of framework consisting of interlocking polygonal units, developed by R. Buckminster Fuller.

geometric pattern Repeated objects, lines, or shapes based on mathematical concepts, such as the circle, square, or rectangle, and regular intervals.

gesso A common ground made of very fine powdered white chalk suspended in glue (the traditional method) or acrylic medium (modern gesso).

gesture A quickly sketched image that captures the essence of the form of the subject.

gild, gilding Coating or layering a surface with gold, gold leaf (a very thin layer of gold), or a gold color.

glaze In painting, a thin layer of glossy, transparent color applied on top of previously painted, dry areas of the painting; in ceramics, a hard, waterproof, often glossy coating fired onto the clay surface of pottery or sculpture.

glyph (glif) A figure or character that has symbolic meaning and is most often carved in relief.

Gothic The history, culture, and art of western Europe from the twelfth through the fourteenth centuries. Local variations include French Gothic and the English Perpendicular Style.

Gothic Revival A nineteenth-century style of art that evoked Medieval Gothic architecture, craft, and painting.

gothic vault A type of vaulting featuring pointed arches.

gouache (gwash) Painting with opaque watercolors.

graffiti Writing or drawing written or painted on public walls.

graver An incising tool used by printmakers and sculptors.

groin vault *See* **vaulting.**

ground A coating on a support that affects its surface quality, for example, making it rough or non-absorbent or smooth, and so on.

guilds (gilds) Organizations of merchants, artisans, and craftsmen that developed in medieval Europe.

H

handscroll A long piece of paper or cloth that is unrolled in one hand and re-rolled in the other to view individual scenes and read text.

Happening An art event that is planned by the artist and that may be performed spontaneously and solicit participation of its audience. This art form was invented by Allan Kaprow.

Harlem Renaissance A revival and celebration of African American culture, values, and aesthetics, which were expressed through all the arts in the 1920s and 1930s in the United States.

harmony The quality of relating the visual elements of a composition through the repetition of similar characteristics. A pleasing visual interaction occurs through harmony.

hatching The placing of lines side by side in parallel groups to create values and tones. Layers of such line groups create crosshatching.

Hellenistic The culture that flourished around Greece, Macedonia, and some areas bordering the Mediterranean Sea from around 323 to 31 BCE.

hieratic scaling (hi-uh-RAT-ik) A system of proportion of figures or subject matter in a work of art that gives emphasis to what or who is considered to be the most important; for example, the largest figure would be the most important or highest in rank.

hieroglyphic (hi-ro-GLIF-ik) Ancient picture writing, especially that used by the Egyptian culture.

Hinduism The dominant religion of India whose basic beliefs encompass the cycle of reincarnation and a supreme being in many forms.

horizon line In linear perspective, a horizontal line that represents eye level.

hue The pure state of color that the eye sees in the spectrum.

Humanism A system of thought that emphasizes human reason, justice, and ethics above supernaturalism and superstition.

hydria (HI-dree-ah) A Greek ceramic water jar, usually with two handles.

hypostyle (HI-puh-style) A large hall in which a grid of columns support the roof.

I

icon A visual image, pictorial representation, or symbol that may have religious or political connotations.

iconography (eye-keh-NOG-reh-fee) The study of visual images and symbols within their cultural and historical contexts.

idealism An artistic interpretation of the world as it should be according to respective cultural aesthetics. Generally, all flaws and imperfections found in nature are removed.

idealized A style of art in which natural imagery is modified in a way that strives for perfection according to the values and aesthetics of a particular culture.

ideological criticism Art criticism that is rooted in the writings of Karl Marx and deals with the political underpinnings of art.

illumination A drawing or painting that decorates a hand-copied book or text.

imago mundi (im-AG-o MUN-dee) Image of the world.

impasto (im-PAHS-toe) Paint that has been thickly applied to the ground.

implied line A drawn line having missing areas that are visually completed by the viewer.

Impressionism A late-nineteenth-century painting style, originating in Western Europe, that attempts to capture subtle light qualities or fleeting moments with small strokes of strong color.

incised A kind of mark that is made by carving or gouging into a surface with a sharp instrument.

inlay To piece together or insert materials, such as ivory or colored wood, into a surface.

installation An art piece usually of mixed media that is organized for and placed in a specific space.

intaglio (in-TAH-lee-oh) A printmaking process in which lines are incised or etched into a metal plate, which is then inked and wiped so that the ink remains only in the incised lines and then transferred to paper.

intensity Brightness or dullness of a hue, or chroma.

International style A style developed in the thirteenth and fourteenth centuries in Europe with characteristics of French Gothic and Sienese art. Later, in the twentieth century, a style of architecture based on simple geometric forms without adornment.

invented [texture] An imaginary surface quality created by the artist.

Ionic Order (EYE-on-ik) *See* **Orders.**

irregular shape A shape that is complex, often organic or biomorphic, that has no simple name.

Islam The religion of Muslims as revealed to the prophet Mohammed and recorded in the Holy Koran, or Quran.

isometric perspective A perspective system for rendering a three-dimensional object on a two-dimensional surface by drawing all horizontal edges at a 30-degree angle from a horizontal base. All the verticals are drawn perpendicularly from the horizontal base.

J

Judaism Religion and way of life of the Jewish people, based on Mosaic law.

juxtapose To place contrasting elements, images, or ideas side by side.

K

ka Part of the spirit or soul of a human being in ancient Egyptian culture. *See also* **ba.**

kachina (kuh-CHEE-nuh) A spirit doll of the Pueblo culture in North America.

Kami (kah-mee) Spirits or deities in the Shinto religion, believed to dwell in nature and in charismatic people.

karma (KAR-muh) The consequences of the actions of this life, which influence the next reincarnation.

keystone The center wedge-shaped stone in an arch that fixed in place the other stones of the arch.

Kitab Khana In the Ottoman Empire, a royal atelier of artists and craftspersons who copied and illuminated books; also a library for storing books.

kinetic Sculpture that moves.

kitsch (kich) Works that are done in what is considered to be poor taste.

kiva (KEE-vuh) An underground, circular ceremonial structure of the Pueblo culture in North America.

Koran (koo-RAN) The sacred book of the Islamic religion; also *Quran.*

L

labret (LA-bret) A mouth ornament.

lacquer A resinous varnish that adds a rich sheen to a surface.

lamassu (lah-MAH-soo) A winged, human-headed bull, from Assyria.

laminated Composed of layers of glued or fused material.

lapis lazuli (LAP-is LAHZ-eh-lee) A semiprecious stone with a deep blue color.

line An element in art with length but negligible width.

line quality Attributes of a line, such as jagged, flowing, rough, angular, and so on.

linear perspective *See* **perspective.**

lintel (LINT-el) In architecture, a horizontal member spanning an opening, and usually carrying a weight from above.

lithography (lith-OG-reh-fee) A form of printmaking, invented in the nineteenth century, based on the principle that water and oil do not mix.

living rock Natural rock formation that may become incorporated in a sculpture or a building.

load-bearing structure A kind of building in which all areas of the walls support the structure above them, and the walls have few openings.

local colors The natural color of an object.

lost wax [*cire perdue*] A sculptural method in which a cast is made from a wax model by coating the model with an investment material that can be heated to high temperatures. The wax melts away, leaving a negative mold of the model, into which molten metal is poured or clay is pressed, creating a hollow duplicate of the original wax work.

M

malagan or **malanggan** (mah-lah-gan *or* mah-lang-gan) The carvings and ritual pieces created to honor the dead in Papua New Guinea; also, the festivals for which the carvings are made.

mana (MAH-na) Supernatural power or influence that flows through some individuals or resides in some objects.

mandala (MUN-duh-luh) A design with geometric elements that delineates deities, the universe, and wholeness in Hinduism or Buddhism.

masjid (MUS-jid) Mosque.

masquerade (mas-ker-ADE) A ceremony or a festive gathering in which masks and costumes are worn.

mass (volume) An area of occupied space. *Mass* usually refers to a solid occupying a space, while *volume* may refer to either a solid mass or an open framework occupying a space.

mausoleum (maw-seh-LEE-um) A stately tomb usually built above the ground.

medieval (meh-DEE-vel) Of or like the period between ancient and modern times.

medium, media Traditional and nontraditional materials used to make art, such as charcoal, paint, clay, bronze, video, or computers.

megalithic (meg-ah-LITH-ik) A structure built with huge stones, especially ancient or Neolithic monuments or tombs.

Mesoamerica (mes-oh-eh-MER-i-kah) The Central American regions of Mexico, Guatemala, El Salvador, and Belize.

Mesolithic (mes-oh-LITH-ik) The middle Stone Age, between the Paleolithic and Neolithic eras, marked by the earliest use of local and permanent food sources.

metaphor An image or visual element that is primarily descriptive of one thing, but is used to describe something else.

Middle Ages A period between ancient and modern times, often used in reference to Europe from the fifth through the fourteenth centuries.

mihrab (MEE-rahb) In a mosque, a niche in the wall that faces Mecca.

minaret A prayer tower that is part of an Islamic mosque.

minbar (MIN-bar) In an Islamic mosque, the pulpit for the imam, a Muslim spiritual and political leader.

Minimalism, Minimalist A nonobjective art movement in the twentieth century in the United States in which artists reduced their images and objects to pure form. These images and forms were called *primary structures*.

mixed media The mixing of art materials and forms in creating an artwork.

moai (moh-eye) A large, stone figure from the Easter Islands (Rapa Nui).

mobile A hanging kenetic sculpture whose movement is determined by air currents.

modeling The process of making a sculpture in which malleable substances such as clay or wax are pushed or pulled into a shape.

Modernism A period of Western art, primarily in the twentieth century, during which innovation and self-critical practice were emphasized.

module, modular Distinct units or sections; a composition that incorporates modules.

monochromatic An artwork that contains the hue, tints, and shades of only one color.

monolithic A large, single block or column.

Monotheism A religion distinguished by the belief in only one god.

monotype A printmaking process involving drawing or painting directly on a plate, resulting in only one impression of an image.

montage (mahn-TAHZH) A composite created by combining several separate pictures or separate clips from movies or videos.

mosaic (mo-ZAY-ik) An image or decoration created by covering a surface with small pieces of variously colored material, such as metal, glass, or stone.

mosque (mosk) An Islamic place of worship.

motif (mo-TEEF) A design or image in a composition that takes on visual significance.

mudra (MOO-druh) A hand gesture with symbolic meaning in Hindu and Buddhist art.

multipoint perspective A kind of drawing that depicts forms in space as receding to two or more vanishing points not on the same horizon line.

muqarna or **mukarna** (moo-KAR-na) Numerous niches and niche fragments, or hanging vaults, clustered in a honeycomb-like pattern, that appear in Islamic domes, arches, portals, and window openings.

mural Images painted directly on a wall, or covering a wall.

museum A physical structure for displaying and storing artwork or important cultural items, ranging from large national museums, state museums, city museums, and private museums.

N

natural pattern Repeated elements that resemble each other, but are not exactly alike; the interval between elements may be irregular.

natron A naturally occurring soda ash used in the mummification process.

Naturalism, Naturalistic A style of art with imagery that resembles what we see in the world around us.

necropolis (neh-KROP-eh-lis) The city of the dead.

negative space Voids within an artwork.

Neoclassic, Neoclassical, Neoclassicism An eighteenth-century revival of the Classical Greek and Roman styles in art and architecture, as well as styles from the European Renaissance.

Neolithic (nee-oh-LITH-ik) A period of the Stone Age in which humans used polished stone tools and developed agriculture; the New Stone Age.

niche (nich) A recess in a wall, usually designed to hold a decorative or votive object.

neutral Low-intensity colors.

neo-modernist Contemporary art movements and art criticism that responds to and critiques modernism.

nirvana (nir-VAH-nah) The ultimate release from the cycle of reincarnation in the Buddhist and Hindu faiths, achieved by the expulsion of individual passion, hatred, and delusion. The attainment of total peace.

nonobjective Artwork that has no imagery that resembles the natural world.

O

obelisk (OB-eh-lisk) A tall, four-sided monolith that is tapered at its apex into a pyramid form.

oblique perspective A method of showing three-dimensional objects in a drawing by rendering all receding planes at thirty degrees from the ground line.

obsidian (ob-SID-ee-en) A dark, volcanic glass.

oculus (AH-kyoo-lus) The round opening in the center of a dome.

odalisque (OH-deh-lisk) A Turkish harem girl.

oil paint A painting medium in which powdered pigments are ground into a slow-drying oil (usually linseed).

one-point perspective A drawing in which all front-facing planes are shown as parallel to the picture plane, and all other planes recede to a single point.

Op Art A 1960s style of art that created unusual visual vibrations with contrasting colors or closely placed lines.

Orders In Classical Greek architecture, an Order consists of a column with a specific style of base, shaft, capital, and entablature that is decorated and proportioned to the Classical Greek canon. The types of Orders are: Doric, Ionic, Corinthian, Tuscan, Roman Doric, and Composite.

organic A shape that seems to be drawn from nature or that is like nature; not geometric.

organic architecture A style of American architecture developed by Louis Sullivan and Frank Lloyd Wright that incorporated flowing natural forms in its design.

oriki A Yoruba praise poem.

outline A line that strictly adheres to the perimeter of a shape, without variations in line thickness.

P

pagan A follower of a polytheistic religion, or an irreligious or a hedonistic person.

pagoda (peh-GO-deh) A multistoried, Asian, towerlike temple with upward sweeping roofs over each story.

paint, painting media Colored pigment ground with a binder, having a semiliquid or paste consistency.

Paleolithic (pay-lee-oh-LITH-ik) Old Stone Age, dating from 25,000 to 8000 BCE; the era of hunters and gatherers.

pantheism A belief that a divine spirit permeates everything in the universe.

papyrus (peh-PI-rus) A tall water plant, abundant around the Nile River, used for making an early form of paper.

pastels Sticks of colored pigments held together by wax or glue, used for drawing.

pathos The power to provoke compassion.

patriarch The male head of a family or family line.

patron A person who supports the artist and the arts.

pattern In art, a repetition of any element in the composition.

pedestal (PED-es-tel) The base of a column or colonnade in Classical architecture, or a base on which a sculpture or a vase may be placed.

pediment (PED-eh-ment) A low, pitched gable resting on columns, a portico, a door, or a window.

pencil A graphite rod in a wood or metal holder, used for drawing.

pendentive (pen-DENT-iv) The triangular concave sections that are created when a dome is supported by a base of arches.

Performance, Performance Art Influenced by the "Happening," performance art consists of live-action events staged as artworks.

personification May be an idea, a virtue/vice, a philosophy, or a force, represented in human form.

perspective A system of rendering the illusion of three-dimensional depth on a flat, two-dimensional surface.

pharaoh (FA-ro) Title of kings in ancient Egypt.

phenomenology The study of phenomena, such as art, from the point of view of a conscious and perceiving subject.

photography Traditionally, a light-sensitive surface such as film is exposed to light through a lens, which creates a negative image on the film; in digital photography, light-sensors in the camera record a light array, creating an image that is displayed on a screen.

photomontage A composition of many photographs, or of one using many prints to create a new image.

photo silk screen A variation on regular screen printing, in which photographs are used with special chemicals to block areas of ink, resulting in an image.

piazza (pee-AT-za) An open court or plaza.

pictograph (PIK-to-graf) A picture or picture-like symbol used in early writing to convey an idea or information.

picture plane The flat, two-dimensional surface of a drawing, a print, or a painting.

pier A solid stone or masonry support, usually rectangular.

pigments Colors in powder form, mixed with binders to create paint.

pillar Any freestanding, column-like structure that does not conform to the Classical Orders. A pillar may or may not be cylindrical.

pinnacle Usually a pointed or conical ornamentation that is placed on a spire or a buttress.

planar space The vertical and horizontal space of a surface for a drawing or painting.

pointed arch As opposed to the rounded arch, this structure narrows upward to a point.

Pointillism An art movement in Europe in the late nineteenth century in which artists applied daubs of pure pigment to a ground to create an image. The paint daubs appear to blend when viewed from a distance.

polytheism The belief in many gods with distinct functions.

Pop Art An art movement in the mid-twentieth century that used common commercial items as subject matter, including newspapers, comic strips, celebrities, political personalities, Campbell's soup cans, and Coca-Cola bottles. Usually created as satire, these artworks glorified the products of mass popular culture and elevated them to twentieth-century icons.

portal An opening, a door, an entrance, or a gate.

portico (POR-ti-ko) A porch or covered walkway, with columns on one side supporting the roof.

post and lintel system A method of construction that uses posts to support a crossbeam that can bear the weight of the roof.

Postimpressionism The late-nineteenth-century movement in European painting that followed Impressionism, in which artists emphasized their subjective viewpoint or the formal qualities of the painting.

Postmodernism The late-twentieth-century movement in art, based to some extent on deconstructivism and accommodating a wide range of styles.

Post-structuralism Various branches of art criticism that are a reaction against Structuralism and hold that there is not one single meaning in an artwork, but rather multiple meanings.

power figure A carved figure that is empowered with magic, which can heal and protect. *See* **fetish.**

Pre-Columbian Refers to civilizations that thrived in the Western Hemisphere before the arrival and impact of Christopher Columbus and the conquests that followed.

preservation Keeping art in conditions that maintain its current state and prevent further deterioration.

primary colors In any medium, those colors that, when mixed, produce the largest range of new colors.

print In printmaking, an image created by pressing an inked plate onto a surface; in photography, a photograph usually made from a negative.

printmaking The process of making multiple artworks or impressions, usually on paper, using a printing plate, woodblock, stone, or stencil.

proportion The size relationship, or relative size, of parts of objects or imagery to a whole or to each other.

Psychoanalytic Criticism Art criticism that holds that art should be studied as the product of individuals who are shaped by their pasts, their unconscious urges, and their social histories.

public art Art that is intended for spaces that are accessible to all people. It is often site-specific, and is frequently funded by tax revenues or new development projects. It can be in any media.

pueblo (PWEB-lo) A type of communal housing built by Native Americans, primarily in the Southwest.

pylon (PIE-lan) A truncated pyramid form usually seen in Egyptian monumental gates.

Q

quatrefoil The shape of a four-leafed clover that is found in architectural plans or a **niche** containing **relief** sculpture.

Quran (koo RAN) Variation of *Koran*.

R

radial balance Visual equilibrium achieved when all the elements in a composition radiate outward from a central point.

ready-mades *See* **found objects.**

Realism A nineteenth-century style of art that depicts everyday life without idealism, nostalgia, or flattery.

rectilinear (rek-teh-LIN-ee-er) Consisting of straight lines set at 90-degree angles in a composition.

reflected [light] The brightness and color of light that is bounced off of objects in the environment.

Reformation (ref-or-MAY-shun) A sixteenth-century European movement aimed at reforming the Catholic Church, but resulting in the establishment of the Protestant churches.

refracted light The range of colors visible when a prism breaks a light beam into a spectrum of color, or in a rainbow after a storm.

register A band that contains imagery or visual motifs; often, several registers are stacked one above the other to convey a narrative sequence.

regular rhythm Standardized visual elements repeated systematically with consistent intervals.

regular shape Geometric shapes with names like circle, square, triangle, etc.

reinforced concrete Also known as ferroconcrete, features steel reinforcing bars embedded in concrete, which makes the concrete much stronger and less brittle.

relational aesthetics Art criticism that focuses on human relationships and social spaces, rather than emphasizing art objects in private galleries, homes, or museums.

relative [color] *See* **relativity of color perception.**

relativity of color perception To the human eye, colors appear different depending upon their surroundings; for example, a tan color might appear greenish when surrounded by strong red, and conversely appear reddish when surrounded by a strong green.

relic A sacred fragment of an object, a deceased saint, or an ancestor.

relief Sculpture that projects from or is carved into a flat surface. When the sculptural form is at least half round or more, it is called a *high relief*; when it is less, it is called a *low* or *bas relief*.

relief printing A group of printmaking techniques in which areas not to be printed are cut away from the printing surface, so that the areas to be printed are left higher.

reliquary (REL-i-kwer-ee) A vessel or receptacle designed to house a holy relic.

Renaissance (ren-eh-SAHNZ) A rebirth of learning and the arts in the fourteenth through the seventeenth centuries in Europe, along with the revival and study of ancient Greek and Roman cultures.

render, rendered To depict or execute in an art form.

representational art Art that presents nature, people, and objects from the world in a recognizable form.

retablo (reh-TAH-blo) A small votive painting.

rhythm A form of repetitive beats that are usually seen in a composition as a pattern. This is accomplished by repeating one or more of the formal elements in the organization of a work.

ribbed vault *See* **vaulting.**

ridgepole The beam running the length of the building, located under the highest point of a gabled roof.

Rococo (ro-ko-KO) The style of art, architecture, music, and decorative arts from early-eighteenth-century Europe, made primarily for the upper class.

Romanesque (Roman-like) An architectural style in Medieval Europe that contained massive walls, barrel vaults, and rounded arches. Romanesque churches had cross-shaped plans.

Romanticism An art movement in nineteenth-century Europe that focused on the intuitive, emotional, and picturesque. It rejected the carefully planned and rationalized compositions of the Renaissance and added a sense of mysticism to art.

rose window A large, circular, stained-glass window in a Gothic church, composed of many parts.

rotunda (ro-TUN-dah) A round building, hall, or room, usually roofed with a dome.

S

saltcellar A dish or a container designed to hold salt.

samurai (SAM-uh-rye) In feudal Japan, a member of the warrior class.

sanctuary A sacred or holy place in a church or temple.

sanskrit (SAN-skrit) The classic Indo-Aryan language from the fourth century BCE, still used in some Buddhist rituals.

sarcophagus (sar-KOF-eh-gus) A coffin.

sarsen A type of sandstone monolith found in ancient ruins, such as Stonehenge in England.

saturation The intensity or brightness of a color.

satyr A part-human part-goat creature who is associated with the beliefs of the ancient Greek god Dionysos.

scale The apparent size of an object or image that is measured by comparing it to other objects and images that are recognized as being normal sized.

scarification (skar-i-fi-KAY-shun) The cutting or scratching of the skin in various designs that will heal as permanent body decoration.

secondary colors Colors that result when any two primary colors are mixed in a particular medium.

semiotics The study of signs and symbols in written and verbal communication.

serigraphy (seh-RIG-reh-fee) A printmaking technique in which ink is applied through a stencil that has been adhered to a stretched cloth.

shade The addition of black to a hue.

shading In drawing, carefully manipulating gradations in values to create the appearance of natural light on objects.

shah (shah) A title of the former rulers of Iran.

shaman (SHAH-men) A person, priest, or priestess who is empowered to use magic to cure and heal, imbue an object with magic, control spirits and commune with ancestors, and foretell the future.

shape A flat, two-dimensional element with a defined outline and usually without interior detail.

Shinto (SHIN-to) A major Japanese religion, with emphasis on ancestor and nature worship.

Shiva (SHEE-veh) Hindu god of destruction and reproduction.

shogun (SHO-gun) Any of the various hereditary leaders of Japan until 1867, who were the real rulers instead of the emperors.

silk screen *See* **serigraphy.**

silverpoint A thin rod of silver that leaves marks on paper or wood coated with layers of gesso as a ground.

simulated [texture] Painting or drawing a texture so that it seems like it could be felt.

site-specific sculpture A sculpture designed to fit into and interact with the elements in one specific location.

skeletal In architecture, relating to a framework of steel that is covered with a "skin" of glass or other light materials.

skene The background building to a performance stage in Greek theater.

slip A liquid clay, often applied to the clay vessel before firing to create surface designs.

spandrel (SPAN-drel) The area between two arches or alongside one arch, or the space between the ribs of a vault.

spectacle Public show on a grand scale.

spectrum The breakdown of white light into its components of red, orange, yellow, green, blue, indigo, and violet.

sphinx (sfinks) A figure made up of a human head and a lion's body, likely of Egyptian origin.

spire A pointed roof of a tower or steeple.

squinches The spatial areas created when a dome is placed on a square or a polygonal base.

stained glass Pieces of colored glass arranged to create an abstract composition or representational image.

stainless steel Steel alloyed with chromium, which is virtually rust-free and corrosion-free.

steel frame construction A kind of structure in which a steel framework serves as a skeleton to support multistoried buildings.

stele (STEE-leh); *pl.* **stelae** (STEE-lee) A stone slab or tablet that is carved with images and/or inscriptions usually in commemoration of a person or an event.

still life An assembled composition of objects set up by the artist to use as subject matter for an artwork.

Stoicism (STO-i-siz-em) Indifference to pleasure or pain.

street art Art in public places that emphasizes imagery, as distinct from graffiti that emphasizes text. Some street art is done with permission of the site's owner and some is not.

structural systems Organized methods of construction that result in functional and durable buildings. These systems must endure the forces of gravity and weather as well as forces within the building itself.

Structuralism Art criticism that holds that the understanding a single work of art is based on the overall structure of art and the complex interrelationship of all its parts, because structure gives the meaning to an artwork like a sentence determines the meaning of individual words within it.

stucco (STUK-oh) A plaster material that may be used for reliefs and architectural ornamentation, such as moldings and cornices. It is also a wall covering made of a thin layer of cement.

stupa (STOO-pah) A dome-shaped Buddhist shrine.

style Specific recognizable attributes and characteristics that are consistent and coherent in the artwork within a historical period, within a cultural tradition, or of an individual artist.

subject matter The specific idea of an artwork.

subtext The underlying ideas or messages in an artwork.

subtractive color system Any system of color mixing in which the addition of more colors gives a duller result.

Subtractive process or method (sculpture) A technique in which a sculptural material, such as stone or wood, is carved away to produce a form.

sultan (SULT-n) A former ruler of Turkey, or a Muslim ruler.

support A surface upon which a two-dimensional artwork, such as a painting, is made.

Suprematism A twentieth-century art style in which artists express their true reality through totally non-objective compositions in painting.

Surreal, Surrealism (ser-REE-el-izm) An art movement in early-twentieth-century Europe influenced by the work of Sigmund Freud. Fantastic and dreamlike imagery drawn from the subconscious; or automatic drawing similar to doodling.

suspension and tensile construction A kind of construction in which steel cables are attached to vertical pylons or masts that can support structures like bridges, exhibition tents, or sports arenas.

symbol A visual element that represents something else, often an abstract concept like peace.

symbolic geometry The use of geometry to demarcate sacred alignments in nature; the use of geometric shapes in art and architecture to symbolize divine attributes.

symmetrical balance Balance achieved by distributing equal weight evenly throughout a composition. If an imaginary line could be drawn vertically down an artwork that has symmetrical balance, one side would mirror the other.

sympathetic magic A form of ritual or prayer that is directed to an image or an object in order to bring about a desired result, such as a successful hunt.

T

tabernacle A sacred place that holds the Holy Eucharist in the Christian religion.

taboo Forbidden for general use; usually applied to sacred rituals, places, or objects.

tactile texture A physical surface variation that can be perceived by the sense of touch.

Tapestry, tapestries A heavy fabric woven with designs or images, intended as a wall hanging or furniture covering.

tempera (TEM-per-ah) Painting with pigments mixed with size, casein, or egg yolk.

tensile strength (TEN-sil) The degree to which a material can withstand stretching, stress, or tension.

terra-cotta (TER-eh KOT-ah) A low-fired ceramic clay, such as that found in red-earth flowerpots.

tertiary colors (TUR-shee-er-ee) Colors that result from the mixing of one primary color and a neighboring secondary color.

tetrahedron (teh-trah-HEE-dren) A solid contained by four triangular planar faces.

texture A surface characteristic that is or appears to be tactile.

thatch A roof covering made of straw or reeds.

three-point perspective A drawing in which only one point of each volume is closest to the viewer, and all planes recede to one of three points.

time The art element that is involved in performances or video work, or is required in the viewing of static artwork.

tint The result when white is mixed with a color.

tone *See* **value.**

Torah The holy scroll of the Hebrews containing the Pentateuch, their first five books of scriptures.

torana (TO-rah-nah) Gateway in the stone fence surrounding a stupa, located at the cardinal points.

totem The emblem or symbol of a family clan.

Tourist Art Art that is based on a particular ethnic tradition, but is specifically created to sell to tourists.

tracery The ornamentation of the upper part of a Gothic window. *Plate tracery* was carved through solid stone, while *bar tracery* was incorporated in the mullions of a window.

traditional animation A style of animation that is completely hand-drawn and painted.

transept (TRAN-sept) In cross-shaped buildings, the lesser space that intersects the main space at a ninety degree angle.

triumphal arch A freestanding Roman arch commemorating an important event.

trompe l'oeil (tromp-LOY) Illusionistic painting that fools viewers into believing that they are seeing actual three-dimensional objects instead of their representation.

truss Wooden or metal beams arranged in connected triangles to make a framework.

tufa (TOO-feh) A porous rock formed from deposits of springs. The material can be easily carved when first exposed to air, then hardens with age.

two-point perspective A drawing in which no planes are parallel to the picture plane, but all recede to one of two points on the horizon.

tympanum (TIM-peh-num) In architecture, a half-circular space below an arch, and above a doorway or window.

U

ukiyo-e (oo-kee-yo-ay) A kind of Japanese print or painting; literally, "pictures from the floating world."

unity A quality achieved in an artwork when the artist organizes all the compositional elements so that they visually work together as a whole.

V

value The lights and darks in a composition; sometimes referred to as *tone*.

vanishing point In linear perspective, a point on the horizon line where parallel lines converge.

Vanitas (VAH-nee-tas) A style of Dutch painting in which the theme is the transitory nature of earthly things along with the inevitability of death.

variety Opposing or contrasting visual elements in a composition that add interest without disturbing its unity.

Vaulting, vaults A system of masonry roofing or ceiling construction based on the principle of the arch. There are several types of vaults: The *barrel* vault is a single arch extended in depth from front to back, forming a tunnel-like structure; a *groin* or a *cross* vault is formed with two barrel vaults positioned at 90-degree angles so as to cross or intersect one another; a *ribbed* vault is a variation of the groin vaulting system in which arches diagonally cross over the groin vault forming skeletal ribs; a *dome* is formed by rotating arches on their vertical axis to form a hemispheric vault.

vellum (VEL-um) A fine kind of parchment.

video; video art Art made with recording cameras and displayed on monitors, and having moving imagery.

vignette (vin-YET) A decorative design that might be used on a page of a book or in a drawing, print, or painting; the outer edges of the composition are softened or blurred.

visual culture Art criticism that integrates and studies all of the visual components of contemporary culture, including fine art, television, advertising, and so on.

visual texture The rendering of illusionary texture on a surface or a ground. This texture may be simulated, abstracted, or invented.

volume *See* **mass.**

votive painting A gift given to a deity in the form of a painting.

voussoir (voo-SWAR) Wedge-shaped stone used to build an arch or a vault.

W

warm colors Generally, reds, oranges, and yellows.

wash A thin layer of watery paint.

watercolors Pigments suspended in a water-soluble glue and applied to paper in transparent layers.

woodcut A kind of printmaking done by cutting away nonprinting areas from the surface of a block of wood.

Y

Yakshi (yah-shee) A lesser Hindu and Buddhist female divinity, associated with fertility and vegetation; the male counterpart is the Yaksha.

Z

Zen A variation of Buddhism, practiced mostly in Japan, Vietnam, and Korea, that seeks intuitive illumination of the mind and spirit, primarily through meditation.

ziggurat (ZIG-oo-rat) A terraced, flat-topped pyramid surmounted by a temple, from the ancient Near East.

BIBLIOGRAPHY

Abbate, Francesco, ed. *Precolumbian Art of North America and Mexico.* Translated by Elizabeth Evans. London: Octopus Books, 1972.

Abbott, Helen, et al., eds. *The Spirit Within: Northwest Coast Native Art from the John H. Hauberg Collection.* New York: Rizzoli, 1995.

Abiodun, Rowland, Henry J. Drewal, and John Pemberton III, eds. *The Yoruba Artist: New Theoretical Perspectives on African Arts.* Washington, DC: Smithsonian Institution Press, 1994.

Adachi, Barbara. "Living National Treasures." *Japanese Encyclopedia.* Tokyo: Kodansha, 1983, pp. 60–61.

Adams, Laurie Schneider. *A History of Western Art.* New York: McGraw-Hill, 1997.

Albarn, Keith, Jenny Miall Smith, Stanford Steele, and Dinah Walker. *The Language of Pattern: An Inquiry Inspired by Islamic Decorations.* New York: Harper and Row, 1974.

Alva, Walter, and Christopher B. Donnan. *Royal Tombs of Sipan.* Los Angeles: The Fowler Museum of Cultural Heritage, University of California, Los Angeles, 1993.

American Film Institute. "Preservation." *American Film Institute.* http://afionline.org (accessed July 16, 1998).

Andah, Bassey W. "The Ibadan Experience to Date." In *Museums and Archeology in West Africa,* edited by Claude Daniel Ardouin. Washington, DC: Smithsonian Institution Press, 1997.

Anderson, Richard L. *Calliope's Sisters: A Comparative Study of Philosophies of Art.* Englewood Cliffs, NJ: Prentice Hall, 1990.

Anfam, David, and Donna De Salvo. *Anish Kapoor. 20th Century Living Masters.* London, New York: Phaidon Press, 2009.

Ardouin, Claude Daniel, ed. *Museums and Archeology in West Africa.* Washington, DC: Smithsonian Institution Press, 1997.

Arnason, H. H. *History of Modern Art.* Englewood Cliffs, NJ: Prentice Hall, 1986.

Art21. *Art in the Twenty-First Century.* Television Series Broadcast on PBS: Season 1 (2001), Season 2 (2003), Season 3 (2005), Season 4 (2007), Season 5 (2009), Season 6 (2012).

Atkins, Robert. *Art Speak: A Guide to Contemporary Ideas, Movements, and Buzzwords, 1945 to the Present.* New York: Abbeville Press, 1997.

Auping, Michael. *Jenny Holzer.* New York: Universe Publishing, 1992.

Baines, John, and Jaromir Malak. *Cultural Atlas of the World: Ancient Egypt.* New York: Facts on File, 1994.

Bal, Mieke. *Of What One Cannot Speak: Doris Salcedo's Political Art.* Chicago: University of Chicago Press, 2011.

Banksy. *Wall and Piece.* London: Century. 2005.

Barrie, Dennis. "The Scene of the Crime." *Art Journal* 50, no. 3 (Fall 1991): 29–32.

Barrow, Terrence. *An Illustrated Guide to Maori Art.* Honolulu: University of Hawaii Press, 1984.

Barrow, Tui Terrence. *Maori Wood Sculpture of New Zealand.* Rutland, VT: Charles E. Tuttle, 1969.

Basualdo, Carlos, Nancy Princenthal, Doris Salcedo, and Andreas Huyssen. *Doris Salcedo.* London: Phaidon Press, 2000.

Baumann, Felix, and Marianne Karabelnik, eds. *Degas Portraits.* London: Merrell Holberton, 1994.

Beaver, R. Pierce, et al., eds. *Eerdmans' Handbook to the World's Religions.* Grand Rapids, MI: William B. Eerdmans, 1982.

Beck, James, and Michael Daley. *Art Restoration: The Culture, the Business and the Scandal.* New York: W. W. Norton, 1993.

Becker, Carol. "Art Thrust into the Public Sphere." *Art Journal* 50, no. 3 (Fall 1991): 65–68.

Beckwith, John. *Early Medieval Art.* New York: Praeger, 1973.

Benton, Janetta Rebold. *The Medieval Menagerie: Animals in the Art of the Middle Ages.* New York: Abbeville Press, 1992.

Benton, Janetta Rebold, and DiYanni, Robert. *Arts and Culture: Volume II.* Upper Saddle River, NJ: Prentice Hall, 1998.

Bernadac, Marie-Laure. *Louise Bourgeois.* Paris: Flammarion, 1996.

Berrin, Kathleen, ed. *The Spirit of Ancient Peru: Treasures from the Museo Arqueológico Rafael Larco Herrera.* London: Thames and Hudson, 1997.

Bersson, Robert. *Worlds of Art.* Mountain View, CA: Mayfield, 1991.

Bertelli, Carlo. *Mosaics.* New York: W. H. Smith, 1989.

Bianchi, Emanuela. *Ara Pacis Augustae.* Rome, Italy: Fratelli Palombi Editori, 1994.

Blair, Sheila S., and Bloom, Jonathon M. *Art and Architecture of Islam 1250–800.* Yale University Press, New Haven, c 1994.

Blake, Nayland, Lawrence Rinder, and Amy Scholder, eds. *In a Different Light: Visual Culture, Sexual Identity, Queer Practice.* San Francisco: City Light Books, 1995.

Blier, Suzanne Preston. *The Royal Arts of Africa.* New York: Harry N. Abrams, 1998.

Bluemel, Carl. *Greek Sculptors at Work.* New York: Phaidon, 1969.

Blunden, Caroline, and Mark Elvin. *The Cultural Atlas of the World: China.* Alexandria, VA: Stonehenge Press, 1991.

Blunt, Wilfrid. *Isfahan, Pearl of Persia.* London: Elek Books, 1966.

Boardman, John. *Greek Art.* London: Thames and Hudson, 1996.

Bond, Anthony, and Joanna Woodall. *Self Portrait: Renaissance to Contemporary.* London: National Portrait Gallery, 2005.

Bourriaud, Nicholas. *Relational Aesthetics.* Dijon: Les Presses Du Reel, 1998.

Boyd, Andrew. *Chinese Architecture and Town Planning 1500 B.C.–A.D. 1911.* London: Alec Tiranti, 1962.

Brainard, Shirl. *A Design Manual.* Upper Saddle River, NJ: Prentice Hall, 1998.

Brotherston, Gordon. *Painted Books from Mexico: Codices in UK Collections and the World They Represent.* London: The British Museum Press, 1995.

Brown, Kendall H., et al. *Light in Darkness: Women in Japanese Prints of Early Showa (1926–1945).* Los Angeles: Fisher Gallery, University of Southern California, 1996.

Buehler, Alfred, Terry Barrow, and Charles P. Mountford. *The Art of the South Sea Islands.* New York: Crown, 1962.

Burson, Nancy. *Faces.* Santa Fe, NM: Twin Palms, 1993.

Burton, Rosemary, and Richard Cavendish. *Wonders of the World.* Chicago: Rand McNally, 1991.

Bushnell, G. H. S. *Ancient Arts of the Americas.* New York: Praeger, 1965.

Cahill, James. *The Lyric Journey: Poetic Painting in China and Japan.* Cambridge, MA: Harvard University Press, 1966.

Cameron, Elisabeth L., with Doran H. Ross. *Isn't S/He a Doll? Play and Ritual in African Sculpture.* Los Angeles: UCLA Fowler Museum of Cultural History, 1996.

Canaday, John. *Mainstreams of Modern Art.* New York: Holt, Rinehart and Winston, 1959.

Cantrell, Jacqueline Phillips. *Ancient Mexico: Cultural Traditions in the Land of the Feathered Serpent.* Dubuque, IA: Kendall/Hunt, 1984.

Carpenter, T. H. *Art and Myth in Ancient Greece.* London: Thames and Hudson, 1991.

Cartiere, Cameron, and Shelly Willis. *The Practice of Public Art.* Routledge Research in Cultural and Media Studies. New York, London: Routledge, 2008.

Caruana, Wally. *Aboriginal Art.* London: Thames and Hudson, 1993.

Casson, Lionel. *Ancient Egypt.* New York: Time-Life Books, 1971.

Caygill, Marjorie, and John Cherry. *A. W. Franks: Nineteenth Century Collecting and the British Museum.* London: The British Museum Press, 1997.

Center for African Art. *ART/artifact: African Art in Anthropology Collections.* New York: Prestel Verlag, 1989.

Chandra, Pramod. *The Sculpture of India 3000 B.C.–1300 A.D.* Washington, DC: The National Gallery of Art, 1985.

Chicago, Judy. *Through the Flower: My Struggles as a Woman Artist.* Garden City, NY: Doubleday, 1975.

Chui, Hu. *The Forbidden City, Collection of Photographs.* Beijing: China Photographic Publishing House, 1995.

Clark, Kenneth. *Animals and Men: Their Relationship as Reflected in Western Art from Prehistory to the Present Day.* New York: William Morrow, 1977.

Clark, Kenneth. *The Nude: A Study in Ideal Form.* Princeton, NJ: Princeton University Press, 1956.

Clearwater, Bonnie. *Mark Rothko: Works on Paper.* New York: Hudson Hills Press, 1984. Distributed by Viking Penguin.

Cocke, Thomas. *900 Years: The Restorations of Westminster Abbey.* London: Harvey Miller, 1995.

Coe, Michael, Dean Snow, and Elizabeth Bensen. *The Cultural Atlas of the World: Ancient America.* Richmond, VA: Stonehenge Press, 1990.

Coe, Michael D. *The Maya.* New York: Thames and Hudson, 1982.

Collcutt, Martin, Marius Jansen, and Isao Kumakuro. *Cultural Atlas of the World: Japan.* Alexandria, VA: Stonehenge Press, 1991.

Collier's. *Photographic History of World War II.* New York: P. F. Collier and Son, 1946.

Collignon, Maxime. *Manual of Mythology in Relation to Greek Art.* New Rochelle, NY: Caratzas Brothers, 1982.

Colton, Joel. *Great Ages of Man: Twentieth Century.* New York: Time-Life Books, 1968.

Colvin, Howard. *Architecture and the After-life.* New Haven and London: Yale University Press, 1991.

Compassion and Protest: Recent Social and Political Art from the Eli Broad Family Foundation Collection. New York: Cross River Press, a Division of Abbeville Press, 1991.

Corbin, George A. *Native Arts of North America, Africa, and the South Pacific.* New York: Harper and Row, 1988.

Cotterell, Arthur. *The First Emperor of China.* New York: Holt, Rinehart and Winston, 1981.

Cowart, Jack, et al. *Georgia O'Keeffe: Art and Letters.* Washington, DC: The National Gallery of Art, 1987.

Craven, Roy C. *Indian Art: A Concise History.* London: Thames and Hudson, 1997.

Crimp, Douglas. "The Photographic Activity of Postmodernism." In *Postmodern Perspectives: Issues in Contemporary Art,* edited by Howard Risatti, 131–139. Englewood Cliffs, NJ: Prentice Hall, 1990.

Culbertson, Judi, and Tom Randall. *Permanent Parisians: An Illustrated Guide to the Cemeteries of Paris.* Chelsea, VT: Chelsea Green, 1986.

Cunningham, Lawrence S., and John J. Reich. *Culture and Values: A Survey of the Western Humanities, Volume II.* Fort Worth, TX: Harcourt Brace College Publishers, 1998.

Cuttler, Charles D. *Northern Painting from Pucelle to Bruegel: Fourteenth, Fifteenth and Sixteenth Centuries.* New York: Holt, Rinehart and Winston. 1968.

Davies, J. G. *Temples, Churches and Mosques: A Guide to the Appreciation of Religious Architecture.* New York: The Pilgrim Press, 1982.

Dawson, Barry, and John Gillow. *The Traditional Art of Indonesia.* London: Thames and Hudson, 1994.

de Franciscis, Alfonso. *Pompeii: Civilization and Art.* Naples, Italy: Edizioni Interdipress, 1997.

De la Mora, Sergio. *Forging a National and Popular Art Cinema in Mexico: "María Candelaria."* Accessed online in June 2010 at http://www.sdlatinofilm.com/trends5.html.

DeMott, Barbara. *Dogon Masks: A Structural Study in Form and Meaning.* Ann Arbor, MI: UMI Research Press, 1982.

Denyer, Susan. *African Traditional Architecture.* New York: Africana Publishing, 1978.

Derson, Denise. *What Life Was Like on the Banks of the Nile, Egypt 3050–30 BC.* Alexandria, VA: Time-Life Books, 1996.

Desai, Vishakha N., and Darielle Mason. *Gods, Guardians, and Lovers: Temple Sculptures from North India A.D. 700–1200.* New York: The Asia Society Galleries; Ahmedabad: Mapin Publishing, 1993.

Dewald, Ernest T. *Italian Painting.* New York: Holt, Rinehart and Winston, 1965.

de Zegher, M. Catherine. *Inside the Visible: An Elliptical Traverse of 20th Century Art.* Cambridge: MIT Press, 1996.

Dickerson, Albert I., ed. *The Orozco Frescoes at Dartmouth.* Hanover, NH: The Trustees of Dartmouth College, 1962.

Drewal, Henry John, and John Pemberton III, with Rowland Abiodun. *Yoruba, Nine Centuries of African Art and Thought.* New York: Center for African Art, 1989.

Duiker, William J., and Jackson J. Spielvogel. *World History.* 4th ed. Belmont, CA: Thomson/Wadsworth, 2004.

Durand, Jorge, and Douglas S. Massey. *Miracles on the Border: Retablos of Mexican Migrants to the United States.* Tucson and London: University of Arizona Press, 1995.

Ebrey, Patricia Buckley. *Cambridge Illustrated History of China.* London: Cambridge University Press, 1996.

Edwards, Jim. *Precarious Links: Emily Jennings, Hung Liu, Celia Munoz.* San Antonio, TX: San Antonio Museum of Art, 1990.

Edwards, I. E. S. *The Treasures of Tutankhamun.* New York: Penguin Books, 1977.

Elkins, James. *Visual Studies: A Skeptical Introduction.* New York: Routledge, 2003.

Encyclopedia Americana. S.v. "Central Park," by Harry L. Coles; "China: Theater," by Chia-pao Wan; "Globe Theater," by Bernard Beckermen; "Japan: Doll Drama," by Donald Richie; "Disneyland and Disney World," "Epcot," "Palenque," by Pedro Armillas; "Zoological Gardens," by William Bridges. Danbury, CT: Grolier, 1986.

Encyclopedia Britannica Online. S.v. "Animal Behaviour: Behaviour of Animals in Groups." *http://www.eb.com:180/cgi-bin/g?DocF=macro/5000/62/94.html* (accessed May 19, 1998).

Etienne, Robert. *Pompeii: The Day a City Died.* New York: Harry N. Abrams, 1992.

Ezra, Kate. *Art of the Dogon.* New York: The Metropolitan Museum of Art, 1988.

Fagan, Brian M. *Rape of the Nile.* Kingston, RI: Moyer Bell, 1992.

Fagg, William. *Yoruba: Sculpture of West Africa.* New York: Alfred A. Knopf, 1982.

Feder, Norman. *American Indian Art.* New York: Harry N. Abrams, 1995.

Feest, Christian F. *Native Arts of North America.* New York: Oxford University Press, 1980.

Fichner-Rathus, Lois. *Understanding Art.* Boston, MA: Wadsworth/Cengage, 2010.

Fiero, Gloria. *The Humanistic Tradition.* Madison, WI: WCB Brown and Benchmark, 1995.

Fiodorov, B., ed. *Architecture of the Russian North, 12th through 19th Centuries.* Leningrad: Aurora Art Publishers, 1976.

Fisher, Robert E. *Mystics and Mandalas: Bronzes and Paintings of Tibet and Nepal.* Redlands, CA: The University of Redlands, 1974.

Flaherty, Thomas H. *Incas: Lords of Gold and Glory.* Alexandria, VA: Time-Life Books, 1992.

——. *The American Indians: The Spirit World.* Alexandria, VA: Time-Life Books, 1992.

——. *The Mighty Chieftains.* Alexandria, VA: Time-Life Books, 1993.

Flaherty, Thomas H., ed. *Aztecs: Reign of Blood and Splendor.* Alexandria, VA: Time-Life Books, 1992.

Fleming, William. *Arts and Ideas.* 3rd ed. New York: Holt, Rinehart and Winston, 1970.

Fletcher, Valerie. *George Rickey: Kinetic Sculpture, A Retrospective.* Vero Beach, CA: Vero Beach Museum of Art, 2007.

Frankfort, Henri. *The Art and Architecture of the Orient.* New Haven, CT: Yale University Press, 1970.

Frank Gehry: Pritzker Architect Prize Laureate 1989. http://www.pritzkerprize.com/gehry.htm (accessed April 13, 2004).

Furst, Peter T., and Jill L. Furst. *North American Indian Art.* New York: Rizzoli, 1982.

Gardner, Joseph L. *Mysteries of the Ancient Americas.* Pleasantville, NY: Reader's Digest, 1986.

Gardner, Paul. *Louise Bourgeois.* New York: Universe Publishing, 1994.

Getty, Adele. *Goddess, Mother of Living Nature.* London: Thames and Hudson, 1990.

Getz-Preziosi, Pat. *Early Cycladic Sculpture: An Introduction.* Malibu, CA: J. Paul Getty Museum, 1994.

Gilbert, Creighton. *History of Renaissance Art Throughout Europe.* New York: Harry N. Abrams, 1973.

Gillon, Werner. *A Short History of African Art.* New York: Penguin Books, 1991.

Godfrey, Tony. *Painting Today.* Phaidon, 2005.

Goggin, Mary-Margaret. "'Decent' vs. 'Degenerate' Art: The National Socialist Case." *Art Journal* 50, no. 4 (Winter 1991): 84–93.

Goodman, Susan Tumarkin, ed. *Russian Jewish Artists in a Century of Change 1890–1990.* Munich: Prestel-Verlag, 1995.

Gowing, Lawrence. *Lucien Freud.* London: Thames and Hudson, 1982.

Graves, Eleanor. *Life Goes to War: A Picture History of World War II.* Boston, MA: Little, Brown, 1977.

Graze, Sue, Kathy Halbreich, and Roberta Smith. *Elizabeth Murray: Paintings and Drawings.* New York: Harry N. Abrams, in association with the Dallas Museum of Art and the MIT Committee on the Visual Arts, 1987.

Greenberg, Clement. "Avant-Garde and Kitsch." *Partisan Review* 6 (Fall 1939). Reprinted in Greenberg, *Art and Culture: Critical Essays.* Boston: Beacon Press, 1961.

Gregory, Richard L. *Eye and Brain: The Psychology of Seeing.* 5th ed. Princeton, NJ: Princeton University Press, 1997.

Grolier Encyclopedia. S.v. "Pacifism and Non-violent Movements," "Gandhi's Campaigns." 1996.

Grube, Ernst J. *The World of Islam.* New York: McGraw-Hill, 1977.

Gruzinski, Serge. *The Aztecs: Rise and Fall of an Empire.* New York: Harry N. Abrams, 1992.

"Guernica." www.web.org.uk/picasso/guernica.html (accessed March 15, 2004).

Guiart, Jean. *The Arts of the South Pacific.* New York: Golden Press, 1963.

Guilbaut, Serge. *How New York Stole the Idea of Modern Art: Abstract Expressionism, Freedom, and the Cold War.* Translated by Arthur Goldhammer. Chicago and London: University of Chicago Press, 1983.

Hadington, Evan. *Lines to the Mountain Gods.* New York: Random House, 1987.

Hanson, Allan, and Louise Hanson, eds. *Art and Identity in Oceania.* Honolulu, HI: University of Hawaii Press, 1990.

Harle, J. C. *The Art and Architecture of the Indian Subcontinent.* London: Penguin Books, 1986.

Harris, Ann Sutherland, and Linda Nochlin. *Women Artists 1550–1950.* New York: Alfred A. Knopf, 1984.

Harrison, Charles, and Paul J. Wood, eds. *Art in Theory 1900–2000: An Anthology of Changing Ideas.* 2nd ed. Malden, MA: Blackwell, 2002.

Hartt, Frederick. *History of Italian Renaissance Art: Painting, Sculpture, Architecture.* Englewood Cliffs, NJ: Prentice Hall, 1969.

Hawthorn, Audrey. *Kwakiutl Art.* Seattle and London: University of Washington Press, 1979.

Hay, John. *Masterpieces of Chinese Art.* Greenwich, CT: New York Graphic Society, 1974.

Heartney, Eleanor. "Pornography." *Art Journal* 50, no. 4 (Winter 1991): 16–19.

Hedgecoe, John. *Henry Moore,* Nelson, London: Simon and Schuster, New York, 1968.

Helm, Mackinley. *Mexican Painters: Rivera, Orozco, Siqueiros, and Other Artists of the Social Realist School.* New York: Dover, 1941.

Hershey, Irwin. *Indonesian Primitive Art.* New York: Oxford Press, 1991.

Heusinger, Lutz. *Michelangelo.* Florence, Italy: Scala; New York: Riverside, 1989.

Hillier, J. *Japanese Colour Prints.* London: Phaidon, 1991.

Historical Anatomies on the Web, http://www.nlm.nih.gov/exhibition/historicalanatomies/home.html. Accessed March 2010.

Hoffman, Katherine. *Concepts of Identity: Historical and Contemporary Images and Portraits of Self and Family.* New York: HarperCollins, 1996.

Holm, Bill. *Northwest Coast Indian Art: An Analysis of Form.* Seattle: University of Washington Press, 1995.

Holt, Elizabeth Gilmore, ed. *Literary Sources of Art History: An Anthology of Texts from Theophilus to Goethe.* Princeton, NJ: Princeton University Press, 1947.

Holt, John Dominis. *The Art of Featherwork in Old Hawaii.* Honolulu: Topgallant, 1985.

Honour, Hugh, and John Fleming. *The Visual Arts: A History.* Englewood Cliffs, NJ: Prentice Hall, 1995.

hooks, bell. *Art on My Mind: Visual Politics.* New York: New Press, 1995.

Hopkins, Jerry. *Yoko Ono.* New York: Macmillan, 1986.

Howard, Jeremy. *Art Nouveau: International and National Styles in Europe.* Manchester, UK: Manchester University Press, 1996.

Hughes, Robert. *American Visions.* New York: Alfred A. Knopf, 1997.

Hulton, Paul, and Lawrence Smith. *Flowers in Art from East and West.* London: British Museum Publications, 1979.

Huntington, Susan L., and John C. Huntington. *Leaves from the Bodhi Tree.* Seattle: University of Washington Press, 1990.

Identity and Alterity: Figures of the Body 1895–1995. Edited by Manlio Brusatin and Jean Clair. Venice, Italy: Marsilio, 1995. Exhibition catalog of La Biennale di Venezia 46, esposizione internationale d'arte.

Indych, Anna. "Nuyorican Baroque: Pepón Osorio's *Chucherías.*" *Art Journal* 60, no. 1 (Spring 2001): 72–83.

Internet Medieval Sourcebook. www.fordham.edu/halsall/sbook.html (accessed March 30, 2004).

Isenberg, Barbara. *Conversations with Frank Gehry.* New York: Knopf, 2009.

Ivory: An International History and Illustrated Survey. New York: Harry N. Abrams, 1987.

J. Paul Getty Museum Handbook of the Collections. Malibu, CA: J. Paul Getty Museum, 1991.

Janson, H. W. *History of Art.* New York: Harry N. Abrams, 1995.

Jellicoe, Geoffrey, and Susan Jellicoe. *The Landscape of Man.* London: Thames and Hudson, 1987.

Jonaitis, Aldona. *From the Land of the Totem Poles.* New York: American Museum of Natural History, 1988.

Jones, Alexander. *The Jerusalem Bible.* Garden City, NY: Doubleday, 1966.

Jones, Amelia, ed. *Sexual Politics: Judy Chicago's Dinner Party in Feminist Art History.* Berkeley: University of California Press, 1996.

Kaplan, Janet A. "*Give and Take* Conversations." *Art Journal* 61, no. 2 (Summer 2002): 68–97.

Kaprow, Allen. *Assemblage, Environments and Happenings.* New York: Harry N. Abrams, 1961.

Kearney, Richard, and David Rasmussen, eds. *Continental Aesthetics: Romanticism to Postmodernism, An Anthology.* Malden, MA: Blackwell Publishers LTD, 2001.

Kessler, Adam T. *Empires Beyond the Great Wall: The Heritage of Genghis Khan.* Los Angeles: Natural History Museum of Los Angeles County, 1994.

Kettering, Alice McNeil. "Gentlemen in Satin: Masculine Ideals in Later Seventeenth-Century Dutch Portraiture." *Art Journal* 56, no. 2 (Summer 1997): 41–47.

Kienholz, Edward, and Nancy Reddin Kienholz. *Kienholz: A Retrospective.* New York: Whitney Museum of American Art, 1996.

Kirsh, Andrea. *Carrie Mae Weems.* Washington, DC: The National Museum of Women in the Arts, 1993.

Kitchen, K. A. *Pharaoh Triumphant: The Life and Times of Ramesses II.* Cairo, Egypt: American University in Cairo Press, 1982.

Koons, Jeff. *The Jeff Koons Handbook.* New York: Rizzoli, 1992.

Kopper, Phillip. *The Smithsonian Book of North American Indians before the Coming of the Europeans.* Washington, DC: Smithsonian Books, 1986.

Kulka, Tomas. *Kitsch and Art.* University Park: Pennsylvania State University Press, 1996.

Kundera, Milan. *The Unbearable Lightness of Being.* Translated by Michael Henry Heim. New York: Harper and Row, 1984.

Kuroda, Taizo, Melinda Takeuchi, and Yuzo Yamane. *Worlds Seen and Imagined: Japanese Screens from the Idemitsu Museum of Art.* New York: The Asia Society Galleries; Abbeville Press, 1995.

Laude, Jean. *African Art of the Dogon.* New York: Viking Press, 1973.

Lauer, David A., and Stephen Pentak. *Design Basics.* Boston, MA: Thomson/Wadsworth, 2008.

Lazzari, Margaret, and Clayton Lee. *Art and Design Fundamentals.* New York: Van Nostrand Reinhold, 1990.

Lee, Sherman E. *A History of Far Eastern Art.* New York: Harry N. Abrams, 1973.

Levenson, Jay A. *Circa 1492.* New Haven, CT: Yale University Press, 1991.

Levi, Peter. *The Cultural Atlas of the World: The Greek World.* Alexandria, VA: Stonehenge Press, 1992.

Lewis, Bernard. *Islam and the Arab World.* New York: Alfred A. Knopf, 1976.

Lewis, Phillip. "Tourist Art, Traditional Art and the Museum in Papua New Guinea." In *Art and Identity in Oceania,* edited by Allan Hanson and Louise Hanson. Honolulu: University of Hawaii Press, 1990.

Lincoln, Louise. *Assemblage of Spirits: Idea and Image in New Ireland.* New York: George Braziller, 1987.

Linker, Kate. *Love for Sale: The Words and Pictures of Barbara Kruger.* New York: Harry N. Abrams, 1990.

Lion King: The Broadway Musical ("Circles of Sound," by Lebe M, "New Visions for Pride Rock," by Eileen Blumenthal and Julie Taymor). *Stagebill,* 1998.

Lippard, Lucy R. *Mixed Blessings: New Art in a Multicultural America.* New York: Pantheon Books, 1990.

Lippard, Lucy. *The Pink Glass Swan: Selected Feminist Essays on Art.* New York: New Press, 1995.

Lossing, Benson J. *Mathew Brady's Illustrated History of the Civil War.* Washington, DC: Fair Fax Press; Barre Publishing, 1912.

Lowe, Sarah M. *Frida Kahlo.* New York: Universe Publishing, 1991.

Lozano-Hemmer, Rafael. *Vectorial Elevation: Relational Architecture No. 4.* English and Spanish ed. Mexico City: Conaculta, 2000.

Lundquist, John M. *The Temple: Meeting Place of Heaven and Earth.* London: Thames and Hudson, 1993.

Lyle, Emily, ed. *Sacred Architecture in the Traditions of India, China, Judaism and Islam.* Edinburgh: Edinburgh University Press, 1992.

Machida, Margo. "Out of Asia: Negotiating Asian Identities in America." In *Asia America: Identities in Contemporary Asian American Art.* New York: The Asia Society Galleries; New Press, 1994.

Mackenzie, Lynne. *Non-Western Art: A Brief Guide.* Upper Saddle River, NJ: Prentice Hall, 2001.

Malone, Maggie, and Hideko Takayama. "A Japanese Buying Spree: The Tycoon Who Spent $160 Million at Auctions." *Newsweek,* May 28, 1990, p. 75.

Mann, A. T. *Sacred Architecture.* Rockport, MA: Element, 1993.

Marcus, George E. "Middlebrow into Highbrow at the J. Paul Getty Trust." In *Looking High and Low,* edited by Brenda Jo Bright and Liza Bakewell. Tuscon: University of Arizona Press, 1995.

Mariani, Valerio. *Michelangelo the Painter.* New York: Harry N. Abrams, 1964.

Mathieu, Paul. *Sex Pots, Eroticism in Ceramics:* Rutgers University Press, New Brunswick, New Jersey. c 2003.

Matilsky, Barbara C. *Fragile Ecologies: Contemporary Artists' Interpretations and Solutions.* New York: Rizzoli, 1992.

Matt, Leonard von, Mario Moretti, and Guglielmo Maetzke. *The Art of the Etruscans.* New York: Harry N. Abrams, 1970.

McLanathan, Richard. *The American Tradition in the Arts.* New York: Harcourt Brace and World, 1968.

Mead, Sidney Moko. *Te Maori: Maori Art from New Zealand Collections.* New York: Harry N. Abrams, 1984.

Media Scape. New York: Solomon R. Guggenheim Museum, 1996.

Mehretu, Julie, M. Catherine De Zegher, and Thelma Golden. *Julie Mehretu: Drawings.* New York: Rizzoli, 2007.

Miller, Kimberly J. "Battle for Iwo Jima." http://www.usmc.mil (accessed 1997).

Miller, Arthur G. *The Painted Tombs of Oaxaca, Mexico: Living with the Dead.* Cambridge: Cambridge University Press, 1995.

Miller, Mary Ellen. *The Art of Mesoamerica from Olmec to Aztec.* New York: Thames and Hudson, 1986.

Mirzoeff, Nicholas, ed. *The Visual Culture Reader.* London and New York: Routledge, 1998.

———. *An Introduction to Visual Culture.* London; New York: Routledge, 1999.

Mitchell, W. J. T., ed. *Art and the Public Sphere.* Chicago and London: University of Chicago Press, 1992.

Mitchell, W. J. T., and Margaret Dikovitskaya. *An Interview with W. J. T. Mitchell, Gaylord Donnelley Distinguished Service Professor of English and Art History, University of Chicago, 11 January 2001.* http://humanities.uchicago.edu/faculty/Mitchell/Dikovitskaya_interviews_Mitchell.pdf.

Monod-Bruhl, Odette. *Indian Temples.* London: Oxford University Press, 1951.

Morgan, William N. *Prehistoric Architecture in the Eastern United States.* Cambridge, MA: MIT Press, 1980.

Mosquera, Gerardo. *Manuel Álvarez Bravo: Jeu de Paume, Paris, October 16, 2012–January 20, 2013: Fundación Mapfre, Madrid, February 11–May 19, 2013.* Alcobendas, Spain: T. F. Editores, 2012.

Moynihan, Elizabeth B. *Paradise as a Garden in Persia and Mughal India.* London: Scolar Press, 1979.

Munroe, Alexandra. *Japanese Art After 1945: Scream Against the Sky.* New York: Harry N. Abrams, 1994.

Murray, Jocelyn. *The Cultural Atlas of the World: Africa.* Alexandria, VA: Stonehenge Press, 1992.

Murray, Peter, and Linda Murray. *The Art of the Renaissance.* New York: Praeger, 1963.

Nagle, Geraldine. *The Arts-World Themes.* Madison, WI: Brown and Benchmark, 1993.

Nemser, Cindy. *Art Talk: Conversations with 15 Women Artists.* New York: HarperCollins, 1995.

Newhall, Beaumont. *History of Photography from 1839 to the Present Day.* New York: Museum of Modern Art, 1964.

Newland, Amy, and Chris Uhlenbeck, eds. *Ukiyo-e to Shin Hanga: The Art of Japanese Woodblock Prints.* New York: Mallard Press, 1990.

Newton, Douglas. *New Guinea Art in the Collection of the Museum of Primitive Art.* New York: Publishers Printing–Admiral Press, 1967.

Nochlin, Linda. *Women, Art, and Power and Other Essays.* New York: Harper and Row, 1988.

Northern, Tamara. *The Art of Cameroon.* Washington D.C.: The Smithsonian Institute, 1984.

Norwich, John Julius, ed. *Great Architecture of the World.* New York: Bonanza Books, 1979.

Nou, Jean-Louis, Amina Okada, and M. C. Joshi. *Taj Mahal.* New York: Abbeville Press, 1993.

Obrist, Hans Ulrich, and Rirkrit Tiravanija. *The Conversation Series.* Cologne, Germany: Walther König, 2011.

Ocvirk, Otto G., Robert E. Stinson, Philip R. Wigg, Robert O. Bone, and David L. Clayton. *Art Fundamentals: Theory and Practice.* Madison, WI: Brown and Benchmark, 1998.

Of Sky and Earth: Art of the Early Southeastern Indians. Edited by Roy S. Dickens. Dalton, GA: Lee Printing Company, 1982. Published in conjunction with the exhibition shown at the High Museum of Art, Atlanta, GA.

O'Hara, Frank. *Robert Motherwell.* New York: Museum of Modern Art, 1965.

Ohashi, Haruzo. *The Japanese Garden: Islands of Serenity.* Tokyo: Graphic-sha, 1997.

Oliver, Douglas L. *The Pacific Islands.* Honolulu: University of Hawaii Press, 1989.

O'Neill, John P., ed. *Mexico: Thirty Centuries of Splendor.* New York: Metropolitan Museum of Art, 1990.

Pacific: A Companion to the Regenstein Halls of the Pacific. Edited by Ron Dorfman. Chicago: Field Museum of Natural History, 1991. Field Museum Centennial Collection.

Papanek, John L. *Mesopotamia: The Mighty Kings.* Alexandria, VA: Time-Life Books, 1995.

Papanek, John L., ed. *Africa's Glorious Legacy, Lost Civilizations.* Alexandria, VA: Time-Life Books, 1994.

———. *Ancient India, Land of Mystery.* Alexandria, VA: Time-Life Books, 1994.

Pasztory, Esther. *Aztec Art.* New York: Harry N. Abrams, 1983.

Pelrine, Diane M. *Affinities of Form: Arts of Africa, Oceania and the Americas from the Raymond and Laura Wielgus Collection.* Munich: Prestel-Verlag, 1996.

Pendlebury, J. D. S. *A Handbook to the Palace of Minos at Knossos.* London: Macmillan, 1935.

Penny, David W. *Art of the American Indian Frontier: The Chandler-Pohrt Collection.* The Detroit Institute of Art. Seattle: University of Washington Press, 1992.

Perani, Judith, and Fred T. Davidson. *The Visual Arts of Africa: Gender, Power and Life Cycle Rituals.* Upper Saddle River, NJ: Prentice Hall, 1998.

Perchuk, Andrew. "Hannah Wilke [exhibition at] Ronald Feldman Fine Arts." *Artforum* (April 1994): 93–94.

Phipps, Richard, and Richard Wink. *Invitation to the Gallery.* Dubuque, IA: Wm. C. Brown, 1987.

Pierson, William H., and Martha Davidson. *Arts of the United States: A Pictorial History.* New York: McGraw-Hill, 1960.

Preble, Duane, Sarah Preble, and Patrick L. Frank. *ArtForms.* Upper Saddle River, NJ: Prentice Hall, 1999.

Ragghianti, Carlo Ludovico, and Licia Ragghianti Collobi. *National Museum of Anthropology, Mexico City.* New York: Newsweek (Simon and Schuster), 1970.

Ramseyer, Urs. *The Art and Culture of Bali.* Singapore and Oxford: Oxford University Press, 1986.

Rawson, Jessica, ed. *The British Museum Book of Chinese Art.* London: Thames and Hudson, 1992.

Reilly, Maura. "The Drive to Describe: An Interview with Catherine Opie." *Art Journal* 60, no. 2 (Summer 2001) 83–95.

Rhodes, Colin. *Outsider Art, Spontaneous Alternatives.* World of Art. New York: Thames and Hudson, 2000.

Richter, Anne. *Arts and Crafts of Indonesia.* San Francisco: Chronicle Books, 1994.

Risatti, Howard, ed. *Postmodern Perspectives: Issues in Contemporary Art.* Englewood Cliffs, NJ: Prentice Hall, 1990.

Rochfort, Dennis. *Mexican Muralists.* New York: Universe Publishing, 1993.

Ross, Doran H. "Akua's Child and Other Relatives: New Mythologies for Old Dolls." In *Isn't S/he a Doll? Play and Ritual in African Sculpture,* by Elisabeth L. Cameron, 43–57. Los Angeles: UCLA Fowler Museum of Cultural History, 1996.

Rowland, Anna. *Bauhaus Source Book.* New York: Van Nostrand Reinhold, 1990.

Roy, Christopher. *Art and Life in Africa: Selections from the Stanley Collection, Exhibitions of 1985 and 1992.* Iowa City: University of Iowa Museum of Art, 1992.

Rubenstein, Raphael. "Provisional Painting." *Art in America,* May 2009. http://www.artinamericamagazine.com/news-features/magazine/provisional-painting-raphael-rubinstein. Accessed October 2, 2013.

Rubenstein, Raphael. "Provisional Painting Part 2: To Rest Lightly on Earth." *Art in America,* February 2012. http://www.artinamericamagazine.com/news-features/magazine/provisional-painting-part-2. Accessed October 2, 2013.

Rubin, Barbara, Robert Carlton, and Arnold Rubin. *Forest Lawn: L.A. in Installments.* Santa Monica, CA: Westside Publications, 1979.

Santini, Loretta. *Pompeii and the Villa of the Mysteries.* Narni-Terni, Italy: Editrice Plurigraf, 1997.

Sasser, Elizabeth Skidmore. *The World of Spirits and Ancestors in the Art of Western Sub-Saharan Africa.* Lubbock: Texas Tech University Press, 1995.

Saunders, J. B. de C. M., and Charles O'Malley. *The Illustrations from the Works of Andreas Vesalius of Brussels.* New York: Dover, 1950.

Sayre, Henry M. *The Object of Performance: The American Avant-Garde since 1970.* Chicago: University of Chicago Press, 1989.

Schmitz, Carl A. *Oceanic Art: Myth, Man and Image in the South Seas.* New York: Harry N. Abrams, 1971.

Schwarz, Hans-Peter. *Media-Art-History.* Munich: Prestel-Verlag, 1997.

Seaford, Richard. *Pompeii.* New York: Summerfield Press, 1978.

Setton, Kenneth M., et al. *The Renaissance, Maker of Modern Man.* Washington, DC: National Geographic Society, 1970.

Sharer, Robert, and Sylvanus Morley. *The Ancient Maya.* Stanford, CA: Stanford University Press, 1994.

Sharp, Dennis. *A Visual History of Twentieth Century Architecture.* Greenwich, CT: New York Graphic Society, 1972.

Shearer, Alistair. *The Hindu Vision: Forms of the Formless.* London: Thames and Hudson, 1993.

Sheets, Hilary. "Click Here for Enlightenmnet." *ARTnews,* April 2010. Accessed online in June 2010 at http://www.artnews.com/issues/article.asp?art_id=2910.

Shohat, Ella, and Robert Stam. "Narrativizing Visual Culture," in *The Visual Culture Reader,* ed. by Nicholas Mirzoeff. London and New York: Routledge, 1998.

Sickman, Lawrence, and Alexander Soper. *The Art and Architecture of China.* New Haven, CT: Yale University Press, 1971.

Silva, Anil de, Otto von Simons, and Roger Hinks. *Man Through Art, War and Peace.* Greenwich, CT: New York Graphic Society, 1964.

Simmons, David. *Whakairo Maori Tribal Art.* New York: Oxford University Press, 1985.

Simon, Joan, ed. *Bruce Nauman.* Minneapolis: Walker Art Center, 1994.

Sitwell, Sacheverell. *Great Palaces.* New York: Hamlyn, 1969.

Skinner, Charles Montgomery. *Myths and Legends of Our Own Land.* Philadelphia and London: J. B. Lippincott, 1924.

Skira, Albert. *Treasures of Asia: Chinese Painting.* Cleveland, OH: World, 1960.

Slatkin, Wendy. *Women Artists in History: From Antiquity to the Present.* Upper Saddle River, NJ: Prentice Hall, 1997.

Smith, Bradley, and Wan-go Wen. *China: A History in Art.* New York: Doubleday, 1979.

Smith, Karen, et al. *Ai Weiwei.* Contemporary Artist Series. London, New York: Phaidon Press, 2009.

Snellgrove, David L., ed. *The Image of the Buddha.* Paris: UNESCO (United Nations Educational, Scientific and Cultural Organization); Tokyo: Kodansha, 1978.

Solomon-Godeau, Abigail. "The Other Side of Vertu: Alternative Masculinities in the Crucible of Revolution." *Art Journal* 56, no. 2 (Summer 1997): 55–61.

Sontag, Susan. *Against Interpretation and Other Essays.* New York: Farrar, Straus and Giroux, 1966.

Spayde, Jon. "Cultural Revolution." *Departures* (September/October 1995): 115–123, 154–157.

Sporre, Dennis J. *The Creative Impulse: An Introduction to the Arts.* Upper Saddle River, NJ: Prentice Hall, 1996.

Staccioli, R. A. *Ancient Rome: Monuments Past and Present.* Rome: Vision, 1989.

Staniszewski, Mary Anne. *Believing Is Seeing: Creating a Culture of Art.* New York: Penguin Books, 1995.

Stanley-Baker, Joan. *Japanese Art.* London: Thames and Hudson, 1984.

Sterling, Charles. *Still Life Painting: From Antiquity to the Twentieth Century.* 2nd ed. rev. New York: Harper and Row, 1980.

Stewart, Gloria. *Introduction to Sepik Art of Papua New Guinea.* Sydney, Australia: Garrick Press, 1972.

Stewart, Hilary. *Looking at Indian Art of the Northwest Coast.* Seattle: University of Washington Press, 1979.

Stierlin, Henri. *Art of the Aztecs and Its Origins.* Translated by Betty and Peter Ross. New York: Rizzoli, 1982.

Stierlin, Henri. *The Pharaohs, Master-Builders.* Paris: Terrail, 1992.

Stiles, Kristine. *Marina Abramovic.* Contemporary Artist Series. London, New York: Phaidon Press, 2008.

Stokstad, Marilyn. *Art History.* Upper Saddle River, NJ: Prentice Hall, 1995.

Stooss, Toni, and Thomas Kellein, eds. *Nam June Paik: Video Time–Video Space.* New York: Harry N. Abrams, 1993.

Stuart, Gene S., and George E. Stuart. *Lost Kingdoms of the Maya.* Washington, DC: National Geographic Society, 1993.

Suh, Do Ho. *Do Ho Suh—Perfect Home.* Kanazawa, Japan: 21st Century Museum of Contemporary Art, Kanazawa, 2013.

Sullivan, Michael. *Art and Artists of Twentieth-Century China.* Berkeley: University of California Press, 1996.

Suther, Judith D. *A House of Her Own: Kay Sage, Solitary Surrealist.* Lincoln: University of Nebraska Press, 1997.

Sutton, Peter C. *The Age of Rubens.* Boston: Museum of Fine Arts, Boston: 1993.

Swann, Peter C. *Chinese Monumental Art.* New York: Viking, 1963.

Tadashi Kobayashi. *Ukiyo-e: An Introduction to Japanese Woodblock Prints.* Tokyo: Kodansha, 1992.

Tallman, Susan. "General Idea." *Arts Magazine* (May 1990): 21–22.

Tannahill, Reay. *Food in History.* New York: Stein and Day, 1973.

Tansey, Richard G., and Fred S. Kleiner. *Gardner's Art Through the Ages.* Fort Worth, TX: Harcourt Brace College Publishers, 1996.

Taylor, Pamela York. *Beasts, Birds and Blossoms in Thai Art.* Kuala Lumpur, Malaysia: Oxford University Press, 1994.

Taylor, Simon. "Janine Antoni at Sandra Gering." *Art in America* 80 (October 1992).

Tello, J. C. "Arte Antiguo Peruano." *Inca: Revista de Estudios Antropolico.* Vol. 2. Lima, Peru: Universidad de San Marcos de Lima, 1924.

Terrace, Edward L. B., and Henry G. Fisher. *Treasures of Egyptian Art from the Cairo Museum.* London: Thames and Hudson, 1970.

Thomas, Nicholas. *Oceanic Art.* London: Thames and Hudson, 1995.

Thucydides. *The Peloponnesian War.* Translated by Rex Warner. Baltimore: Penguin Books, 1954.

Time-Life Books. *Lost Civilizations: Anatolia—Cauldron of Cultures.* Richmond, VA: Time-Life Books, 1995.

Tom, Patricia Vettel. "Bad Boys: Bruce Davidson's Gang Photographs and Outlaw Masculinity." *Art Journal* 56, no. 2 (Summer 1997): 69–74.

Townsend, Richard F., ed. *The Ancient Americas: Art from Sacred Landscapes.* Chicago: Art Institute of Chicago, 1992.

Tregear, Mary. *Chinese Art.* London: Thames and Hudson, 1991.

Truettner, William H. *The Natural Man Observed: A Study of Catlin's Indian Gallery.* Washington, DC: Smithsonian Institution Press, 1979.

Turner, Jane, ed. *The Dictionary of Art.* New York: Grove, 1996.

Vercoutter, Jean. *The Search for Ancient Egypt.* New York: Harry N. Abrams, 1992.

Vickers, Michael, ed. *Pots and Pans.* Oxford: Oxford University Press, 1986.

Vogel, Susan. *Africa Explores: 20th Century African Art.* New York: Center for African Art, 1991.

Vogel, Susan Mullin. *African Art, Western Eyes.* New Haven and London: Yale University Press, 1997.

Von Blum, Paul. *The Art of Social Conscience.* New York: Universe Books, 1976.

von Hagen, Victor W. *The Desert Kingdoms of Peru.* London: Weidenfeld and Nicolson, 1965.

Vroege, Bas, and Hripsim Visser, eds. *Oppositions: Commitment and Cultural Identity in Contemporary Photography from Japan, Canada, Brazil, the Soviet Union and the Netherlands.* Rotterdam: Uitgeverij, 1990.

Wallach, Alan. *Exhibiting Contradiction: Essays on the Art Museum in the United States.* Amherst: University of Massachusetts Press, 1998.

Wallis, Brian, ed. *Hans Haacke: Unfinished Business.* New York: The New Museum of Contemporary Art; Cambridge: MIT Press, 1986.

Washburn, Dorothy, ed. *Hopi Kachina: Spirit of Life.* San Francisco: California Academy of Sciences, 1980. Distributed by the University of Washington Press.

Weibiao, Hu. *Scenes of the Great Wall.* Beijing: Wenjin Publishing House, 1994.

Weintraub, Linda, ed. *Art What Thou Eat: Images of Food in American Art.* Mount Kisco, NY: Moyer Bell, 1991.

Weiwei, Ai. *Ai Weiwei: Spatial Matters—Art, Architecture and Activism,* edited by Anthony Pins. Cambridge, MA: MIT Press, 2014.

Wescoat, James L., Jr., and Joachim Wolschke-Bulmahn. *Mughal Gardens: Sources, Places, Representations and Prospects.* Washington, DC: Dumbarton Oaks Research Library and Collection, 1996.

Wheat, Ellen Harkins. *Jacob Lawrence: American Painter.* Seattle: University of Washington Press, 1986.

Willett, Frank. *African Art.* New York: Thames and Hudson, 1993.

——. *Ife in the History of West African Sculpture.* New York: McGraw-Hill, 1967.

Willis, Deborah, ed. *Picturing Us: African American Identity in Photography.* New York: New Press, 1994.

Willis-Braithwaite, Deborah. *VanDerZee Photographer 1886–1983.* New York: Harry N. Abrams, 1993.

Wilson, David M., and Ole Klindt-Jensen. *Viking Art.* Minneapolis: University of Minnesota Press, 1980.

Wilson, Sir David M., ed. *The Collections of the British Museum.* Cambridge: Cambridge University Press, 1989.

Wingert, Paul S. *An Outline of Oceanic Art.* Cambridge, MA: University Prints, 1970.

——. *Art of the South Pacific.* New York: Columbia University Press, 1946.

Winkelmann-Rhein, Gertraude. *The Paintings and Drawings of Jan "Flower" Bruegel.* New York: Harry N. Abrams, 1968.

Witherspoon, Gary. *Language and Art of the Navajo Universe.* Ann Arbor: University of Michigan Press, 1977.

Wolff, Janet. *The Social Production of Art.* New York: New York University Press, 1984.

Yau, John. "Hung Liu [exhibition at] Nahan Contemporary." *Artforum* (March 1990): 162.

Yenne, Bill, and Susan Garratt. *North American Indians.* China: Ottenheimer, 1994.

Yood, James. *Feasting: A Celebration of Food in Art.* New York: Universe Publishing, 1992.

Zarnecki, George. *Art of the Medieval World.* New York: Harry N. Abrams, 1975.

Zelanski, Paul, and Mary Pat Fisher. *Design Principles and Problems.* Fort Worth, TX: Harcourt Brace College Publishers, 1996.

Zelevansky, Lynn, et al. *Love Forever: Yayoi Kusama 1958–1968.* Los Angeles: Los Angeles County Museum of Art, 1998.

Zigrosser, Carl. *Prints and Drawings of Käthe Kollwitz.* New York: Dover, 1969.

CREDITS

1: The Great Wave off Kanagawa from the series 36 Views of Mt. Fuji, 1831 (hand-coloured woodblock print)/Hokusai, Katsushika (1760–1849)/STAPLETON COLLECTION/Private Collection/Bridgeman Images.

Chapter 1: 1.1: max homand/iStockphoto.com; **1.2:** Image copyright © The Metropolitan Museum of Art. Image source: Art Resource, NY; **1.3:** Danilo Ascione/Shutterstock.com; **1.4:** Scala/Art Resource, NY; **1.5:** © 2019 Estate of Pablo Picasso/Artists Rights Society (ARS), New York, Digital Image © The Museum of Modern Art/Licensed by SCALA/Art Resource, NY; **1.6:** Werner Forman/Art Resource, NY; **1.8:** Peter Adams/Corbis; **1.9:** © Roger Wood/CORBIS; **1.10:** Scala/Art Resource, NY; **1.11:** Erich Lessing/Art Resource, NY; **1.12:** Atlantide Phototravel/Corbis; **1.13:** Yadid Levy/Robert Harding World Imagery/Corbis; **1.14:** Courtesy of the author; **1.15:** Atlantide Phototravel/Corbis; **1.16:** The University of New Mexico; **1.17:** John Van Hasselt/Corbis; **1.18:** Photo courtesy of the Pasadena Tournament of Roses; **1.19:** © Tim Hawkinson, courtesy Pace Gallery, University of California, San Diego; **1.20:** Erich Lessing/Art Resource, NY; **page 16(b):** Skyscan/Terra/Corbis; **1.21:** Ian McKinnell/Alamy; **1.22:** Smithsonian American Art Museum, Washington, DC/Art Resource, NY; **1.23:** Ando or Utagawa (1797–1858)/Leeds Museums and Galleries (City Art Gallery) U.K./The Bridgeman Art Library; **page 19(b):** Erich Lessing/Art Resource, NY; **1.24:** Reuters/CORBIS; **page 20(r):** Nursing-mother-effigy bottle, Cahokia Culture, Mississippian Period, 1200–1400 (ceramic), American School/St. Louis Museum of Science & Natural History, Missouri, US/Photo © The Detroit Institute of Arts/The Bridgeman Art Library; **1.25:** © 1993 Jaune Quick-to-See Smith; **1.26:** Lindsay Hebberd/CORBIS; **1.27:** Heini Schneebeli/The Bridgeman Art Library; **1.28:** Galleria dell' Accademia, Venice, Italy/The Bridgeman Art Library; **1.29:** Malcolm Park editorial/Alamy.

Chapter 2: 2.1: © age fotostock/SuperStock; **2.3:** Shoki the Demon Queller, c.1849–53 (woodblock print), Kunisada, Utagawa (1786–1864)/Burrell Collection, Glasgow, Scotland/© Culture and Sport Glasgow (Museums)/The Bridgeman Art Library; **2.4:** Peter Horree/Alamy. © 2019 Artists Rights Society (ARS), New York; **2.5:** Foto Marburg/Art Resource, NY; **2.6:** Princeton University Art Museum/Art Resource, NY; **2.7:** Albright-Knox Art Gallery/Art Resource, NY © 2019 Stephen Flavin/Artists Rights Society (ARS), New York; **2.9:** Erich Lessing/Art Resource, NY; **2.10:** Mirror Image 1, 1969 (painted wood), Nevelson, Louise (1899–1988)/Museum of Fine Arts, Houston, Texas, USA/Museum purchase funded by The Brown Foundation, Inc. and the Brown Foundation Accessions Endowment Fund/Bridgeman Images © 2019 Estate of Louise Nevelson/Artists Rights Society (ARS), New York; **2.11:** National Gallery, London/Art Resource, NY; **2.14:** © Cengage Learning; **2.15:** Benoy K. Behl; **2.16:** Adam Woolfitt/Terra/Corbis; **2.17:** The Newark Museum/Art Resource, NY; **2.18:** Paul Almasy/Corbis; **2.19:** Gianni Dagli Orti/The Art Archive at Art Resource, NY; **2.21:** Albright-Knox Art Gallery/Art Resource, NY; **2.23:** Werner Forman/Art Resource, NY; **2.24:** Philippe Sauvan-Magnet/Active Museum/Alamy © 2019 Artists Rights Society (ARS), New York/SIAE, Rome; **2.25:** Barbara Gladstone Gallery; **2.26:** Philippe Sauvan-Magnet/Active Museum/Alamy © Association Marcel Duchamp/ADAGP, Paris/Artists Rights Society (ARS), New York 2019; **2.27:** CAI GUO-QIANG; **2.28:** Richard A. Cooke/Corbis; **2.29:** Vanni/Art Resource, NY; **2.30:** Robert Estall Photo Library; **page 42(l):** J. Paul/The Getty Museum; **2.31:** Christophe Loviny/Corbis; **2.32:** National Geographic Image Collection/Alamy; **2.33:** Nik Wheeler/CORBIS; **2.34:** Richard A Cooke III/The Image Bank/Getty Images; **page 45(t):** Michael S. Yamashita/Encyclopedia/Corbis; **page 46(b):** Scala/Art Resource, NY; **2.36:** Roger Wood/CORBIS; **2.40:** Vanni Archive/Value Art/Corbis; **2.42:** Bettmann/Corbis; **page 53(l):** Paul O Connell/Shutterstock.com; **(br):** Tibor Bognar/Alamy; **2.44:** Bettmann/Corbis.

Chapter 3: 3.1: Smithsonian American Art Museum, Washington, DC/Art Resource, NY; **3.2:** Prudence Cuming Associates/Handout/Files/REUTERS; **page 56(tr):** RMN-Grand Palais/Art Resource, NY; **3.3:** Erich Lessing/Art Resource, NY; **3.4:** Digital Image © The Museum of Modern Art/Licensed by SCALA/Art Resource, NY, © Robert Gober, Courtesy Matthew Marks Gallery; **3.5:** Smithsonian American Art Museum, Washington, DC/Art Resource, NY. Baca, Judith F. (b. 1946) Las Tres Marias. 1976. Colored pencil on paper

mounted on panel with upholstery backing and mirror. ©SPARC www.sparcmurals.org; **3.6:** Douglas Schlesier/Image courtesy of the Author Dona Schlesier; **3.7:** Digital Image © The Museum of Modern Art/Licensed by SCALA/Art Resource, NY; **3.8:** Courtesy National Gallery of Art, Washington; **3.9:** Réunion des Musées Nationaux/Art Resource, NY; **3.10:** Digital Image © The Museum of Modern Art/Licensed by SCALA/Art Resource, NY. © Yoshitomo Nara, courtesy Pace Gallery; **3.11:** Digital Image © The Museum of Modern Art/Licensed by SCALA/Art Resource, NY, Photo by Hiro Ihara, Courtesy Cai Studio; **3.12:** The Museum of Modern Art/Licensed by SCALA/Art Resource, NY; **3.14:** Réunion des Musées Nationaux/Art Resource, NY; **3.15:** RMN-Grand Palais/Art Resource, NY; **3.16:** Courtesy National Gallery of Art, Washington; **3.17:** © Kiki Smith, courtesy Pace Gallery. Digital Image © The Museum of Modern Art/Licensed by SCALA/Art Resource, NY; **3.18:** Michael Latz/AFP/Getty Images; **3.19:** Erich Lessing/Art Resource, NY; **3.20:** © Cengage Learning; **3.21:** Erich Lessing/Art Resource, NY; **3.22:** View Stock/Alamy; **3.23:** Digital Image © The Museum of Modern Art/Licensed by SCALA/Art Resource, NY. Art © Jasper Johns/Licensed by VAGA, New York, NY; **3.24:** Erich Lessing/Art Resource, NY; **3.25:** Scala/Ministero per i Beni e le Attività culturali/Art Resource, NY; **3.26:** Réunion des Musées Nationaux/Art Resource, NY; **3.27:** © Copyright Wangechi Mutu, Digital Image © The Museum of Modern Art/Licensed by SCALA/Art Resource, NY; **3.28:** Scala/Ministero per i Beni e le Attività culturali/Art Resource, NY; **3.29:** David Hockney, "A Bigger Splash" 1967. Acrylic on canvas 96 × 96", © David Hockney. Collection Tate, London/Art Resource, NY; **3.30:** Margaret Lazzari/Image courtesy of the Author; **3.31:** KHALED DESOUKI/AFP/Getty Images; **page 70(b):** Image copyright © The Metropolitan Museum of Art. Image source: Art Resource, NY; **3.32:** Faith Ringgold. The Bitter Nest, Part II: The Harlem Renaissance Party. 1988. Acrylic on canvas with printed, dyed and pieced fabric. 94 × 83 in. (238.8 × 210.8 cm). Faith Ringgold © 1987; **3.33:** Werner Forman/Art Resource, NY; **3.34:** CNAC/MNAM/Dist. Réunion des Musées Nationaux/Art Resource, NY; **3.35:** vietphotography/Alamy; **3.36:** Alistair Laming/Alamy; **3.37:** Vincent West/Reuters; **3.38:** Yadid Levy/Alamy; **3.39:** Werner Forman/Art Resource, NY; **3.40:** John Bigelow Taylor/Art Resource, NY; **3.41:** Golf Bag, 1976 (ceramic), Levine, Marilyn (b.1935)/Private Collection/The Bridgeman Art Library; **3.42:** Smithsonian American Art Museum, Washington, DC/Art Resource, NY; **3.44:** Nimatallah/Art Resource, NY; **3.45:** Gavriel Jecan/Photodisc/Jupiter Images; **3.46:** Giraudon/Art Resource, NY; **3.47:** North Carolina Museum of Art/CORBIS. Art © The Joseph and Robert Cornell Memorial Foundation/Licensed by VAGA, New York, NY; **page 78(b):** Albright-Knox Art Gallery/Art Resource, NY. Art © Dedalus Foundation/Licensed by VAGA, New York, NY; **3.48:** The Museum of Modern Art/Licensed by SCALA/Art Resource, NY. Art © Robert Rauschenberg Foundation/Licensed by VAGA, New York, NY; **3.49:** Courtesy of Ann Page; **3.50:** Erich Lessing/Art Resource, NY; **3.51:** Art Resource, Inc. © 2014 Succession H. Matisse/Artists Rights Society (ARS), New York; **3.52:** John and Lisa Merrill/Terra/Corbis; **3.53:** Wolfgang Volz/laif/Redux; **page 82(b):** Árbol de la Vida, 1976. Lifetime color photograph. 10 × 8 inches (25.4 × 20.3 cm). © The Estate of Ana Mendieta Collection, Courtesy Galerie Lelong, New York; **3.54:** Suzanne Lacy; **3.55:** J. R. Eyerman/Time Life Pictures/Getty Images; **3.56:** CNAC/MNAM/Dist. RMN-Grand Palais/Art Resource, NY © Andreas Gursky/Courtesy Sprüth Magers/Artists Rights Society (ARS), New York; **3.57:** CNAC/MNAM/Dist. RMN-Grand Palais/Art Resource, NY © 2019 Artists Rights Society (ARS), New York/VG Bild-Kunst, Bonn/ADAGP, Paris; **3.58:** Sean Kelly Gallery, NY; **3.59:** Albright-Knox Art Gallery/Art Resource, NY. Tony Oursler, Junk, 2003, courtesy of the artist and Metro Pictures, New York.

Chapter 4: 4.1: Joseph Sohm/Visions of America/Encyclopedia/Corbis; **4.2:** AZA/Archive Zabé/Art Resource, NY; **4.3:** Dona Schlesier/Courtesy of the Author; **4.4:** Francis G. Mayer/Fine Art/Corbis; **4.5:** José Antonio Moreno/age fotostock/Alamy; **page 90(t):** Werner Forman/Art Resource, NY; **4.6:** Image copyright © The Metropolitan Museum of Art. Image source: Art Resource, NY; **4.7:** Rembrandt Harmensz. van Rijn (1606–69)/Rijksmuseum, Amsterdam, The Netherlands/The Bridgeman Art Library; **4.8:** Barbara Gladstone Gallery; **4.9:** Justin Lane/epa/Corbis Wire/Corbis; **4.10:** Alison Wright/Documentary Value/Corbis; **4.11:** Vietnamese School/The Art Gallery Collection/Alamy; **4.12:** Peter Horree/Alamy © 2019 Georgia O'Keeffe Museum/Artists Rights Society (ARS), New York; **4.13:** Blue Veil, © 1959 Morris Louis (1912–62)/Fogg Art Museum, Harvard University Art Museums, USA/Gift of Lois Orswell and Special Uses Fund/The Bridgeman Art Library; **4.14:** Schalkwijk/Art Resource, NY; **4.15:** Image copyright © The Metropolitan Museum of Art. Image source: Art Resource, NY © 2019 Estate

of Kay Sage/Artists Rights Society (ARS), New York; **4.16:** Digital Image © The Museum of Modern Art/Licensed by SCALA/Art Resource, NY; **4.17:** Untitled (Self-Portrait of Marilyn Monroe), 1982 (ektachrome photo), Sherman, Cindy (b.1954)/Museum of Fine Arts, Houston, Texas, USA/Gift A. Cadell and Cynthia Chapman/The Bridgeman Art Library. Courtesy of the artist and Metro Pictures, New York; **page 100(r):** Guerrilla Girls; **4.18:** Image copyright © The Metropolitan Museum of Art. Image source: Art Resource, NY; **4.19:** Judith and Holofernes, 1612–21 (oil on canvas), Gentileschi, Artemisia (1597–c.1651)/Galleria degli Uffizi, Florence, Italy/The Bridgeman Art Library; **4.20:** Marcio Lima/LatinContent/Getty Images; **4.21:** Charlotte Southern/Bloomberg/Getty Images; **page 102(l):** Robert Landau/Alamy.

103: Turning vase on pottery wheel in potter's workshop, Manama, Bahrain/DE AGOSTINI EDITORE/Bridgeman Images.

Chapter 5: 5.1: Images & Stories/Alamy; **5.2:** Bison carving, c.12000 BC (ivory), Paleolithic/Private Collection/Ancient Art and Architecture Collection Ltd./The Bridgeman Art Library; **5.3:** Erich Lessing/Art Resource, NY; **page 108(tl):** Stephen A. Edwards; **(tr):** Réunion des Musées Nationaux/Art Resource, NY; **(cl):** The Newark Museum/Art Resource, NY; **(cr):** Morandi Bruno/hemis.fr/Alamy; **(b):** Werner Forman/TopFoto/The Image Works; **page 109(tl):** Catalhoyuk Research Project; **(tc):** © Ashmolean Museum, University of Oxford; **(tr):** Shimizu Kohgeisha Co., Ltd. Permission Ryoko-in Management; **(cl):** Newark Museum/Art Resource, NY; **(cr):** Pei Cobb Freed & Partners; **(b):** Art Resource, NY/© estate of the artist, licensed by Aboriginal Artists Agency Ltd. Photography: Jennifer Steele; **page 110(t):** Bildarchiv Preussischer Kulturbesitz/Art Resource, NY; **(b):** Ali Meyer/Corbis; **page 111(tl):** The Art Archive/Fine Art/Corbis; **(tr):** The Art Gallery Collection/Alamy; **(c):** Smithsonian American Art Museum, Washington, DC/Art Resource, NY; **(bl):** Werner Forman/Art Resource, NY; **(br):** Lindsay Hebberd/CORBIS; **5.4:** Jean Vertut; **5.5:** Art Resource, NY/© estate of the artist, licensed by Aboriginal Artists Agency Ltd. Photography: Jennifer Steele; **5.6:** © Charles & Josette Lenars/CORBIS; **page 113(b):** Gianni Dagli Orti/The Picture Desk Limited/CORBIS; **5.7:** Sue Coe: There Is No Escape. 1998. Copyright © 1998 Sue Coe. Courtesy Galerie St. Etienne, New York; **5.8:** "Hydria (water jug)." Greek, Archaic period, ca. 520 b.c.e. Attributed to the Priam Painter. Greece, Athens. Ceramic, black-figure, 0.53 m in height and 0.37 m in diameter (with handles). William Francis Warden Fund. © Museum of Fine Arts, Boston. Accession #61.195; **5.9:** © Ashmolean Museum, University of Oxford; **5.10:** The Newark Museum/Art Resource, NY; **5.11:** Newark Museum/Art Resource, NY; **5.12:** Superintendent of the National Museum of Prehistory and Ethnography L. Pigorini. Rome • reproductions and photographic rights (Chapter 29, Sec. 2S84.art. 3); **5.13:** © 2019 The Andy Warhol Foundation for the Visual Arts, Inc./Licensed by Artists Rights Society (ARS), New York; **5.14:** Réunion des Musées Nationaux/Art Resource, NY; **5.15:** © 2004 The Whitney Museum of American Art. © Wayne Thiebaud/Licensed by VAGA, New York, NY; **5.16:** Shimizu Kohgeisha Co., Ltd. Permission Ryoko-in Management; **5.17:** Werner Forman/TopFoto/The Image Works; **5.18:** Artichoke, halved, 1930 (gelatin silver print), Weston, Edward Henry (1886–1958)/Fred Jones Jr. Museum of Art, University of Oklahoma, USA/Museum Purchase 1937/The Bridgeman Art Library © 2019 Center for Creative Photography, Arizona Board of Regents/Artists Rights Society (ARS), New York; **5.19:** The Gallery Collection/Corbis; **5.20:** Just Art Gallery; **5.21:** Freer Gallery of Art, Smithsonian Institution, Washington, D.C.: Gift of Charles Lang Freer, Fl899.83; **5.22:** © 2019 Judy Chicago/Artists Rights Society (ARS), New York; **5.23:** © Estate of Duane Hanson/Licensed by VAGA, New York, NY; **5.24:** © Janine Antoni. Courtesy of the artist and Luhring Augustine, New York; **5.25:** Timothy Hursley; **5.26:** Catalhoyuk Research Project; **5.27:** Dewitt Jones/CORBIS; **5.28:** Morandi Bruno/hemis.fr/Alamy; **5.29:** Scala/Art Resource, NY; **5.30:** Scala/Art Resource, NY; **page 128(c):** Erich Lessing/Art Resource, NY; **5.31:** Model of a Multi-Storied Tower, Chinese, 1st century C.E., Eastern Han Dynasty (25-220 C.E.). Earthenware with unfired pigments, 52 × 33½ × 27 inches (132.1 × 85.1 × 68.6 cm). The Nelson-Atkins Museum of Art, Kansas City, Missouri. Purchase: William Rockhill Nelson Trust, 33-521; **5.32:** Annie Owen/Robert Harding World Imagery/Corbis; **5.33:** Werner Forman/Art Resource, NY; **5.34:** H. Mark Weidman Photography/Alamy; **5.35:** Scala/Art Resource, NY; **page 132(b):** JP Collection/Cengage Learning; **5.36:** Stephen A. Edwards; **page 133(l):** Richard Glover/Terra/Corbis; **5.37:** Tibor Bognar/Alamy; **5.38:** Pei Cobb Freed & Partners; **5.39:** Philip Scalia/Alamy; **5.40:** AP Images/Carlos Osorio; **page 136(b):** Tibor Bognár/Terra/Corbis.

Chapter 6: 6.1: Ellen McKnight/Alamy. Reproduced by permission of The Henry Moore Foundation; **6.2:** Gianni Dagli Ort/The Art Archive at Art Resource, NY; **page 140(t):** akg/De Agostini Pict. Lib; **(cl):** © The Trustees of the British Museum; **(c):** Male figure (love doll) Potawatomi, 1800–60 (wood & wool fabric), American School, (19th century)/Cranbrook Institute of Science, Michigan, US/Photo © The Detroit Institute of Arts/The Bridgeman Art Library; **(cr):** Standing Female Figure, Bamana, Mali, 19th–20th century (wood, copper, beads and metal)/Detroit Institute of Arts, USA/Bequest of Robert H. Tannahill/The Bridgeman Art Library; **(bl):** Museo Larco, Lima—Perú; **(br):** North Carolina Museum of Art/Fine Art/Corbis; **page 141(tl):** Scala/Art Resource, NY; **(tc):** Victoria & Albert Museum, London/Art Resource, NY; **(tr):** The Trustees of The British Museum/Art Resource, NY; **(bl):** Charles Walker/Topfoto/The Image Works; **(br):** © The Trustees of the British Museum; **page 142(tr):** Erich Lessing/Art Resource, NY; **(c):** Library of Congress Prints and Photographs Division [LC-DIG-fsa-8b29516]; **(bl):** U.S. National Library of Medicine; **(br):** Digital Image: The Museum of Modern Art/Licensed by SCALA/Art Resource, NY. Art © Marisol Escobar/Licensed by VAGA, New York, NY; **page 143(tl):** Araldo de Luca/Corbis Art/Corbis; **(tcl):** Araldo de Luca/Fine Art Premium/Corbis; **(tcr):** © Gianni Dagli Orti/Fine Art/Corbis; **(tr):** Erich Lessing/Art Resource, NY; **(bl):** Dominique Darbois; **(br):** © Copyright Wangechi Mutu, Digital Image © The Museum of Modern Art/Licensed by SCALA/Art Resource, NY; **6.3:** Ali Meyer/Corbis; **6.4:** © Ashmolean Museum, University of Oxford; **6.5:** © The Trustees of the British Museum; **6.6:** © The Trustees of the British Museum; **6.7:** Scala/Art Resource, NY; **6.8:** Male figure (love doll) Potawatomi, 1800–60 (wood & wool fabric), American School, (19th century)/Cranbrook Institute of Science, Michigan, US/Photo © The Detroit Institute of Arts/The Bridgeman Art Library; **6.9:** Standing Female Figure, Bamana, Mali, 19th–20th century (wood, copper, beads and metal)/Detroit Institute of Arts, USA/Bequest of Robert H. Tannahill/The Bridgeman Art Library; **6.10:** North Carolina Museum of Art/Fine Art/Corbis; **6.11:** Scala/Art Resource, NY; **6.12:** Image copyright © The Metropolitan Museum of Art/Art Resource, NY; **6.13:** © National Gallery, London/Art Resource, NY; **6.14:** The Art Archive at Art Resource, NY; **6.15:** Scala/Art Resource, NY; **6.16:** Museo Larco, Lima—Perú; **page 154(l):** Museum of Fine Arts, Boston; **6.17:** The Trustees of The British Museum/Art Resource, NY; **6.18:** Victoria & Albert Museum, London/Art Resource, NY; **6.19:** Charles Walker/Topfoto/The Image Works; **page 157(b):** Paul Panayiotou/Corbis; **6.20:** Réunion des Musées Nationaux/Art Resource, NY; **page 158(b):** Scala/Ministero per i Beni e le Attività culturali/Art Resource, NY; **6.21:** Réunion des Musées Nationaux/Art Resource, NY; **6.22:** Lynn Hershman; **6.23:** Zindman/Fremont/Mary Boone Gallery; **6.24:** courtesy Regen Projects, Los Angeles © Catherine Opie; **6.25:** Metropolitan Museum of Art, New York © 2004 The Georgia O Keeffe Foundation/Artists Rights Society (ARS), New York./Art Resource, NY; **6.26:** Hirshhorn Museum and Sculpture Garden; **6.27:** Photo: Allan Finkelman. Art © The Easton Foundation/Licensed by VAGA, New York, NY; **6.28:** Robert Miller Gallery; **6.29:** Photograph © Justin Kerr; **6.30:** Museo Larco, Lima—Perú; **6.31:** akg/De Agostini Pict. Lib; **6.32:** Nursing-mother-effigy bottle, Cahokia Culture, Mississippian Period, 1200–1400 (ceramic), American School/St. Louis Museum of Science & Natural History, Missouri, US/Photo © The Detroit Institute of Arts/The Bridgeman Art Library.

Chapter 7: 7.1: Catalog #16/6770 AB, Courtesy, Division of Anthropology, American Museum of Natural History; **7.2:** Réunion des Musées Nationaux/Art Resource, NY; **page 170(tl):** Catalog #16/6770 AB, Courtesy, Division of Anthropology, American Museum of Natural History; **(tc):** © Sylvain Sonnet/Corbis; **(tr):** Skyscan/Terra/Corbis; **(cl):** Kennet Havgaard/Aurora/Getty Images; **(cr):** Francis G. Mayer/Fine Art/Corbis; **(bl):** Gianni Dagli Orti/The Picture Desk Limited/Corbis; **(br):** Nail figure (nkisi n'kondi) Yombe, Congo (mixed media), African School, (19th Century)/Detroit Institute of Arts, USA/Founders Society Purchase/Eleanor Clay Ford Fund for African Art/The Bridgeman Art Library; **page 171(tl):** Nimatallah/Art Resource, NY; **(tcl):** © J. Paul Getty Trust. The Getty Research Institute, Los Angeles (96.P.21); **(tcr):** Andy Clarke/Shutterstock.com; **(tr):** eye35.pix/Alamy; **(bl):** © Kelly-Mooney Photography/Corbis; **page 172(tl):** Richard A Cooke III/The Image Bank/Getty Images; **(tr):** Andrea Jemolo/Fine Art/Corbis; **(bl):** Alistair Laming/Alamy; **(br):** Scala/Art Resource, NY; **page 173(tl):** © Roger Wood/Corbis; **(tr):** © Paul Almasy/Corbis; **(cl):** Erich Lessing/Art Resource, NY; **(cr):** Giraudon/Art Resource, NY; **(bl):** Erich Lessing/Art Resource, NY; **(bc):** © Peter Adams/Corbis; **(br):** Art Resource, Inc. © 2014 Succession H. Matisse/Artists Rights Society (ARS), New York;

7.3: Nimatallah/Art Resource, NY; **7.4:** Nimatallah/Art Resource, NY; **7.5:** Sandro Vannini; **7.6:** Gianni Dagli Orti/The Picture Desk Limited/Corbis; **7.7:** Angelo Hornak/Corbis Art/Corbis; **7.8:** Hemis/Alamy; **7.9:** Benoy K. Behl; **page 179(t):** Robert Harding World Imagery; **7.10:** Guanyin of the Southern Sea, Chinese, Liao (907–1125) or Jin Dynasty (1115–1234). Wood with polychrome, 95 × 65 inches (241.3 × 165.1 cm). The Nelson-Atkins Museum of Art, Kansas City, Missouri. Purchase: William Rockhill Nelson Trust, 34-10; **7.11:** Erich Lessing/Art Resource, NY; **7.12:** Francis G. Mayer/Fine Art/Corbis; **7.13:** The Art Archive at Art Resource, NY; **7.14:** Art Resource, NY; **page 184(b):** Just Art Gallery; **7.15:** Jorge Durand; **7.16:** Hans Kemp/Alamy; **7.17:** Erich Lessing/Art Resource, NY; **7.18:** Photograph (c) Justin Kerr; **page 187(b):** Image copyright © The Metropolitan Museum of Art. Image source: Art Resource, NY; **7.19:** Ahola Kachina, Jimmy Kewanwytewa, 1942, Courtesy of the Museum of Northern Arizona, E690b; **7.20:** Nail figure (nkisi n'kondi) Yombe, Congo (mixed media), African School, (19th century)/Detroit Institute of Arts, USA/Founders Society Purchase/Eleanor Clay Ford Fund for African Art/The Bridgeman Art Library; **7.21:** Kennet Havgaard/Aurora/Getty Images; **7.22:** The Newark Museum/Art Resource, NY; **7.23:** Courtesy Israel Antiquities Authority; **7.24:** Michael S. Yamashita/Corbis **page 192(t):** Annie Owen/Robert Harding World Imagery/Corbis; **7.25:** Sylvain Grandadam/age footstock; **7.26:** Skyscan/Terra/Corbis; **7.27:** © Sylvain Sonnet/Corbis; **7.28:** Lowell Georgia/Corbis; **7.29:** Jens Stolt/Shutterstock.com; **7.30:** Andy Clarke/Shutterstock.com; **7.32:** Adam Crowley/Photodisc/Getty Images; **page 200(b):** © Roger Wood/Corbis; **7.33:** Nimatallah/Art Resource, NY; **7.34:** © Kelly-Mooney Photography/Corbis; **7.35:** Scala/Art Resource, NY; **7.36:** Paul Panayiotou/Corbis; **7.38:** eye35.pix/Alamy; **7.39:** © Alinari Archives/Corbis; **7.40:** © Angelo Hornak/Corbis; **7.41:** Roger Wood/Corbis; **7.42:** © J. Paul Getty Trust. The Getty Research Institute, Los Angeles (96.P.21); **7.43:** Robert Harding Picture Library Ltd/Alamy; **7.44:** Reproduction of the fresco from the Palace of Tepantitla (fresco), Teotihuacan/Museo Nacional de Antropologia, Mexico City, Mexico/Jean-Pierre Courau/The Bridgeman Art Library.

Chapter 8: 8.1: The Fine Arts Museum of San Francisco; **8.2:** Carmen Redondo/Corbis Art/Corbis; **page 216(tl):** Araldo de Luca/Corbis Art/Corbis; **(tr):** Geray Sweeney/Encyclopedia/Corbis; **(cl):** AP Images/Ron Edmonds; **(cr):** Adam Eastland Italy/Alamy; **(bl):** Dr. Chris Donnan; **(br):** © Christie's Images/Corbis; **page 217(tl):** Image copyright © The Metropolitan Museum of Art. Image source: Art Resource, NY; **(tc):** Scala/Art Resource, NY; **(tr):** Thomas Coex/AFP/Getty Images; **(bl):** The innermost coffin of the king, from the Tomb of Tutankhamun (c.1370–1352 BC) New Kingdom (gold inlaid with semi-precious stones) (for detail see 343642), Egyptian 18th Dynasty (c.1567–1320 BC)/Egyptian National Museum, Cairo, Egypt/Photo © Boltin Picture Library/The Bridgeman Art Library; **(bc):** Sheldan Collins/Encyclopedia/Corbis; **(br):** Helmet Mask (tatanua), Northern New Ireland, Papua New Guinea, late 19th century (wood, paint and opercula shells) (see also 169883), New Guinean, (19th century)/Museum of Fine Arts, Houston, Texas, USA/The Bridgeman Art Library; **page 218(tl):** The Ancient Art & Architecture Collection; **(tc):** Erich Lessing/Art Resource, NY; **(tr):** © The Trustees of the British Museum; **(c):** National Anthropological Archives, Smithsonian Institution [NAA MS 2367a (Inv. 08569200)]; **(bl):** Erich Lessing/Art Resource, NY; **(br):** Library of Congress Prints and Photographs Division [LC-B811-3175]; **page 219(t):** Erich Lessing/Art Resource, NY; **(bl):** Werner Forman/Art Resource, NY; **(bc):** David Hockney, "A Bigger Splash" 1967. Acrylic on canvas 96 × 96", © David Hockney. Collection Tate, London/Art Resource, NY; **(br):** © Kiki Smith, courtesy Pace Gallery. Digital Image © The Museum of Modern Art/Licensed by SCALA/Art Resource, NY; **8.3:** Geray Sweeney/Encyclopedia/Corbis; **page 220(t):** Skyscan/Terra/Corbis; **8.4:** Eugen Strouhal-Werner Forman Archive/Art Resource, N.Y.; **8.5:** The innermost coffin of the king, from the Tomb of Tutankhamun (c.1370–1352 BC) New Kingdom (gold inlaid with semi-precious stones) (for detail see 343642), Egyptian 18th Dynasty (c.1567–1320 BC)/Egyptian National Museum, Cairo, Egypt/Photo © Boltin Picture Library/The Bridgeman Art Library; **8.6:** Erich Lessing/Art Resource, NY; **8.7:** Free Agents Limited/Encyclopedia/Corbis; **8.8:** Araldo de Luca/Corbis Art/Corbis; **8.9:** © BeBa/Iberfoto/The Image Works; **8.10:** Superstock; **8.11:** Thomas Coex/AFP/Getty Images; **8.12:** Dr. Chris Donnan; **page 228(t):** Werner Forman/TopFoto/The Image Works; **8.13:** Dr. Chris Donnan; **8.14:** Yvette Cardozo/Alamy; **8.15:** Marie Mauzy/Art Resource, NY; **8.16:** Scala/Art Resource, NY; **page 232(b):** © Gianni Dagli Orti/Fine Art/Corbis; **8.17:** Adam Eastland Italy/Alamy; **page 233(b):** Adam Woolfitt/Terra/Corbis; **8.18:** Scala/Art Resource, NY; **8.19:** akg/Bildarchiv Monheim; **8.20:** Sheldan Collins/Encyclopedia/Corbis; **8.21:** Image copyright © The Metropolitan

Museum of Art. Image source: Art Resource, NY; **8.22:** Christie's Images/Corbis **8.23:** JP Collection/Cengage Learning; **8.24:** Tate, London/Art Resource, NY; **8.25:** Schalkwijk/Art Resource, NY © 2019 Banco de México Diego Rivera Frida Kahlo Museums Trust, Mexico, D.F./Artists Rights Society (ARS), New York; **8.26:** Helmet Mask (tatanua), Northern New Ireland, Papua New Guinea, late 19th century (wood, paint and opercula shells) (see also 169883), New Guinean, (19th century)/Museum of Fine Arts, Houston, Texas, USA/The Bridgeman Art Library; **8.27:** Mario Savoia/Shutterstock.com; **8.28:** AP Images/Ron Edmonds; **8.29:** Rommel Pecson/The Image Works; **8.30:** John Kellerman/Alamy.

Chapter 9: 9.1: Yoshio Tomii/SuperStock; **9.2:** Museum of Fine Arts, Boston; **page 248(t):** National Anthropological Archives, Smithsonian Institution [NAA MS 2367a (Inv. 08569200)]; **(cr):** The Gallery Collection/Corbis © 2019 Estate of Pablo Picasso/Artists Rights Society (ARS), New York; **(bl):** David Cole/Alamy; **(br):** Schuster; **page 249(tl):** Alinari Archives/The Image Works; **(tr):** © pinggr/Shutterstock.com; **(cr):** Museum of Fine Arts Boston; **(bl):** Erich Lessing/Art Resource, NY; **(br):** age footstock/SuperStock; **page 250(tl):** Eugen Strouhal-Werner Forman Archive/Art Resource, N.Y.; **(tc):** Superstock Inc; **(tr):** Richard Glover/Terra/Corbis; **(bl):** Persian School/The Art Gallery Collection/Alamy; **(b):** Sheldan Collins/Encyclopedia/Corbis; **(br):** Joseph Sohm/Visions of America/Encyclopedia/Corbis; **page 251(tl):** King K'inich Janaab Pakal I, portrait head from the Temple of the Inscriptions, Mayan classical epoch, 7th century (stucco)/Museo Nacional de Antropologia, Mexico City, Mexico/The Bridgeman Art Library; **(tr):** Christophe Loviny/Corbis; **(bl):** Giraudon/Art Resource, NY; **(bc):** Peter Adams/Corbis; **(br):** Mark Karrass/Corbis; **9.3:** Museum of Fine Arts, Boston; **9.4:** Superstock; **9.5:** Werner Forman/Fine Art Value/Corbis; **9.6:** Erich Lessing/Art Resource, NY; **page 254(t):** age footstock/SuperStock; **(bl):** Christie's Images/Corbis; **9.7:** Cloak and feather hat, Hawaiian School/Museo de America, Madrid, Spain/© Paul Maeyaert/The Bridgeman Art Library; **9.8:** National Museum of the American Indian, Smithsonian Institution (14/1174). Photo by Ernest Amoroso; **9.9:** The Kobal Collection at Art Resource, NY; **9.10:** Alinari Archives/The Image Works; **9.11:** SEF/Art Resource, NY; **9.12:** David Cole/Alamy; **9.13:** © robinimages2013/Shutterstock.com; **9.14:** Thomas Coex/AFP/Getty Images; **9.15:** The Art Institute of Chicago/Art Resource, NY; **page 262(l):** By kind permission of the Trustees of the Wallace Collection, London/Art Resource, NY; **9.16:** r.nagy/Shutterstock.com; **9.17:** age fotostock/SuperStock; **9.18:** Luke Daniek/iStockphoto; **9.19:** szabozoltan/Shutterstock.com; **9.20:** Schuster; **9.21:** © President and Fellows of Harvard College, Peabody Museum of Archaeology and Ethnology, PM# 16-43-50/B1481; **page 267(t):** Danilo Ascione/Shutterstock.com; **9.22:** © pinggr/Shutterstock.com; **9.23:** Jurgen Liepe; **9.24:** Museum of Fine Arts Boston; **9.25:** Library of Congress Prints and Photographs Division [LC-B811-3175]; **9.26:** National Anthropological Archives, Smithsonian Institution [NAA MS 2367a (Inv. 08569200)]; **9.27:** The Kobal Collection at Art Resource, NY; **9.28:** The Gallery Collection/Corbis © 2019 Estate of Pablo Picasso/Artists Rights Society (ARS), New York; **9.29:** Martin Child/Digital Vision/Getty Images; **9.30:** Siri Stafford/Iconica/Getty Images; **page 274(b):** Scala/Art Resource, NY; **9.31:** AP Images/Eddie Adams; **9.32:** Edward Hicks (American, 1780–1849). The Peaceable Kingdom, ca. 1833–1834. Oil on canvas, 17 7/16 × 23 9/16 in. (44.3 × 59.8 cm). Brooklyn Museum, Dick S. Ramsay Fund, 40.340; **9.33:** Scala/Art Resource, NY; **9.34:** Kunsthistorisches Museum; **9.35:** The Detroit Institute of Arts/Bridgeman Art Library.

Chapter 10: 10.1: Galerie Lelong; **10.2:** Gianni Dagli Orti/Fine Art/Corbis; **page 282(t):** Art © Estate of Ben Shahn/Licensed by VAGA, New York, NY; **(bl):** Museum of Latin American Art; **(bc):** Bronx Museum of the Arts/Courtesy Ronald Feldman Fine Arts, New York; **(br):** Erich Lessing/Art Resource, NY; **page 283(t):** RMN-Grand Palais/Art Resource, NY; **(cl):** CNAC/MNAM/Dist. Réunion des Musées Nationaux/Art Resource, NY; **(cr):** Digital Image © The Museum of Modern Art/Licensed by SCALA/Art Resource, NY; **(bl):** Marian Goodman Gallery; **(br):** National Gallery of Art, Canberra © Ramingining Community/Copyright Agency. Licensed by Artists Rights Society (ARS), New York, 2019; **page 284(t):** John Bigelow Taylor/Art Resource, NY; **(c):** Image copyright © The Metropolitan Museum of Art/Art Resource, NY; **(bl):** J. R. Eyerman/Time Life Pictures/Getty Images; **(br):** Réunion des Musées Nationaux/Art Resource, NY; **page 285(t):** Judith and Holofernes, 1612–21 (oil on canvas), Gentileschi, Artemisia (1597–c.1651)/Galleria degli Uffizi, Florence, Italy/The Bridgeman Art Library; **(bl):** Smithsonian American Art Museum, Washington, DC/Art Resource, NY; **(bc):** Smithsonian American Art Museum, Washington, DC/Art Resource, NY. Baca, Judith F. (b. 1946) Las Tres Marias. 1976. Colored pencil on paper mounted on

INDEX

Page numbers in *italics* refer to pages that contain illustrations.